SEBASTIÃO SALGADO WORKERS

WOR

SEBASTIÃO SALGADO

KERS

AN ARCHAEOLOGY OF THE INDUSTRIAL AGE

AN APERTURE BOOK

Conception and design by LÉLIA WANICK SALGADO

Duotone separations and printing by
Offset-Litho JEAN GENOUD SA,
Le Mont-Lausanne, Switzerland.
Composition by DANIELLE WHITESON.
Reproduction prints by ISABELLE MENU.

The Staff at Aperture for WORKERS is
MICHAEL E. HOFFMAN, Executive Director
REBECCA BUSSELLE, Editor
MICHAEL SAND, Managing Editor
WENDY BYRNE, Designer
STEVAN BARON, Production Director
SANDRA GREVE, Production Associate
JENNY ISAACS, Editorial Work Scholar

APERTURE publishes a periodical, books,
and portfolios of fine photography to
communicate with serious photographers
and creative people everywhere.
A complete catalog is available upon request.
The address is: 20 East 23rd Street,
New York, New York 10010

10 9 8 7 6

Mr. Salgado's endeavors on this project
and the publication of this book
have been underwritten by
the Professional Imaging business unit
of Eastman Kodak Company
through its continuing support of
photography in journalism.

This book is an homage to workers,
a farewell to a world of manual labor
that is slowly disappearing and a
tribute to those men and women who
still work as they have for centuries.

These photographs tell the story of an era. The images offer a visual archaeology of a time that history knows as the Industrial Revolution, a time when men and women at work with their hands provided the central axis of the world.

Concepts of production and efficiency are changing, and, with them, the nature of work. The highly industrialized world is racing ahead and stumbling over the future. In reality, this telescoping of time is the result of the work of people throughout the world, although in practice it may benefit few.

The developed world produces only for those who can consume— approximately one-fifth of all people. The remaining four-fifths, who could theoretically benefit from surplus production, have no way of becoming consumers. They have transferred so many of their resources and wealth to the prosperous world that they have no way of achieving equality.

So the planet remains divided, the first world in a crisis of excess, the third world in a crisis of need, and, at the end of the century, the second world—that built on socialism—in ruins.

The destiny of men and women is to create a new world, to reveal a new life, to remember that there exists a frontier for everything except dreams. In this way, they adapt, resist, believe, and survive.

History is above all a succession of challenges, of repetitions, of perseverances. It is an endless cycle of oppressions, humiliations, and disasters, but also a testament to man's ability to survive. In history there are no solitary dreams; one dreamer breathes life into the next.

The worker in the sugarcane fields is a warrior. The machete, his long knife, is his sword. He lives in a hostile world, the cane leaf is sharp, he must fight against the leaves, he suffers cuts, he becomes coated in the black grime of cane burned before it is slashed.

I knew warriors of the cane fields in Cuba and in Brazil. They live far from each other, but they think in the same way, play in the same way, talk in the same way. They are gentle and they are aggressive. They rest, they laugh aloud, they stretch out on the ground.

Yet a fundamental difference exists. The Cuban warrior is a hard-working hero who is proud of his war. He is well treated by his boss, the state. In Brazil, by contrast, trucks that leave the outskirts of small provincial towns at dawn take him to the battlefields. Then, as often as not, he ends up working on land that once belonged to him or fellow warriors. Today, Brazil's warriors are mere day laborers: increased use of sugarcane alcohol as a gasoline substitute led large companies to buy up small farms once dedicated to food production. Brazil's wild inflation then eroded the proceeds from the small plots. Now they are virtually slaves of the truckers, who collect them, receive their money, and hand out their meager wages. The workers are known as *boias-frias*, meaning "cold lunch." They take their food in little tin boxes, they eat it silently, unheated. They chew the cold beans that taste of defeat.

Galicia is a beautiful land, one of legends and mists. Its estuaries are like fjords: deep waters, trapped in bays formed by sharp cliffs, emerge from immense forests before tumbling into the sea. Galicia has many estuaries, or *rias*, and I worked in several of them. In Vigo, I found the peasant women of the sea.

Mothers, usually fishermen's wives, they work in the canning factories. Yet, as each day passes, more lose their jobs. The fish-freezing plants are putting the canning industry out of business. Galicia still feels old, but it is experiencing change. Fishing is no longer what it was, the old canning industry is dying, ancient factories are in a state of abandonment.

They are strong and handsome, even sensual, these peasant women of the

sea who hoe the land at low tide. They are peasants because fishing for *almejas*, which are like clams, is not fishing but harvesting. The *almeja* is cultivated, left to grow on the bottom of the sea near the coast. Then, with October and the largest tides of the year, the water recedes one or two miles from the shoreline and women come to pick their crop every day for two to three months.

But even this tradition now runs the risk of becoming part of the legends and mists of Galicia. In Vigo, a few fishing cooperatives still survive. Their boats bouncing gently on the water of the *ria* are part of the scenery.

Vigo Bay is ever more polluted by the waste of the 300,000 people who live around it. The fisherman's son is no longer a fisherman. Industrial fishing has replaced family fishing. On the high seas, boats no longer fish for Galicia; they fish for the whole world.

But the women do not belong to this world. Their feet stand on the muddy flats of the *ria*, the wind blows in their face. What can they remember, these peasant women of the waters, as they pull the fruit of the sea at low tide? Why do they smile?

The island stands in the Indian Ocean between Madagascar and Mauritius. It is called Réunion and, since the seventeenth century, it has been a French overseas territory. A beautiful volcanic island, it stretches from ten thousand feet below the waves to ten thousand feet above sea level. The island is a curious whim of God: a mountain cut exactly in half by the waterline. It has no continental shelf. A few yards from the shore, the precipice begins. And no fish live in these waters.

It is an island of perfume. From it come the purest essences of geranium, vetiver, and vanilla. Those of geranium and vetiver serve as fixatives in industrial perfume production. Without them, for example, the scent of rose would evaporate in a few seconds. Réunion's output is small but its quality serves as a standard. For many years, it was a major world producer. But France's disastrous agricultural policies in its overseas territories have resulted in production levels that are 15 percent of what they were thirty years ago.

The inhabitants of Réunion are French citizens. Those who work in the production of perfumes and essences are special citizens: they are barefoot Frenchmen.

Earning a wage far below the legal minimum in France, they live tucked away on the terraces of that volcanic land. Their work is hard and lonely. Their past is lost in time, perhaps in Corsica, perhaps in Brittany. And now these barefoot Frenchmen produce just a few bottles of perfume each year. For days on end, they work in small, smoky copper stills, counting the drops of perfume. Then they walk for hours down the mountains, carrying their pure but scanty treasure.

Far from Réunion, their weeks of work will be trapped in tiny flasks of perfume. These barefoot Frenchman will never be able to buy the result of their labor. But they will never need to buy it: Réunion is impregnated with the purest of perfumes and nothing can imprison its essence.

Cocoa has a strange fate. The price of every product that includes it never stops rising, yet the price of cocoa itself never ceases to fall. On the other hand, perhaps it is not so strange. As with so many other commodities, the price is set by those who have never produced it.

Many cocoa trees are over one hundred years old, verdant, generous, in ancient shapes, as if they come from other times, phantasmagorical trees of strange designs, unexpected caprices. Yet they are also fragile: cocoa trees are protected by other enormous fruit trees because the cocoa needs shade and humidity. It cannot face the sun because it carries the sun in its very fruit.

The fruit trees that protect the cocoa trees also shade the cocoa pickers, asphyxiated by heat and humidity, who earn so little that even the fruit falling from the trees helps to feed them. And from the sweet milk that oozes from the open fruit the cocoa provides pure energy.

The women who collect cocoa wrap turbanlike cloths around their heads to protect them from the cocoa fruit as it falls to the ground. They wear tall boots as a protection against the snakes that live in the trees.

The cocoa people are open, they sing and dance. Much loving goes on in

the plantations, and the children to be seen wandering in that sensual heat are children of the heat of the cocoa. In the swirl of heat, humidity, and shade, the party in the cocoa fields is intimate. Nothing is sinful. Everything is energy and life. A powerful vigor shines from bodies that reach out to each other among the trees.

Working with tobacco is sweet and gentle. It can be compared to making bread: it is ancient, meticulous, exact, unique work. In the fields, the tobacco picker wears a hat much like that of a baker: it is made of cloth because a straw hat could harm the delicate tobacco leaves.

The leaves are collected almost ceremoniously. The baskets are lined with cloth like warm cradles, and the leaves are placed inside them like sleeping babies. Everything to do with tobacco is a ritual.

The tobacco houses are made of wood, and this wood exhales tobacco. The leaves are kept there for two or three years. They are rolled into cigars by female hands. And while the hands work, the cigars grow to the sound of poems, words, and songs. The room is large and airy and, in front of the cigar makers, a person sits whose job it is to read aloud.

He gently scatters words that help the mind travel while fingers and palms gently roll the cigars, the leaves capturing the dreams that will rise in clouds of smoke.

They had all the time in the world to grow old, yet there they are in Sicily, as if the Middle Ages were just dawning. But now, suddenly, they are also disappearing.

At the end of World War II, more than thirty groups of Sicilian fishermen would, with the punctuality of the tides, participate in the ceremony of *La Mattanza,* the great annual catch of tuna. Today only two groups sustain the tradition.

The Mediterranean is also dying from pollution, and its death has frightened off the tuna. But there is another curse: industrial fishing carried out by many nations, above all Japan, is decimating fish stocks. The old Sicilian *Mattanzas* were always carried out with special nets that caught only large tuna, those that leave

the warm waters of the Atlantic at a certain time of the year and head for the Mediterranean to breed.

The fishermen stretch huge nets close to the shore, isolating the escape routes and creating an endless labyrinth. The tuna can never turn back, forced to keep going until trapped in the chamber of death.

La Mattanza is a unique spectacle. In charge of it is the *raiz,* the grand master, the great fisherman, the man who holds the secrets to the fish, the currents, the tides. Once the tuna are inside the chamber, the men begin to draw in the nets, bringing the tuna toward their death. And the men sing their thanks with reverence as they slowly close the chamber. Once the nets are pulled up, they bring with them hundreds of tuna, and the sea begins to boil with the thrashing of bodies and tails that sprinkle the light of their silver as they try to escape into the sky. Then, with great iron hooks, the fishermen pull the wounded tuna aboard.

The fish are taken to the tuna factory at San Cusumano. There the Japanese wait with cloths on their heads and sharp knives in their hands. The tuna is bled and its white meat is shipped to Japan. Only the head, the entrails, the tail, and the smell of blood stay behind in Italy.

The old weaving mills still used in Bangladesh are like a sound shell, a strange symphony played by the wooden looms, the friction of fiber, swirling soot in the air, and tiny threads dancing and hiding in light. From them come the cloths that wrap around bodies in motion, the delicate weavings of unexpected colors and designs that become saris.

Textile production is part of Bangladesh's tradition because its main export is jute, the very best in the world. But behind this production hides a cruel irony: sales rise sharply whenever a war is taking place in some far-off country. There is nothing to match a sack made of jute fiber when it comes to protecting a trench or barricade. When it is struck by a bullet, the fiber does not tear. Rather, it makes a hole that is quickly sealed by pressure of the sand inside the sack.

The textile factories in Bangladesh are old, built by the British at the turn of the century. They are magnificent and noisy. Their workers are cordial and deli-

cate. Even in such an atmosphere, they do not lose their gentle grace. And the workers of Bangladesh toil twice as hard in times of war.

Facing the shores of Bangladesh, the ship blows its sharp whistle for a last time. It puts its engine on full speed and heads for the land, wailing and groaning as it reaches a speed that it would never have dared risk at sea. Its steel hull scrapes the sand, reaching into the earth from where it came. Then it stops, grounded, the end of its final charge, its last journey.

The demolition soon follows, as if this moment had not always hovered over the ship. There it is, stuck in the sand of the most faraway beach in the world, the same world that it wandered when it sliced smoothly through deep waters. Now the demolition teams use blowtorches to cut open its belly so that water can at last invade its bowels, condemning it to death. It is a coup de grace, a tired and dignified end that will result in new life.

Soon the ship is attacked from all sides. Blowtorches cut through its steel skin, giant hammers break up its iron and wood structure. Everything from that huge animal lying on the beach has a use. Iron and steel will be melted down and given new roles as utensils. The entire ship will be turned into what it once carried: machines, knives and forks, hoes, shovels, screws, things, bits, pieces. In time, the sea will make sure that the scar left by the ship will disappear under the sand of that beach in Bangladesh. And the ship itself will be carried away.

The huge bronze propellers that guided the ship through the secret paths of the sea will provide the most elegant of items—bracelets, earrings, necklaces, and rings, which one day will adorn the bodies of working women, as well as pots from which men will pour tea.

When I was a boy, I would travel with my mother to Belo Horizonte, the capital of my home state. We would go by train, and we would have to change trains. Then, at a certain moment, we would go through the Vale do Aco, the Valley of Steel, where the great steel complexes of Minas Gerais were located. And it was then that I would see the spectacle of fire lighting up the night,

chimneys throwing out vast clouds of fire—and nothing impressed me more.

To this day, steel making is for me an almost religious exercise. And the high priest of this institution called production is the steelworker.

For me, the mills are like huge, powerful gods who rule the frightening production of metal that dominates our system. Everything inside is violent, disproportionate, and dangerous. The steelworker knows full well that he works on the frontier of death, between rivers of liquid fire, around caldrons of hell. He also knows that through steel the world is controlled.

It was in one such factory that I found the ratman: his job is to smell gas, to look for leaks beneath the red-hot caldrons. His job is to find the smell of death. He works in the catacombs of the cathedral of fire. He is furtive, he hides, he escapes.

The steelworker has an exemplary nobility, a unique posture: he looks at those who come from the outside with a certain condescension. He dominates the industrial world.

When his workday is over, he casts off his asbestos suit and becomes one of us. He loses his mystery, much as a priest loses his power when he takes off his vestment and leaves the sanctuary.

Time and technology modernized trains and forever transformed the world of railroads, those same railroads that had once before transformed the world. The railroads gave dynamism to the first Industrial Revolution: besides coal, they carried raw materials to factories and food to cities.

But today railroads are undergoing rapid change. The best example is to be found in France: in the 1950s, France's railroads employed 550,000 workers; today they employ 220,000; by the early twenty-first century, the number will be down to 90,000. Railroad workers retire, but are not replaced. Most French railroad lines still work with equipment ten to twelve years old. Soon it will be sent to museums.

The modern high-speed train, the *train à grande vitesse,* or TGV, has killed off the traditional train. It travels at close to two hundred miles per hour. Once, dozens of people working three shifts controlled the signals and lines between

Paris and Lyons; today, just ten people do it from a sophisticated computer control room at the Gare de Lyon in Paris.

Now the system employs specialized technicians, not railroad workers. On the ultramodern trains, the driver is now called the pilot. His main function is to reassure passengers through his physical presence. Computers do the rest.

Coal lies in the heart of the earth and the heart of the earth is hot and humid. The miners of Dhanbad work in temperatures of 120 degrees, close to danger, close to death. The history of mines worldwide is a history of tragedies.

In Dhanbad, coal mines give work to 400,000 people. One hundred and five thousand men descend into the mines; until 1950, women also dug for coal, worked at night, and died in the explosions and landslides set off by the heart of the earth. Since India became independent, a law has protected them from the darkness of tunnels and death. But they still work twelve hours a day, now under an unforgiving sun.

A miner's face is permanently covered by a tarry dust, all except for a small area around his eyes where the movement of his eyelids keeps away the dust, and his mouth, which he keeps clean with his lips. He emerges from the mine transformed into a specter of black dust, only eyes and lips shining out.

But his eyes also carry a burden of fatalism, a burden shared by coal miners throughout the world. He lives with the constant threat of death in the heart of the earth. And he knows that the same fate awaits his son just as it had done his father. These miners are forever tied to coal; they belong to coal.

The smell of hell was born in paradise, or at least that corner of paradise that was forgotten, in the volcanic region of Kawah Idjen on the island of Java. This is the last of a rosary of volcanoes stretching across the island, forming a surprising and marvelous landscape.

The volcano is alive, exhaling gas. And this hot gas is channeled into vast tubes thirty to forty-five feet long. Some of it condenses and eventually drips into wells, becoming red at first, then orange, and eventually, as it solidifies, yellow.

When it is yellow, it has become pure sulfur and is ready to be collected.

Men leave the small town of Licin, just fifteen miles from the crater of the volcano. They climb through rice plantations, through clover trees, through a tropical forest. When they reach the top, they have a perfect view of the entire plain of Java, which stretches out toward the Pacific Ocean. The men start walking at 1:00 A.M. and seven hours later they reach the mouth of the volcano, seven thousand feet above sea level, where the air is clearer. Then they must climb down to the bottomless lake at the heart of the crater, almost two thousand feet below them.

The men work in clouds of poison. They cover their mouths with thick cloth, which they bite to give it moisture. This becomes the mask that protects them from the gases. Several times a day, when huge clouds of sulfur spew out, they look for pockets of air. Then they continue, placing pieces of sulfur in their baskets. Men who may weigh only 150 pounds end up carrying 180 pounds or more. With a basket balancing from each end of a bamboo staff, they start the long climb back to the mouth of the volcano. They descend the crater in just a few minutes; it takes them two hours to go back up. When they reach the top, they stop to rest and eat dry fish and rice. Then finally they head down, this time running to lighten the weight of the baskets.

They work one day in the sulfur and rest for two days; they could not repeat the feat daily. Their legs are deformed from the weight they carry—angels mutilated by the constant trips between paradise and hell. For each day's work, they earn the equivalent of $3.50. Ten years ago, for the same work, the same sulfur, they earned twice as much.

Swept along by winds that carry the hint of fortune, men come to Serra Pelada. No one is taken there by force, yet once they arrive, all become slaves of the dream of gold and the need to stay alive. And once inside, it becomes impossible to leave.

Every time a section finds gold, the men who carry up the loads of mud and earth have, by law, the right to pick one of the sacks they brought out. And inside they may find fortune and freedom. So their lives are a delirious sequence of

climbs down into the vast hold and climbs out to the edge of the mine, bearing a sack of earth and the hope of gold.

Anyone arriving there for the first time confronts an extraordinary and tormented view of the human animal: 50,000 men sculpted by mud and dreams. All that can be heard are murmurs and silenced shouts, the scrape of shovels driven by human hands, not a hint of a machine. It is the sound of gold echoing through the soul of its pursuers.

One union leader was also leader of the homosexual miners in Serra Pelada. He was head of a large number of workers who gave and received affection, the only available source in this vast army of desperate men. He was brave, respected by everyone, and he had but one dream: to find gold and to go to Paris. "There," he said, "I will get artificial breasts. No one can do this operation as well as the French. The breasts of Paris are the most beautiful in the world, the very best silicones." This was his dream, this was his enslavement.

I went to Kuwait after the war against Iraq, when the oil wells were still burning and flowing out of control. There I lived the apocalypse and saw the black symbol of humanity.

The war had ended just thirty days earlier, and the entire region was covered in oil: clouds of burned oil darkening the sky, lakes of oil polluting the land. For the first time, the people of Kuwait were seeing, touching, their own oil.

For weeks, teams of specialists from different parts of the world fought the flames and spills. It was like fighting against the end of the world, a world drenched in black and death.

No Kuwaiti was in charge of the work. Only the real owners of Kuwait's oil were participating, only the companies that control the world's oil. It took a war to show Kuwaitis what their own treasure looked like.

The Channel Tunnel is much more than an enormous underwater highway linking England to the European continent. It is also a thermometer of cultures, a mirror of history.

On the French side, the workers felt that to build the tunnel was to join an epic feat. All came from the Channel region and worked on the construction project of the century as if they were recovering part of their memory. Right there, Napoleon had begun to build a tunnel; the remains exist of his premonitory dream.

On the English side the workers were hidden, almost fugitives, living in carefully controlled camps. They did not come from the region; they simply came looking for work. They showed no pride, they showed nothing.

For hundreds of years invasions of England were meant to begin in that region, Kent. But the English always resisted right there, most recently in World War II, in the skies above during the Battle of Britain. Local pubs are still decorated with photographs of pilots and propellers of Spitfire fighter planes.

In these pubs, the explanation for the English attitude can be found: for the first time since 1066, the English have been invaded from the Continent—from France, no less. And the tunnel is the invader. Through it will advance the barbarians from the Continent, which is why English workers cannot show pride, why they cannot admit that deep down they feel like accomplices to a frightening defeat.

At the bottom of the English Channel are buried two gigantic machines, two excavators that tore at the earth beneath the seabed. When they finally met, the tunnel was open and they could not return. Like the tuna in the Sicilian *Mattanza,* they could only move forward to their final end. So one was diverted to the right and walled off; the other was buried beneath the open passageway.

In India, since 1954, thousands of people have fought incessantly against the desert. Now, five hundred miles of the Rajasthan Canal have finally defeated the absolute aridity of good soil that never received rain. The canal will rescue life hidden in this dried-up land. The works will be completed after the year 2000.

The canal is being built by families that for four or five centuries have been building roads, dams, temples: routes, water, prayers. With the desert rolled back, the new lands will produce food for India and its 850 million inhabitants.

For six months each year, entire villages move as the canal advances, following the line torn in the desert to bring new life. Men have the most desirable jobs; they are stonecutters, they run the machines, drive the camels. The hard work is left for the women. They carry the earth and the stones.

As the canal advances, so do water, secondary canals, and newly planted trees. A green carpet appears and life returns.

Rajasthan is a strange desert. Wherever life can be sustained, huge numbers of pheasants appear. The canal workers themselves are no less strange, not least the women—women dressed in colorful dresses and adorned in sparkling bracelets, earrings, necklaces, women with jewelry attached to their bodies almost as if soldered to their skin, beautiful warriors of extraordinary dignity attacking the earth.

In another part of India, at Gujurat, a dam is being built on the River Narmada that eventually will link up with the Rajasthan Canal. This dam will irrigate an area of 185 million acres and, in place of desert, cotton and grain will grow.

A large number of women are working on the dam. They represent a majority of all the workers. And, as ever, in India, Bangladesh, and Pakistan, they do the hardest work. Men only do hard work when sheer physical strength is needed. Then the men become human bulldozers, tearing at the earth with their shoulders, legs, and hands. But the women carry the earth away.

They do this for six days a week, carrying soil, stone, mud, tubes, pipes, removing the desert that they are helping to transform. On the seventh day, they do not work at the dam, but they do not rest: they stay home preparing food for the week ahead. Then they return to the desert for six more days of building life, shelter, and bread.

In October 1992, Sebastião Salgado and writer Eric Nepomuceno met and talked for several days in the home of Maria Thereza and José Solano Bastos in Vila do Riacho, Espírito Santo, Brazil. The result of those days was this text, written by four hands.

PHOTOGRAPHS

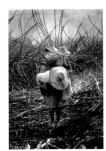
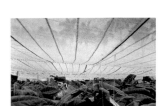

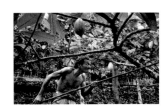
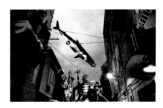
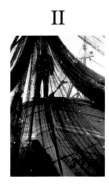

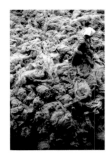
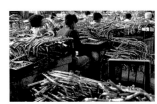
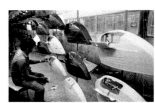
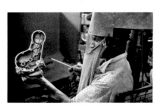
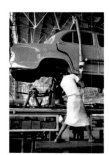

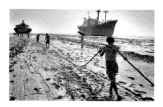
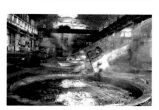
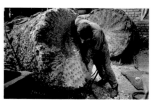
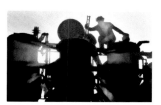
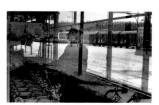
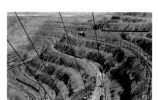
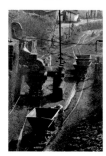
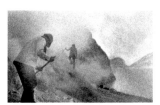
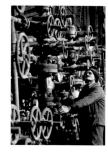
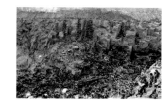
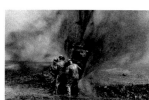
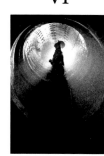
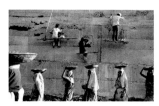
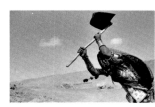
*The captions for the photographs
are to be found at the back of the book.*

I

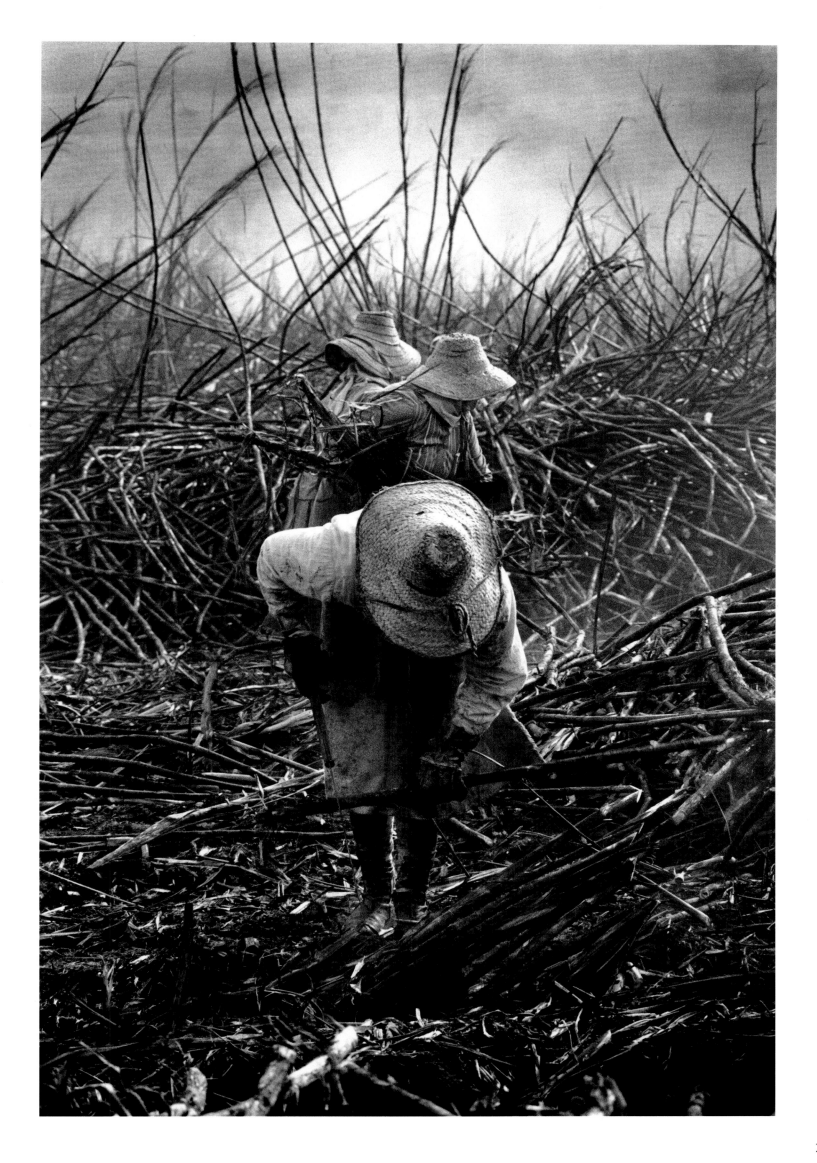

23

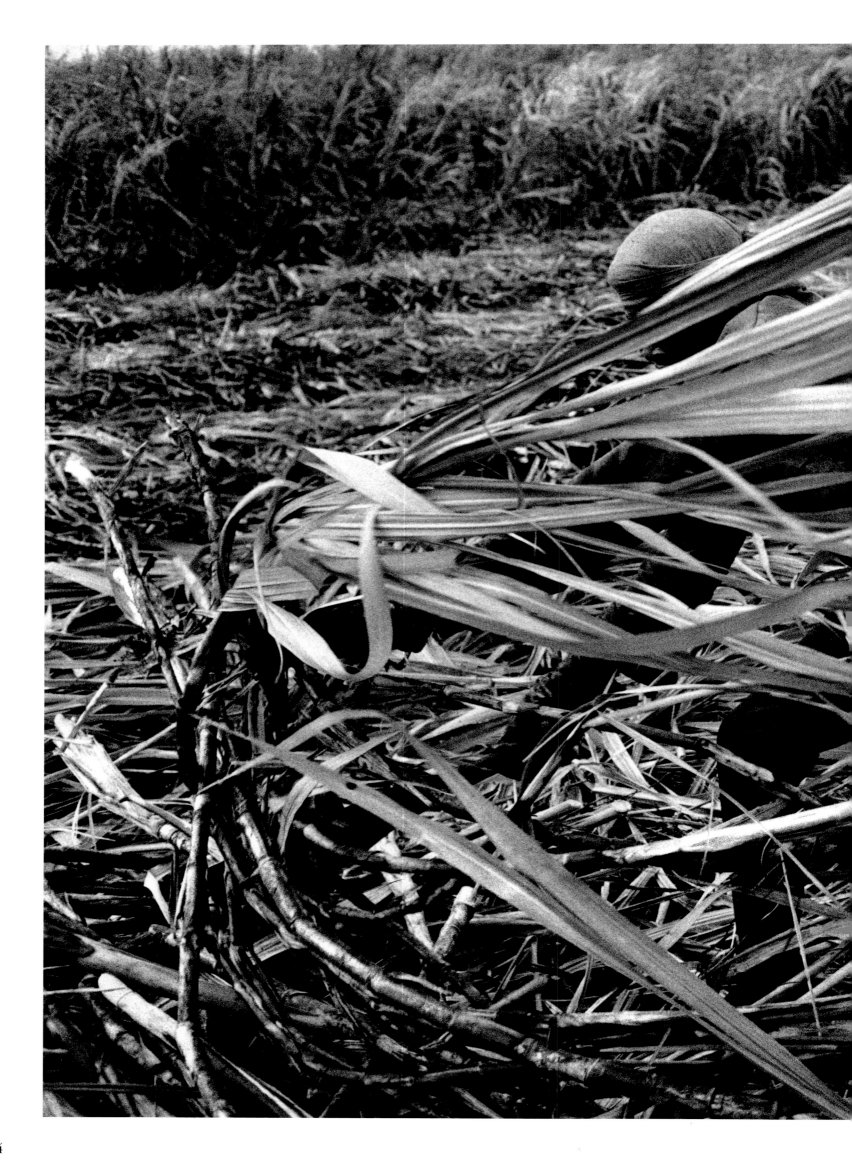

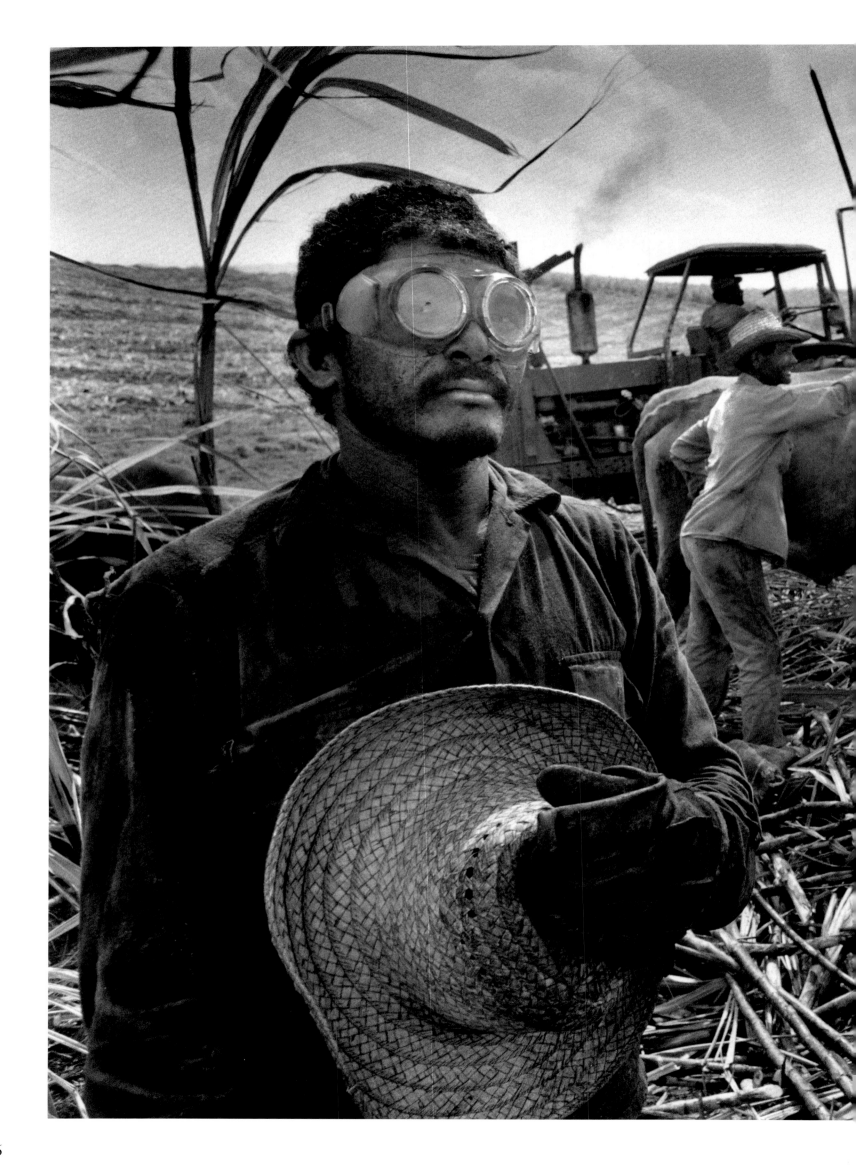

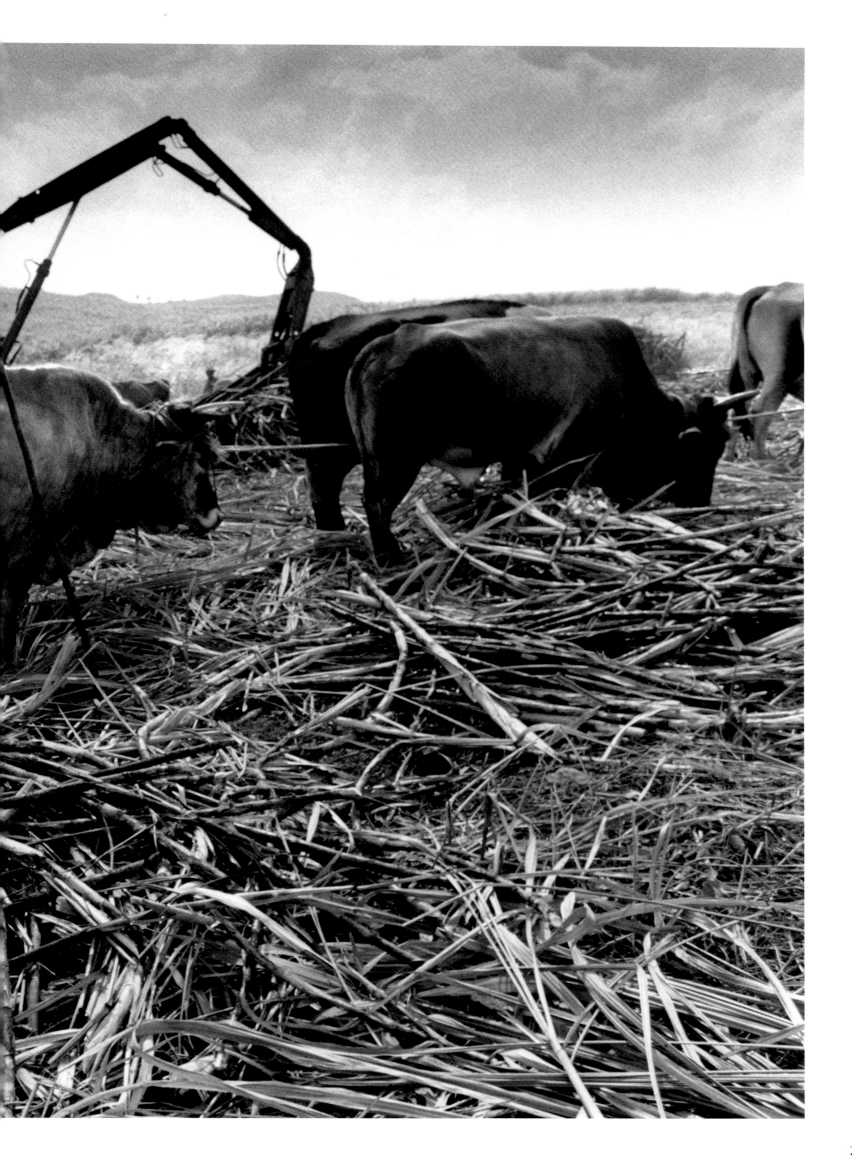

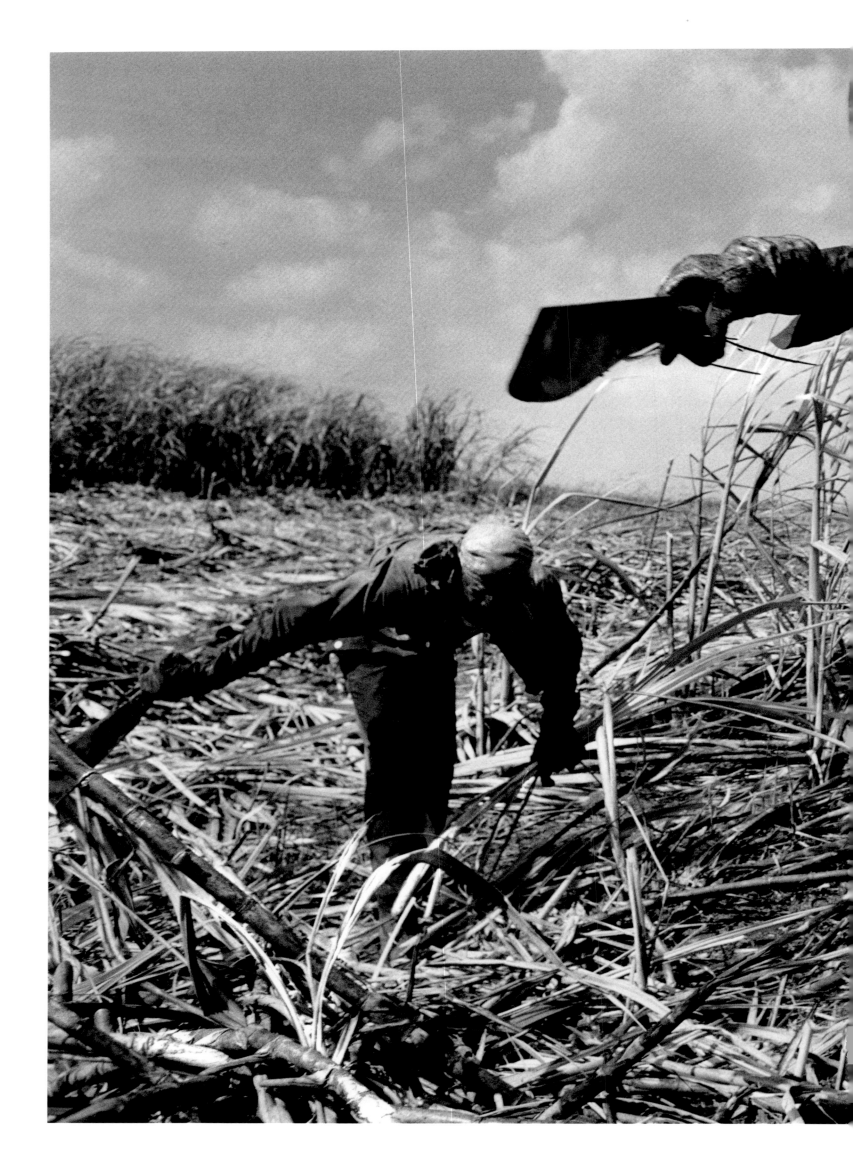

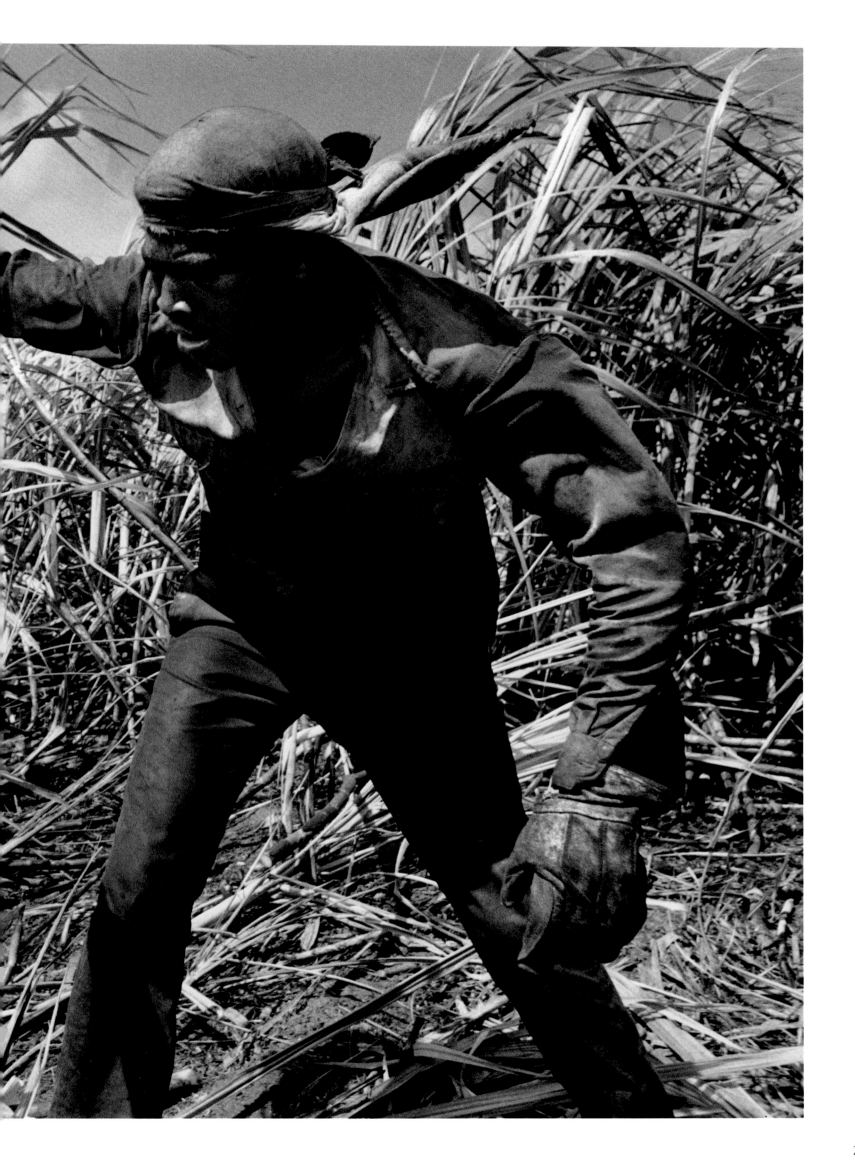

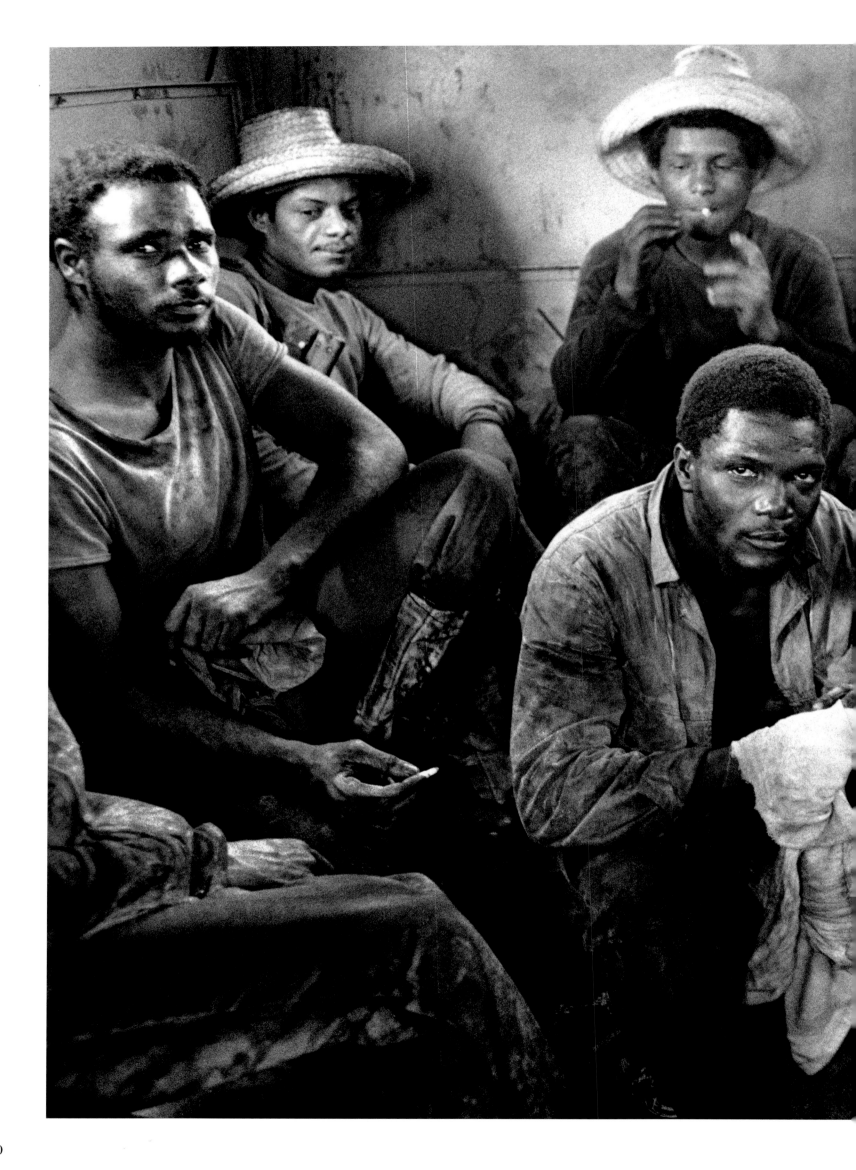

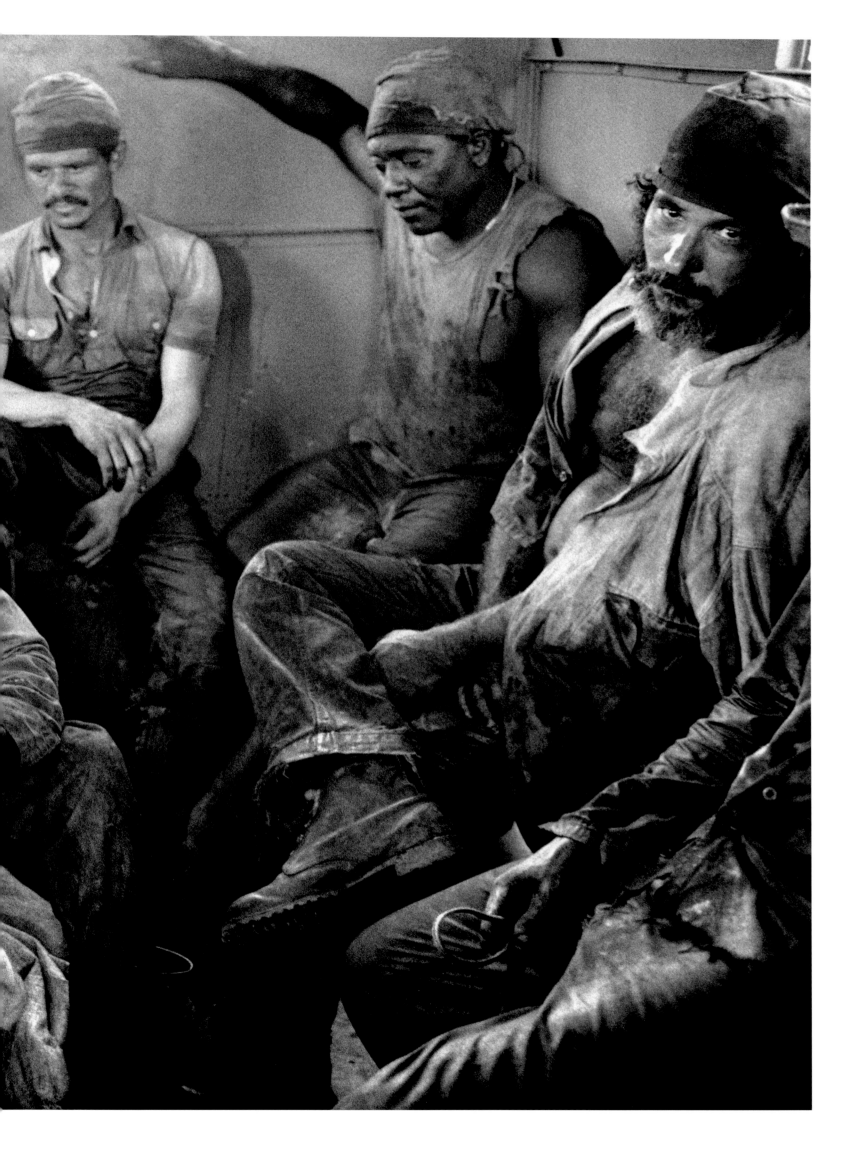

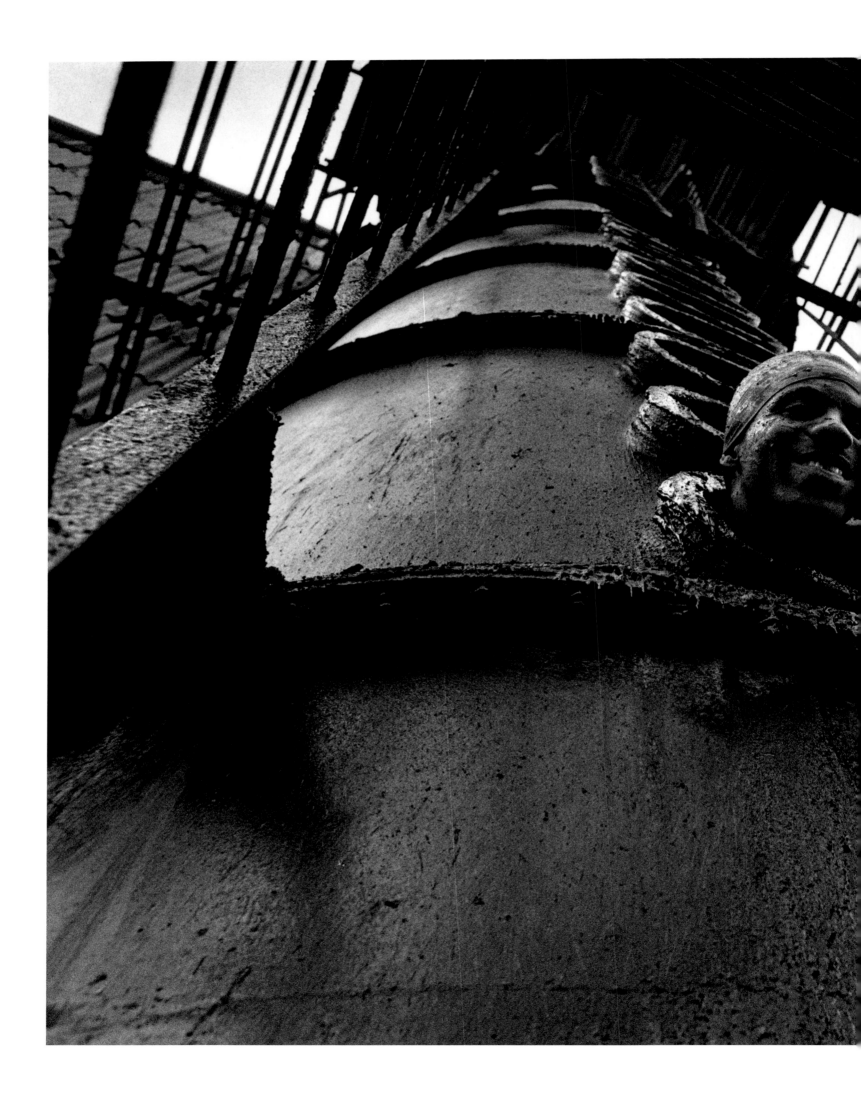

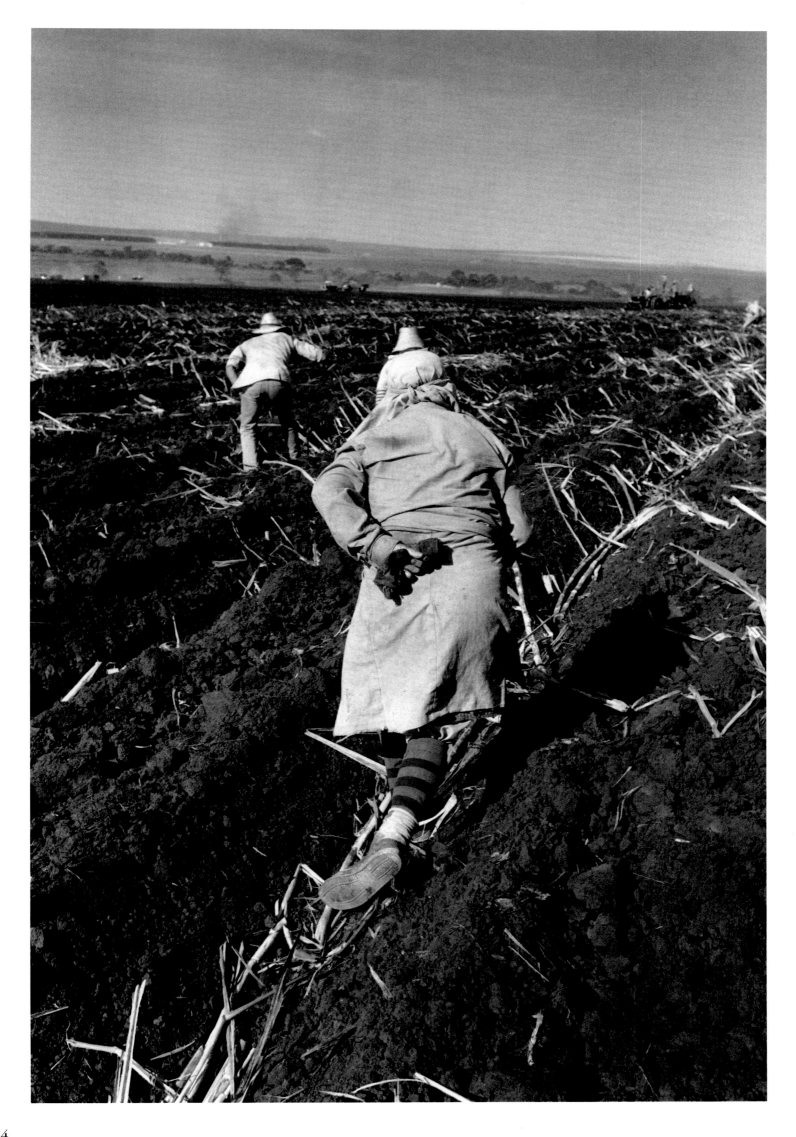

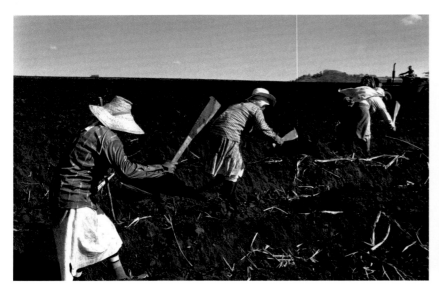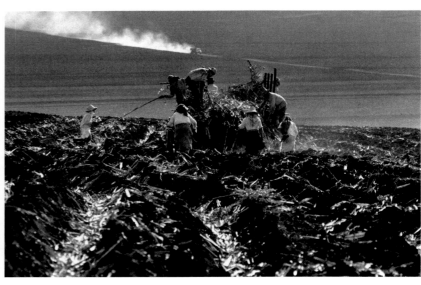

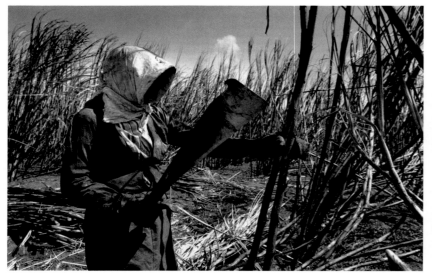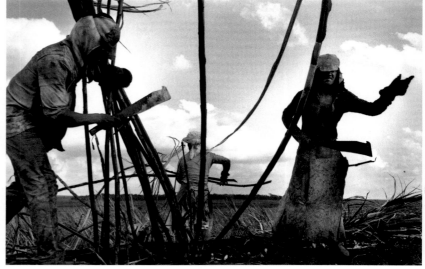

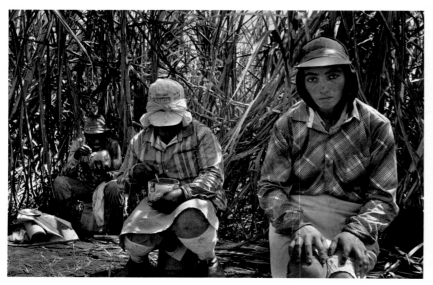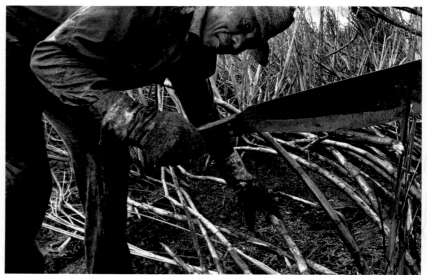

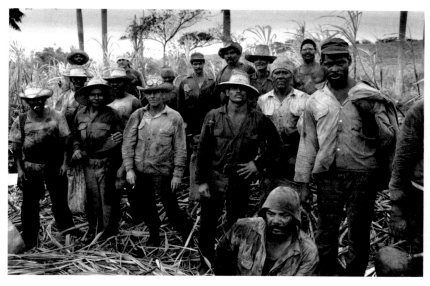
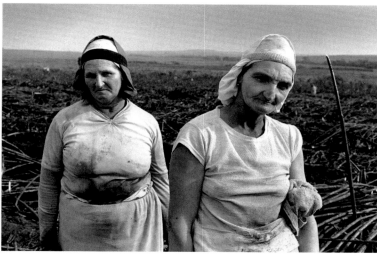
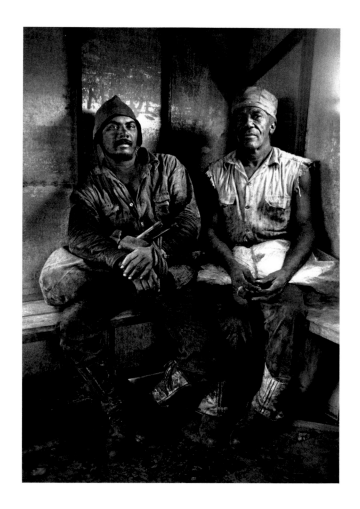
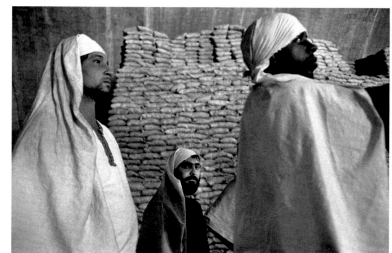
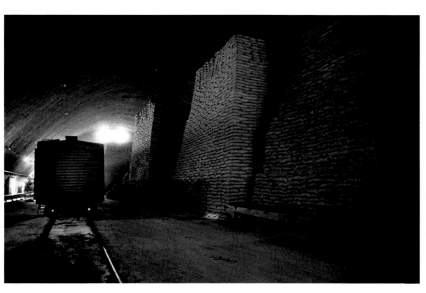
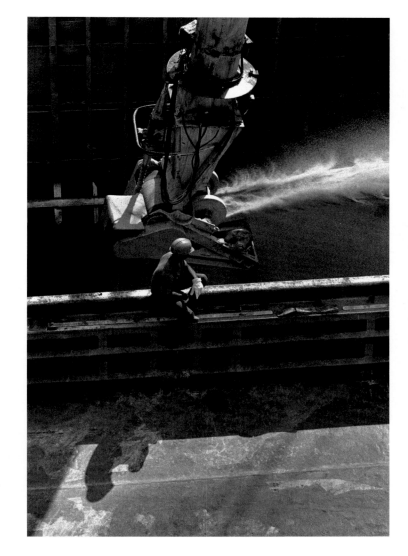

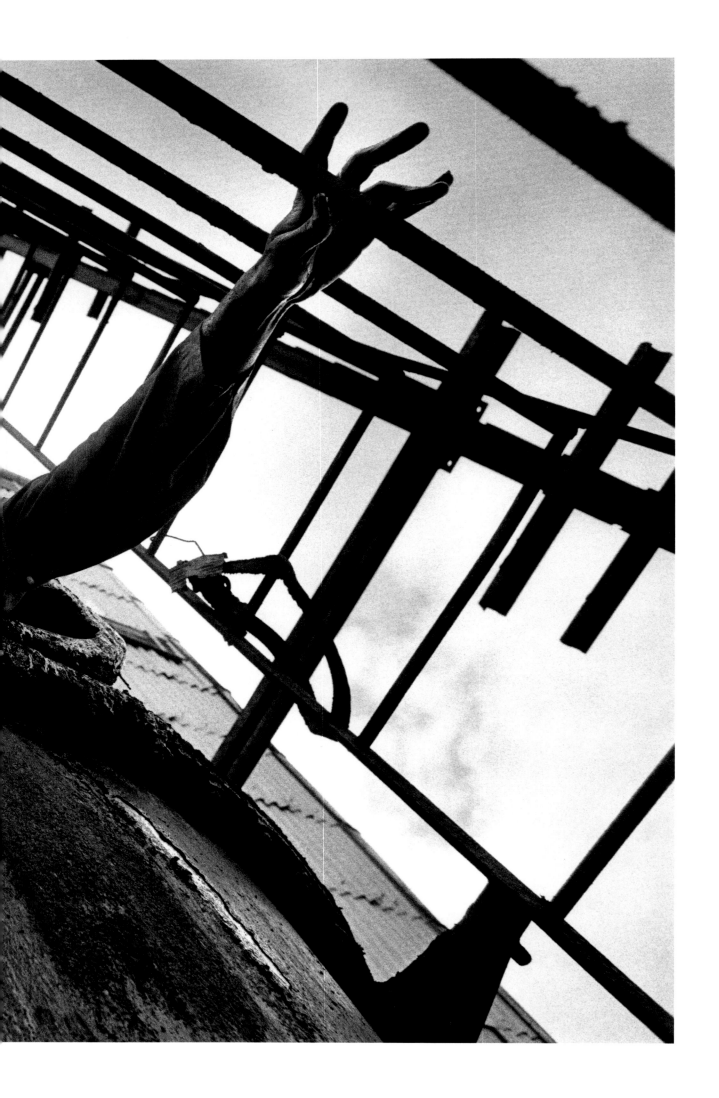

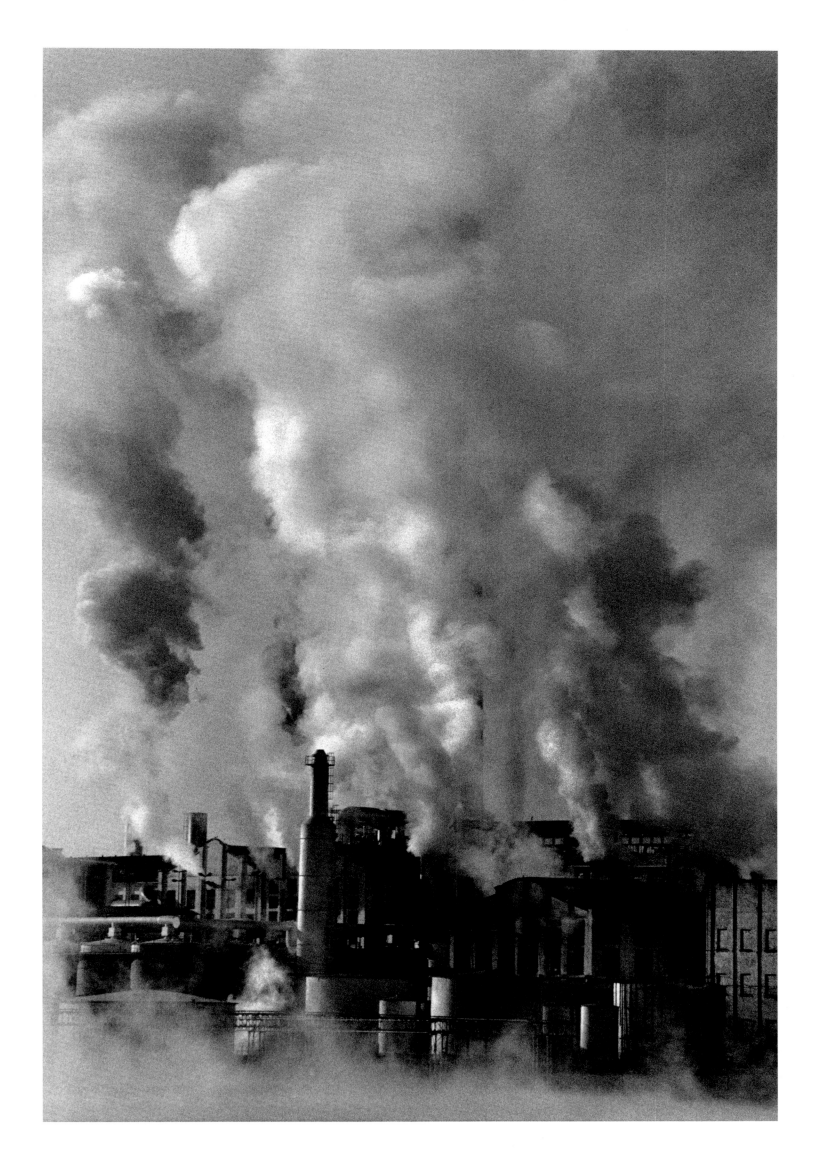

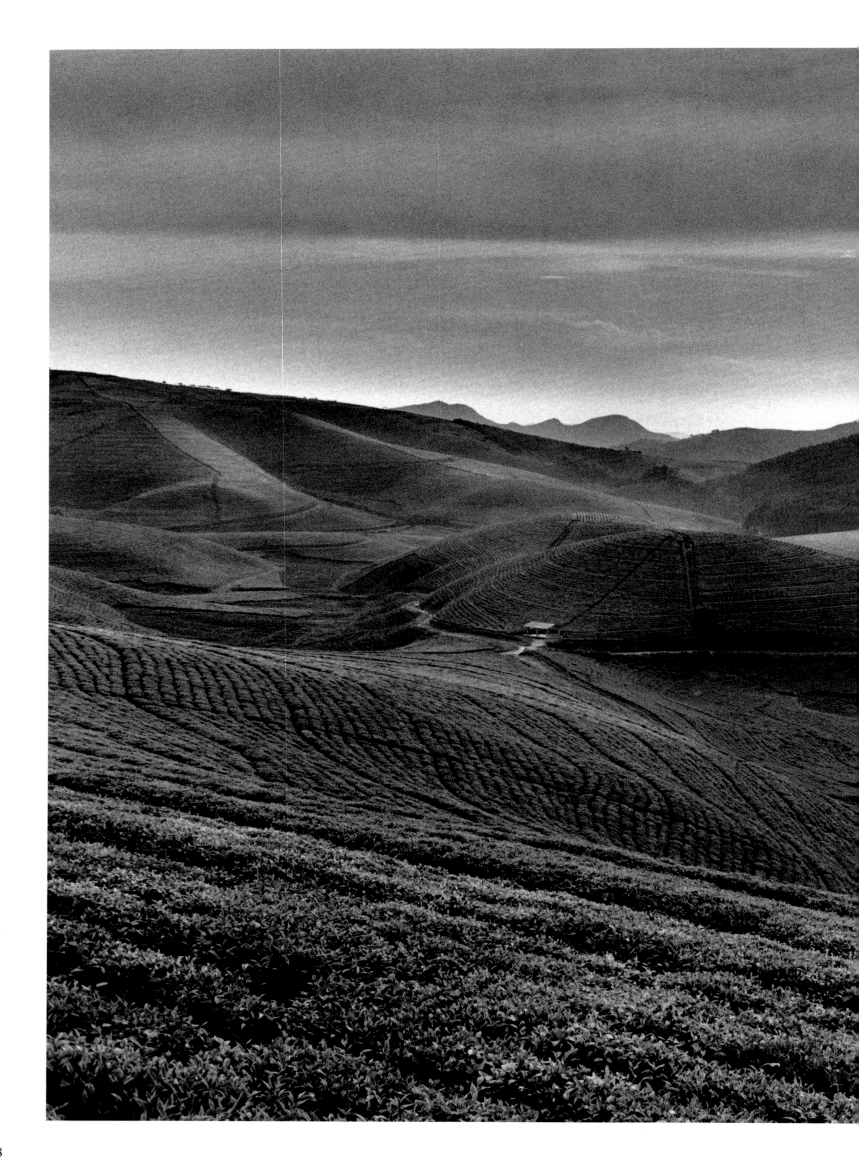

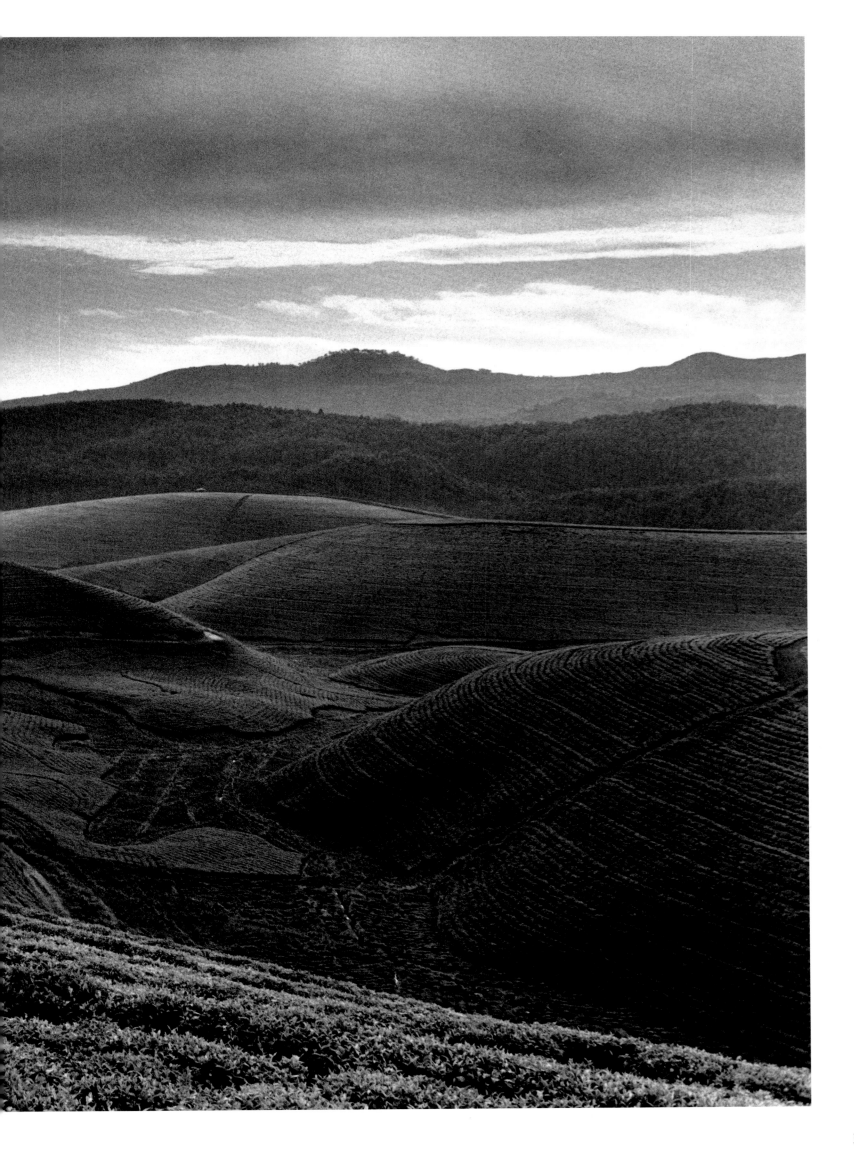

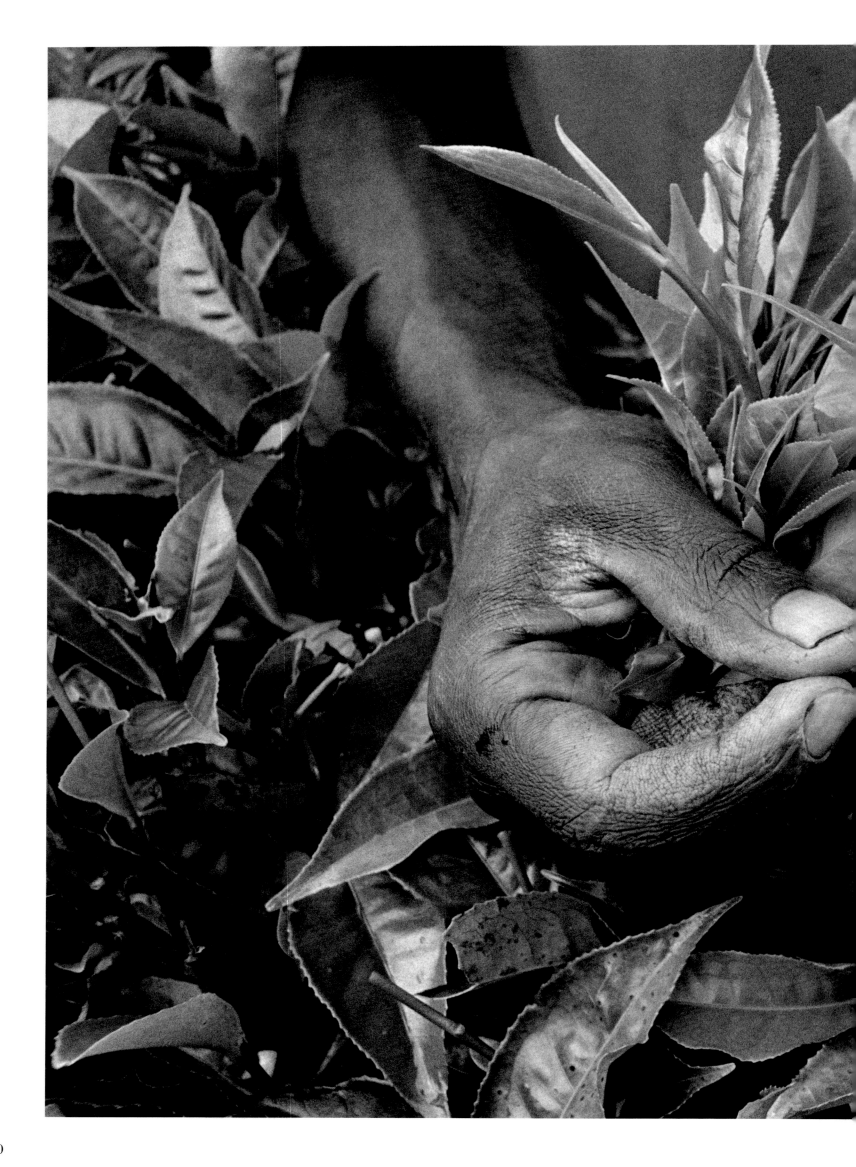

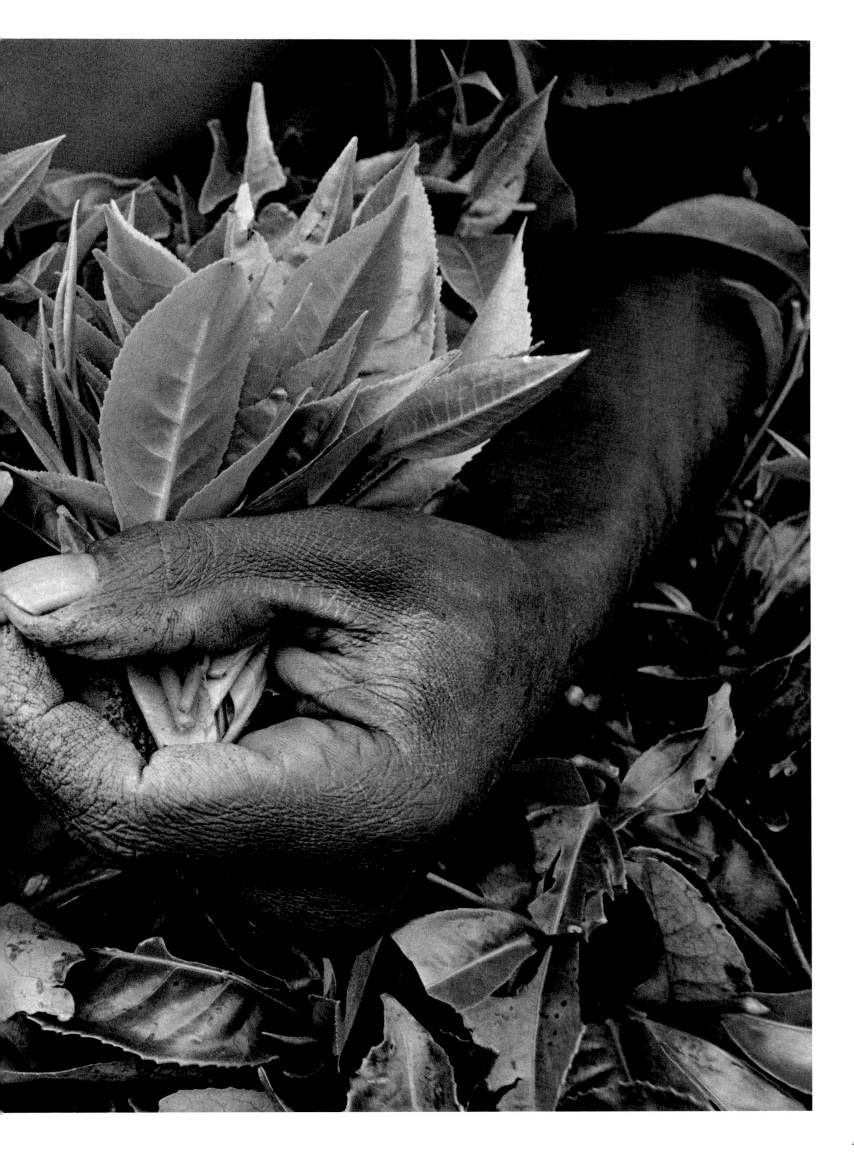

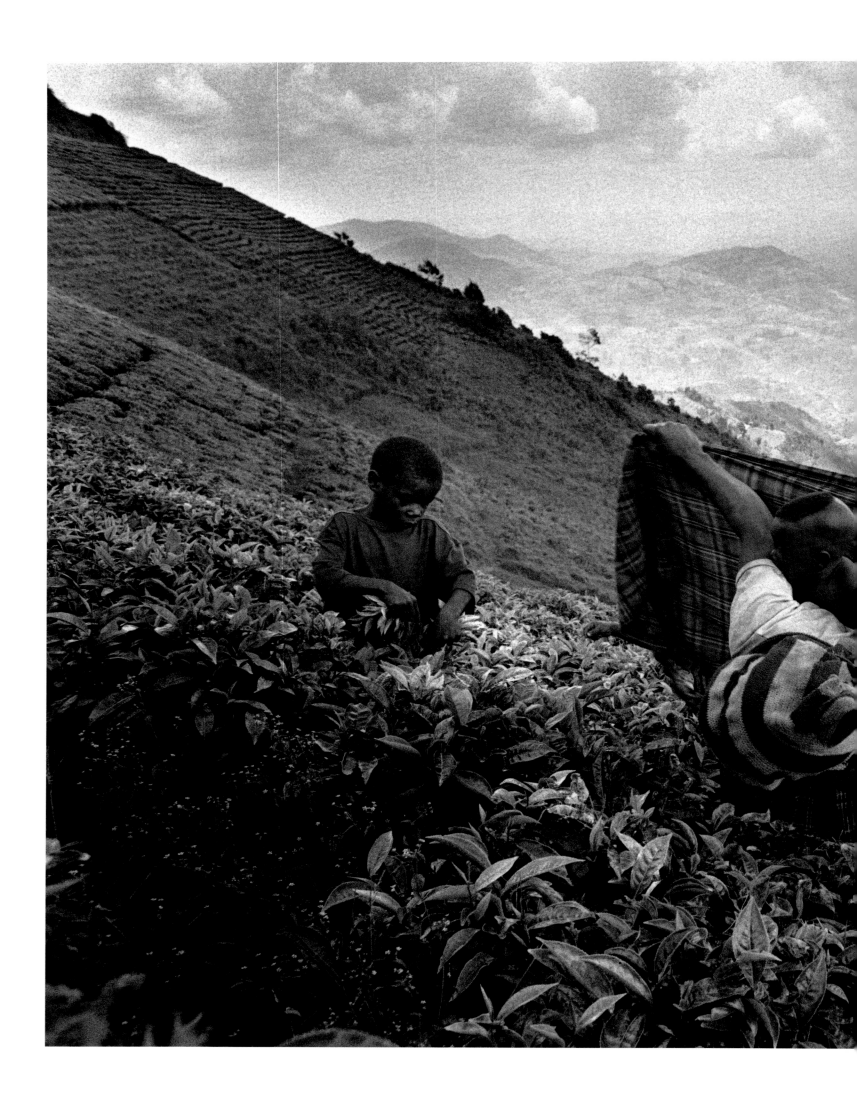

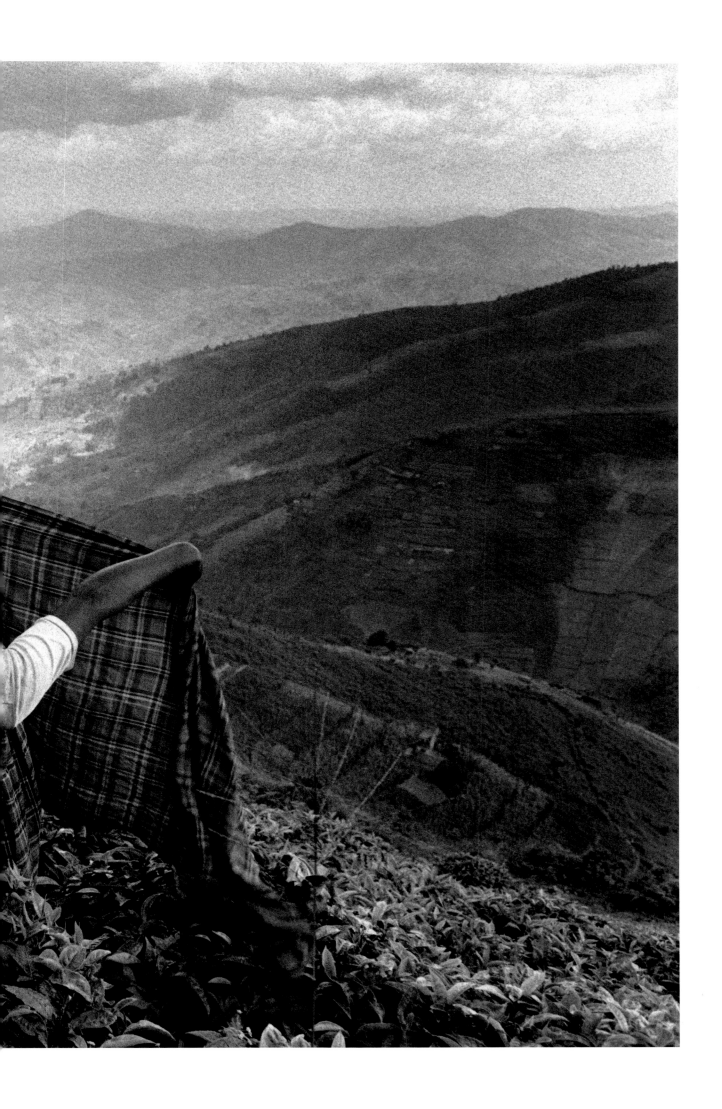

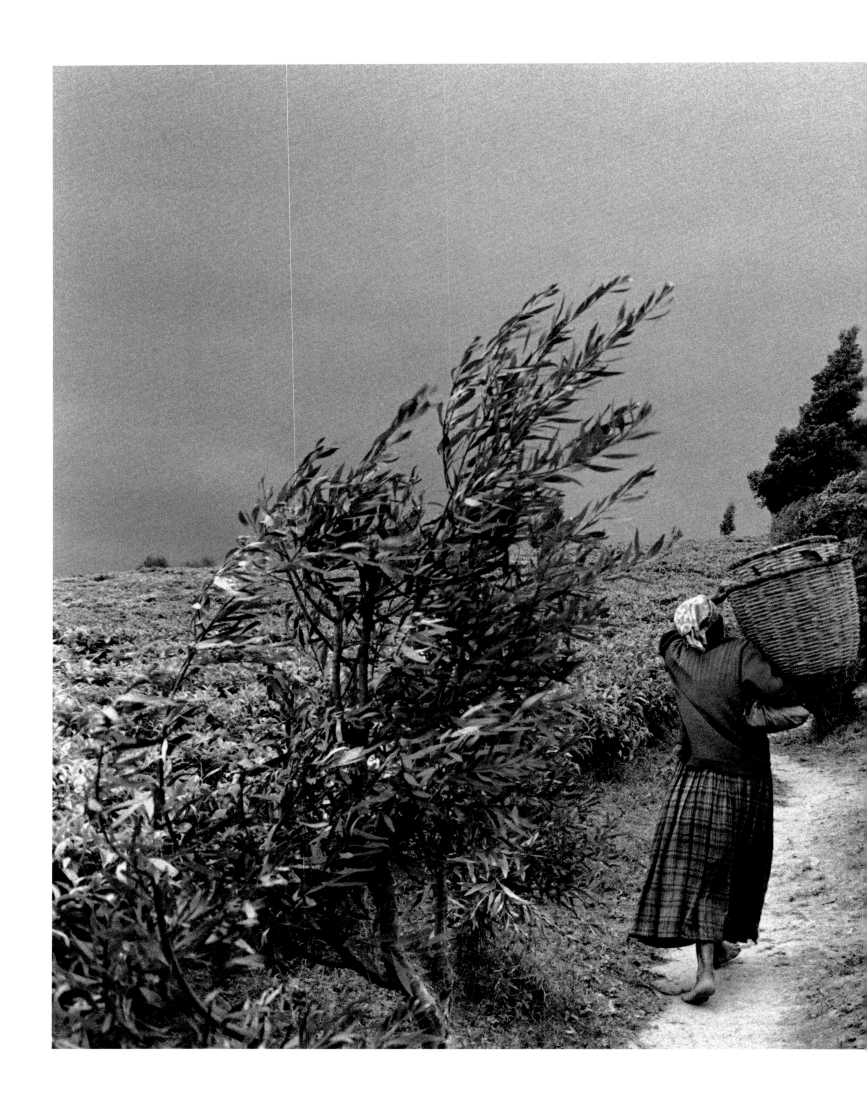

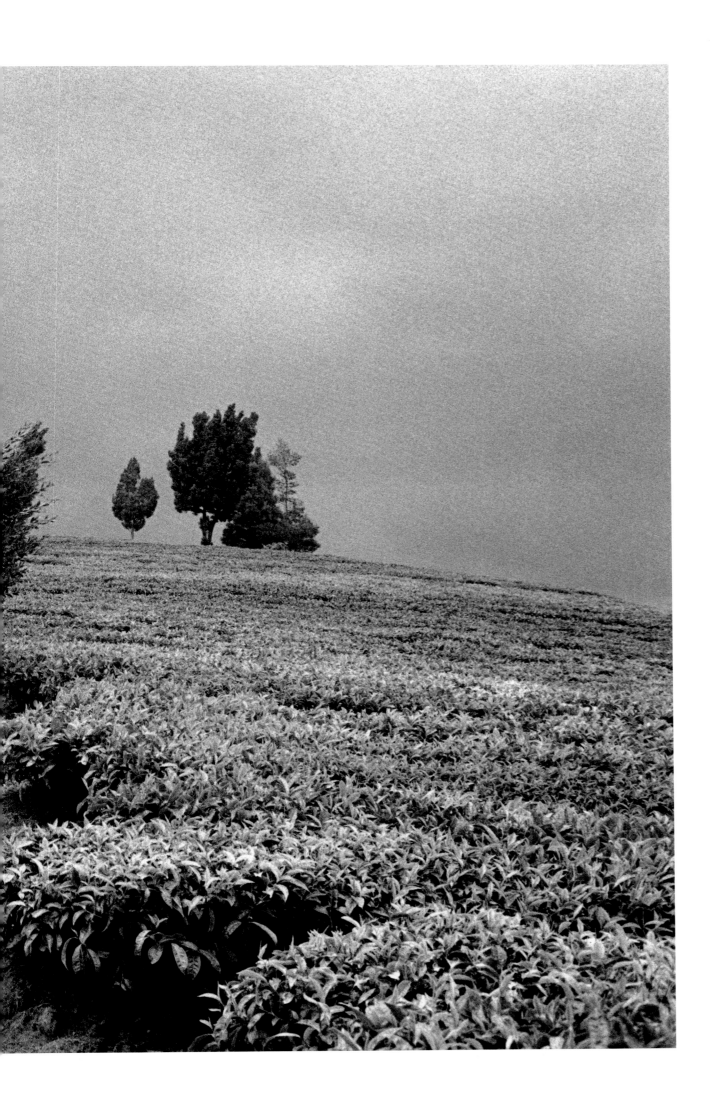

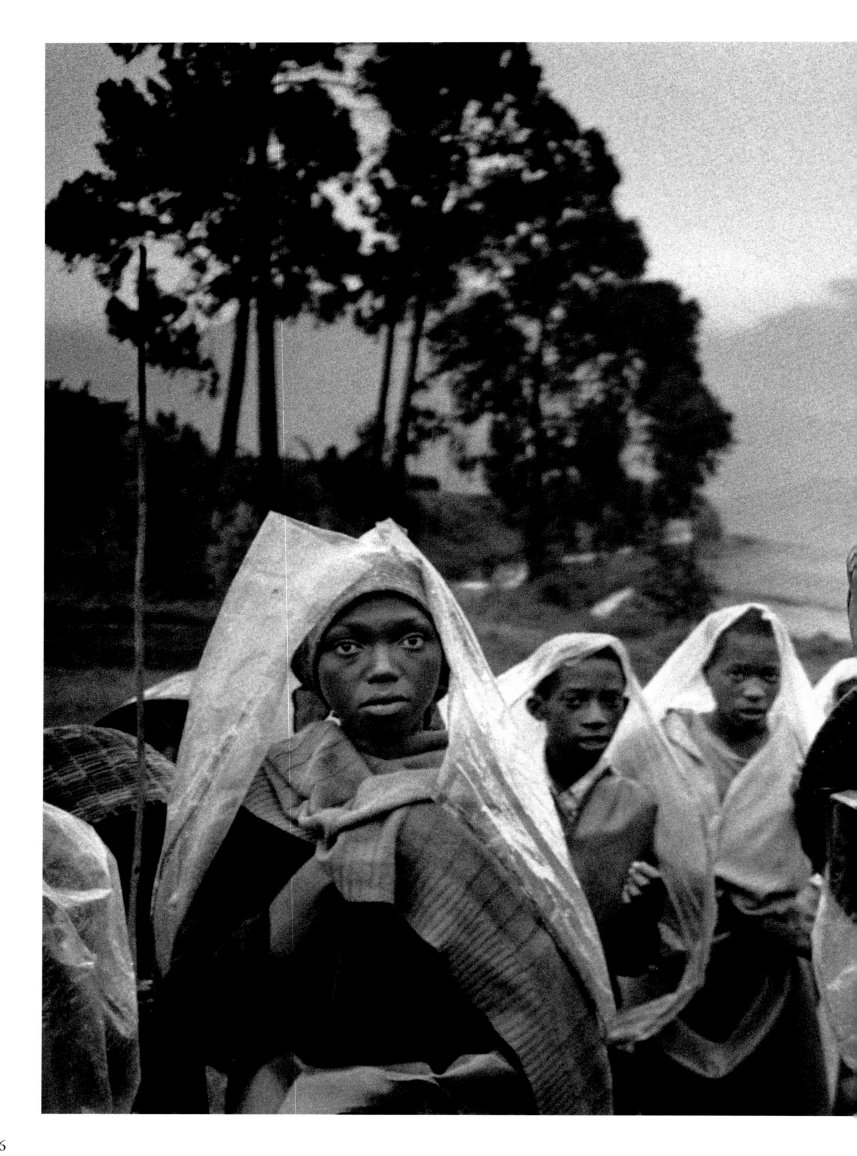

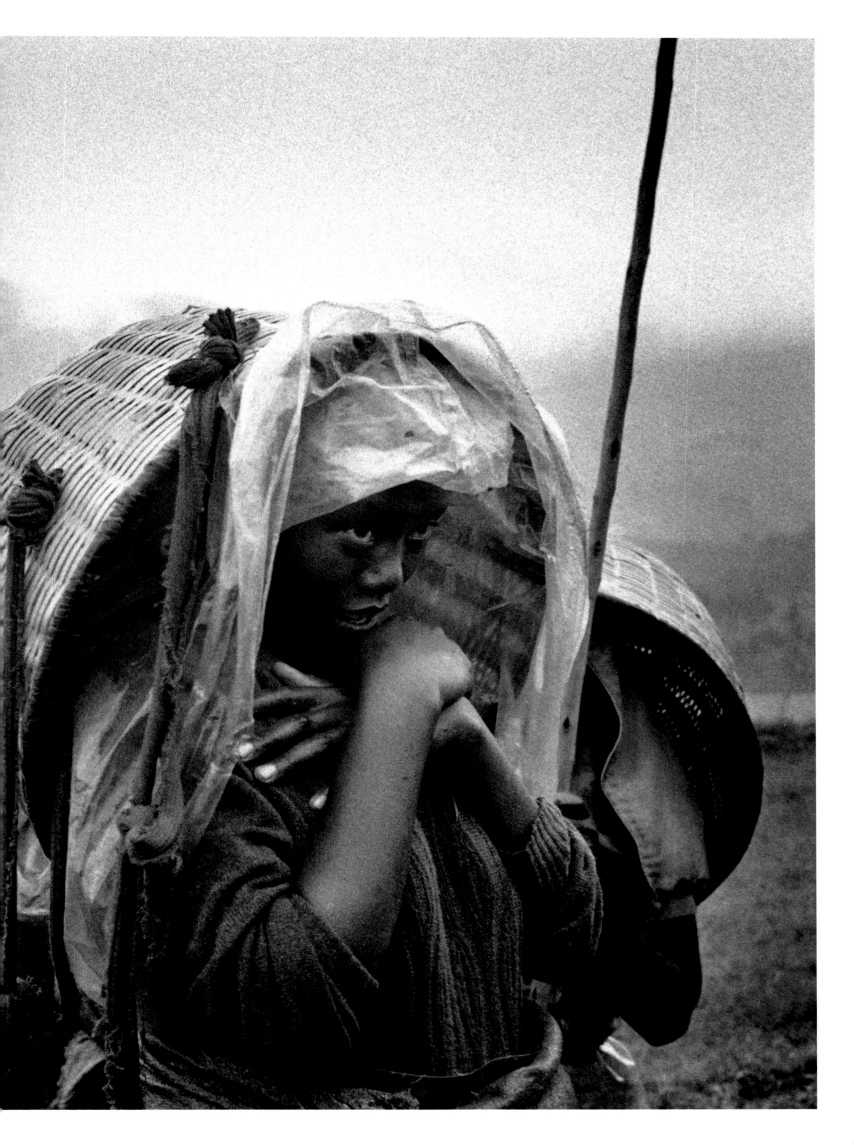

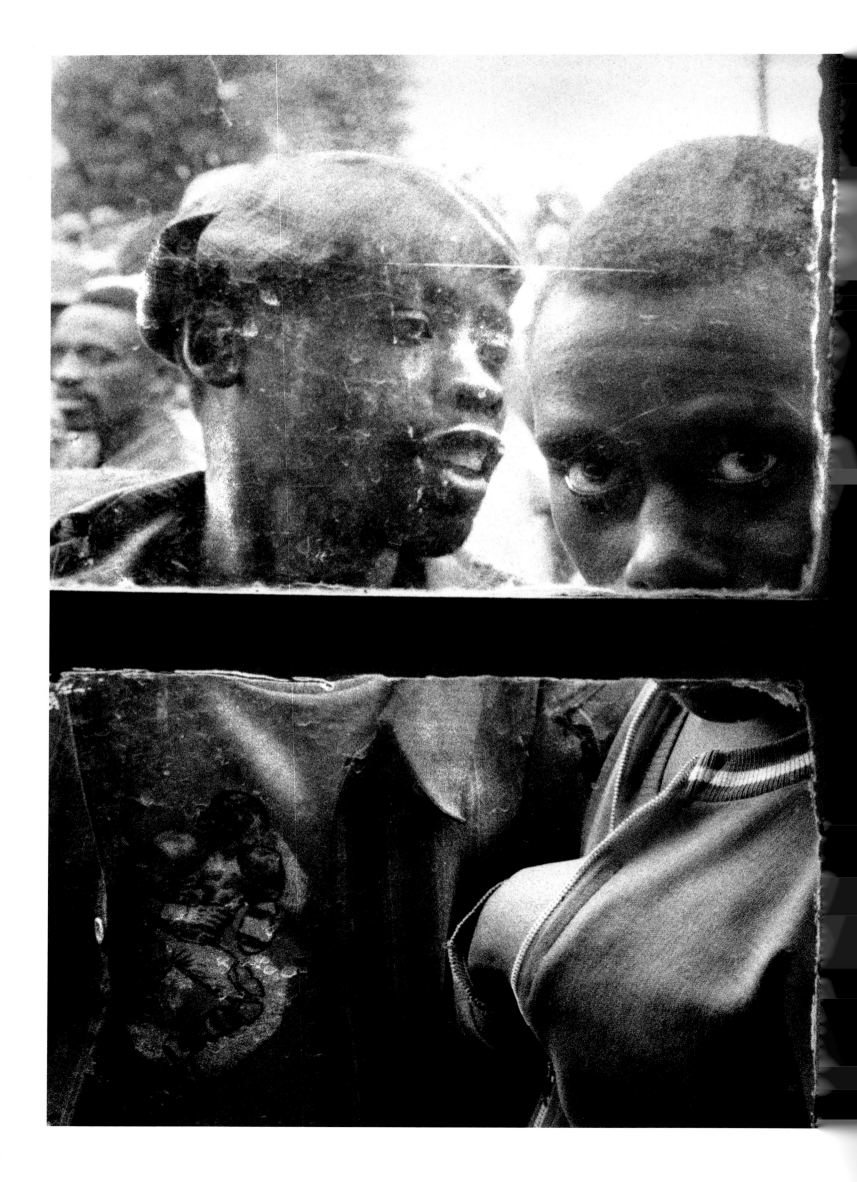

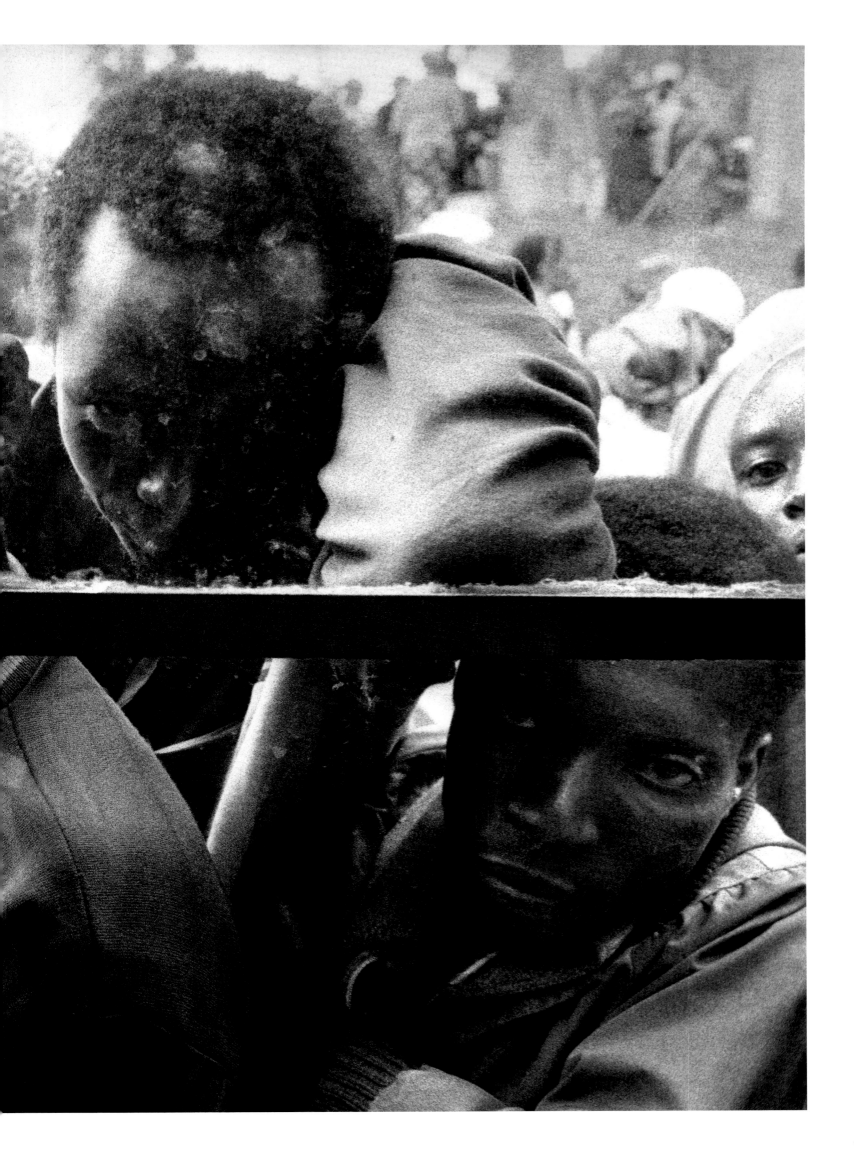

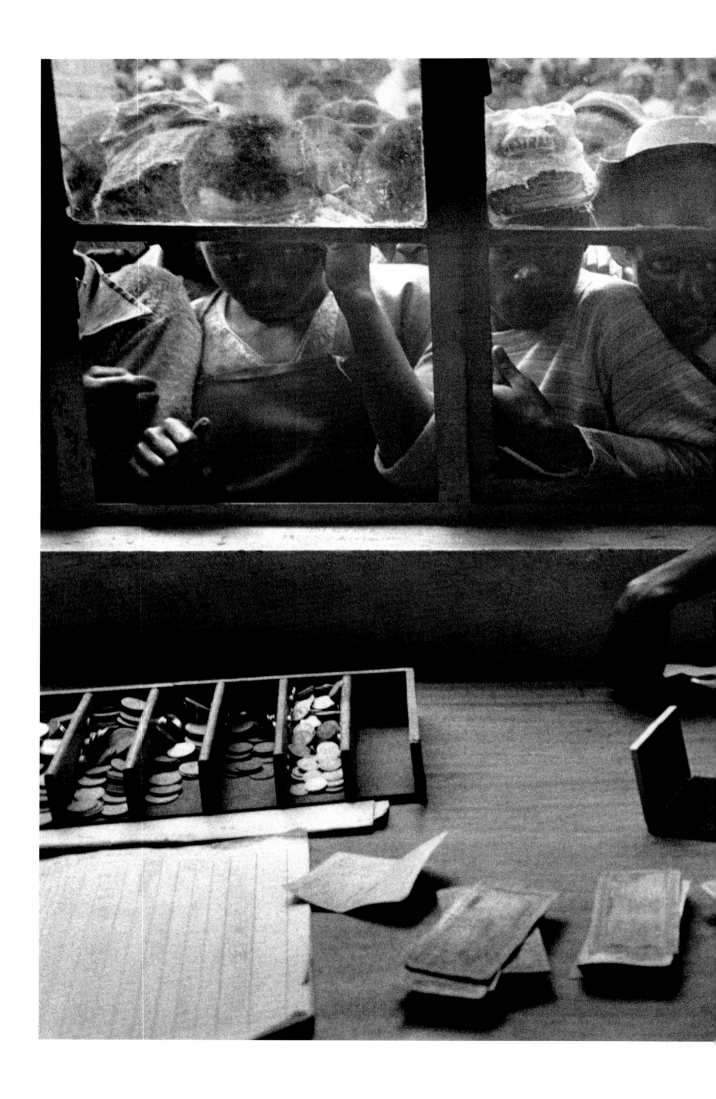

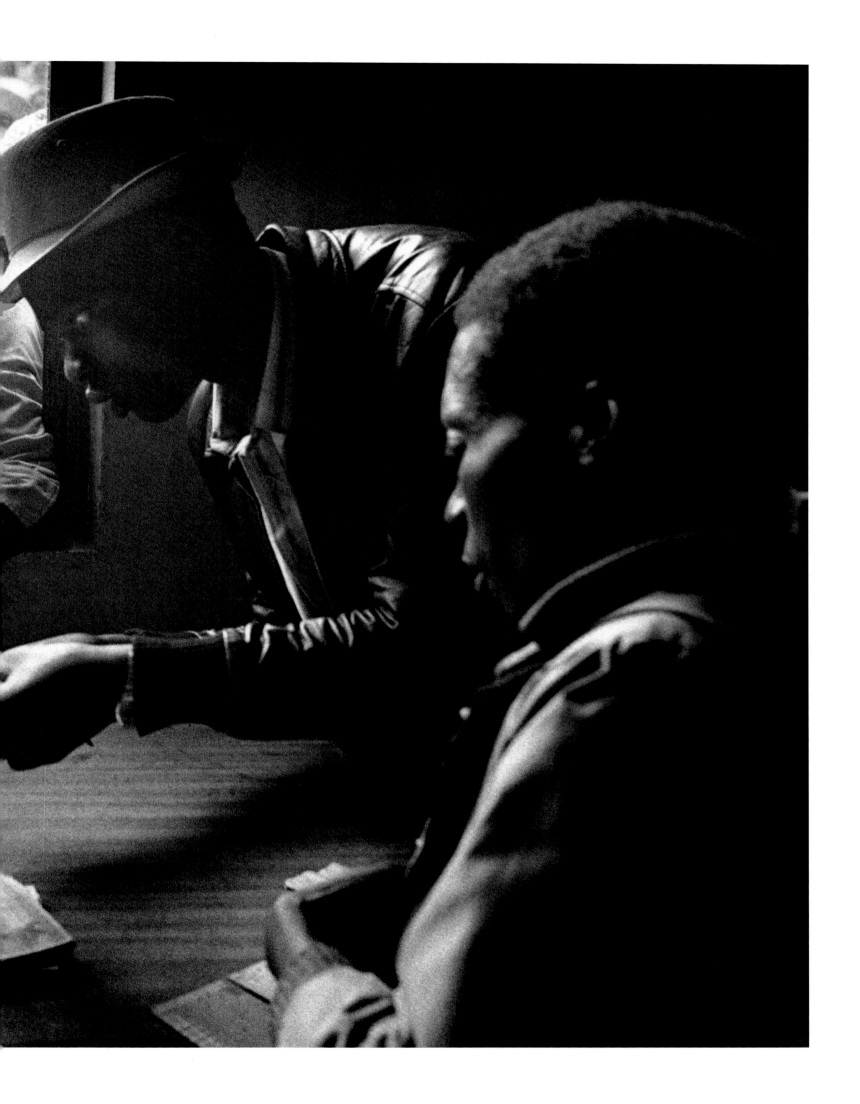

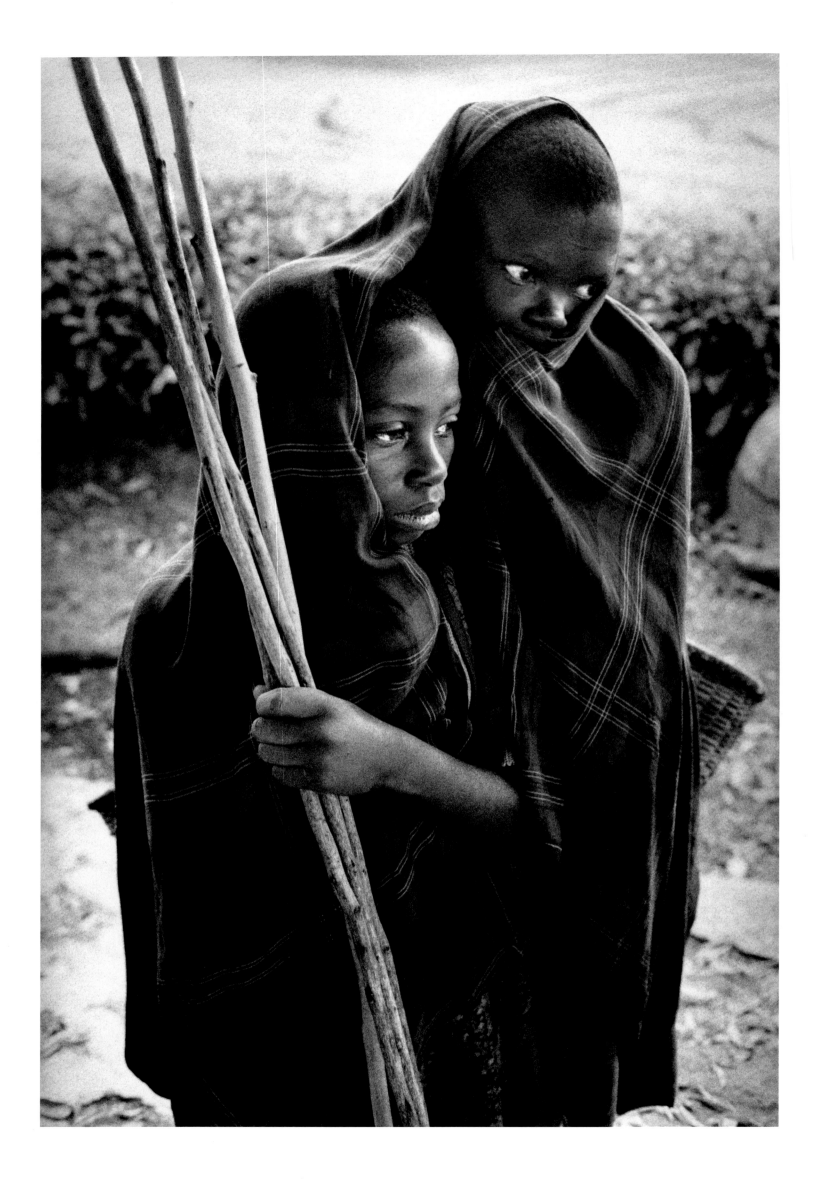

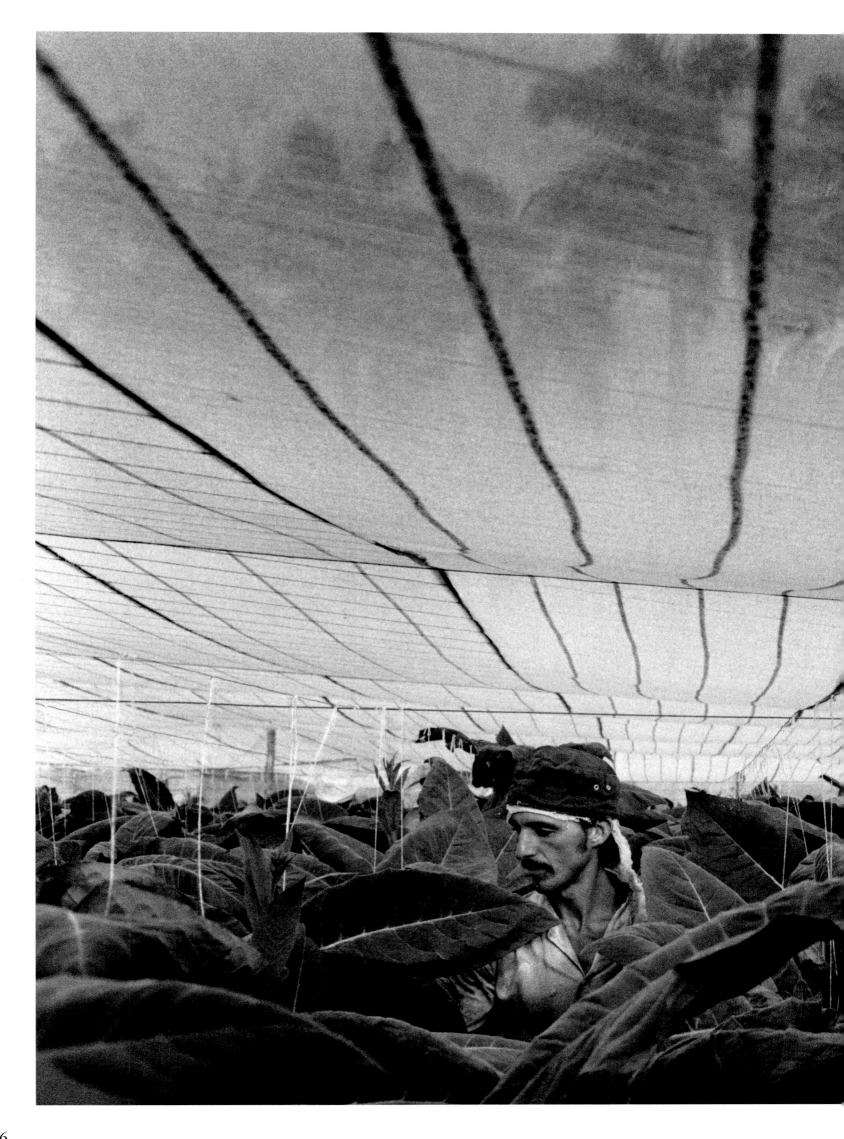

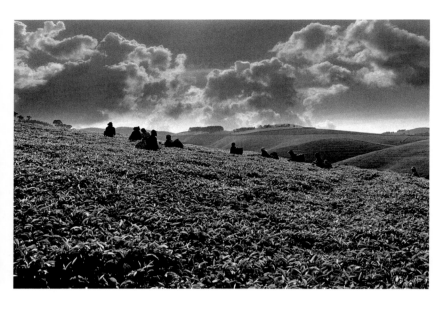
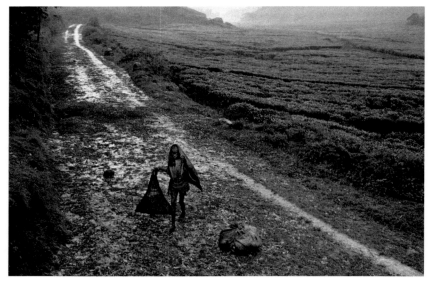
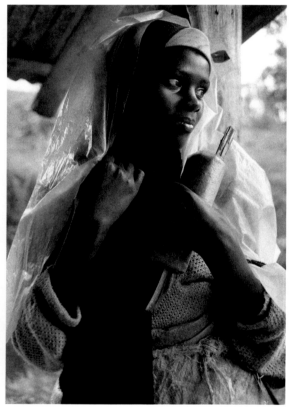
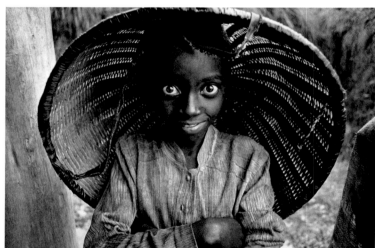
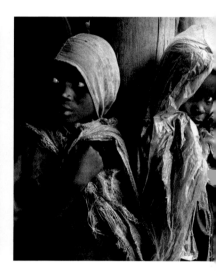
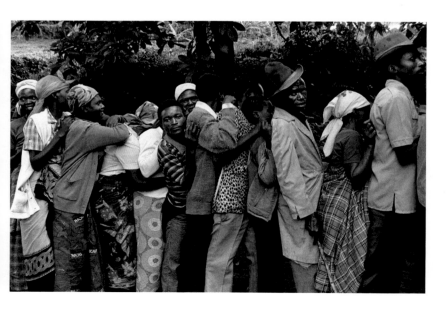
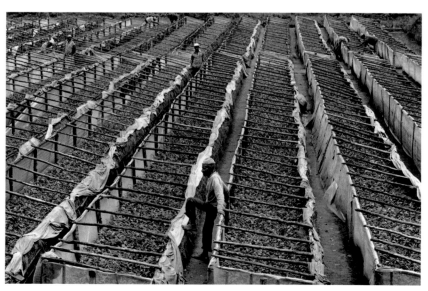

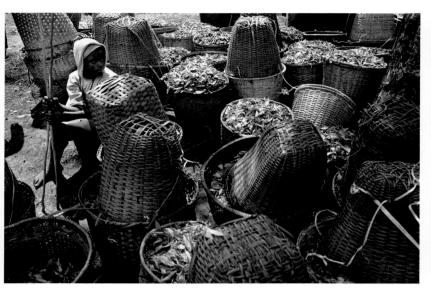
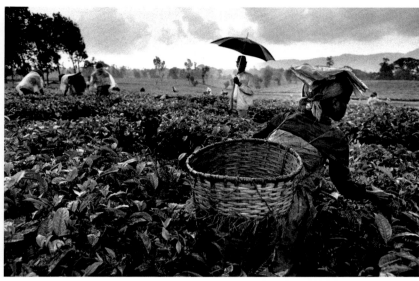
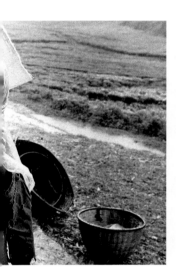
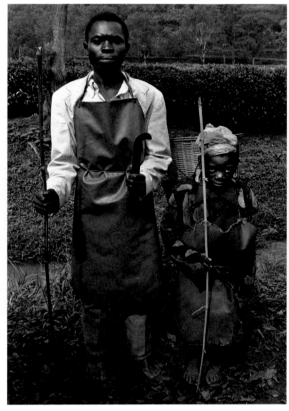
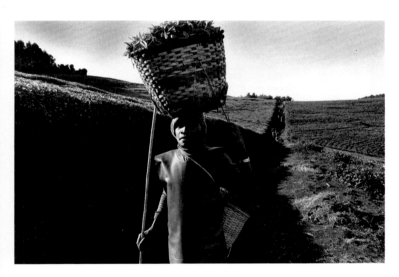
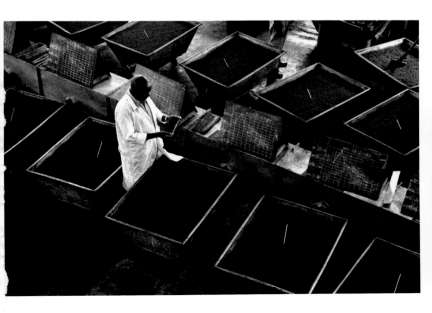
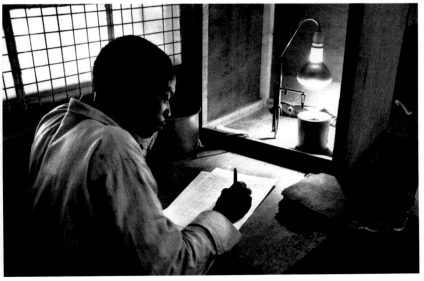

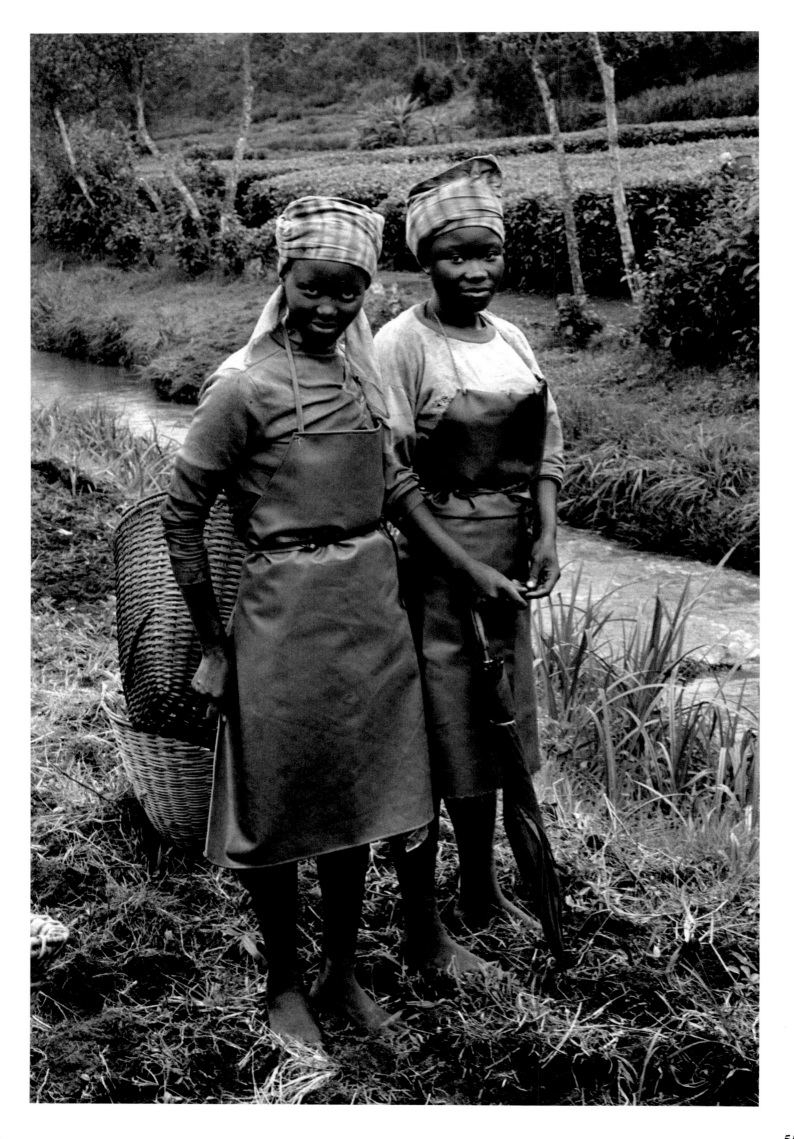

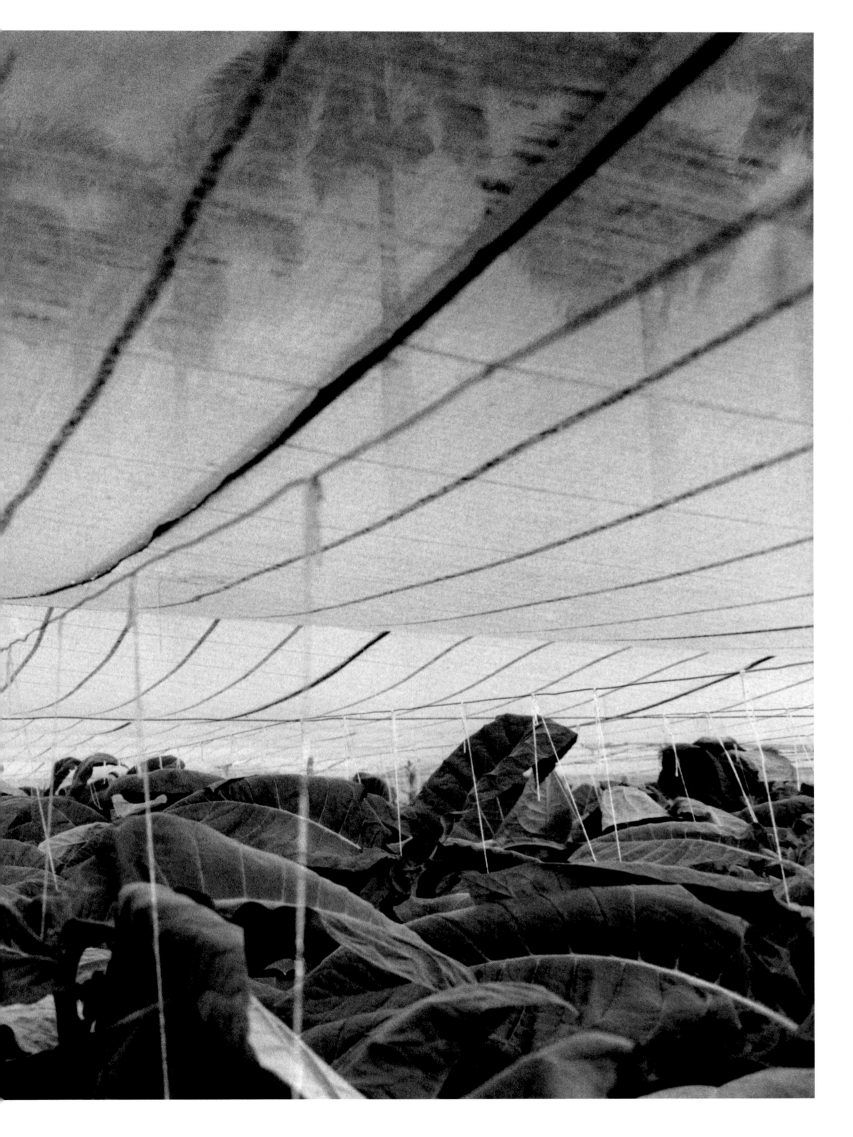

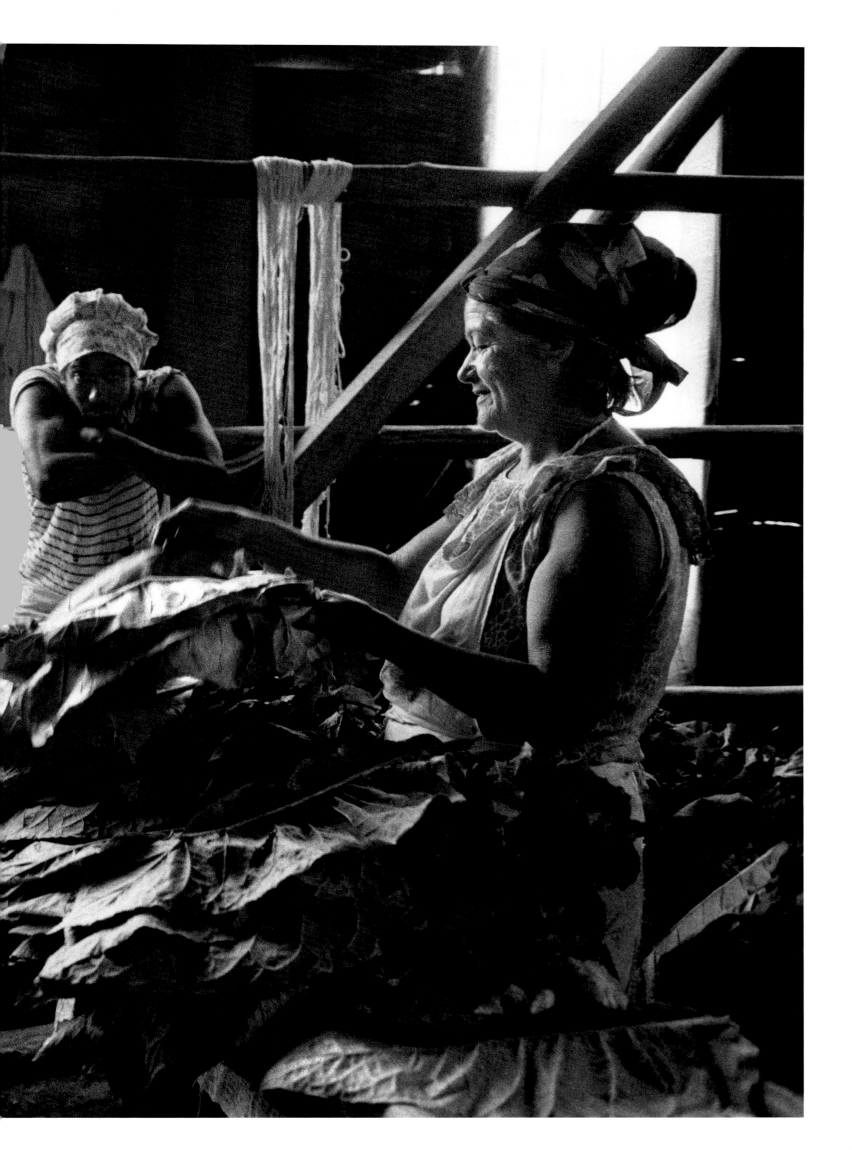

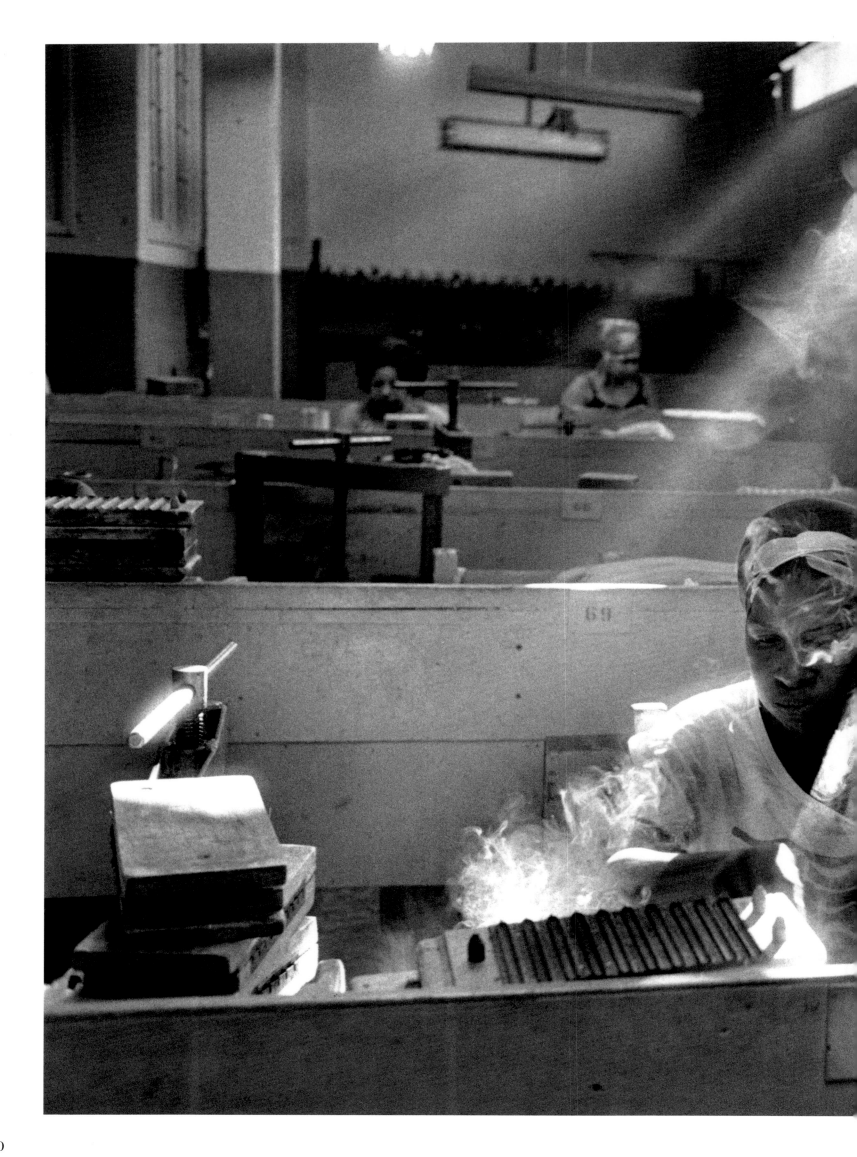

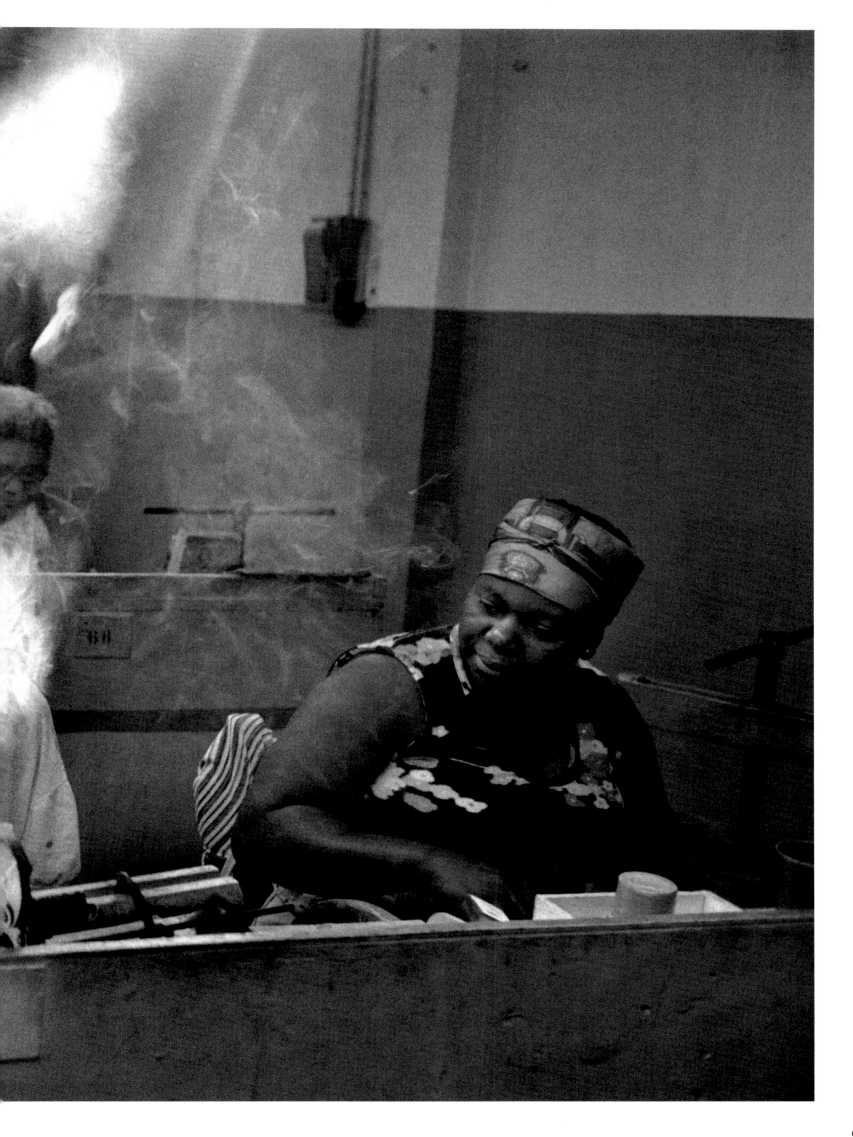

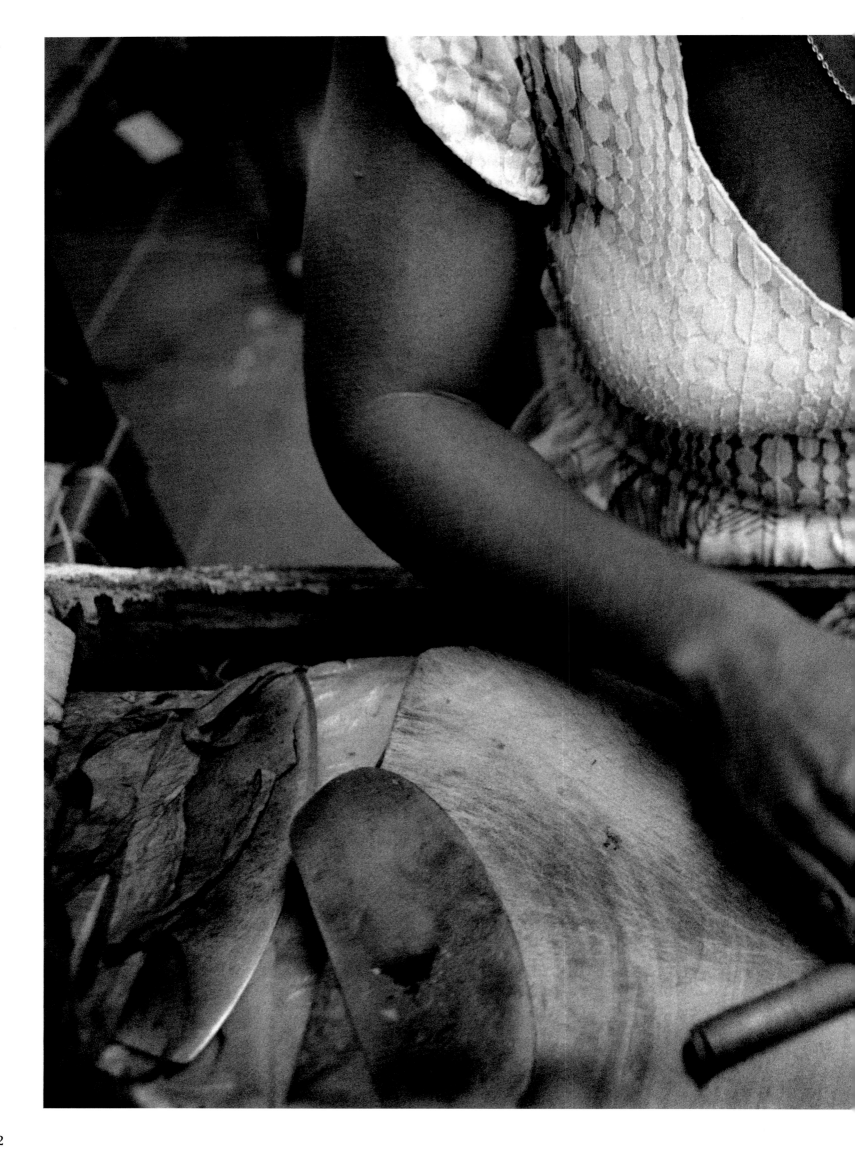

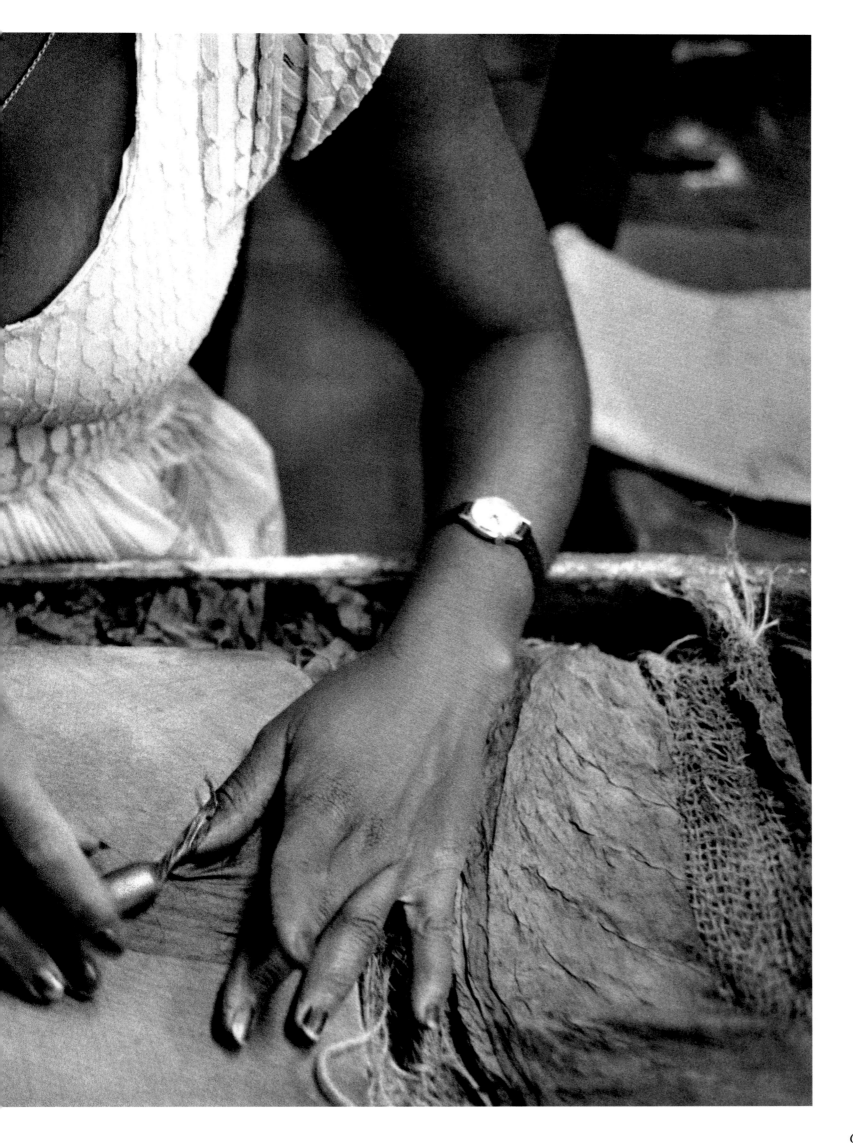

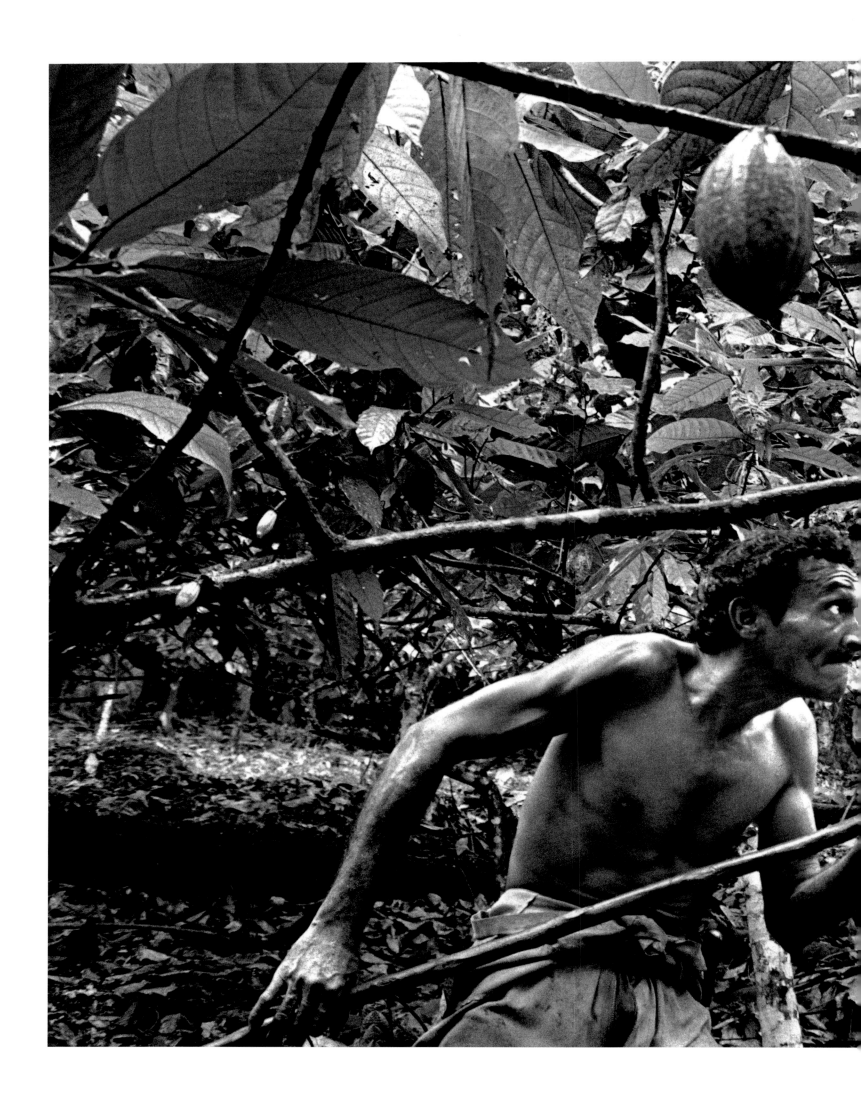

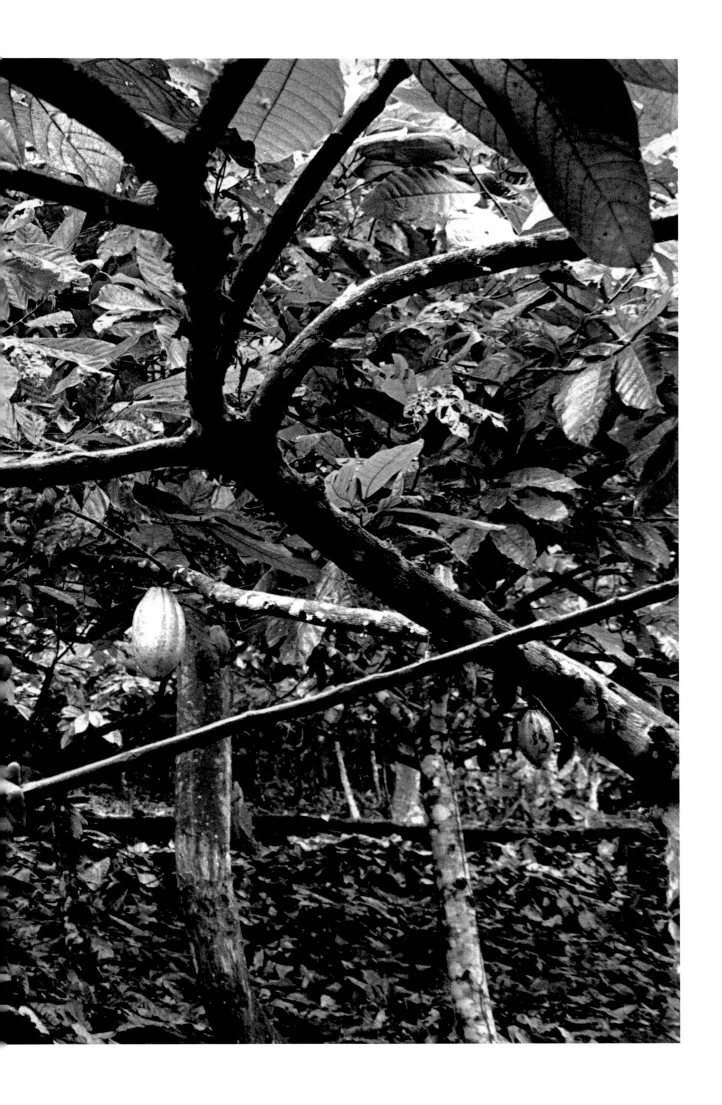

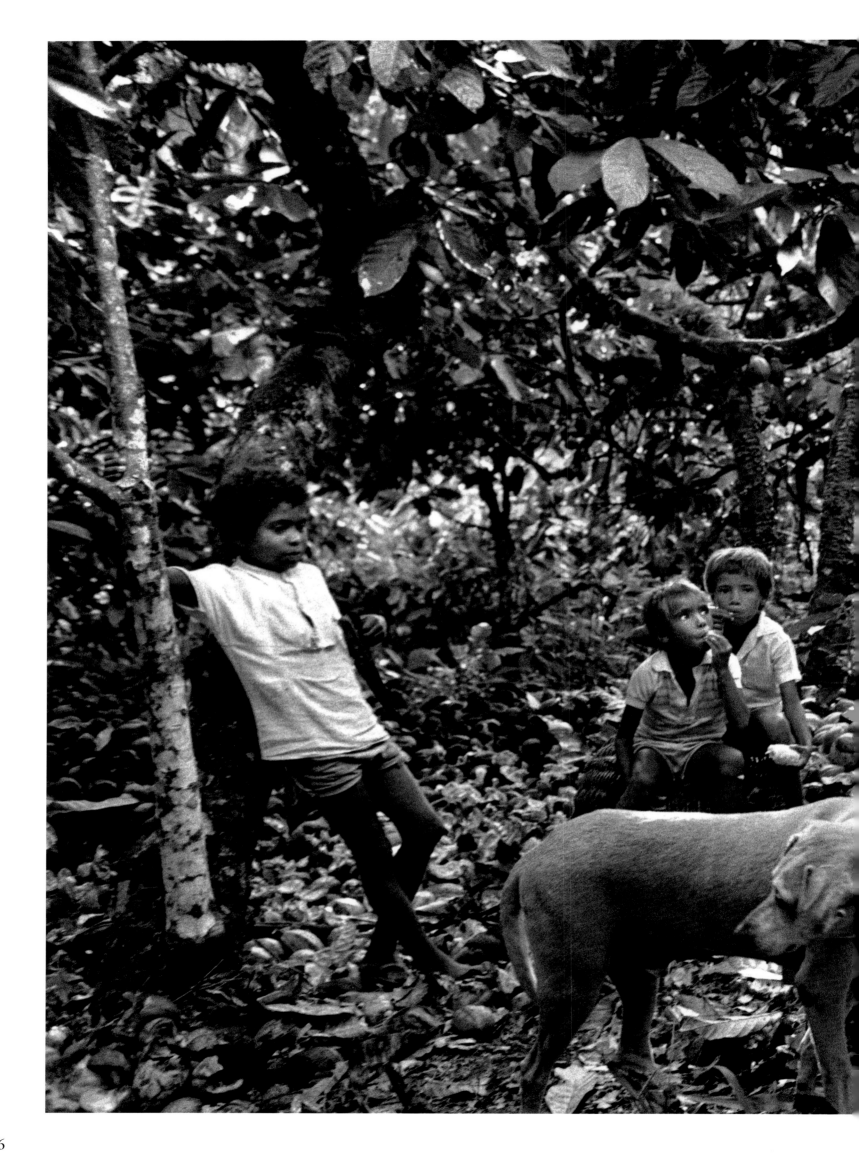

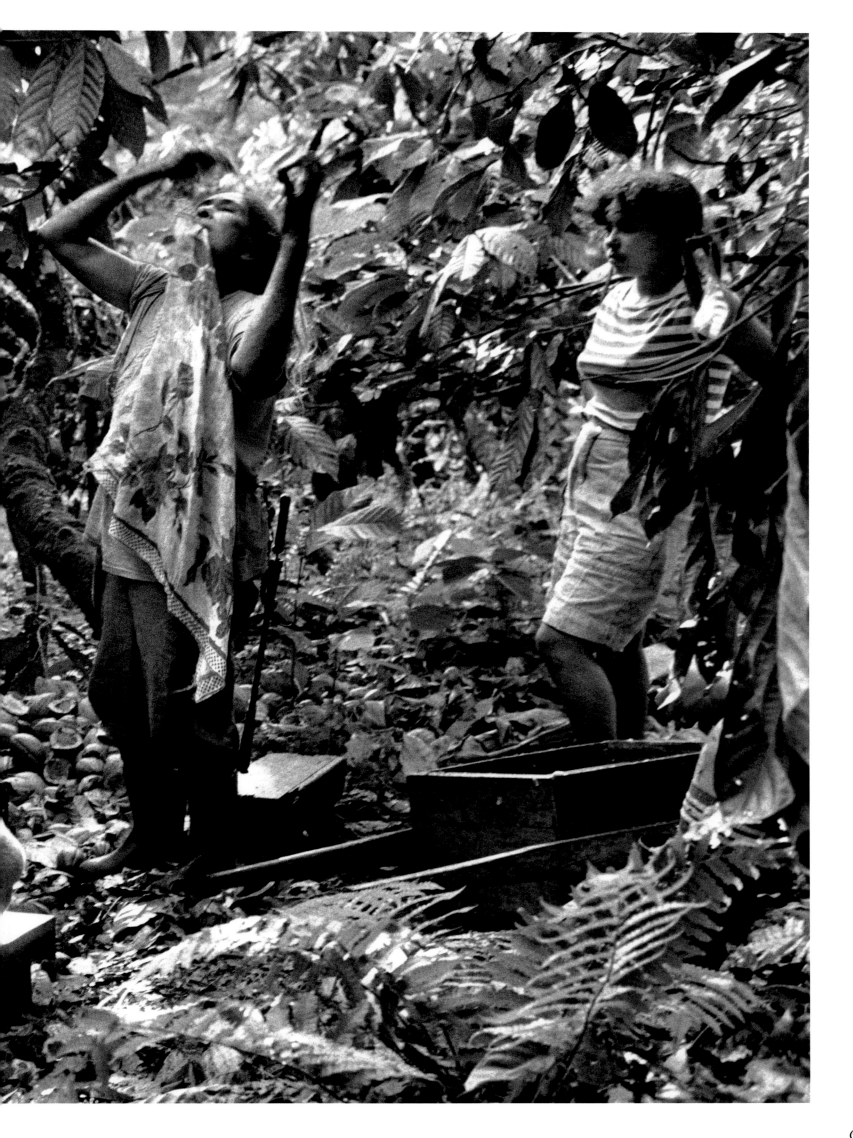

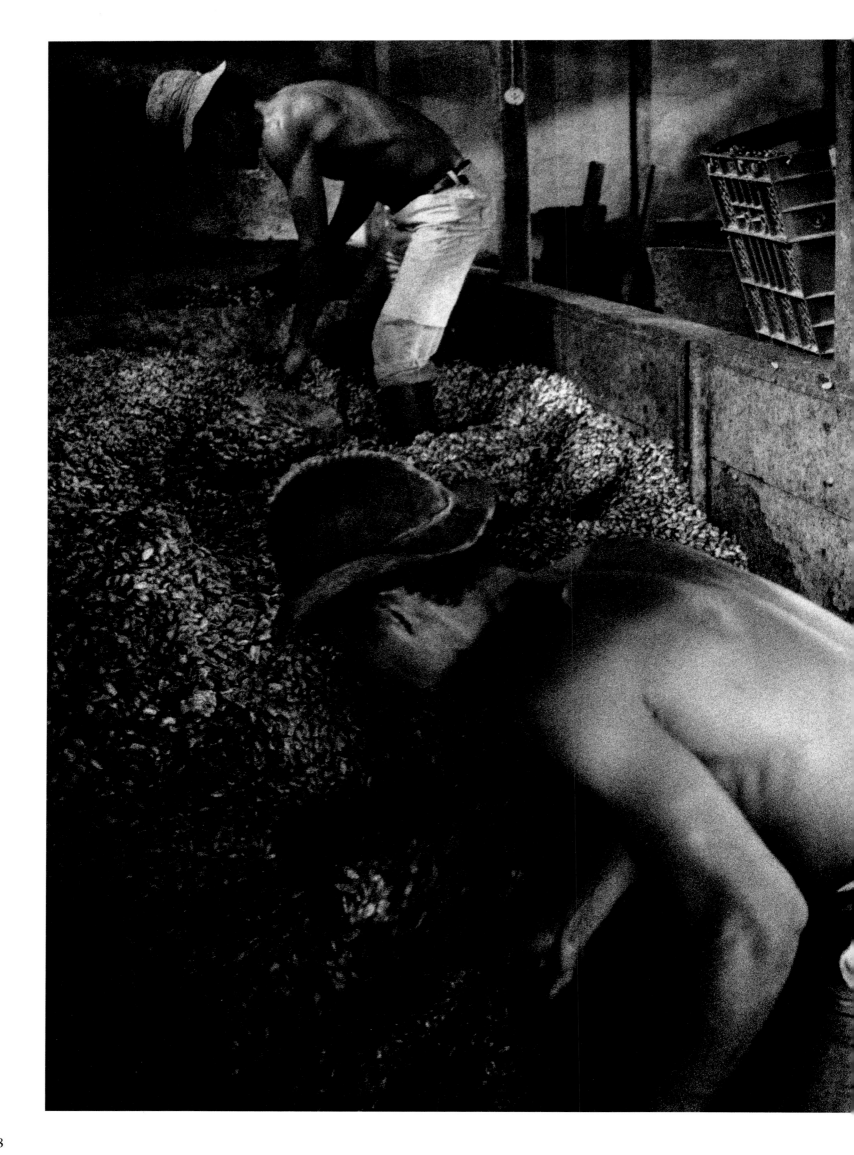

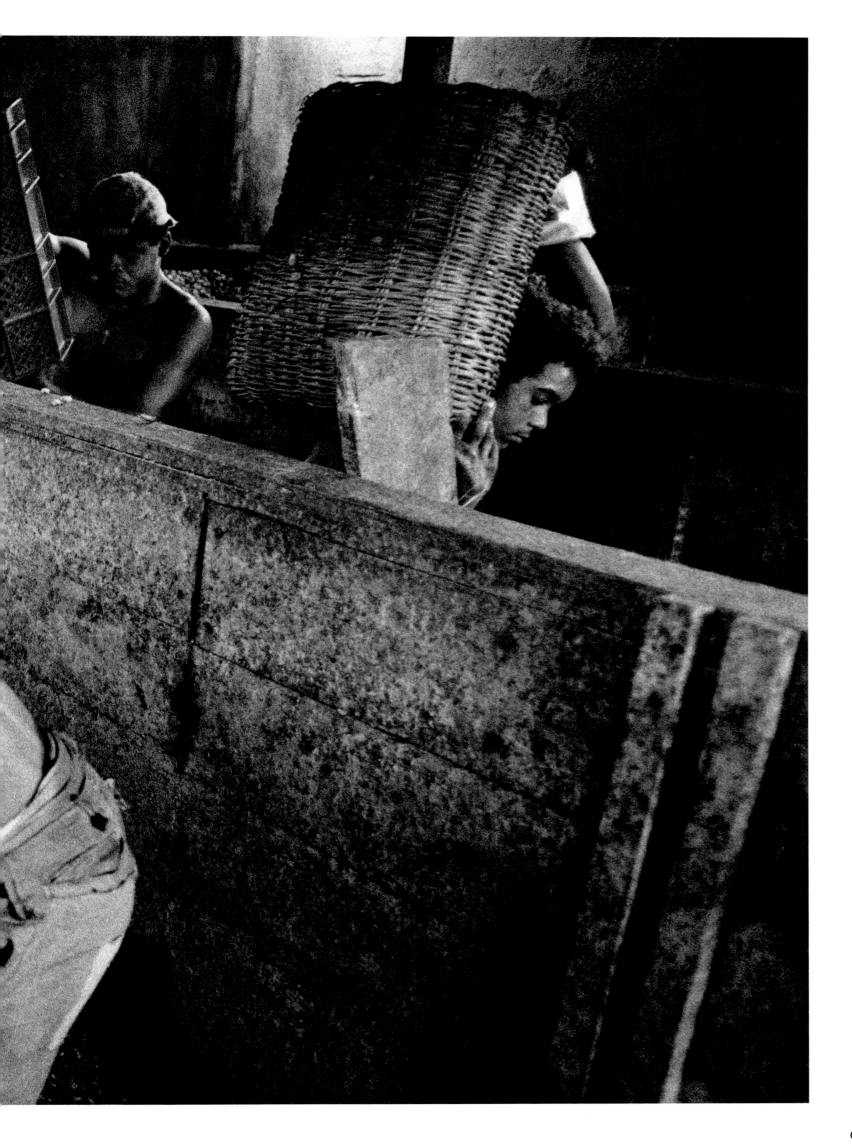

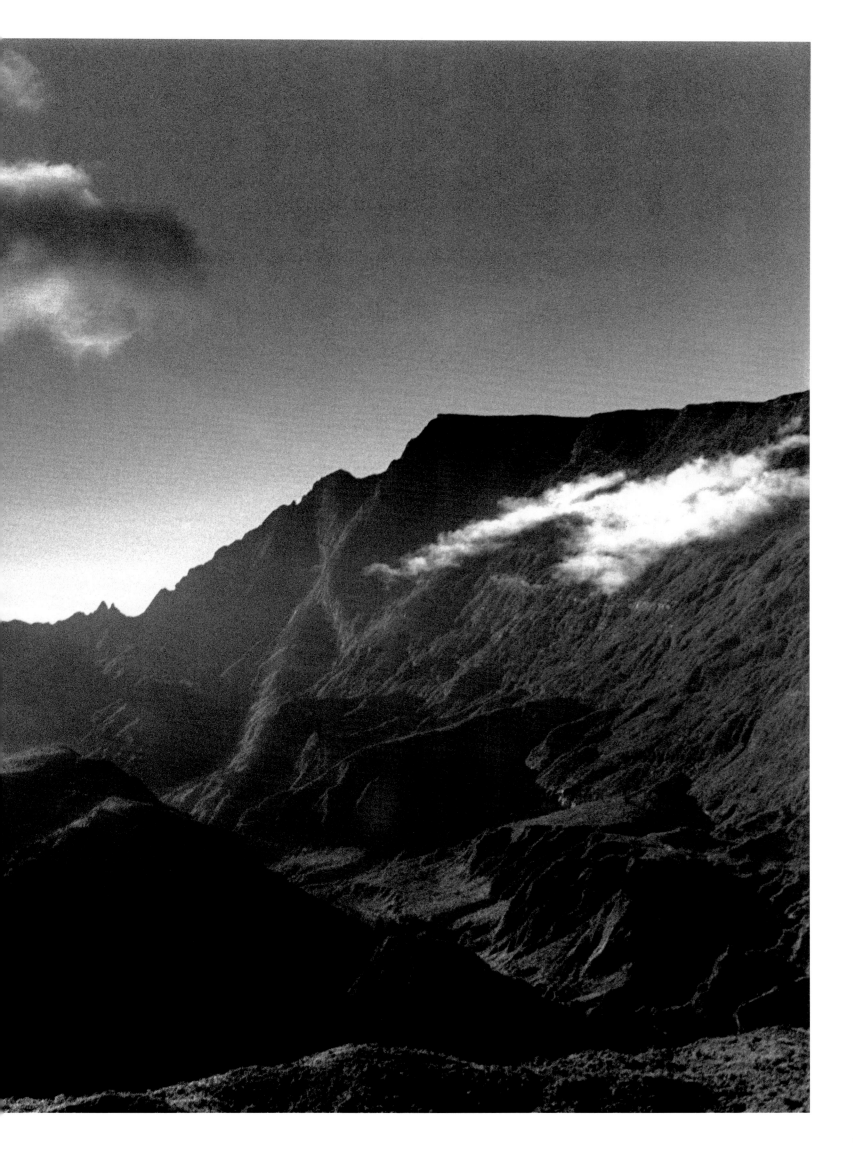

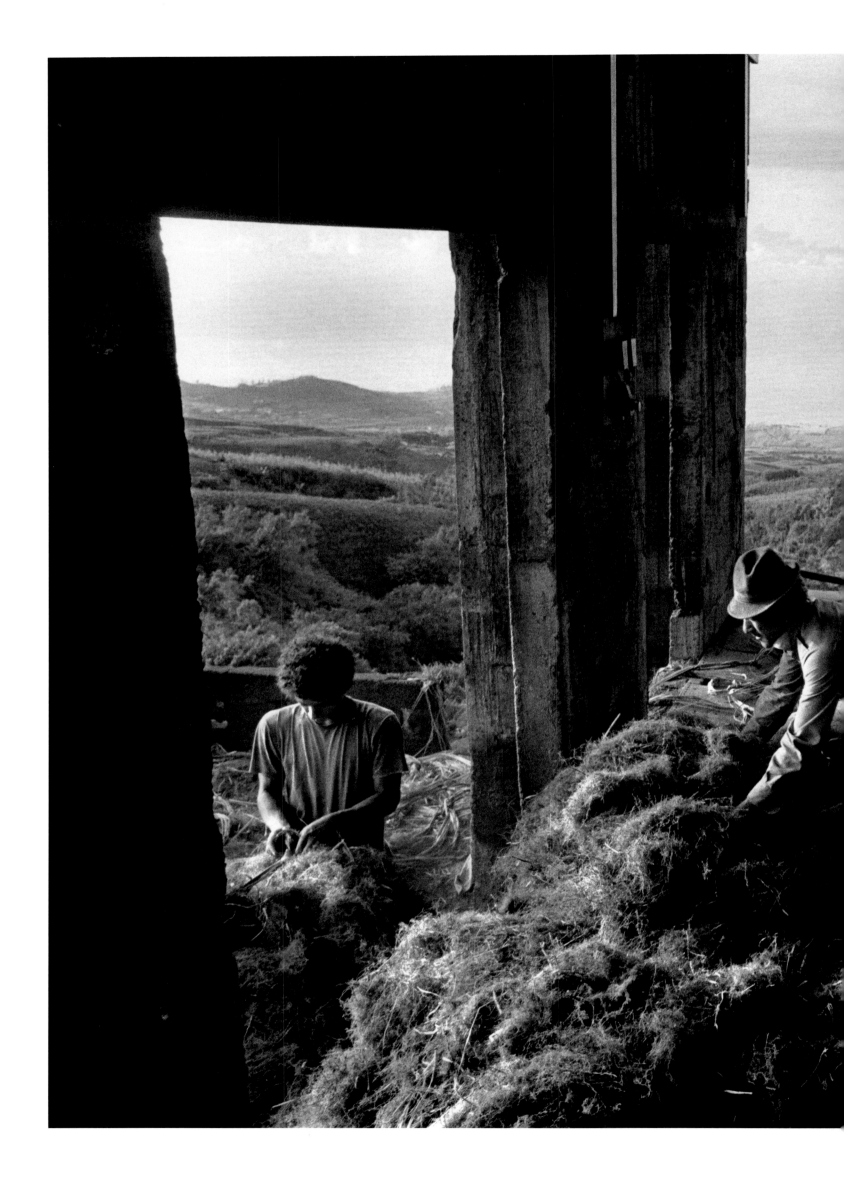

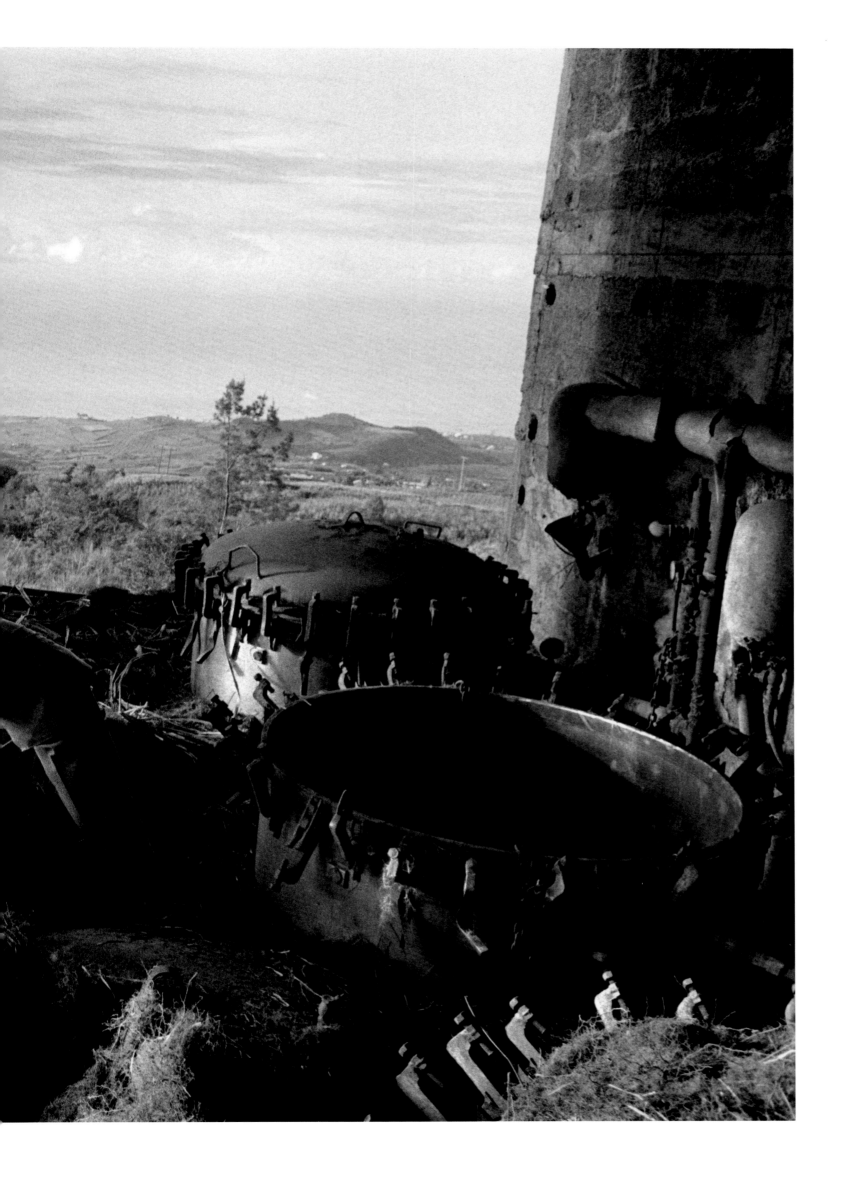

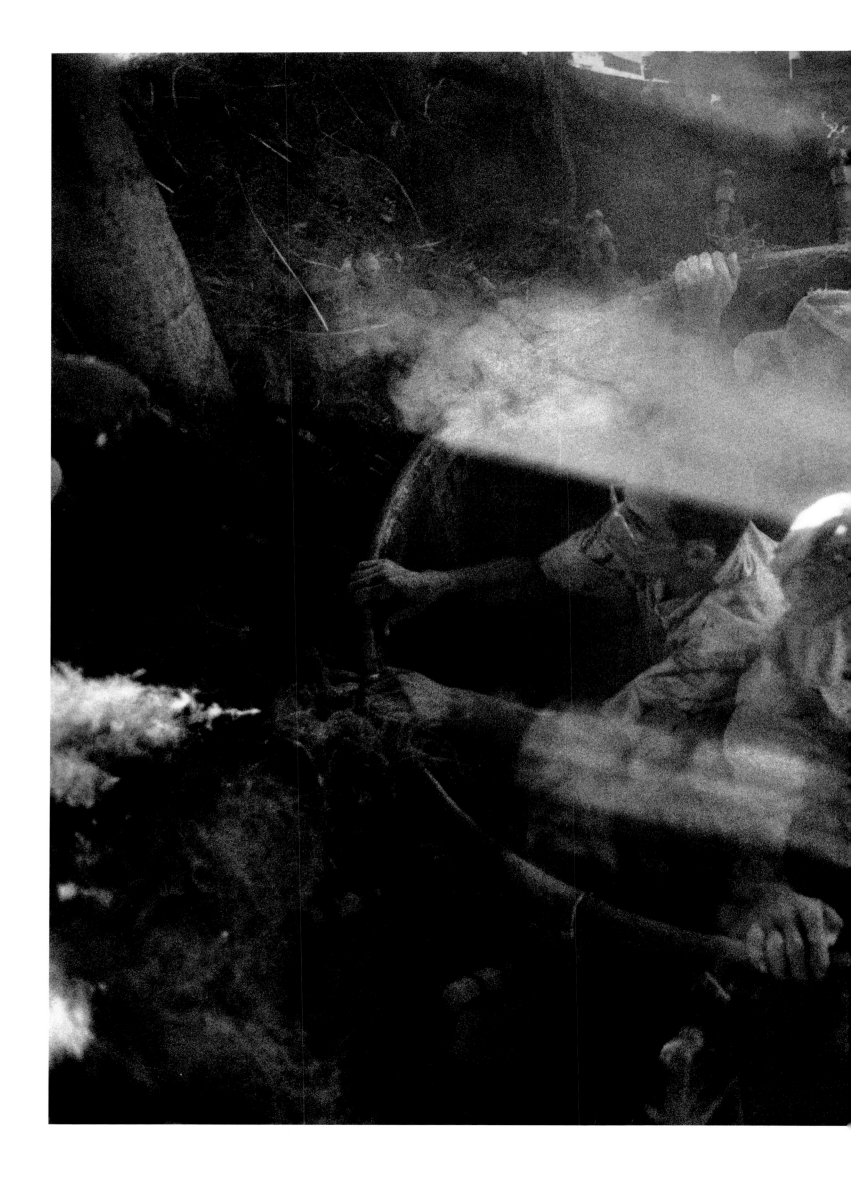

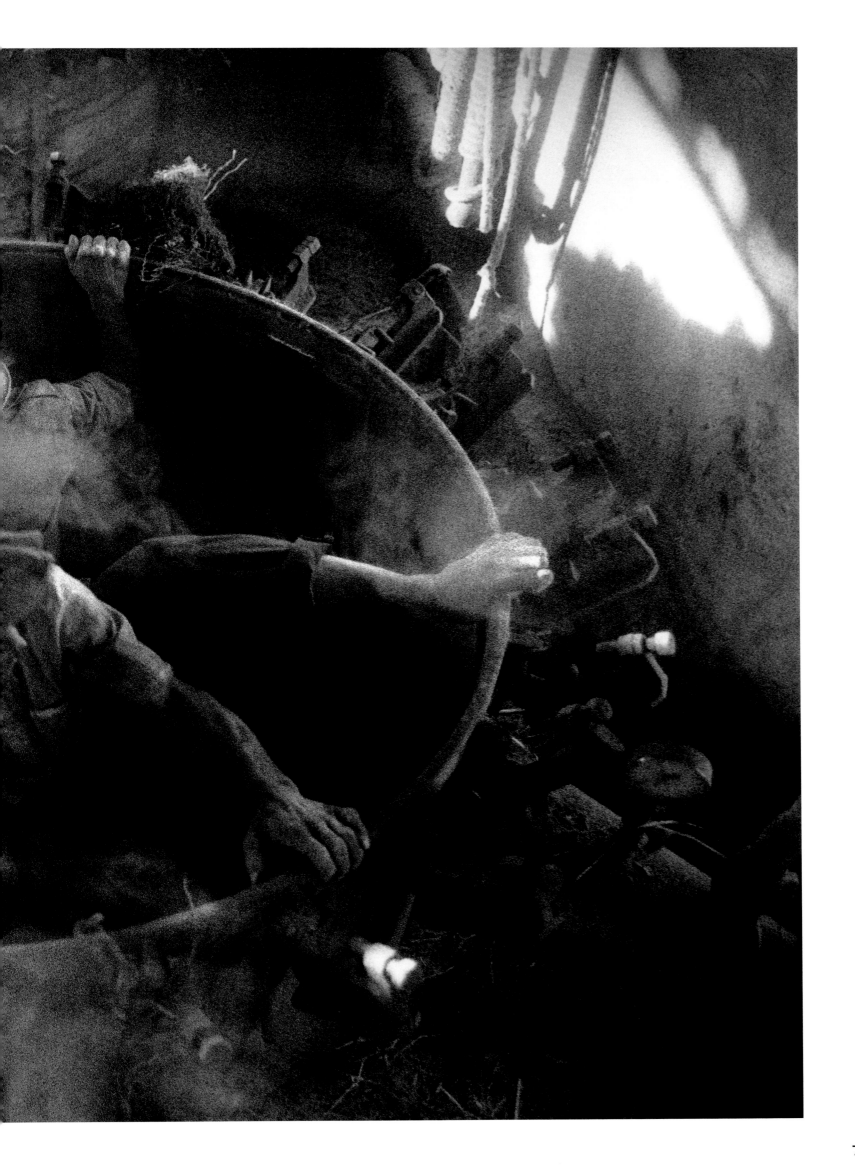

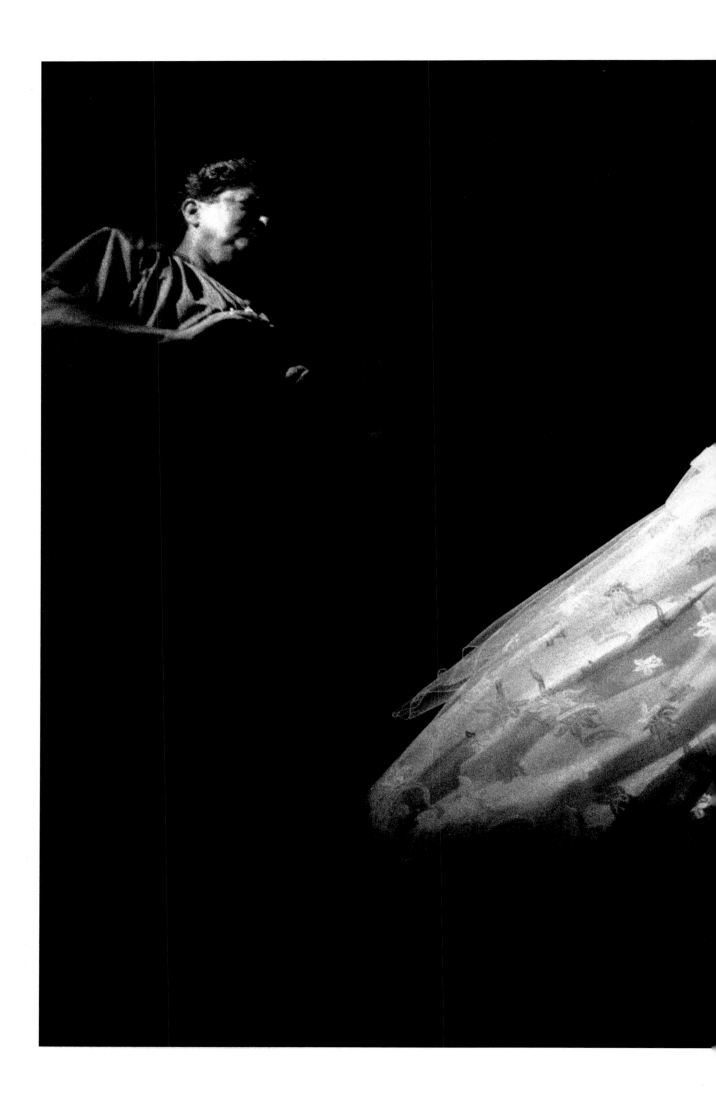

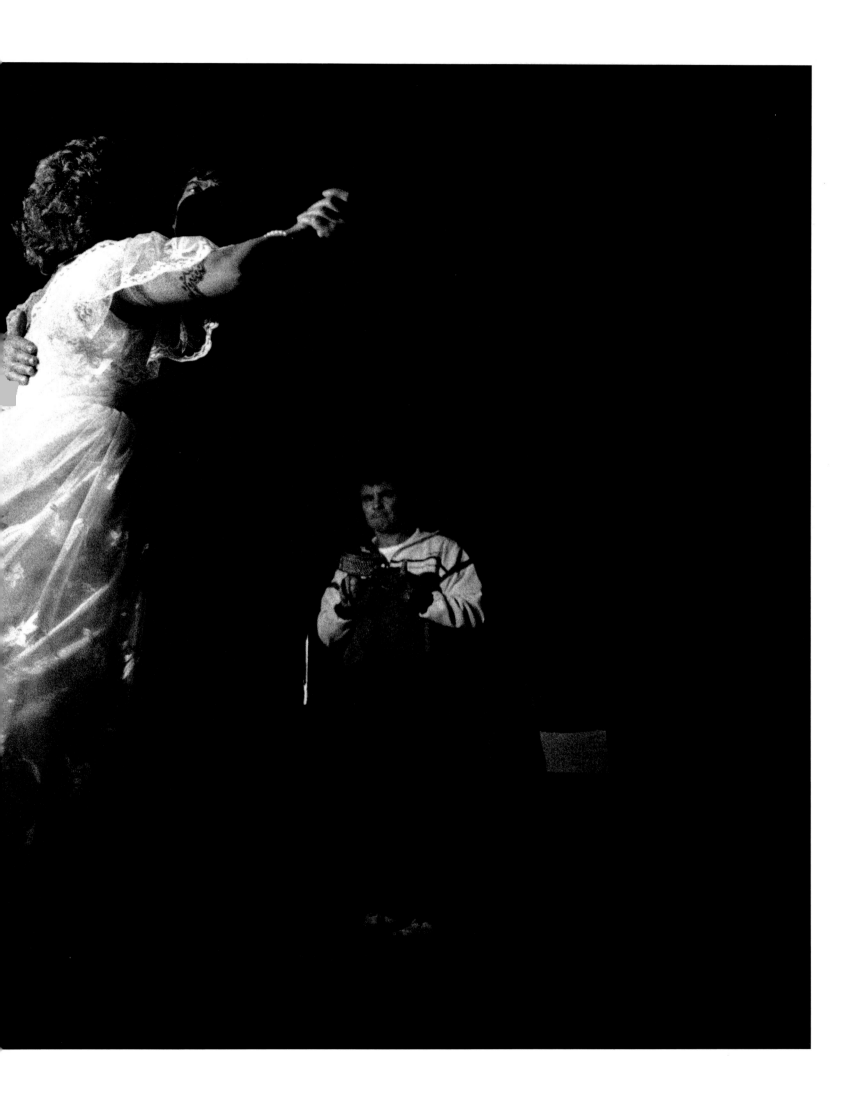

II

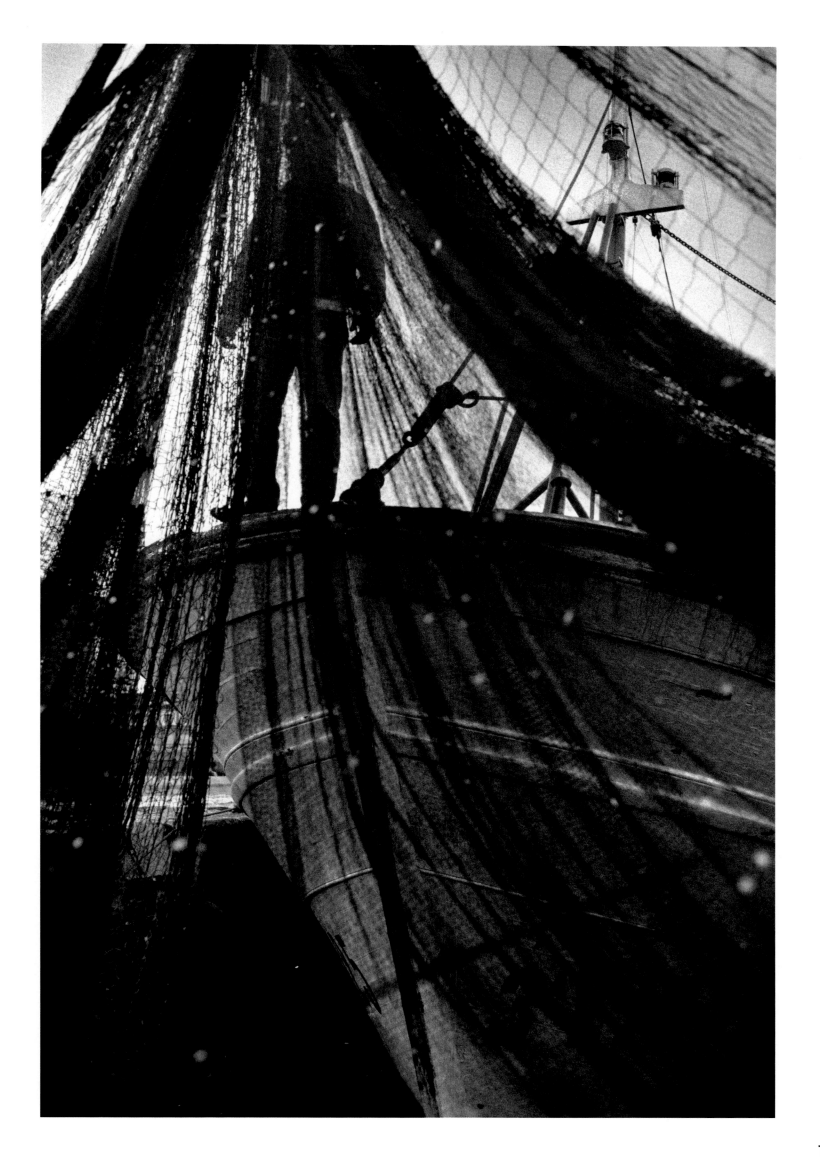

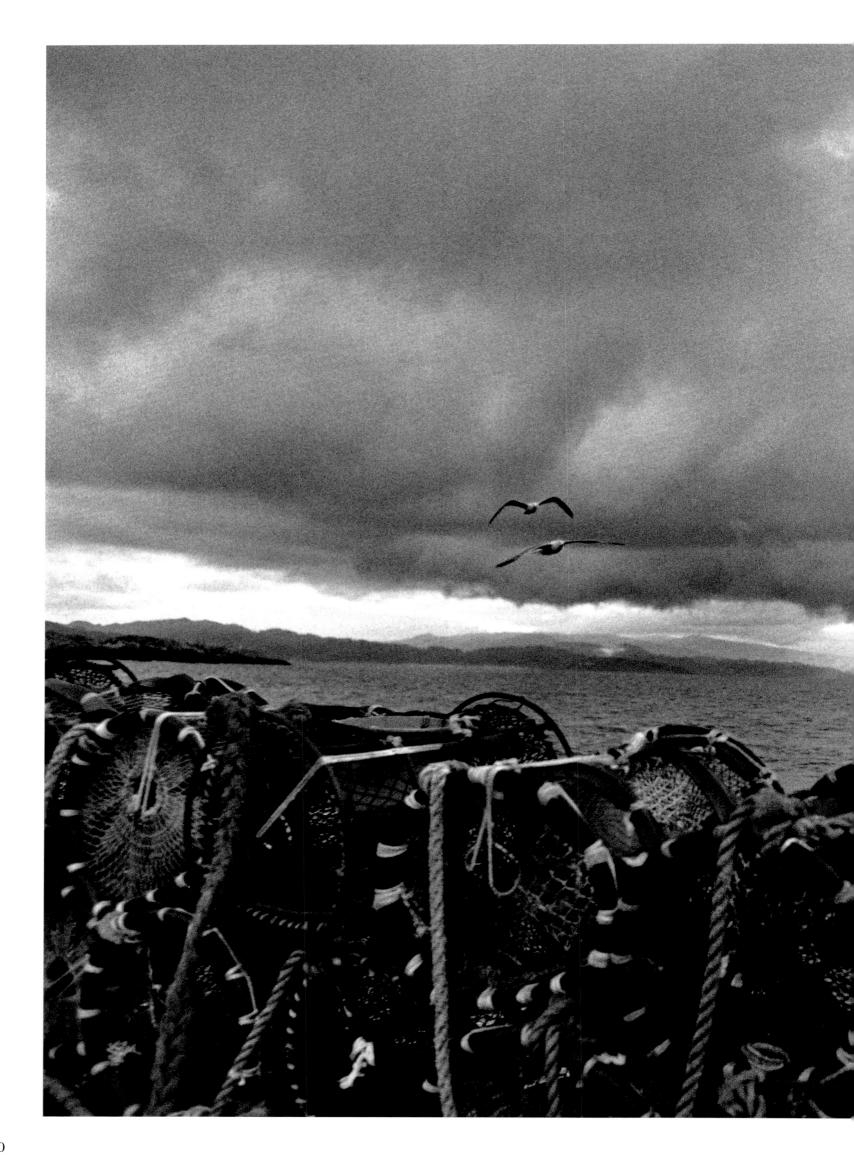

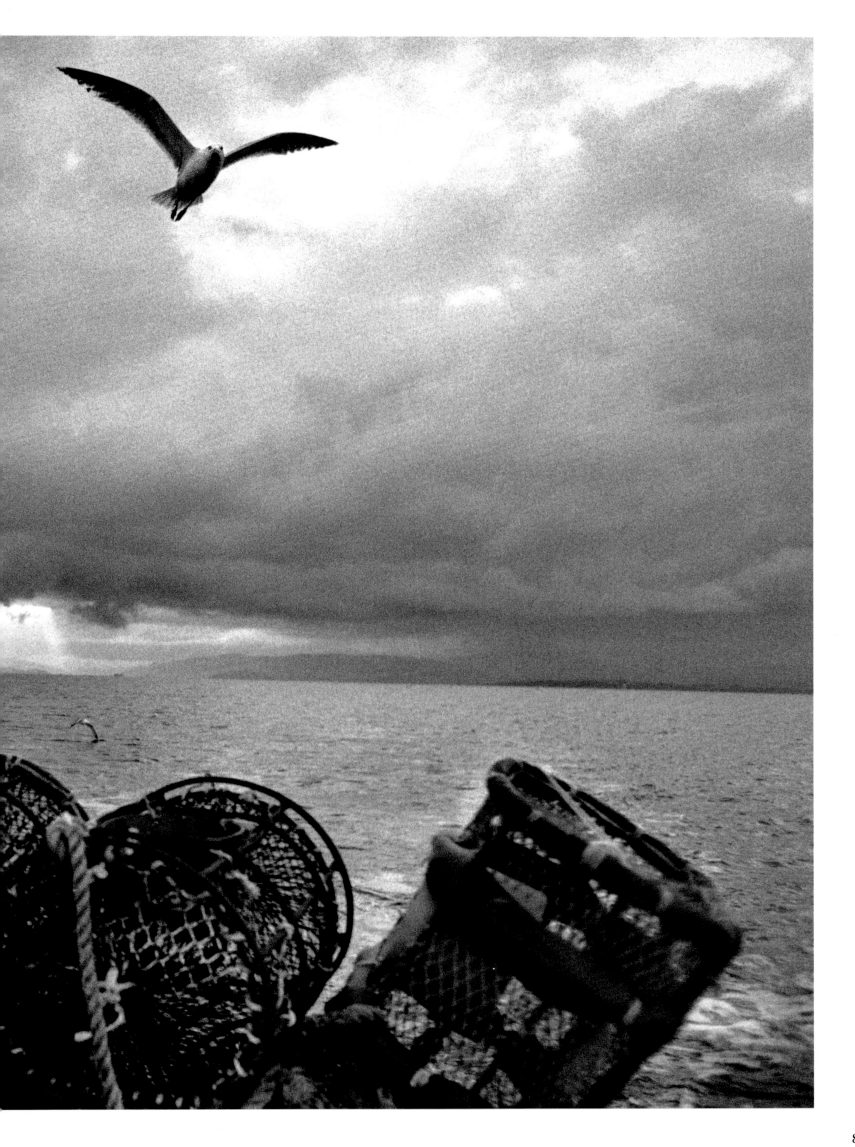

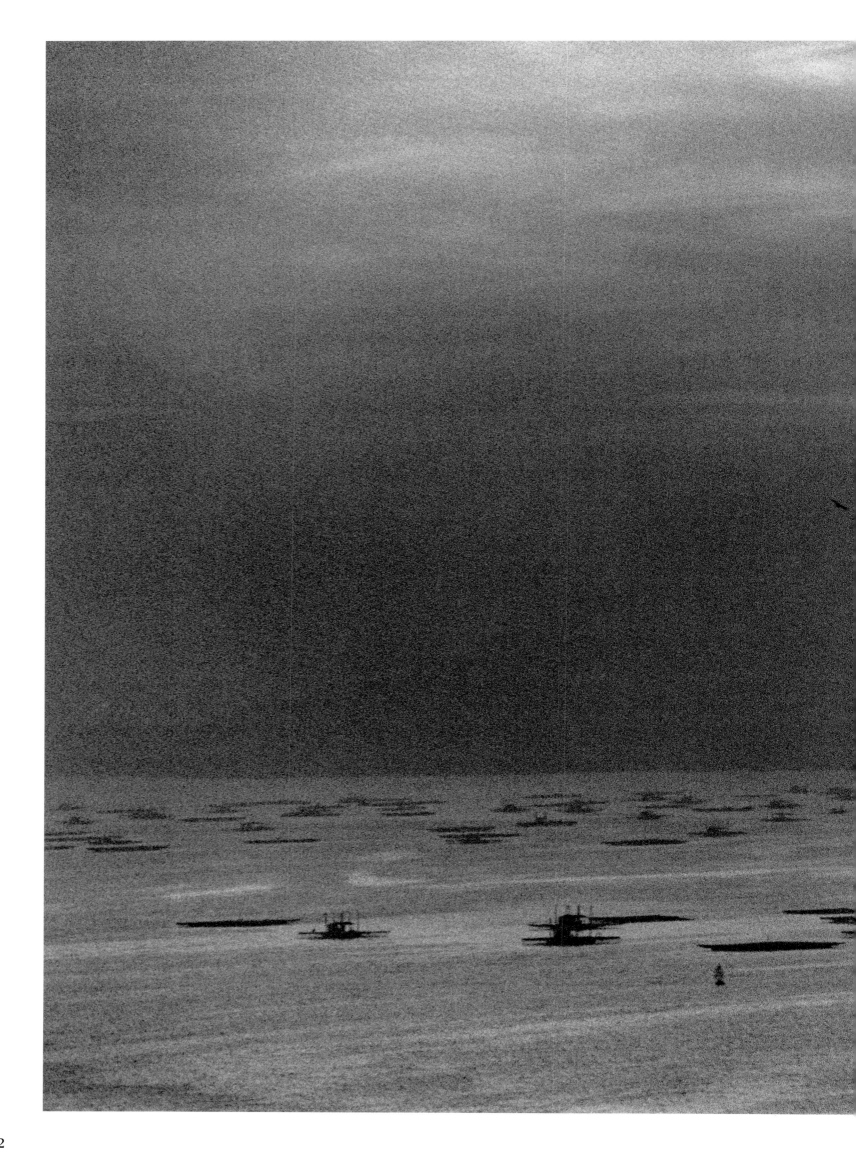

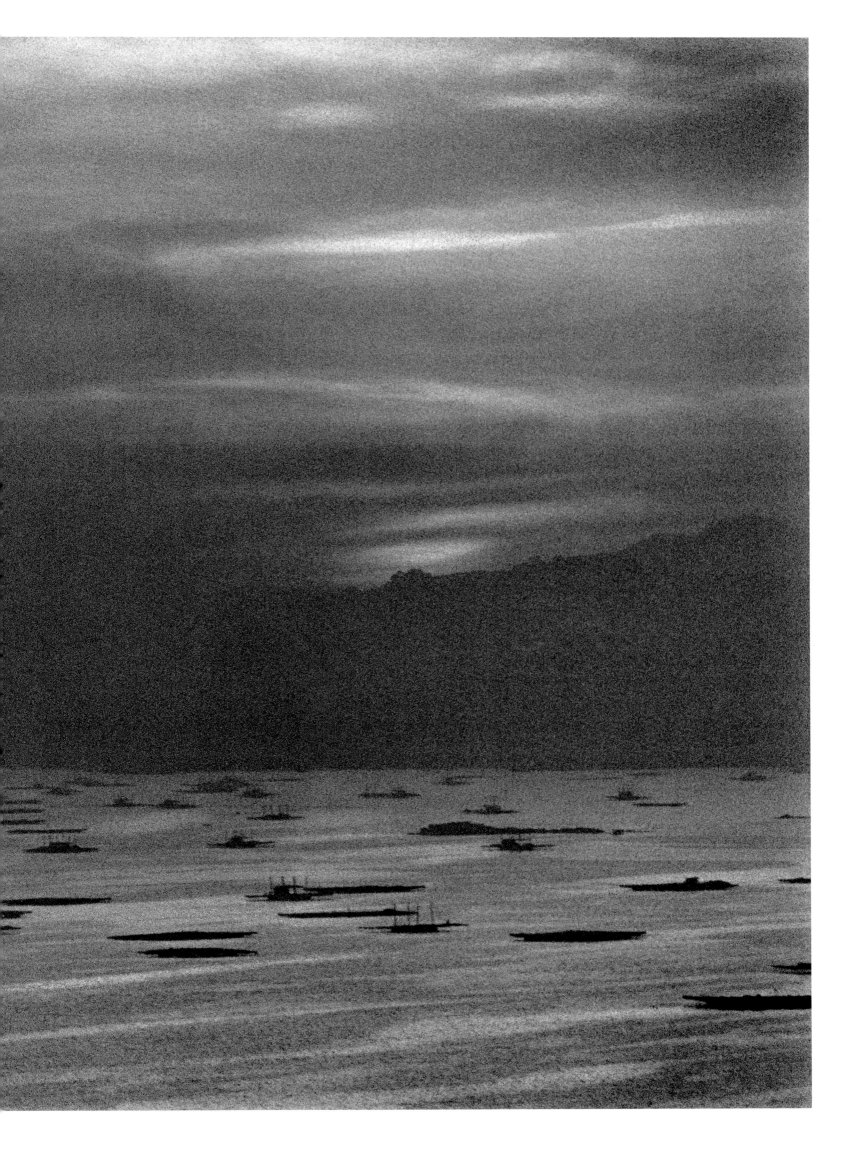

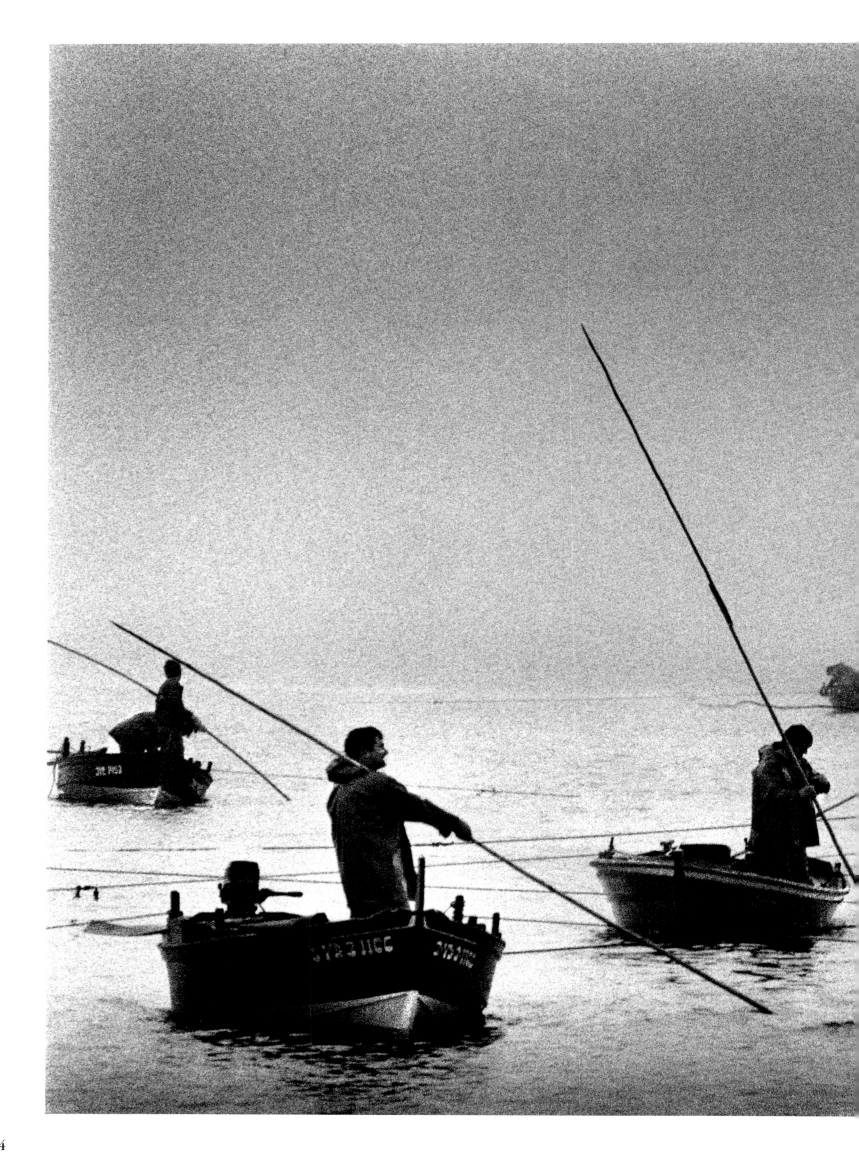

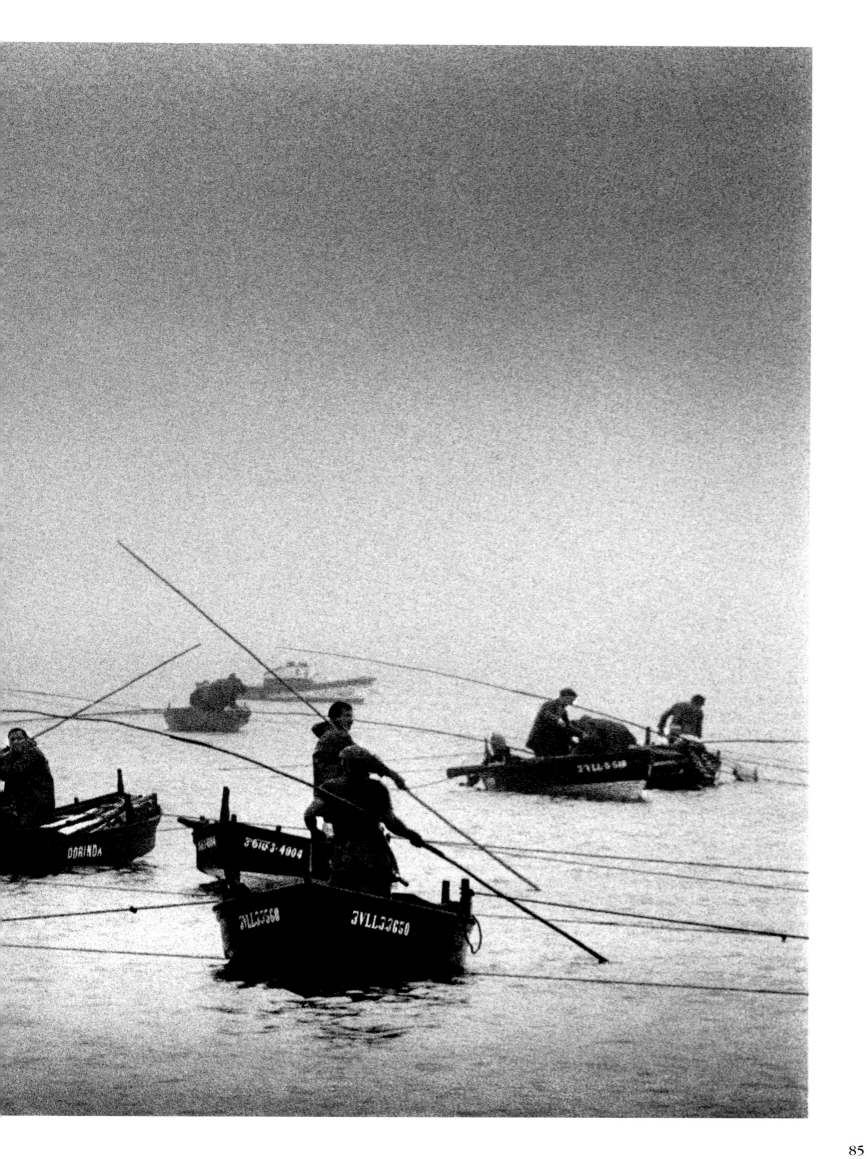

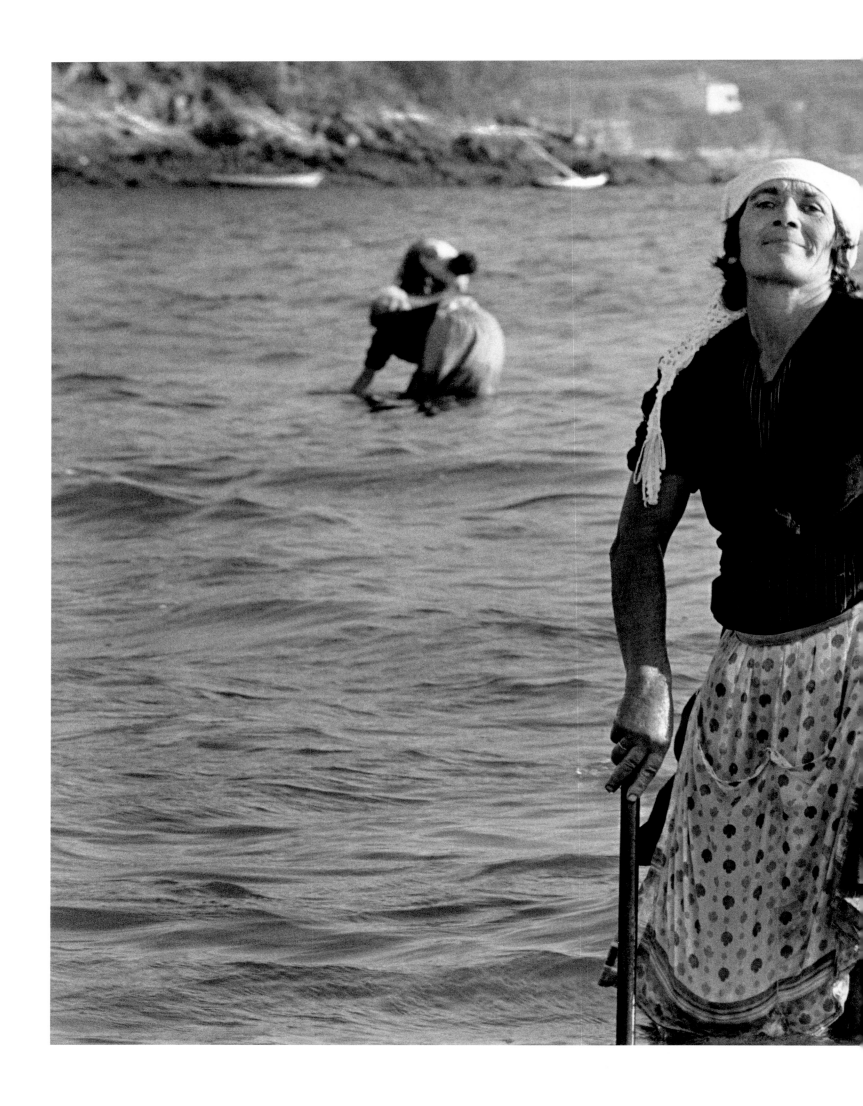

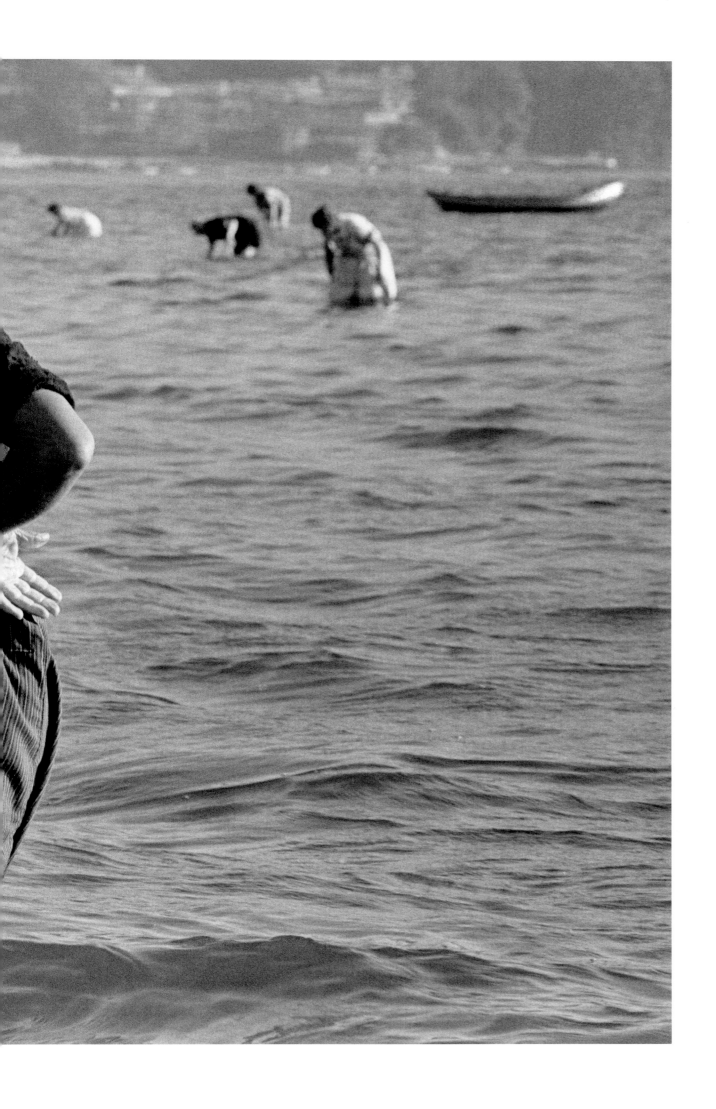

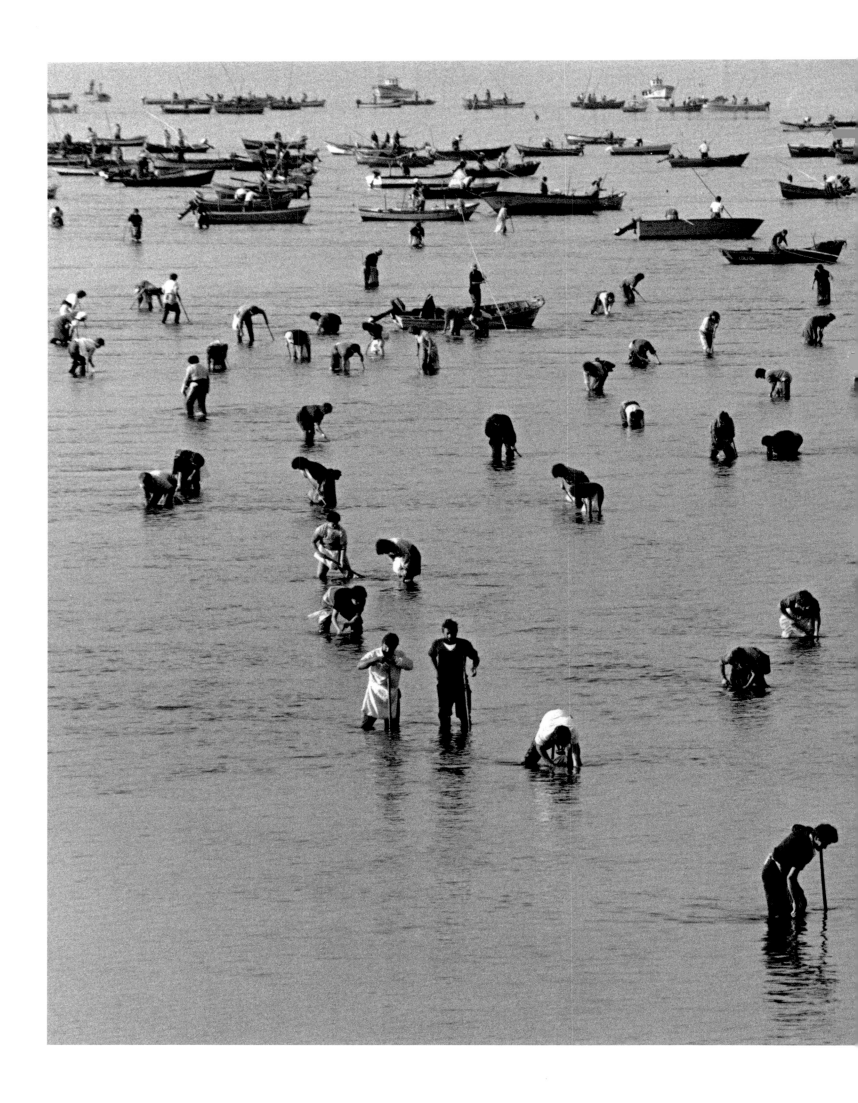

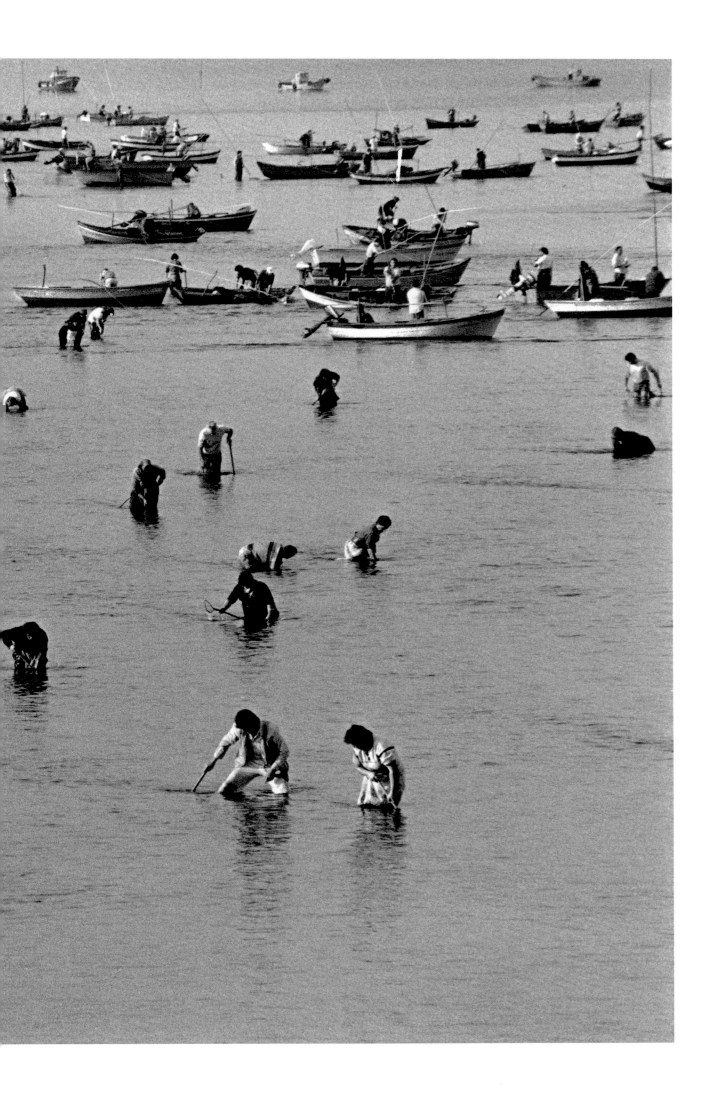

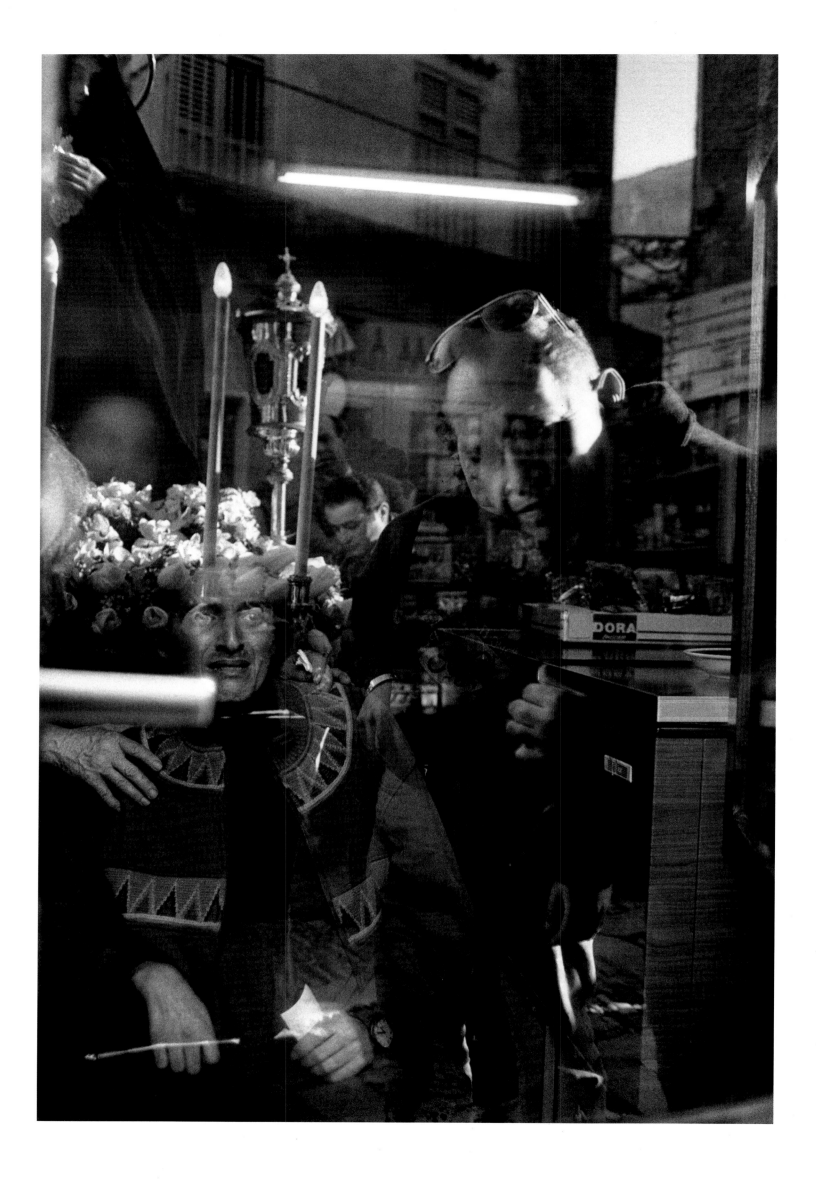

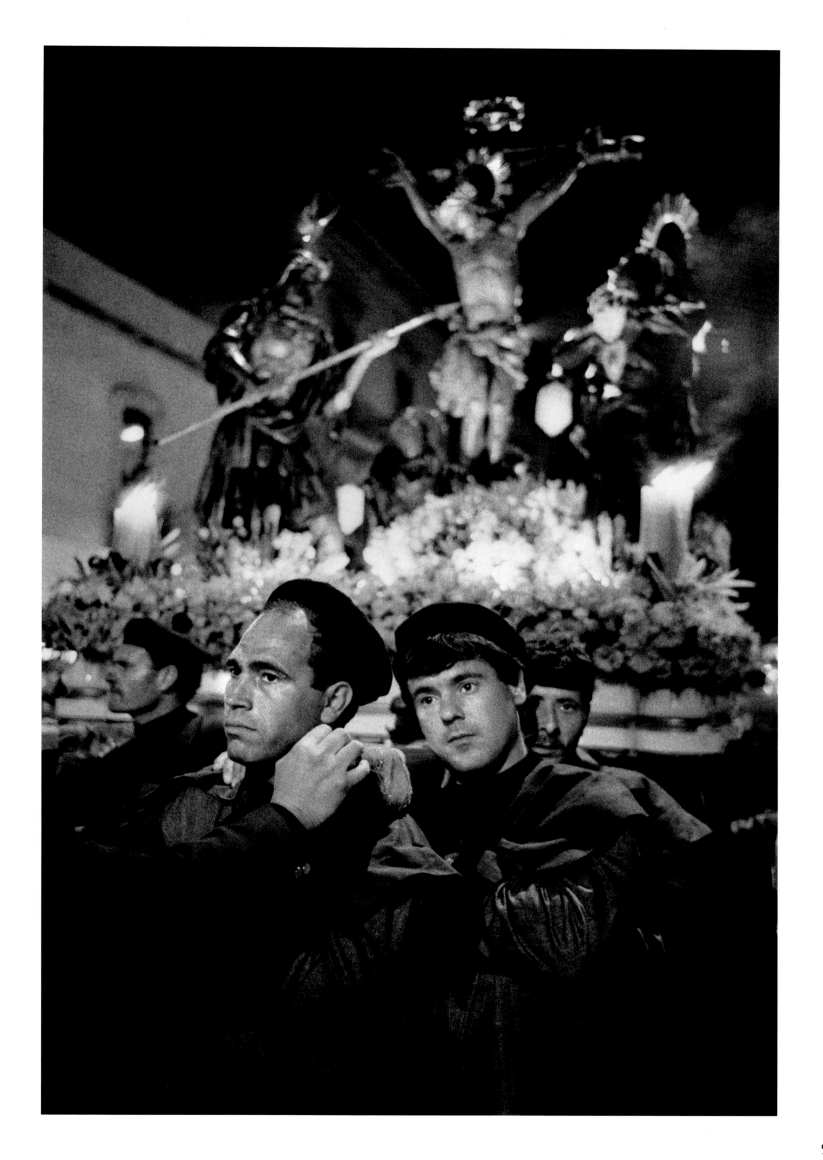

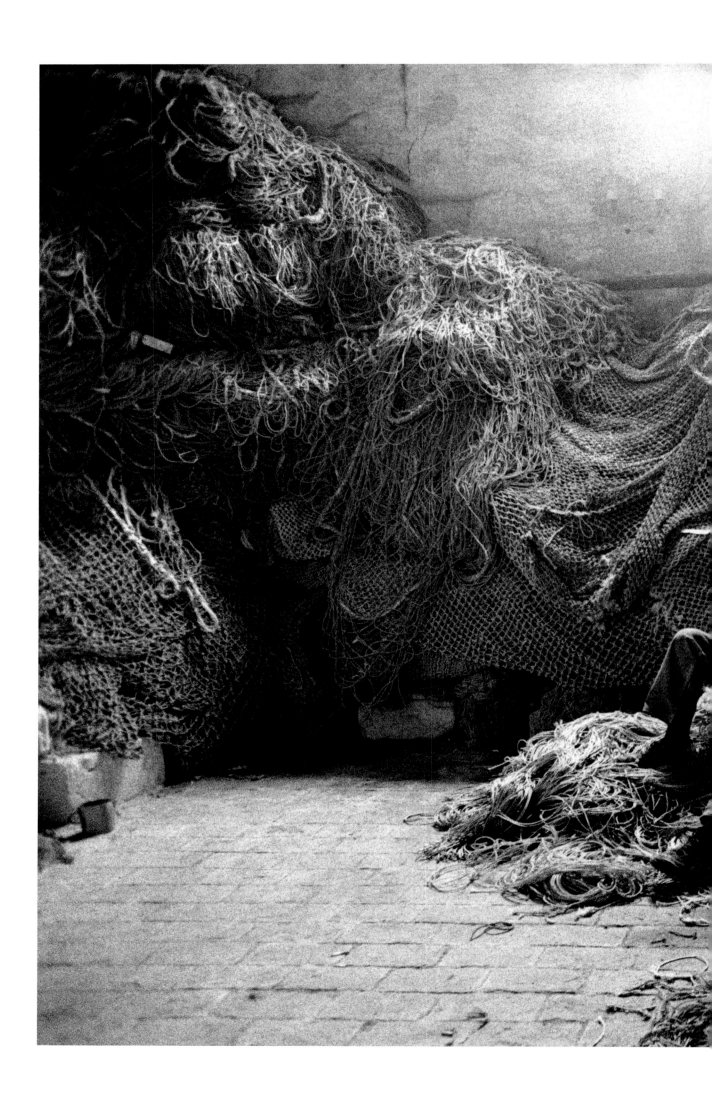

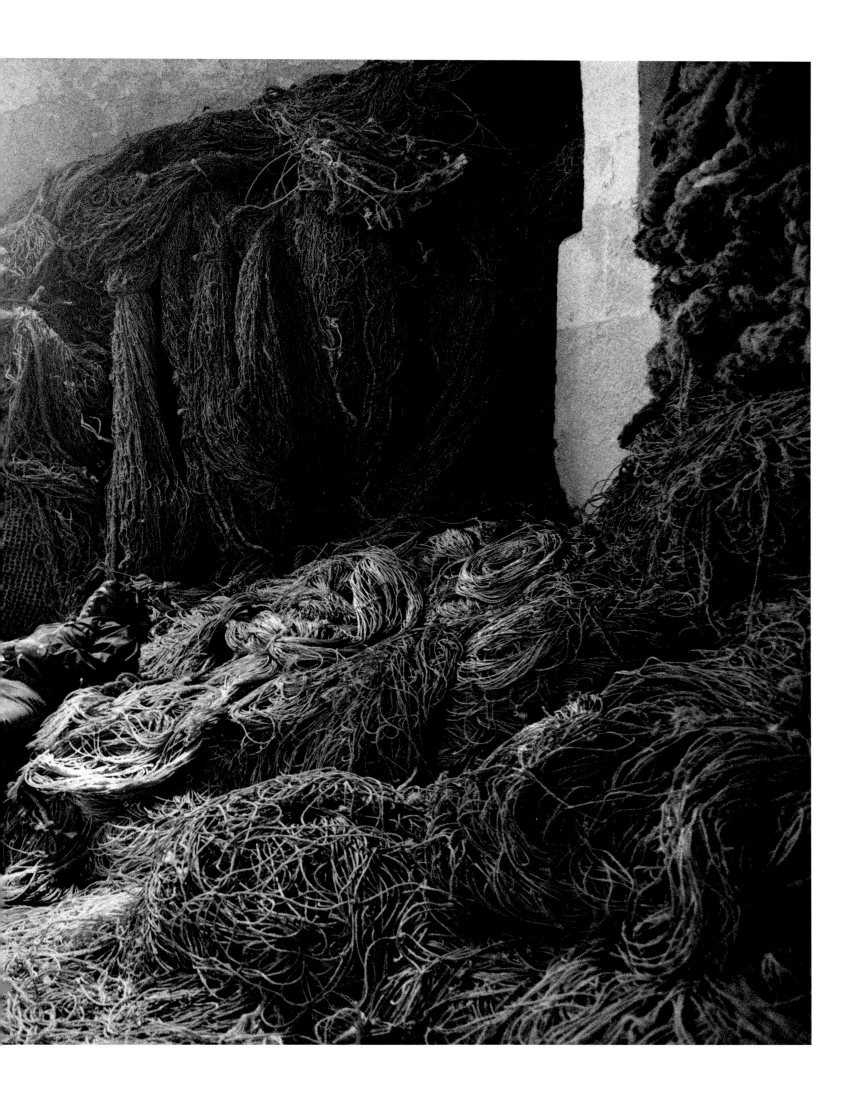

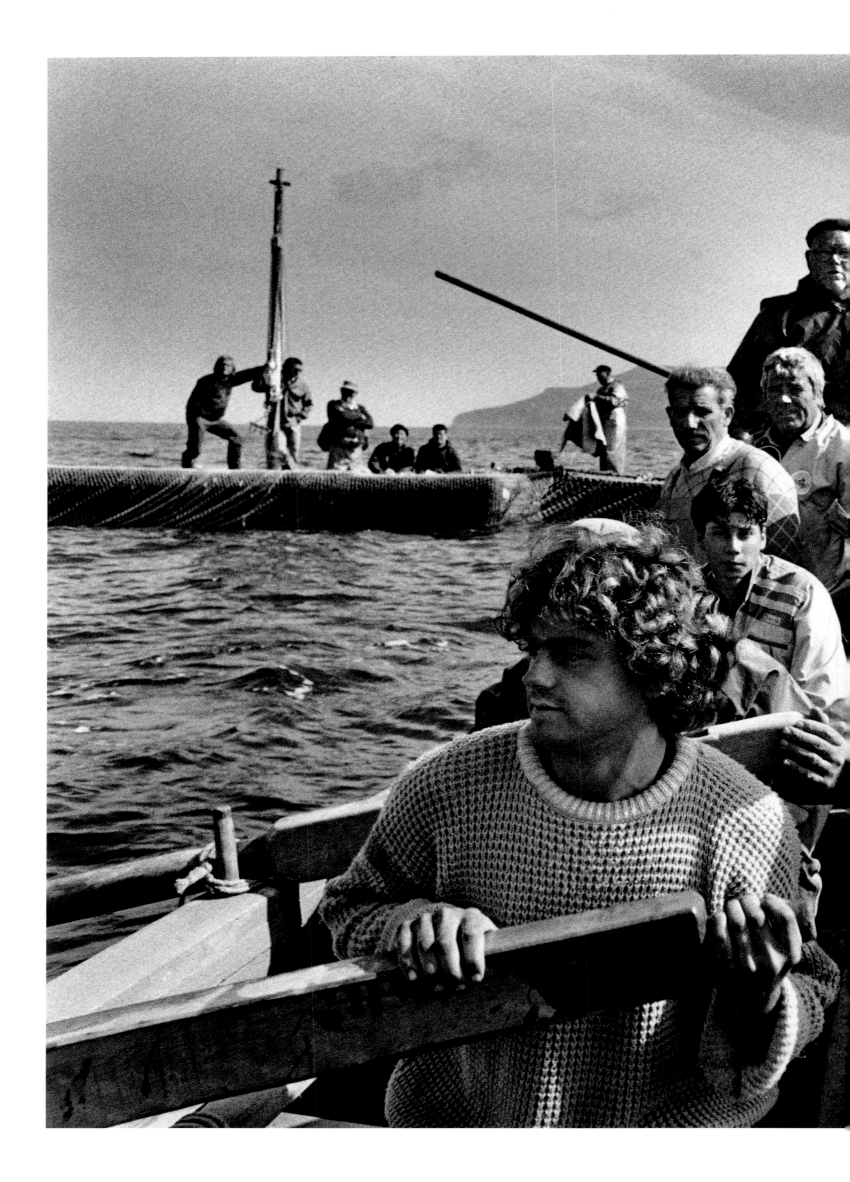

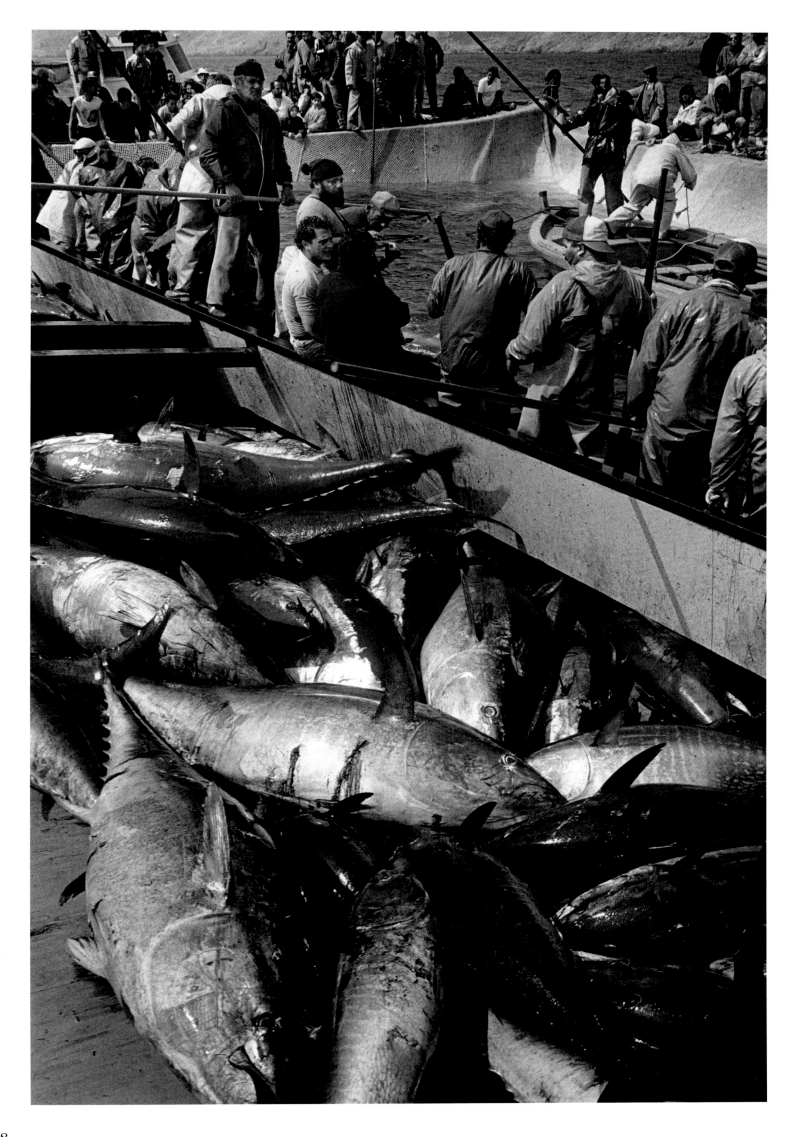

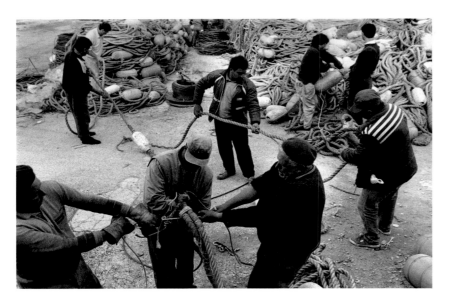

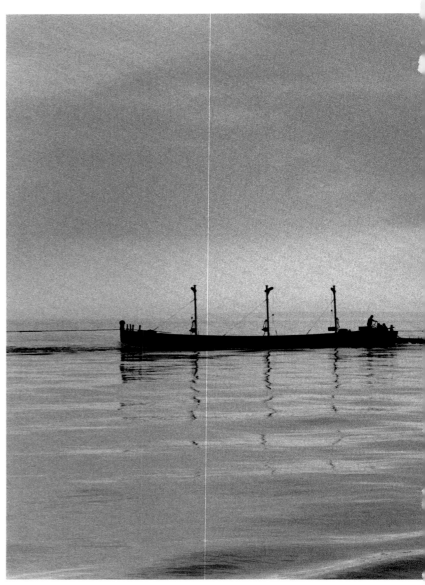

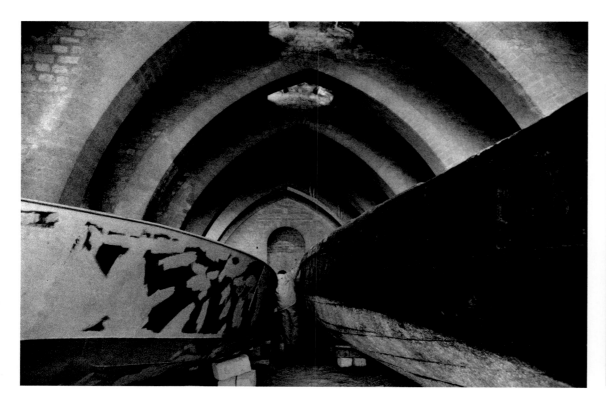

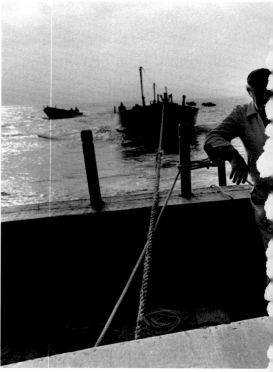

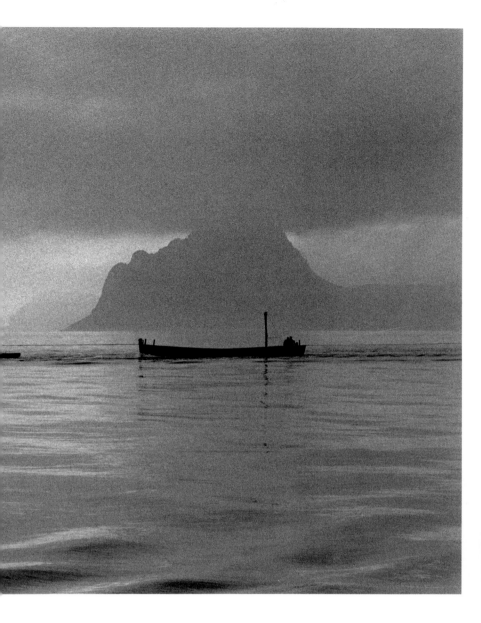
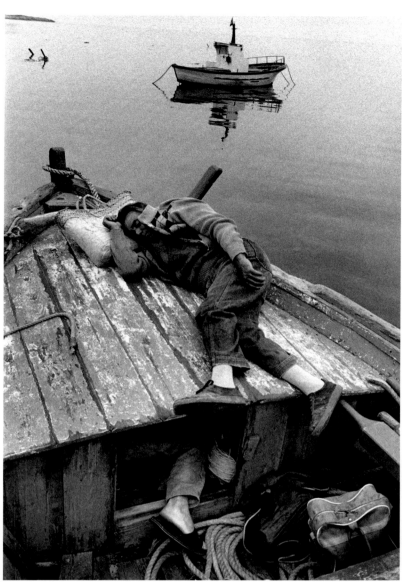
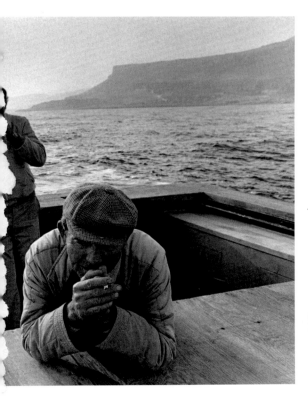
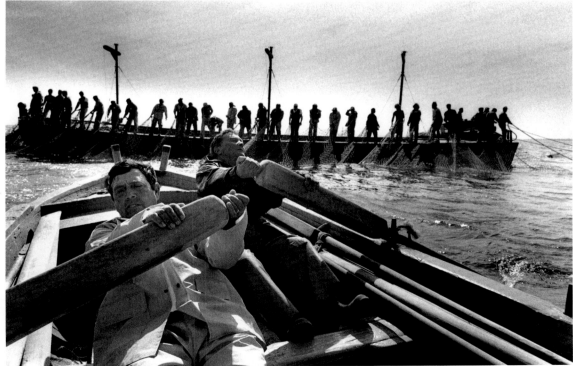

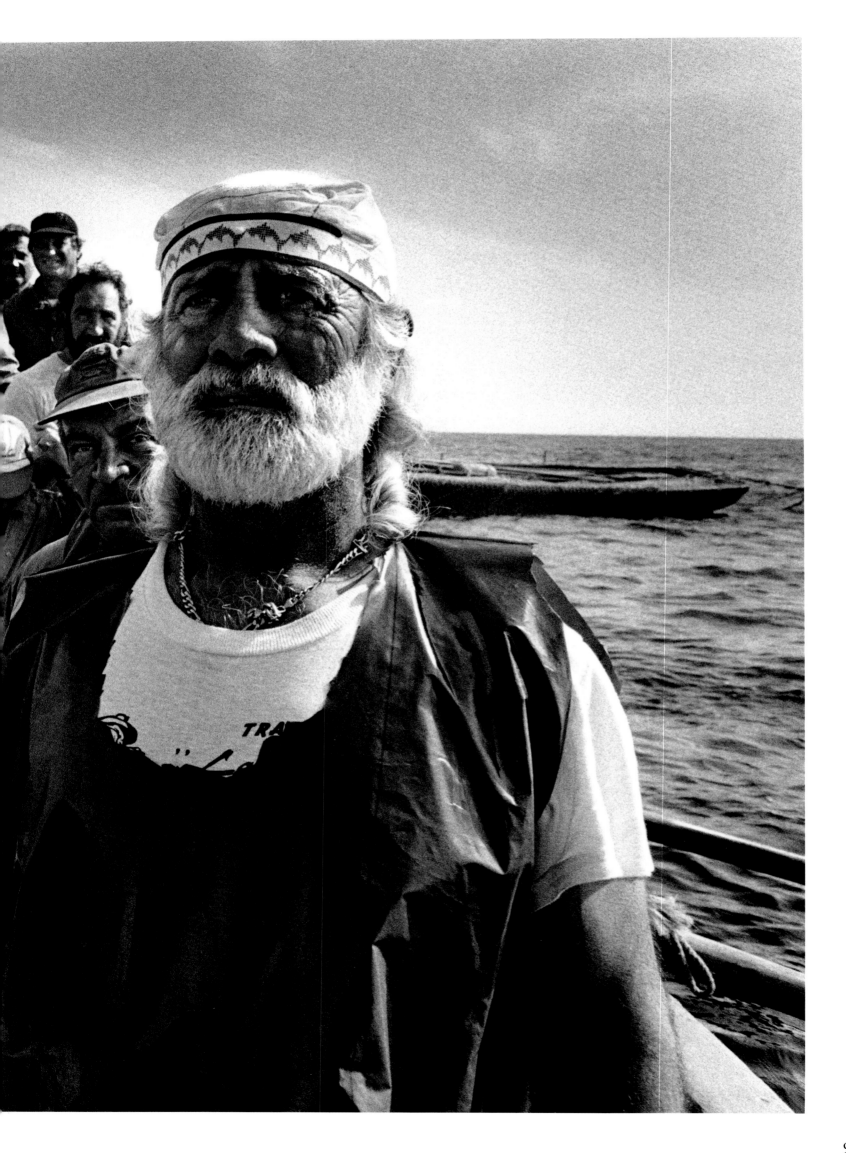

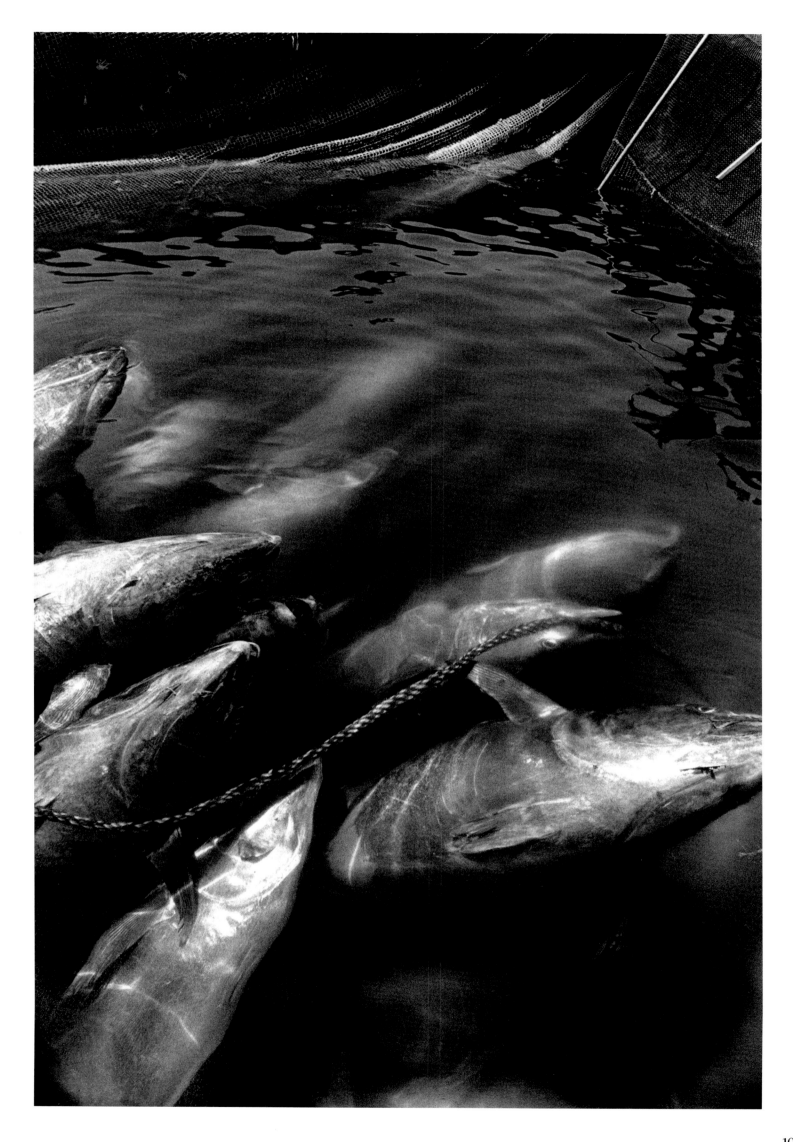

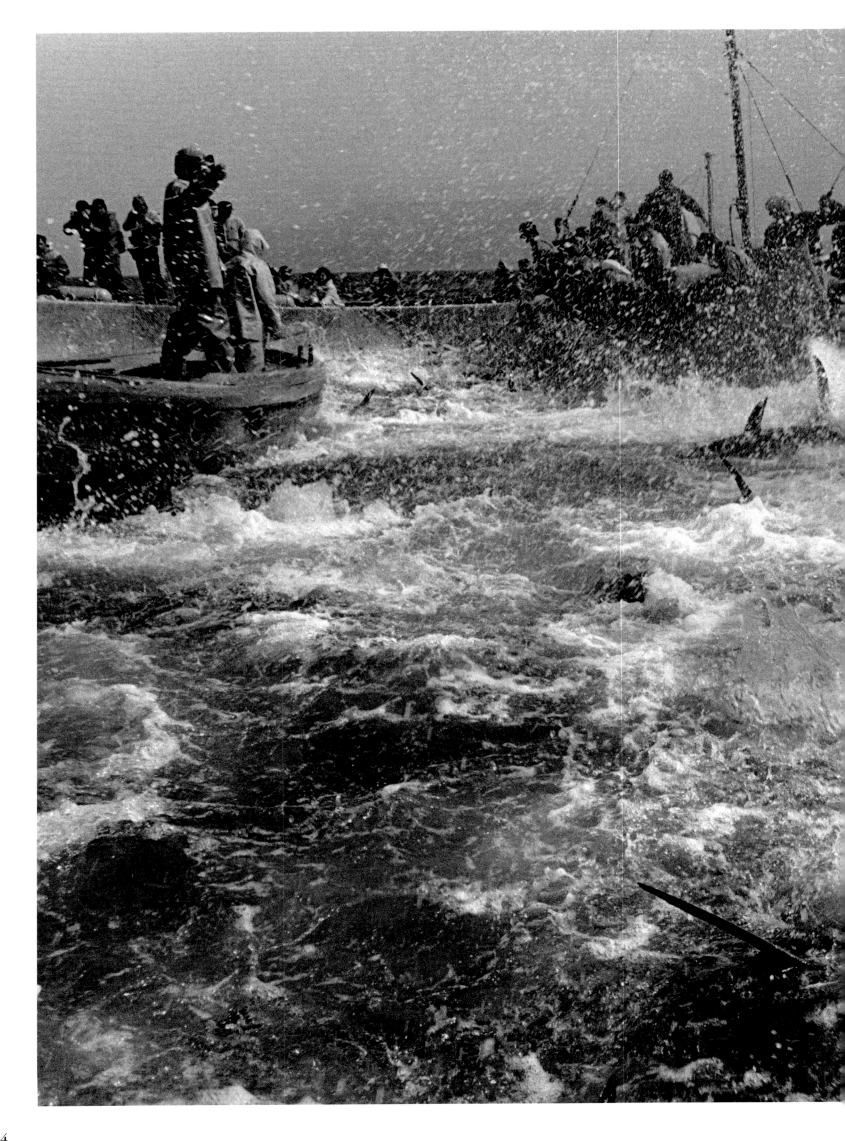

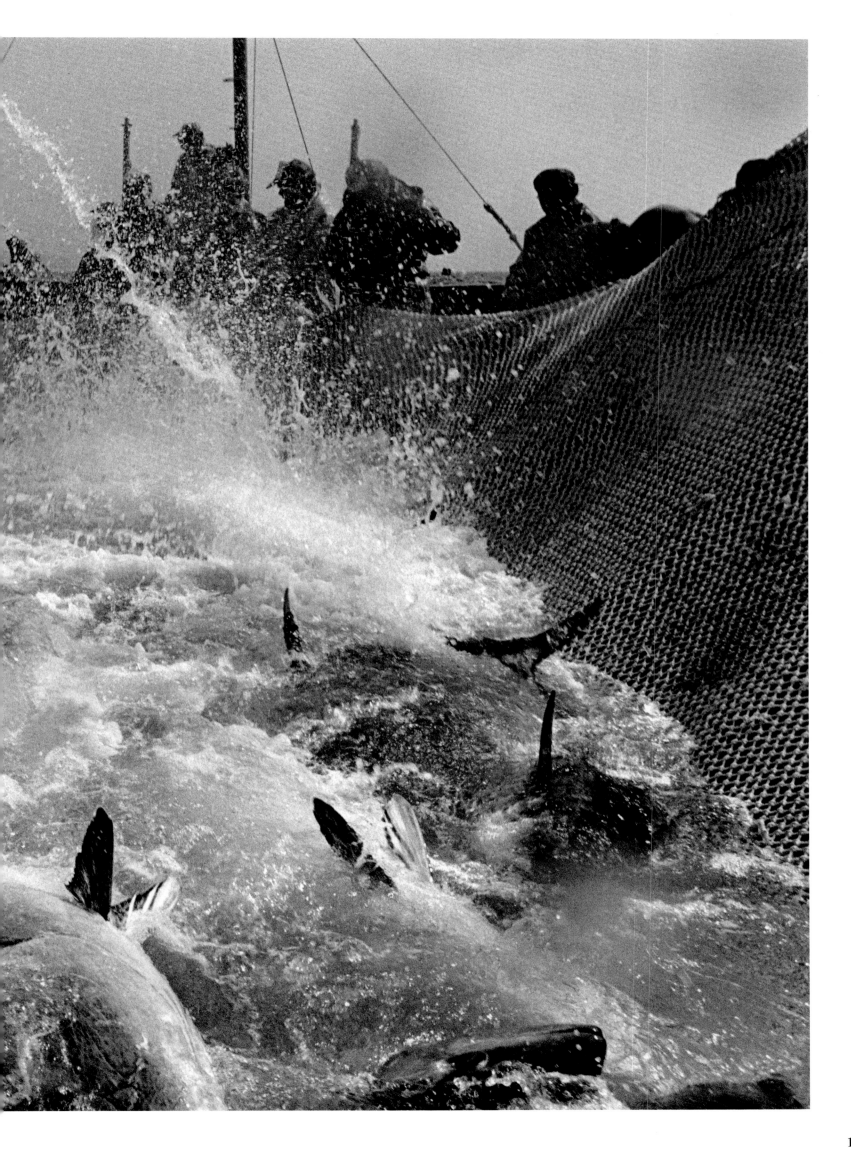

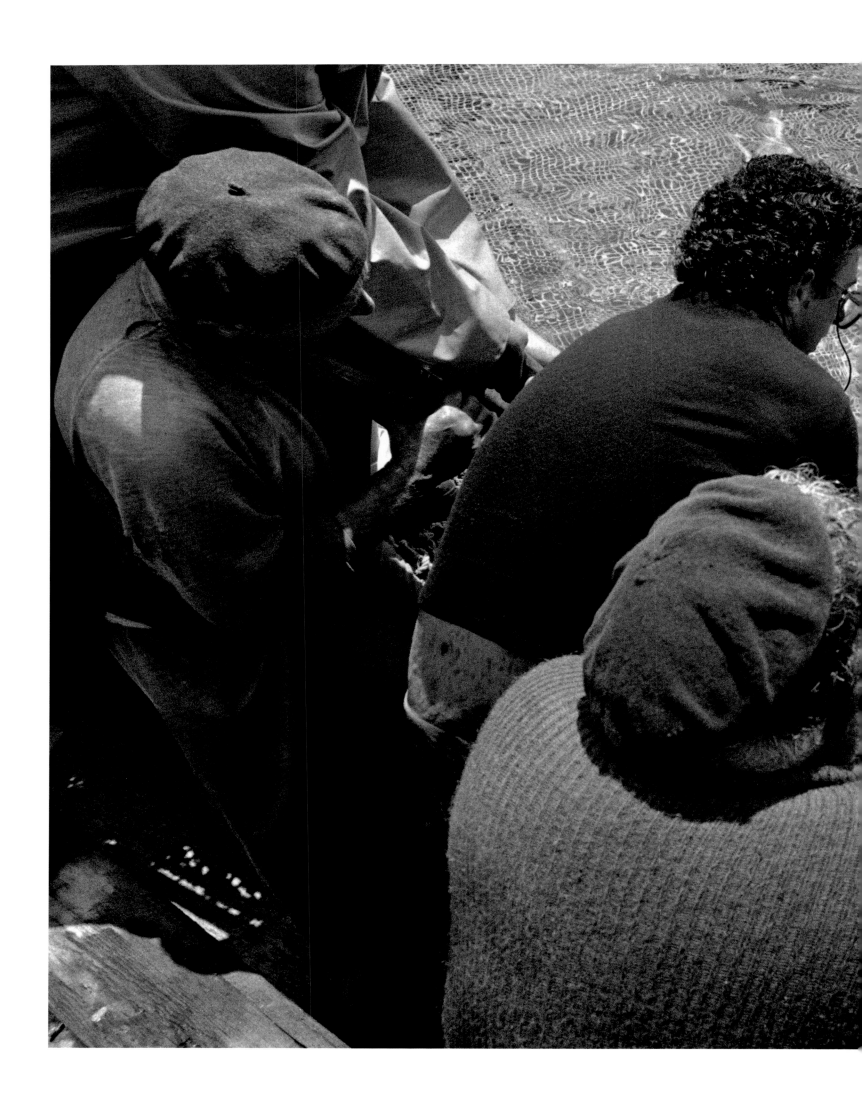

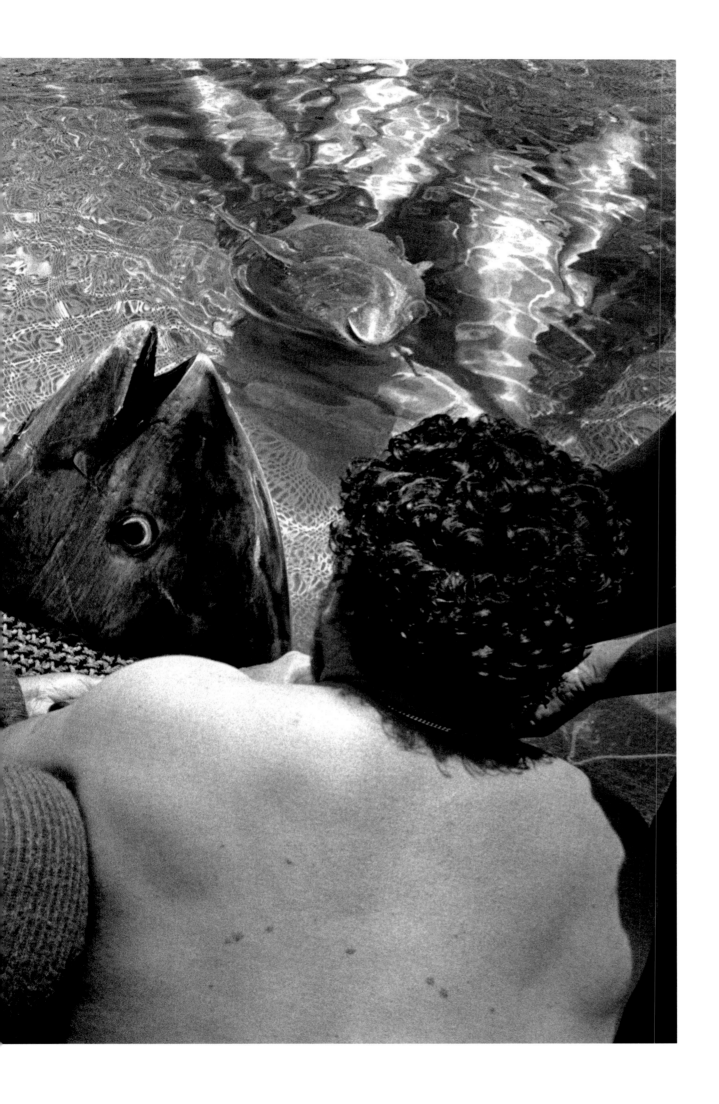

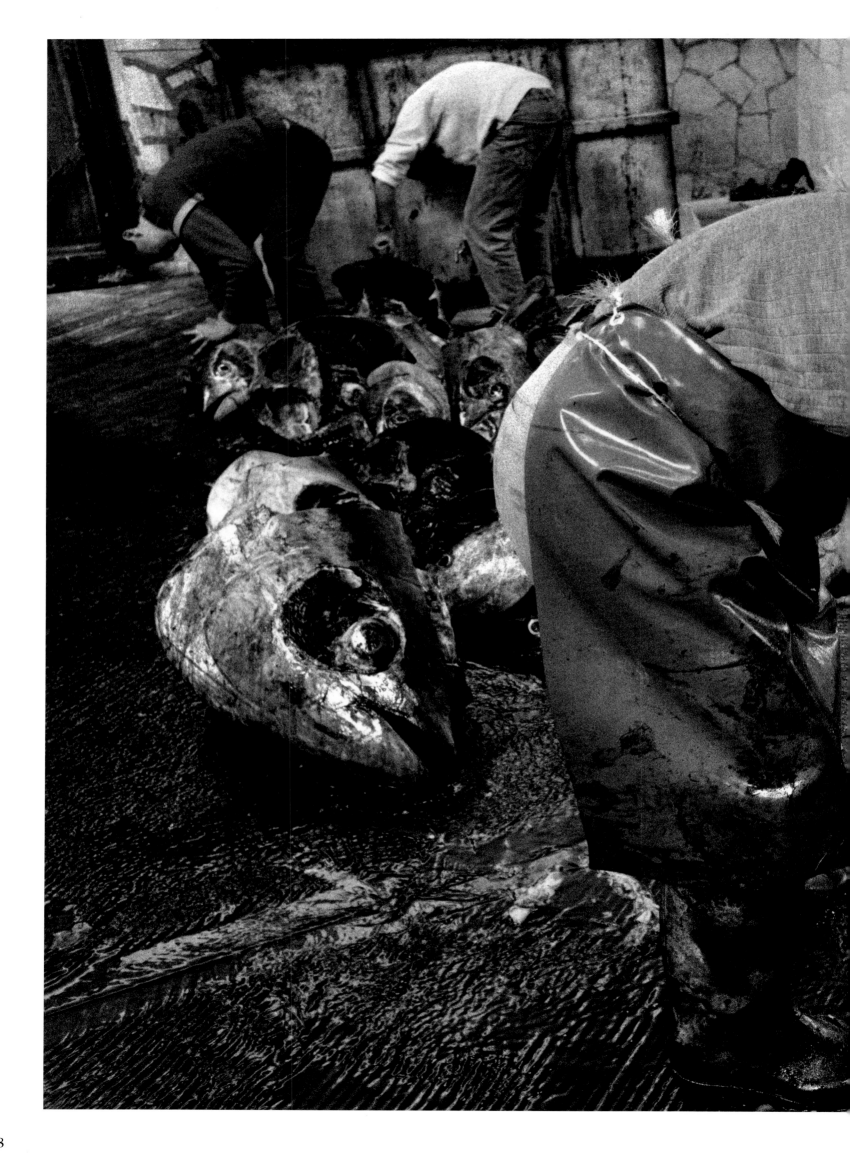

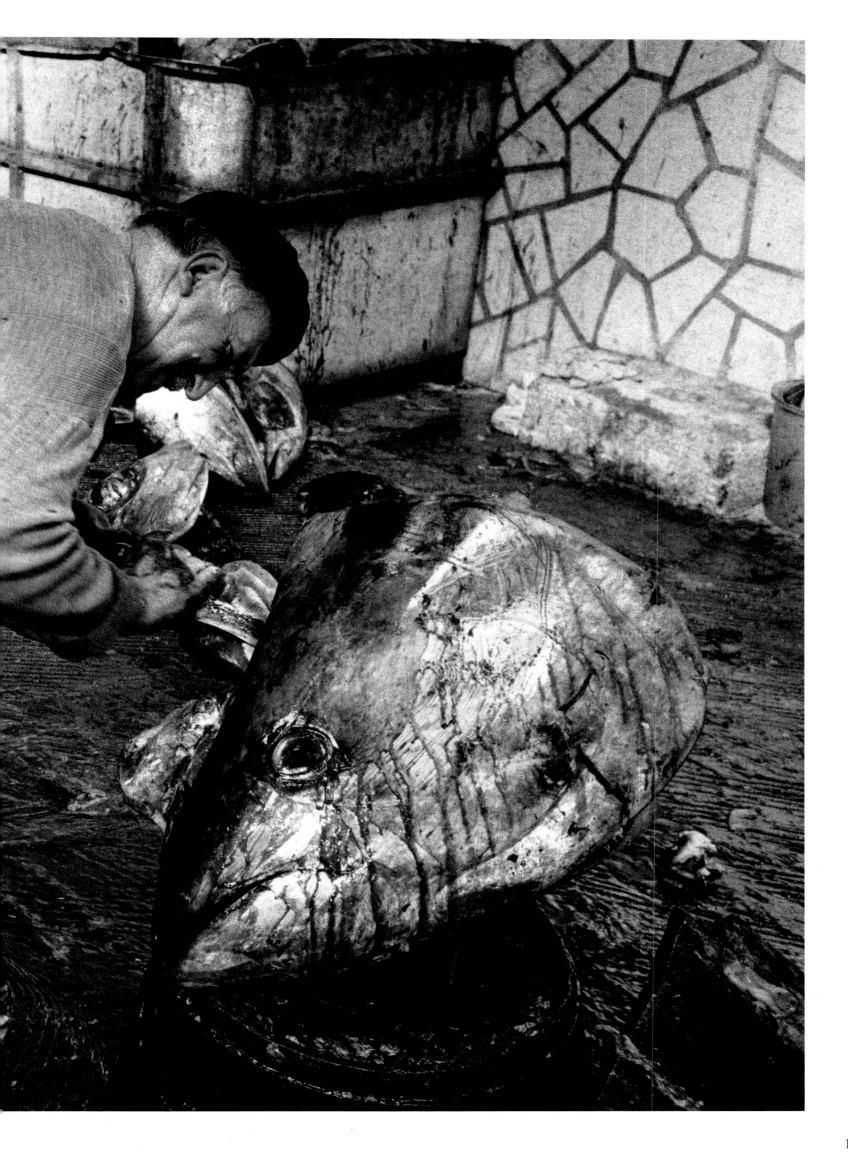

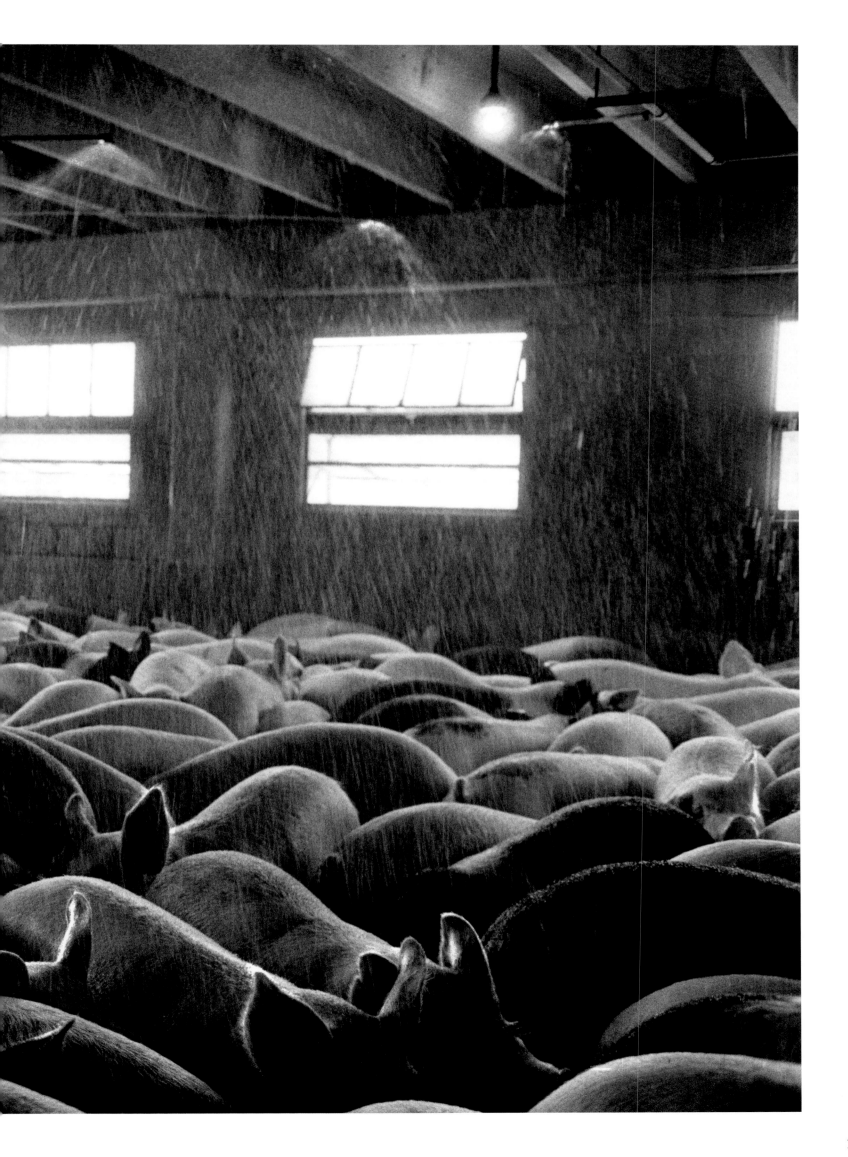

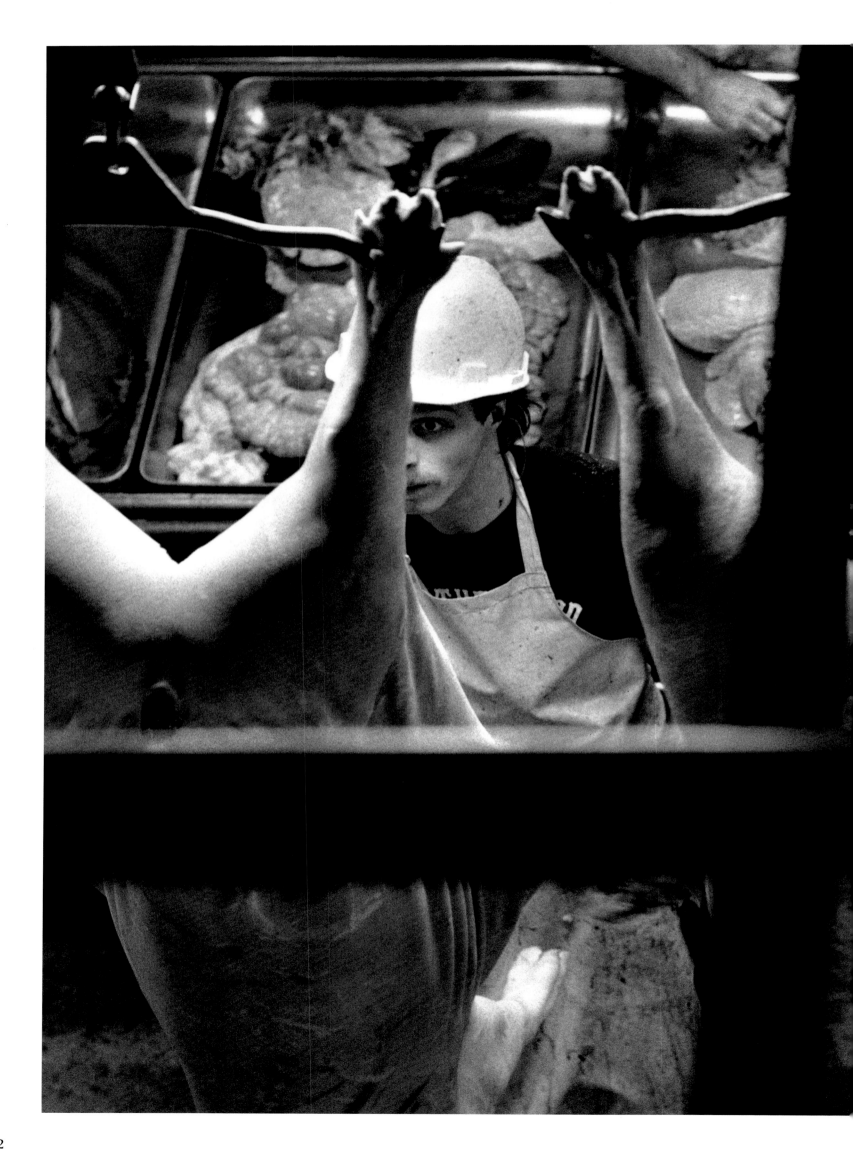

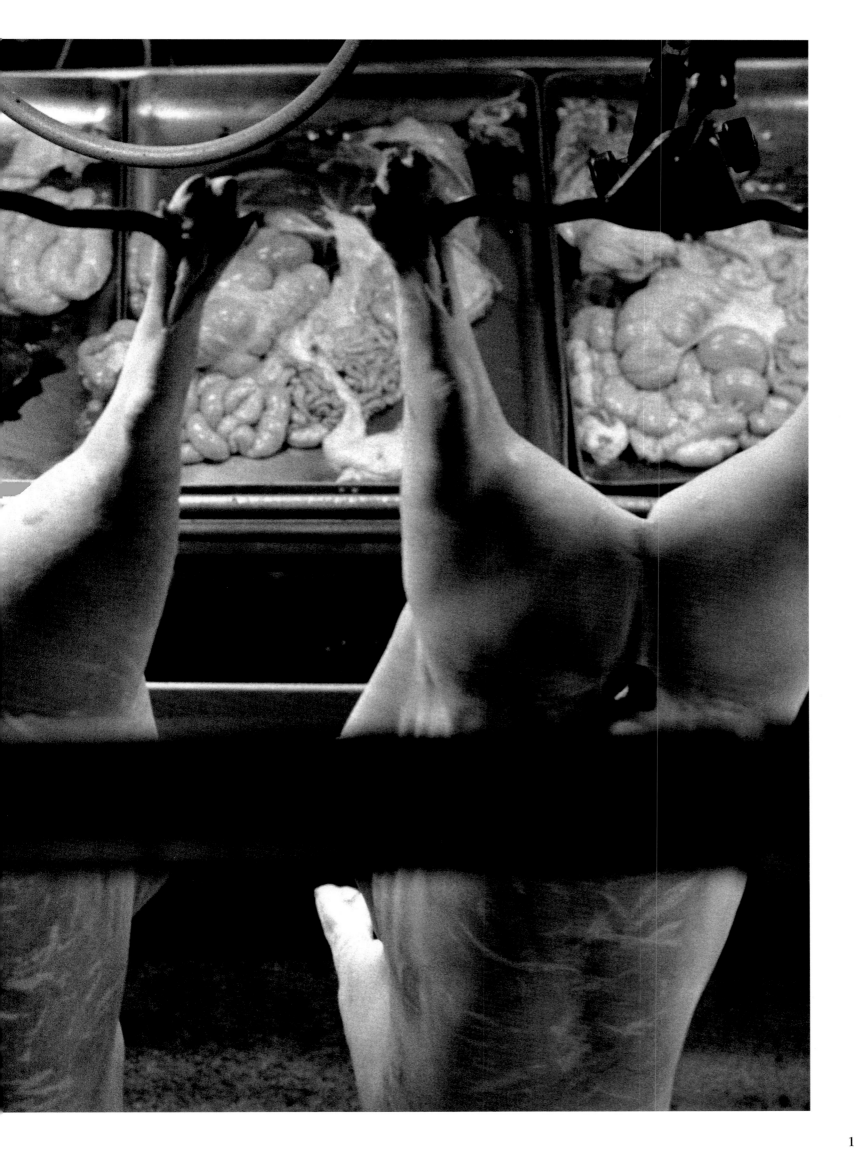

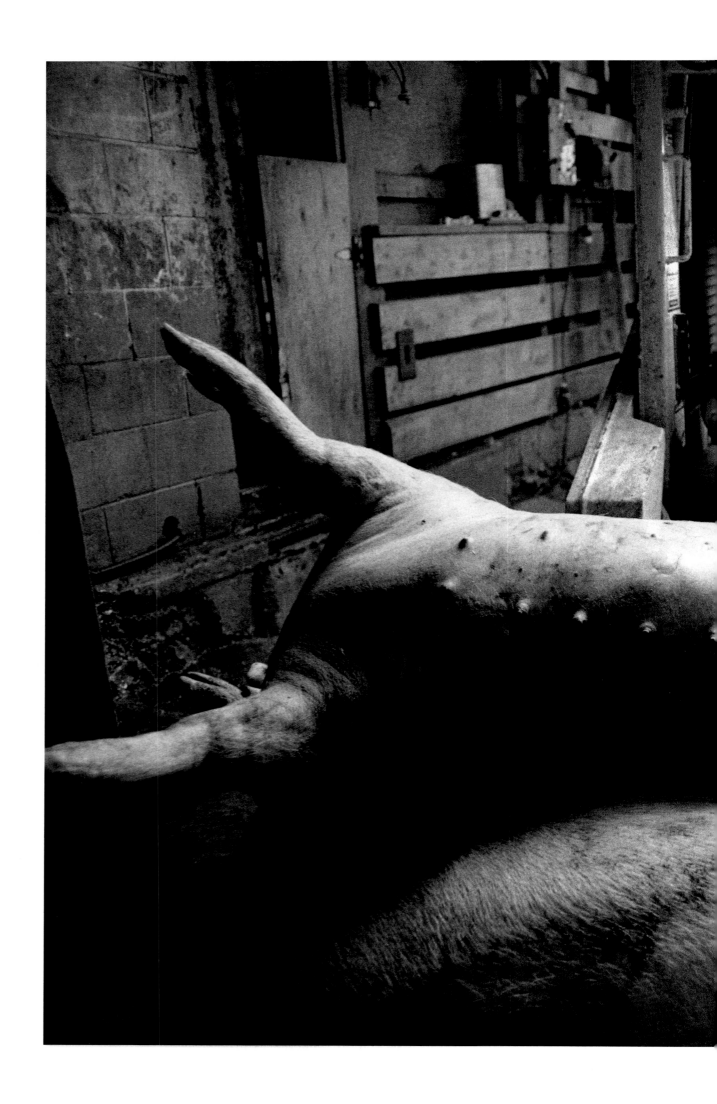

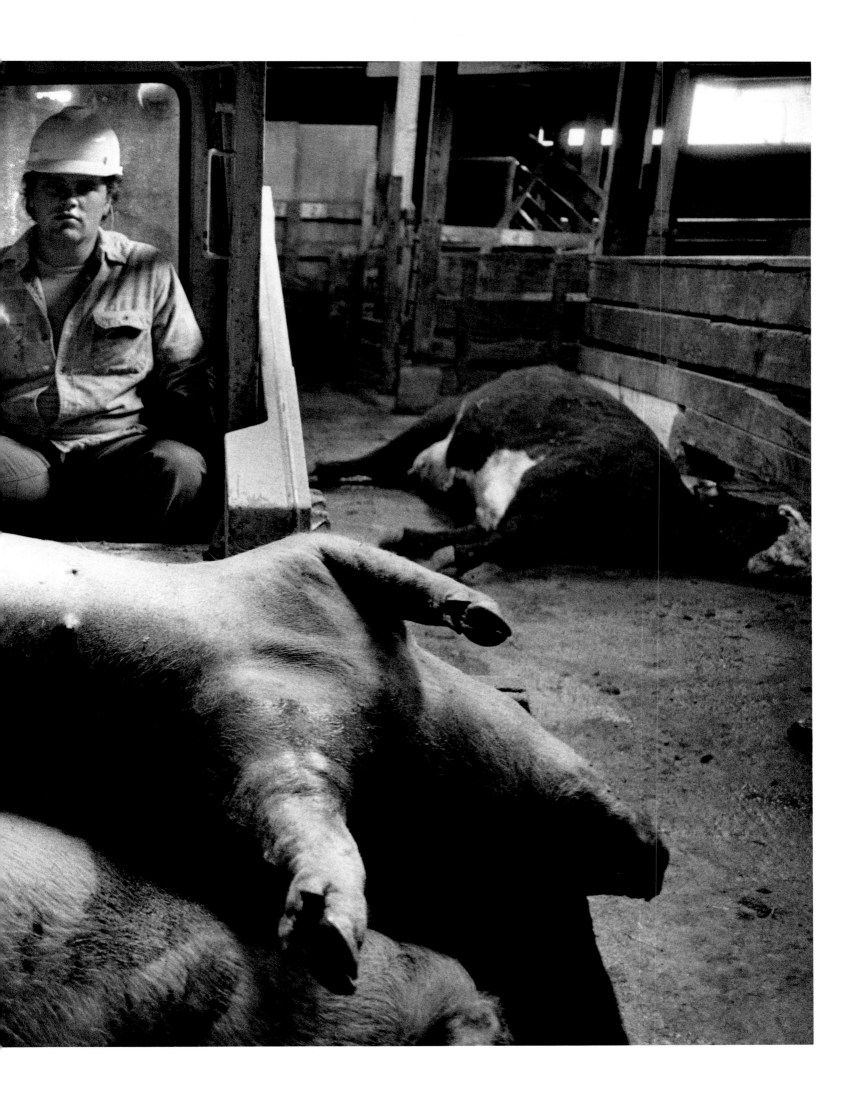

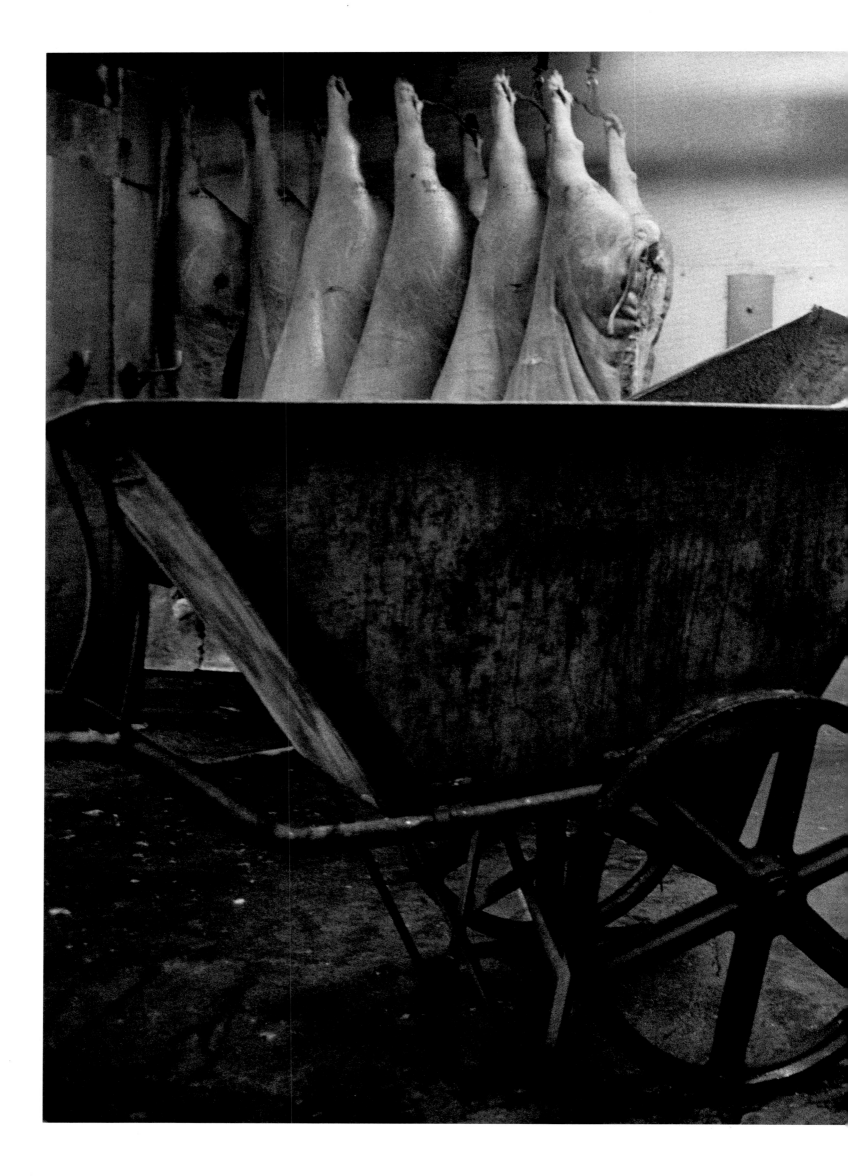

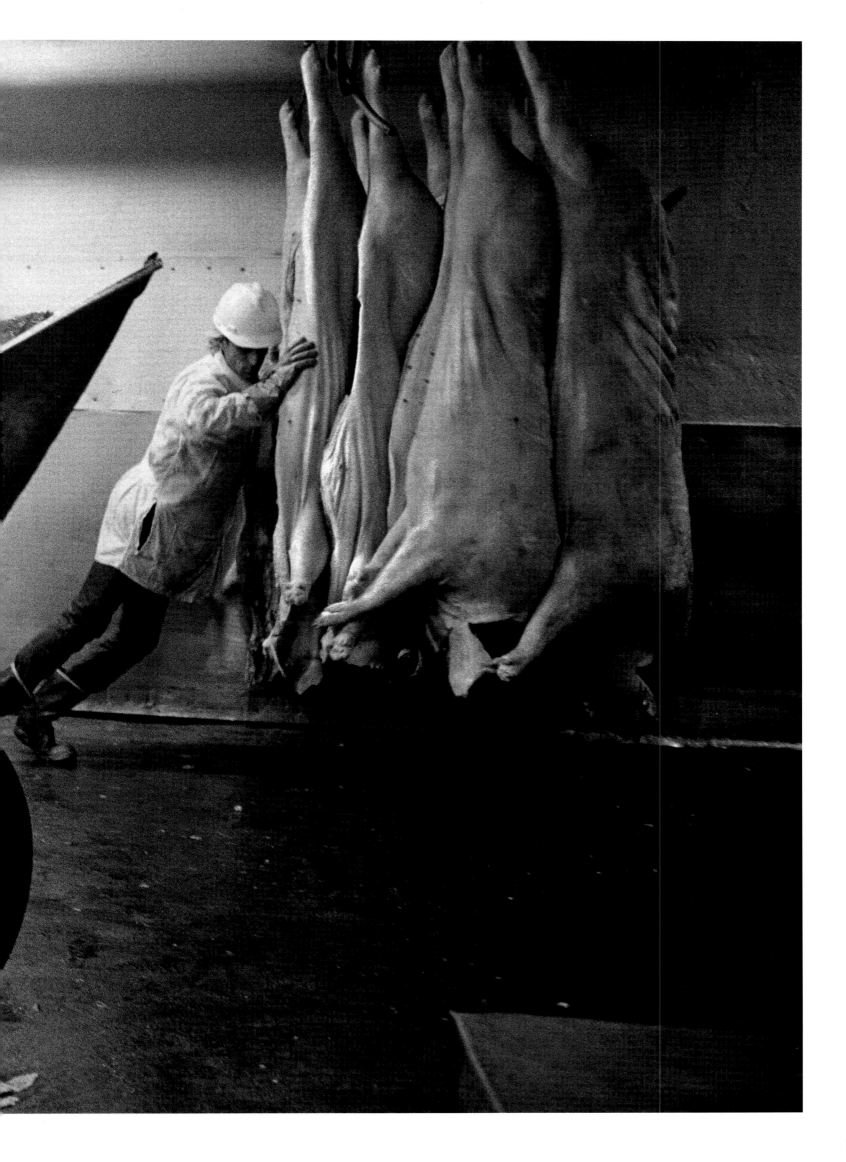

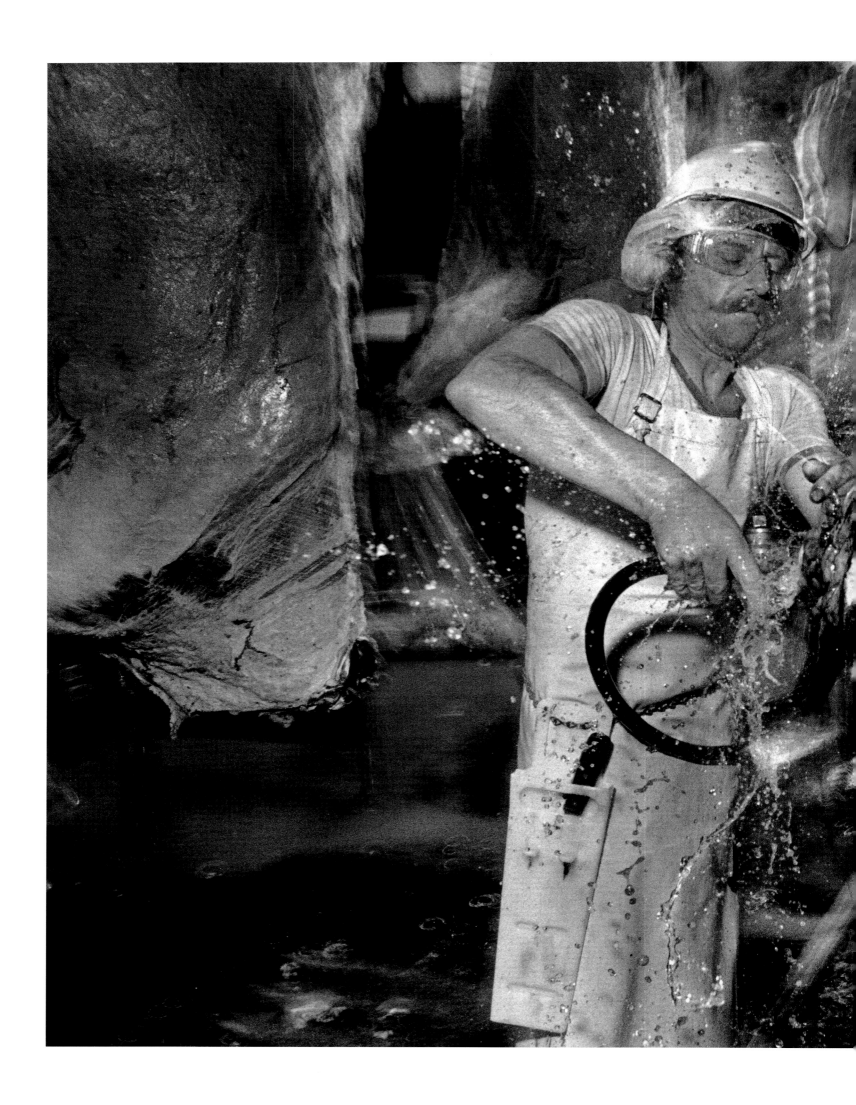

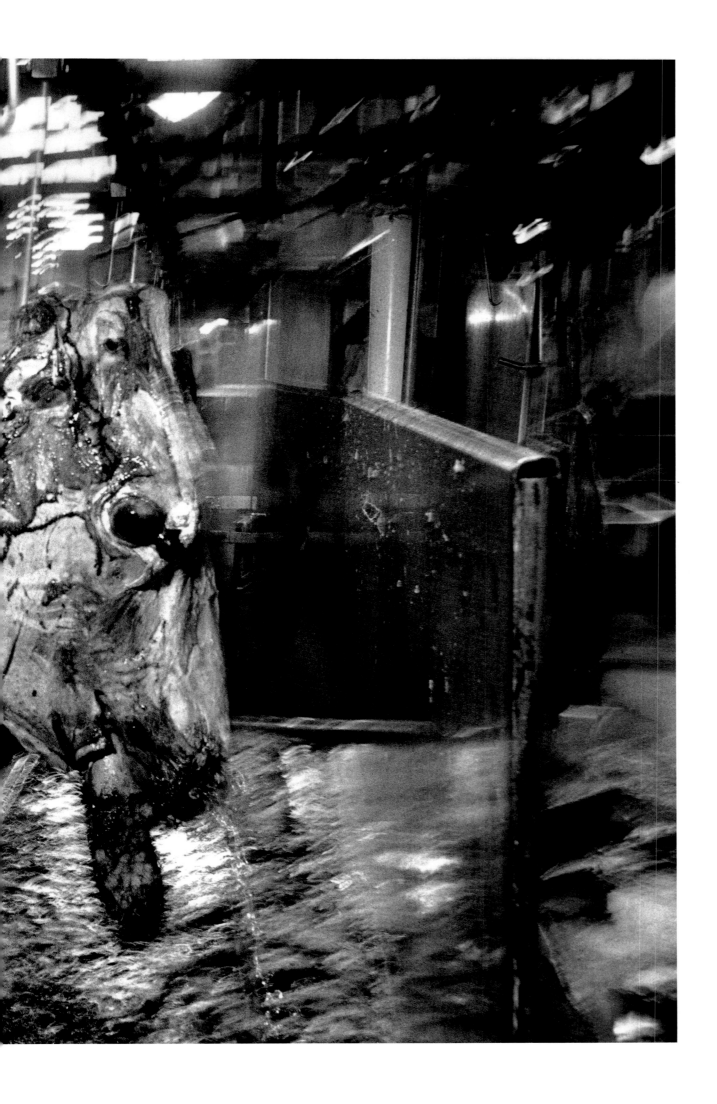

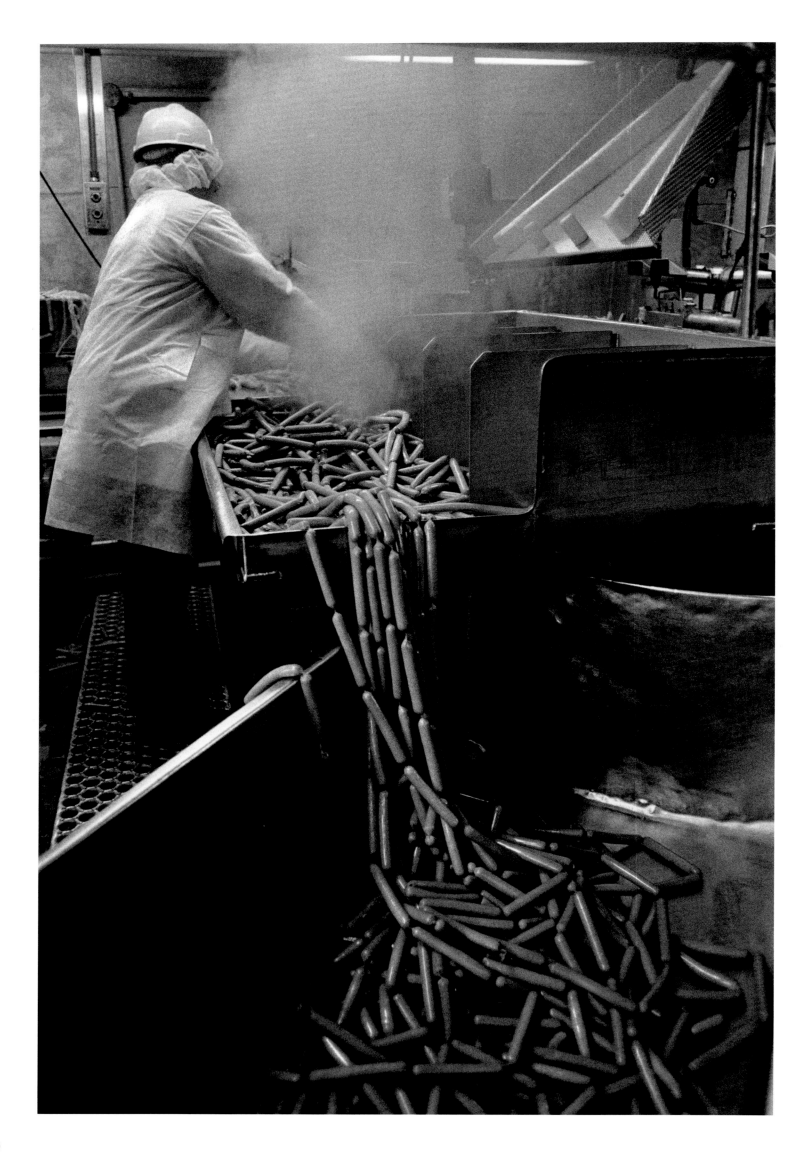

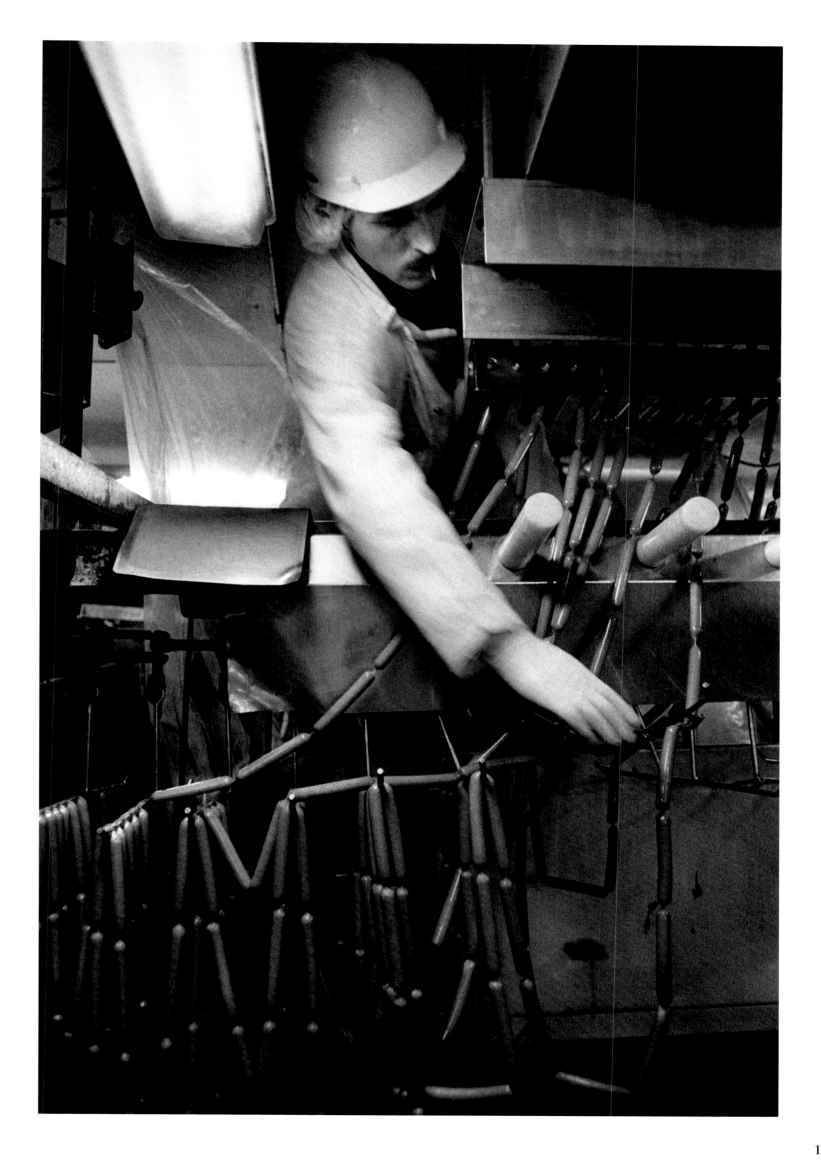

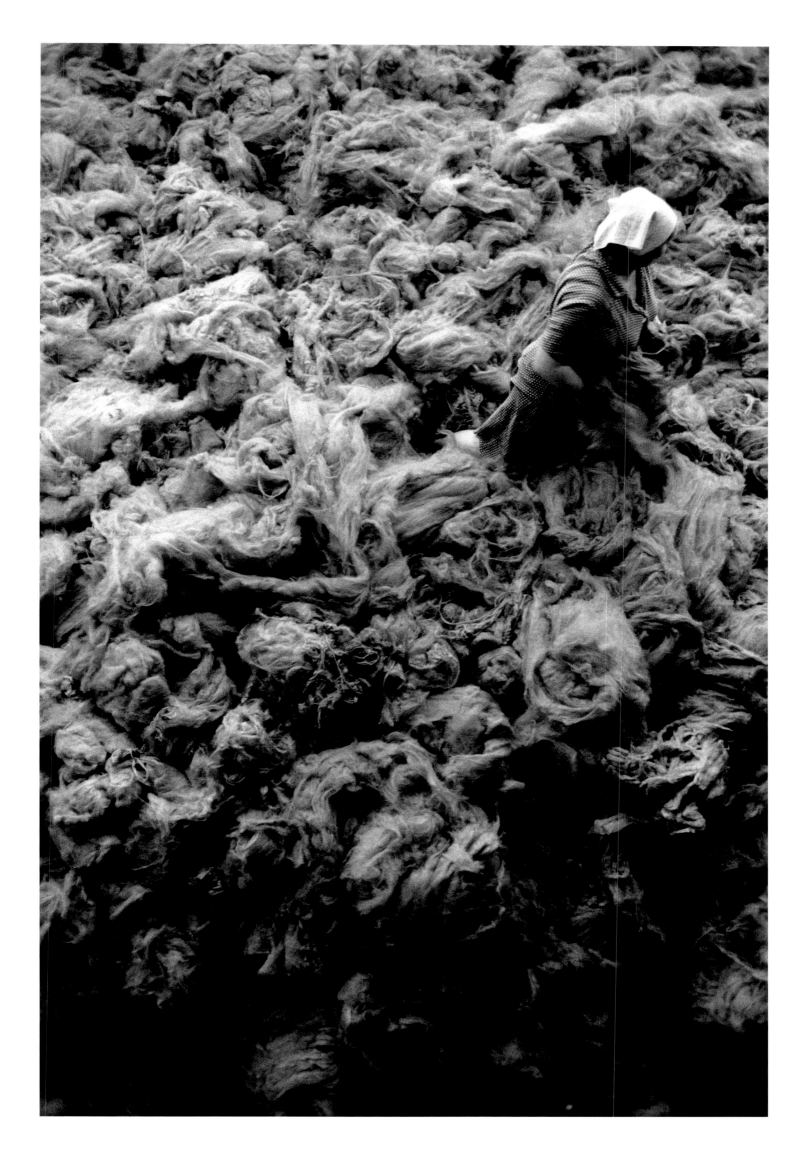

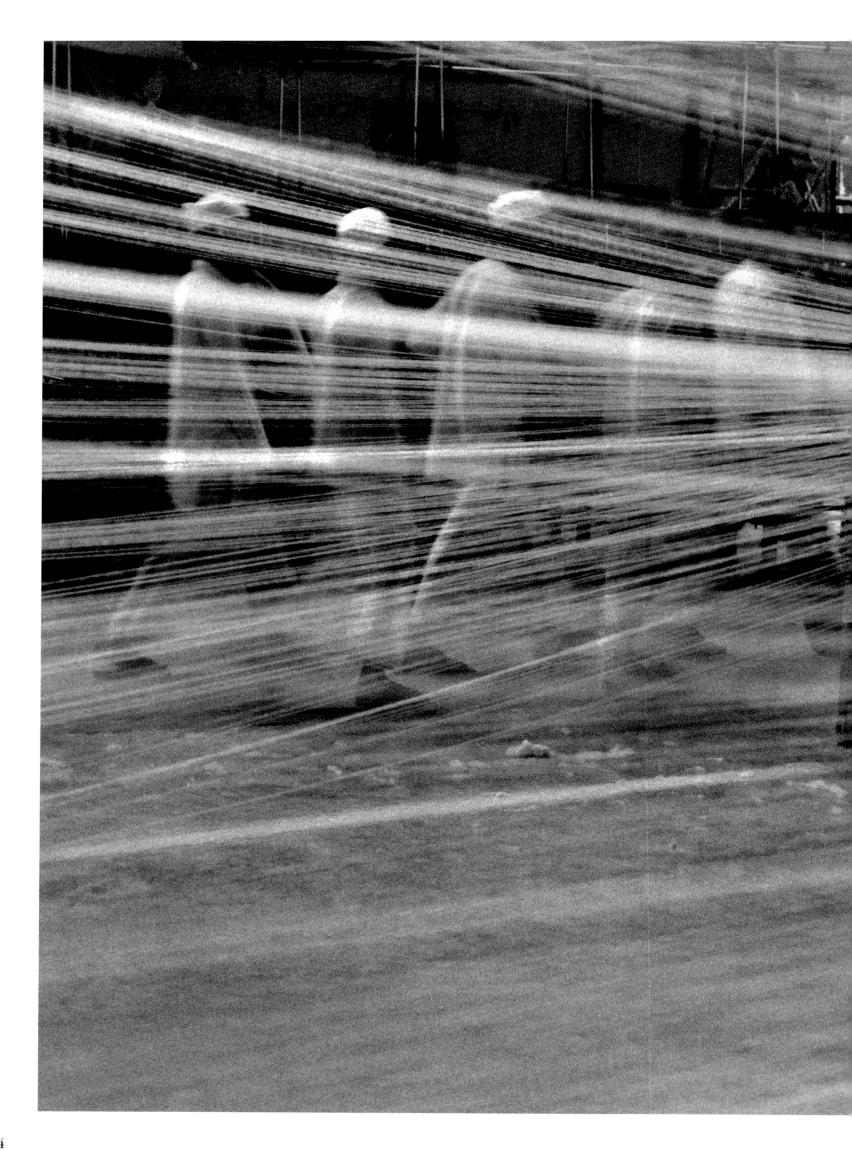

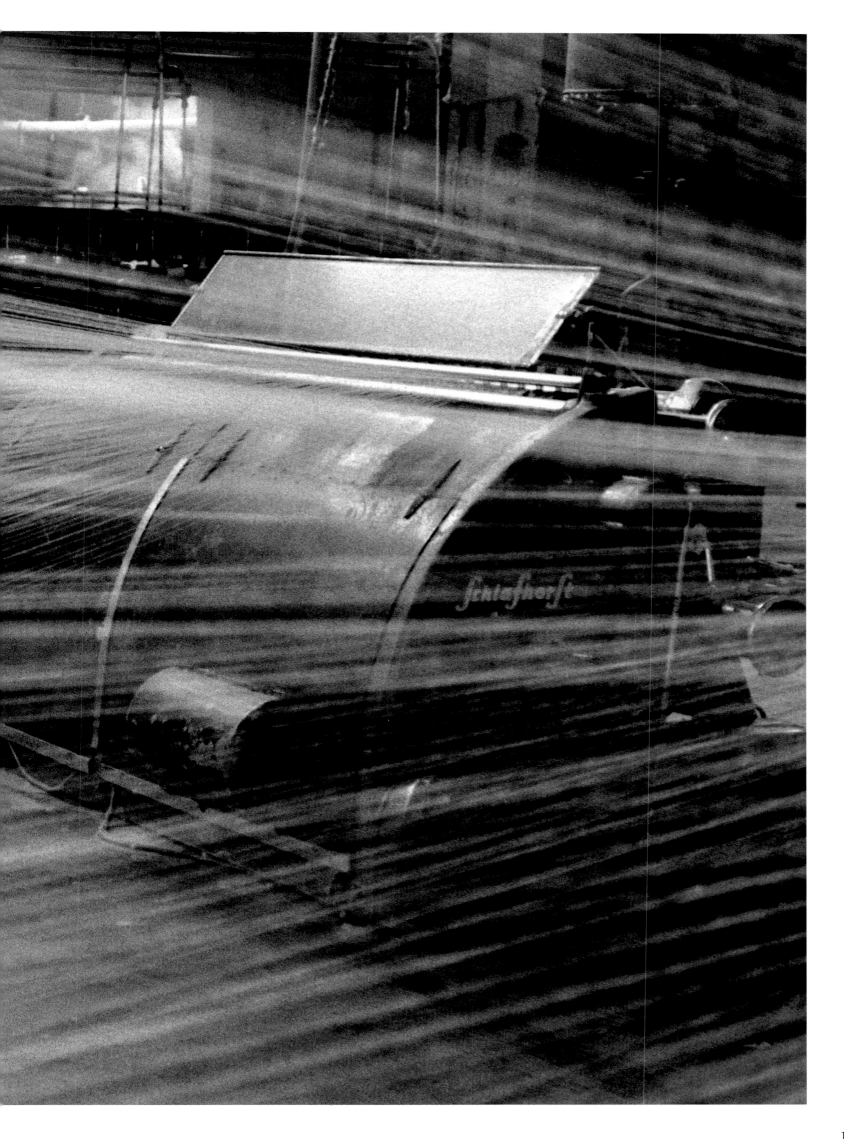

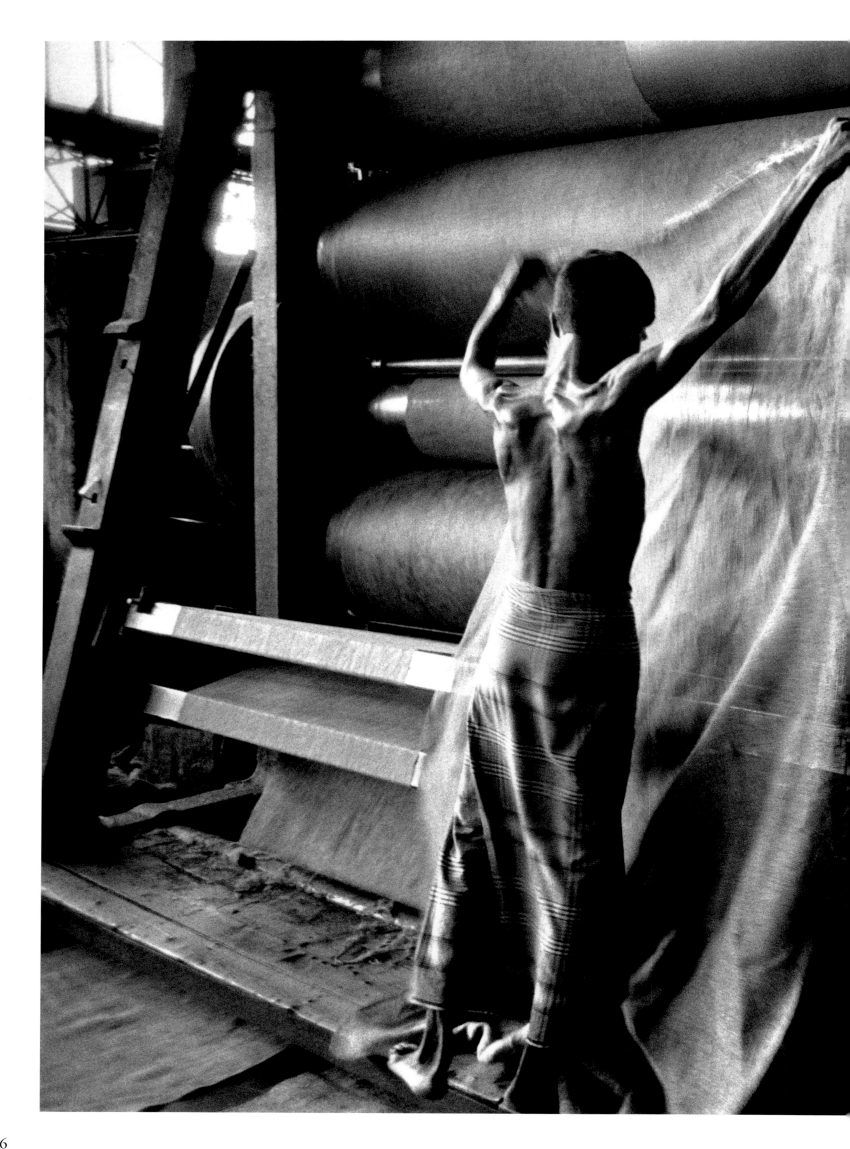

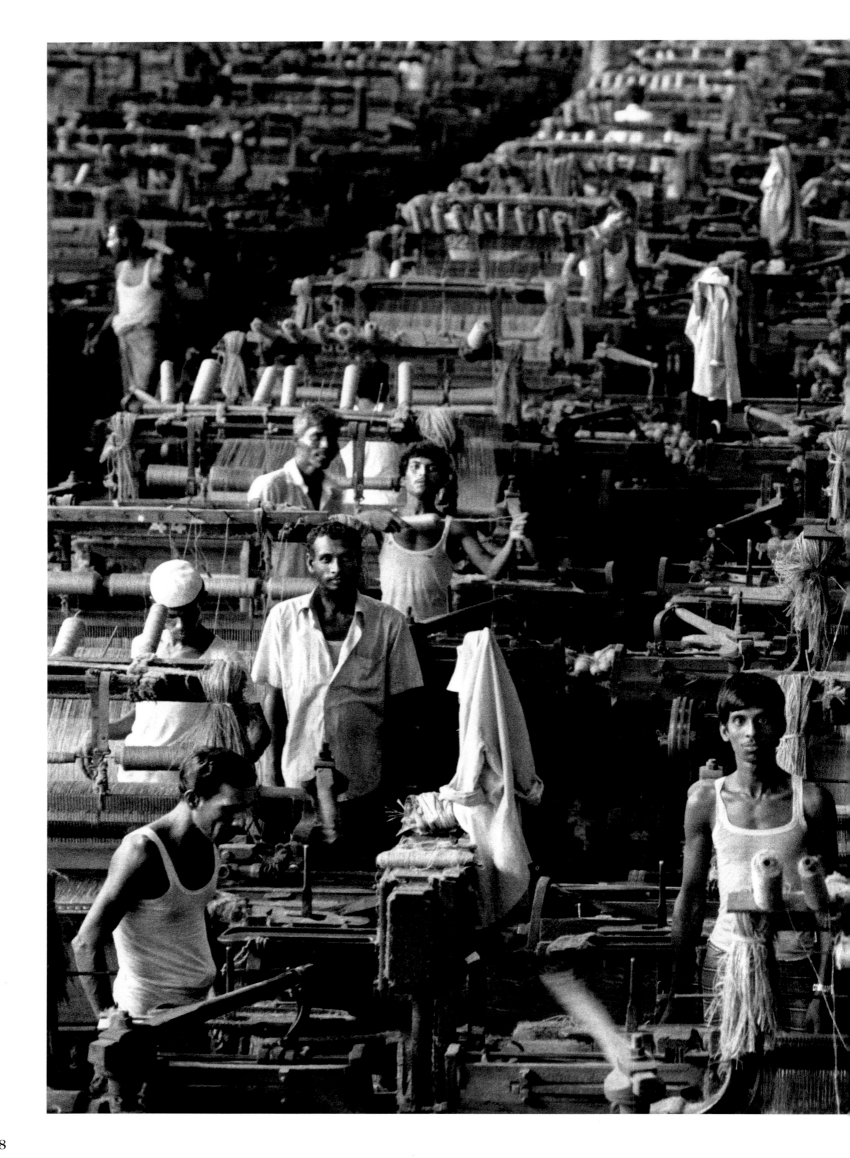

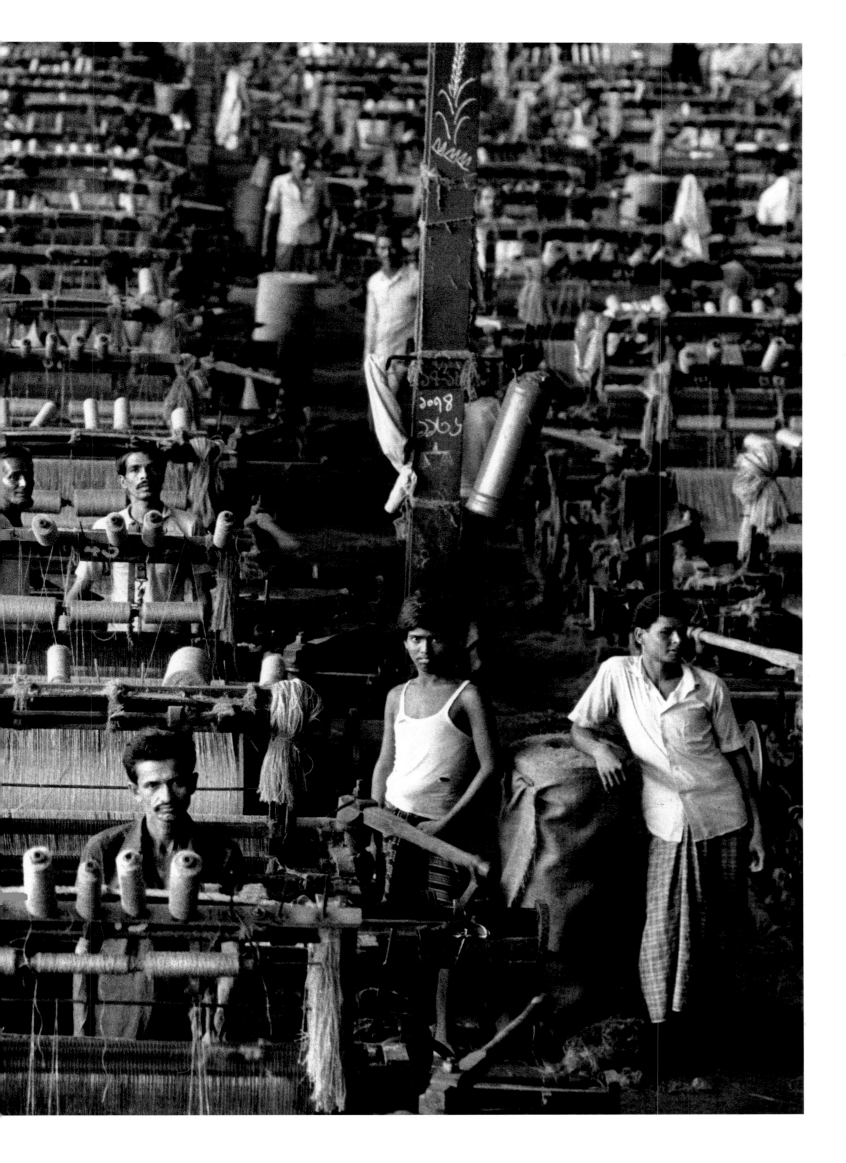

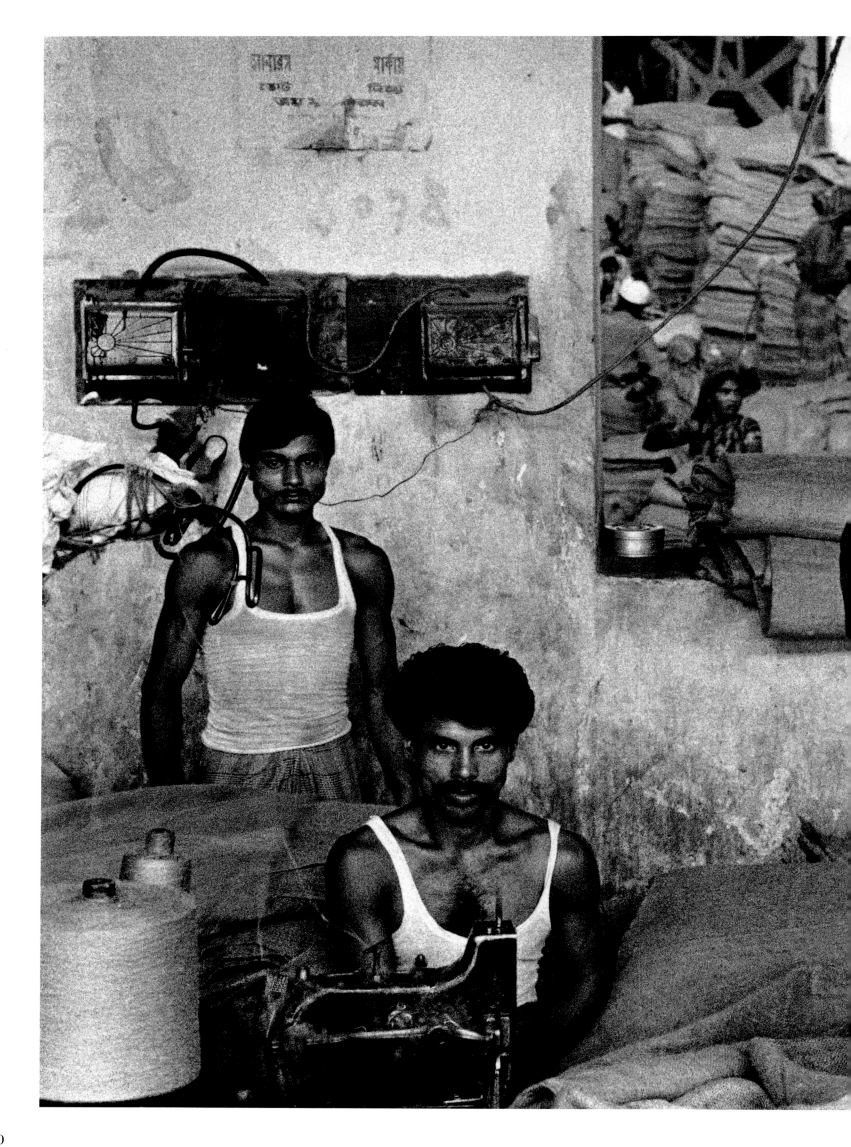

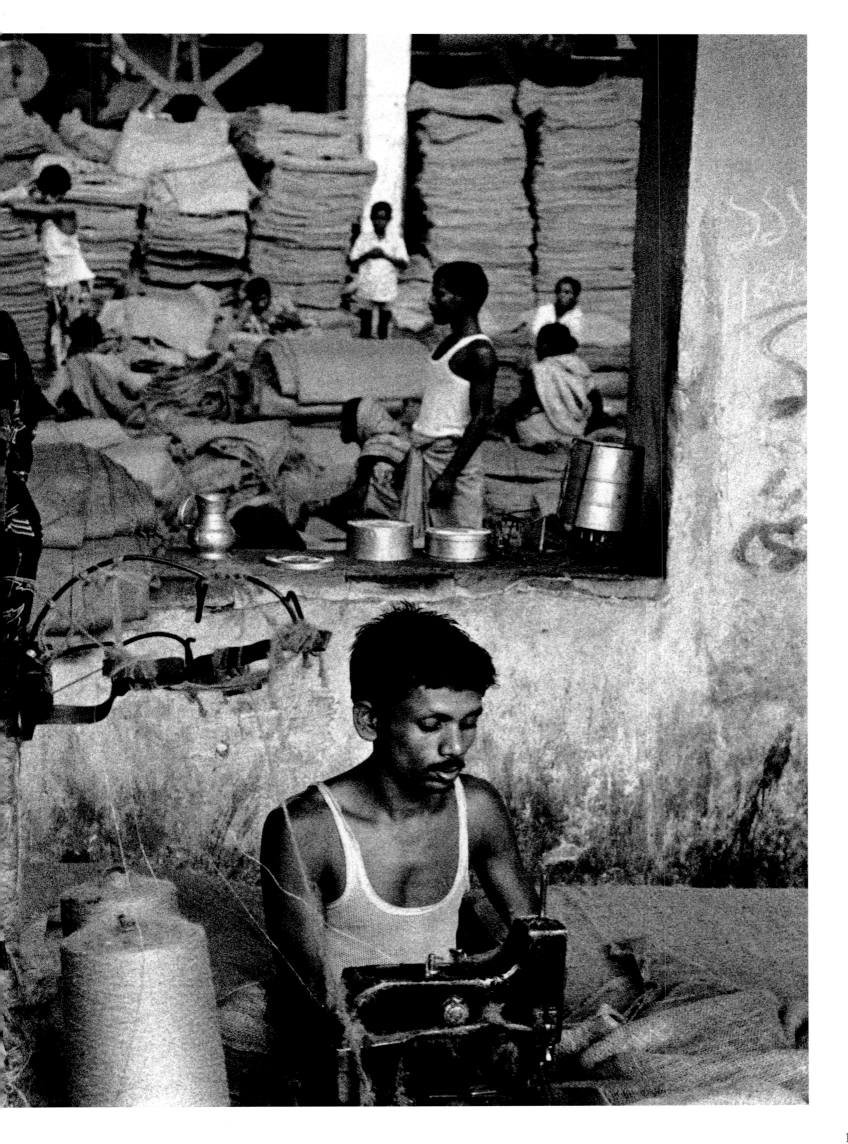

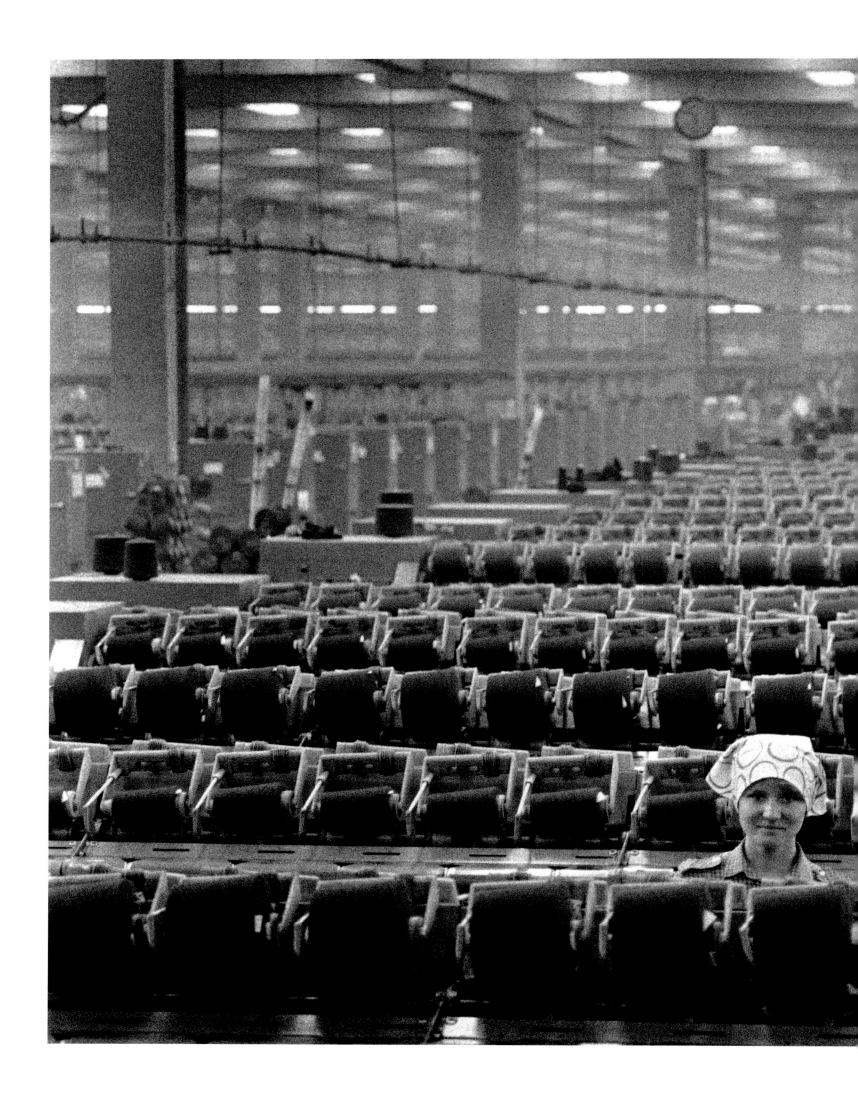

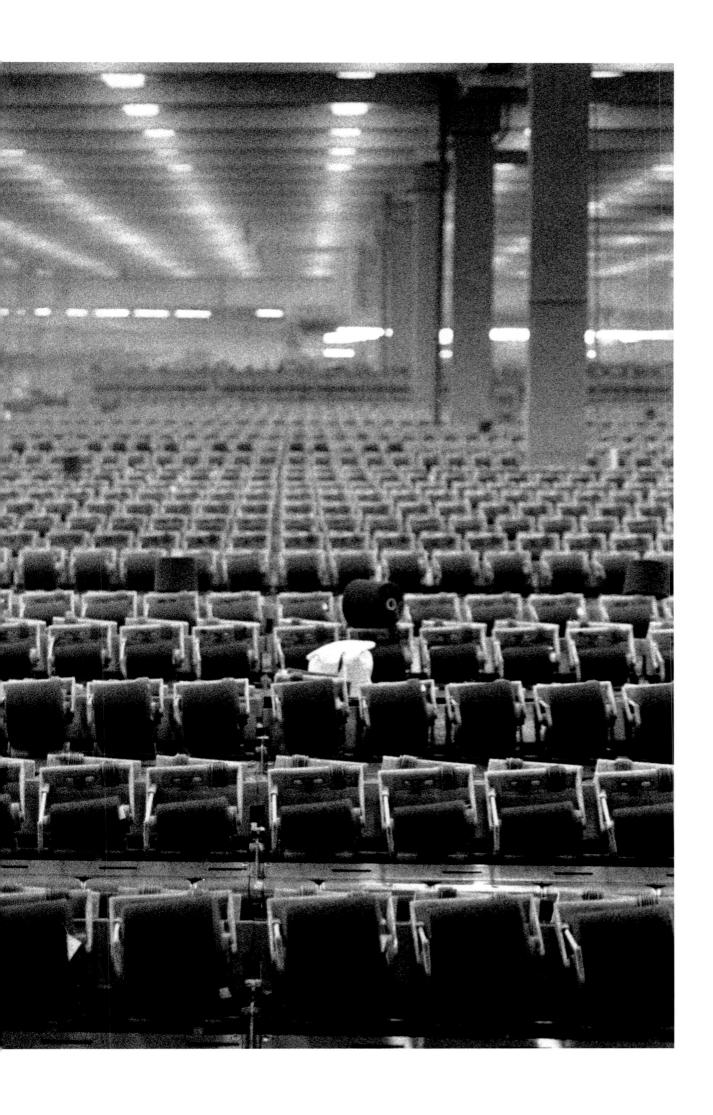

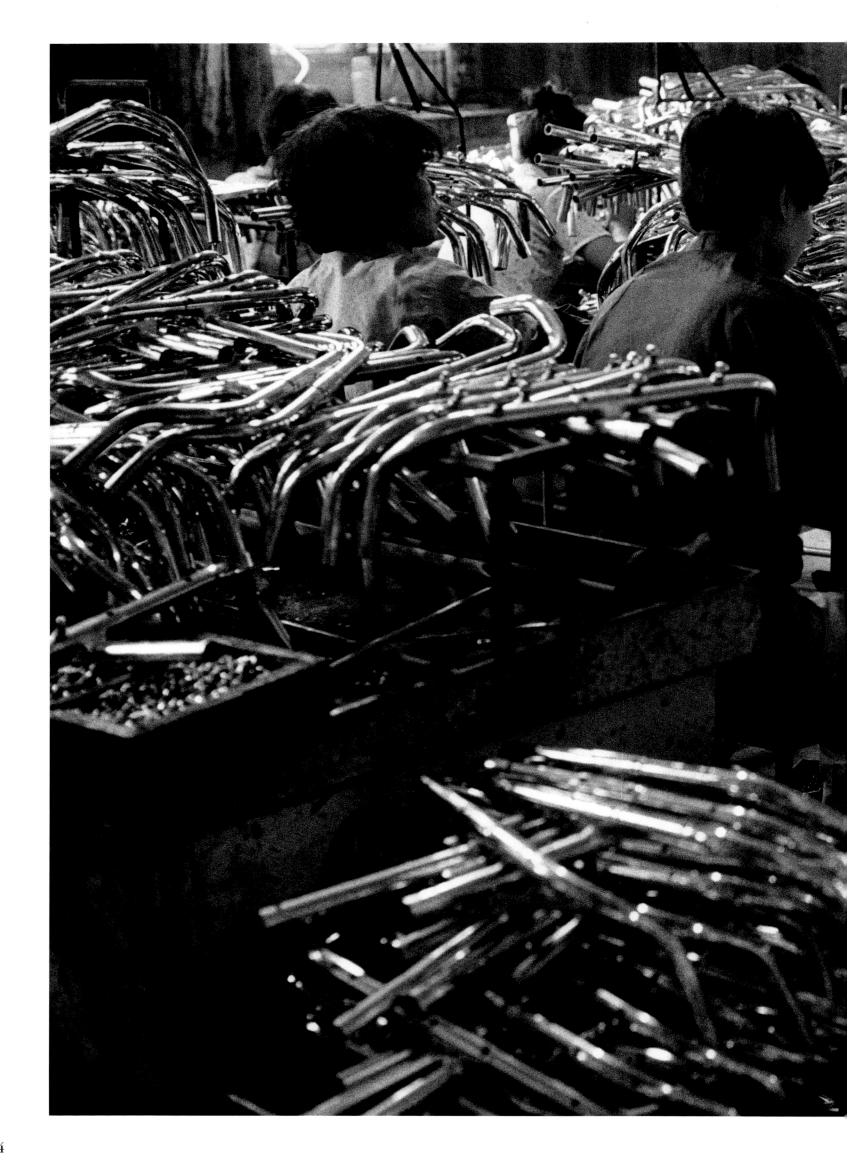

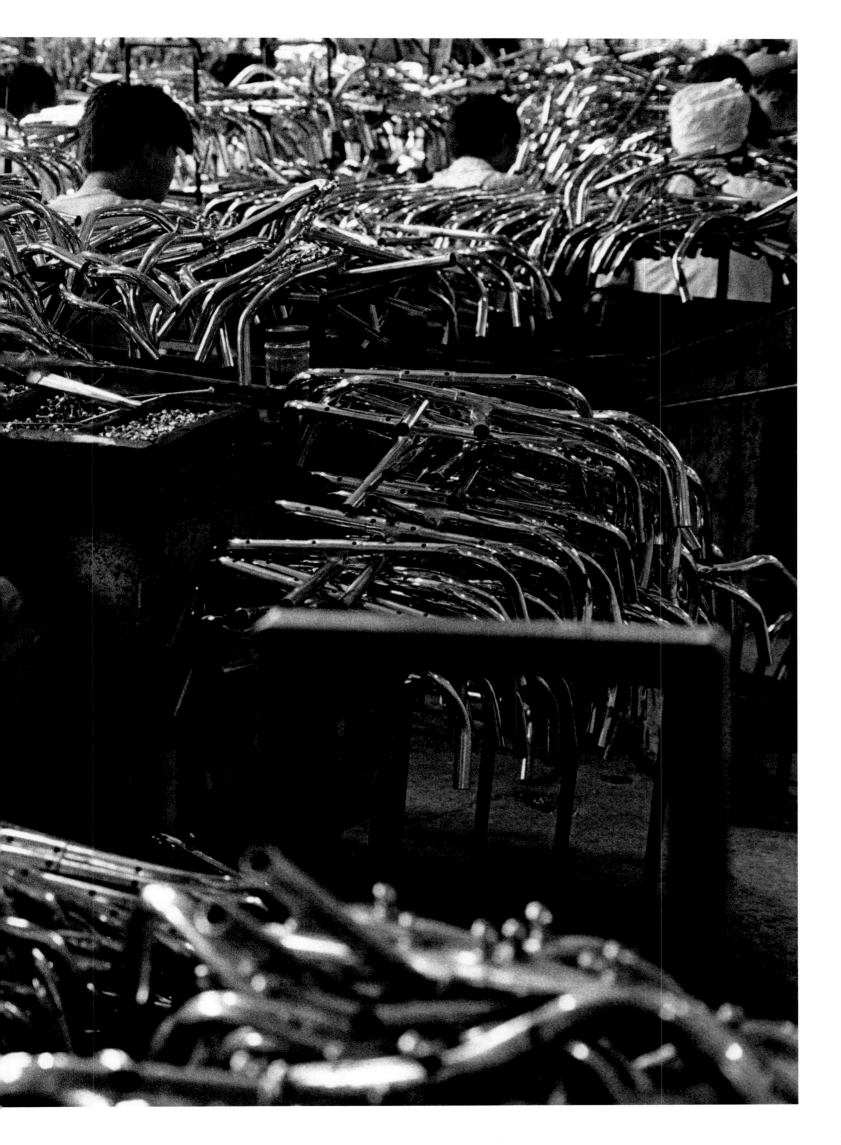

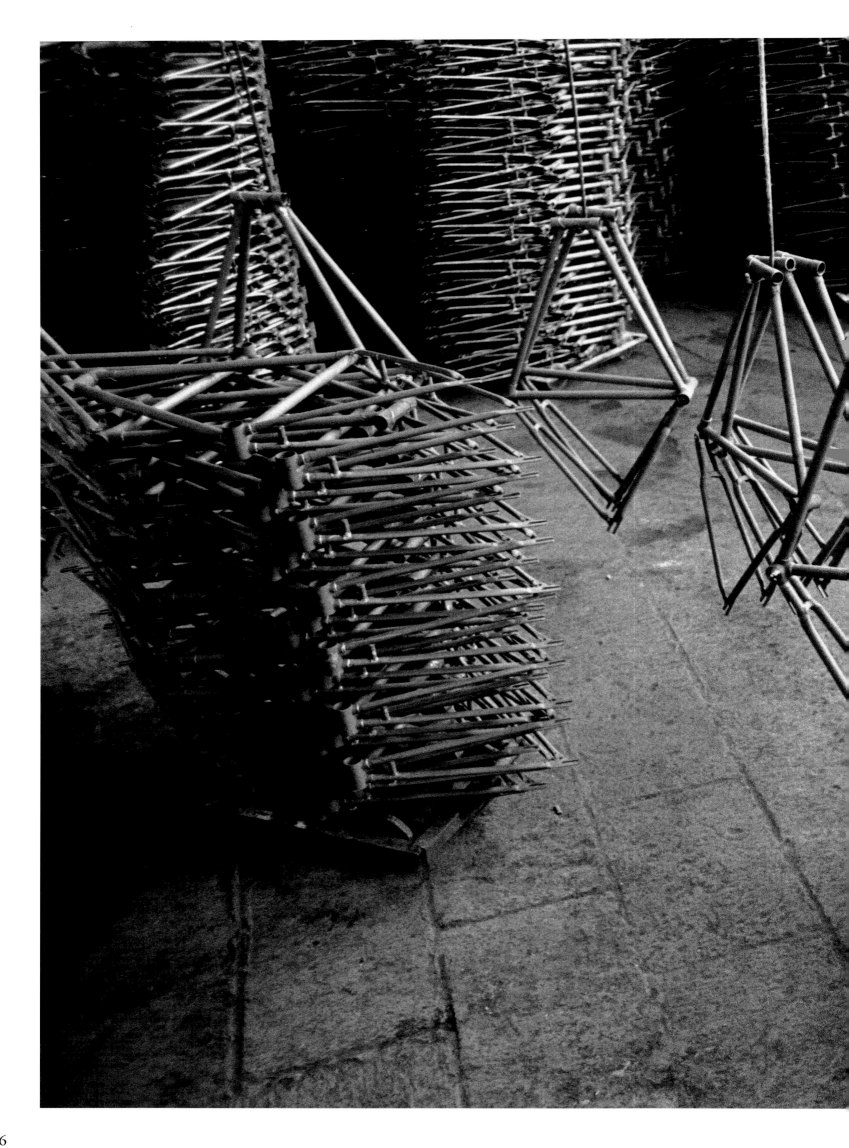

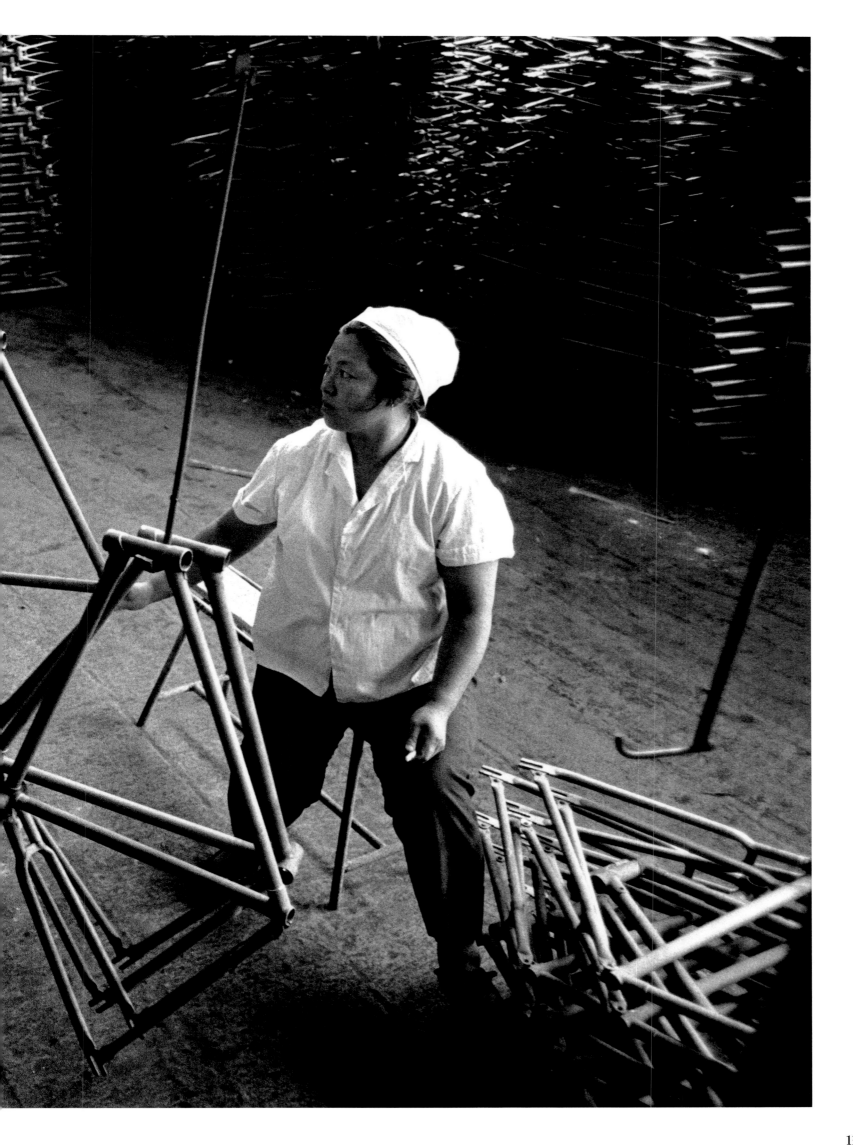

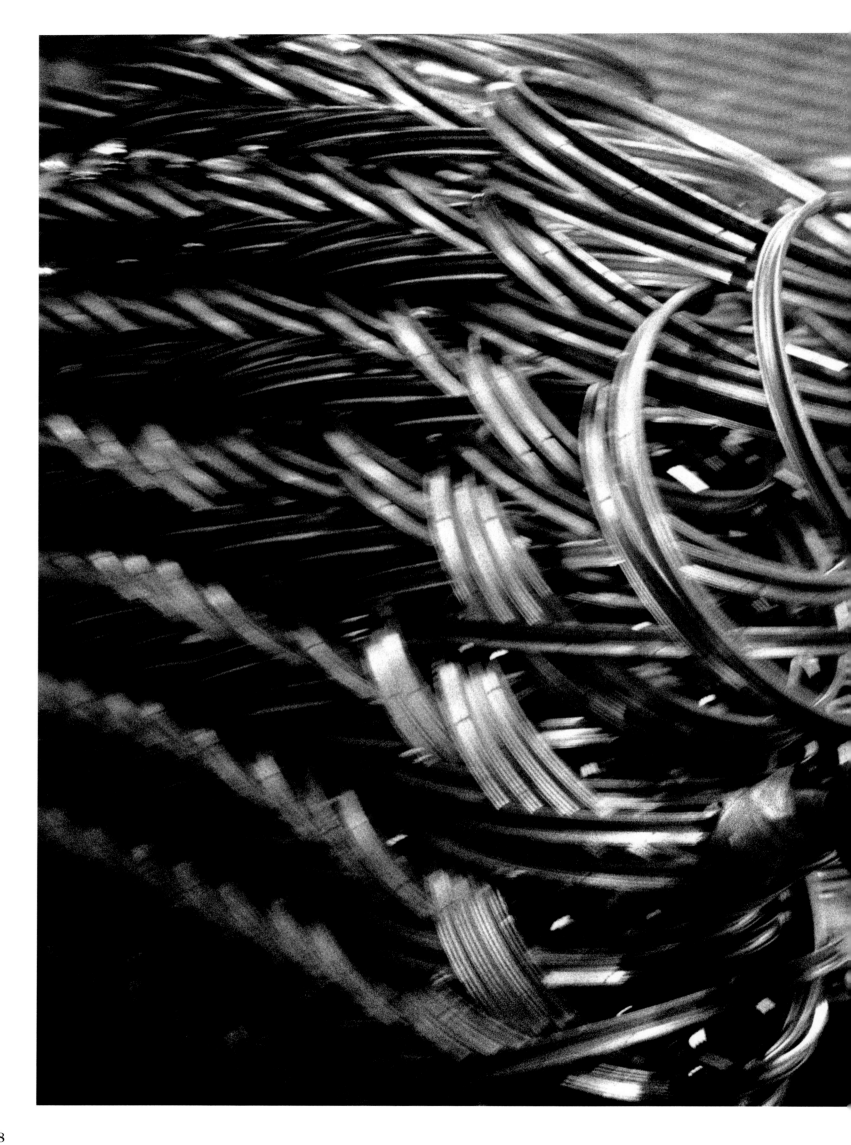

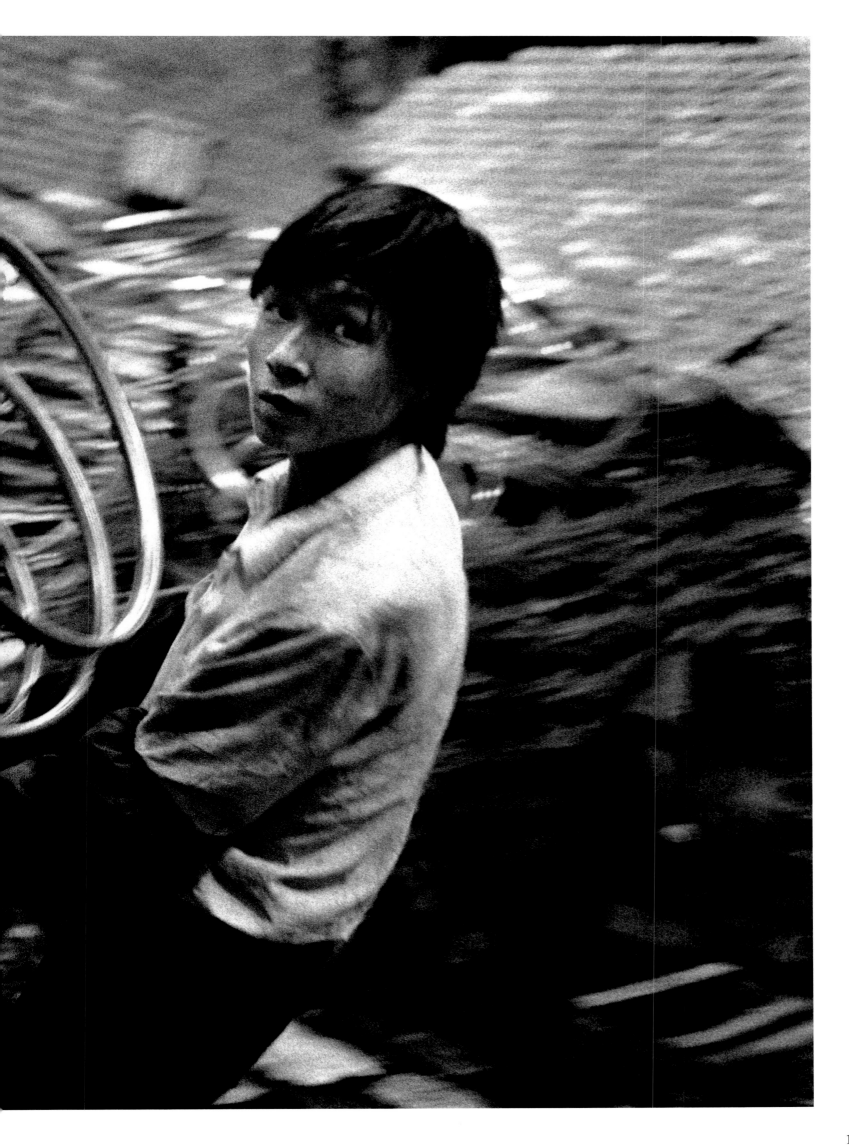

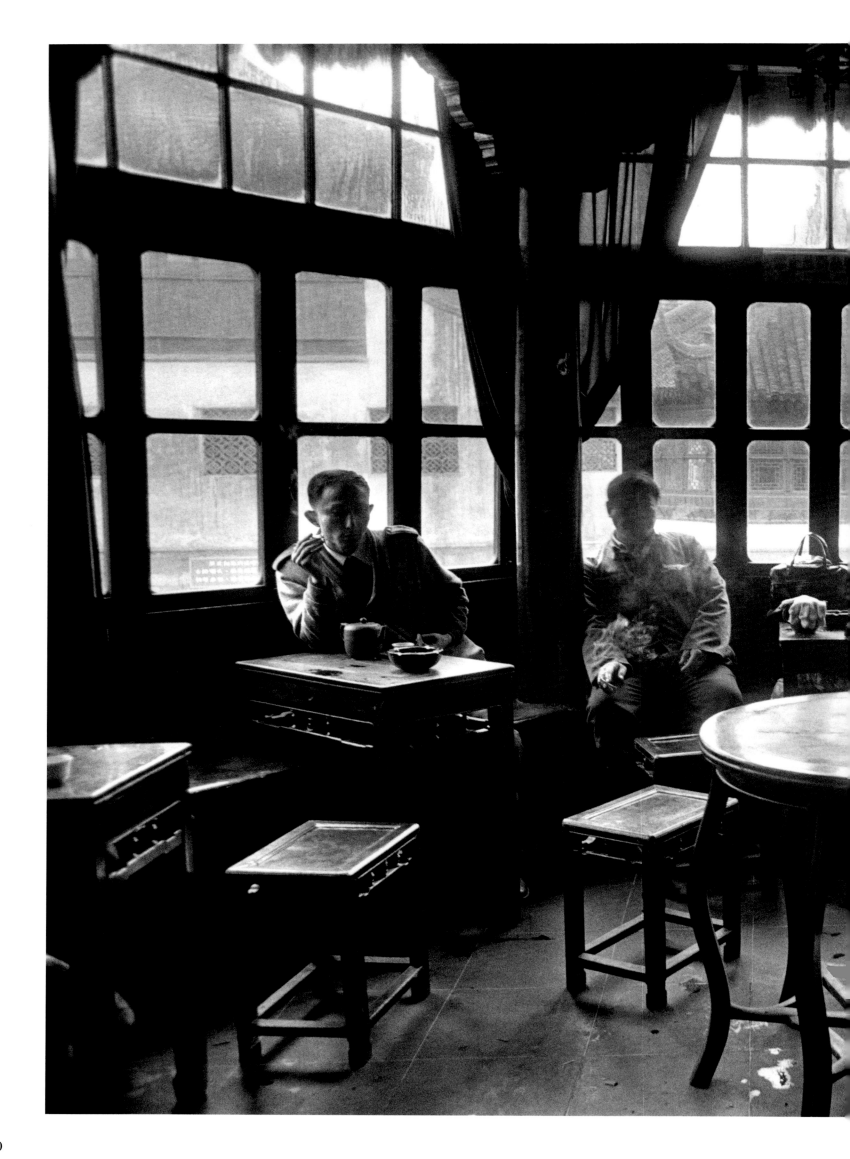

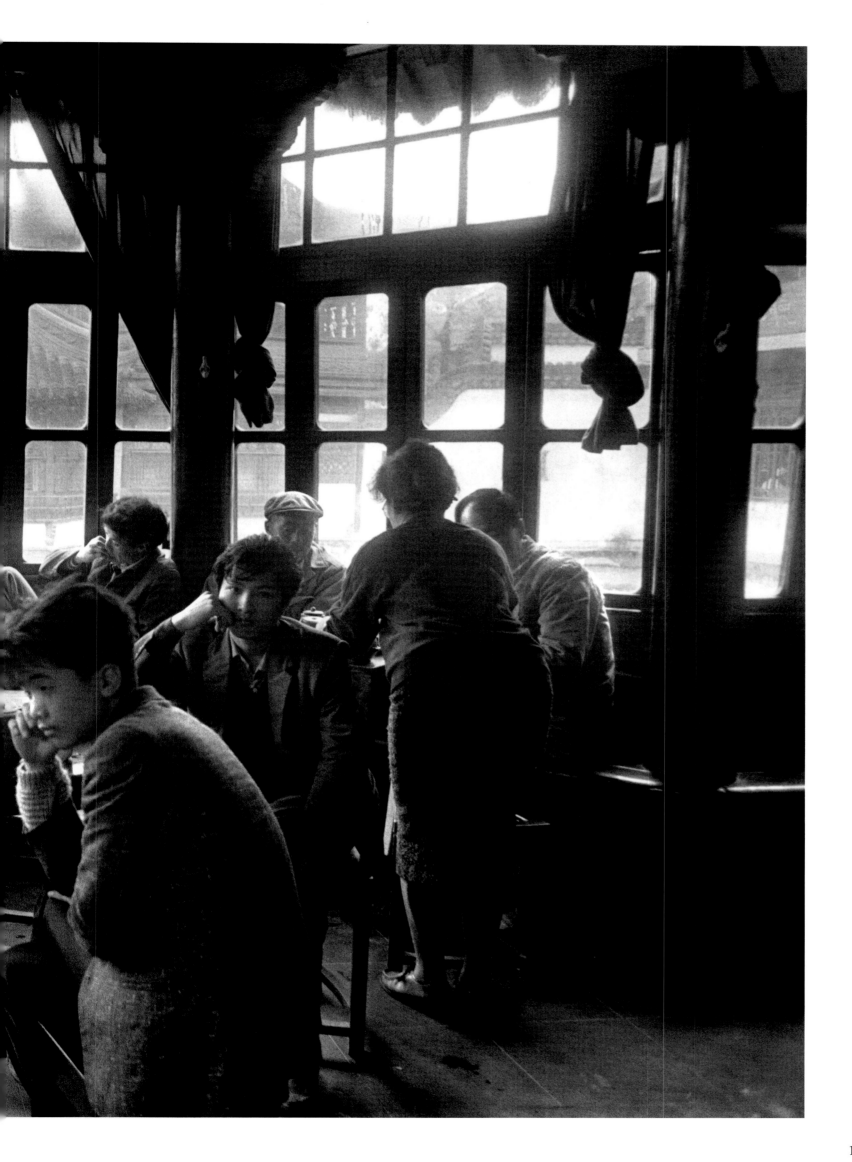

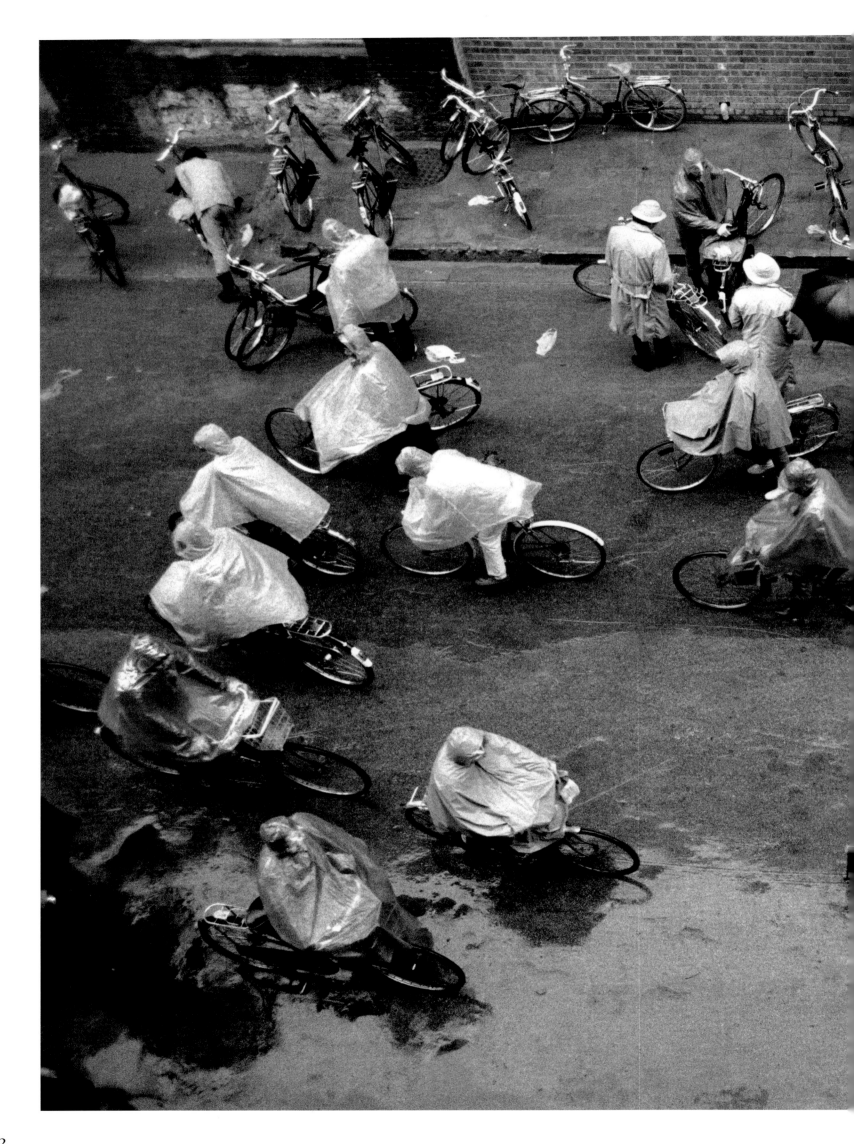

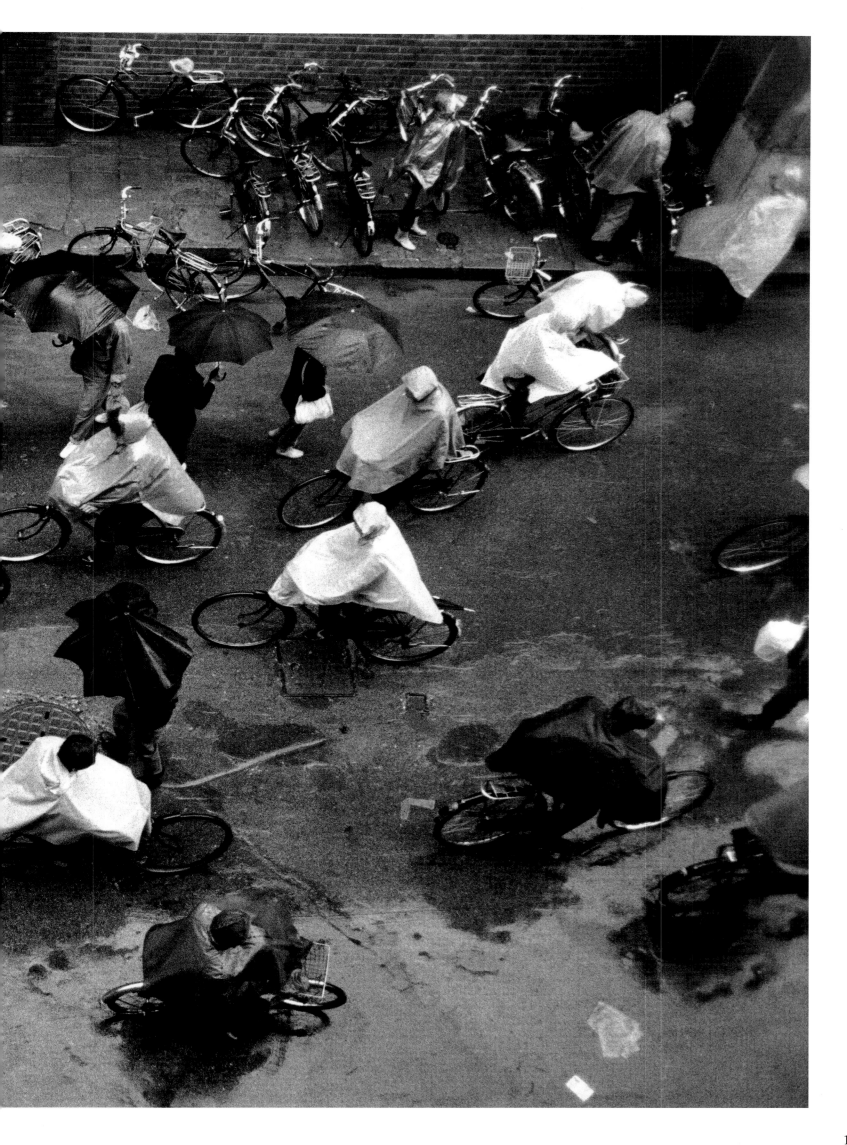

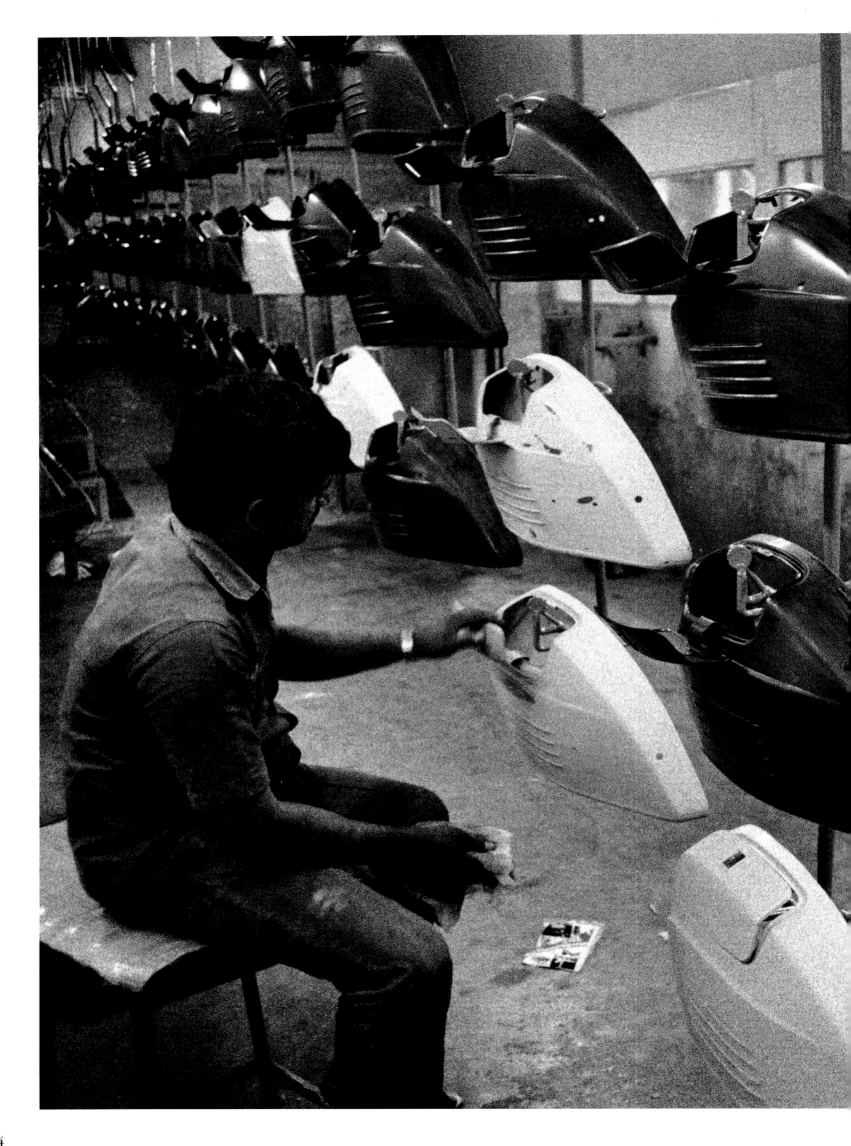

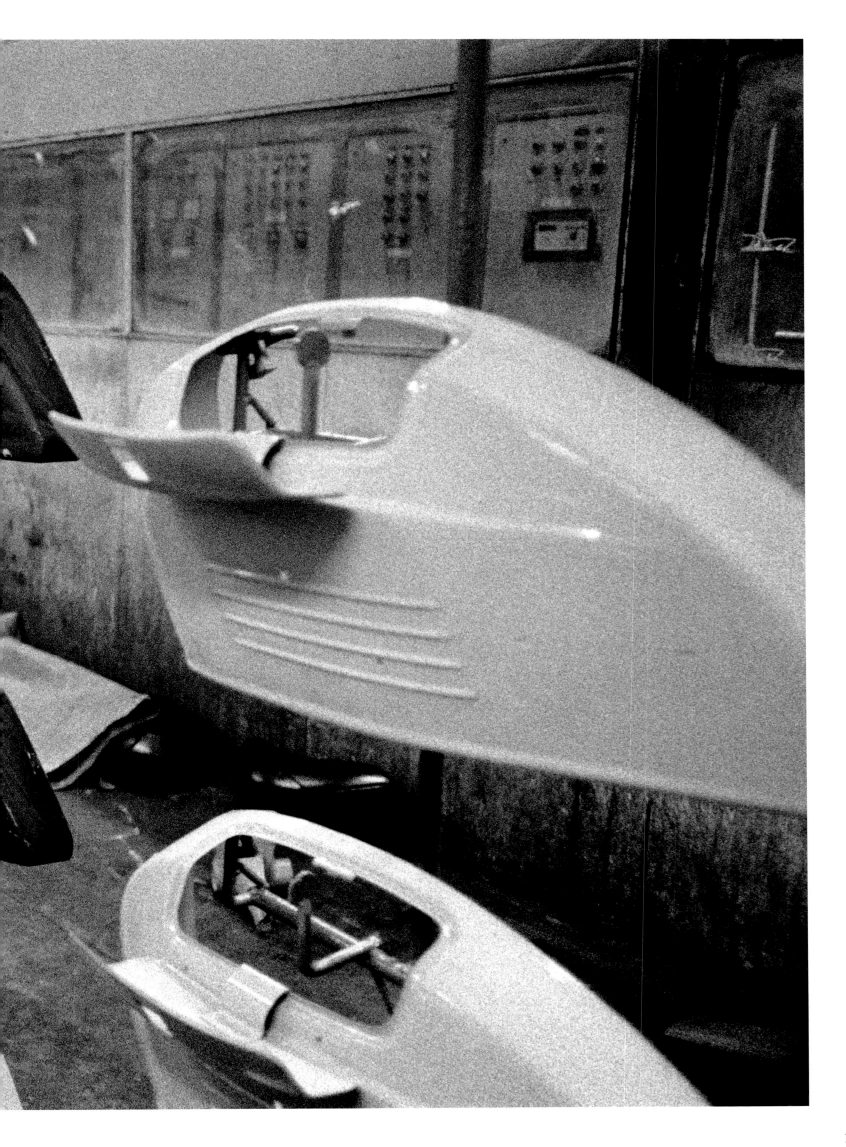

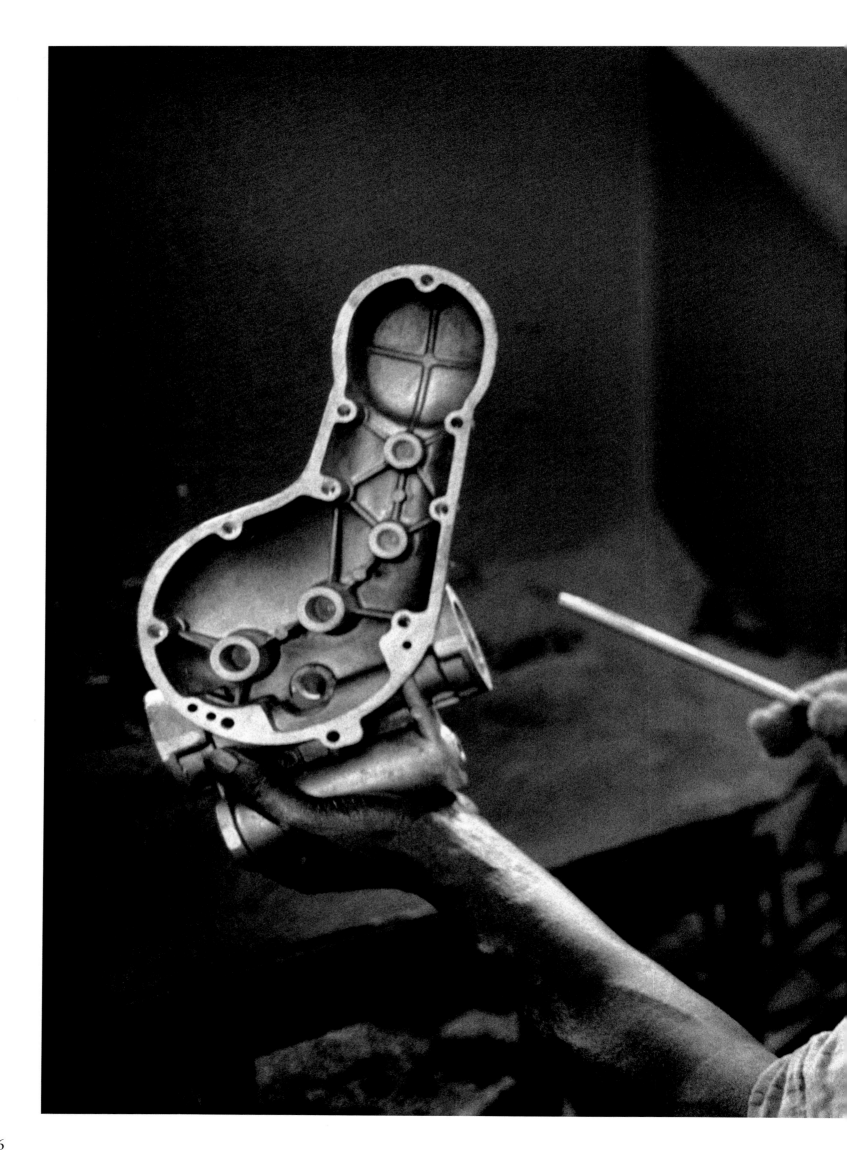

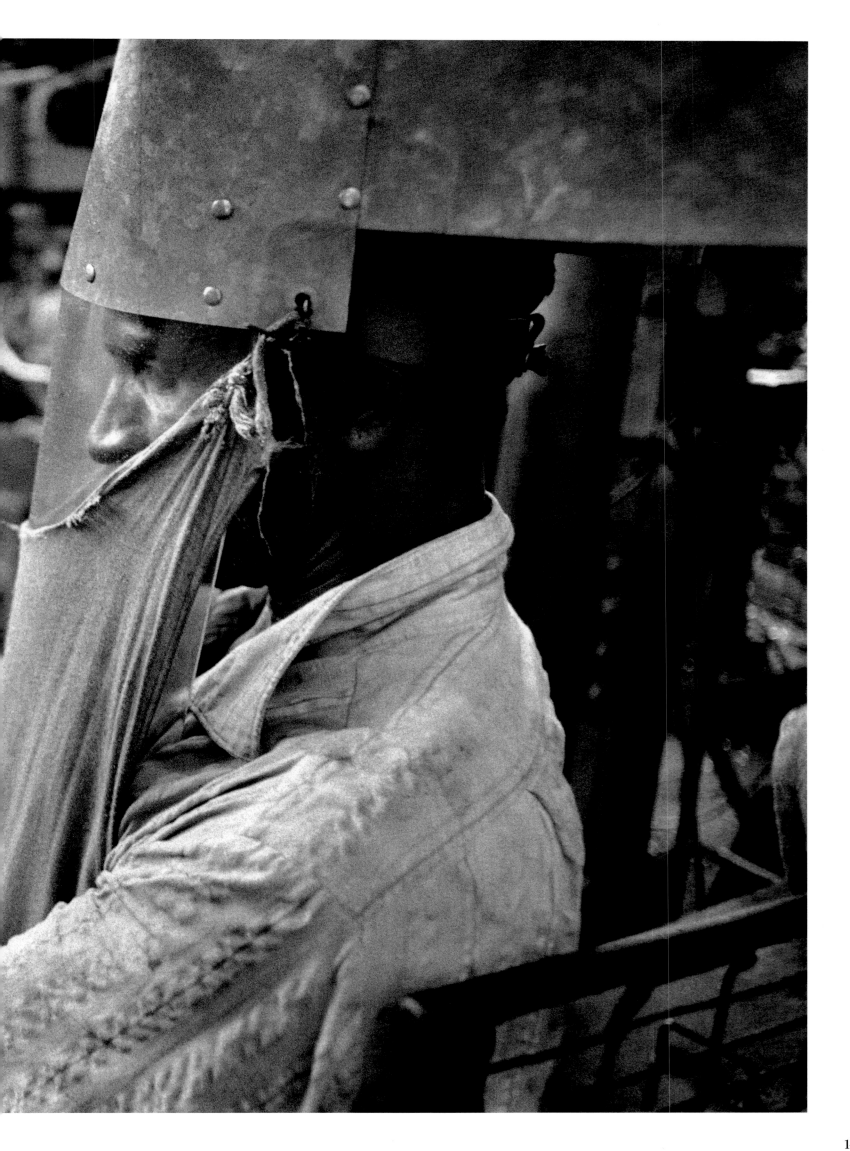

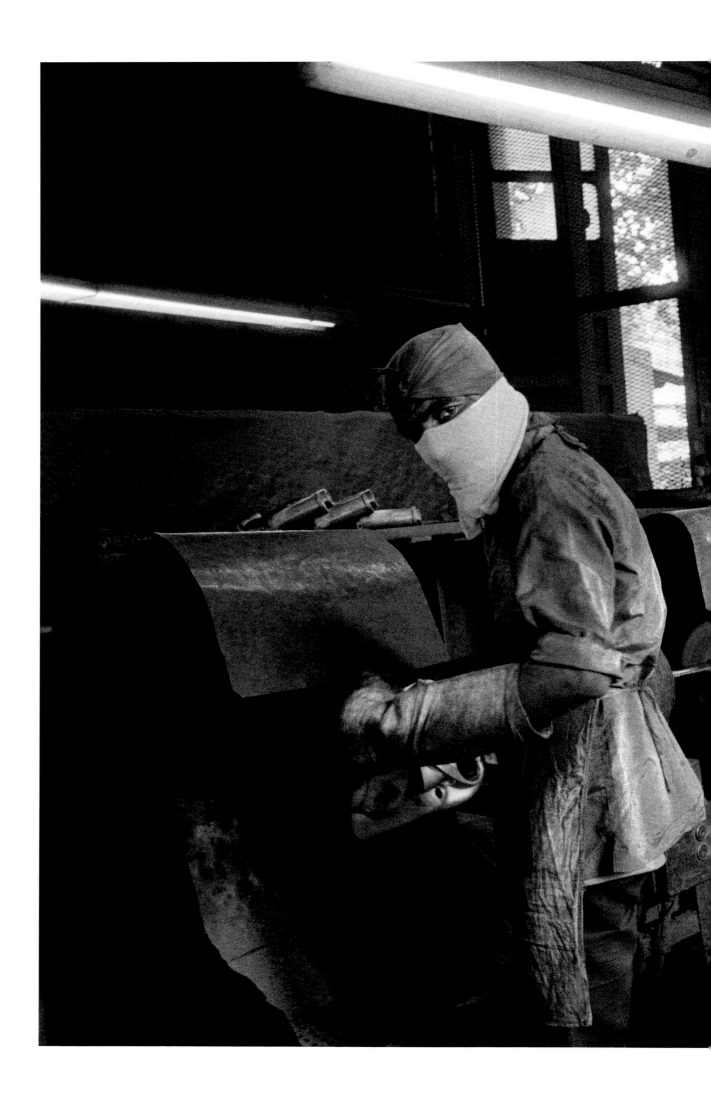

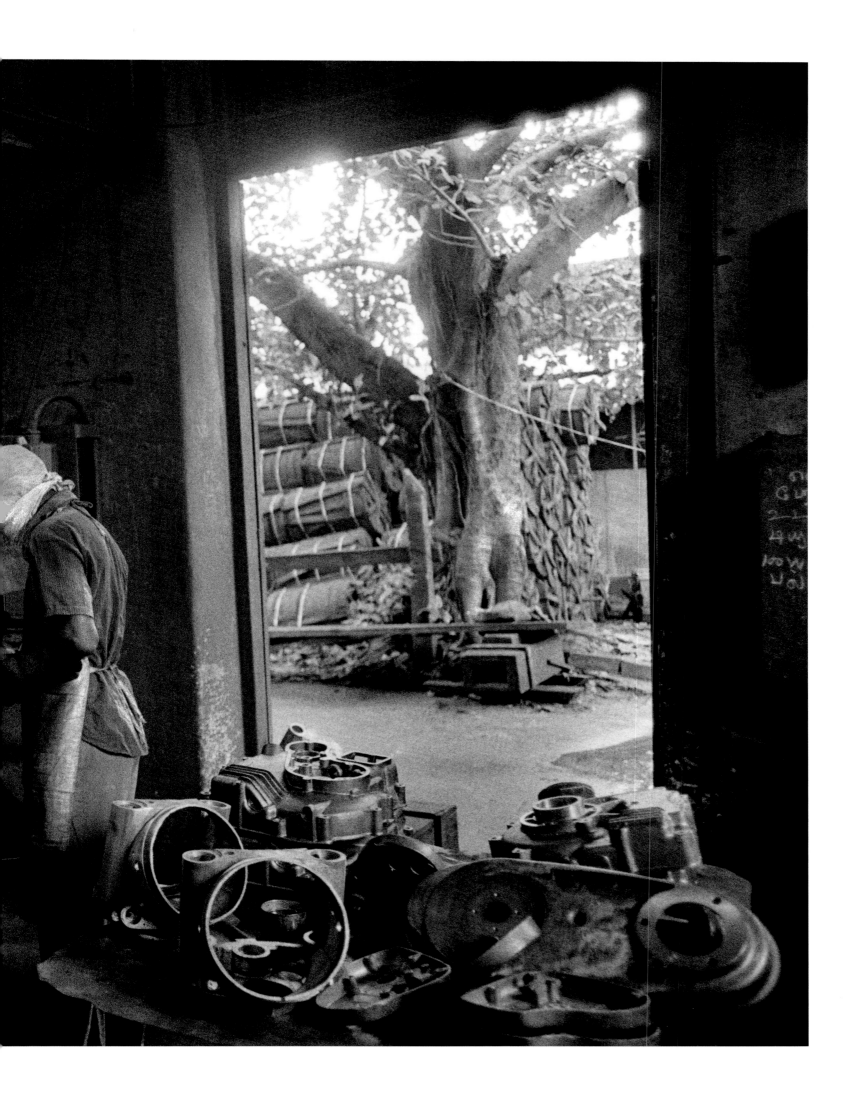

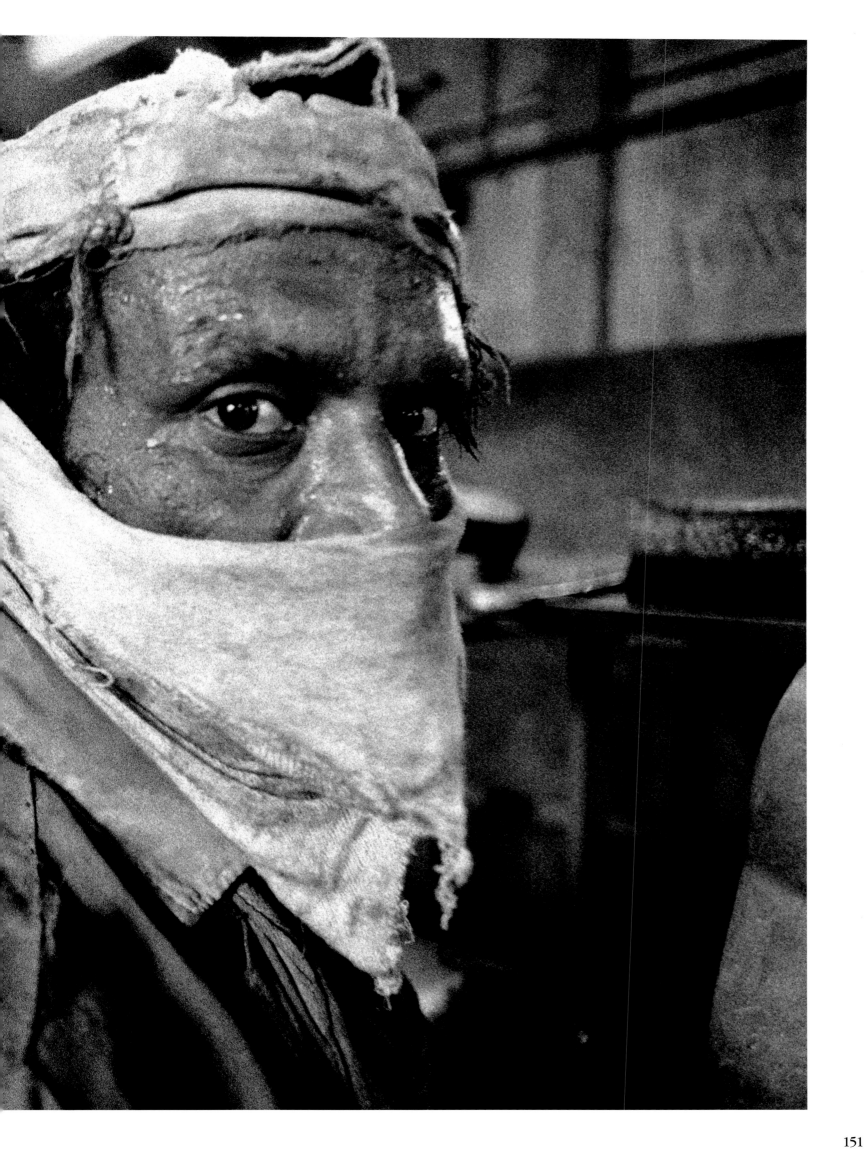

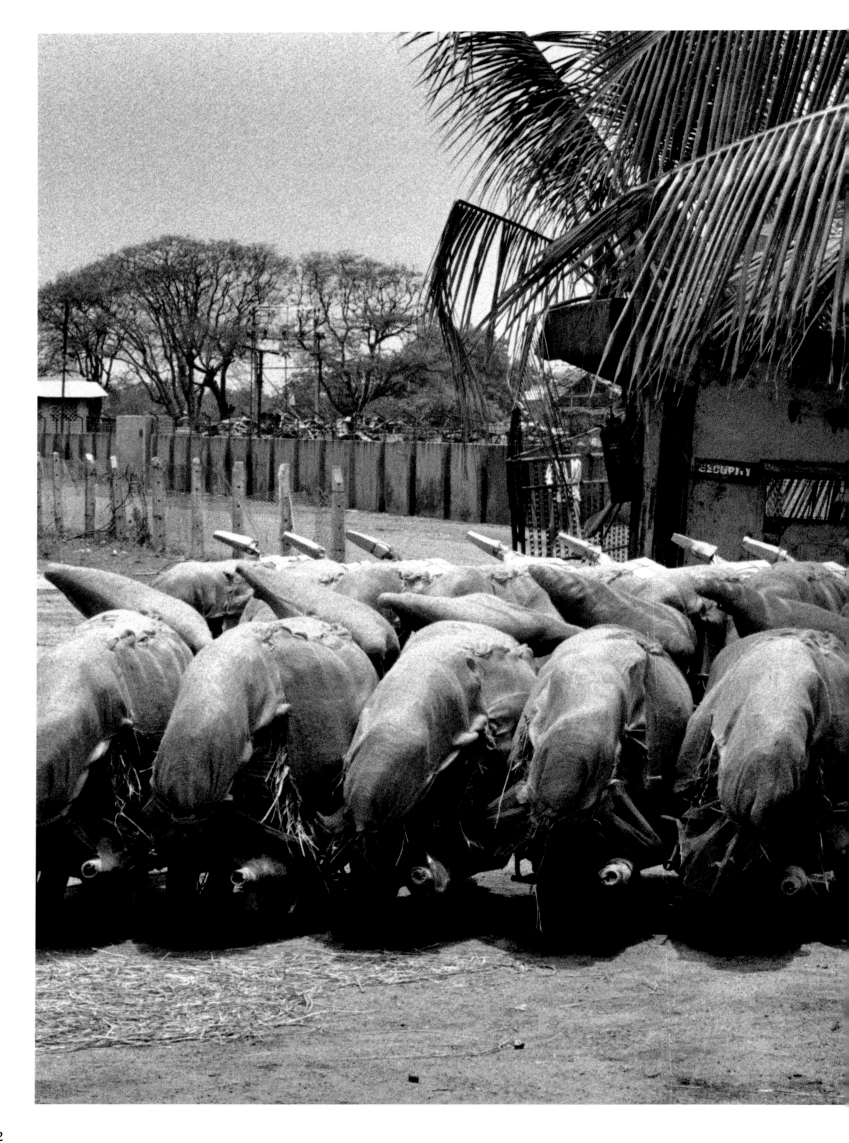

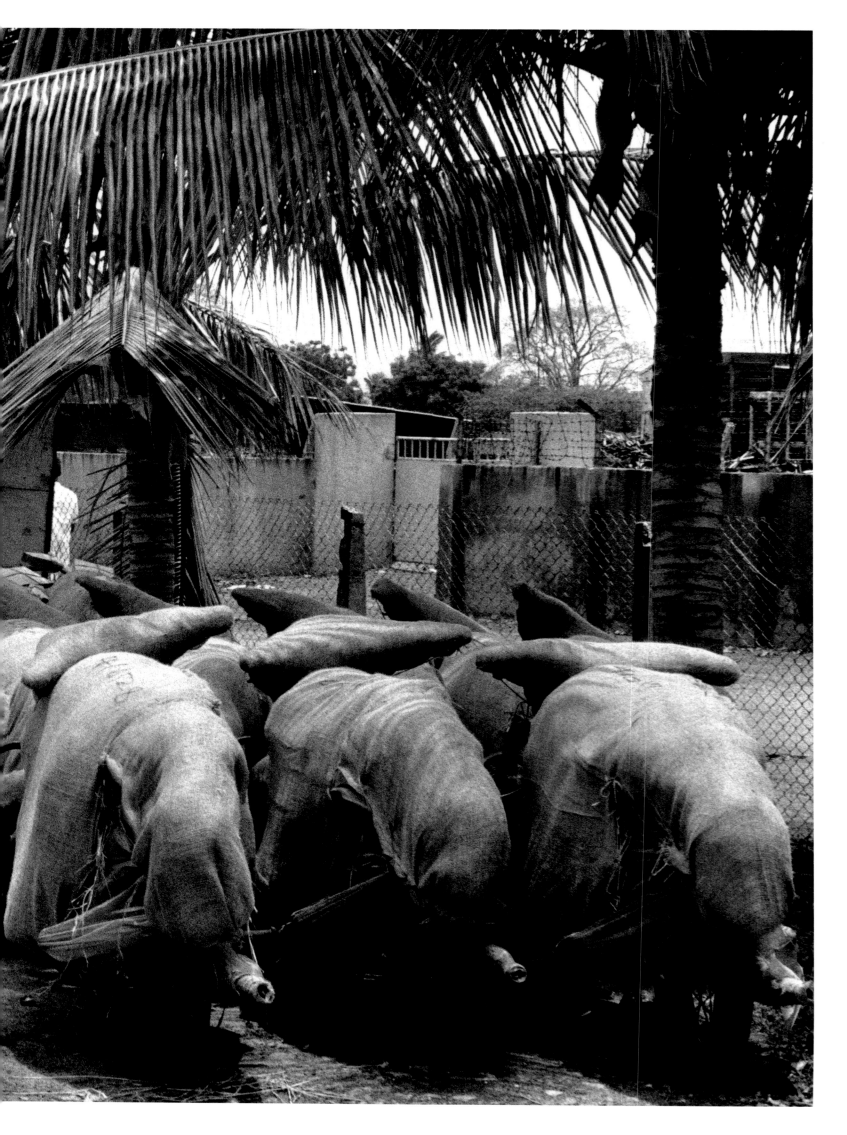

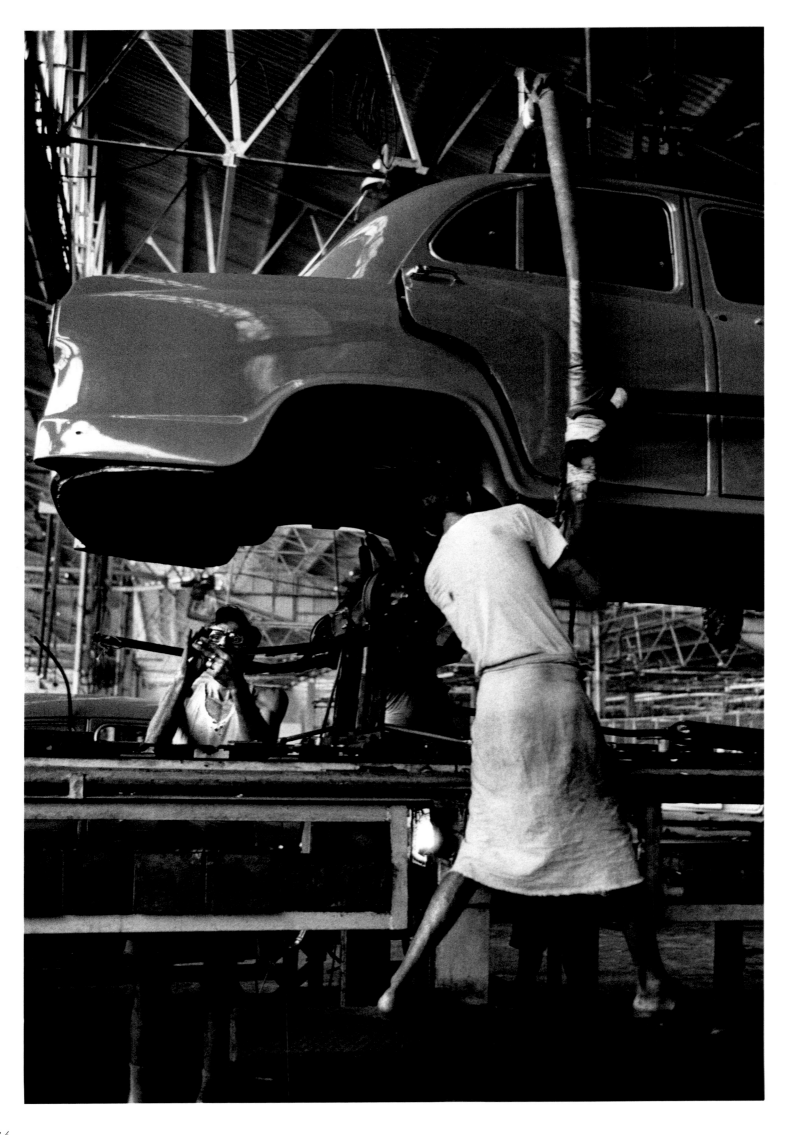

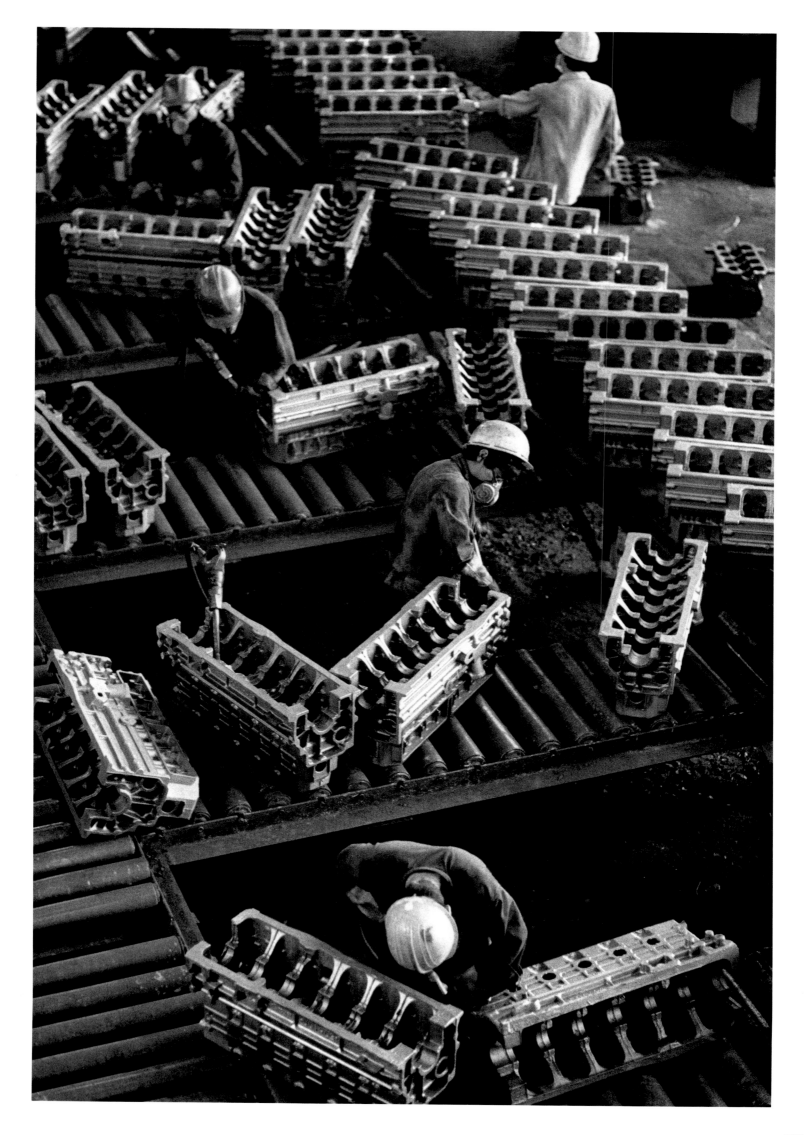

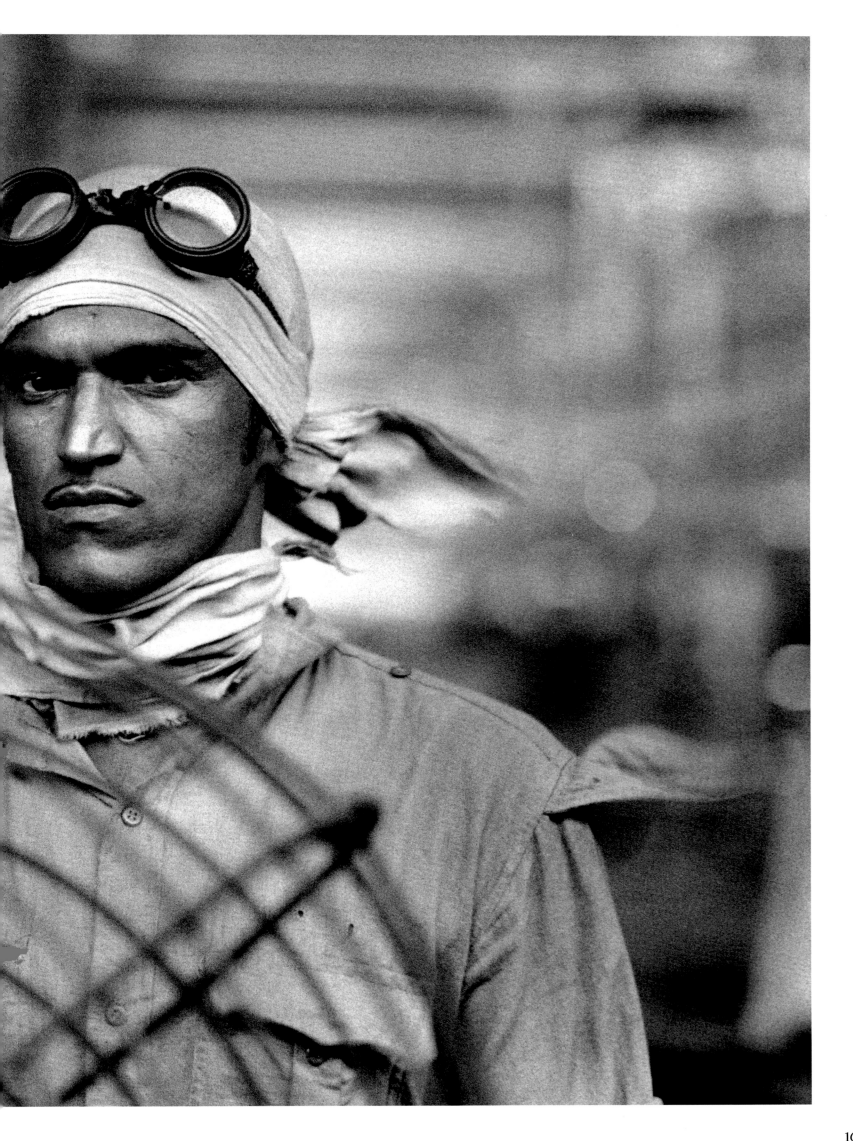

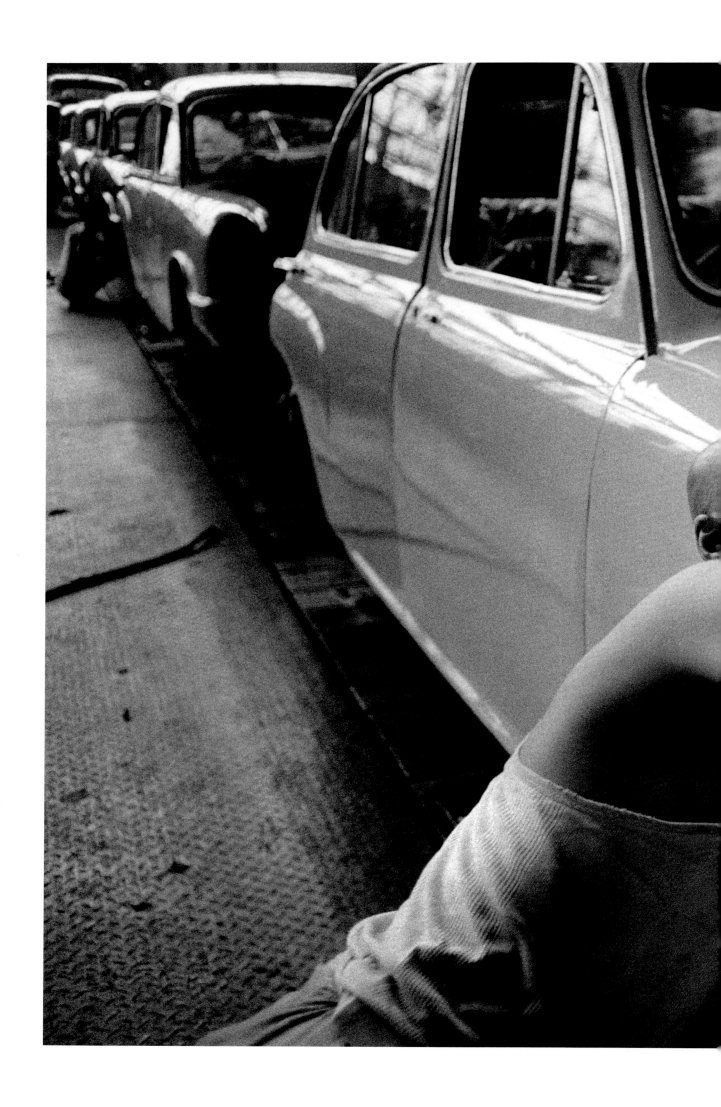

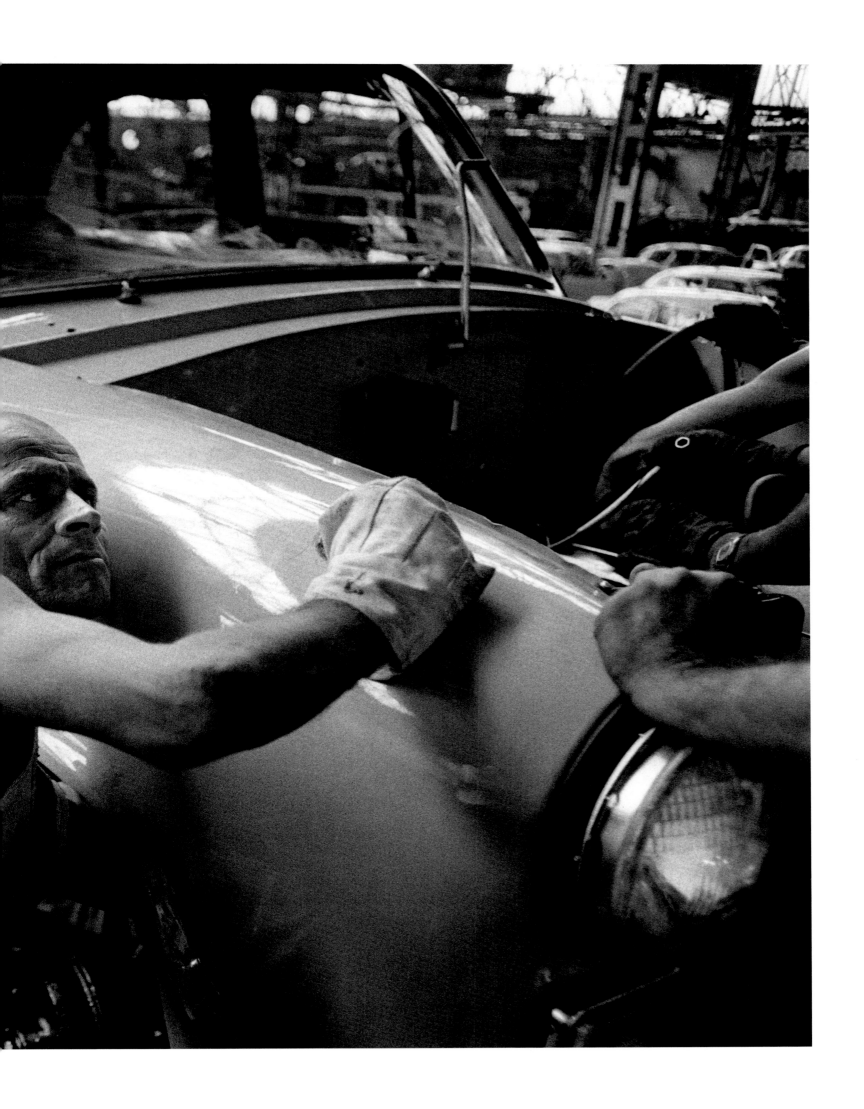

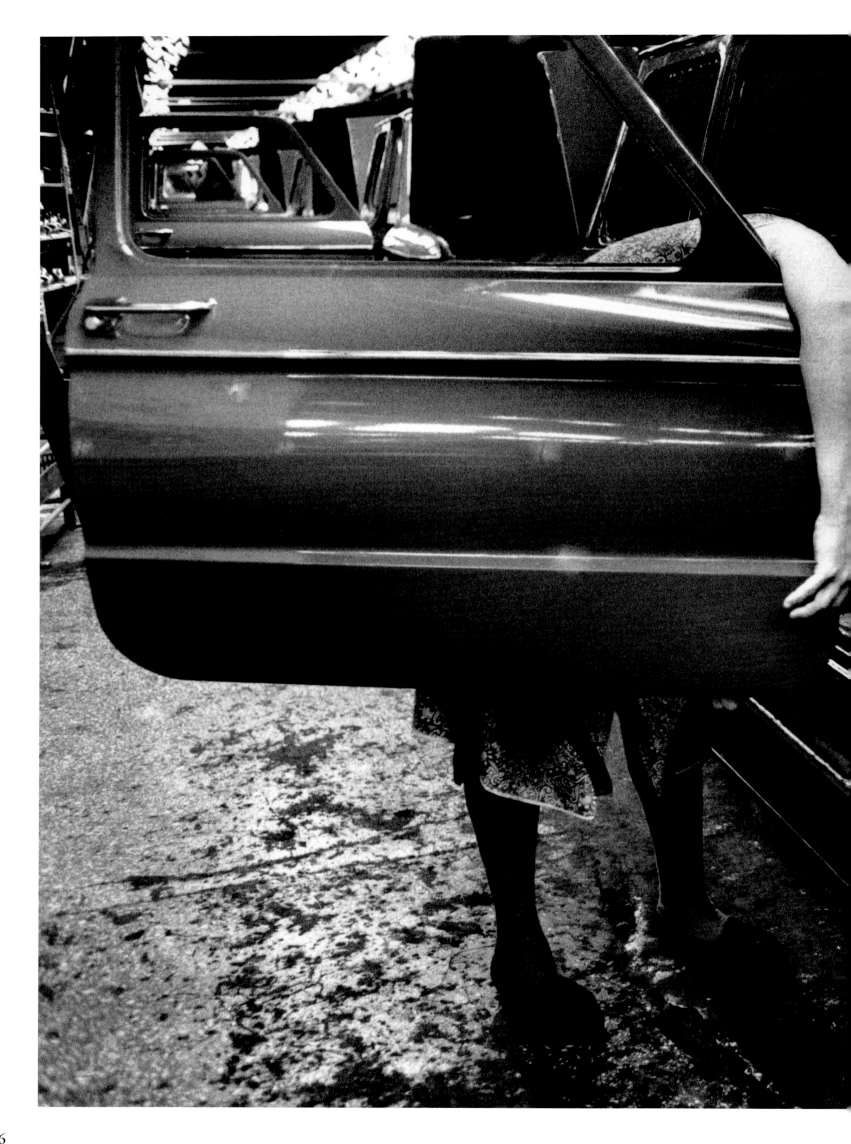

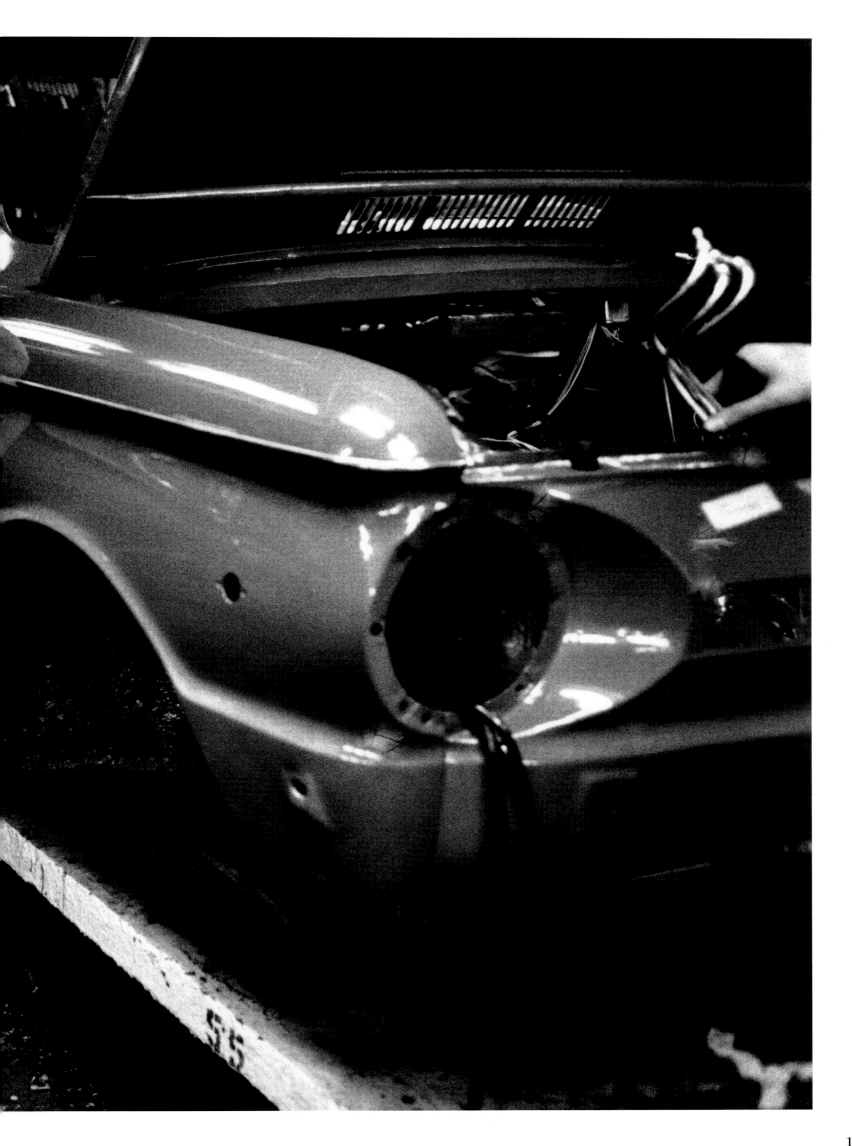

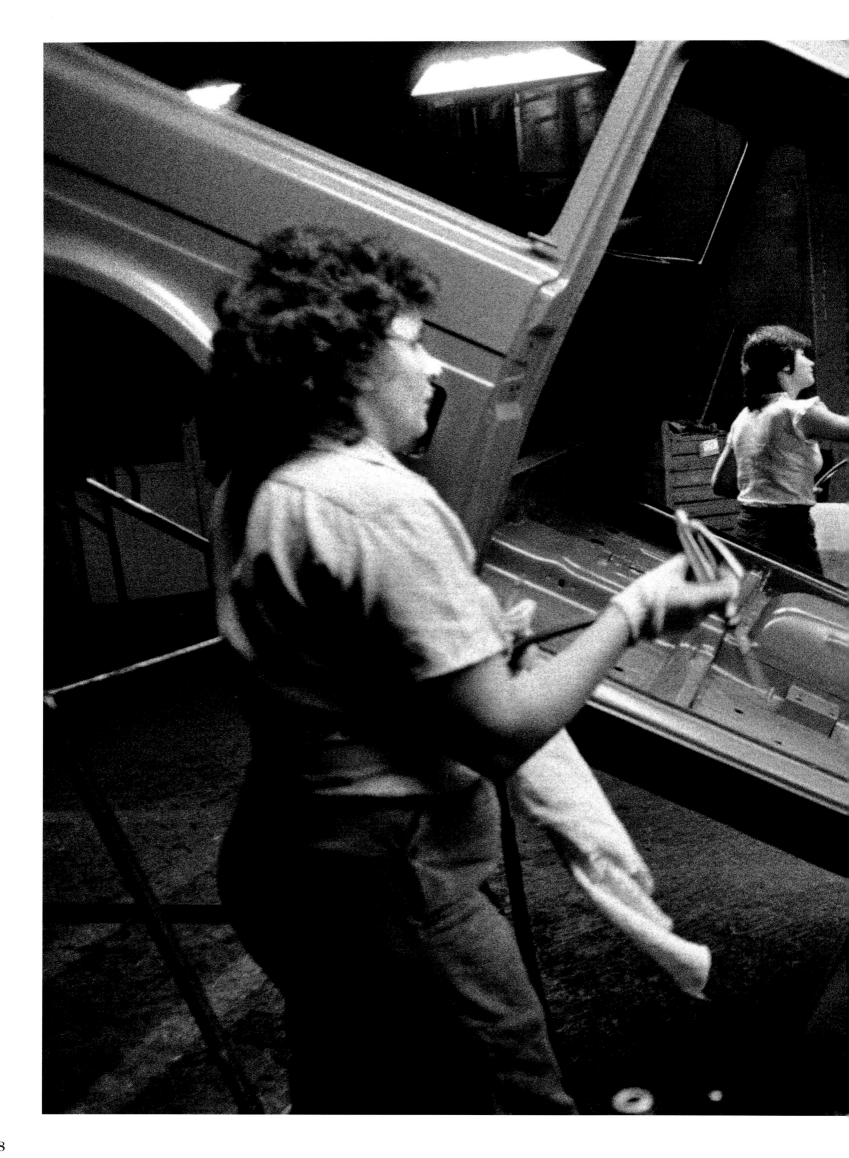

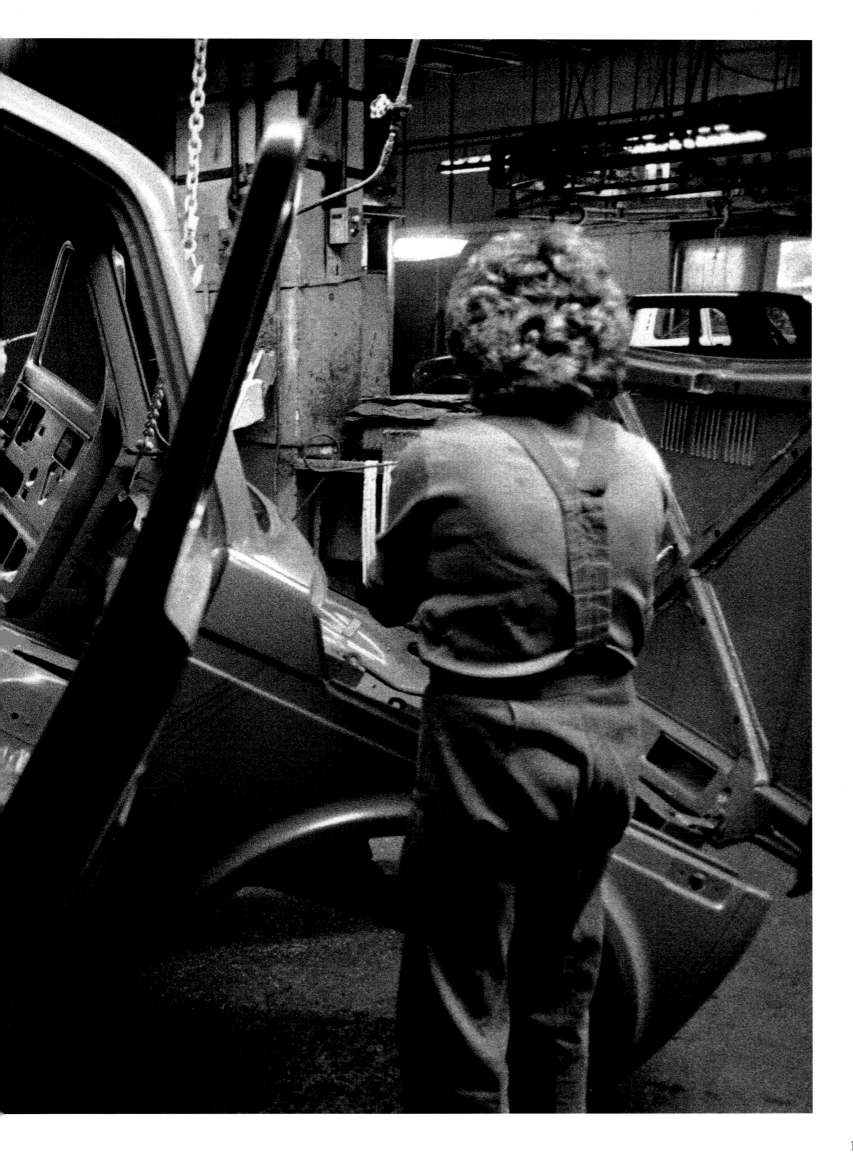

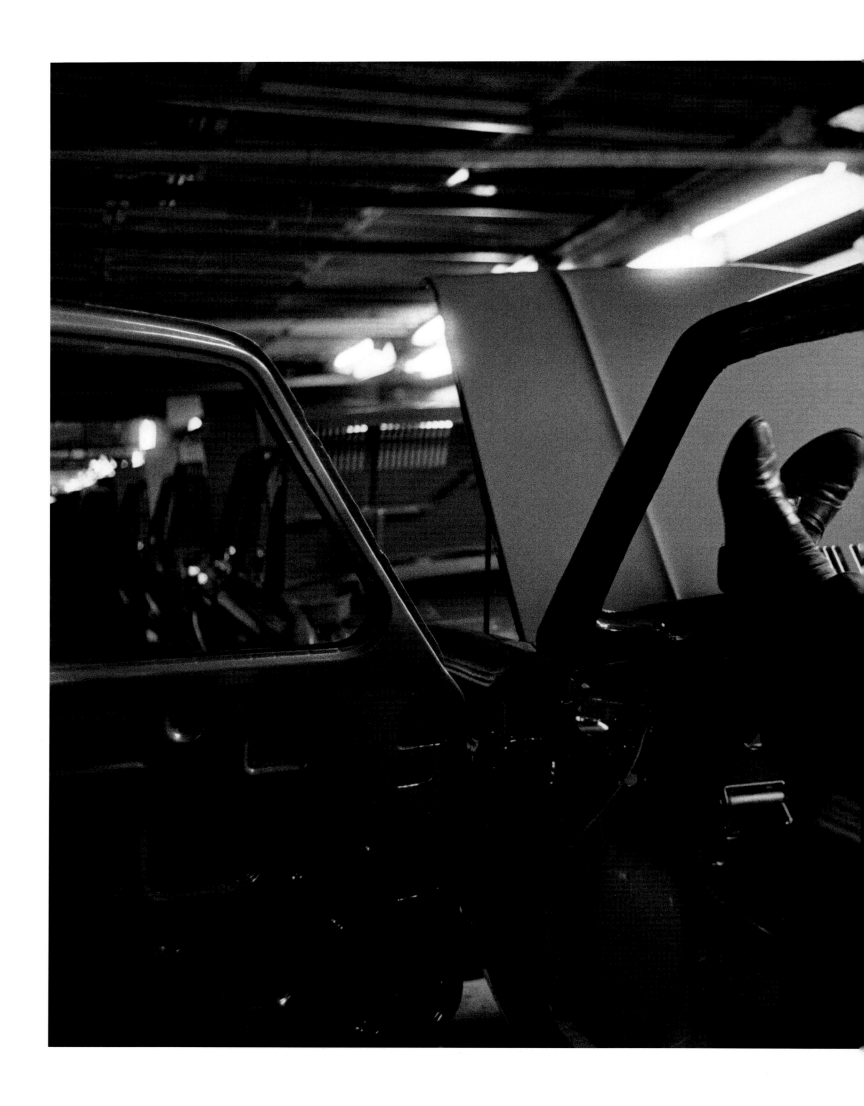

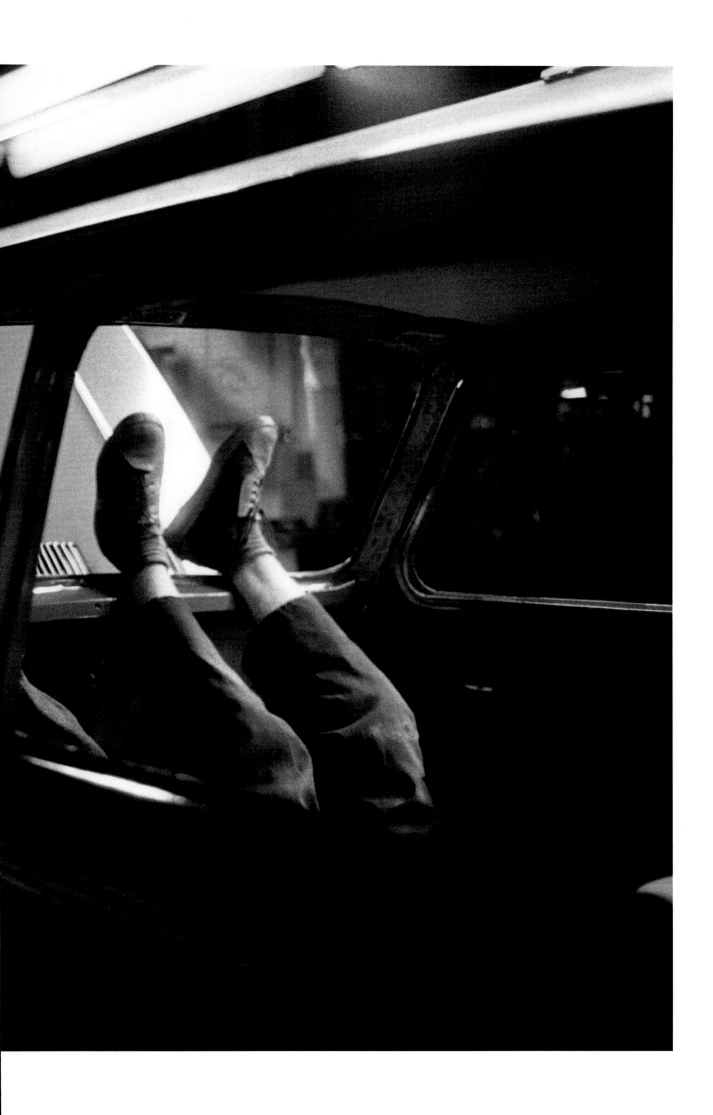

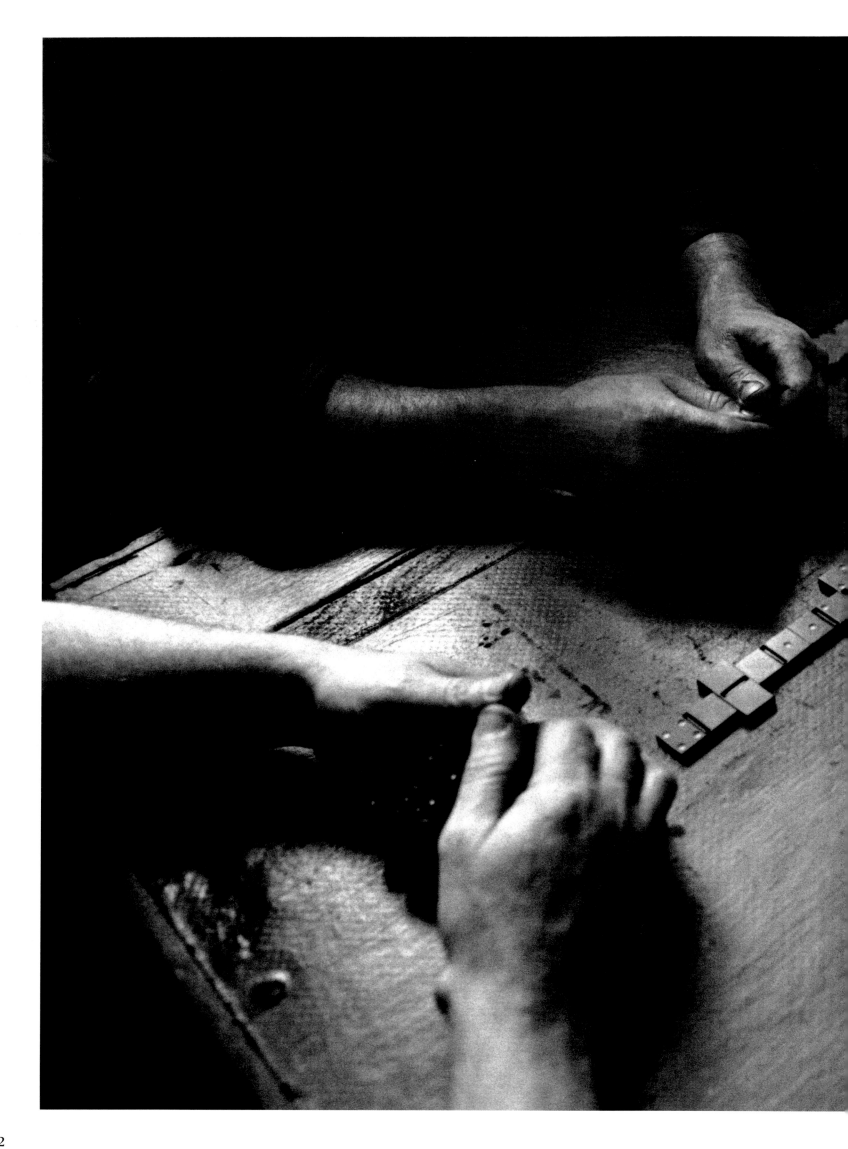

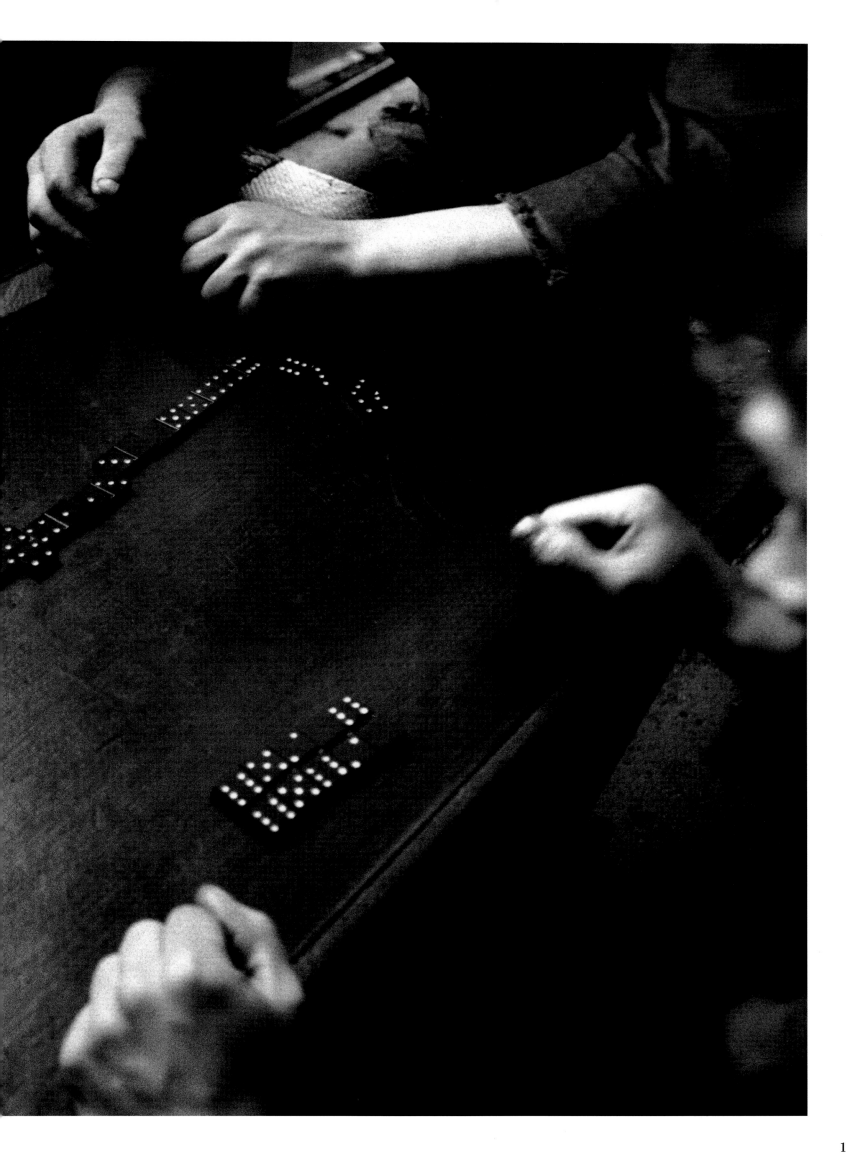

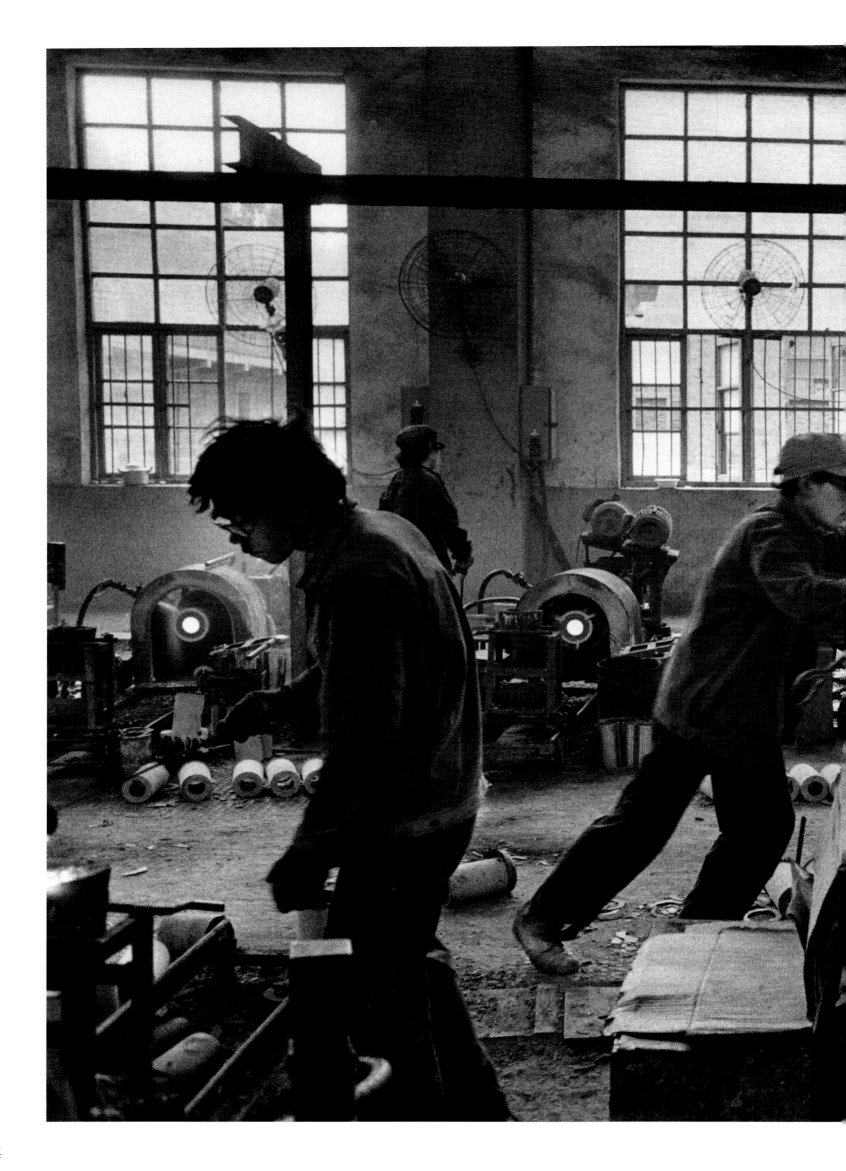

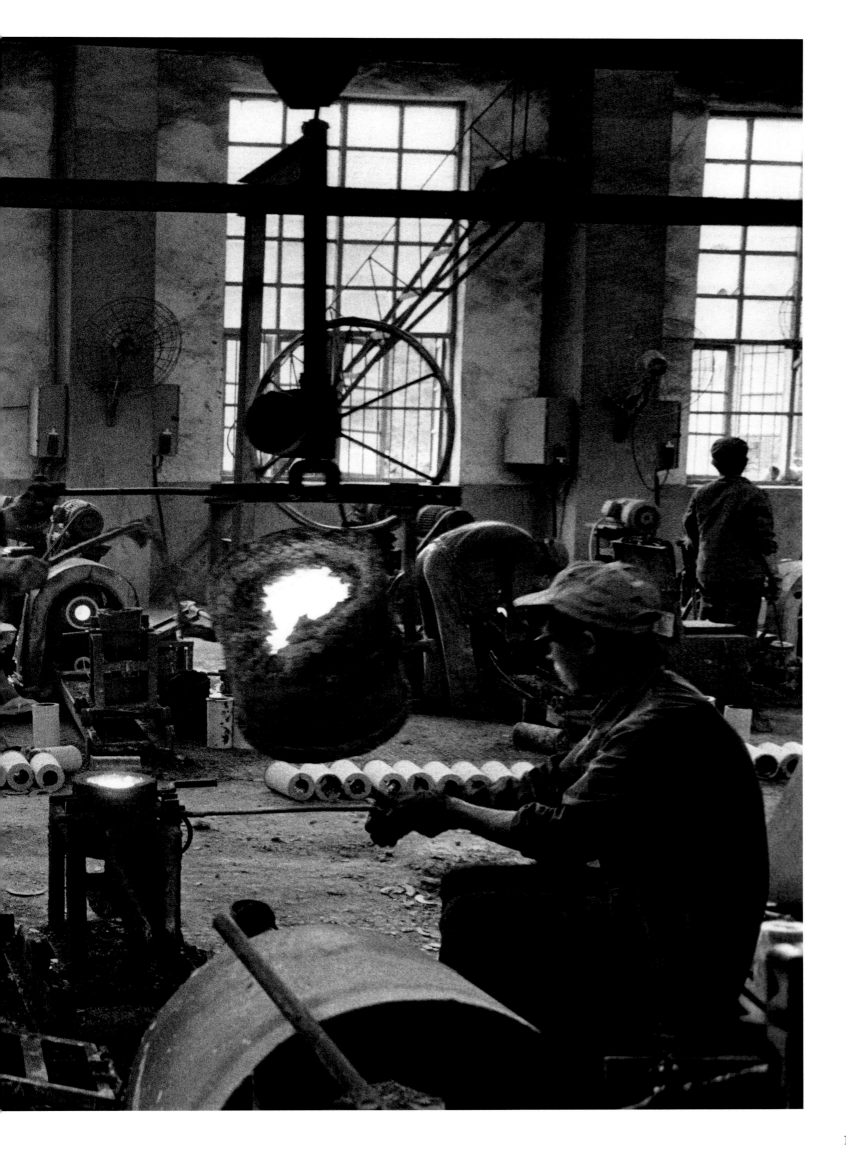

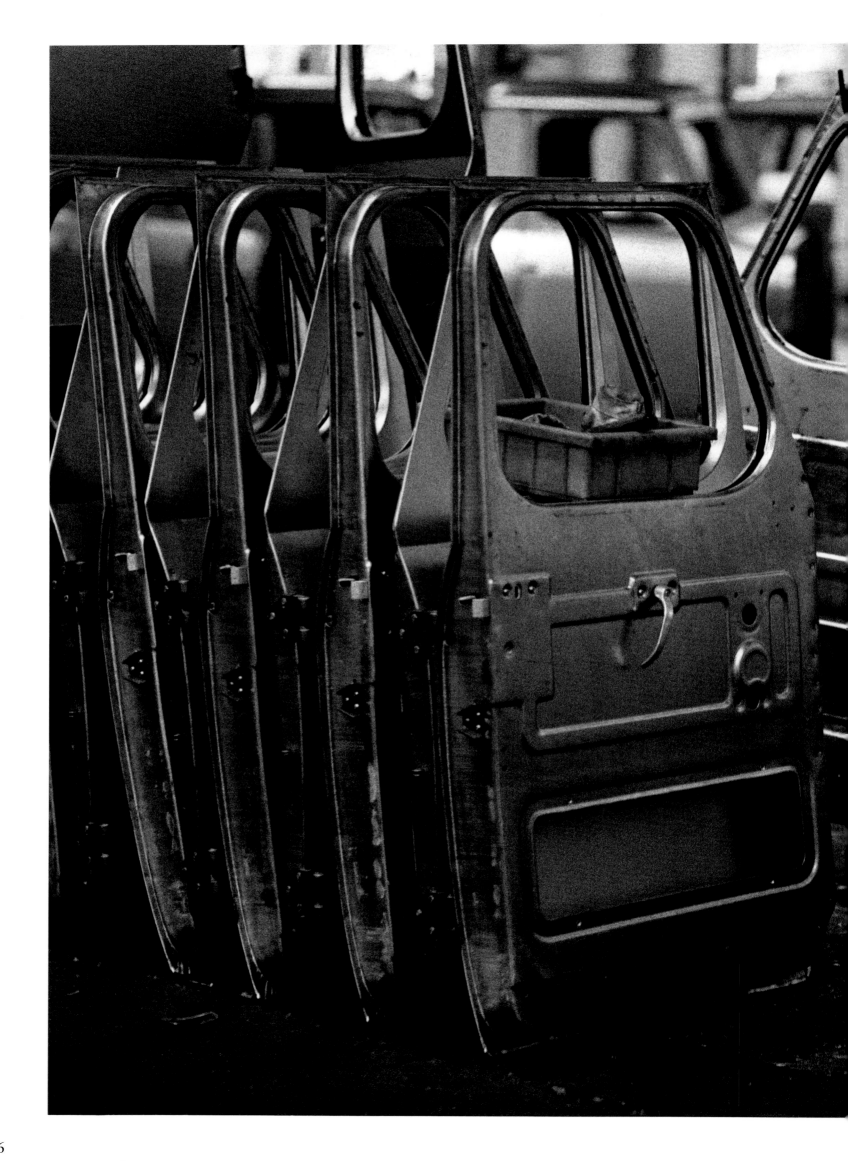

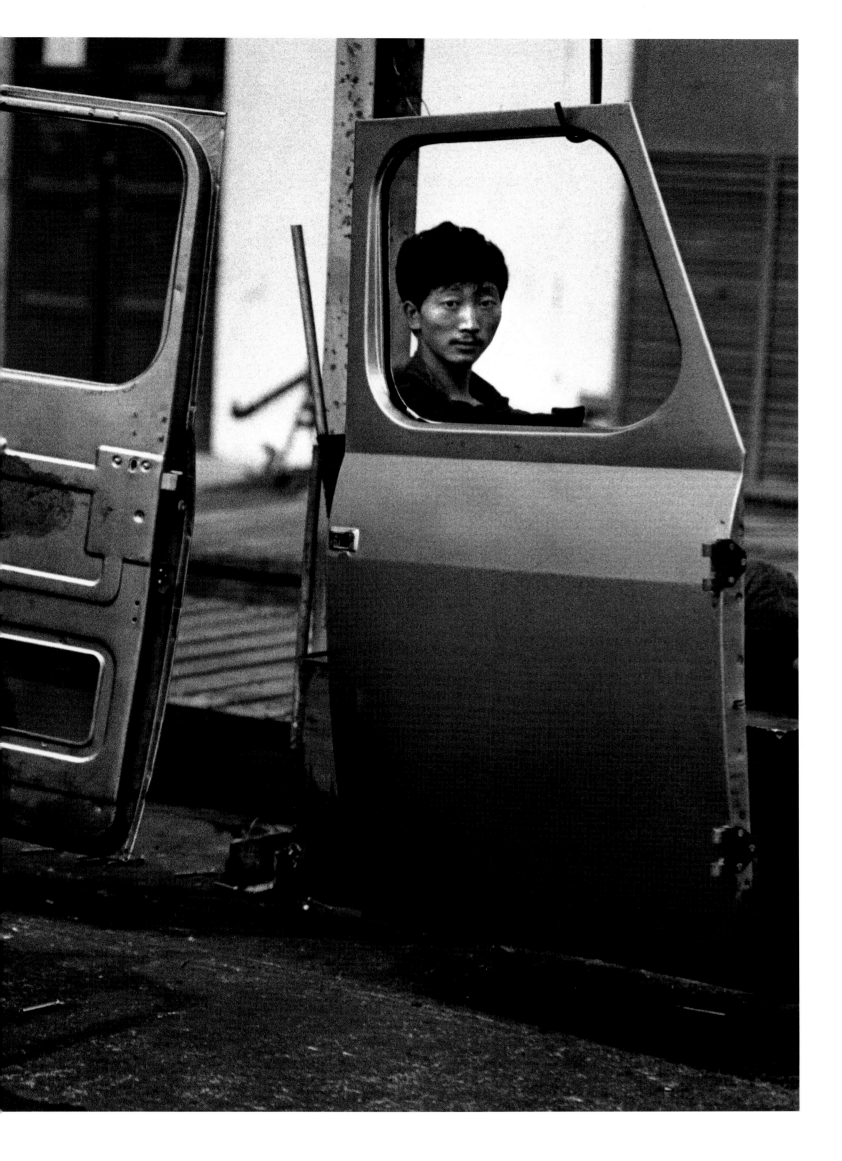

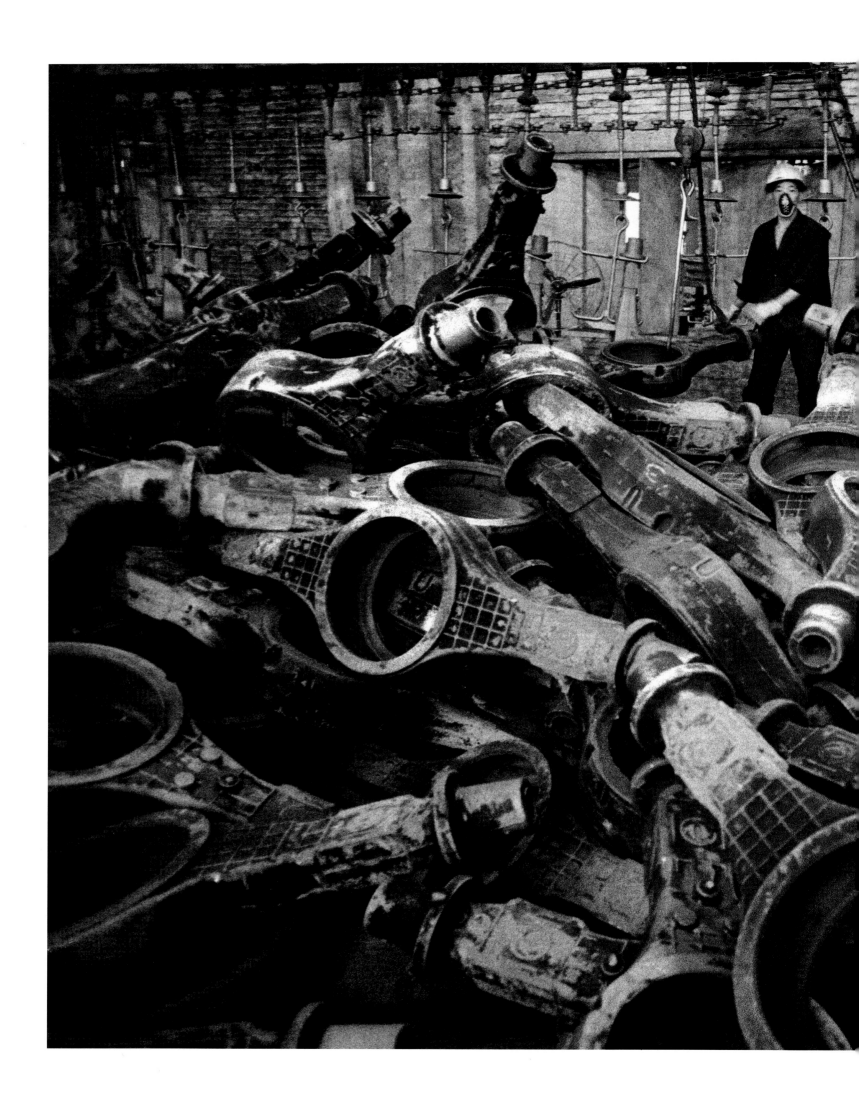

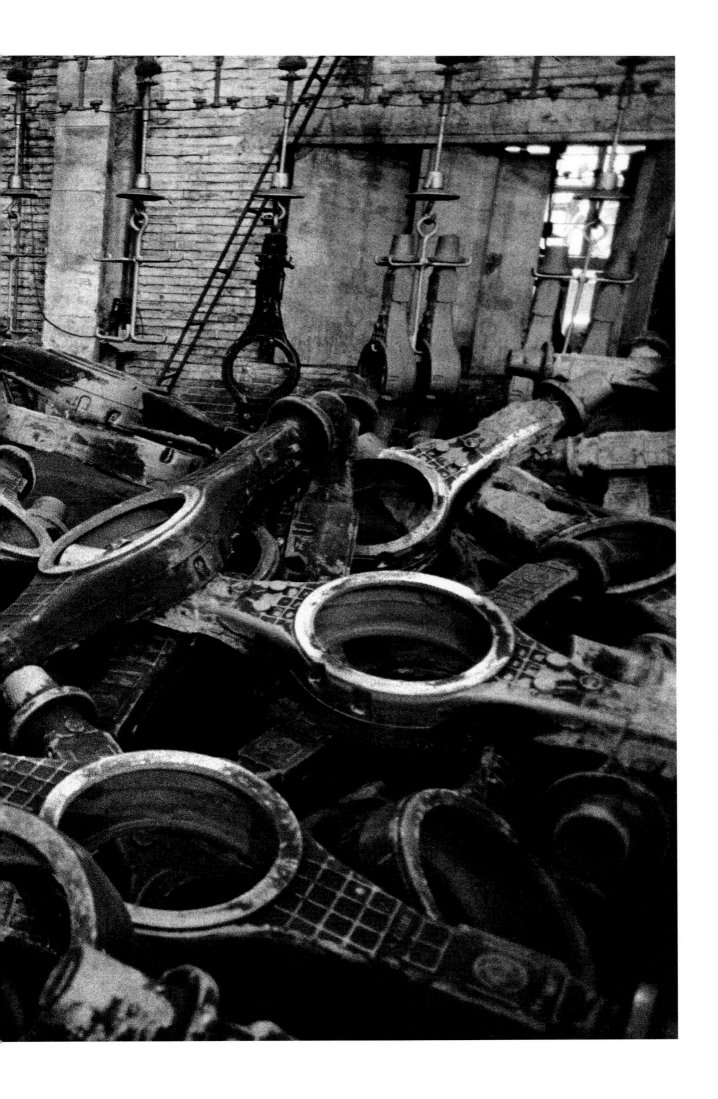

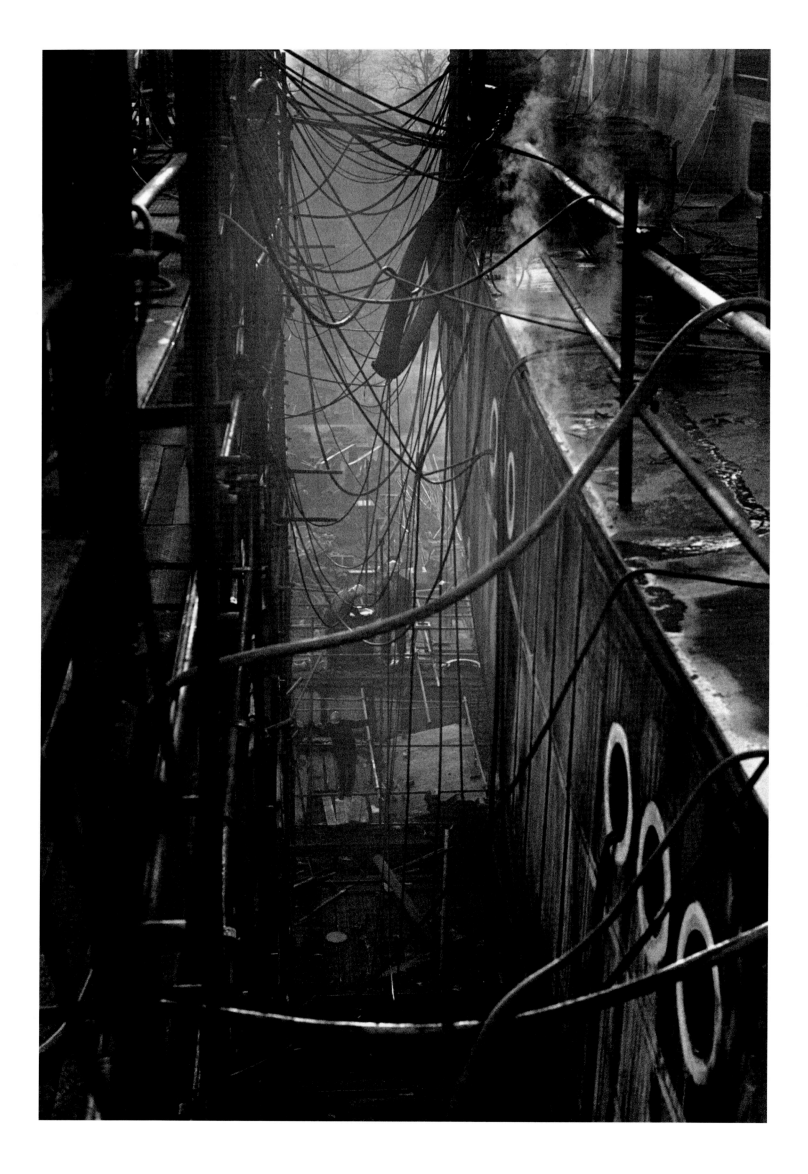

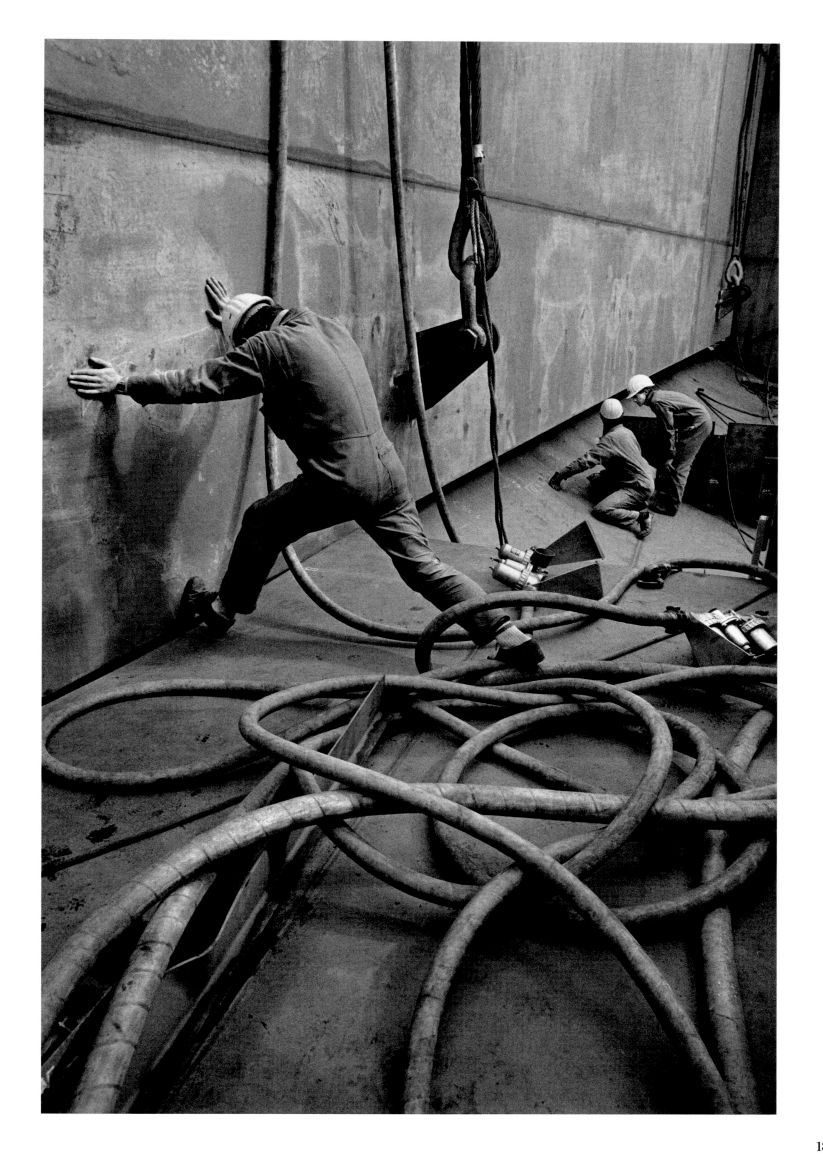

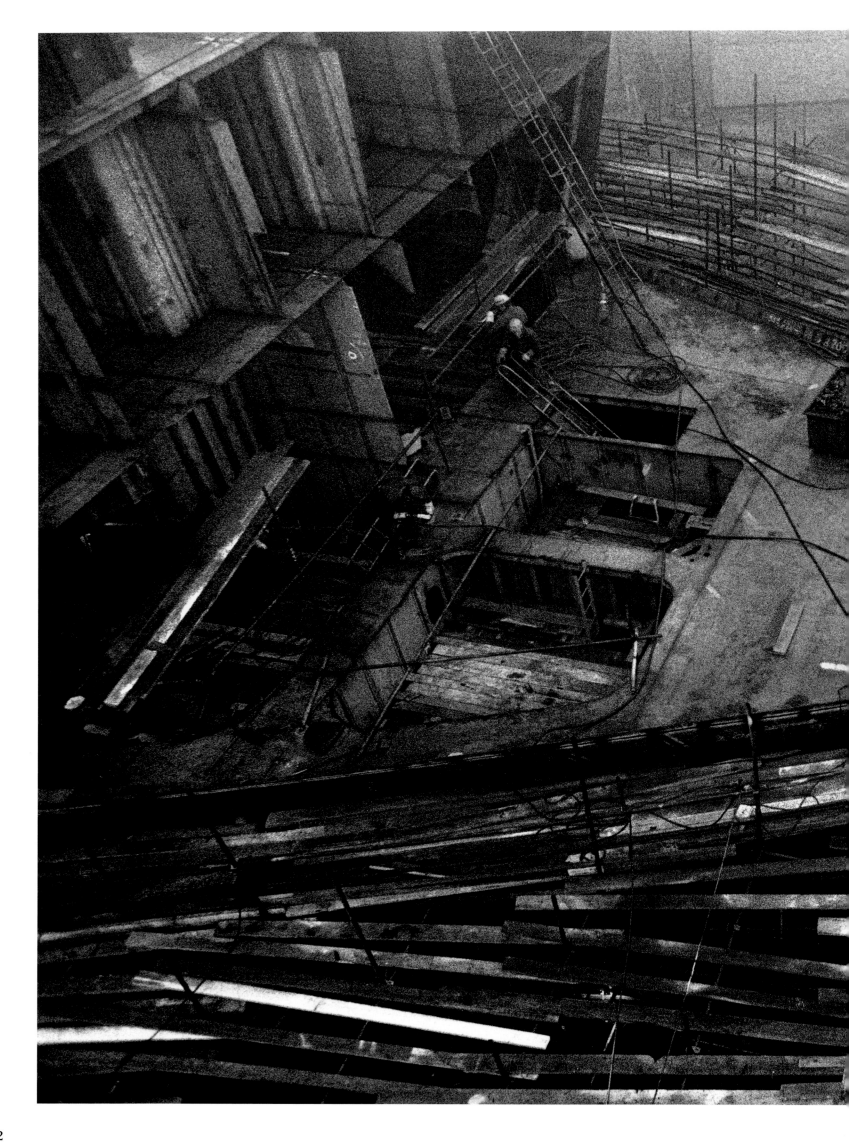

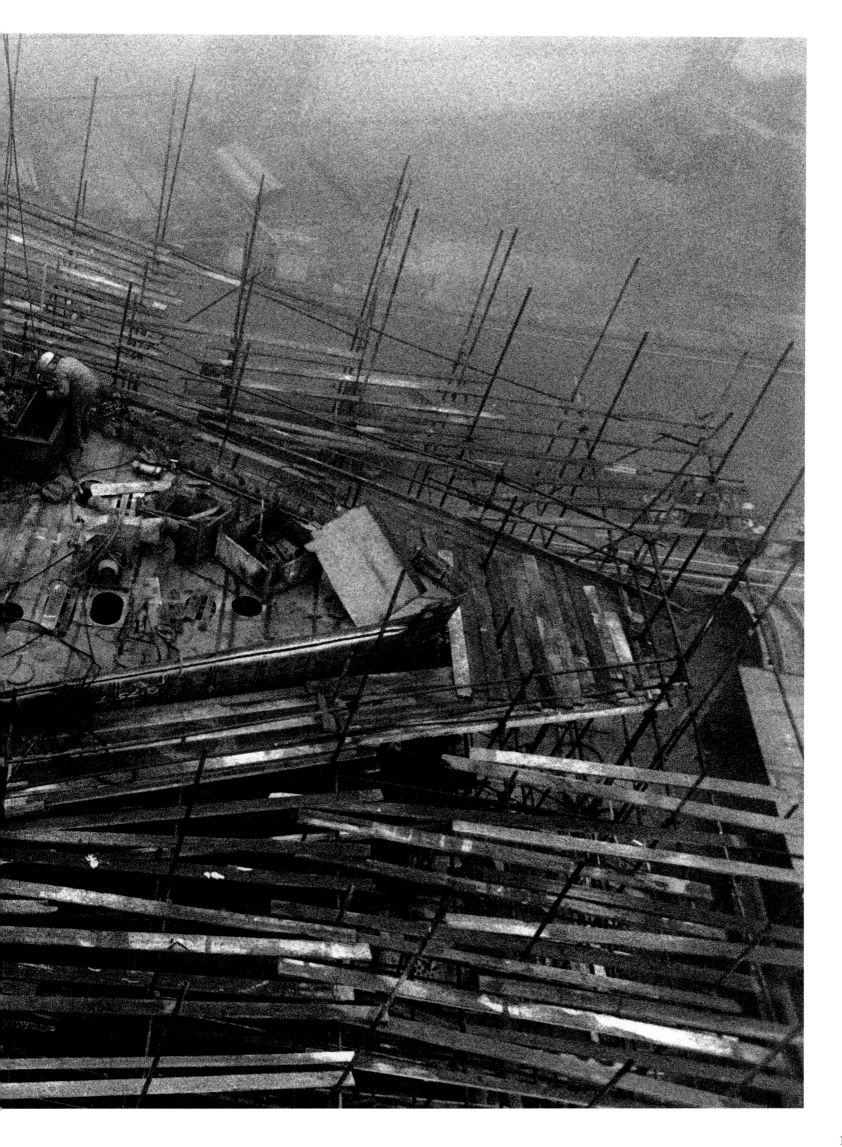

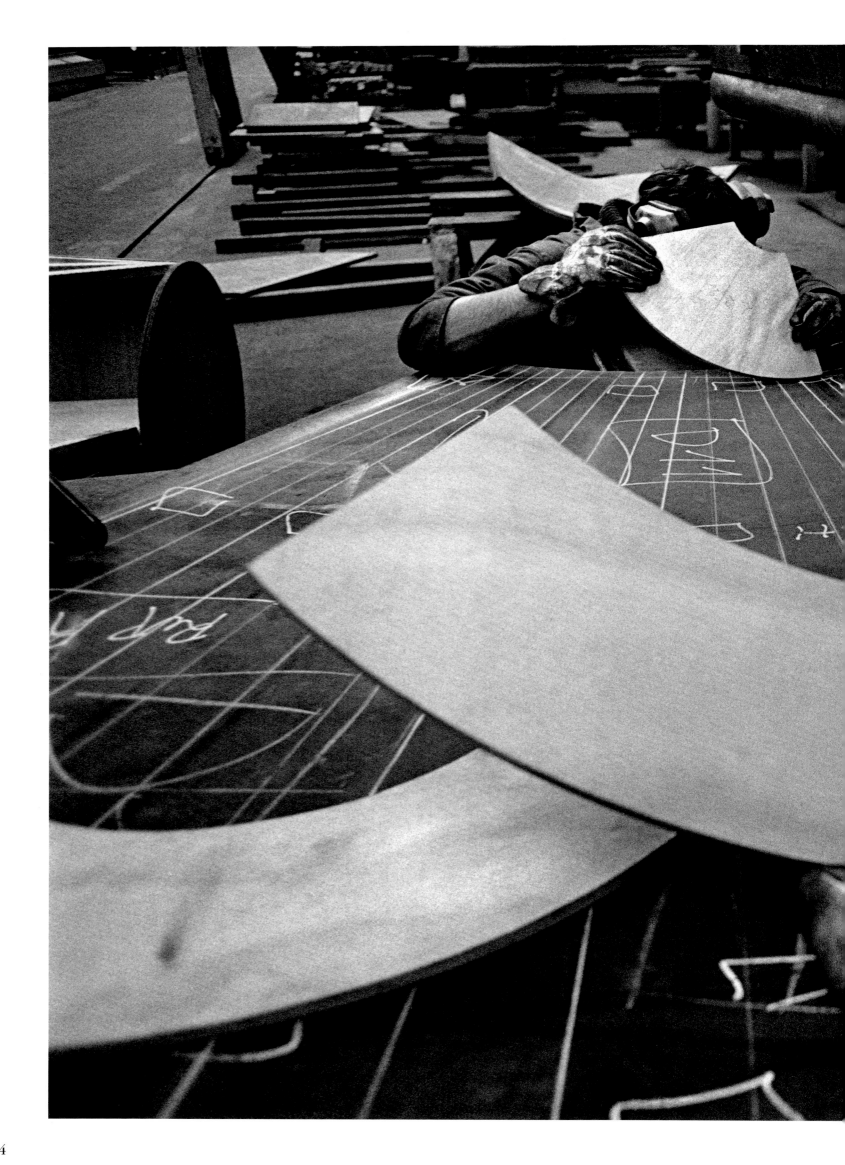

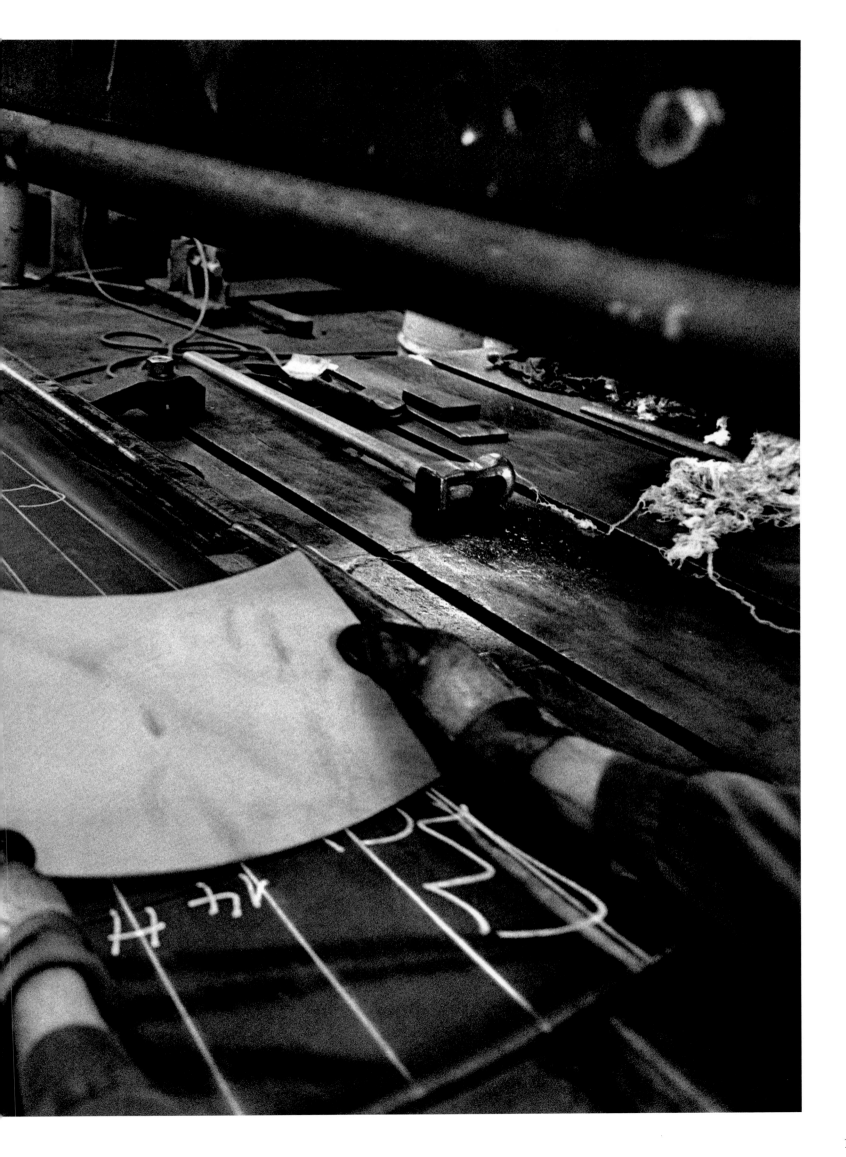

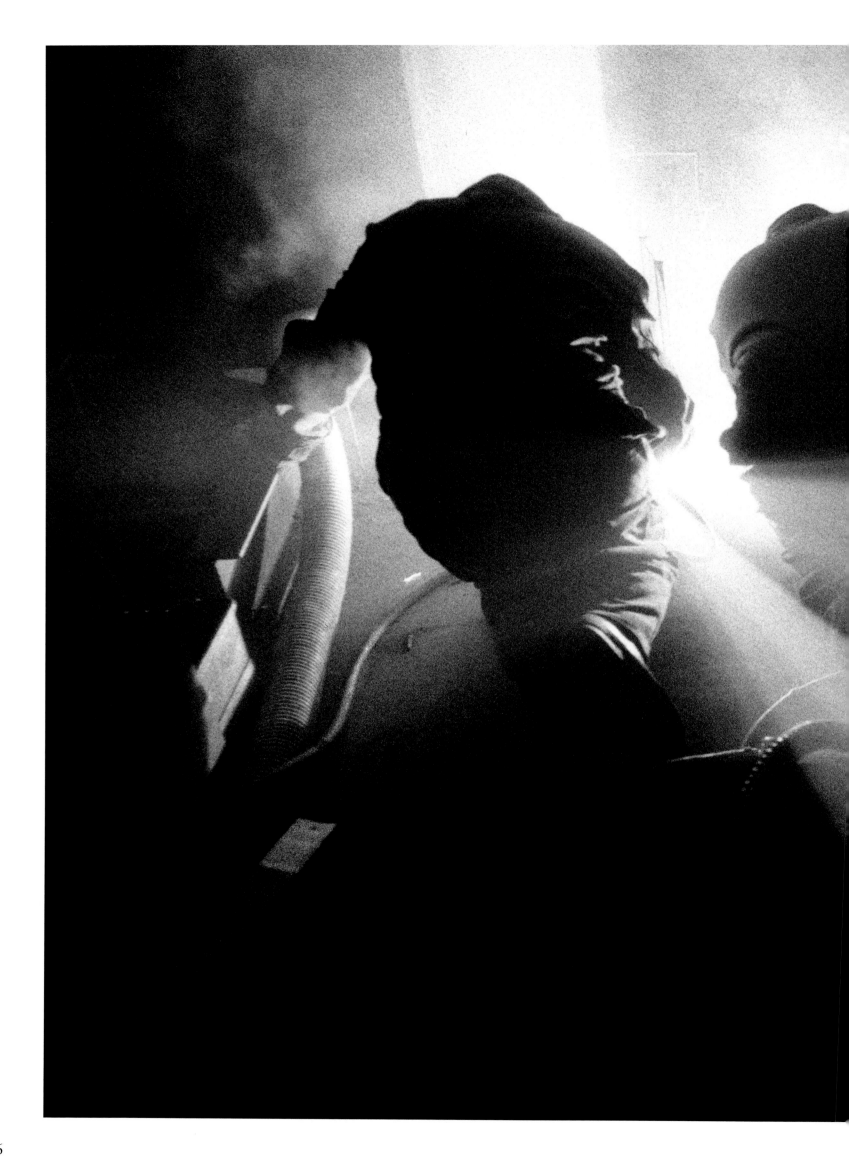

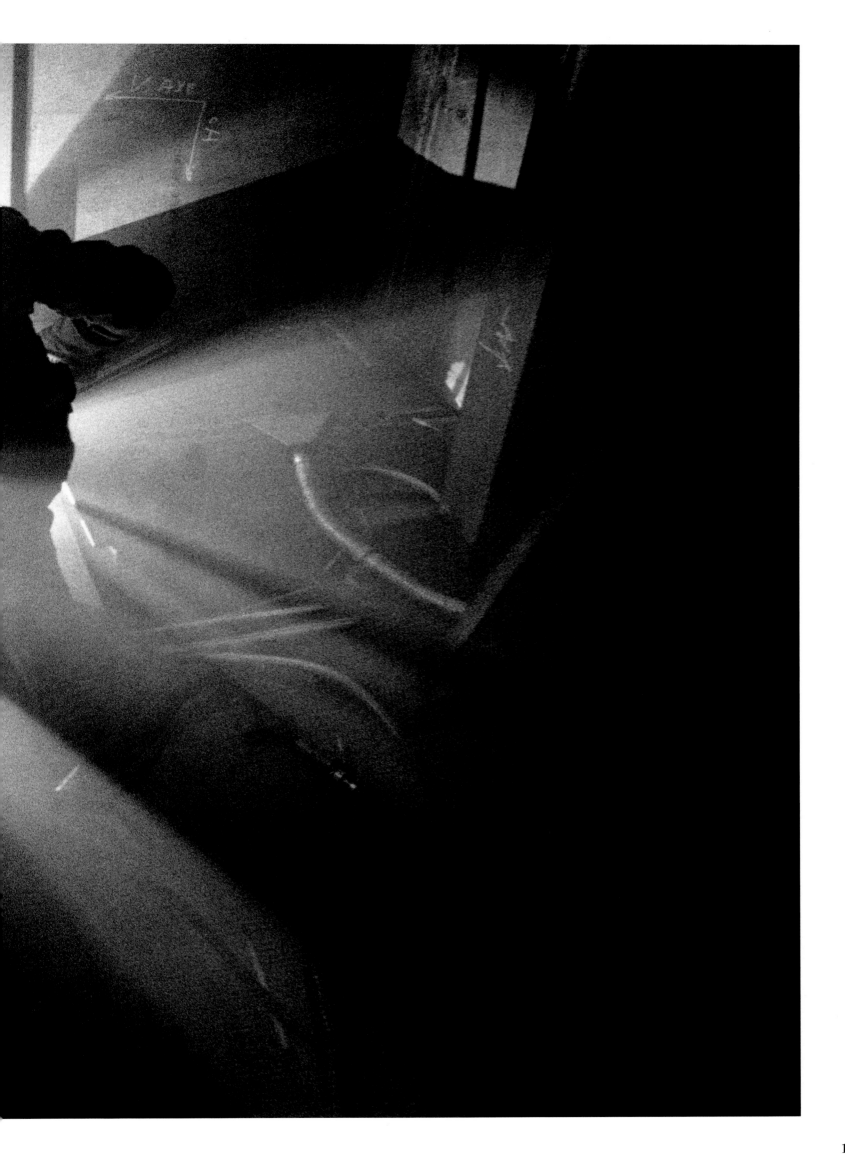

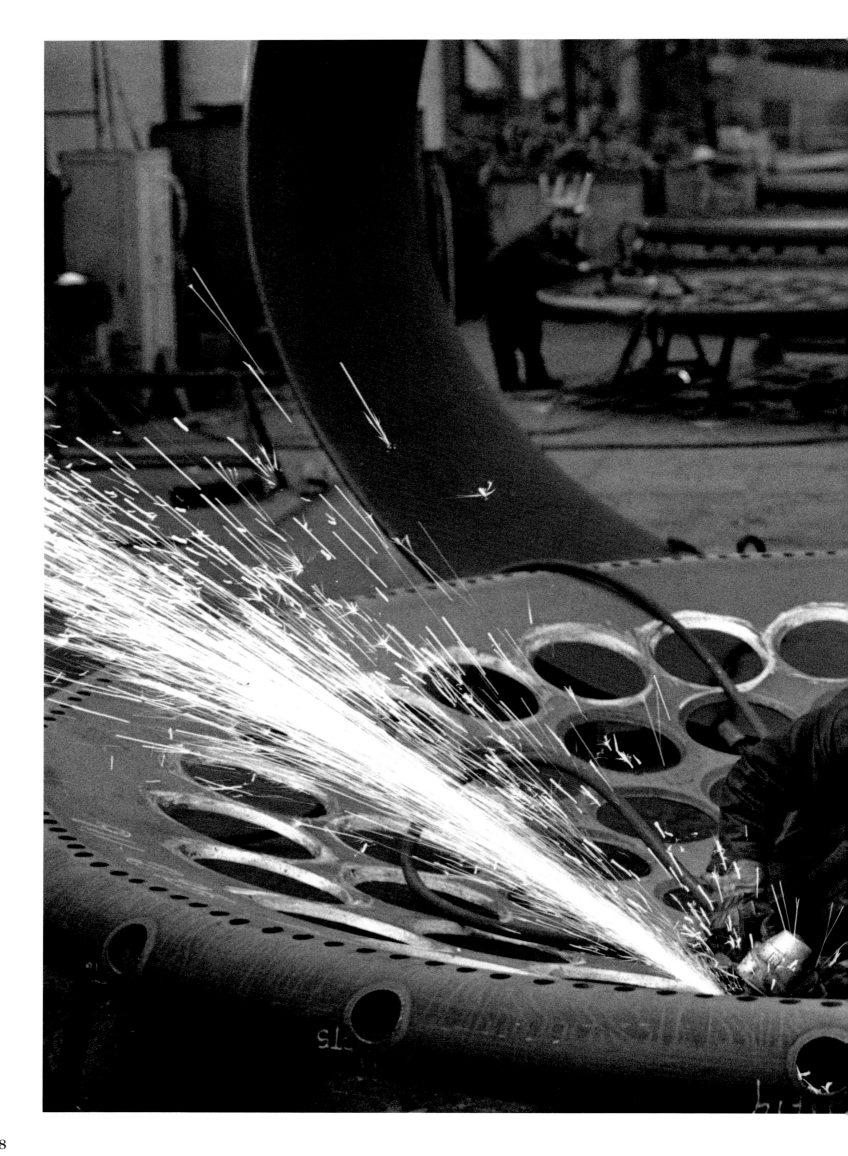

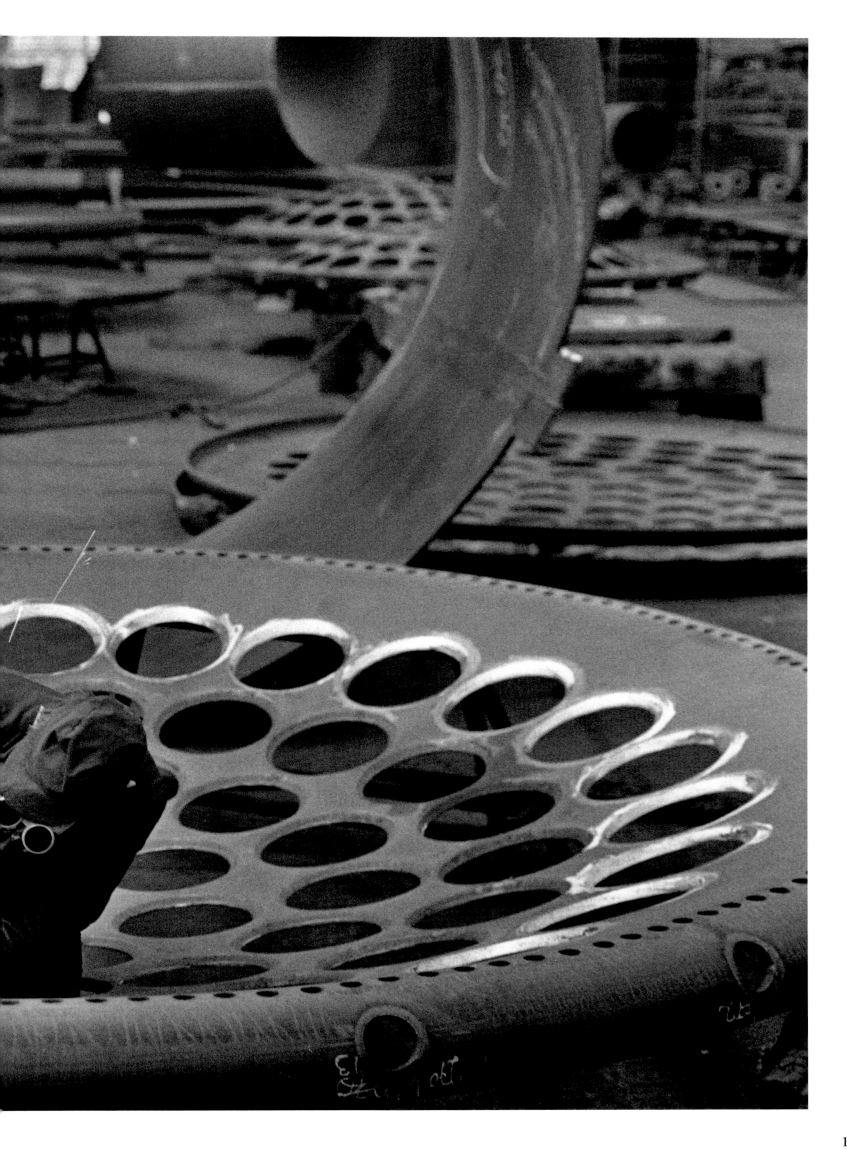

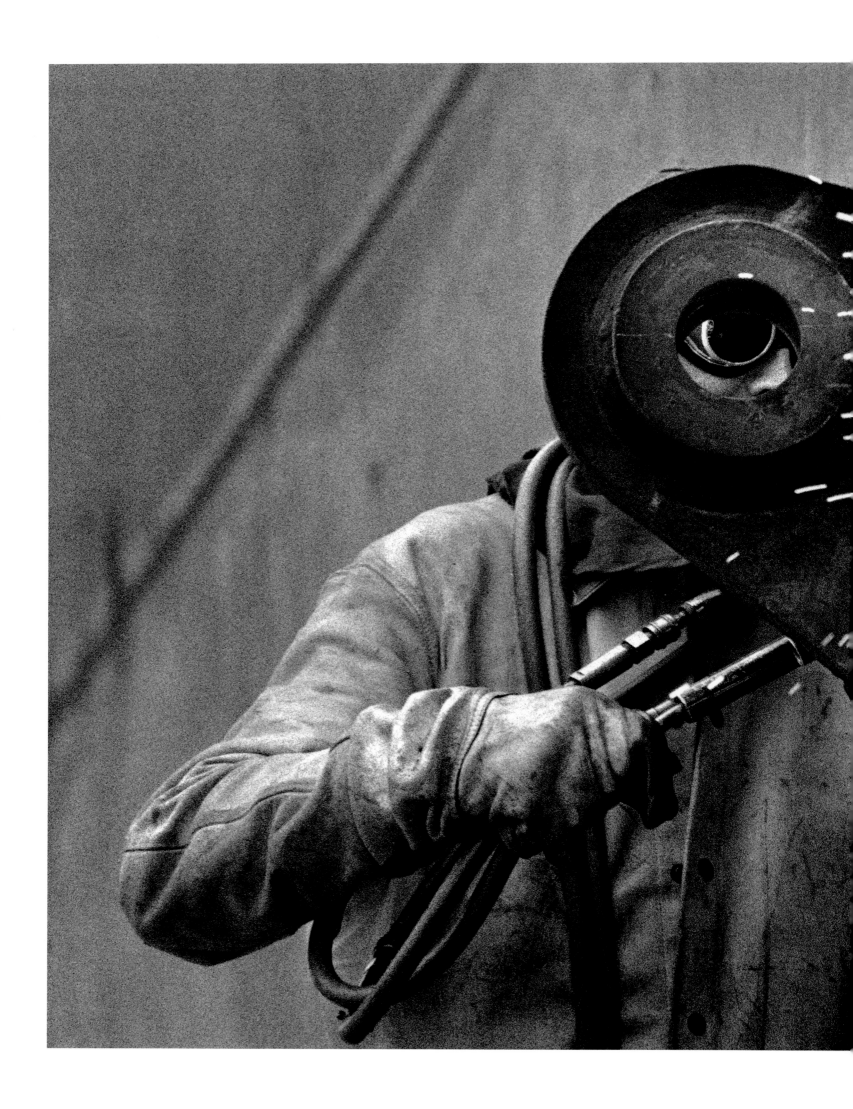

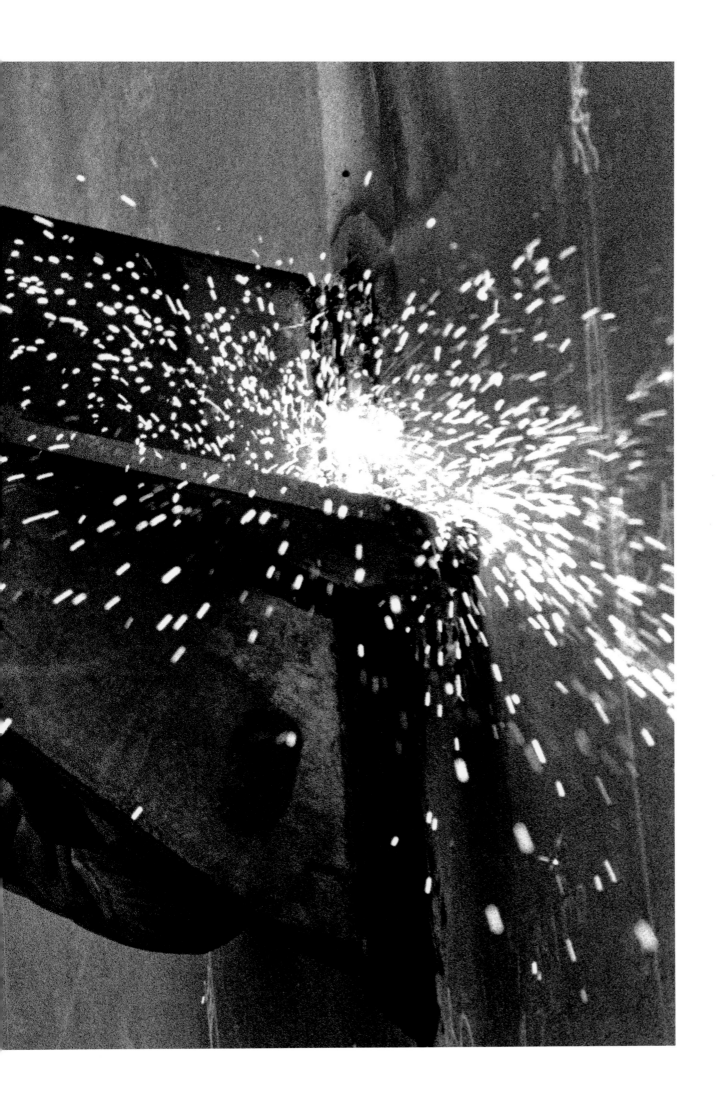

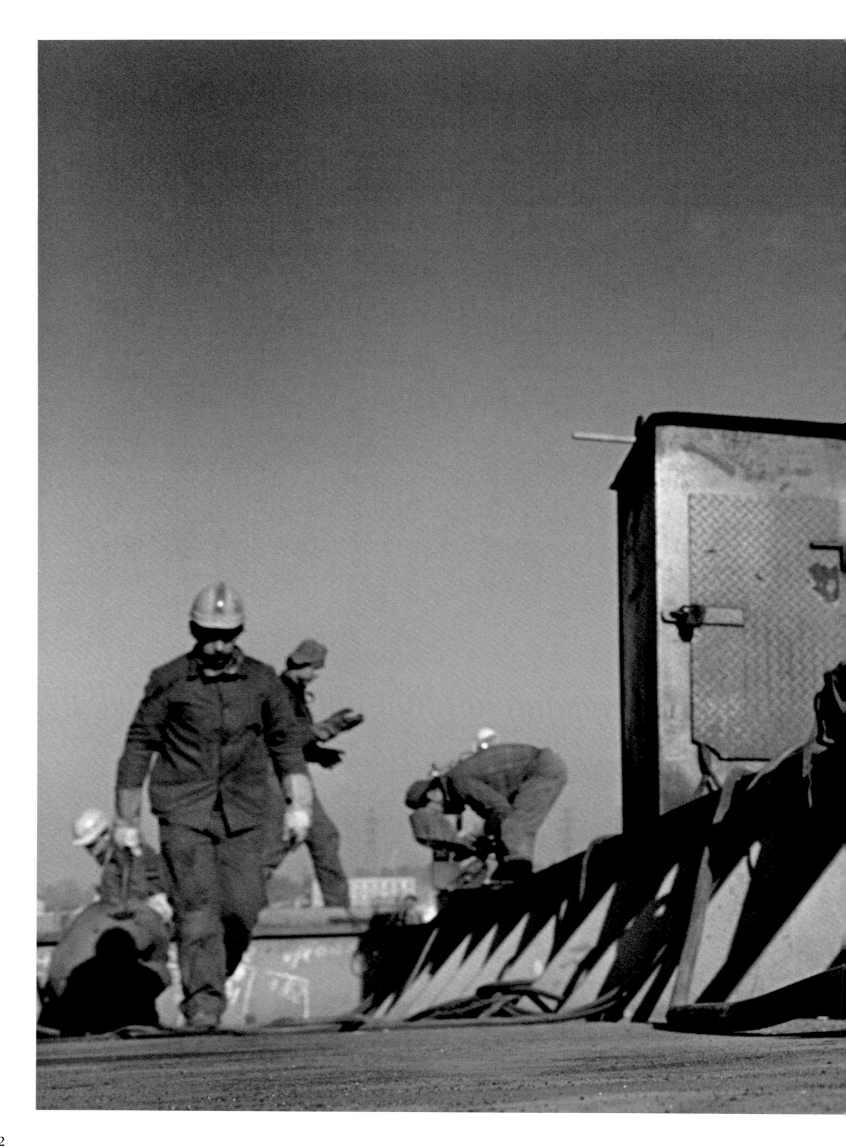

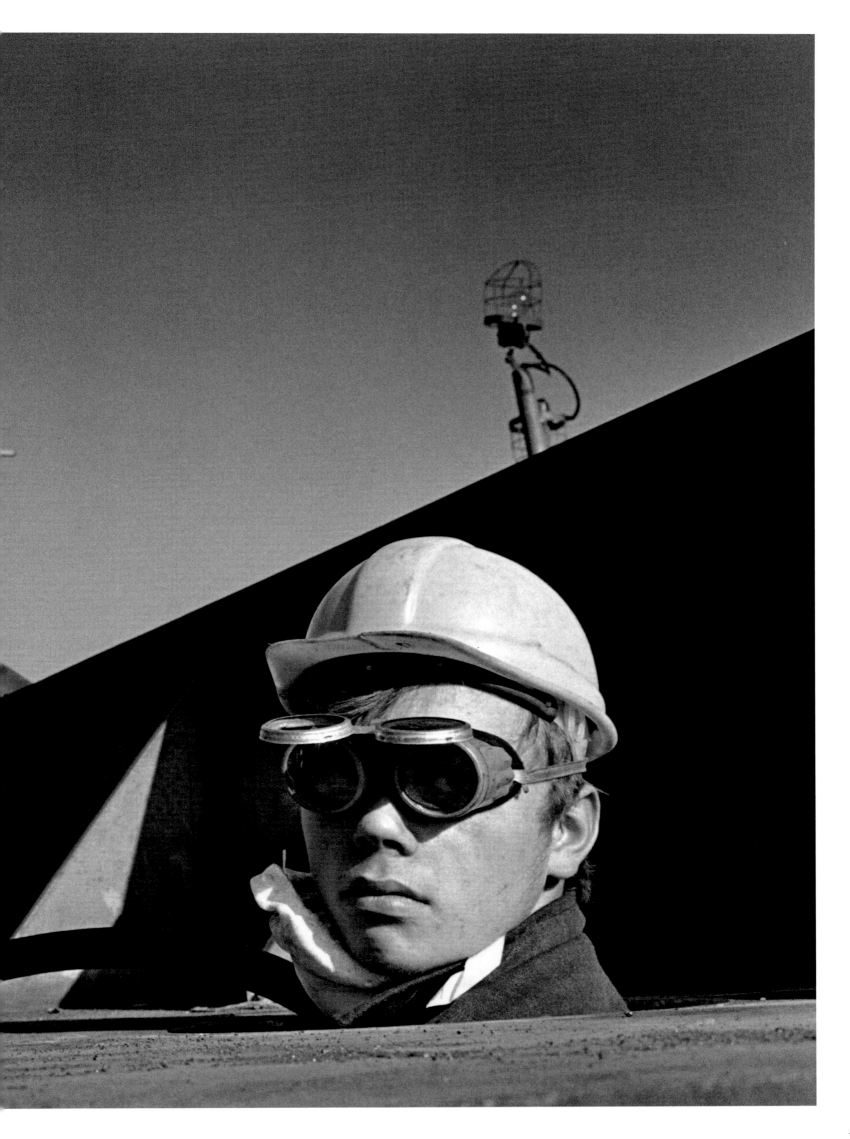

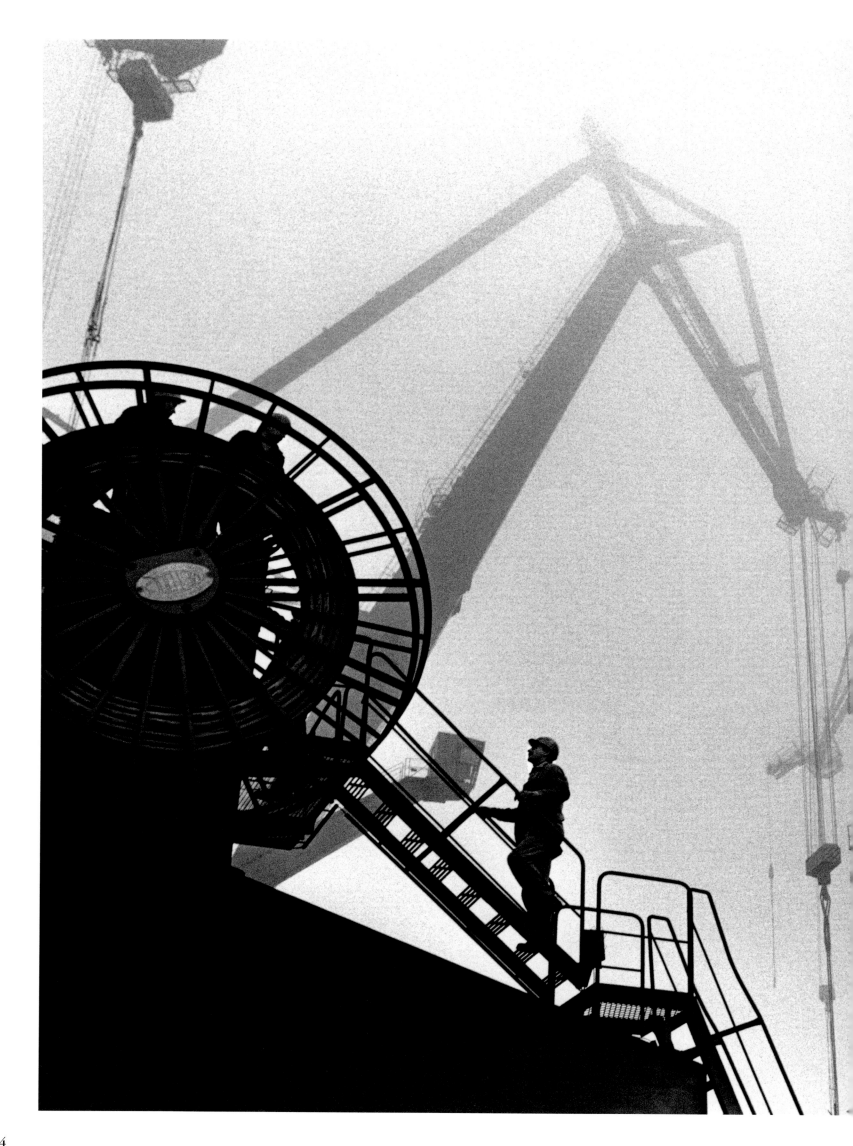

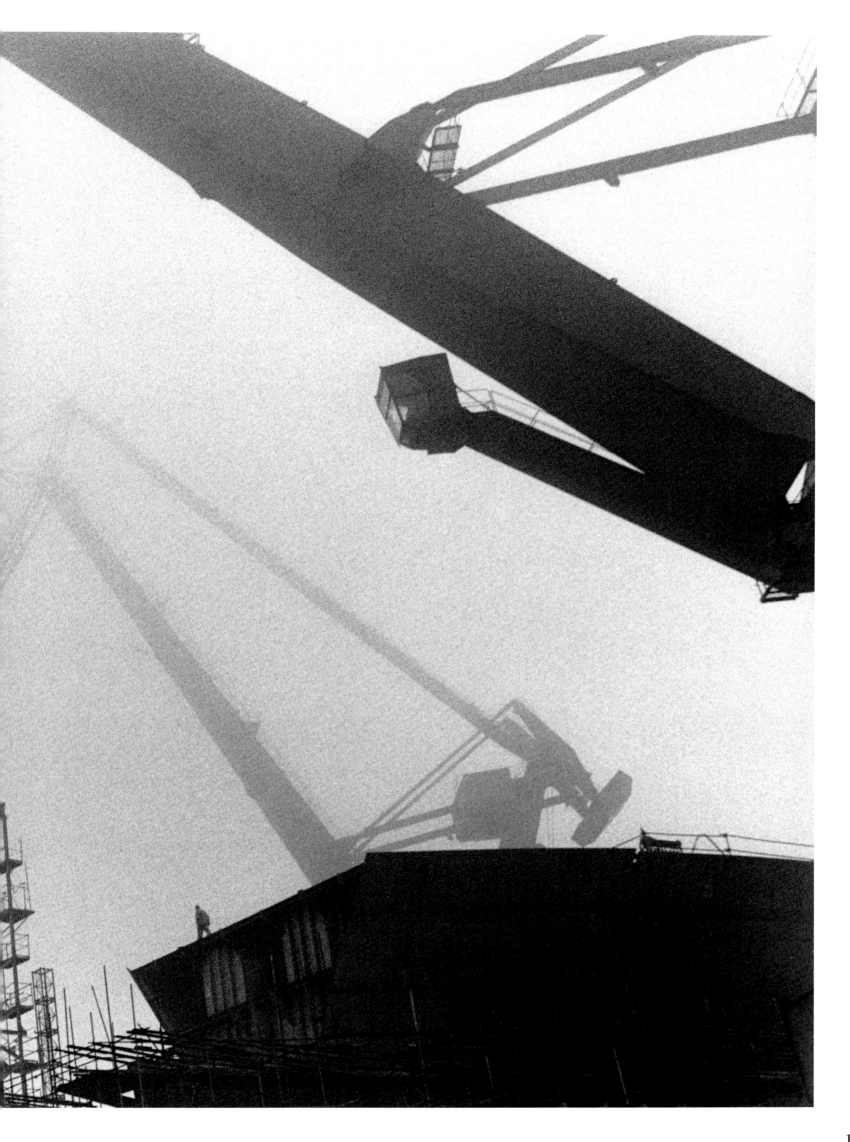

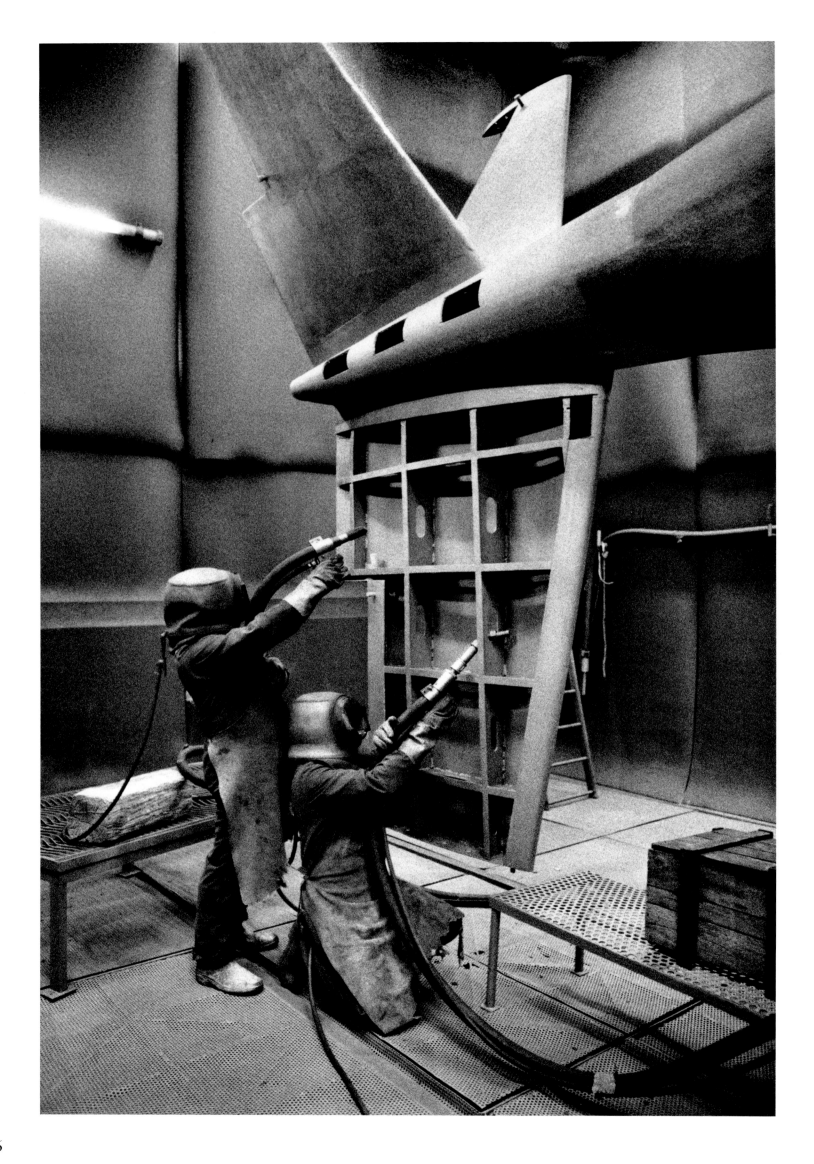

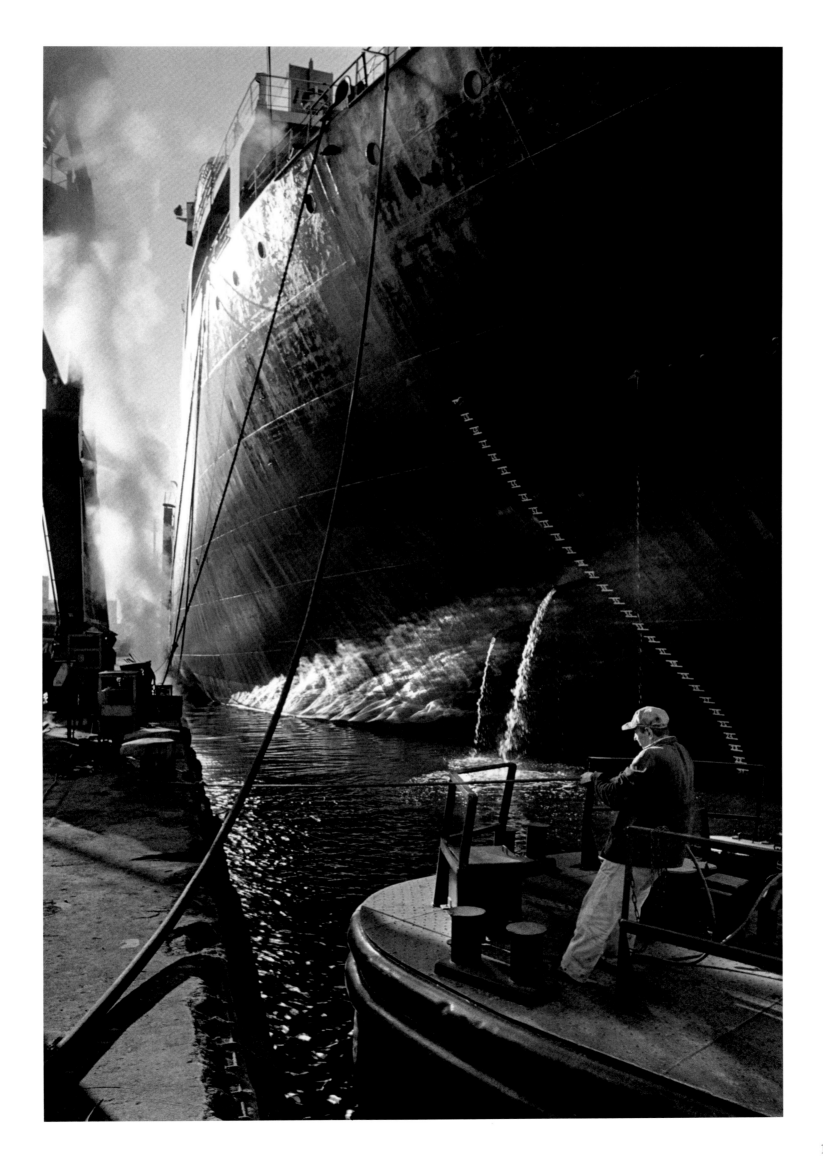

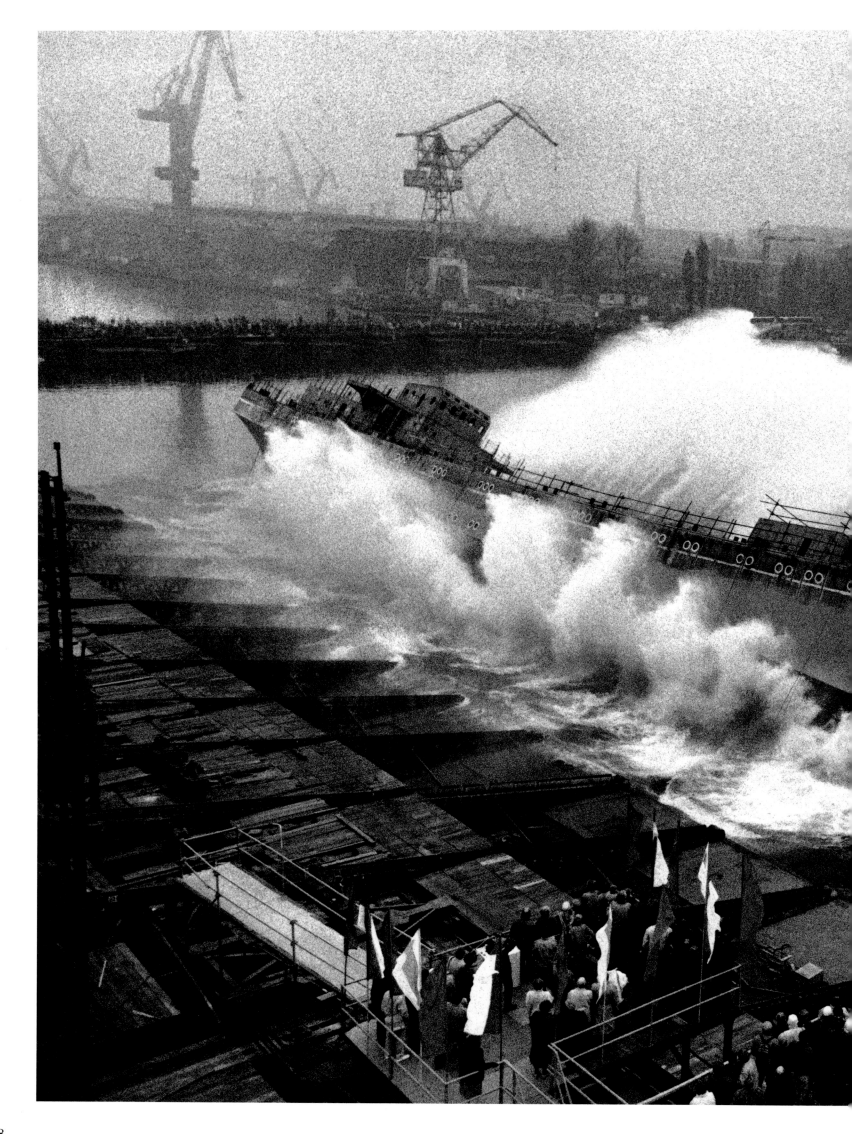

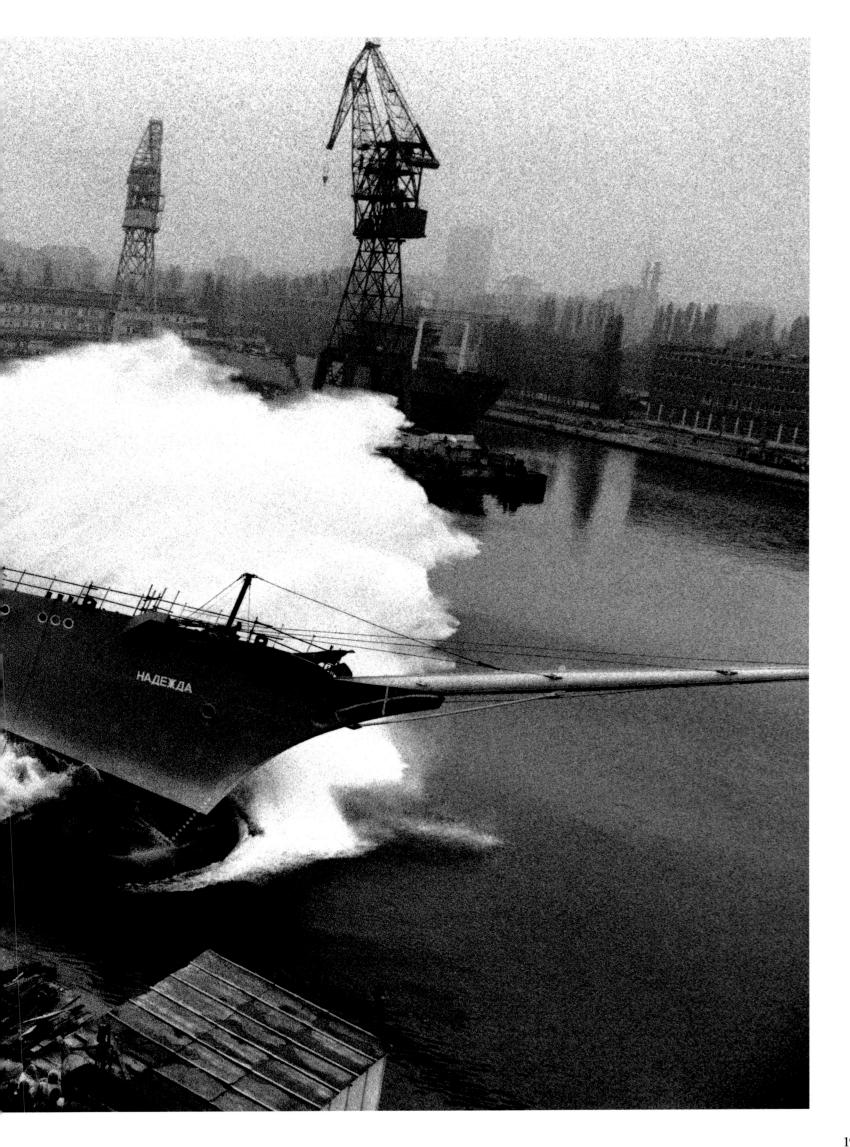

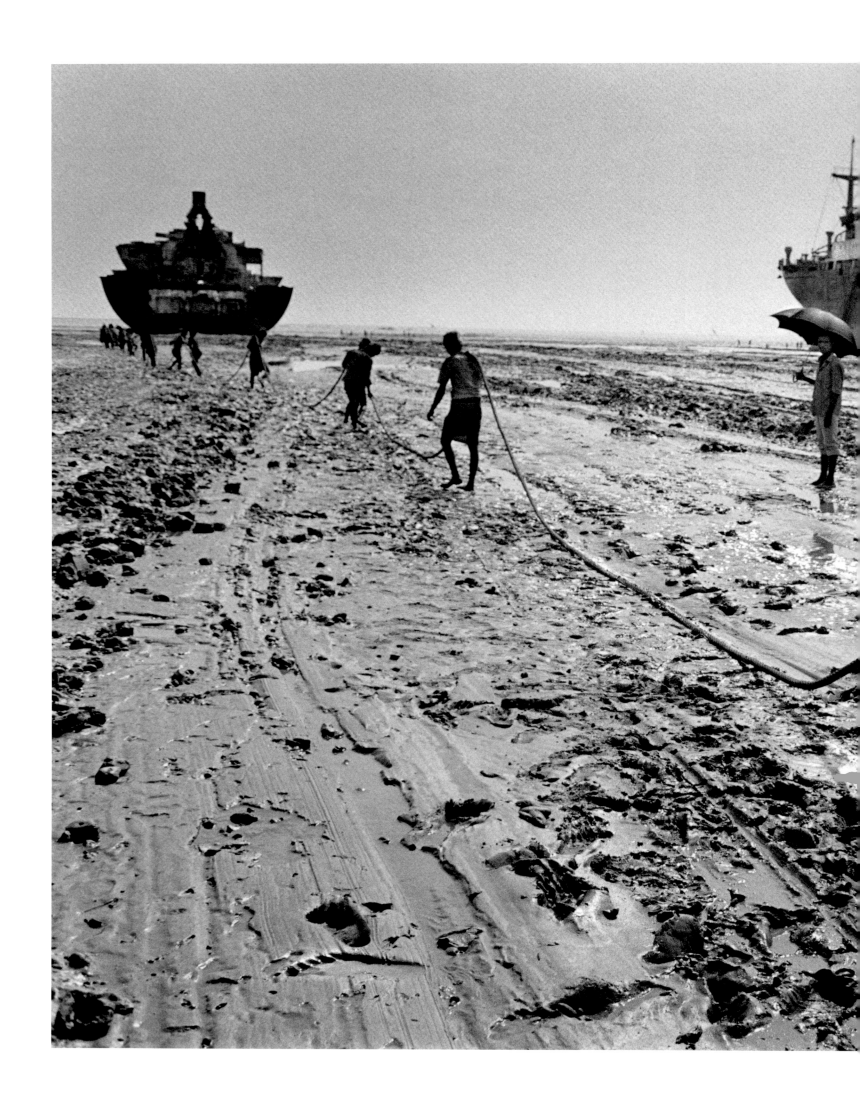

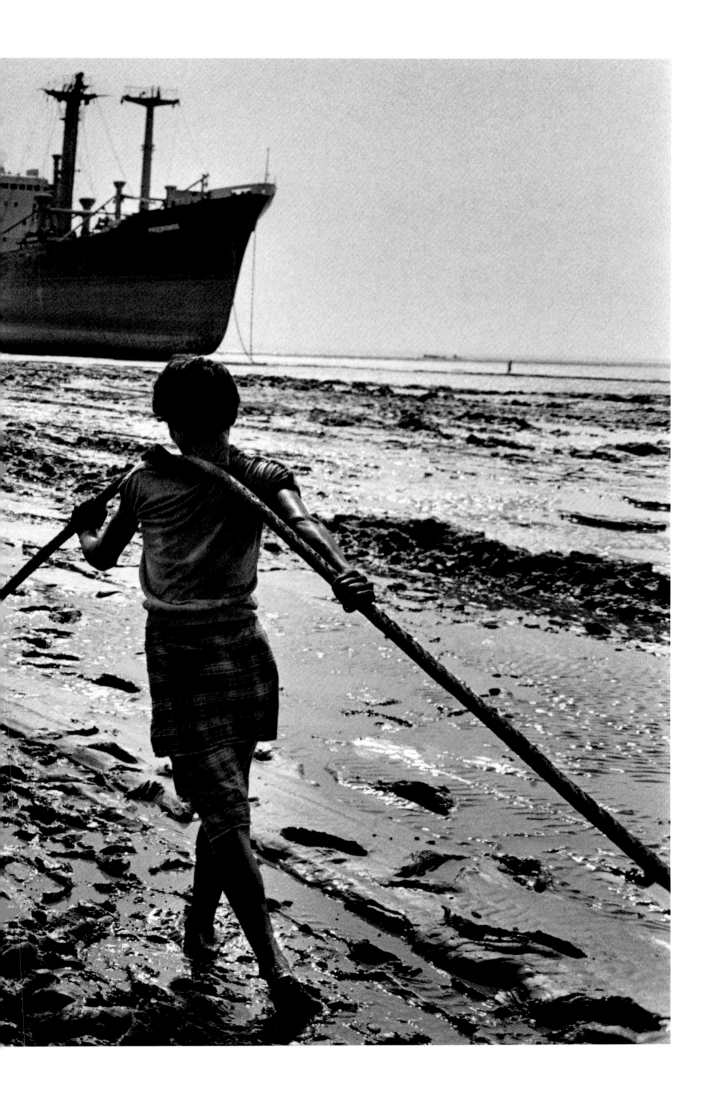

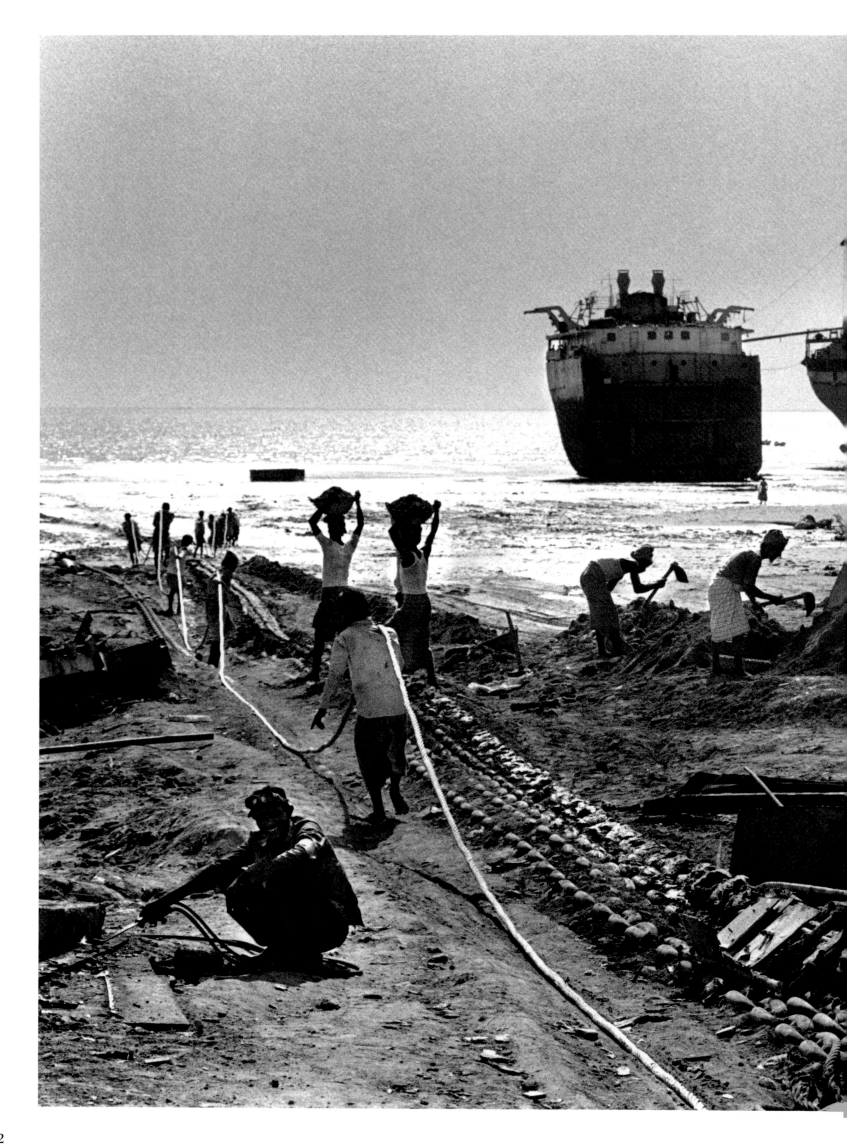

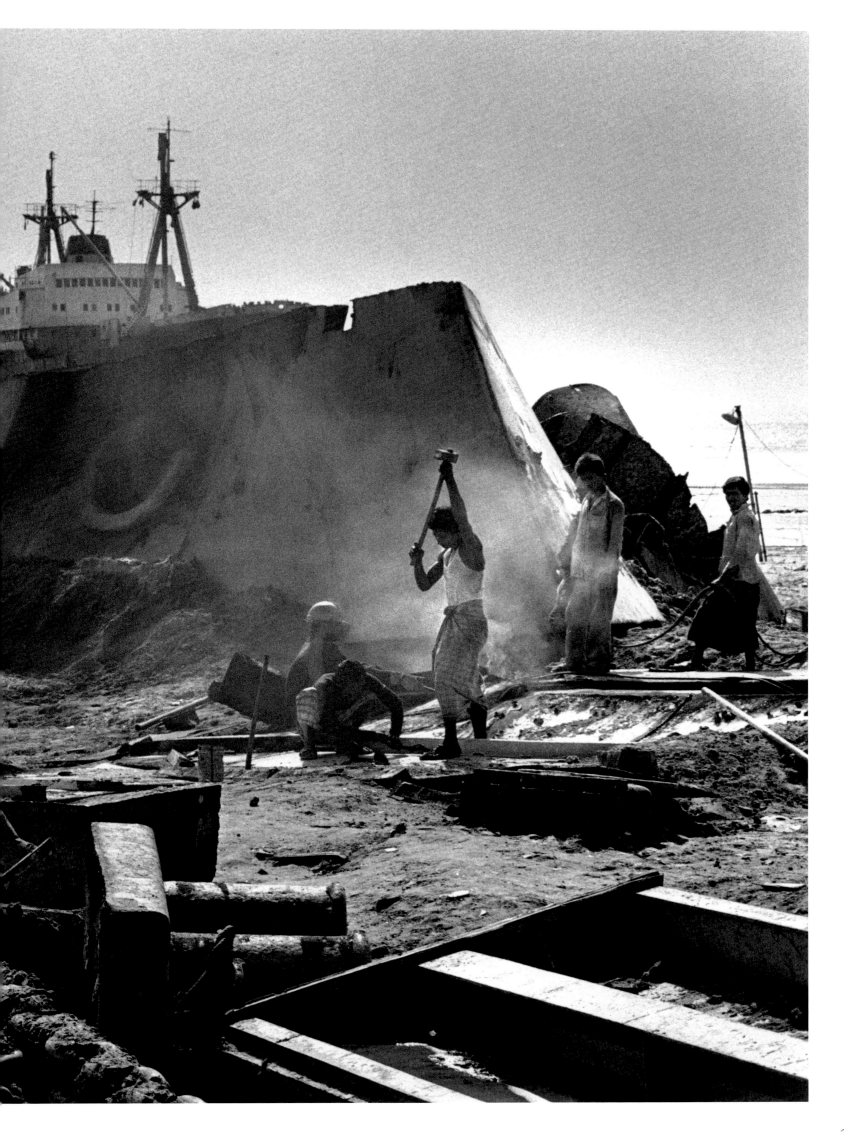

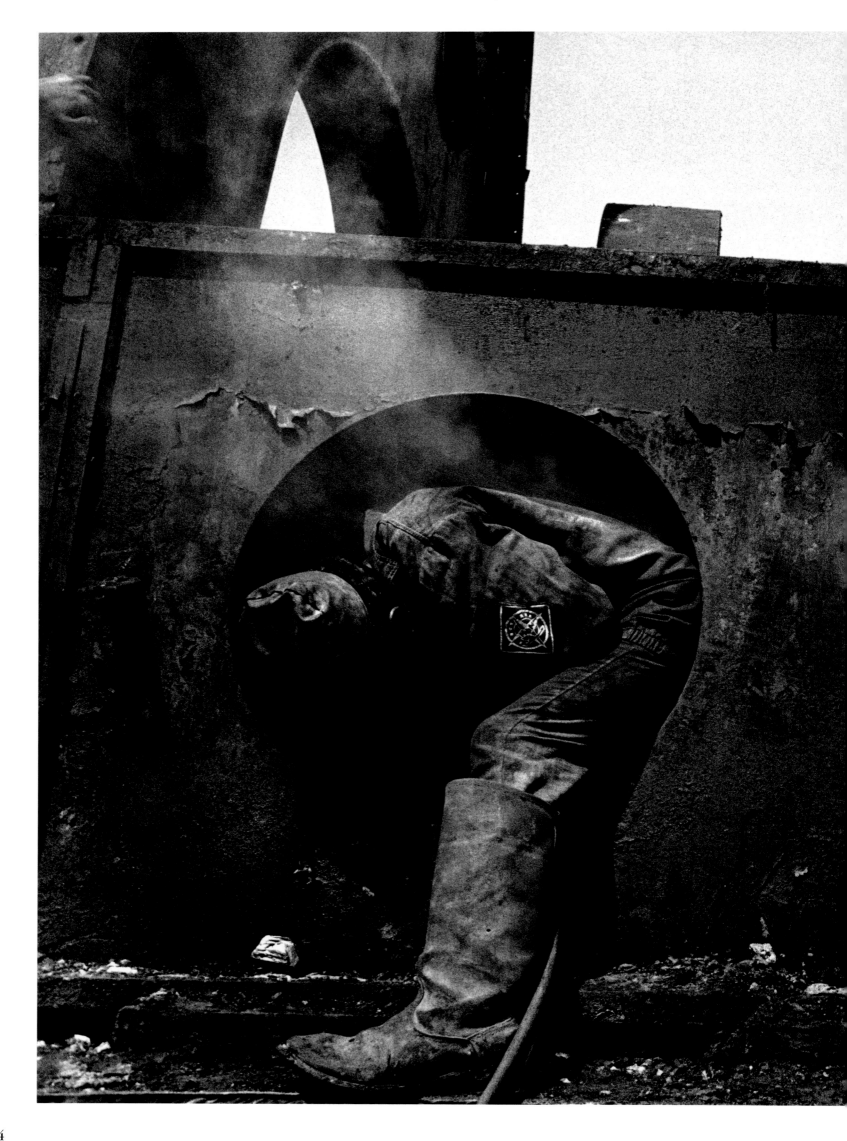

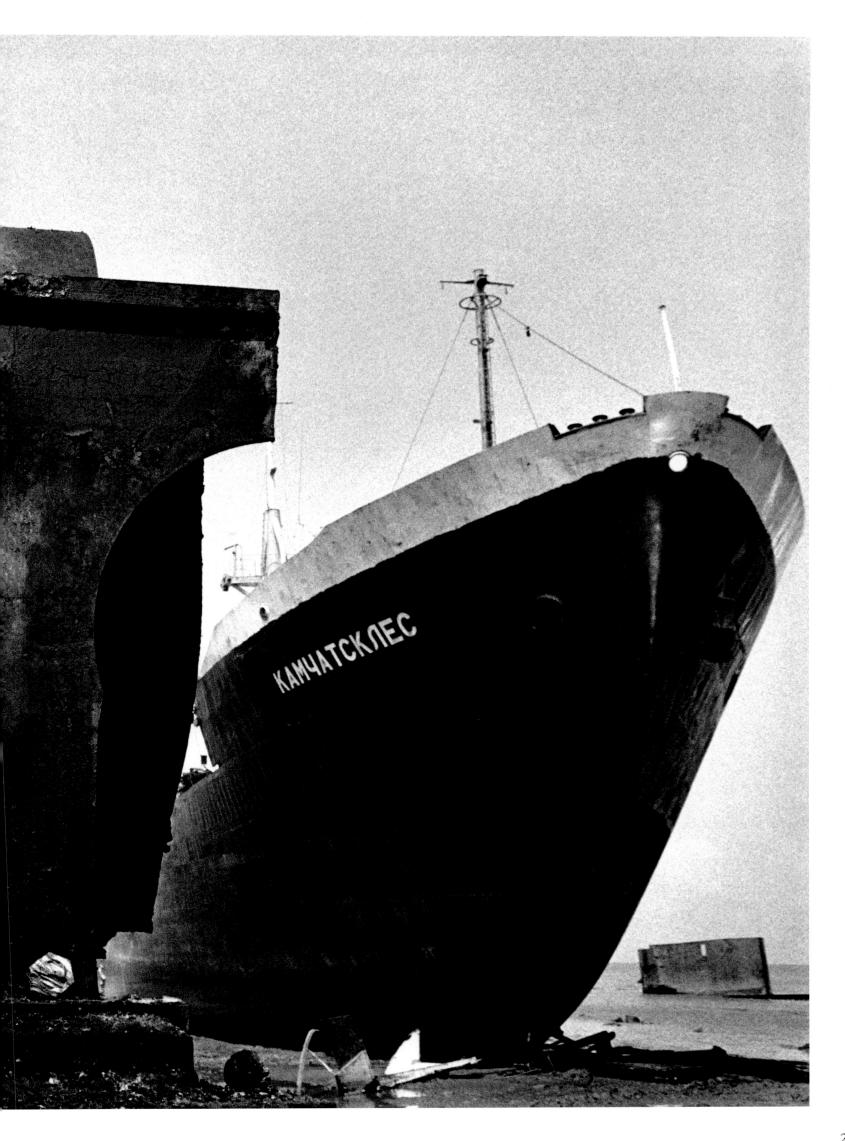

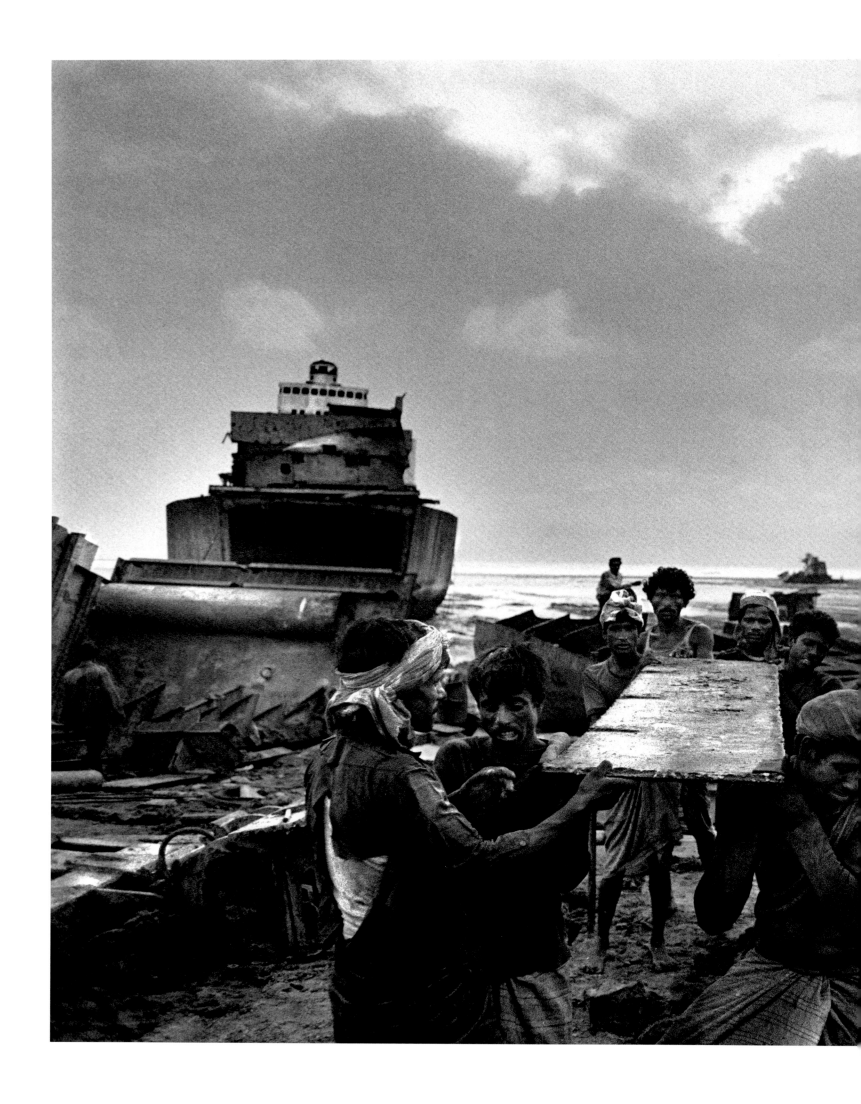

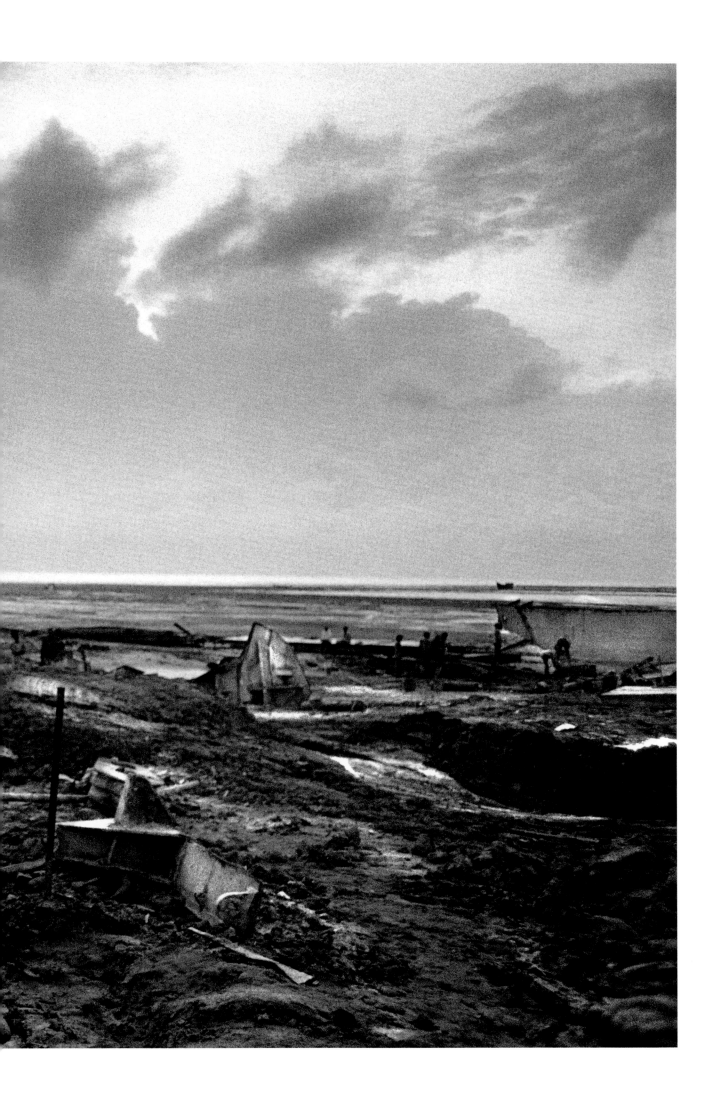

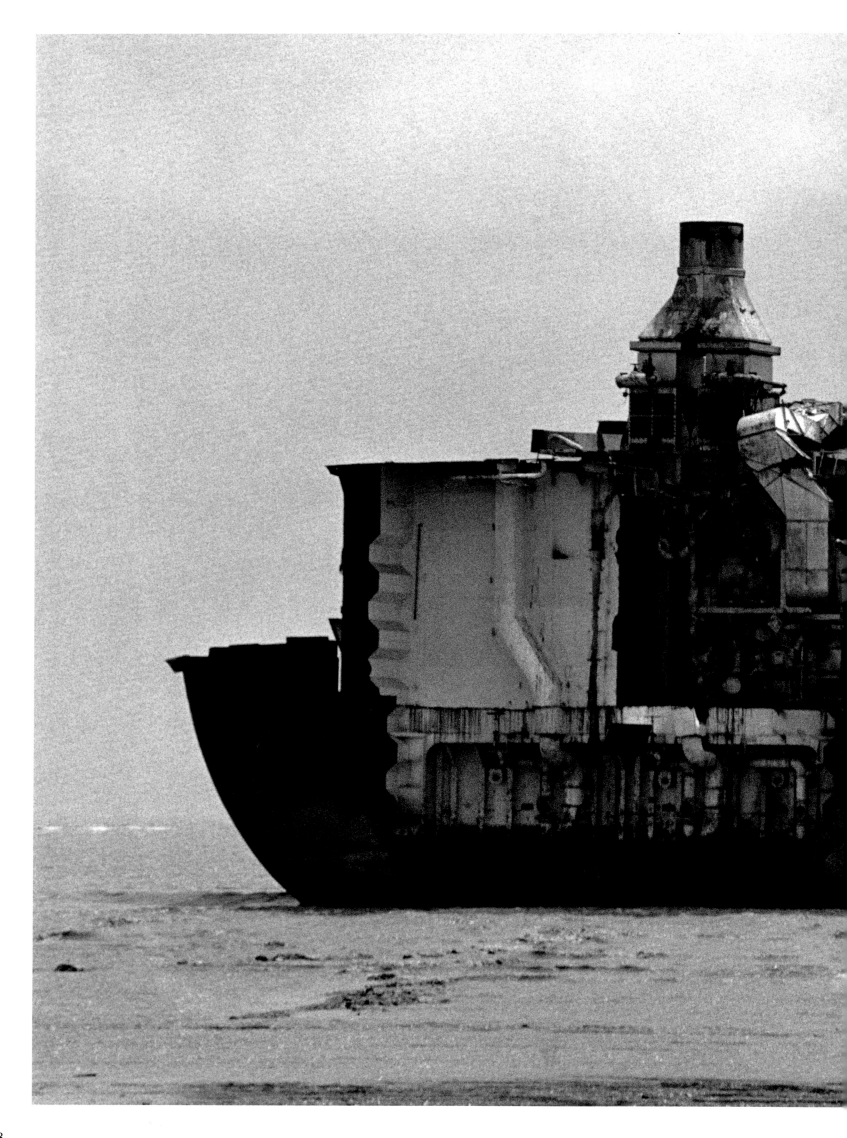

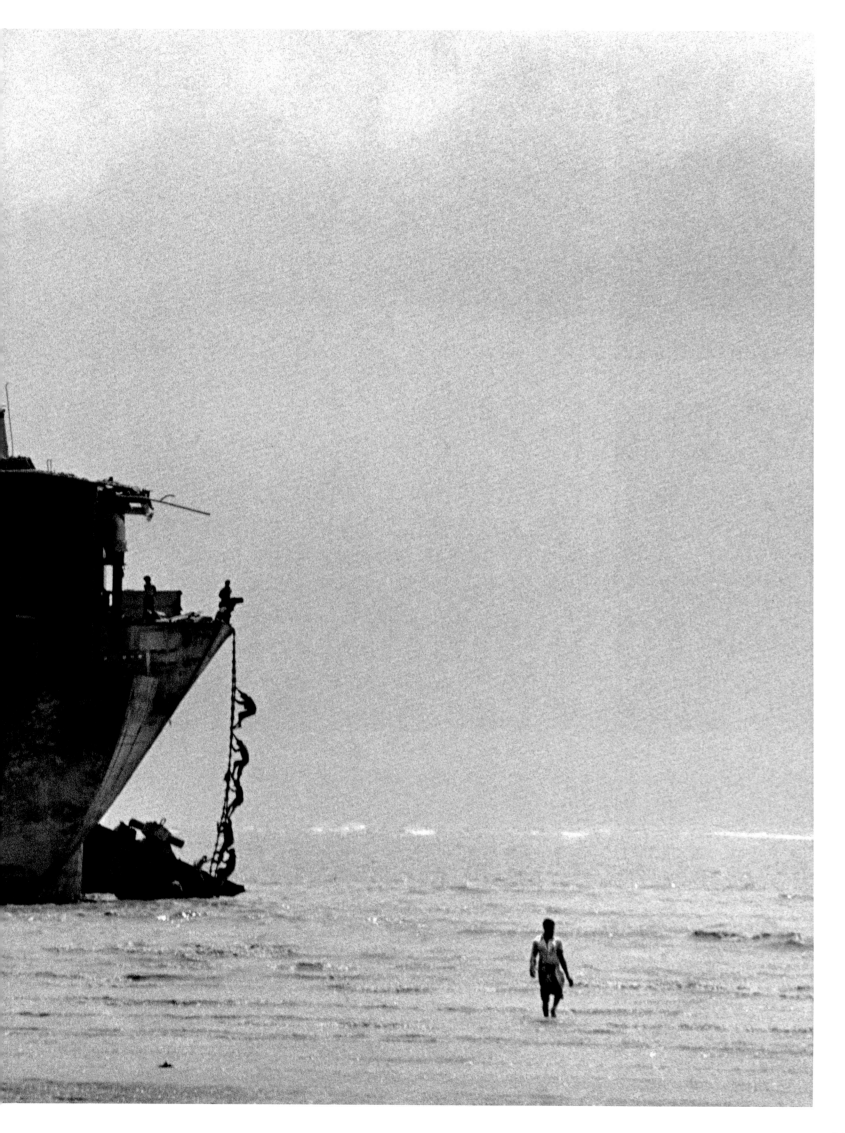

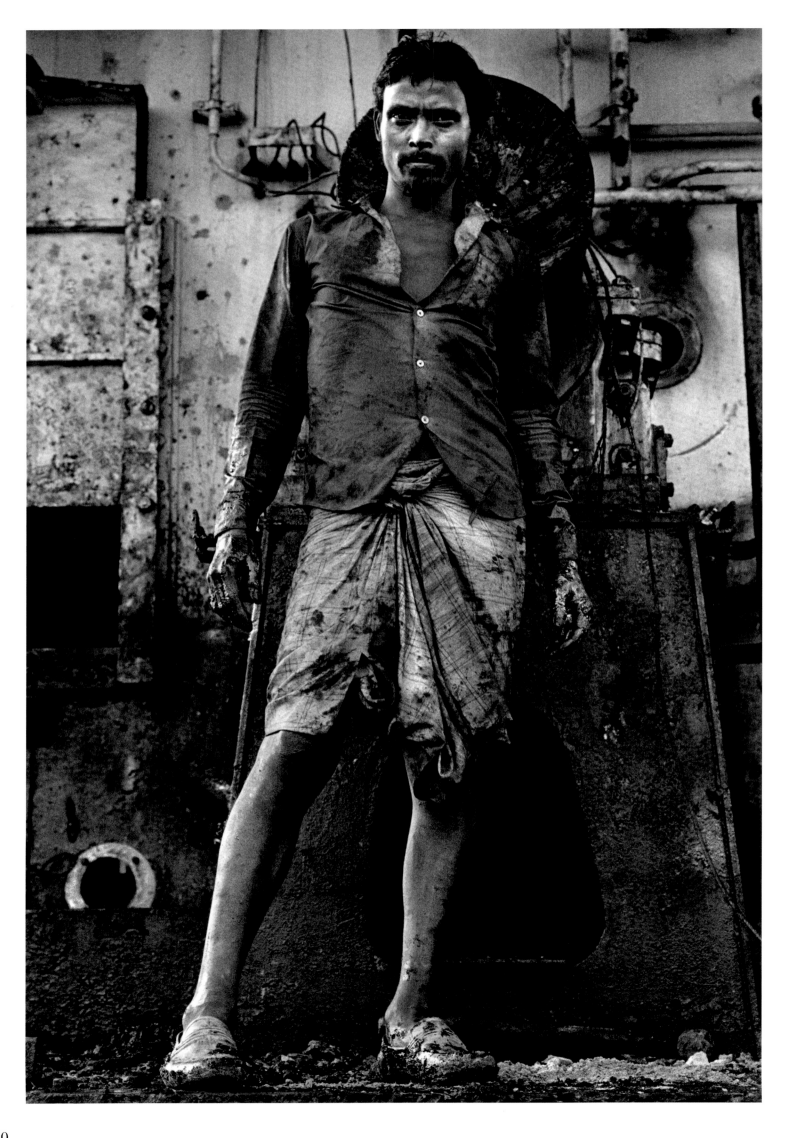

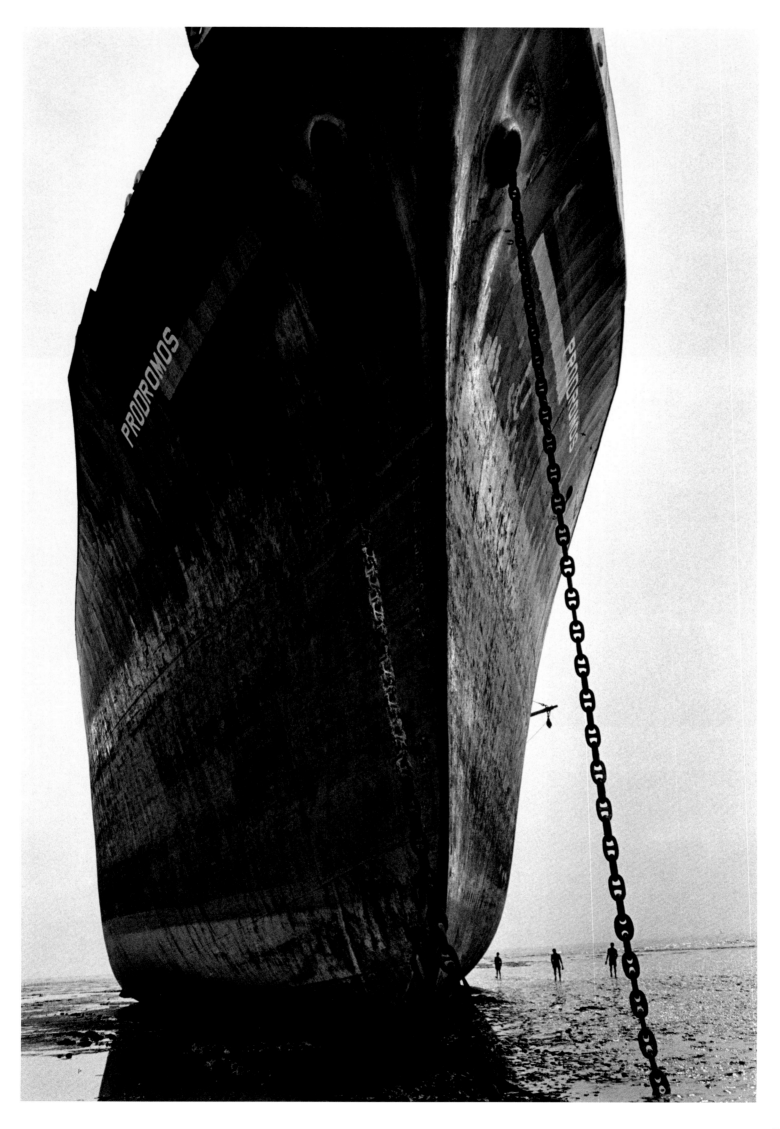

215

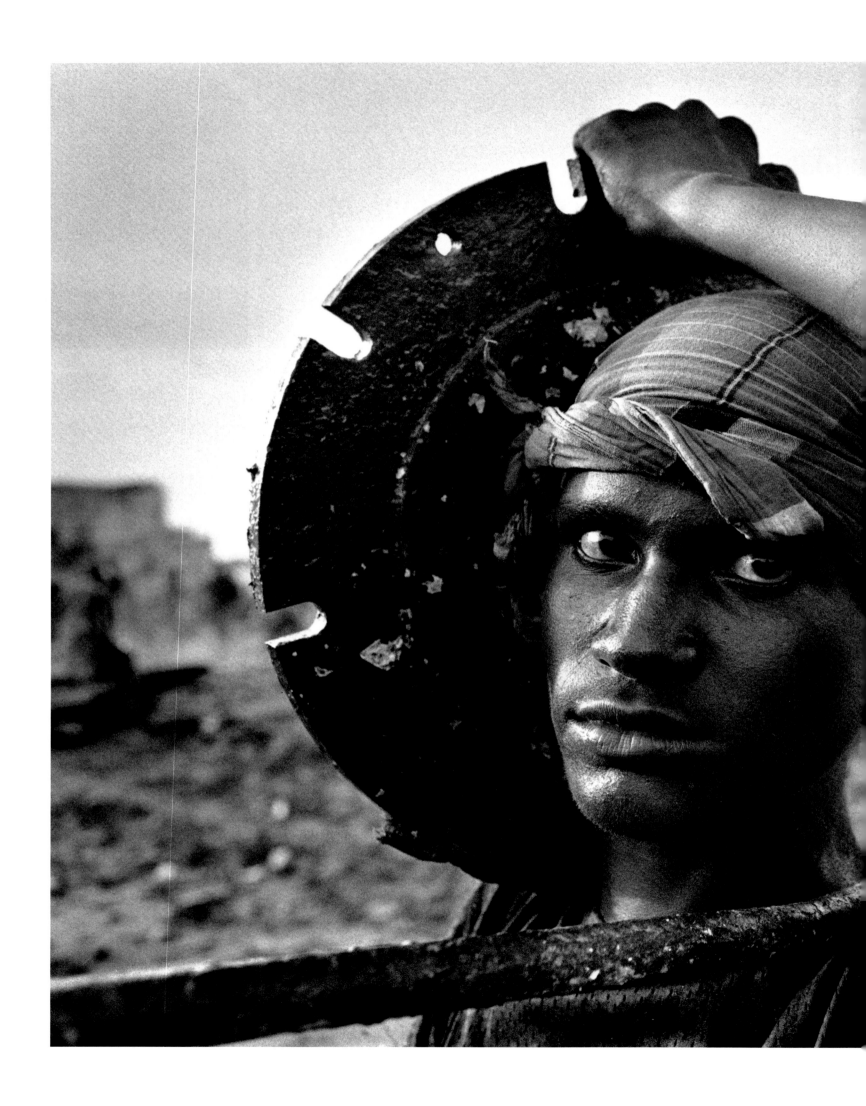

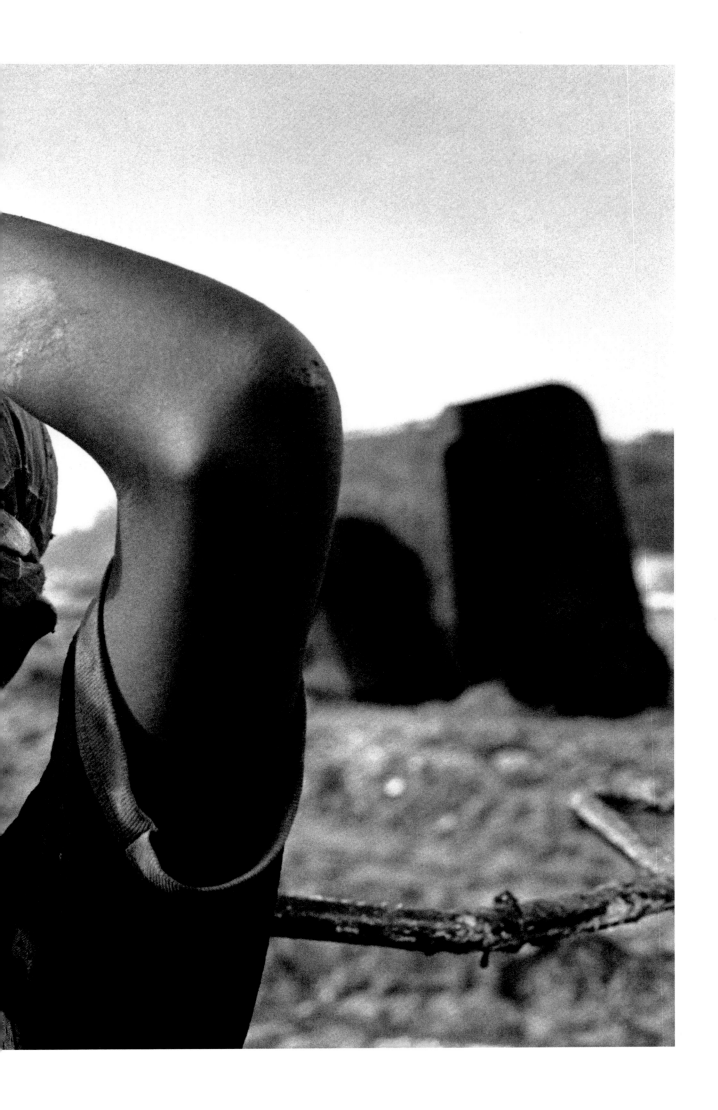

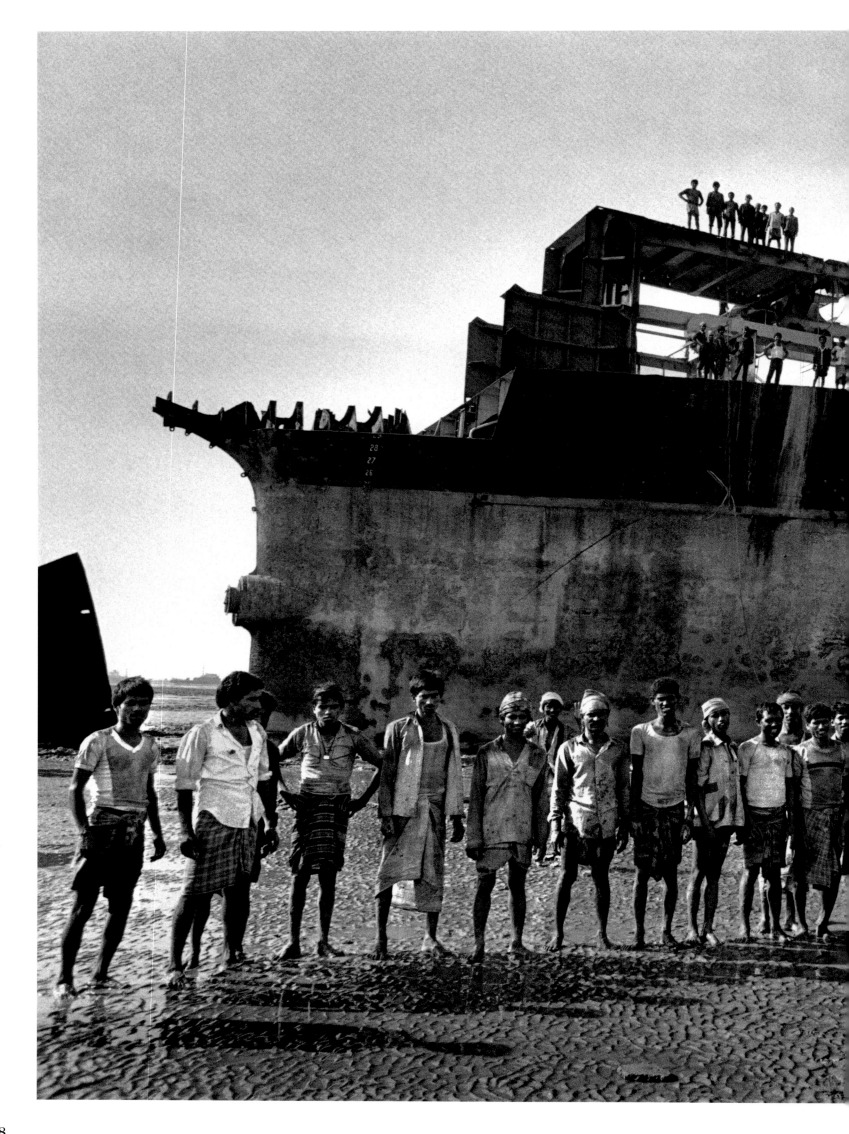

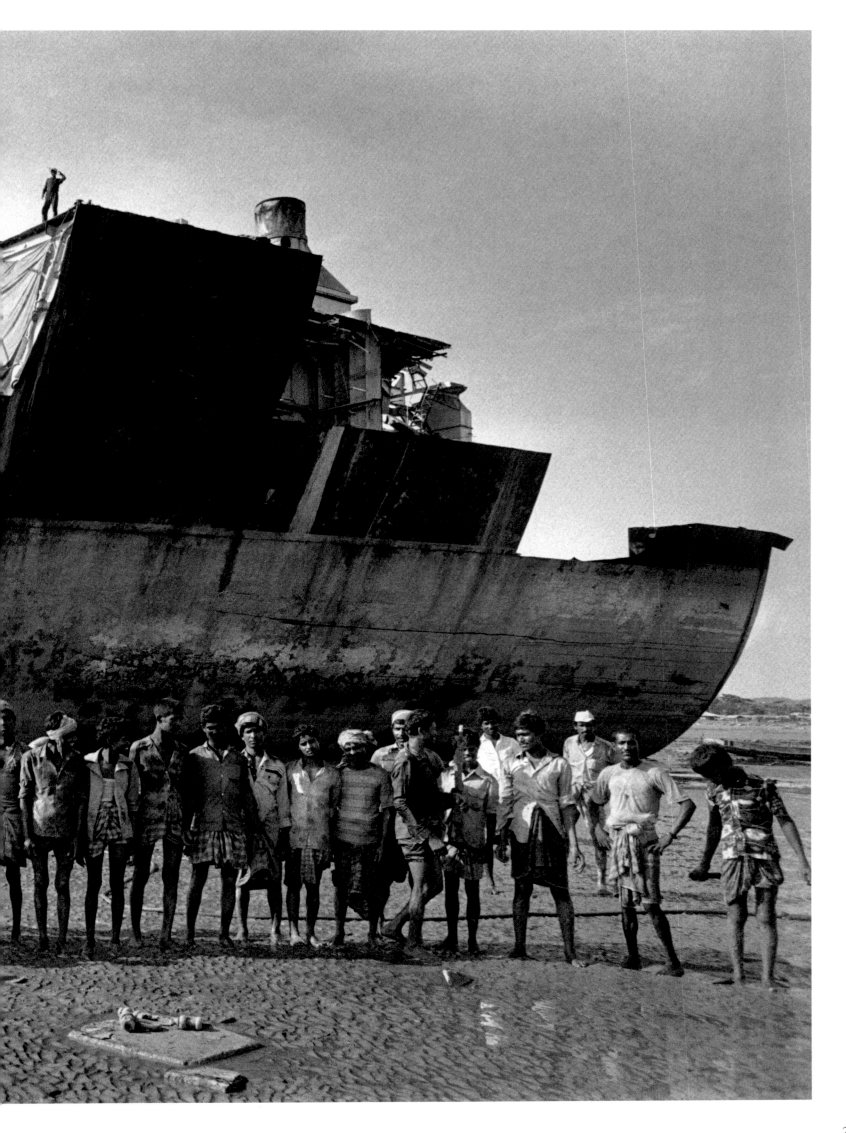

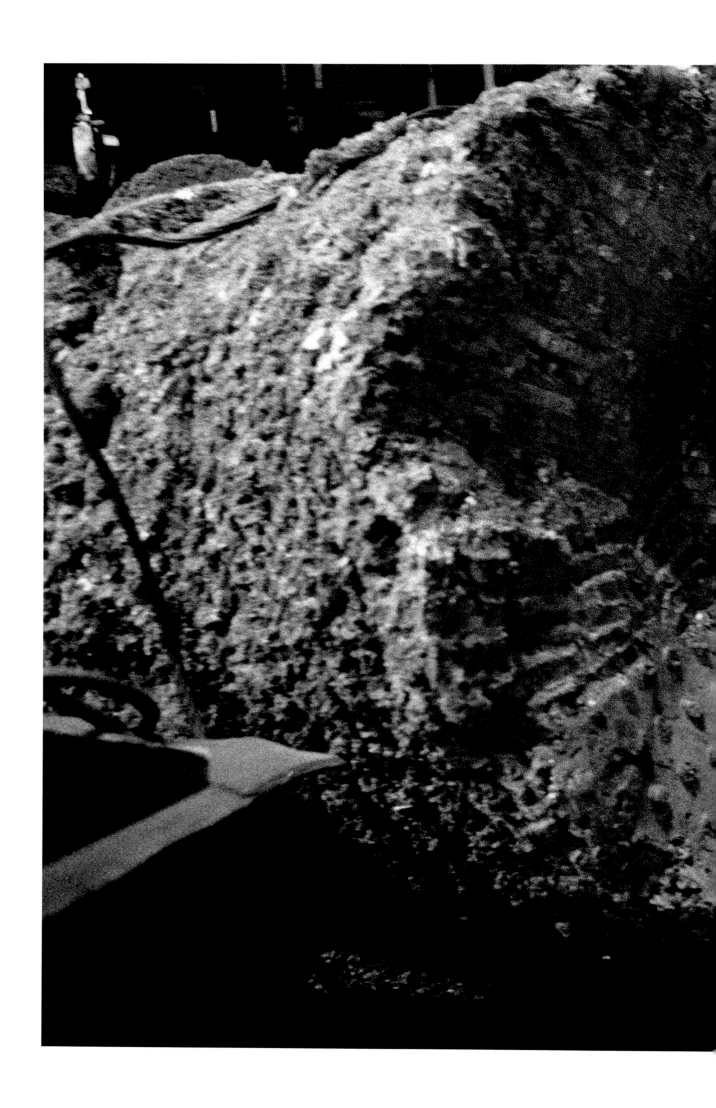

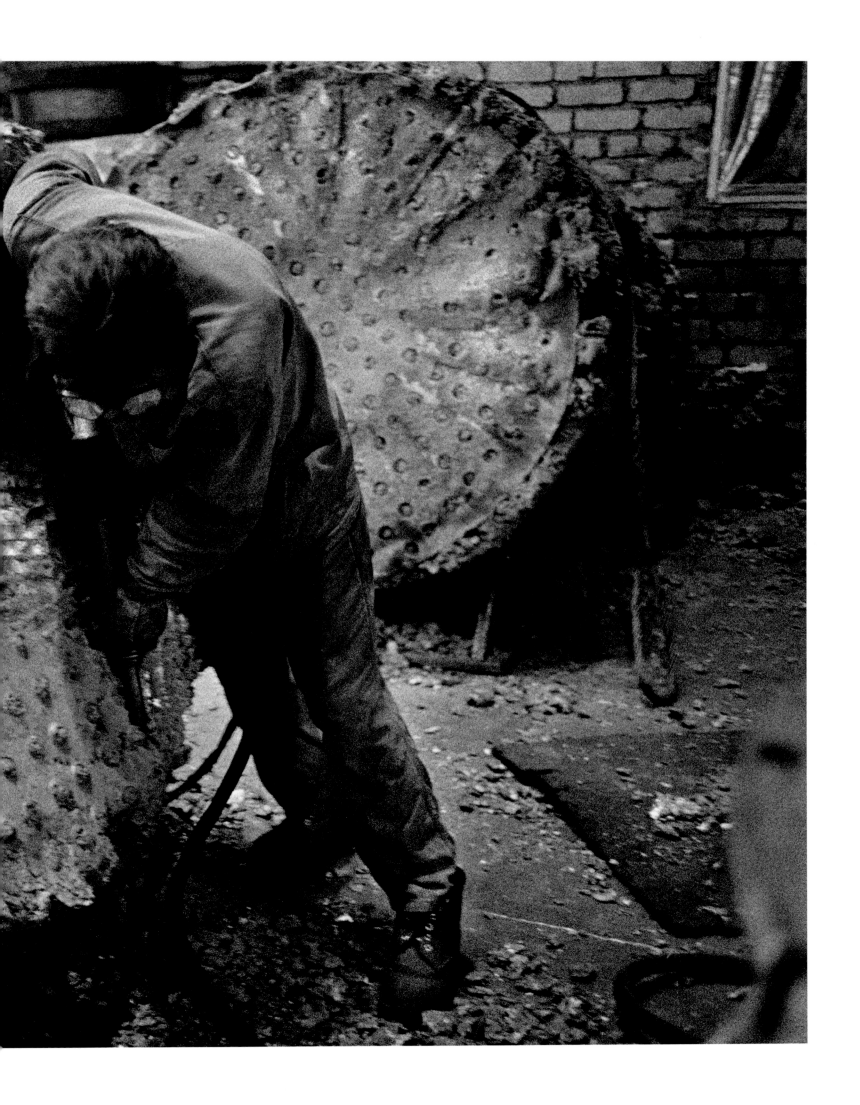

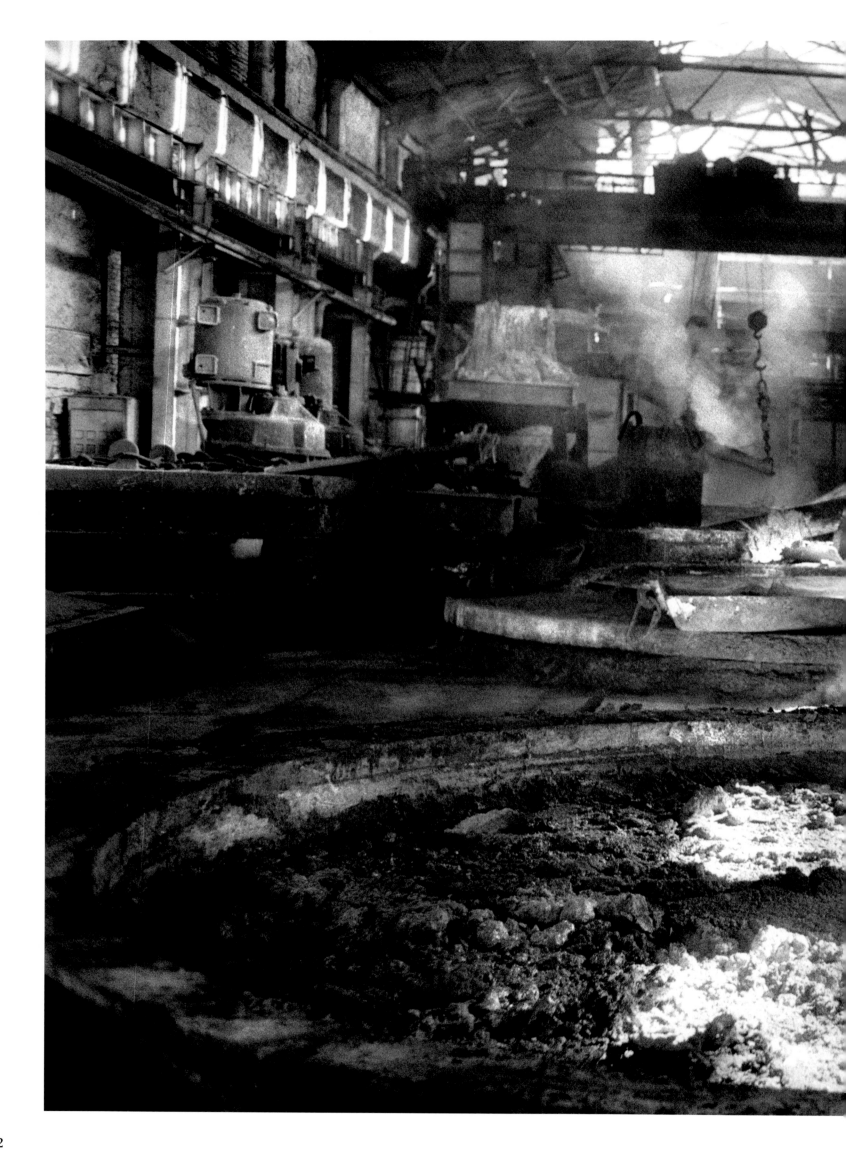

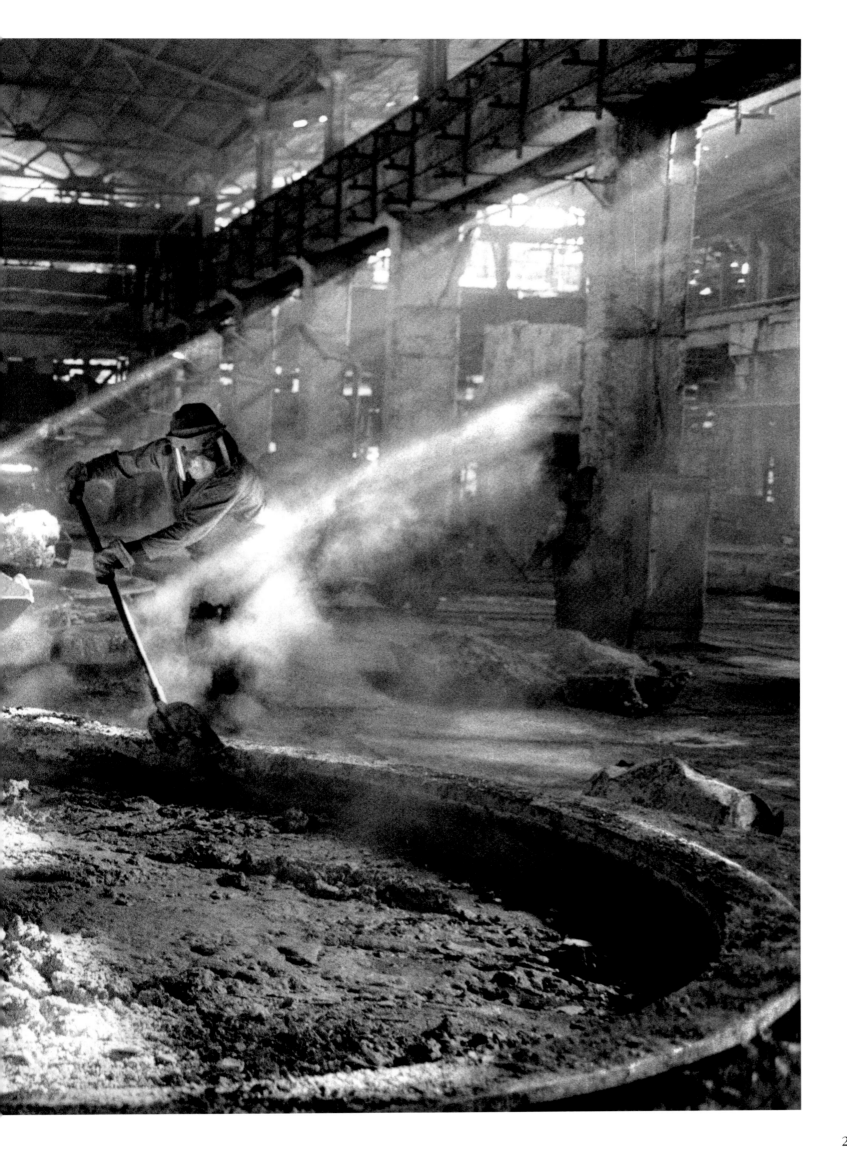

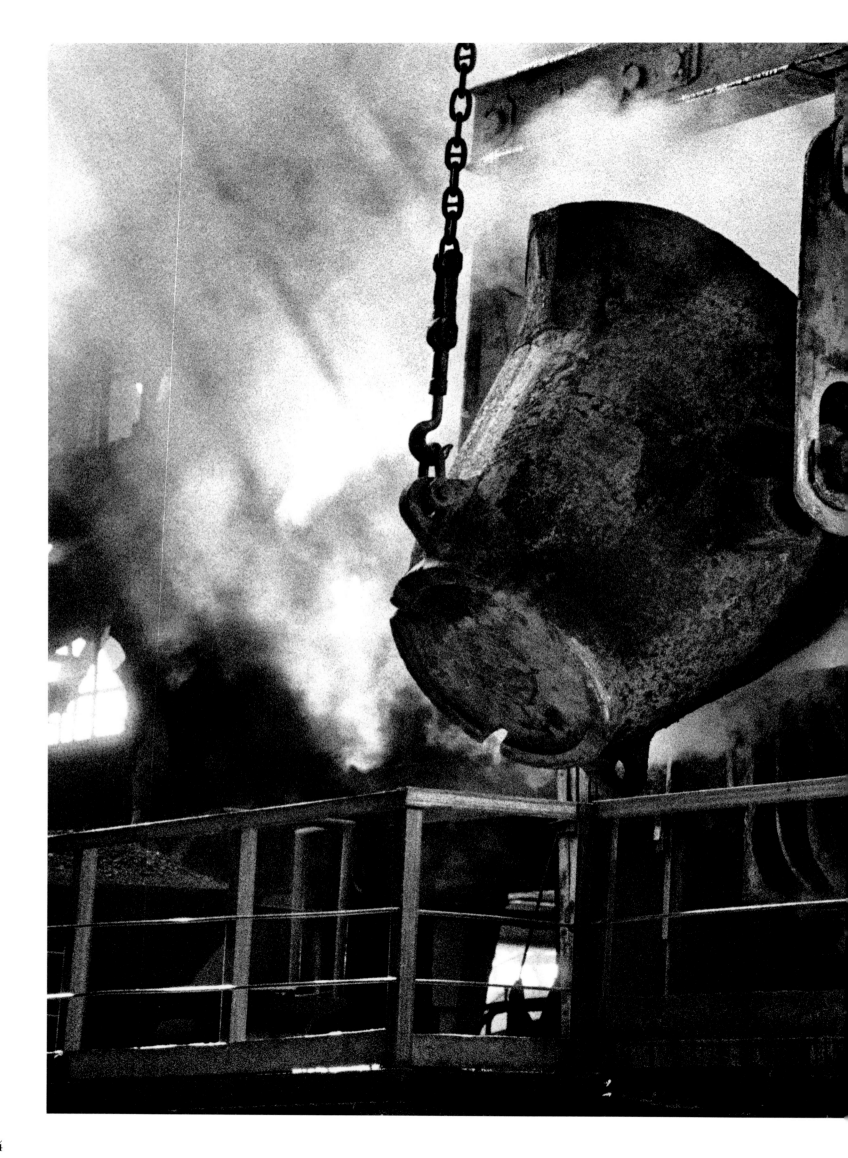

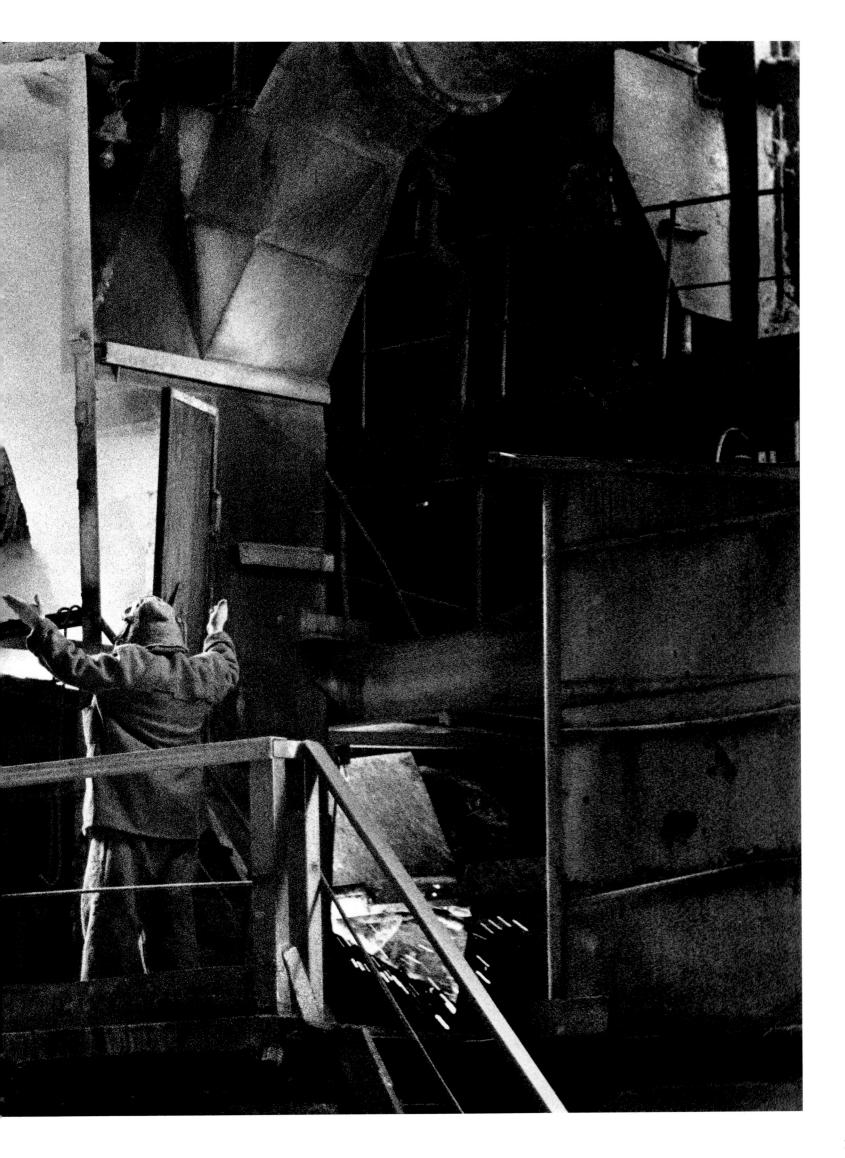

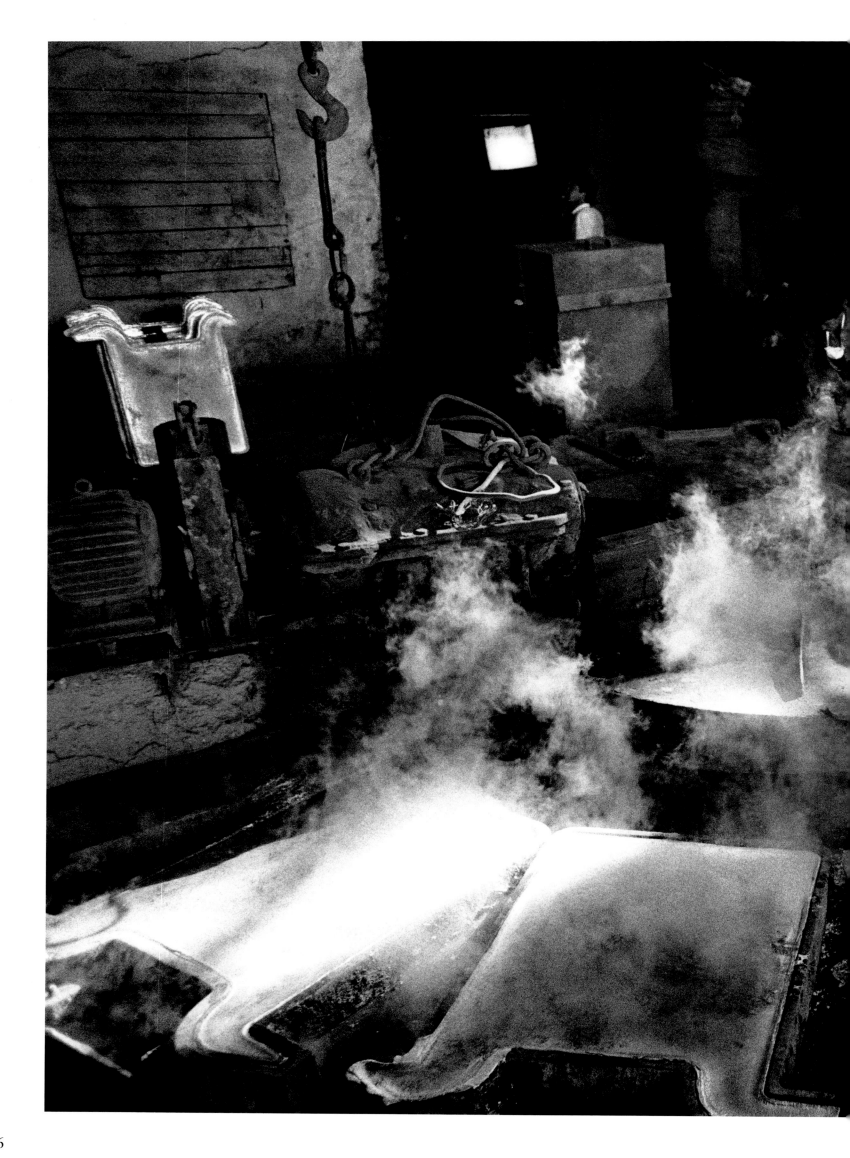

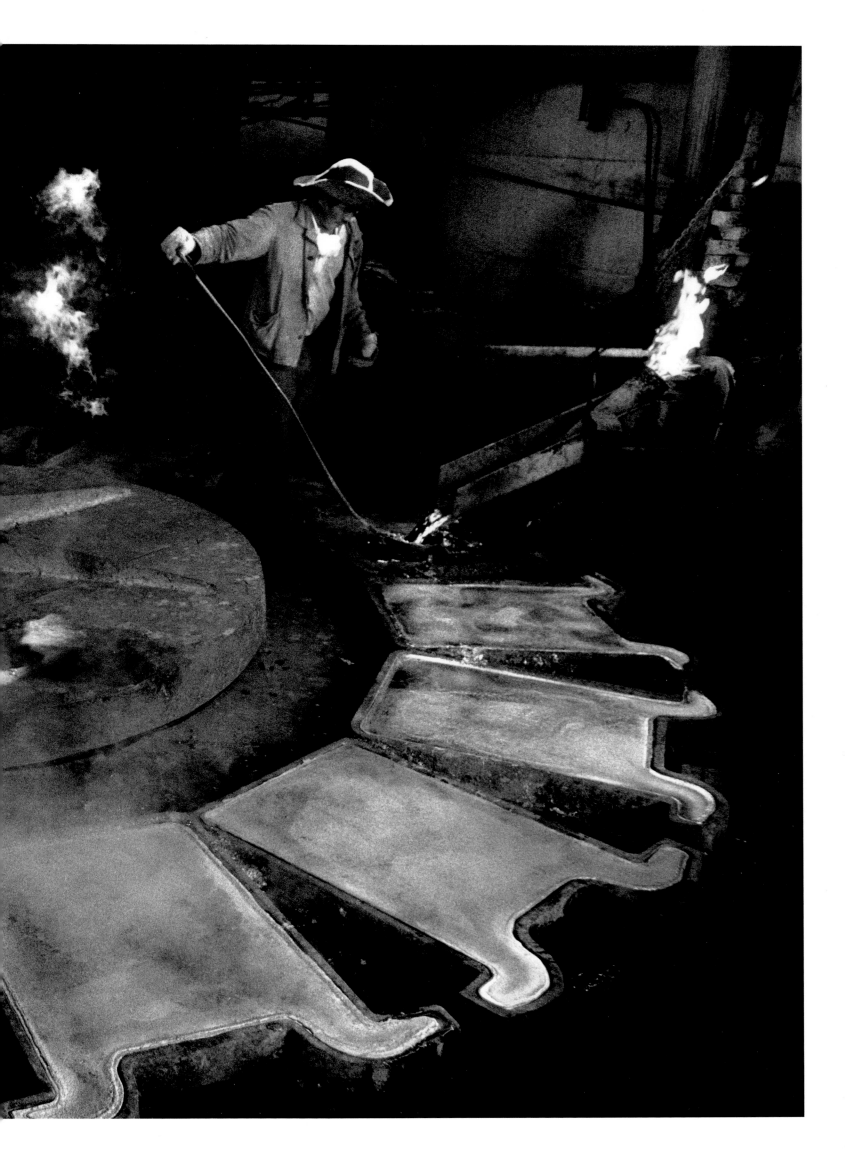

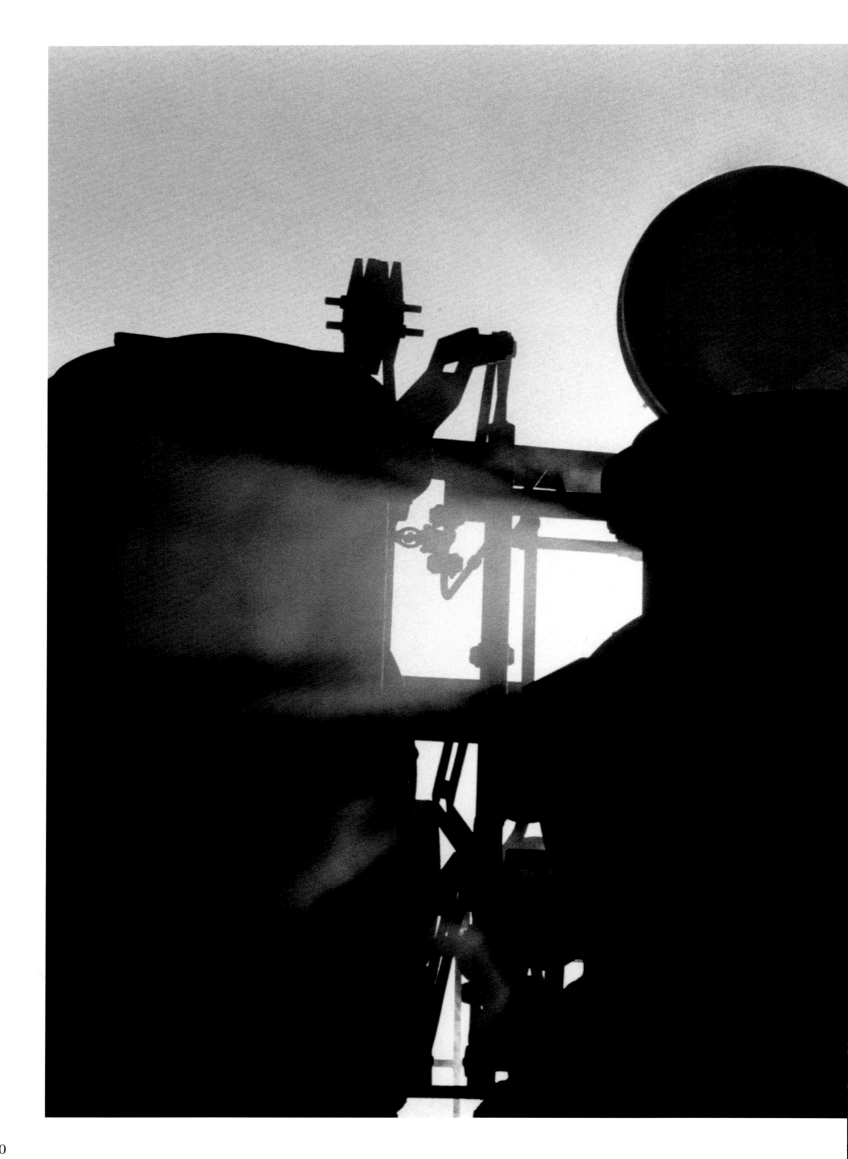

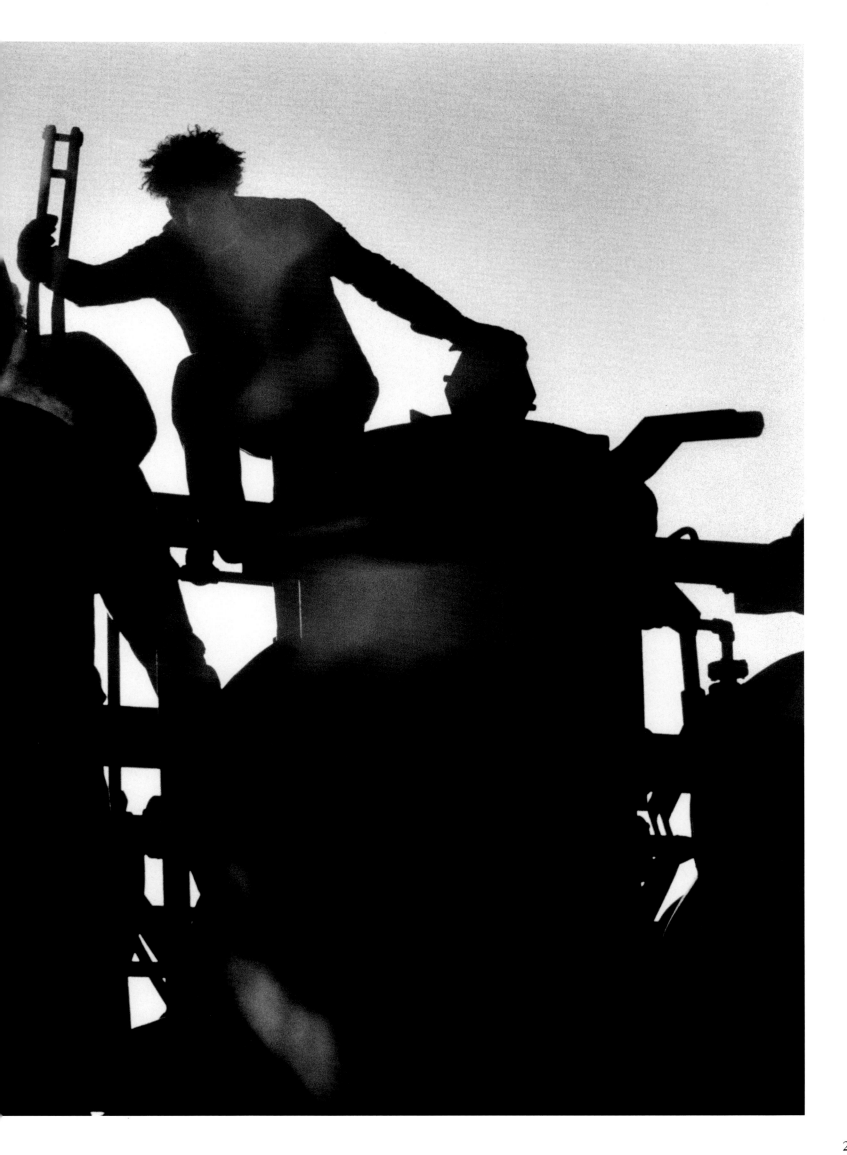

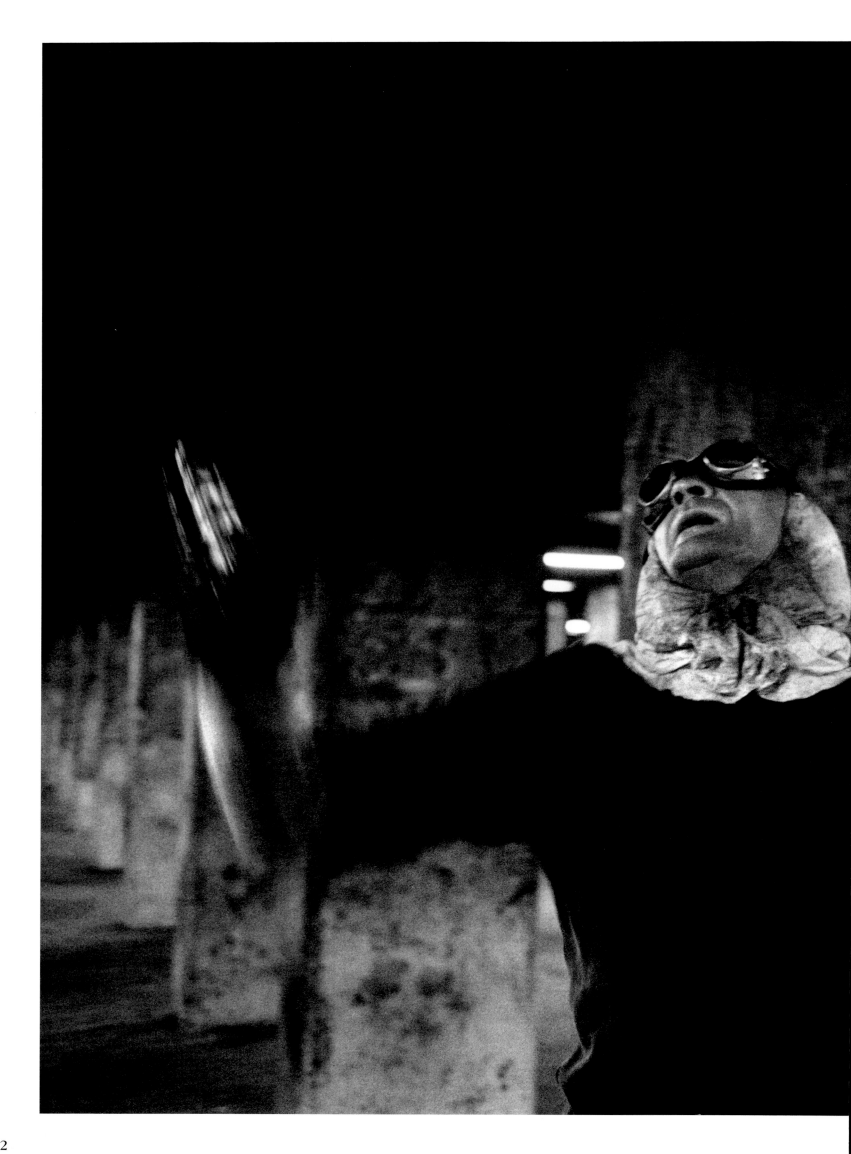

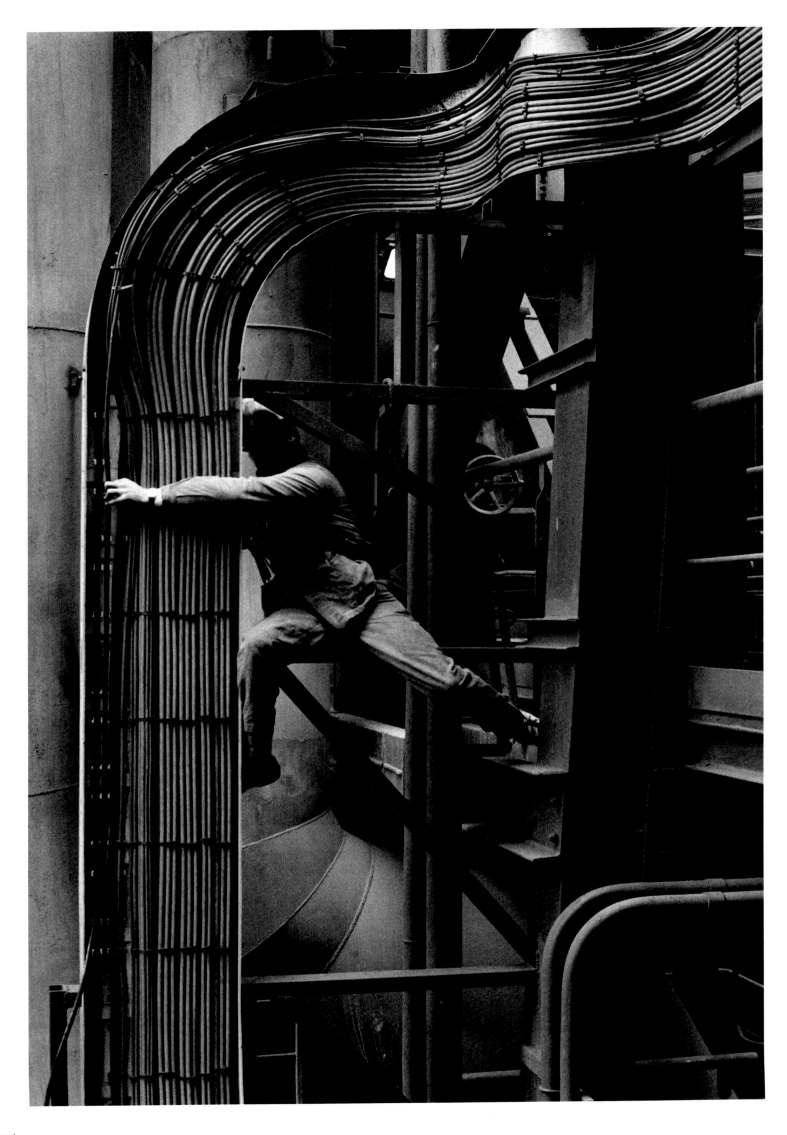

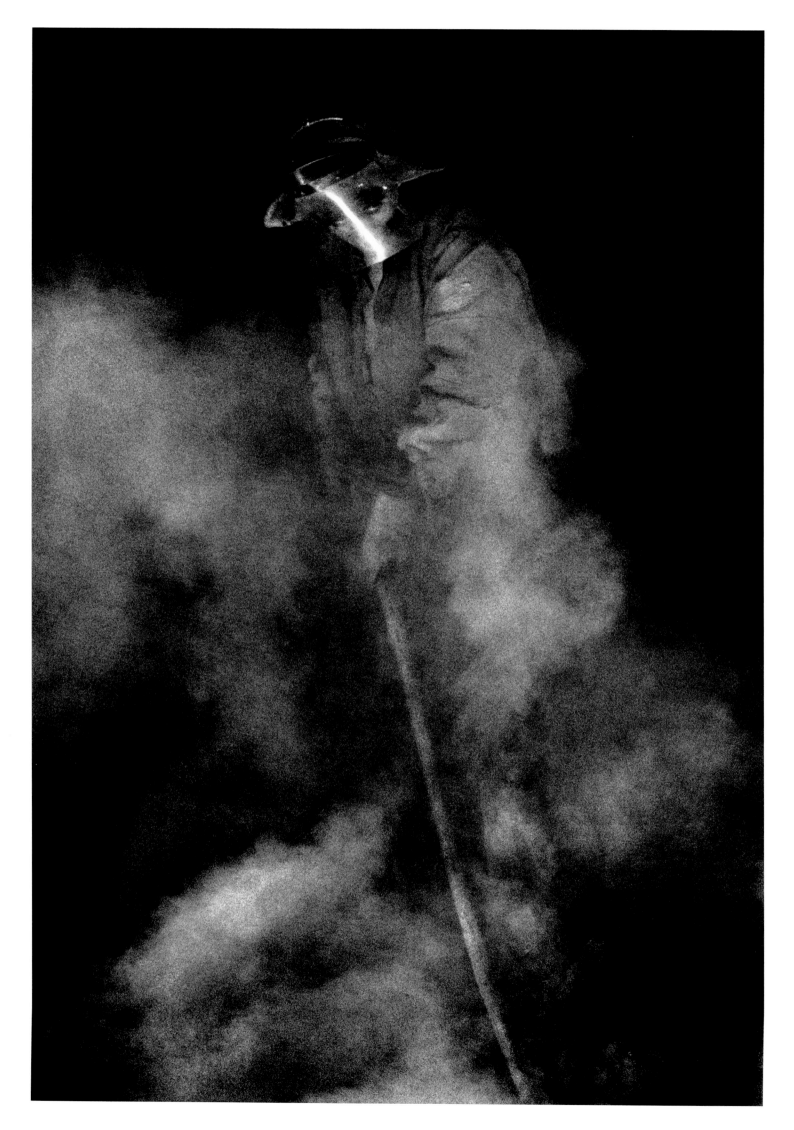

239

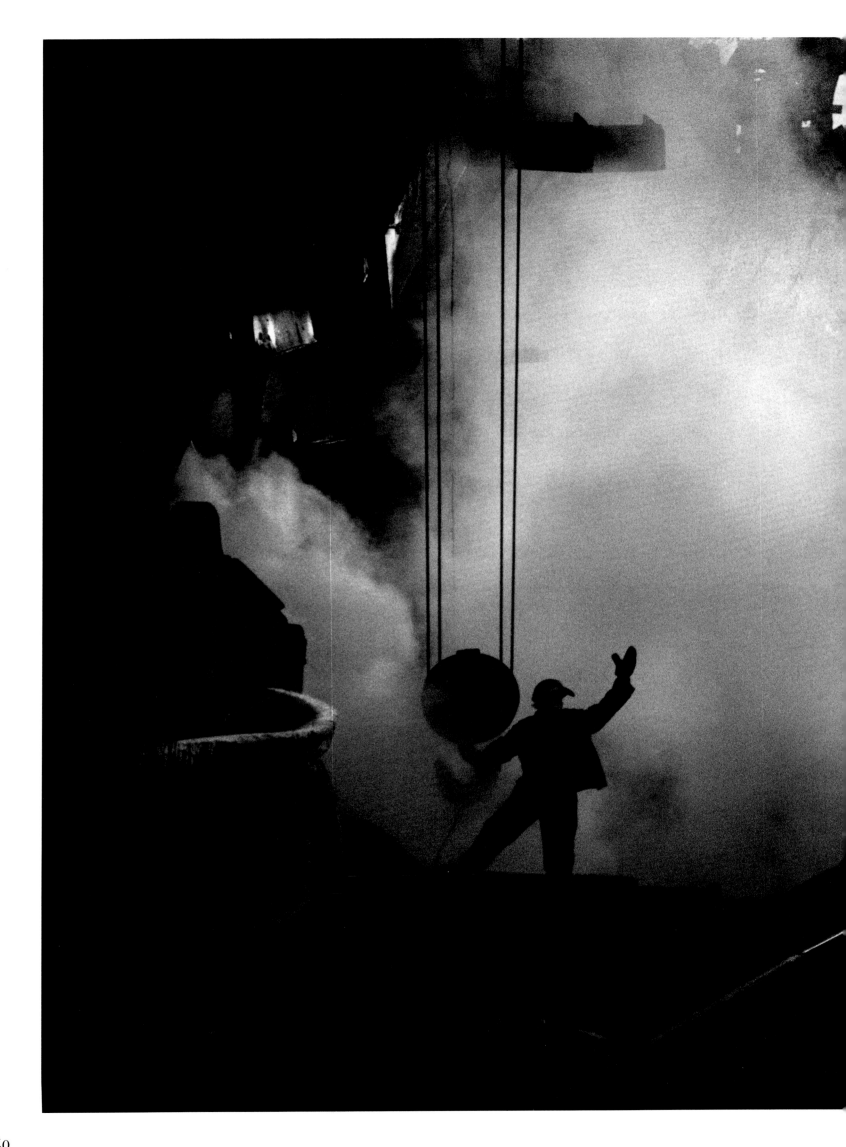

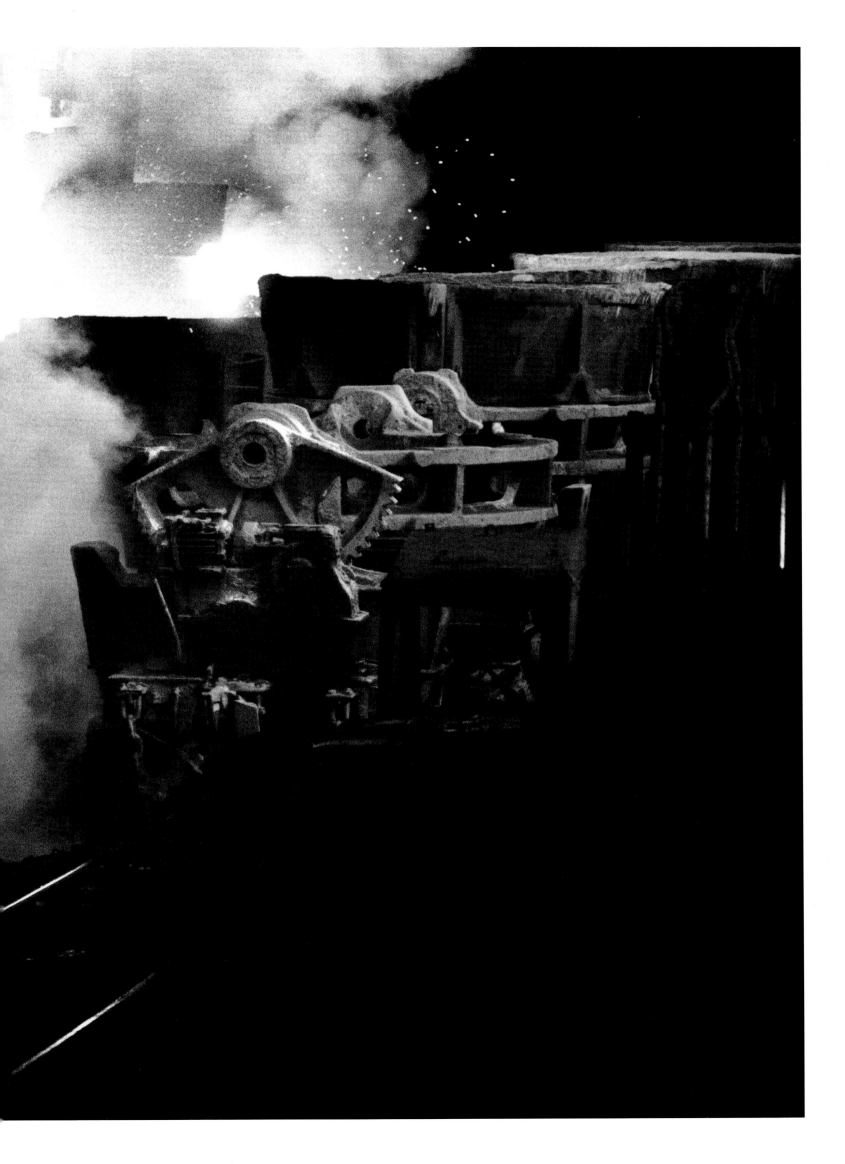

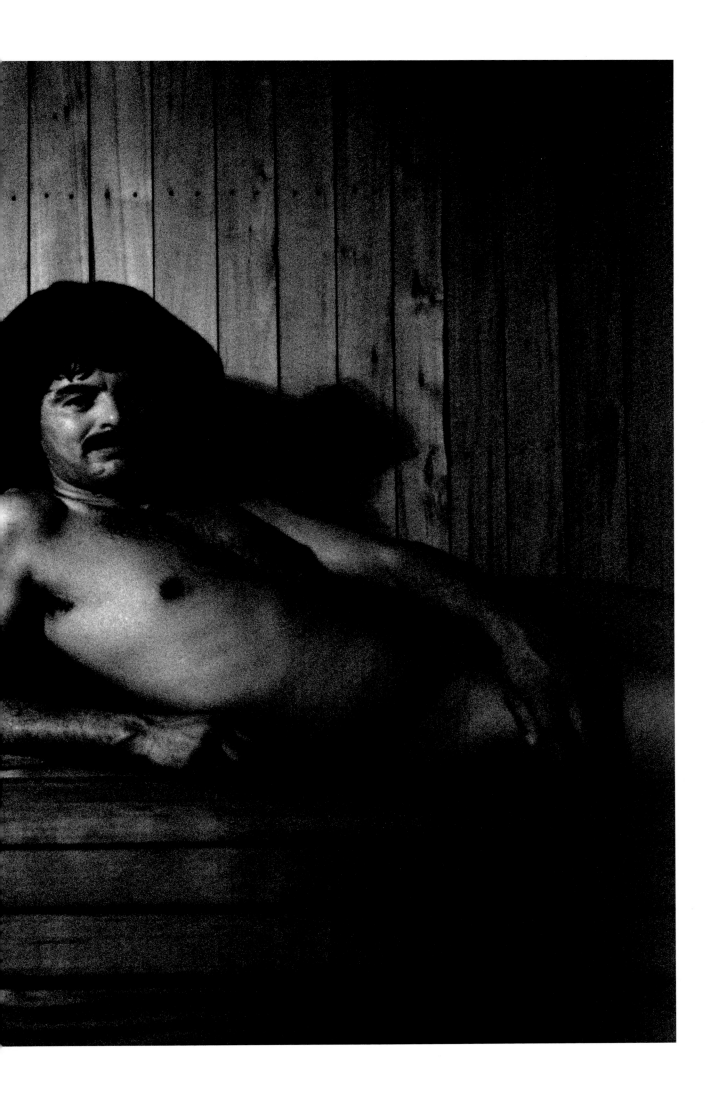

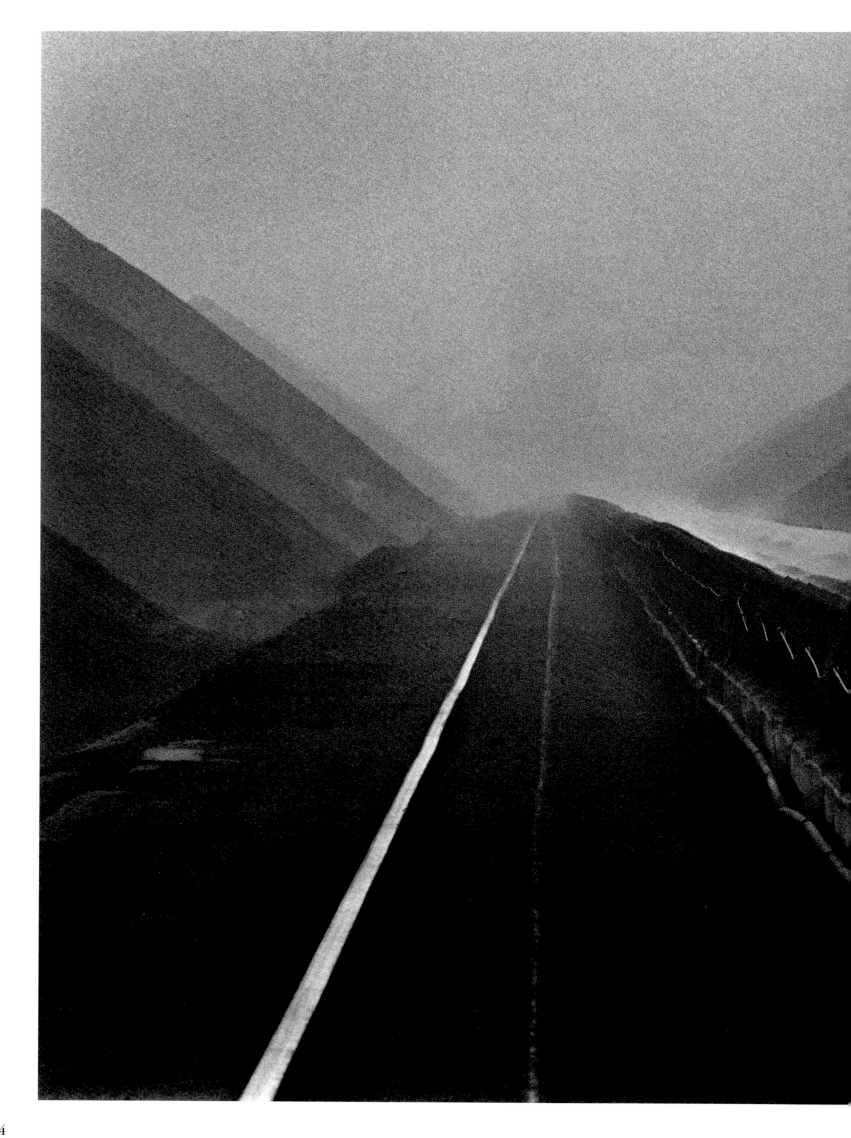

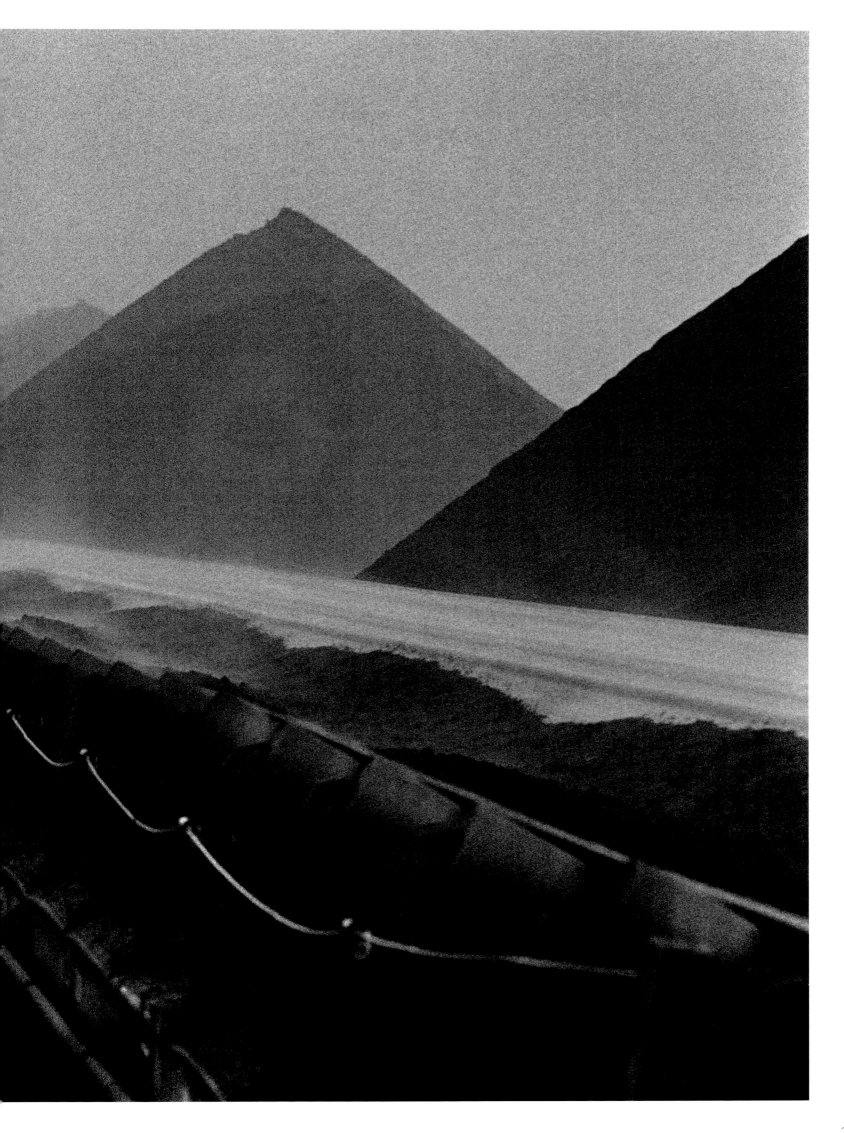

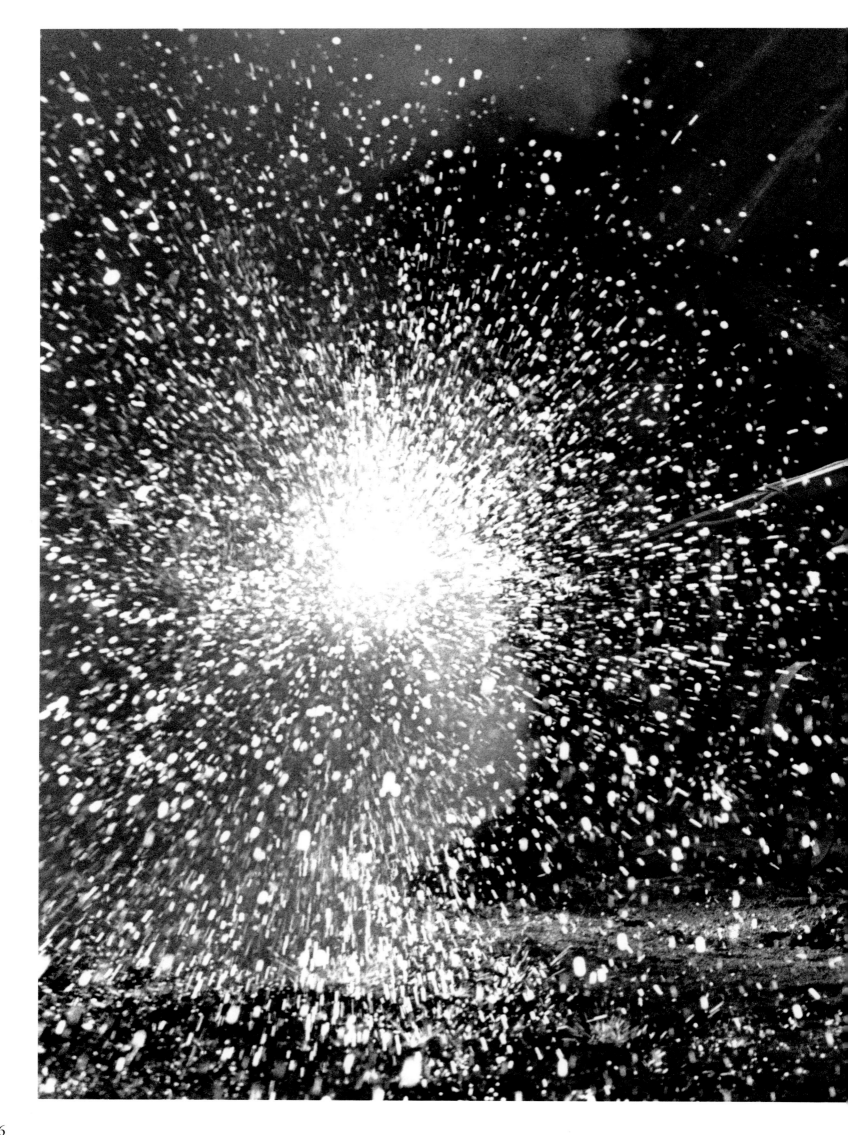

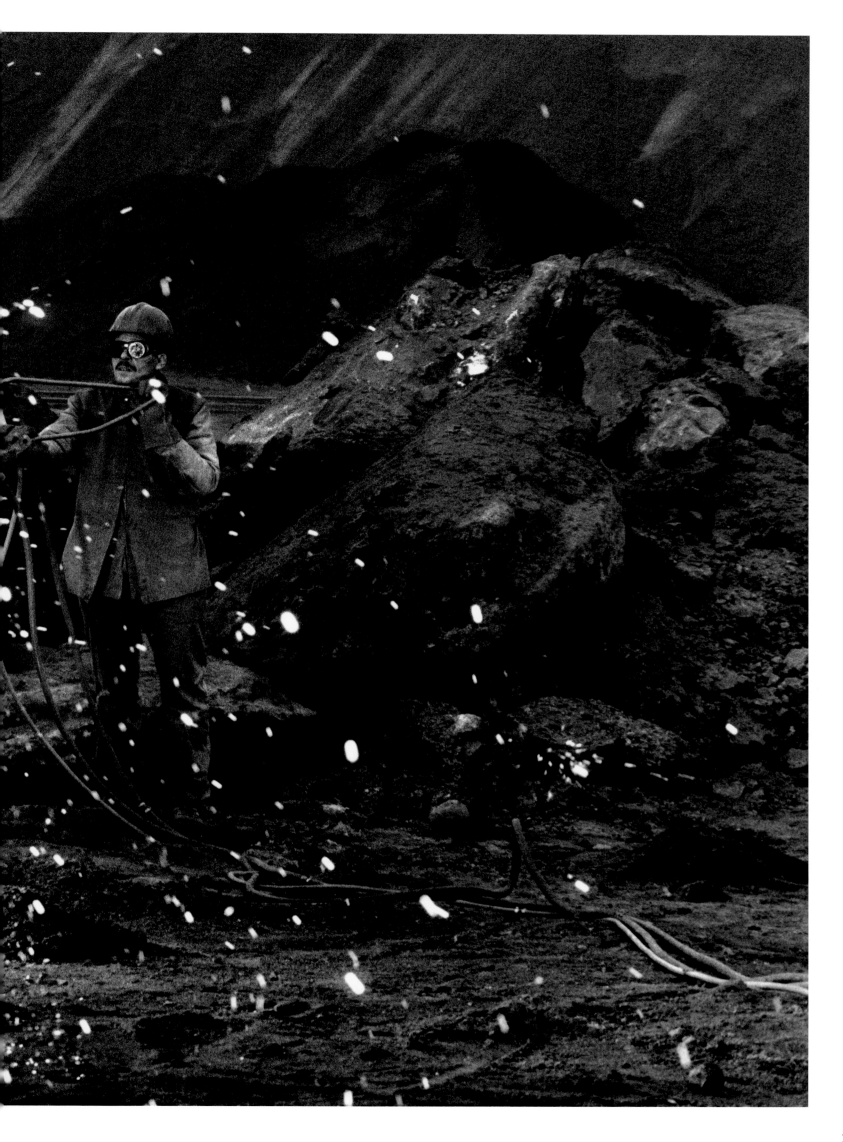

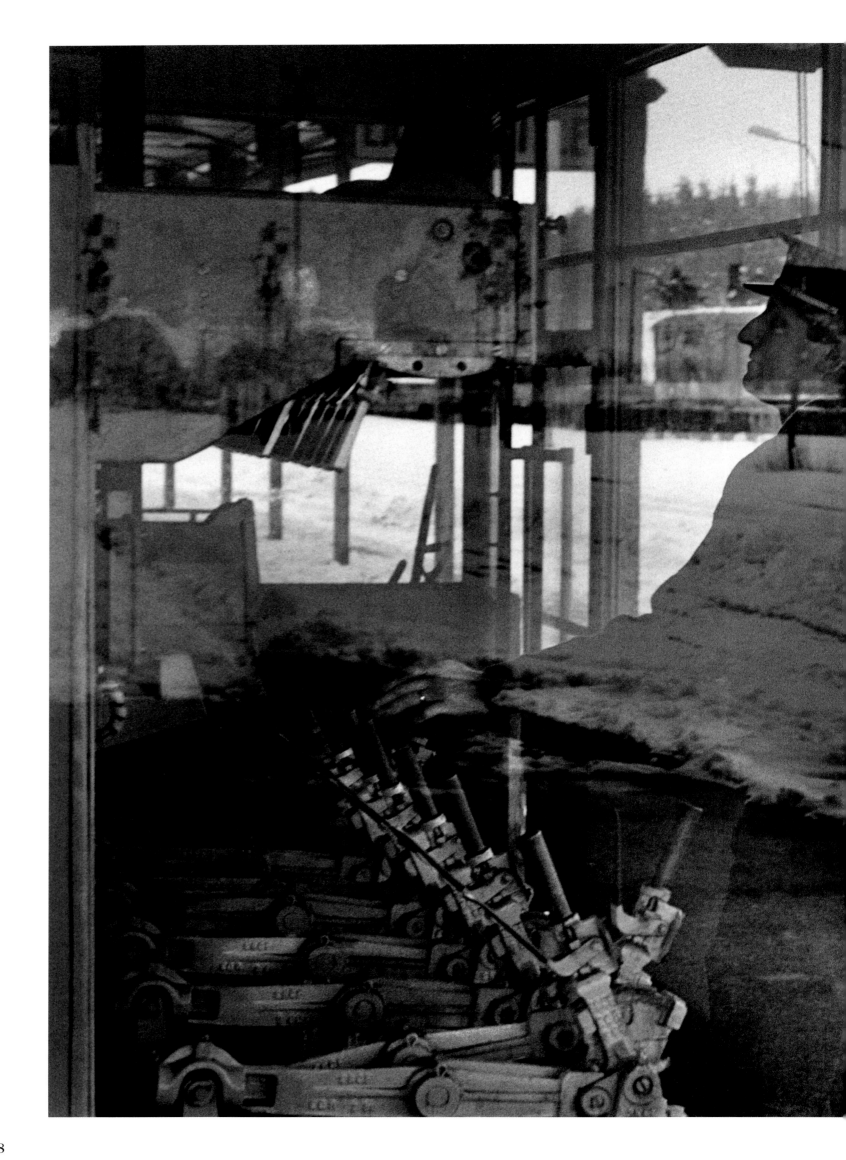

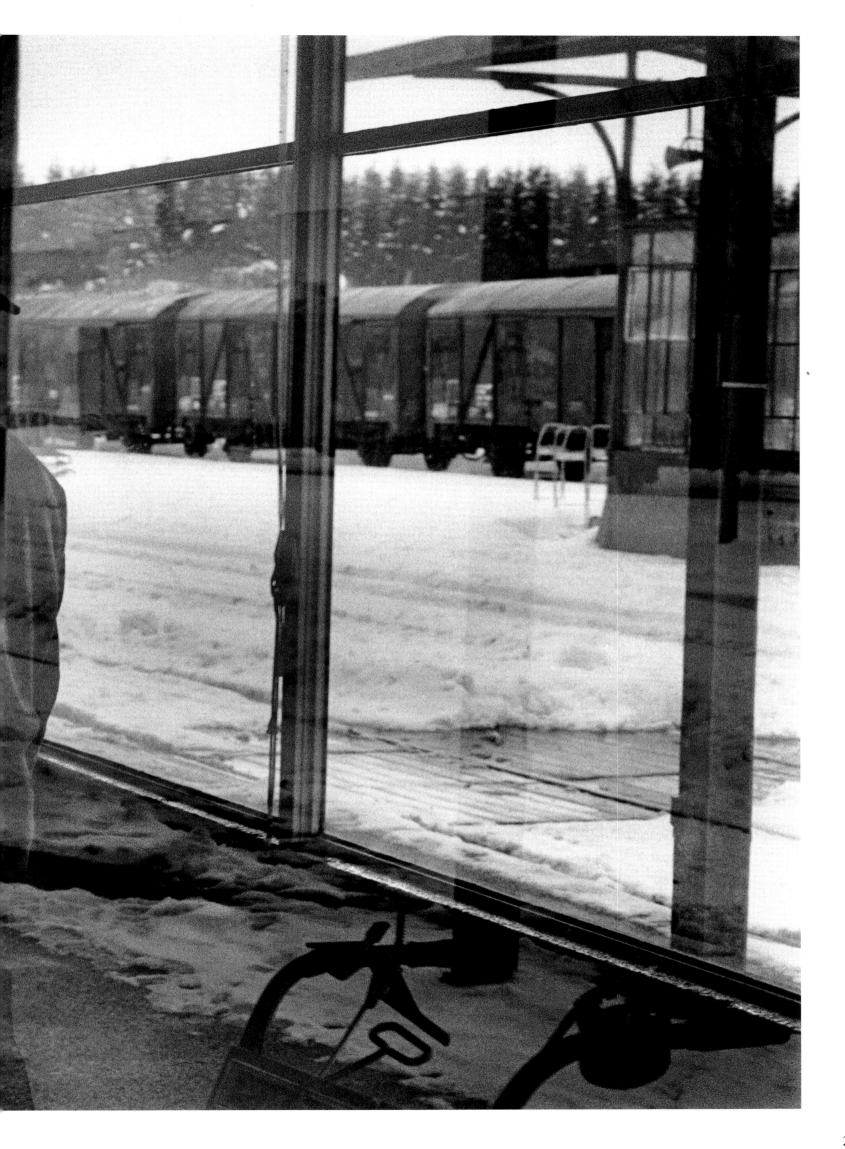

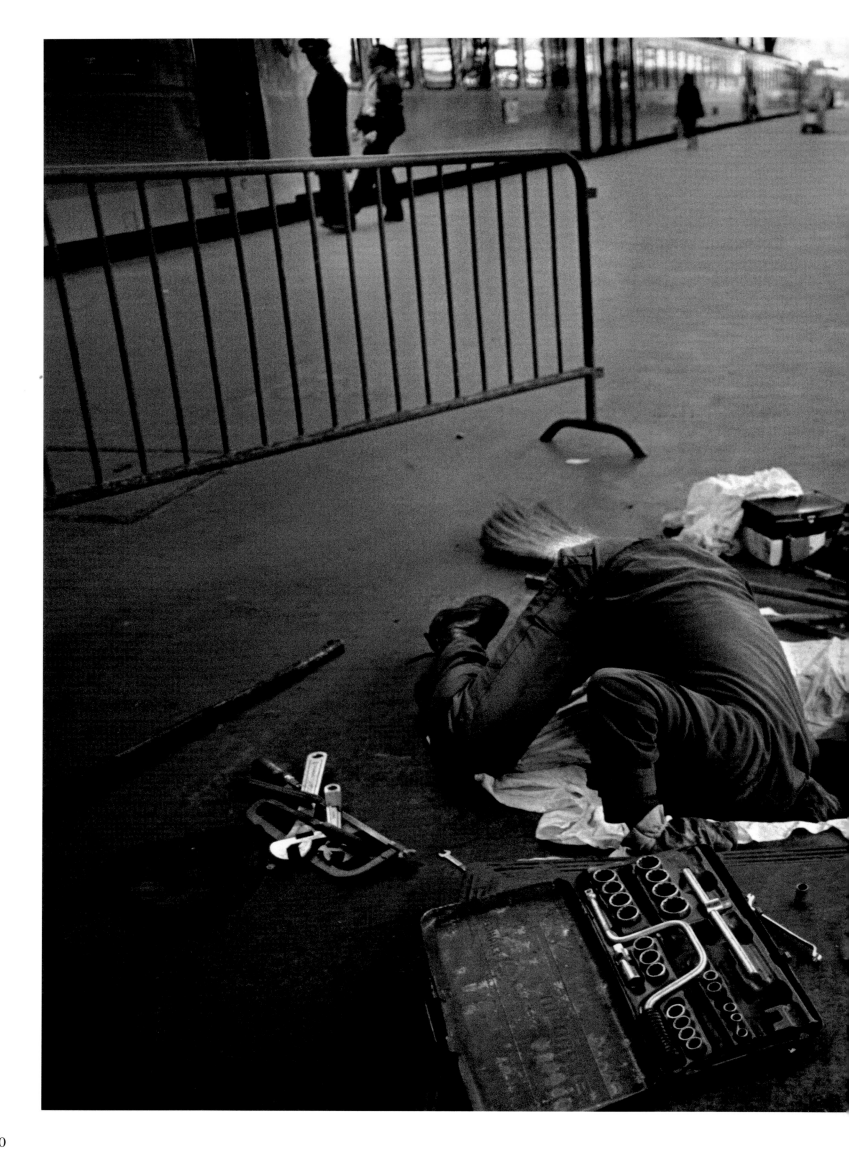

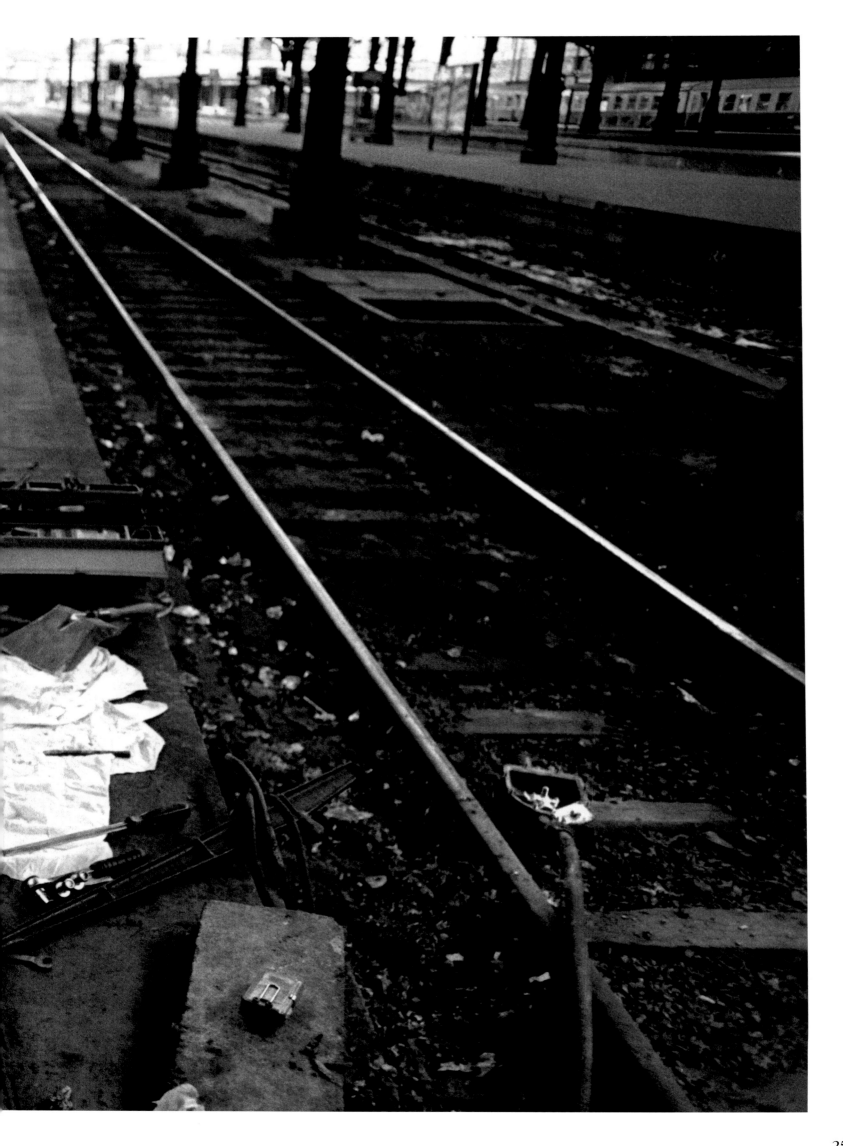

251

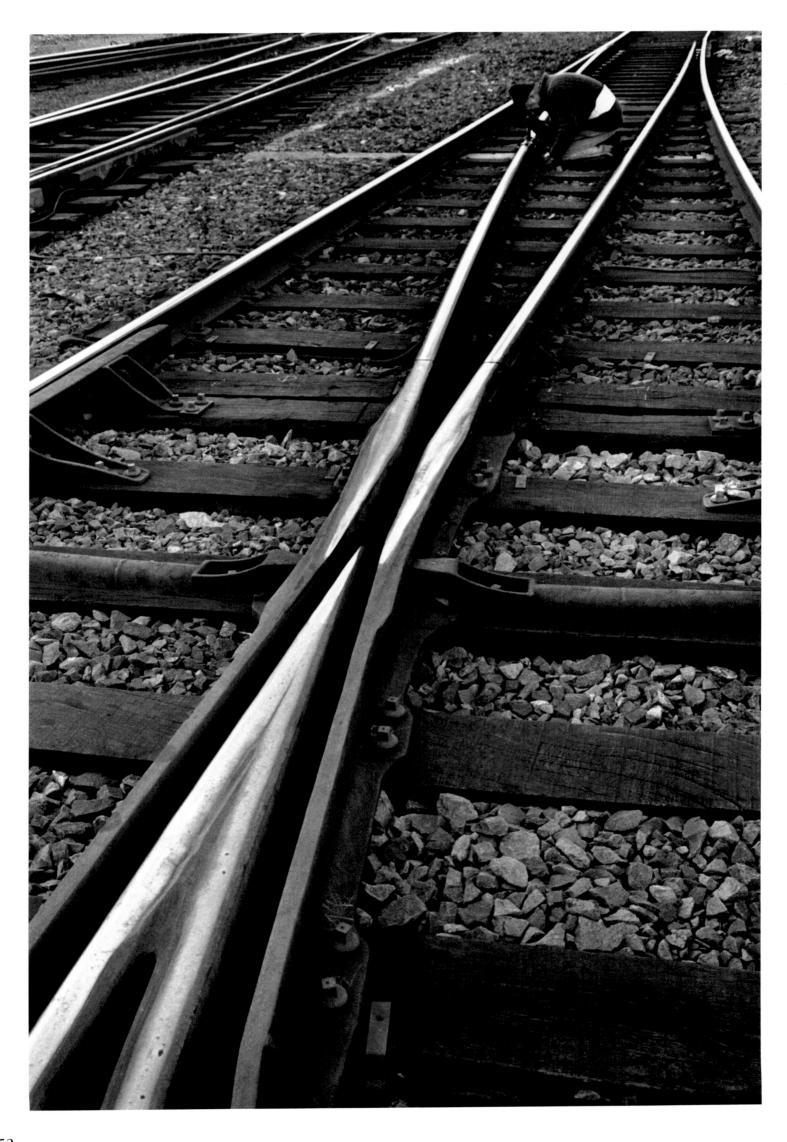

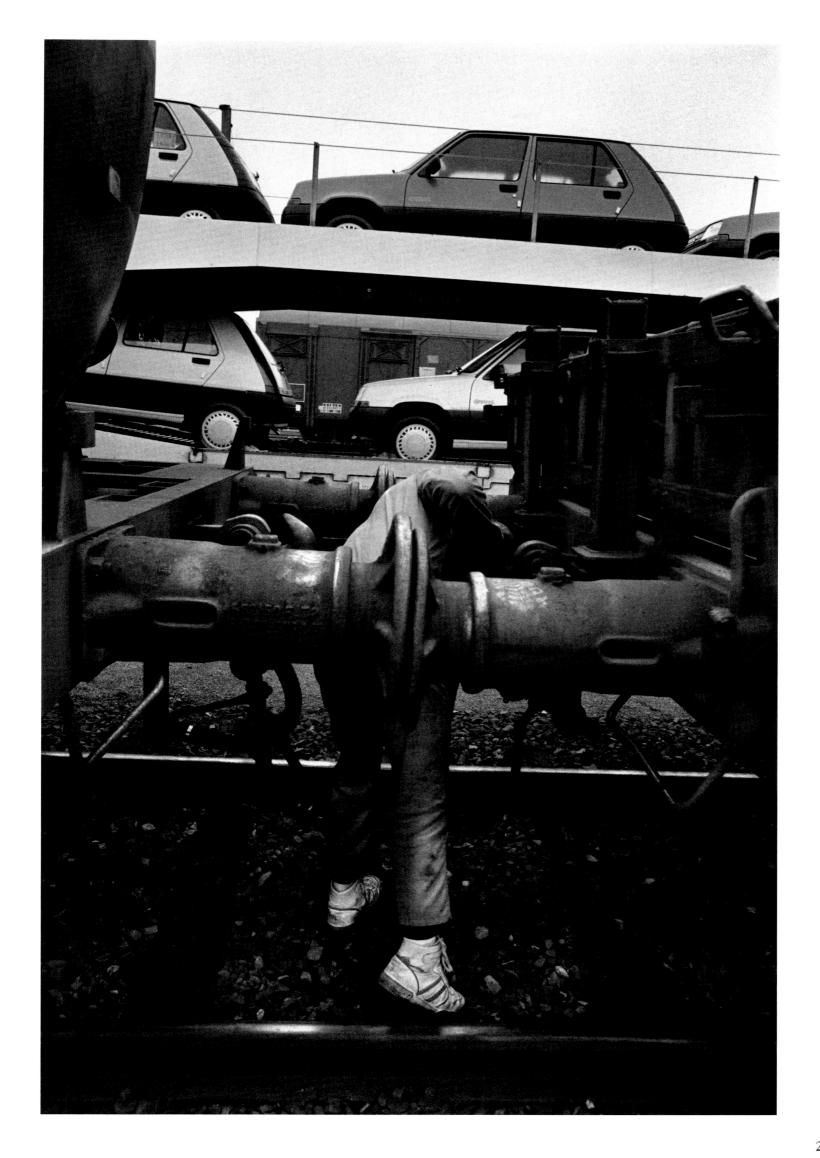

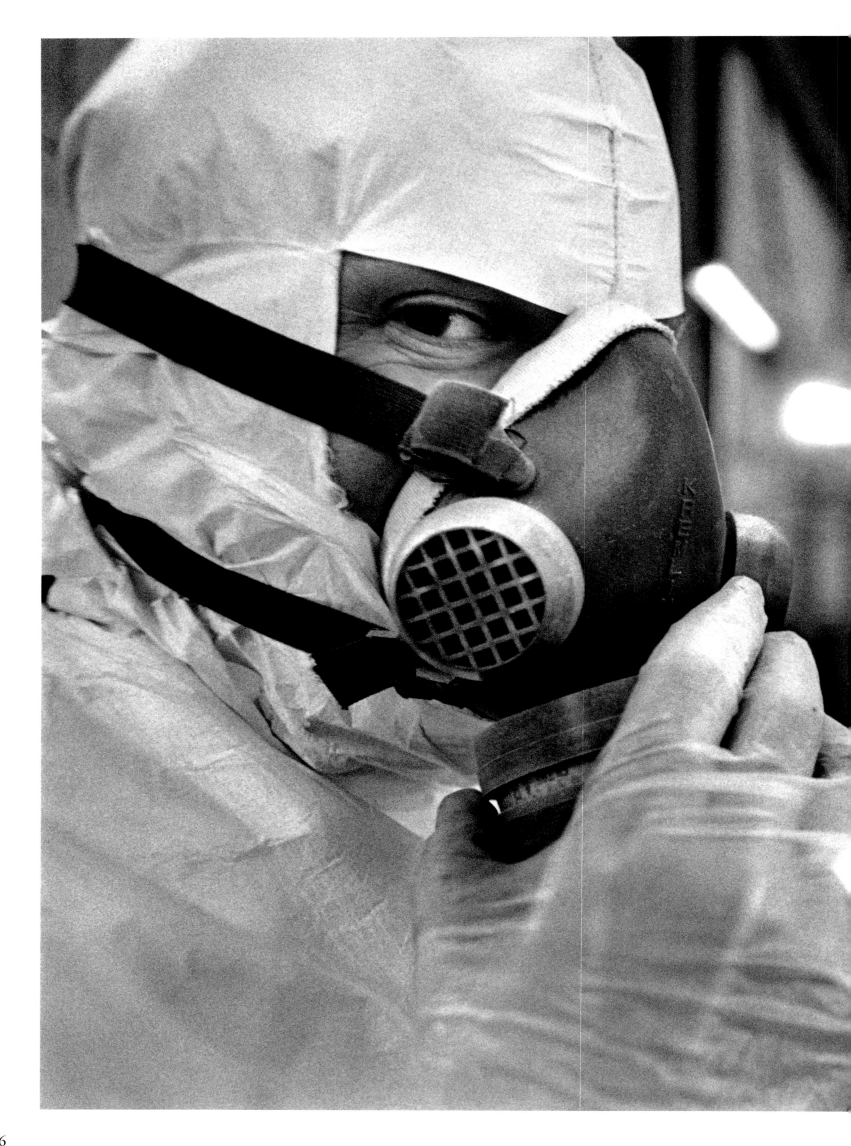

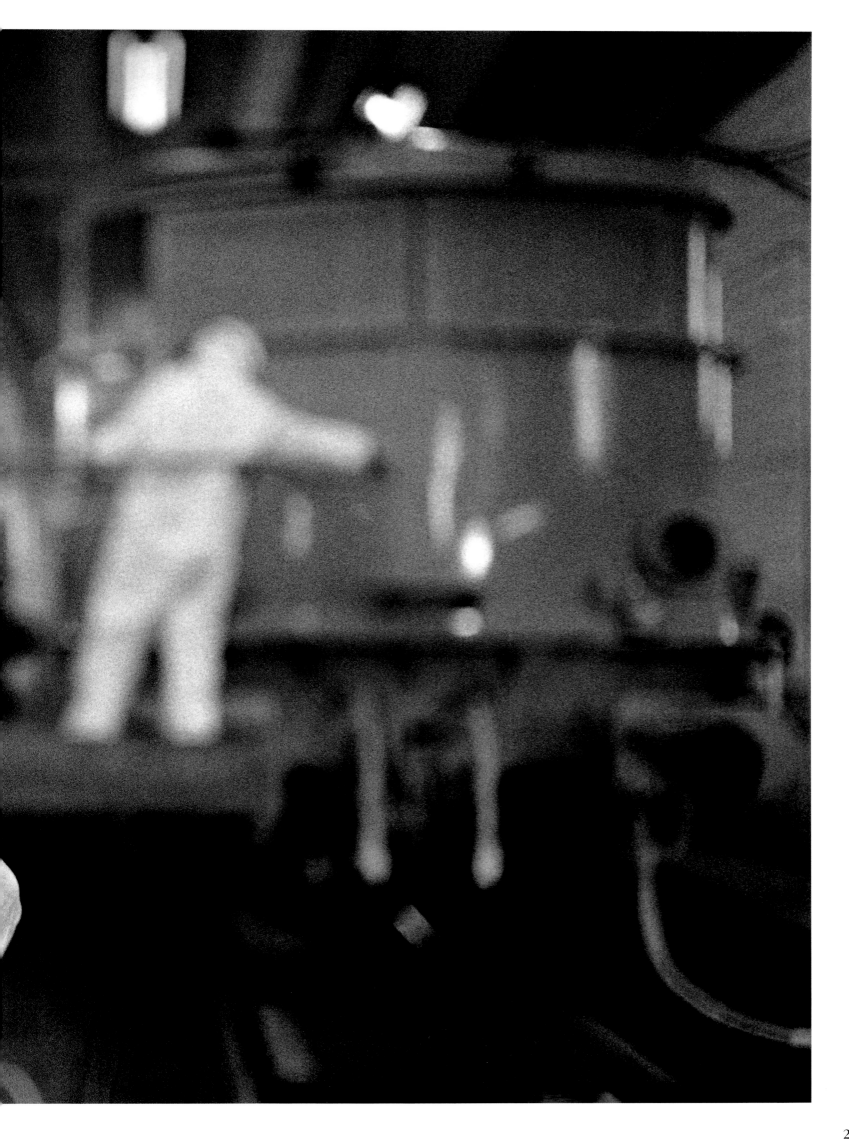

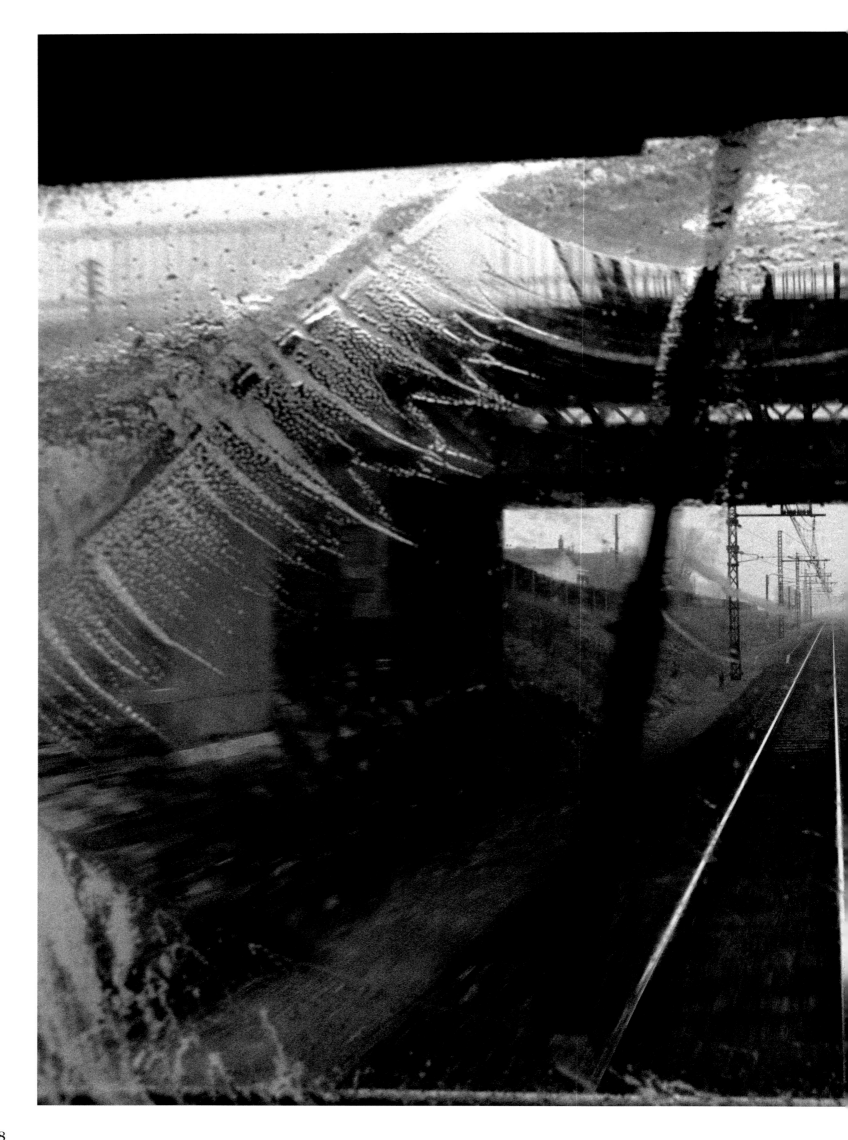

258

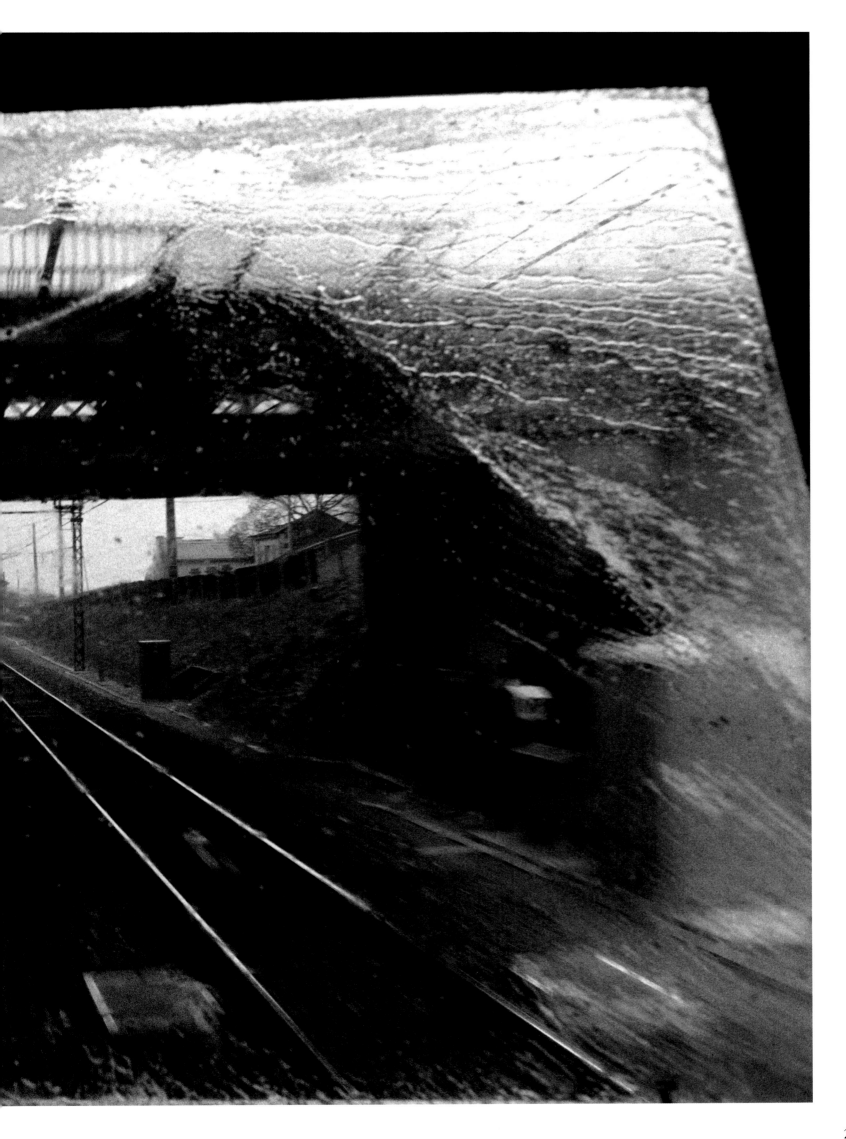

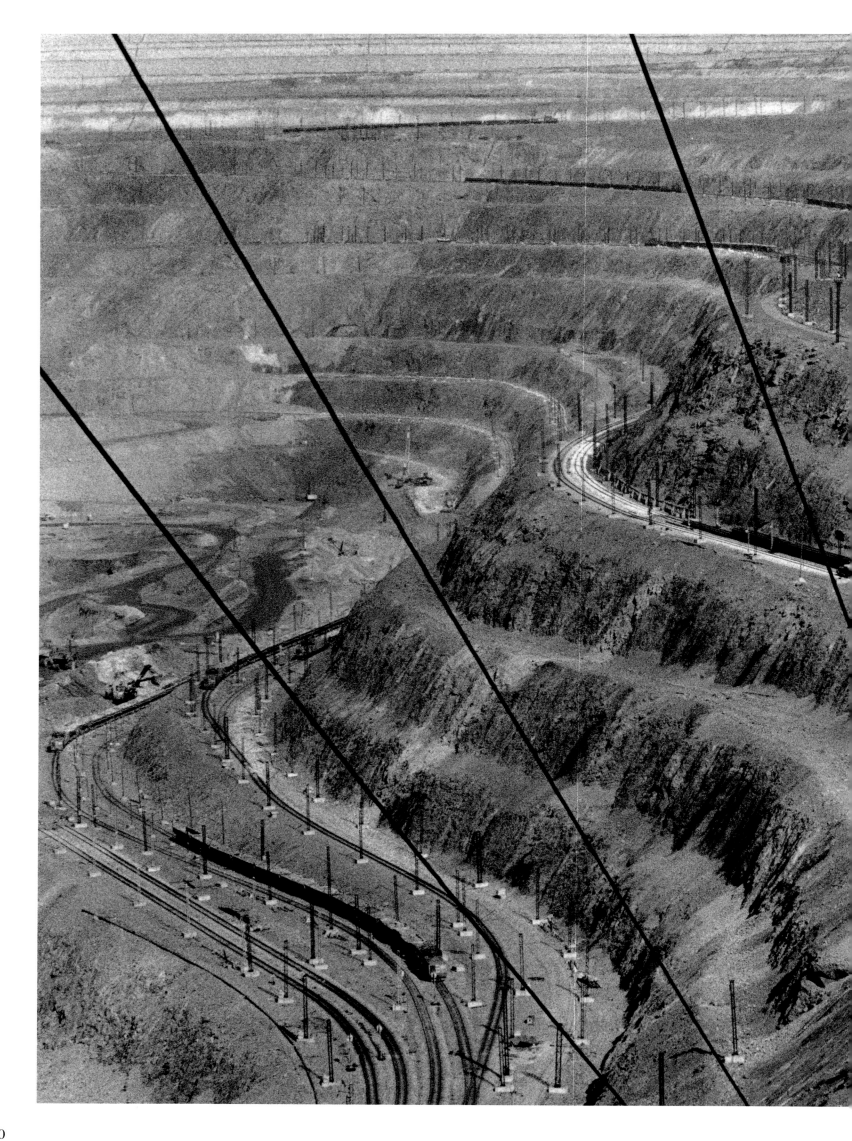

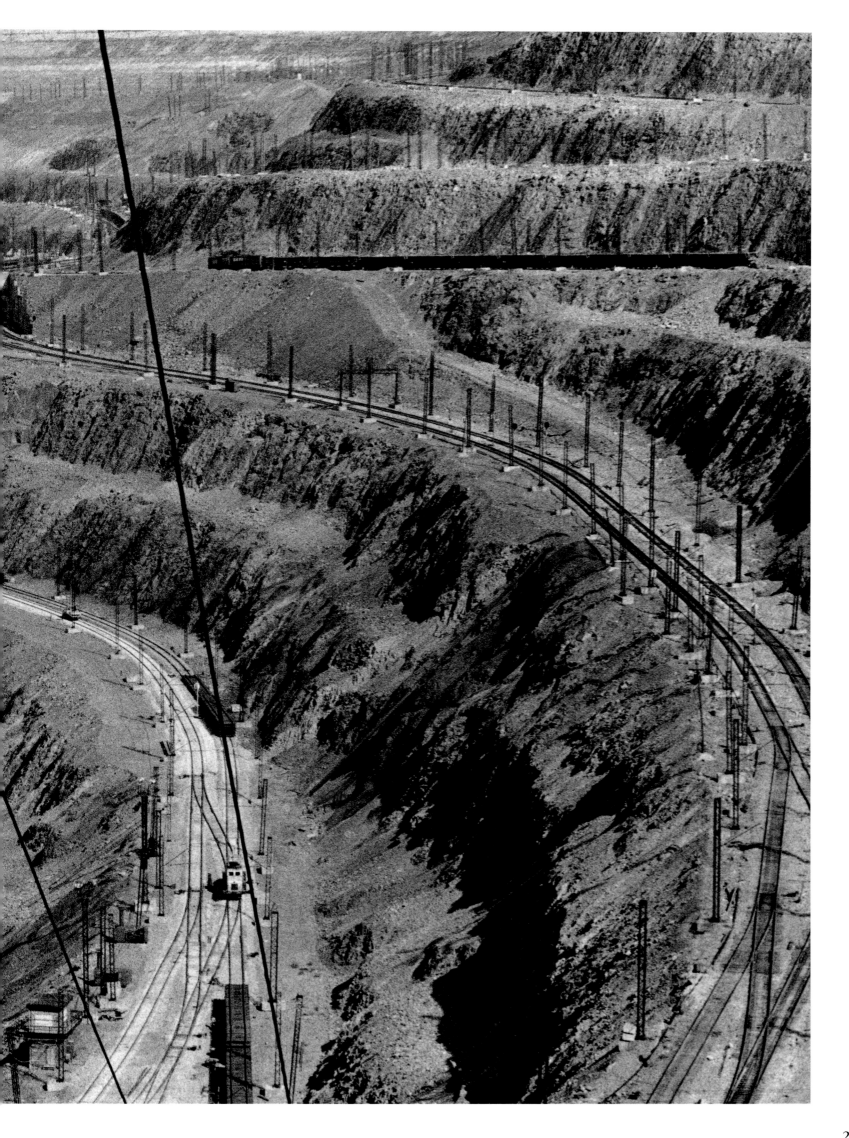

IV

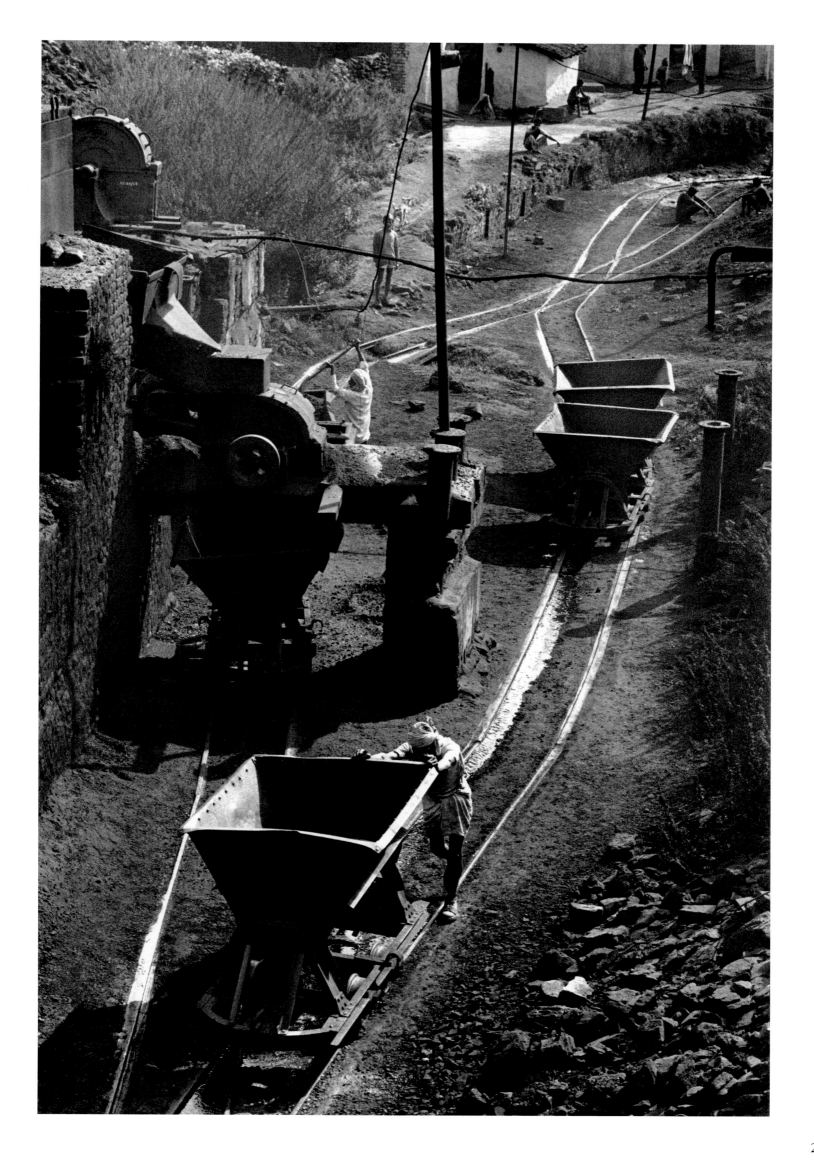

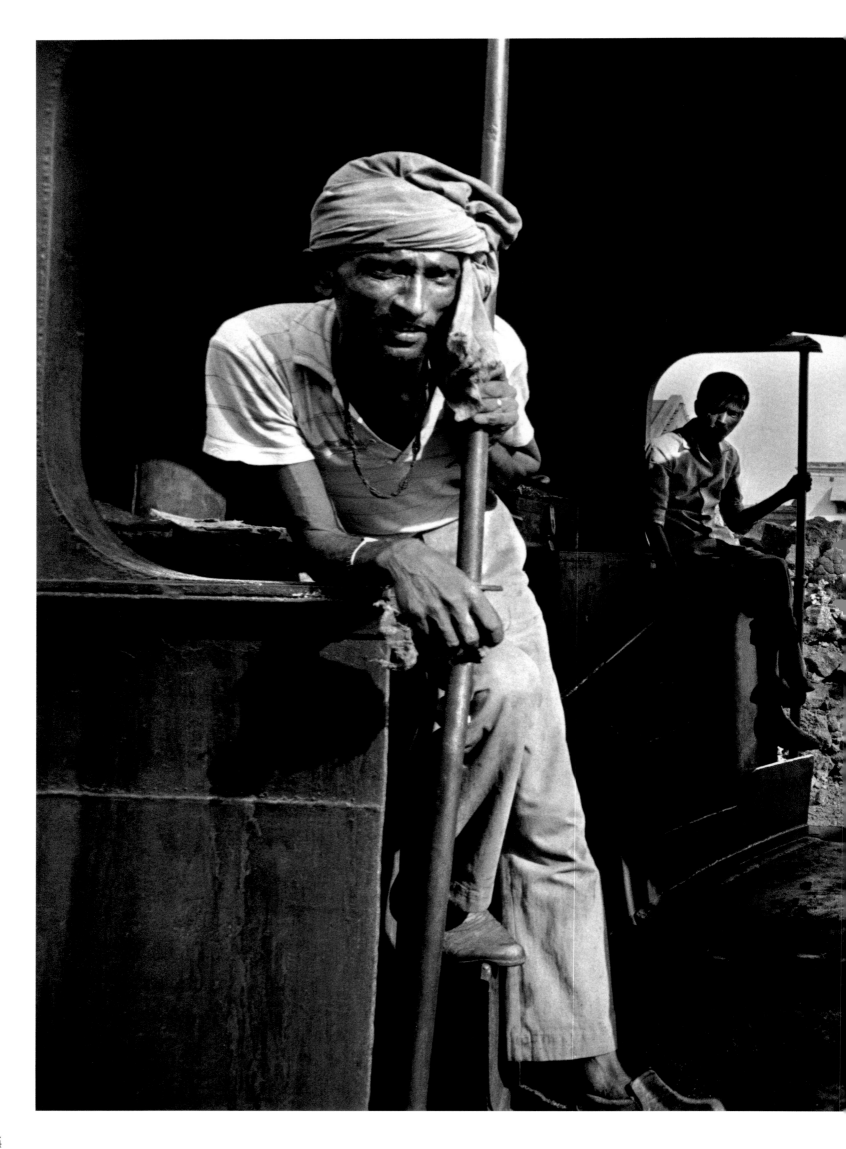

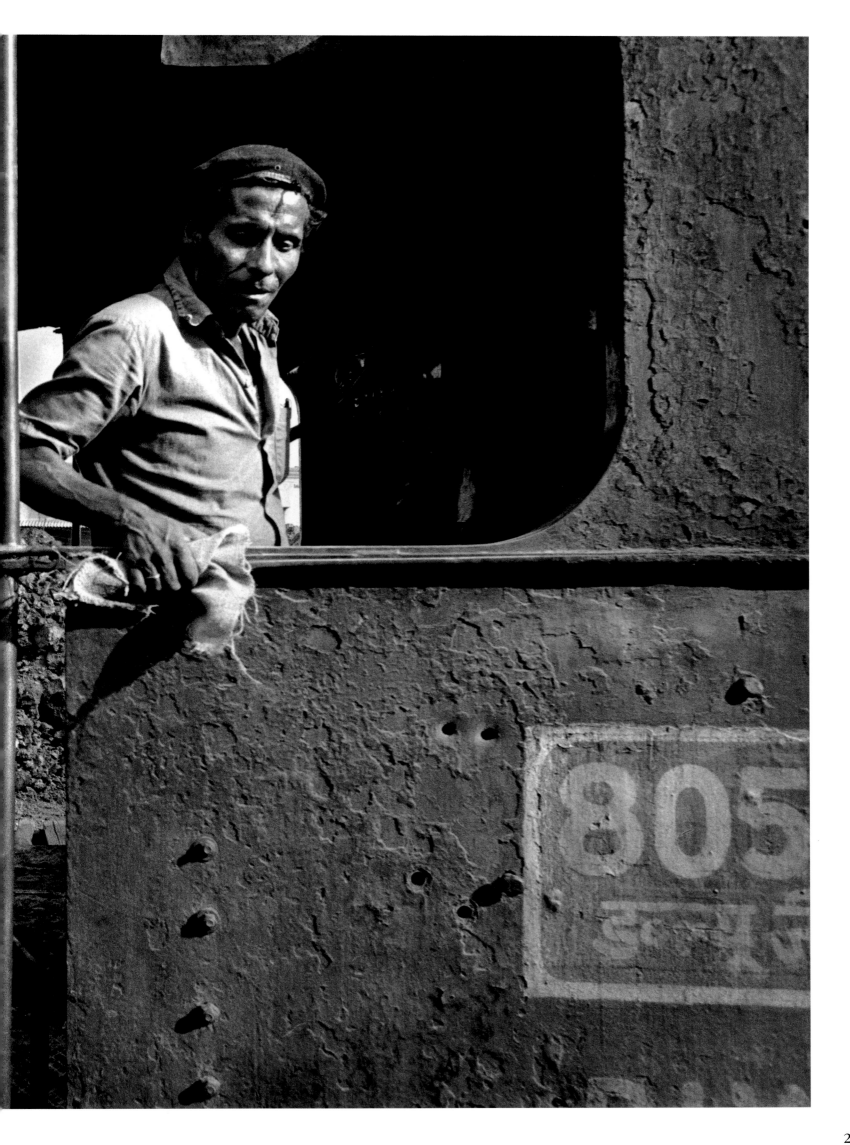

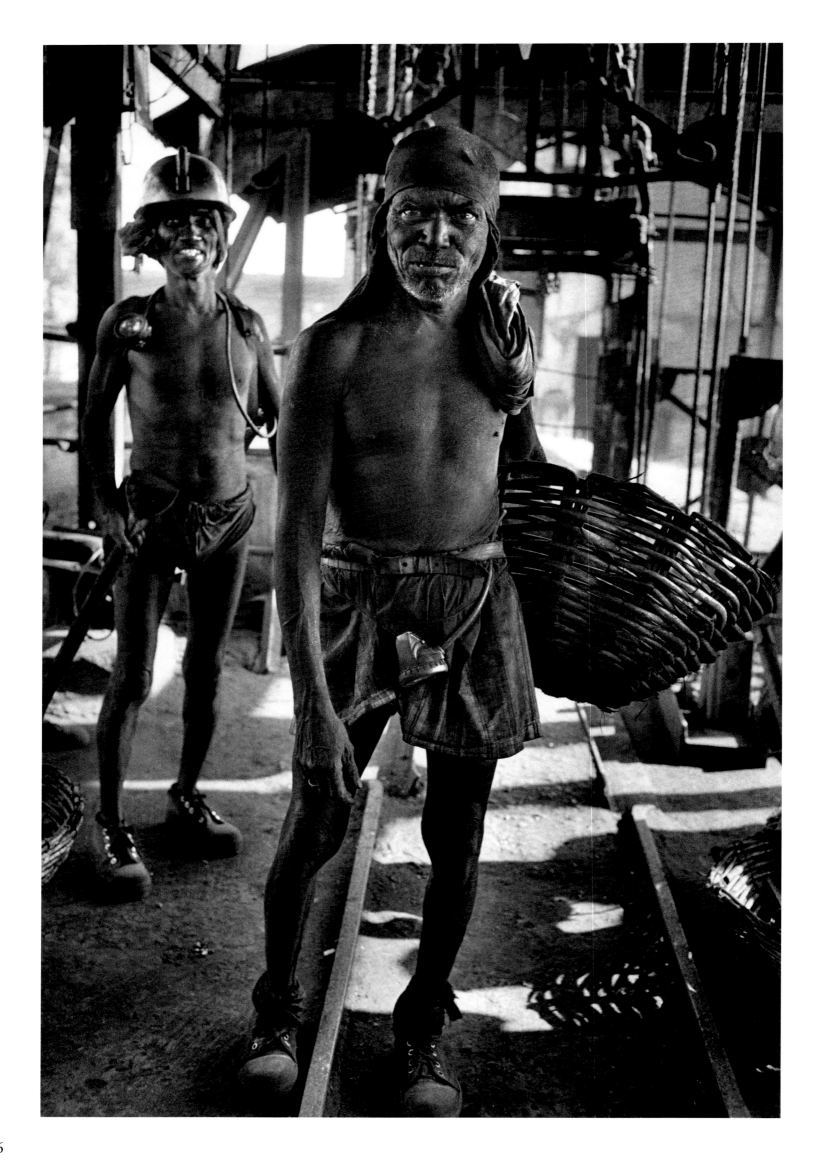

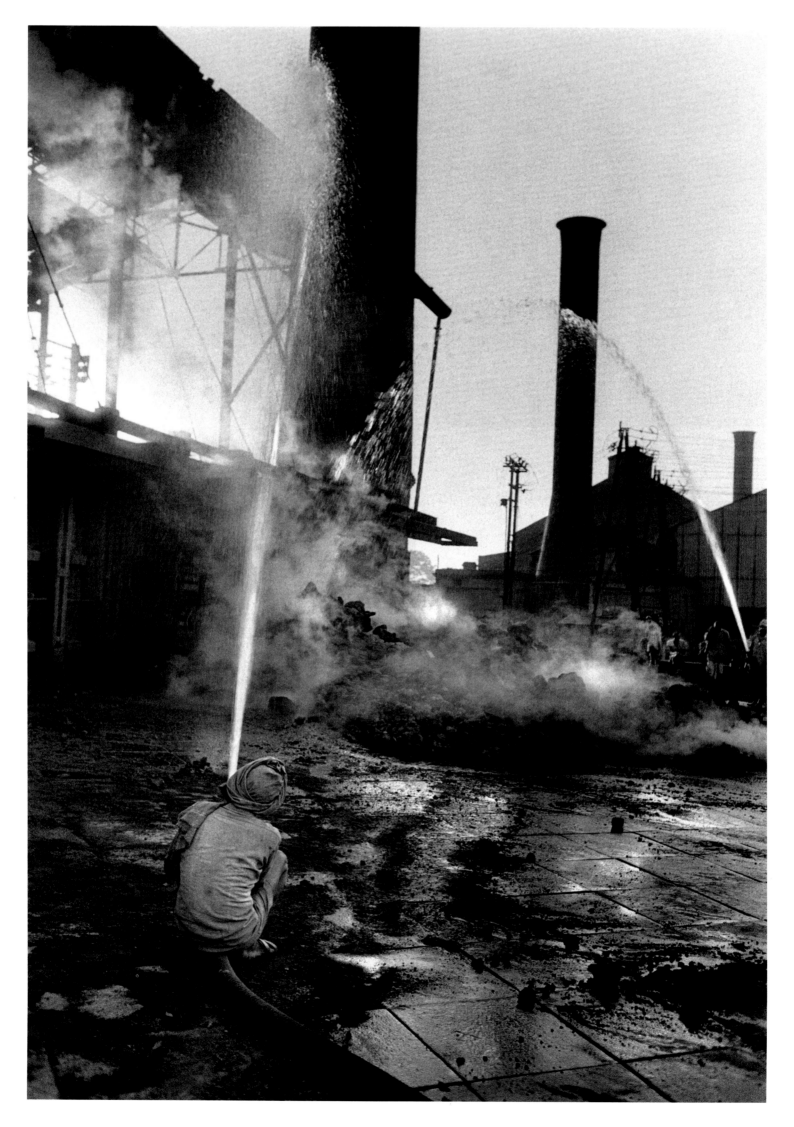

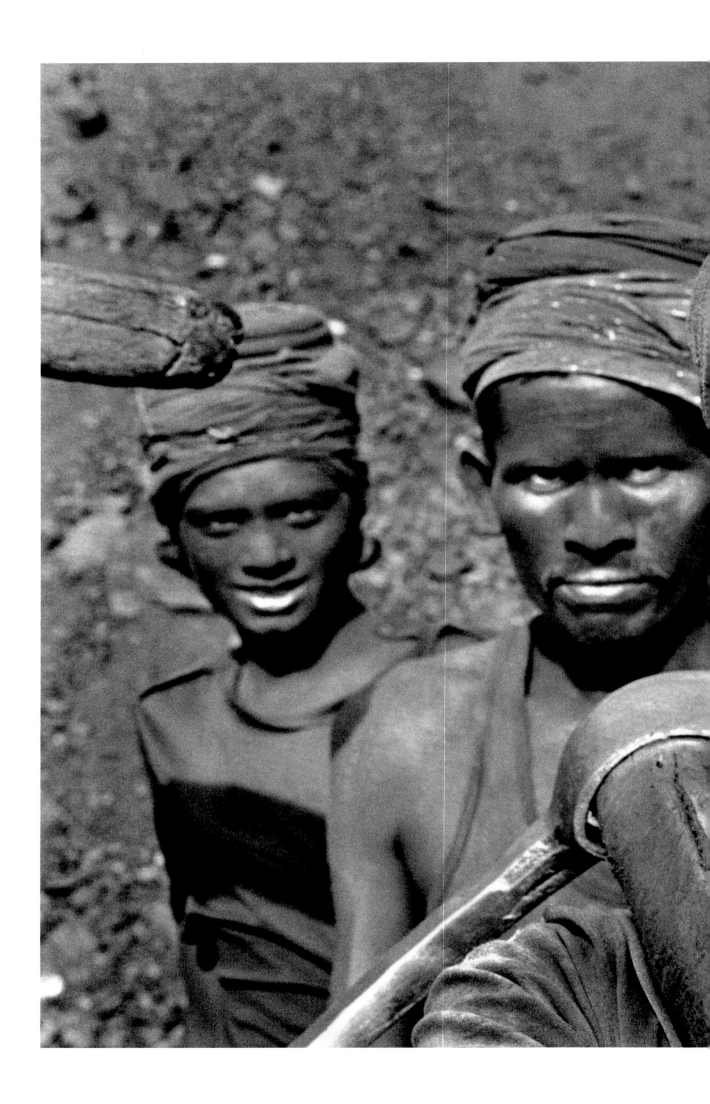

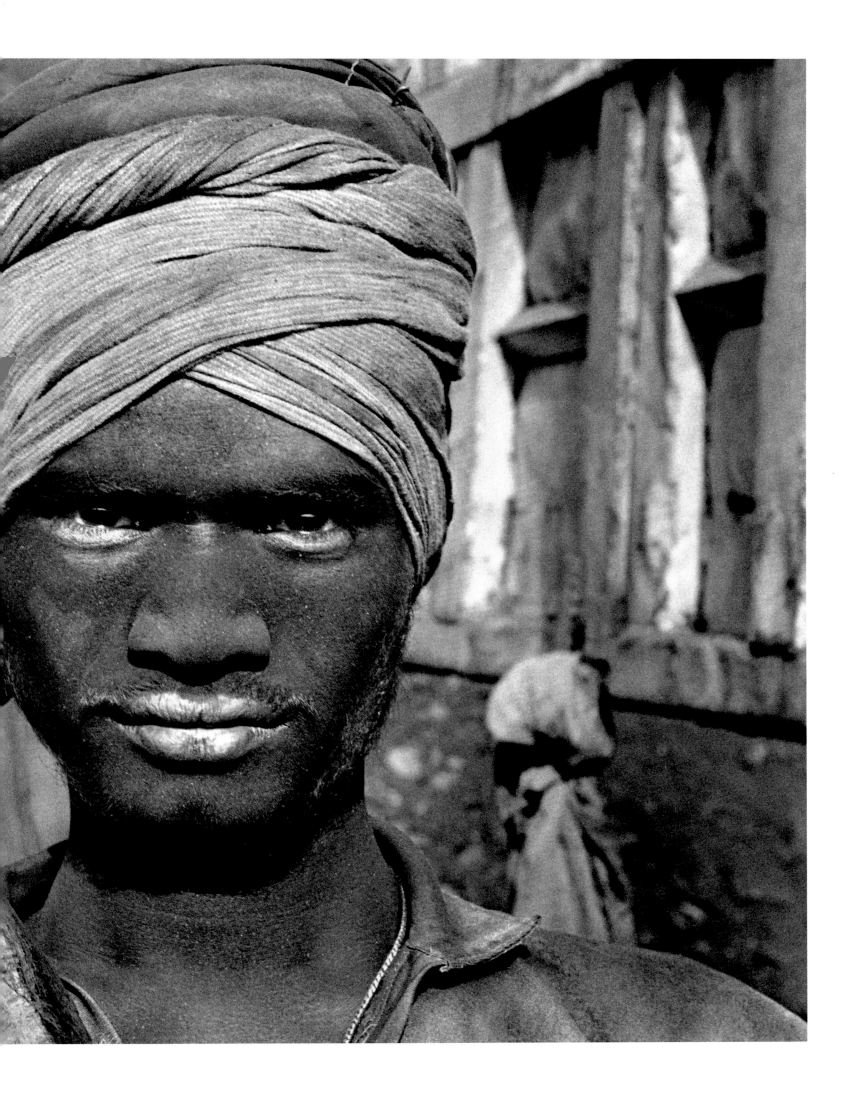

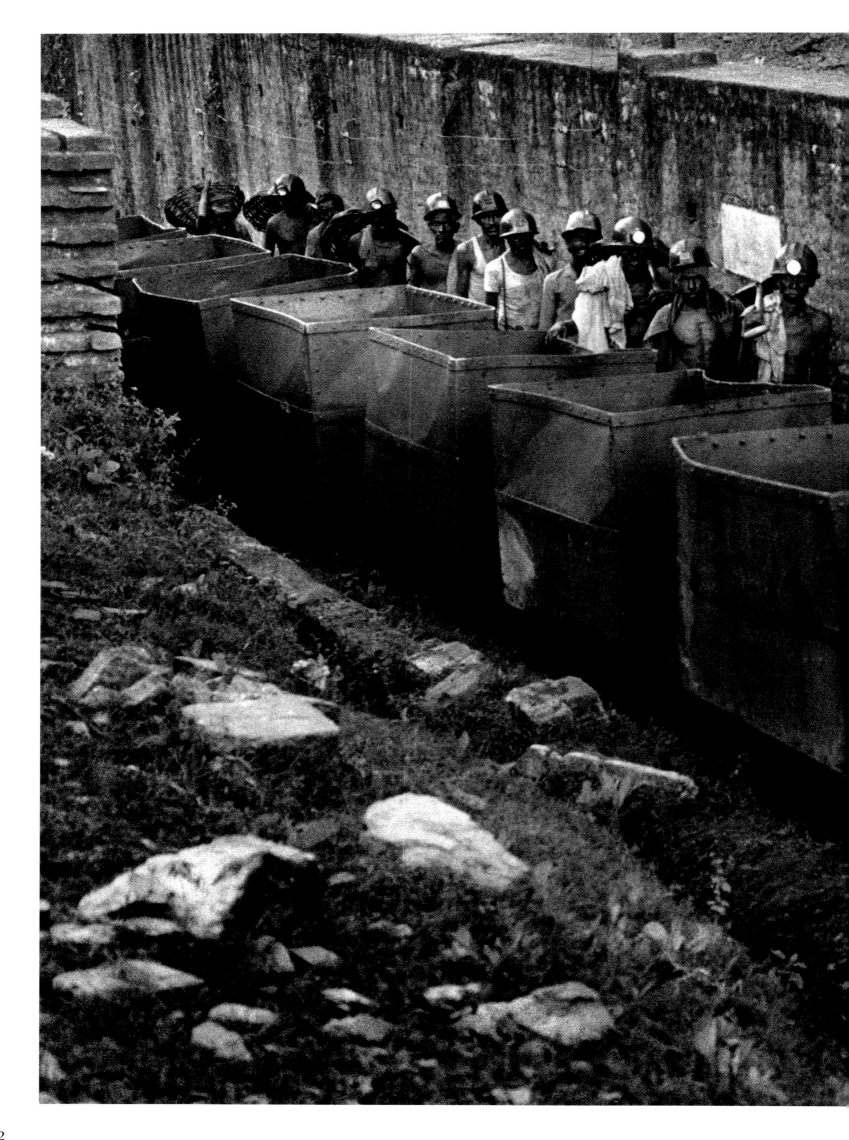

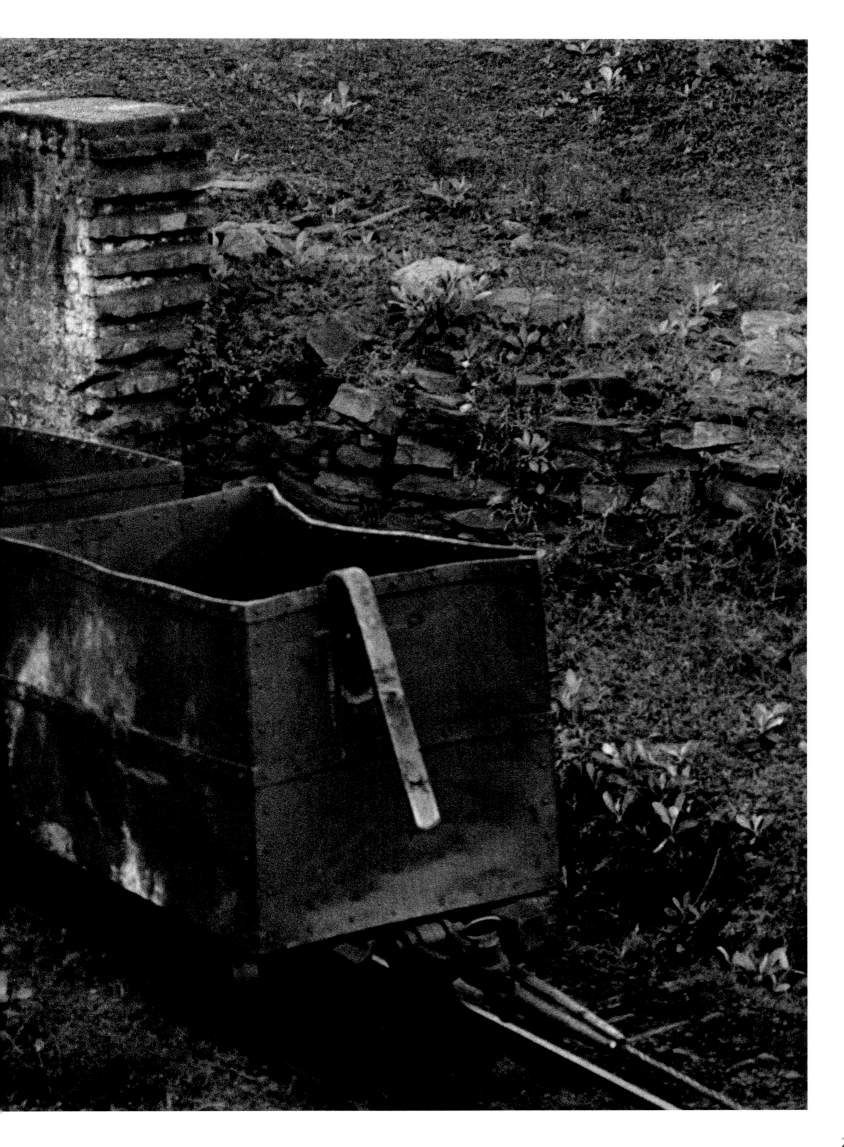

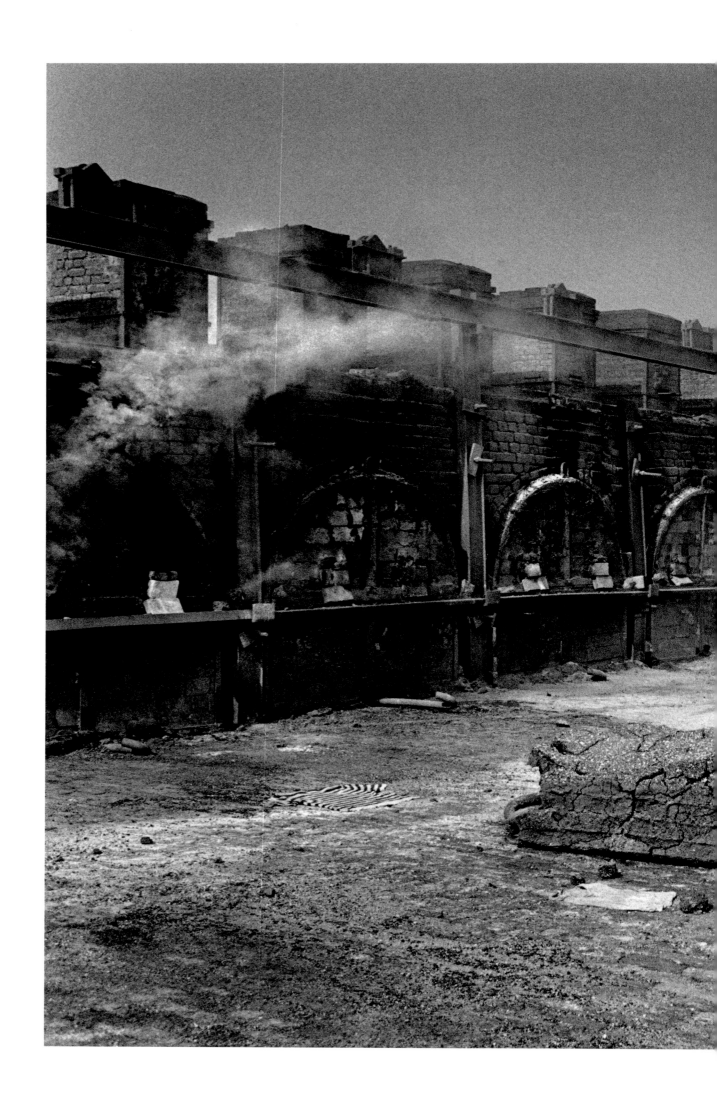

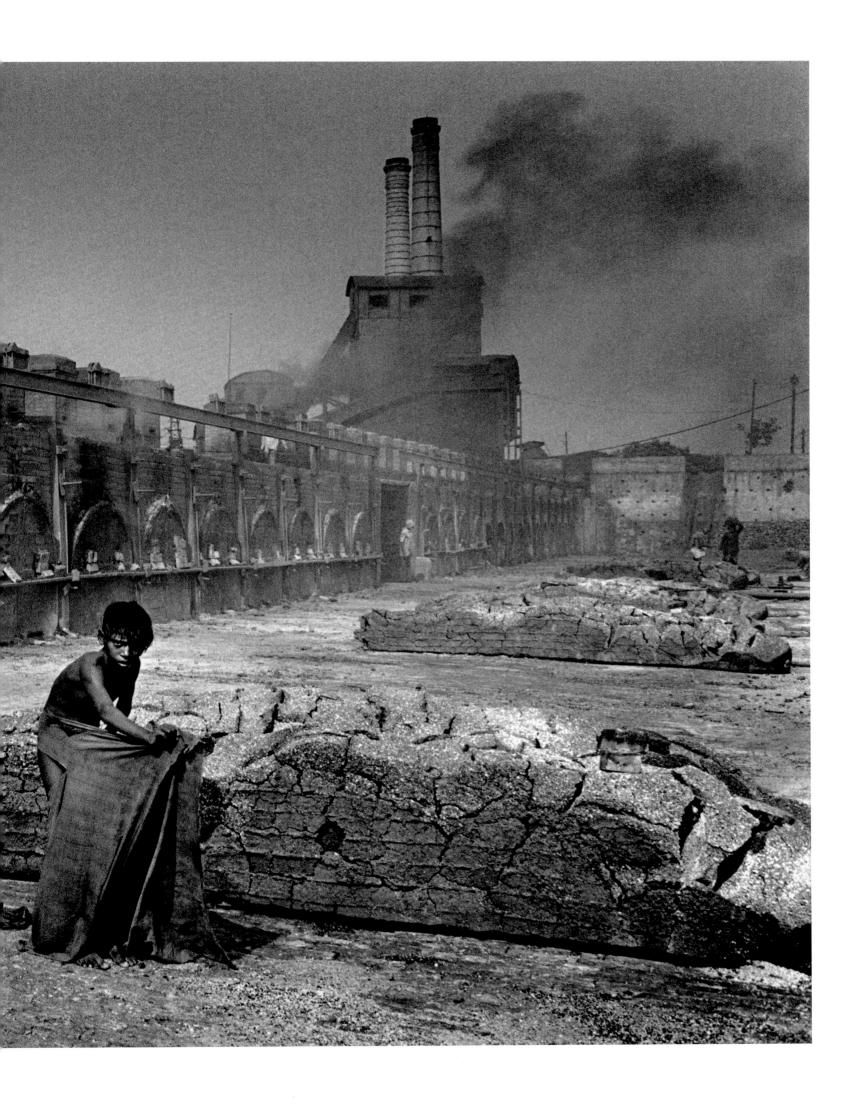

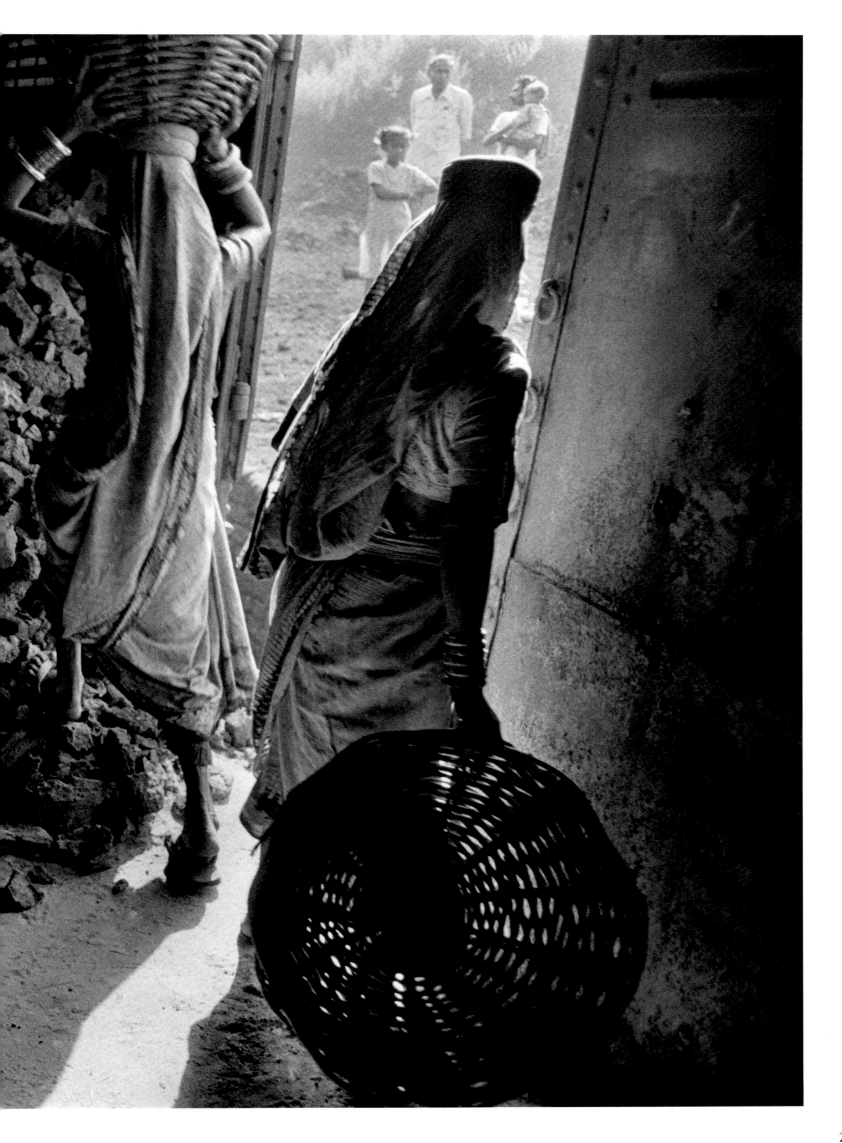

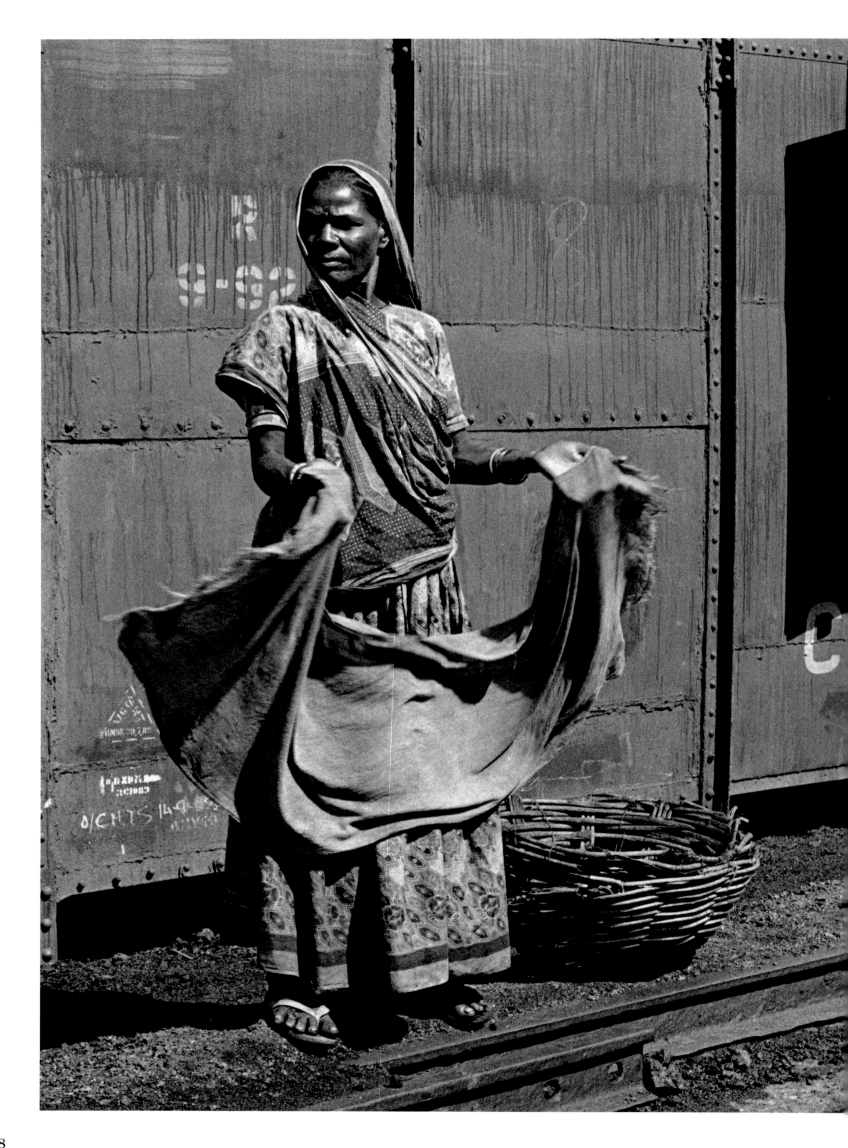

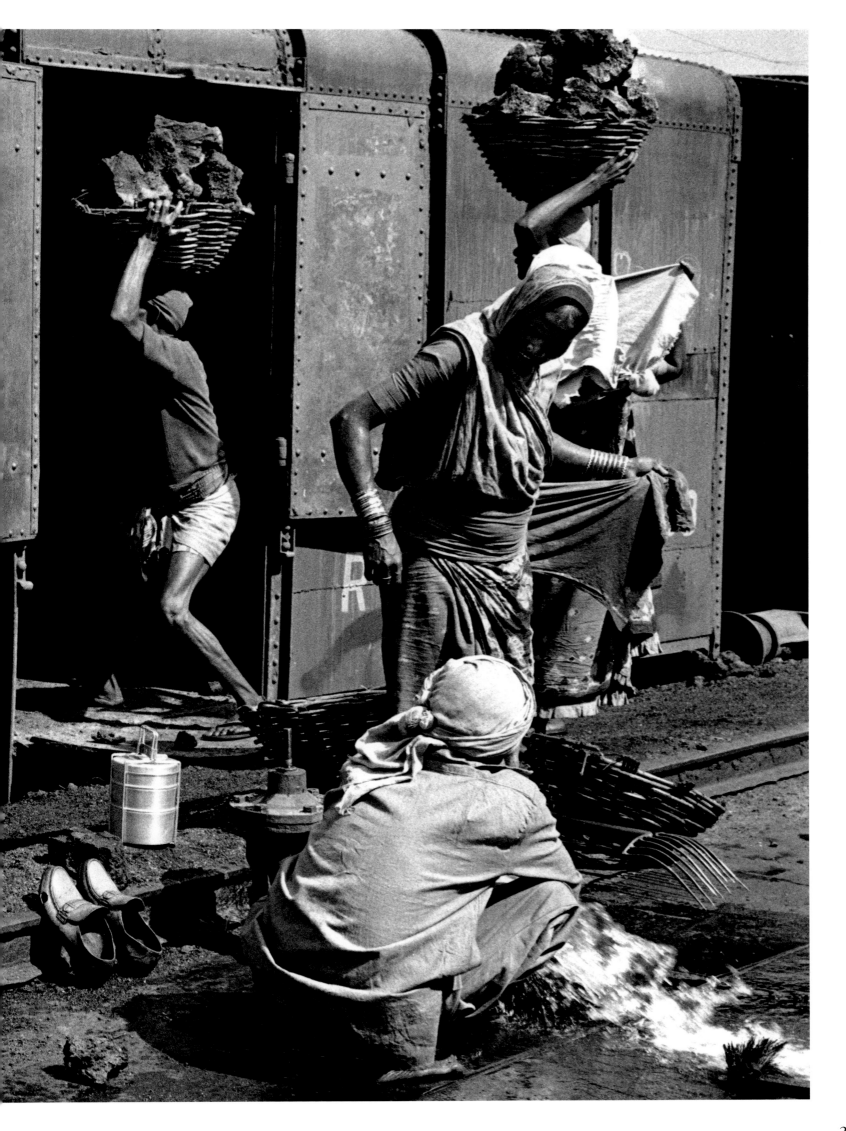

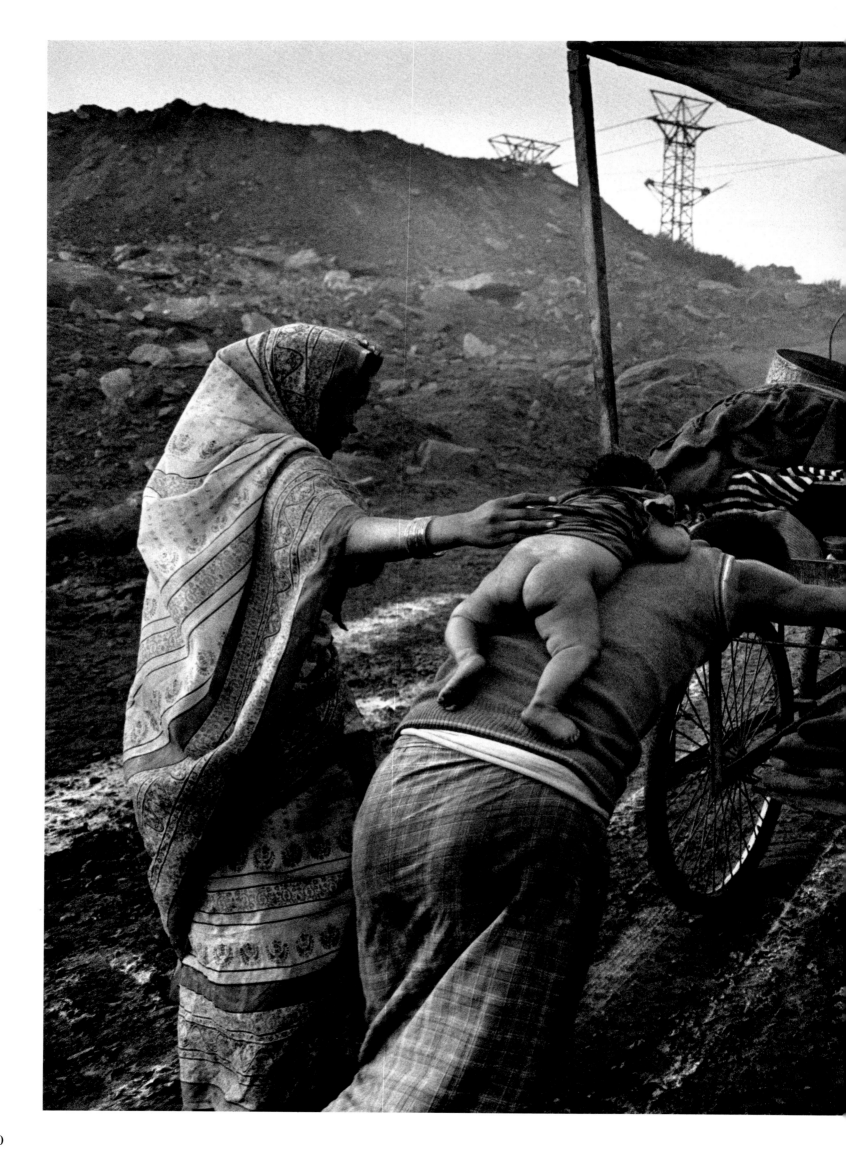

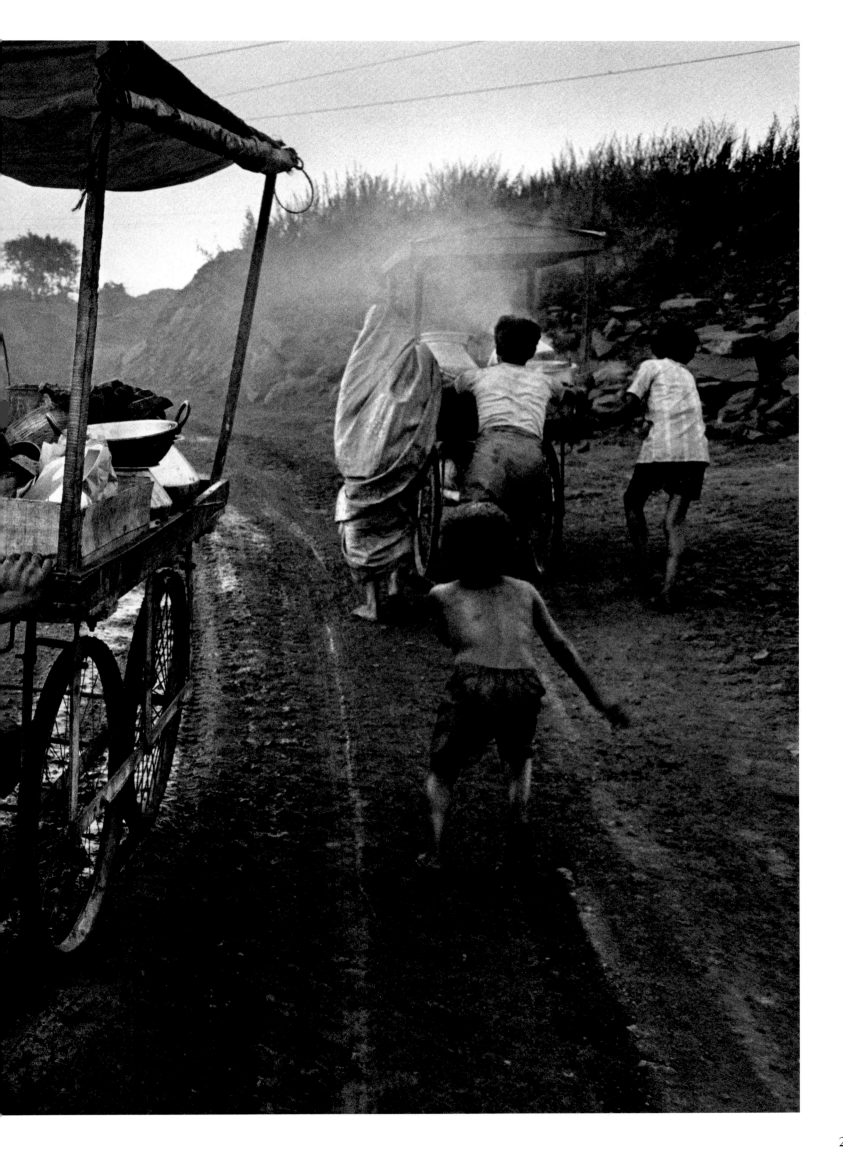

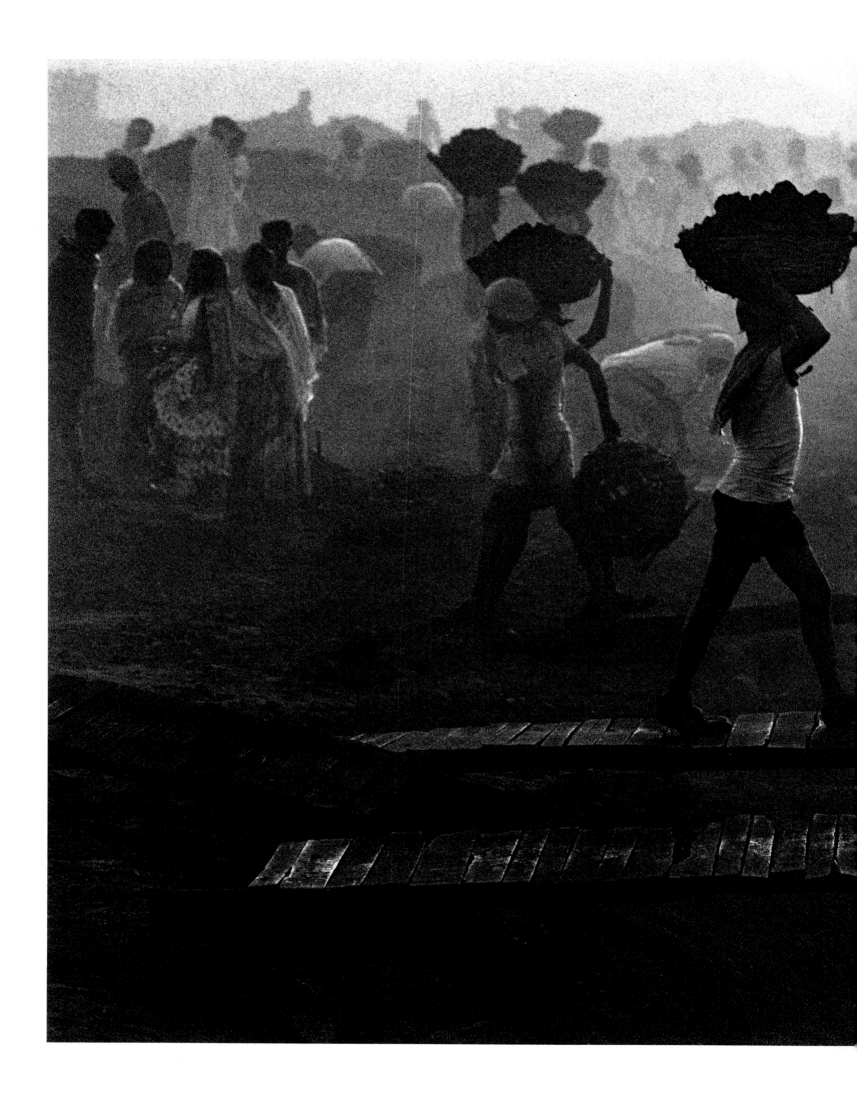

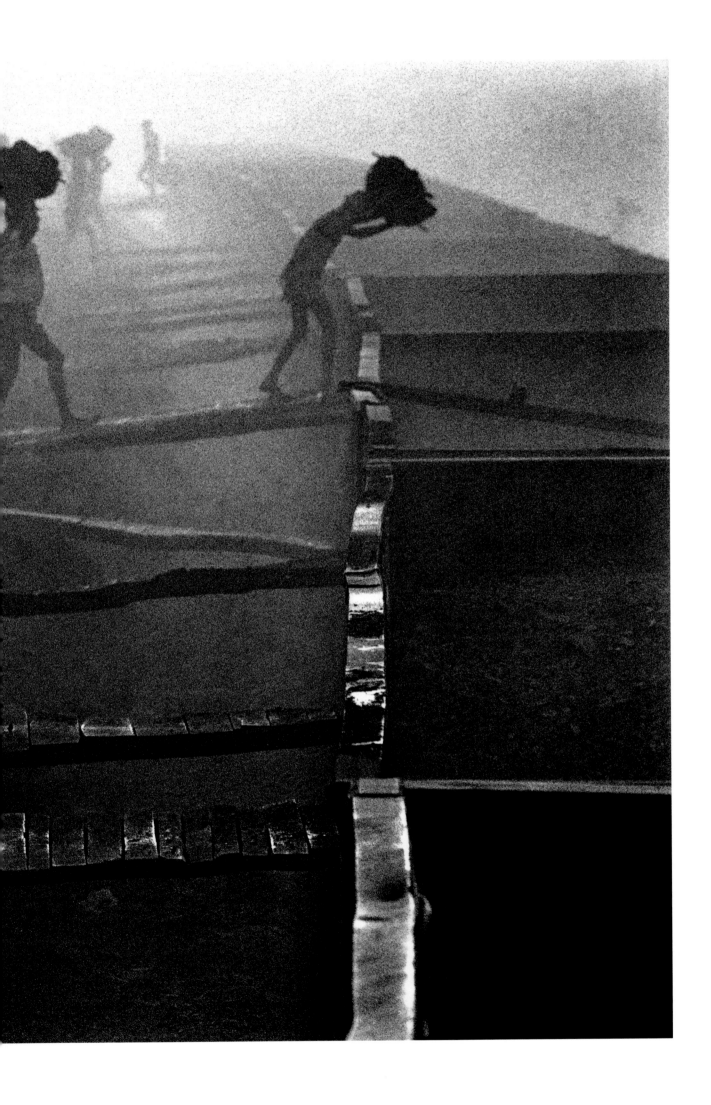

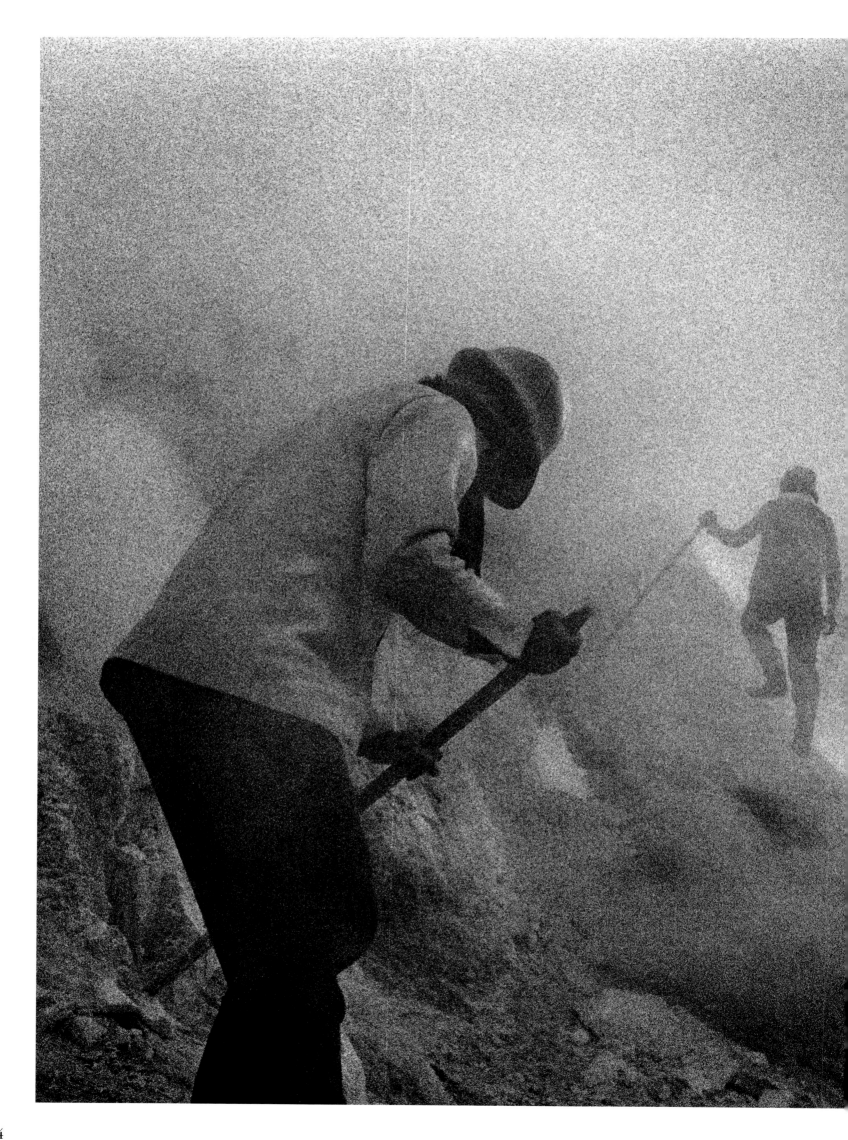

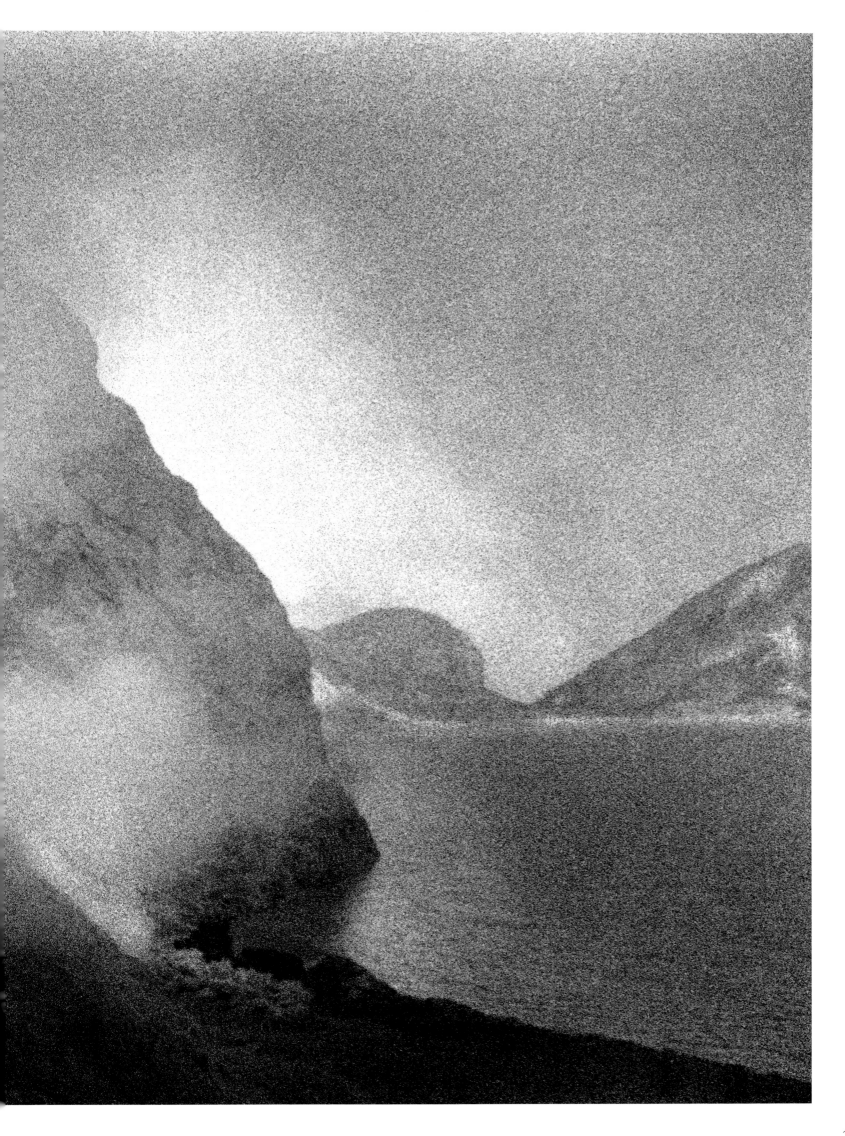

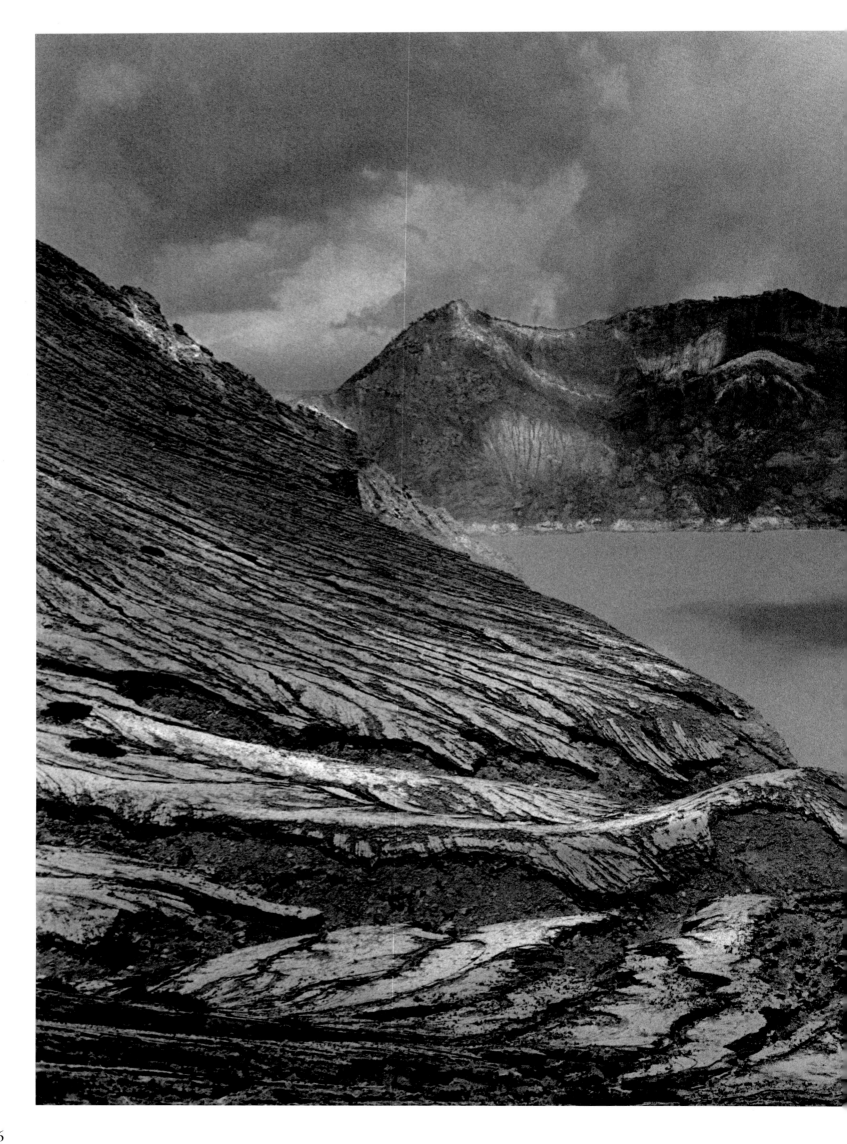

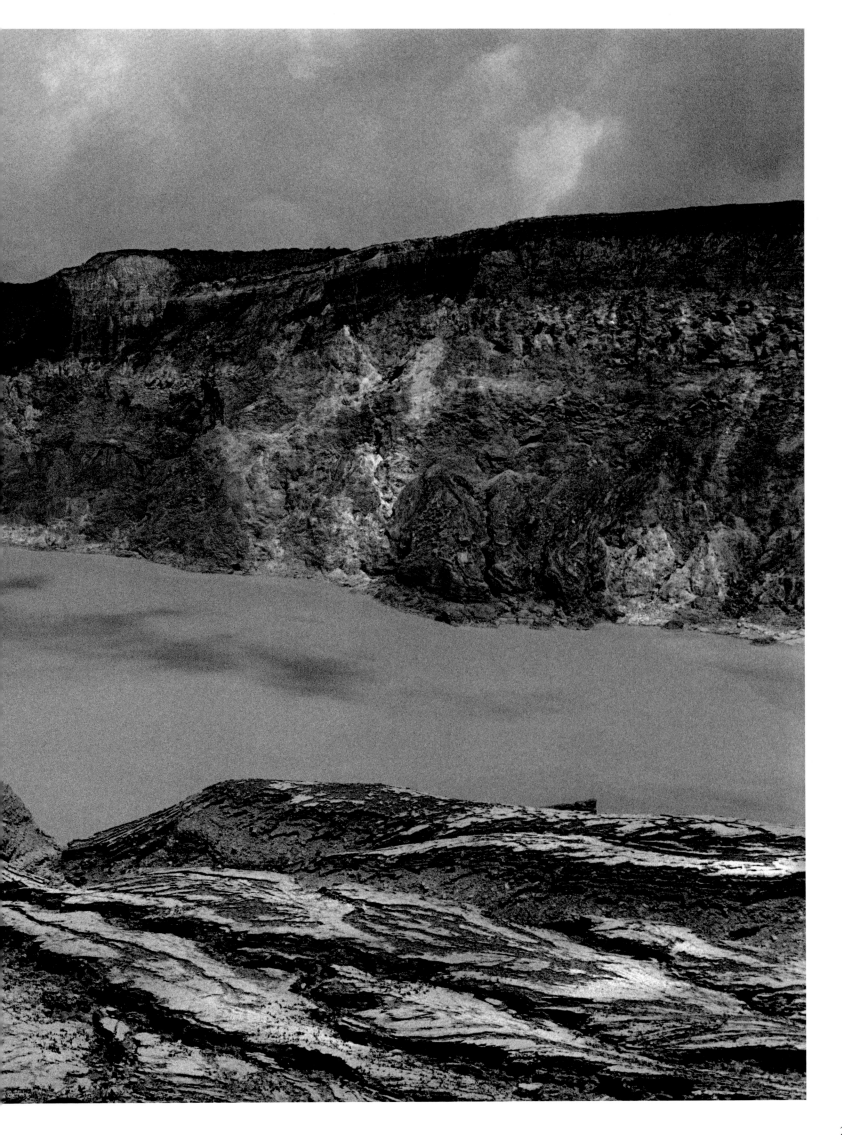

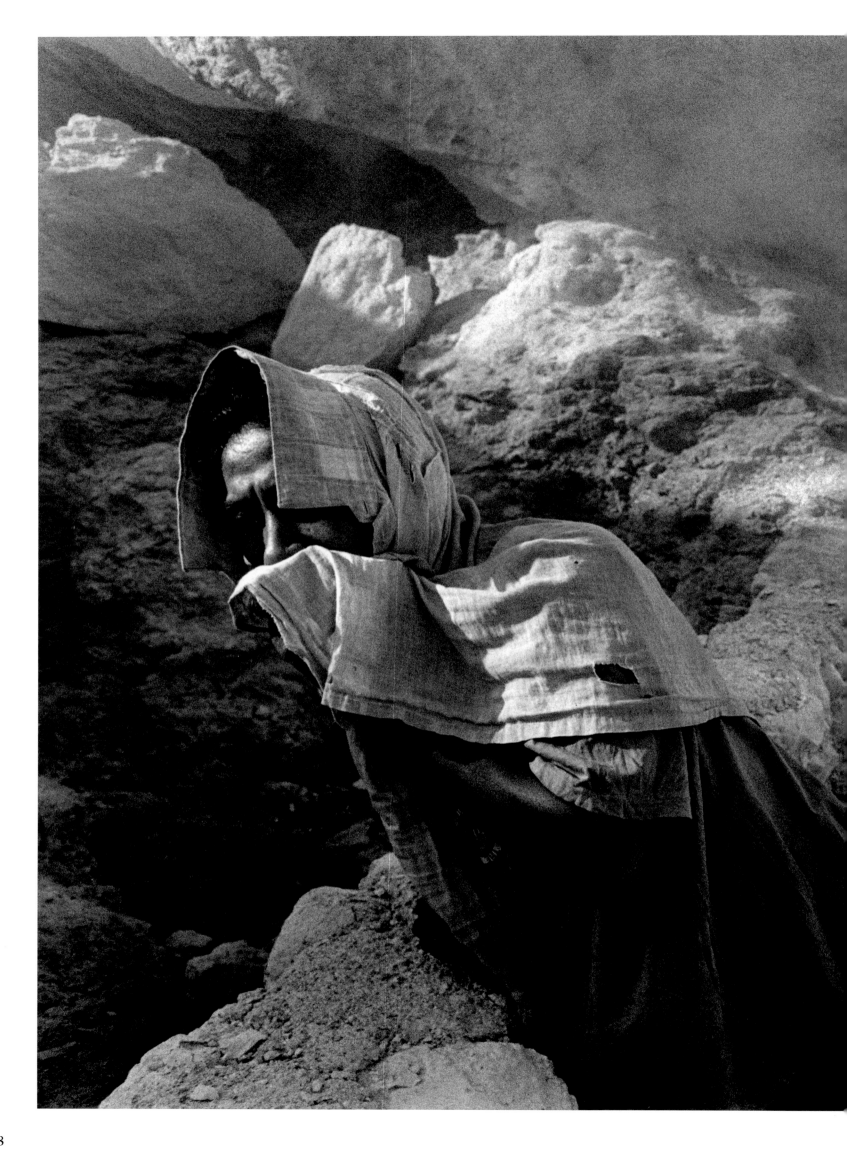

288

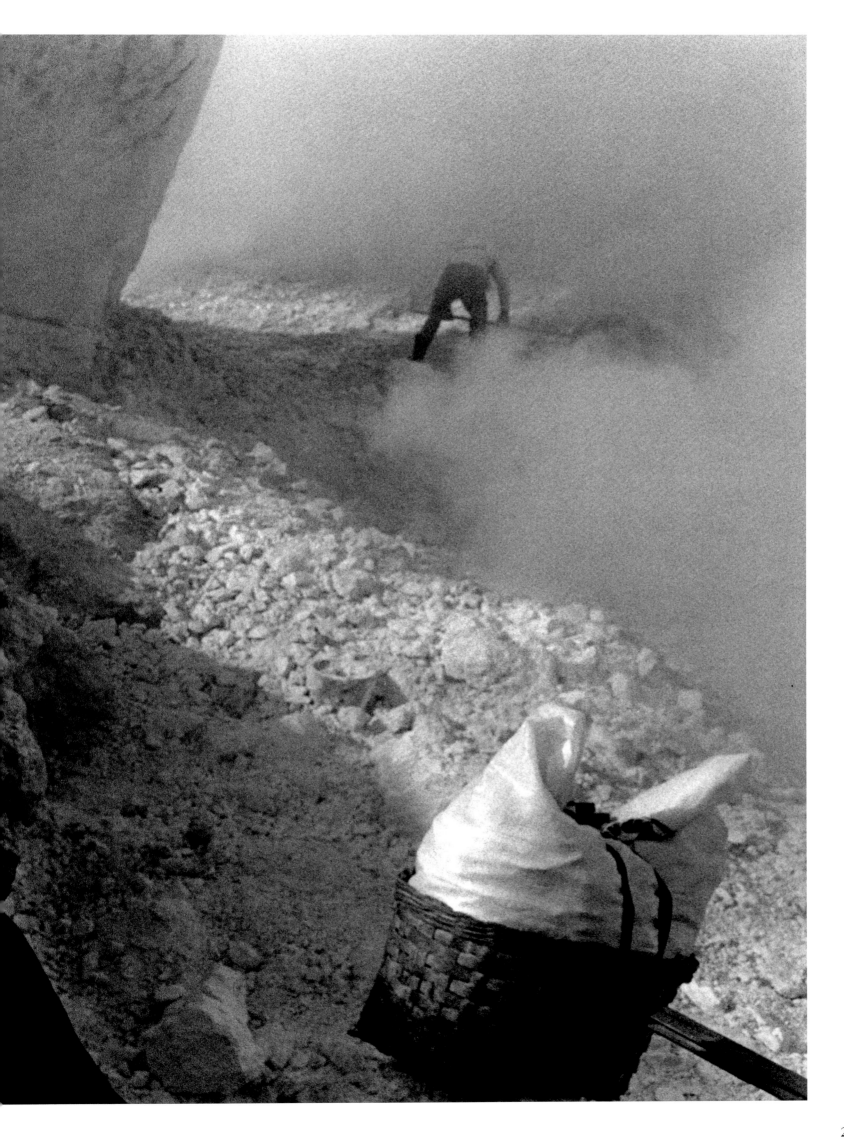

289

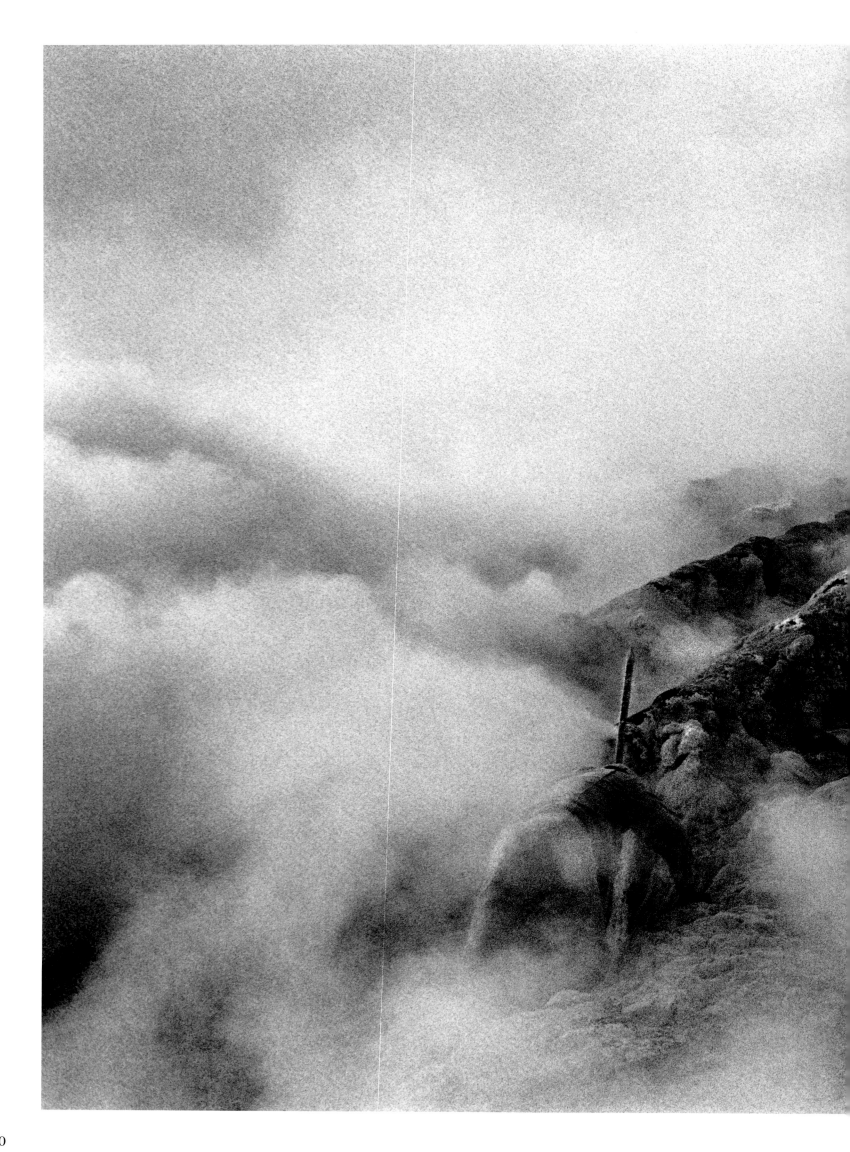

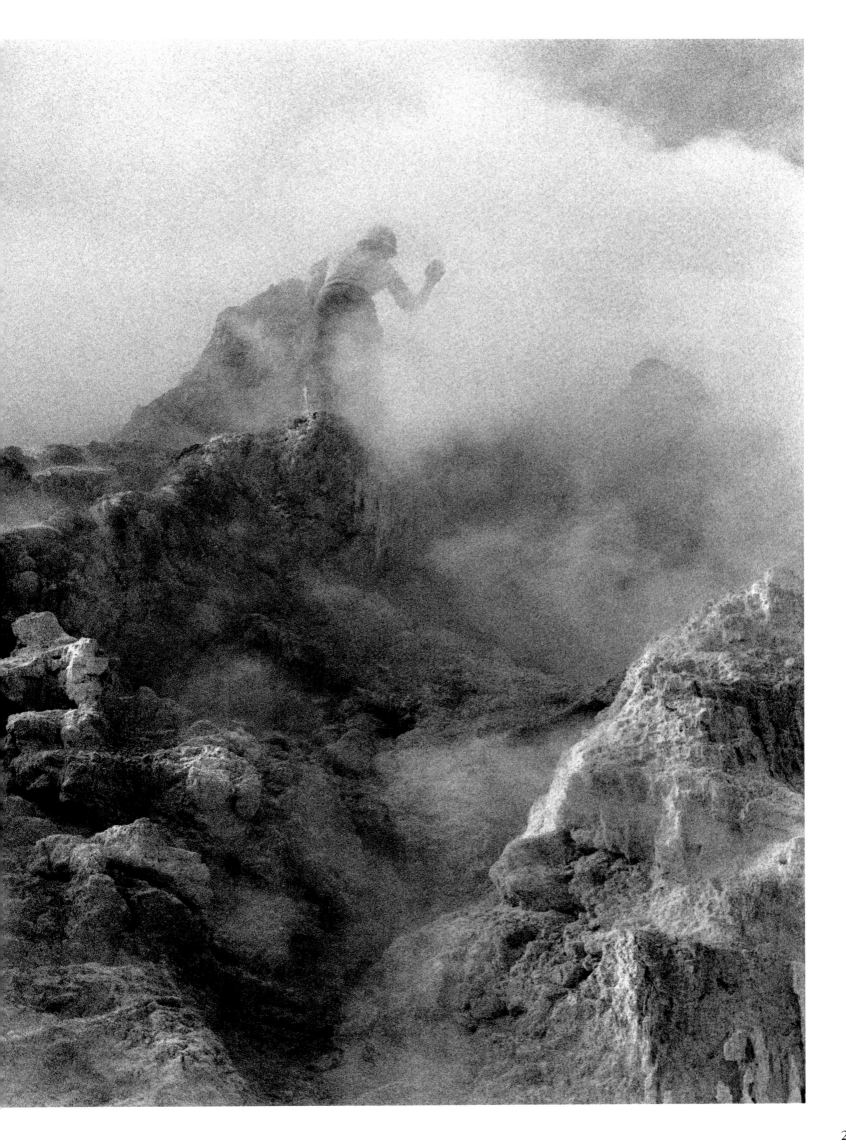

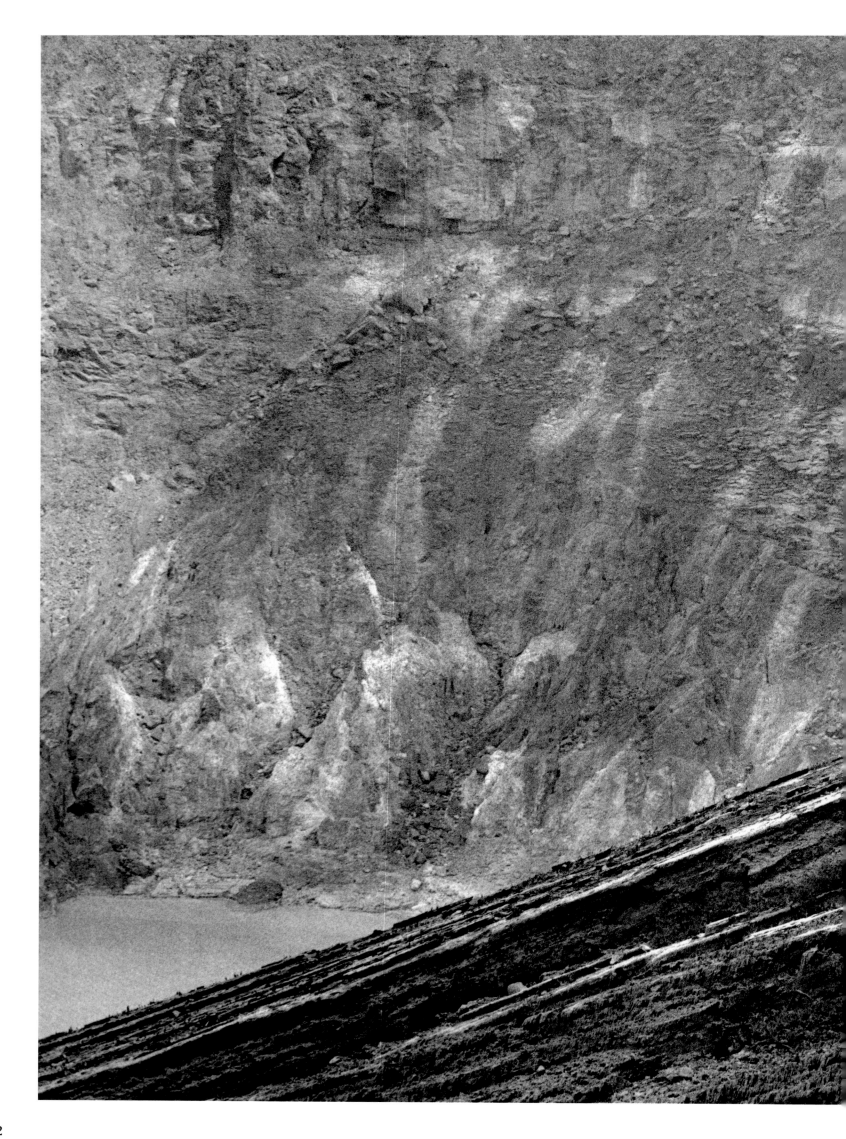

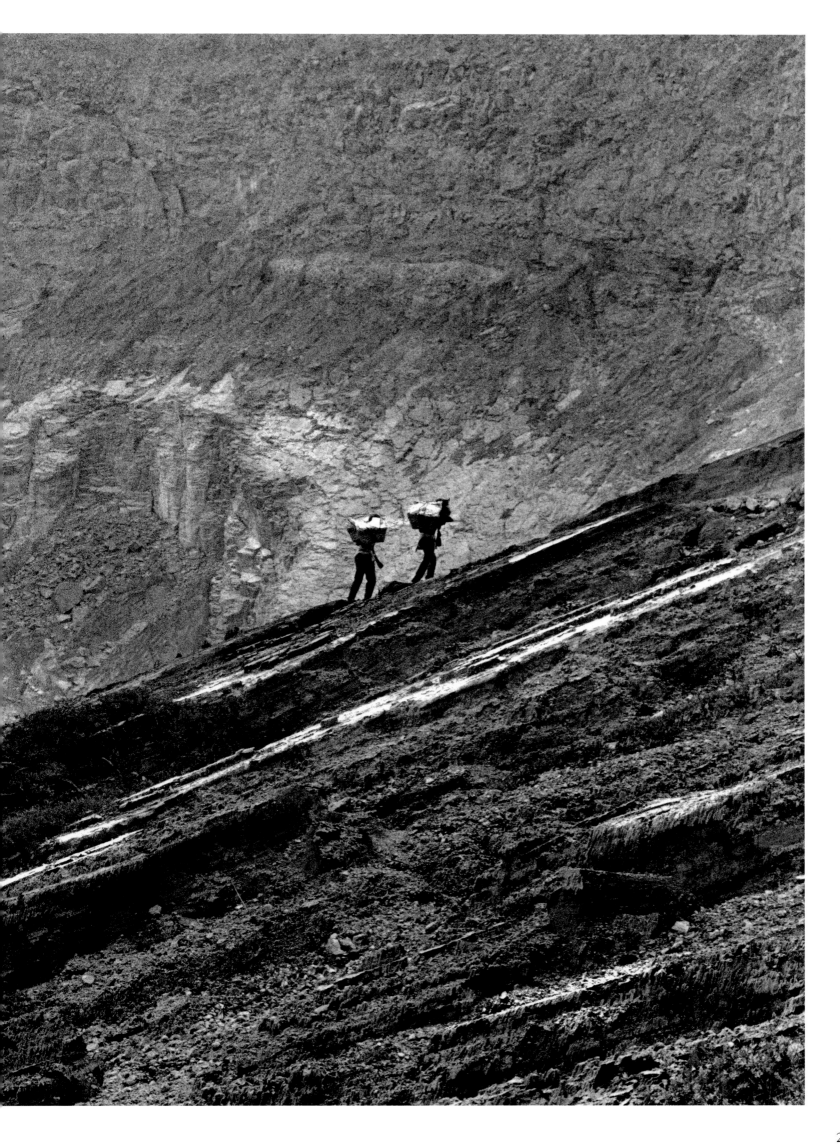

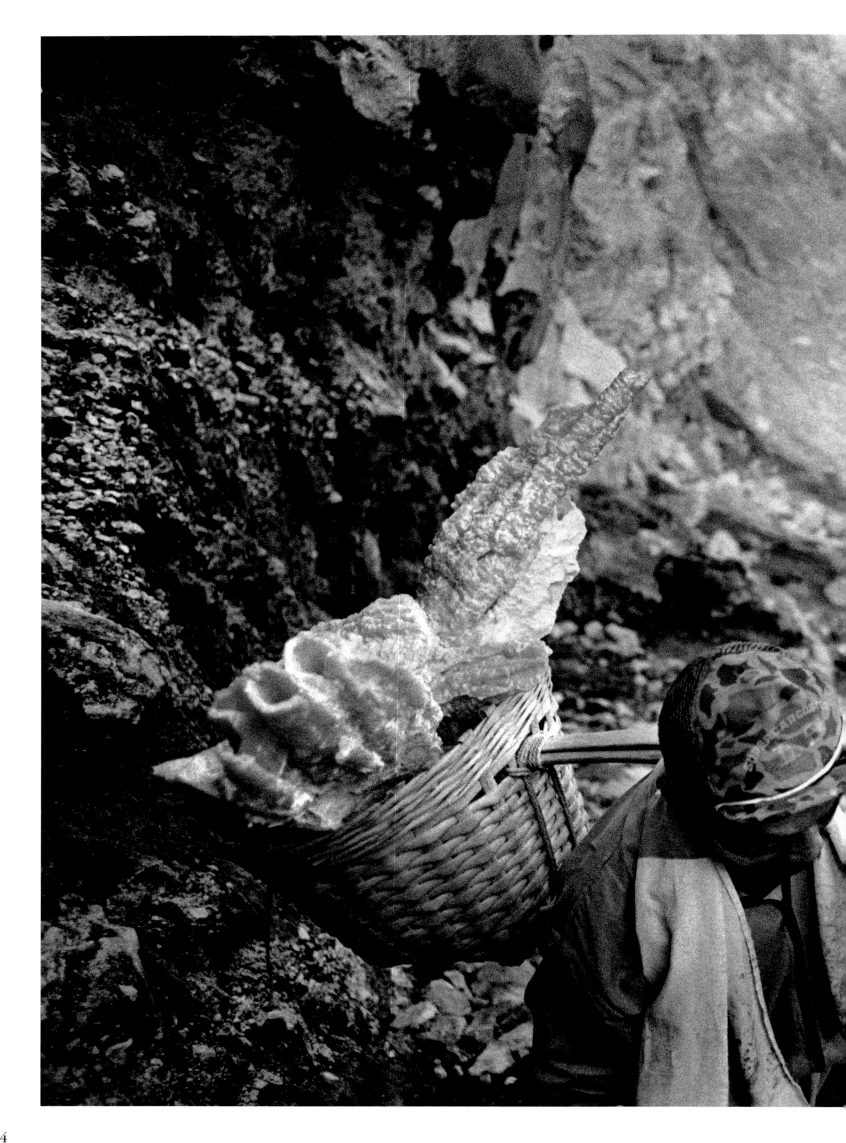

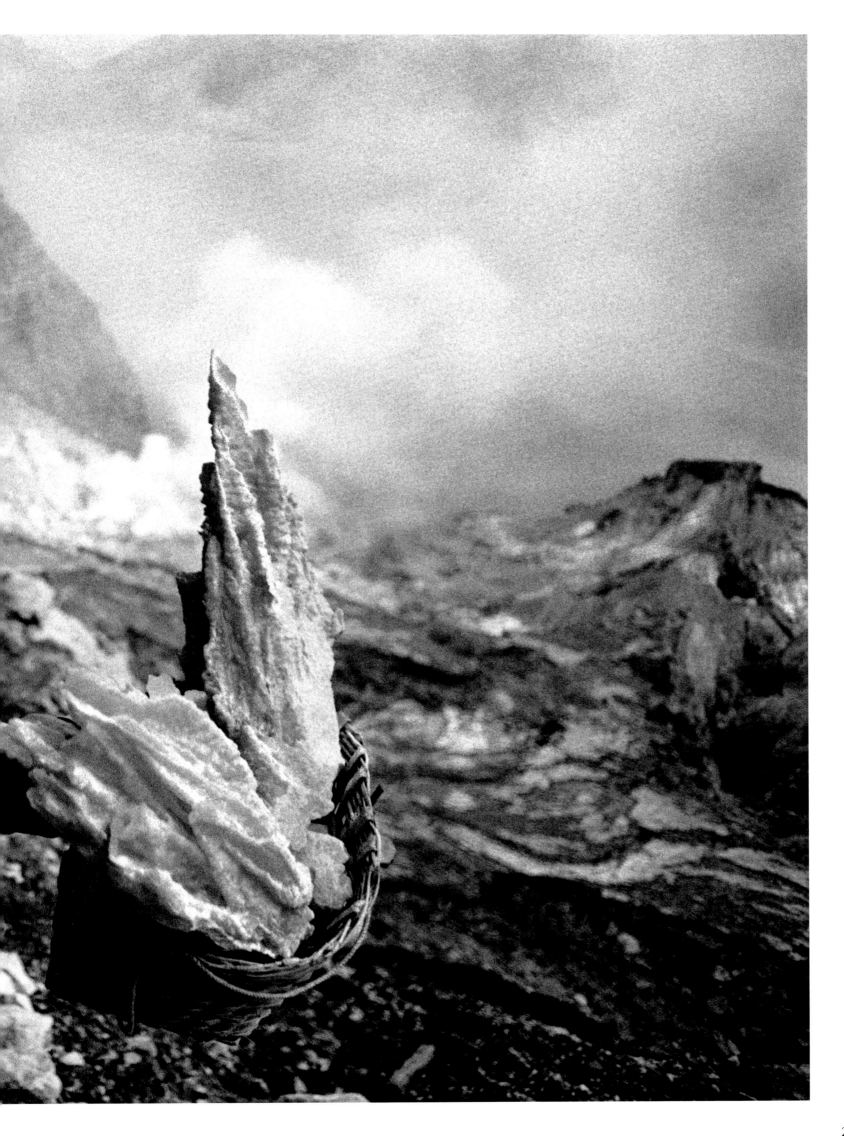

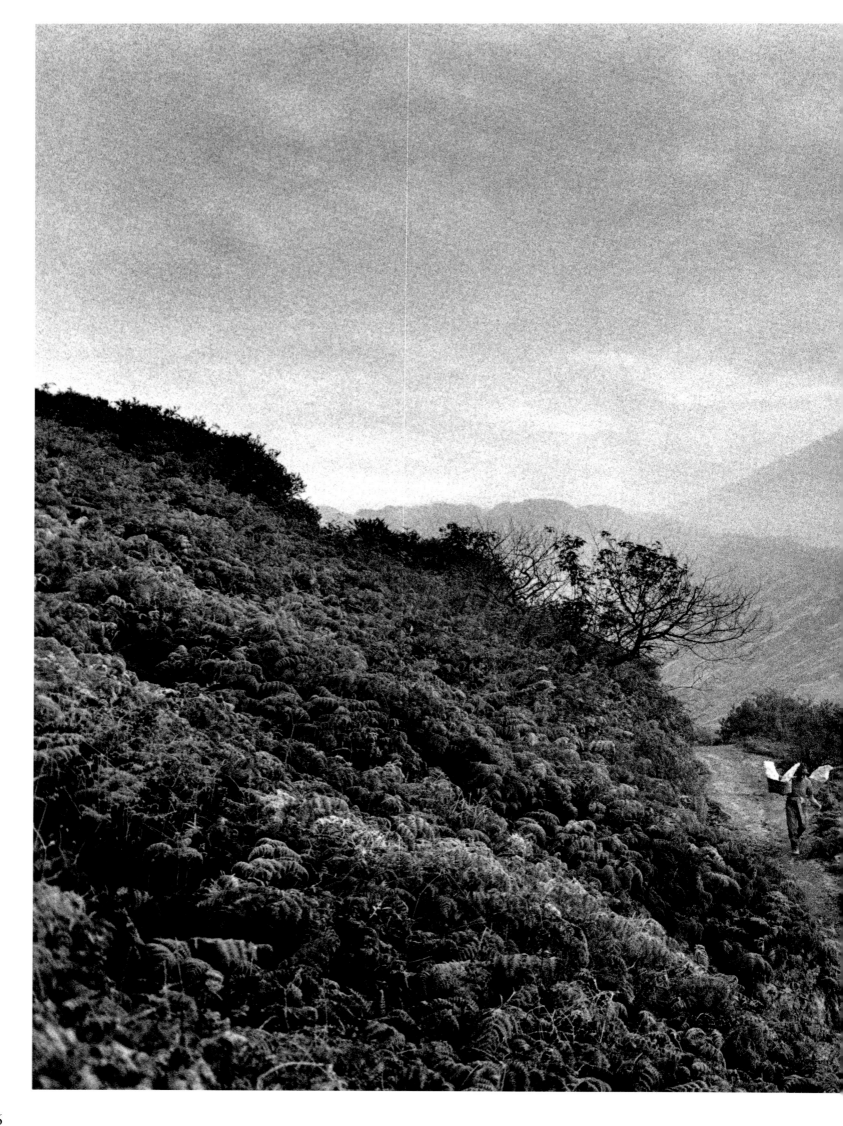

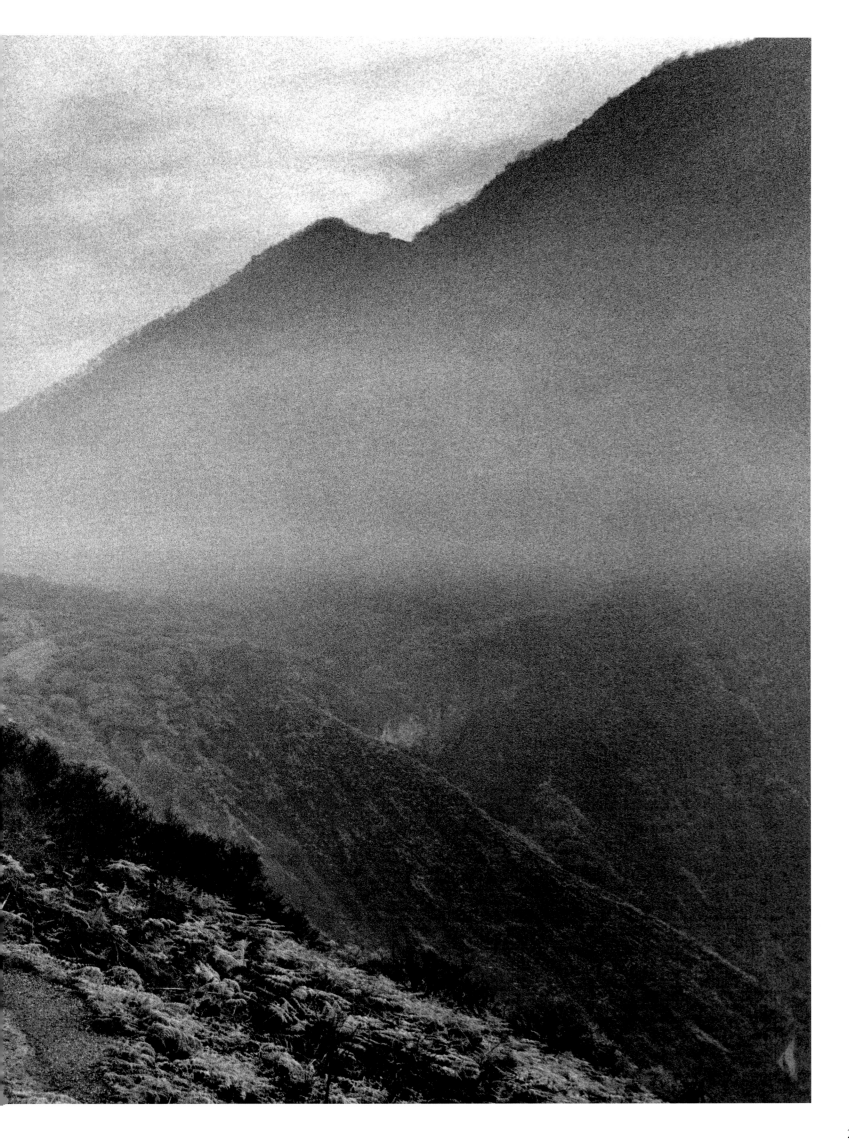

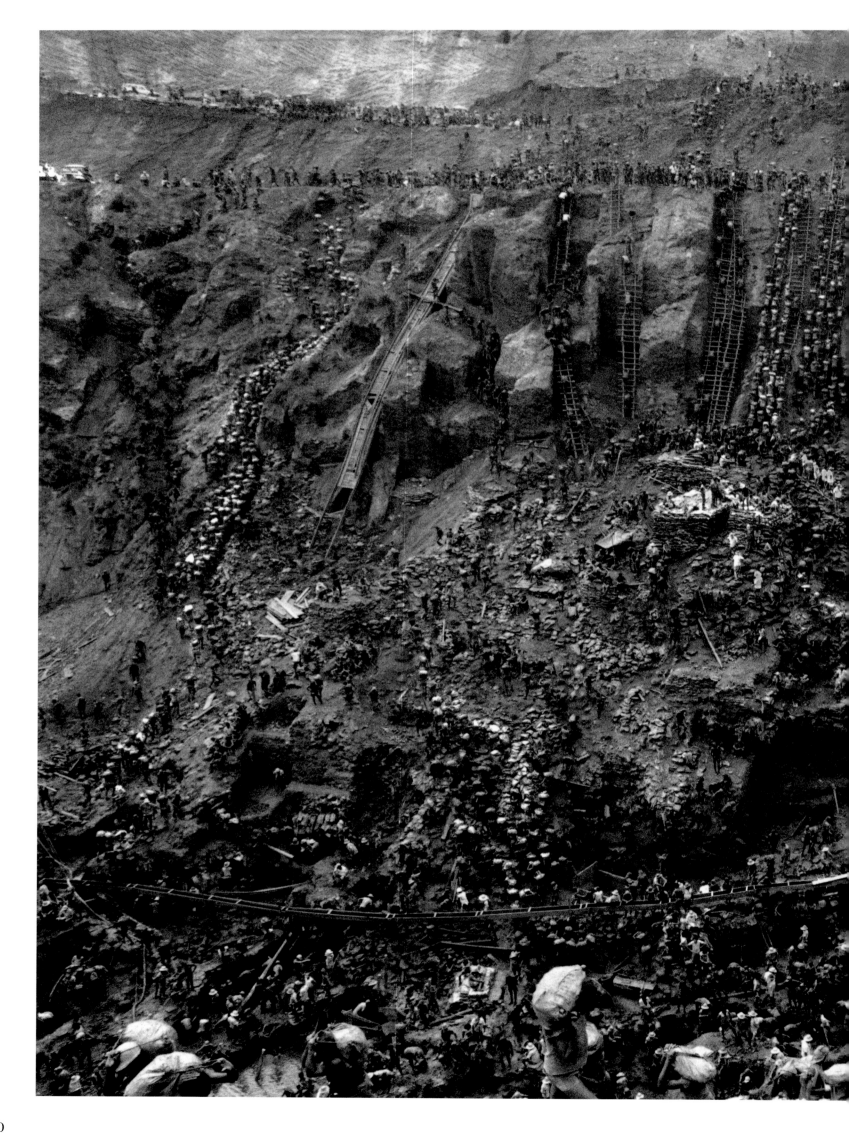

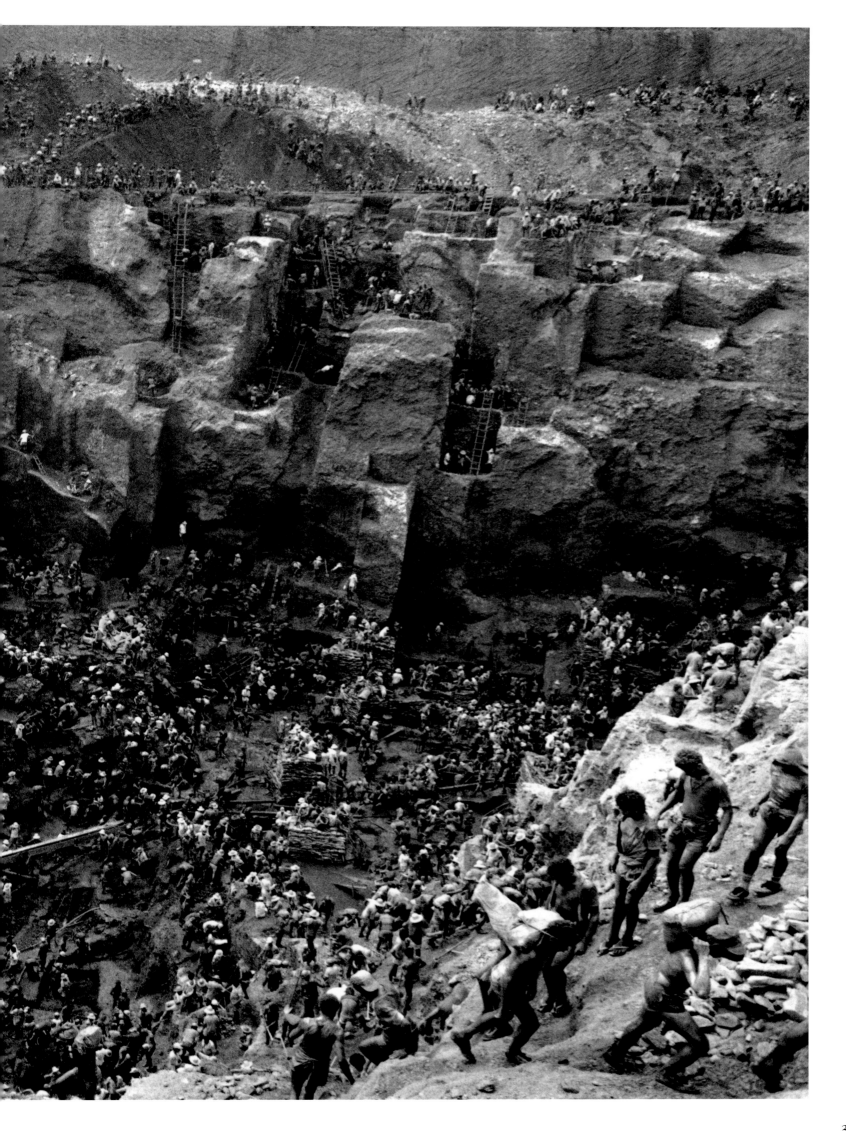

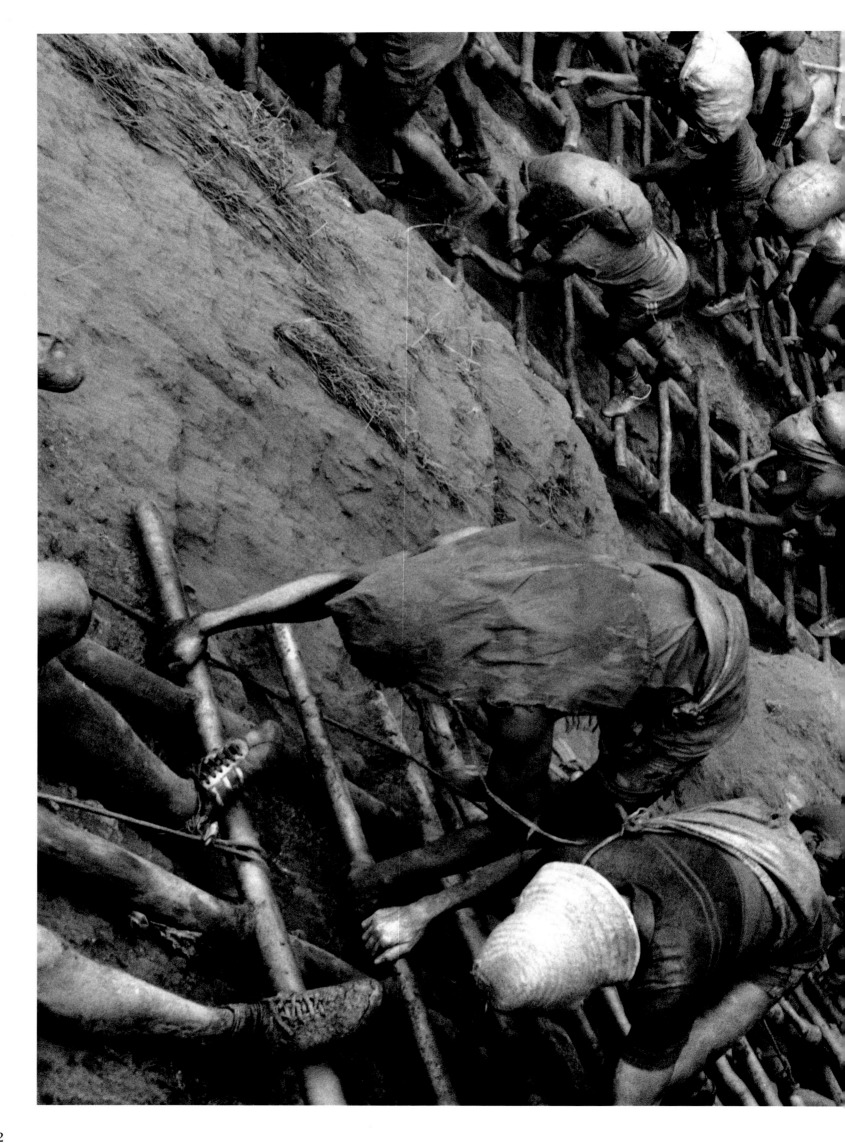

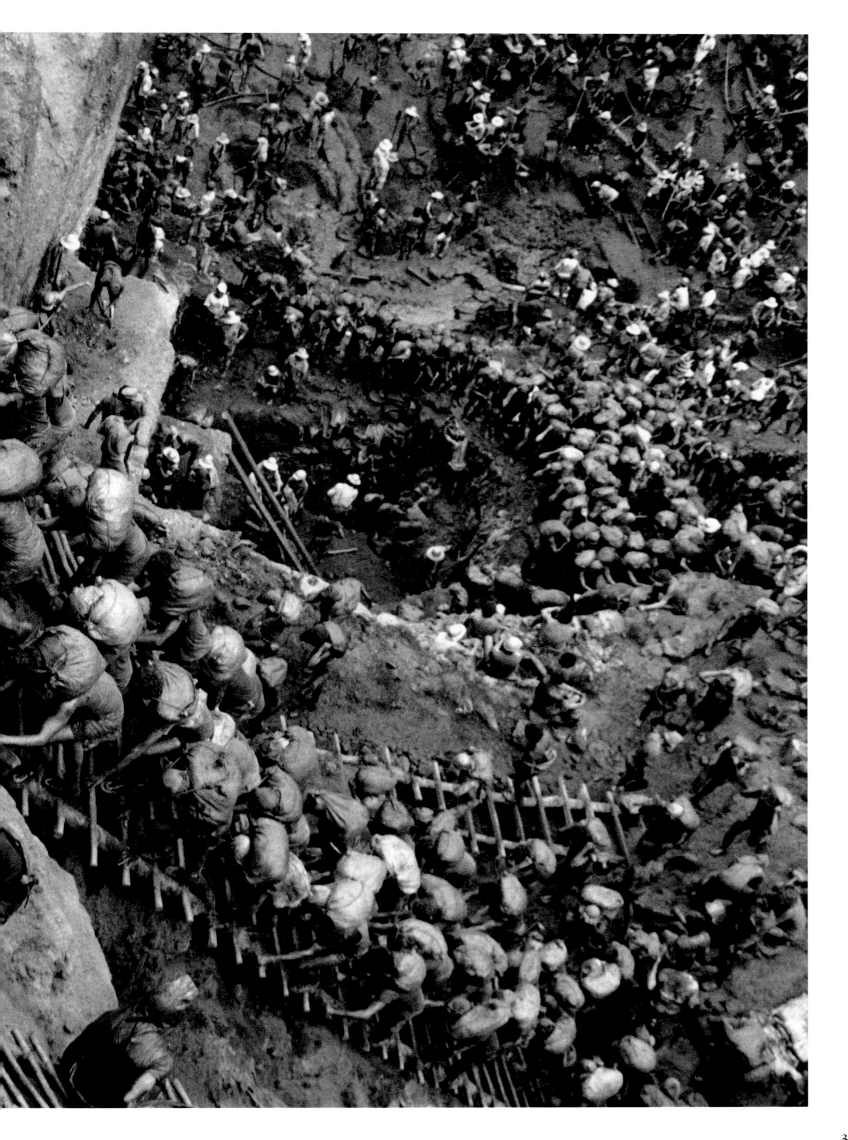

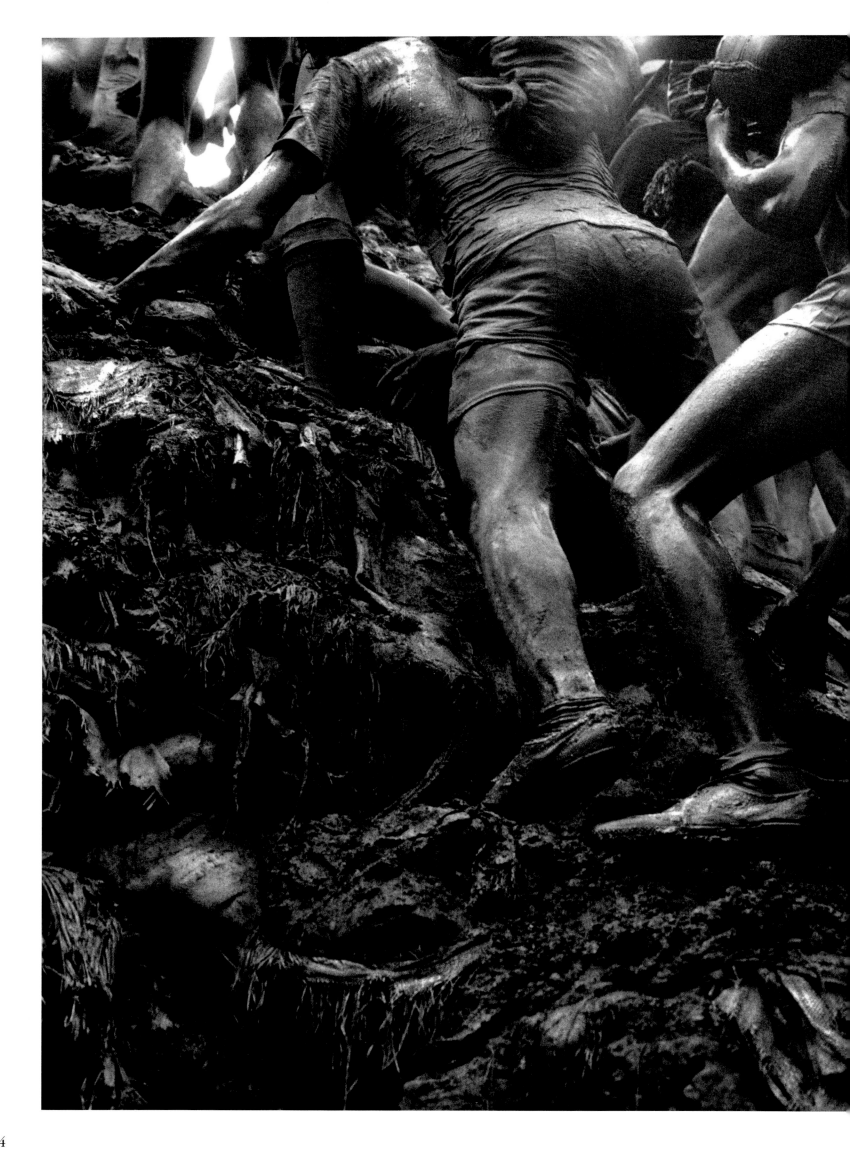

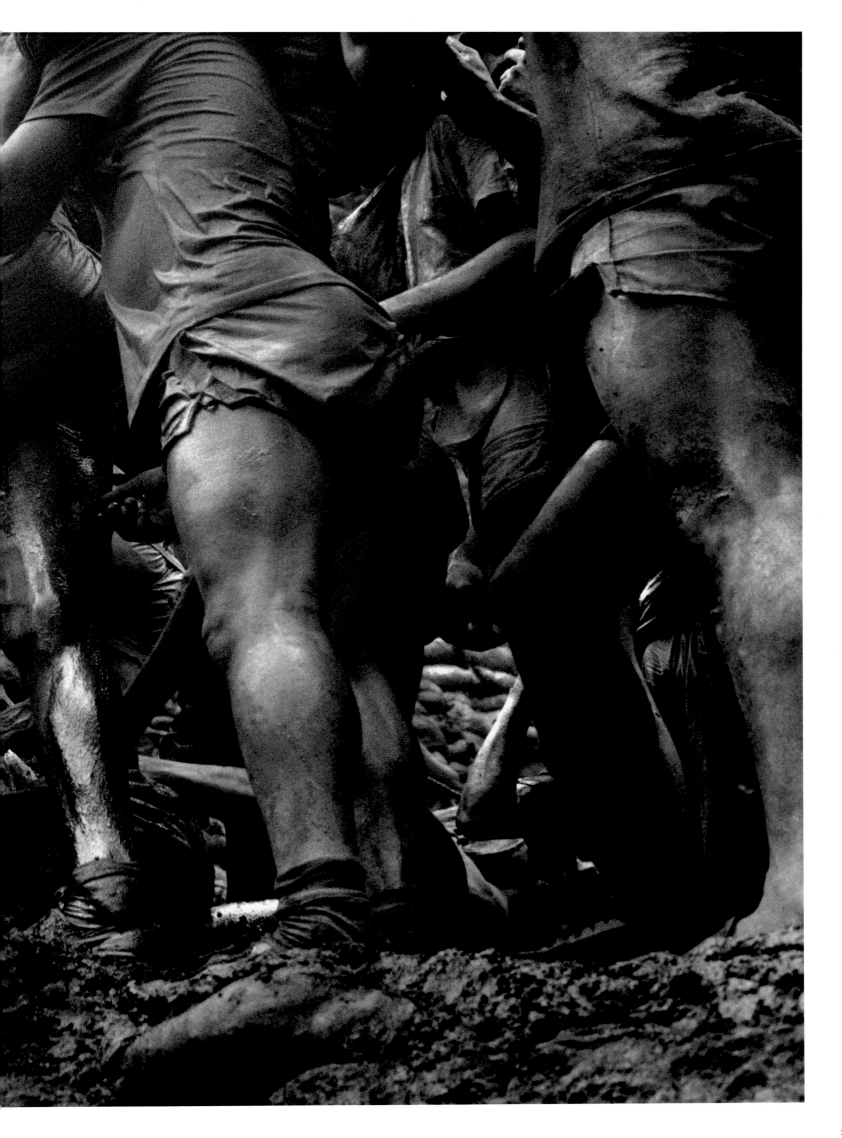

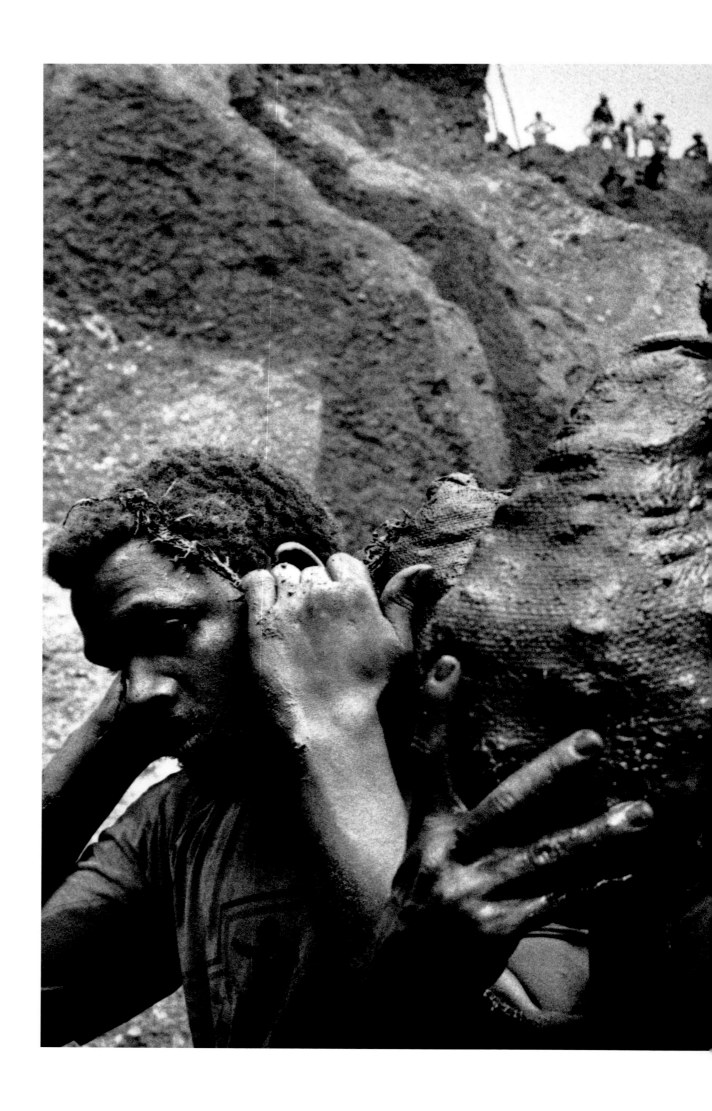

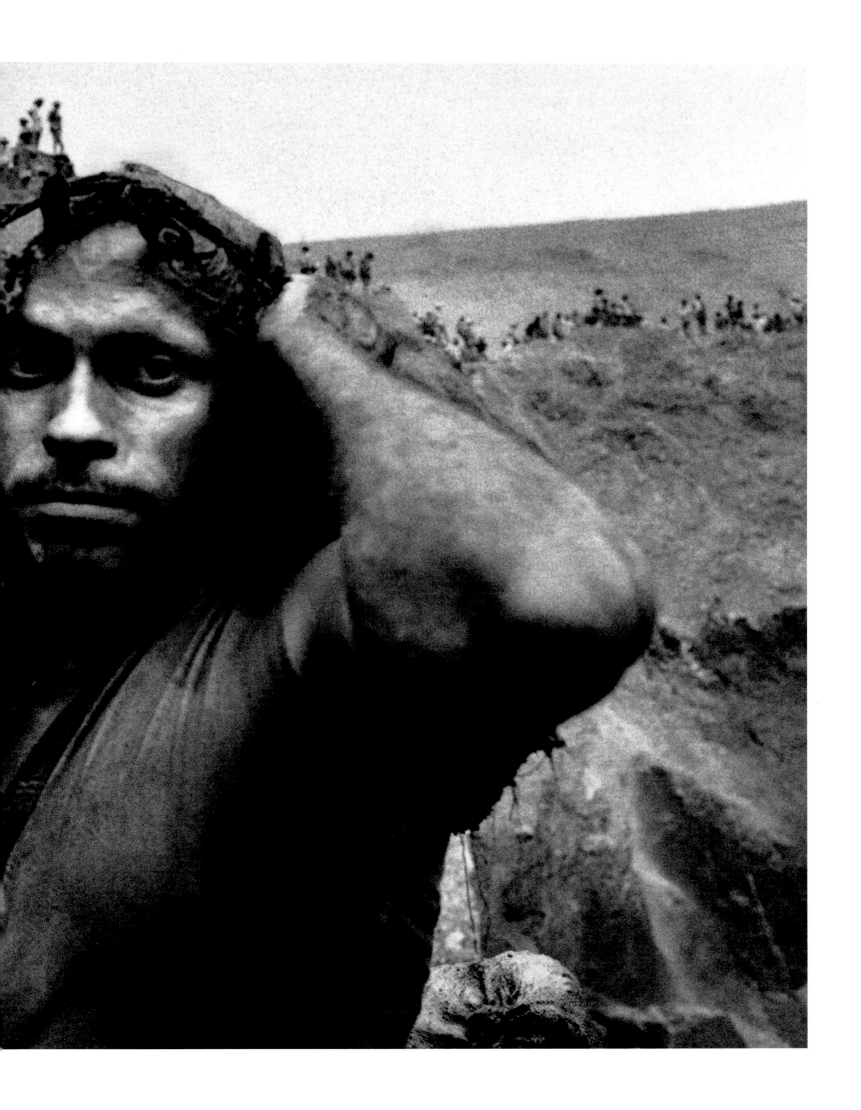

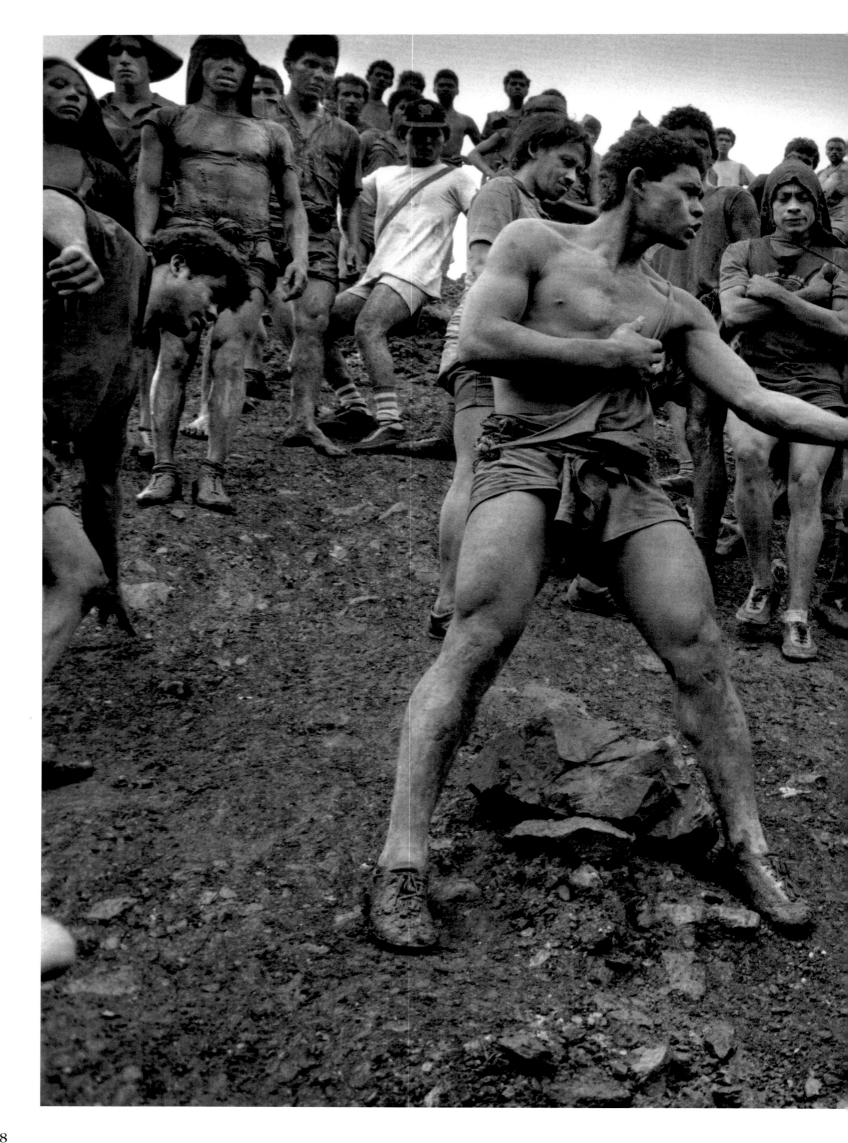

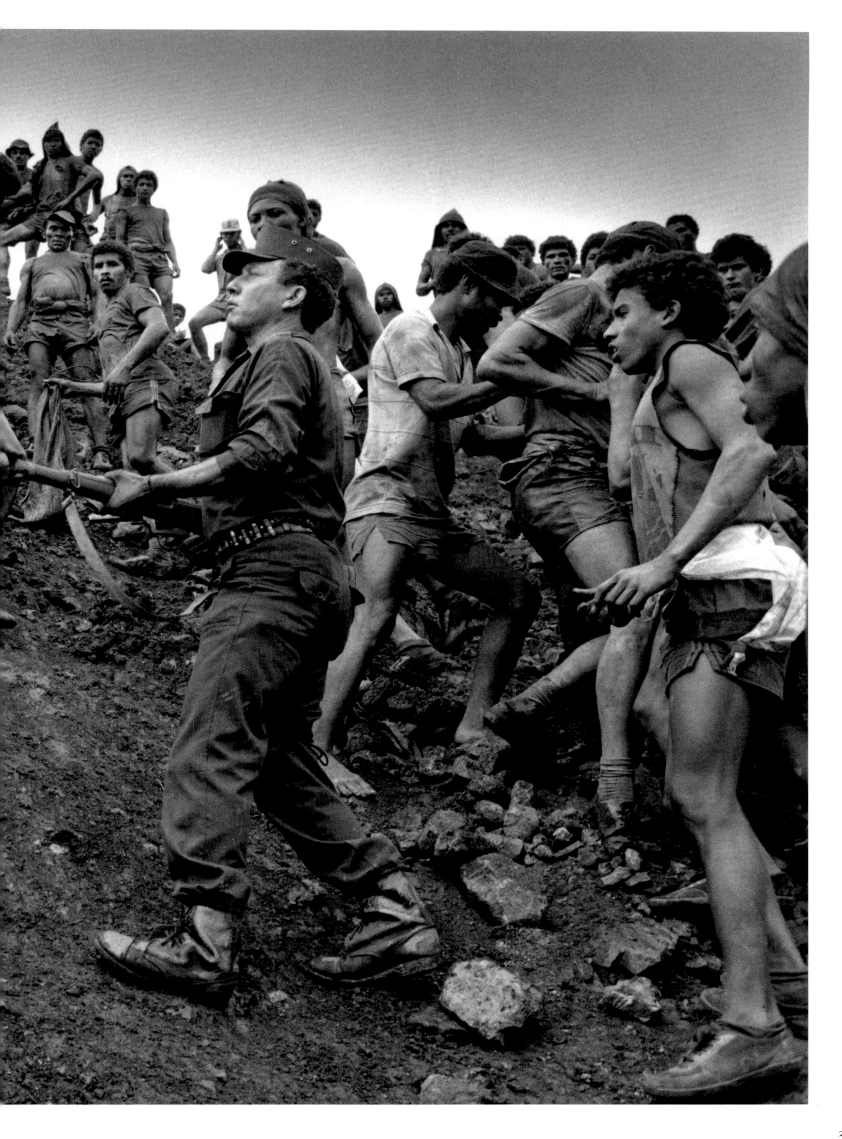

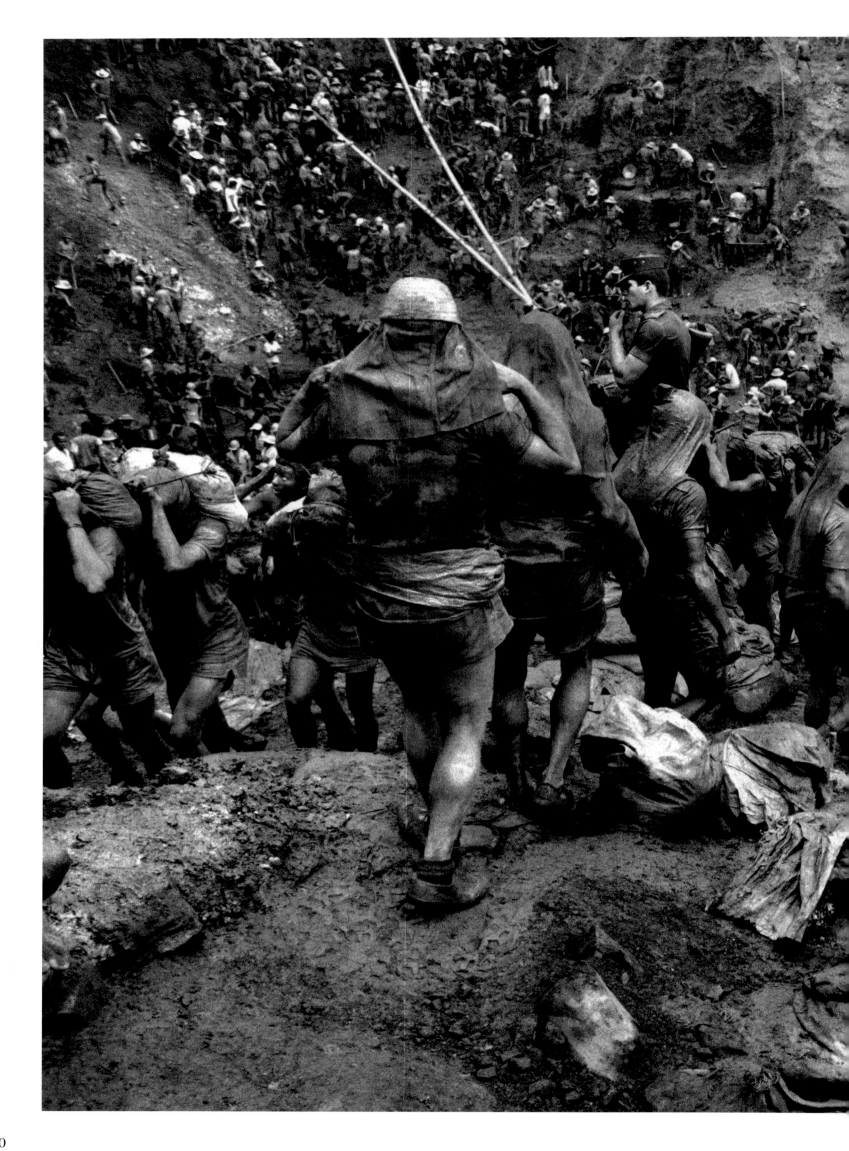

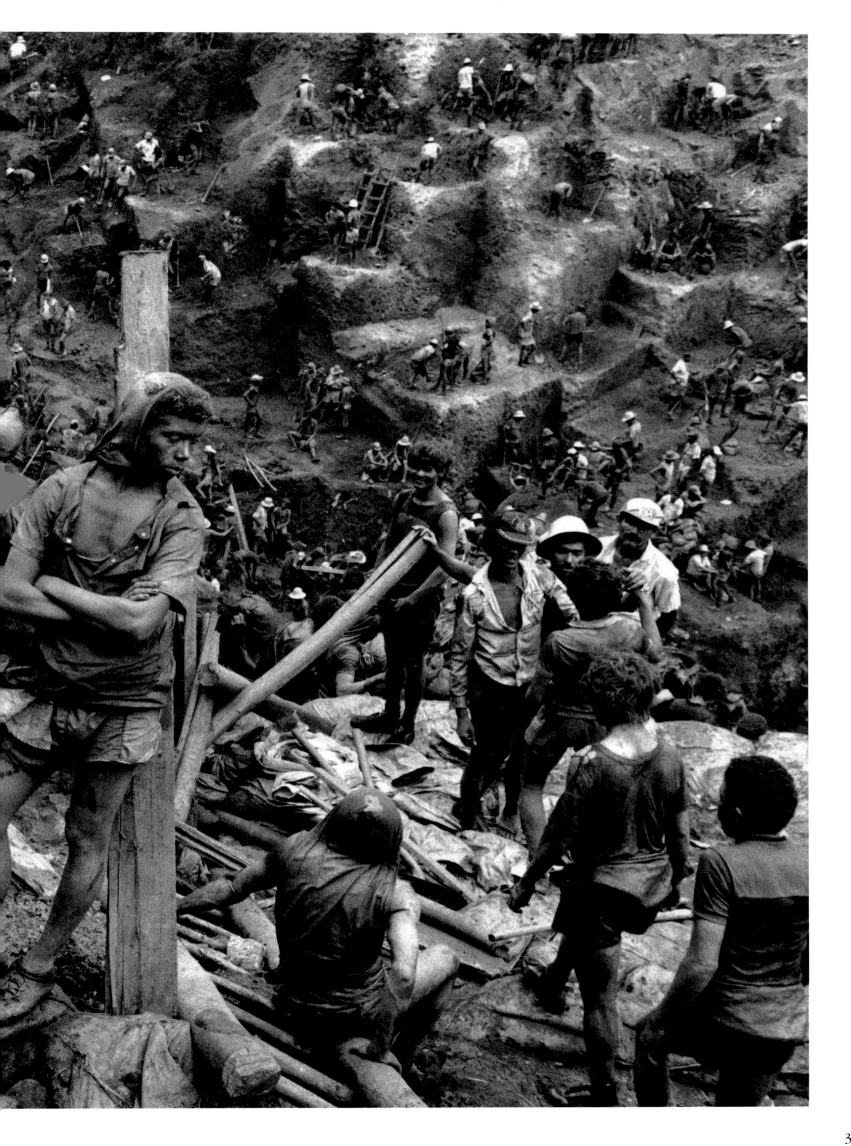

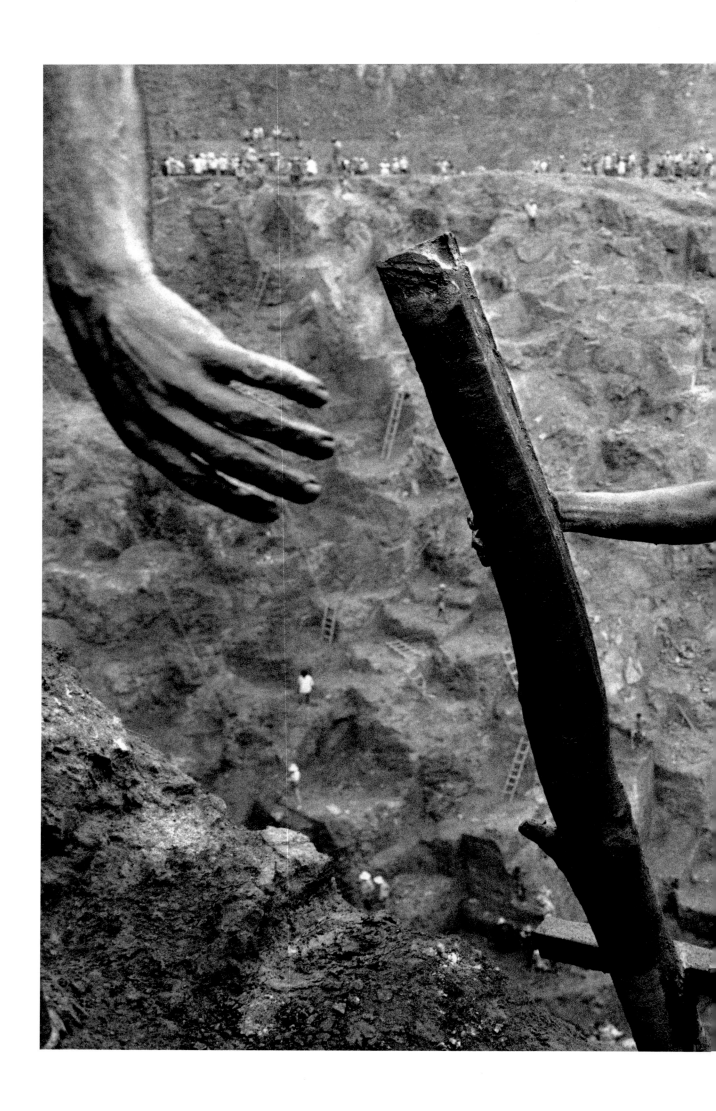

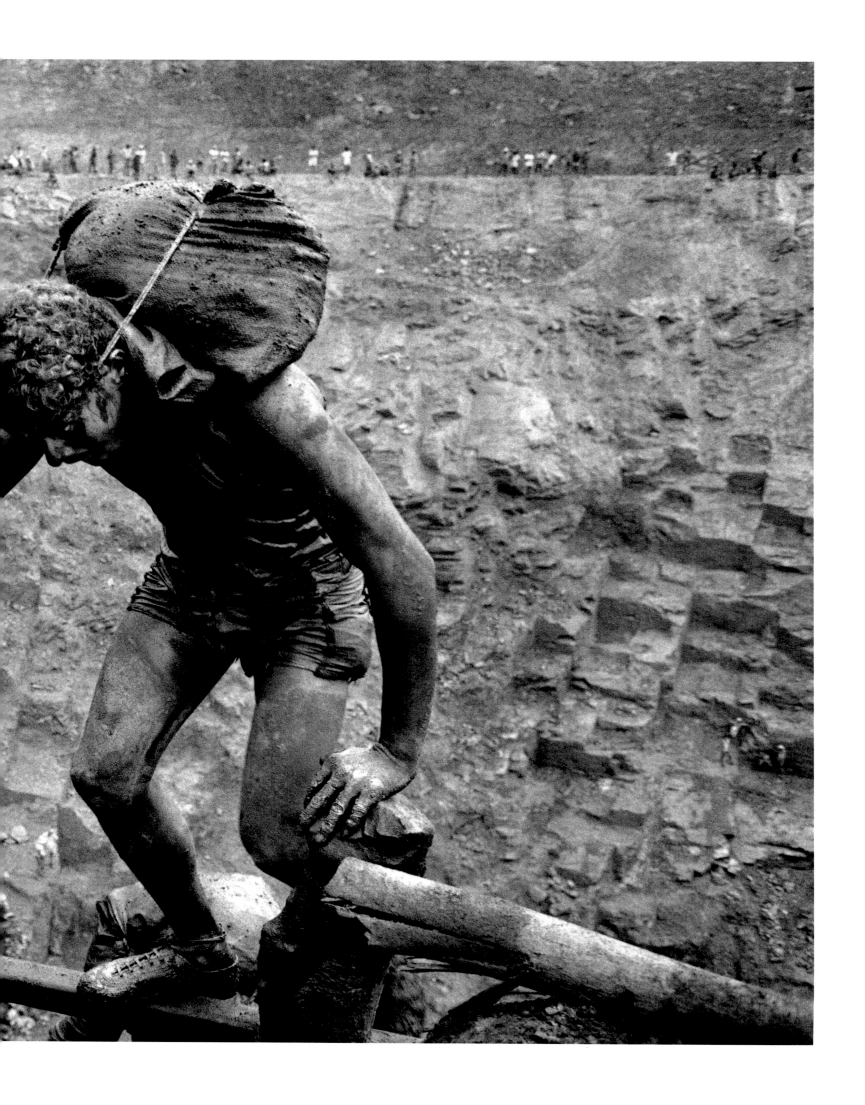

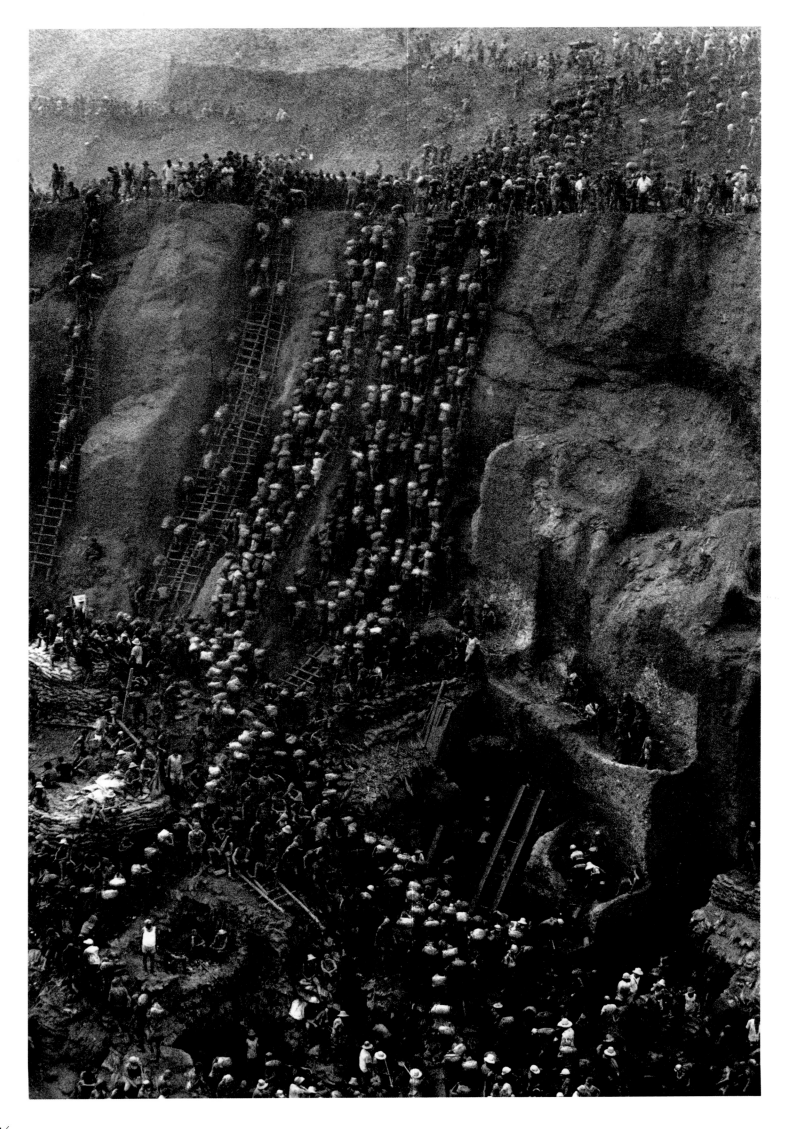

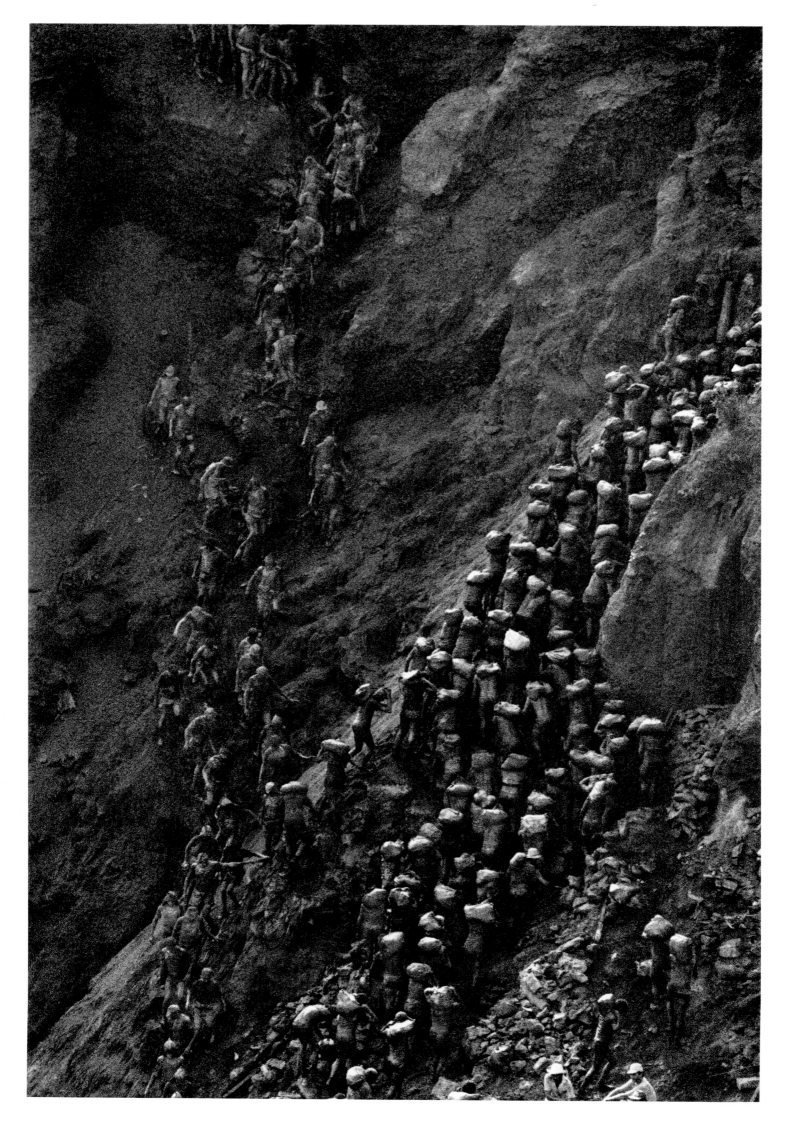

V

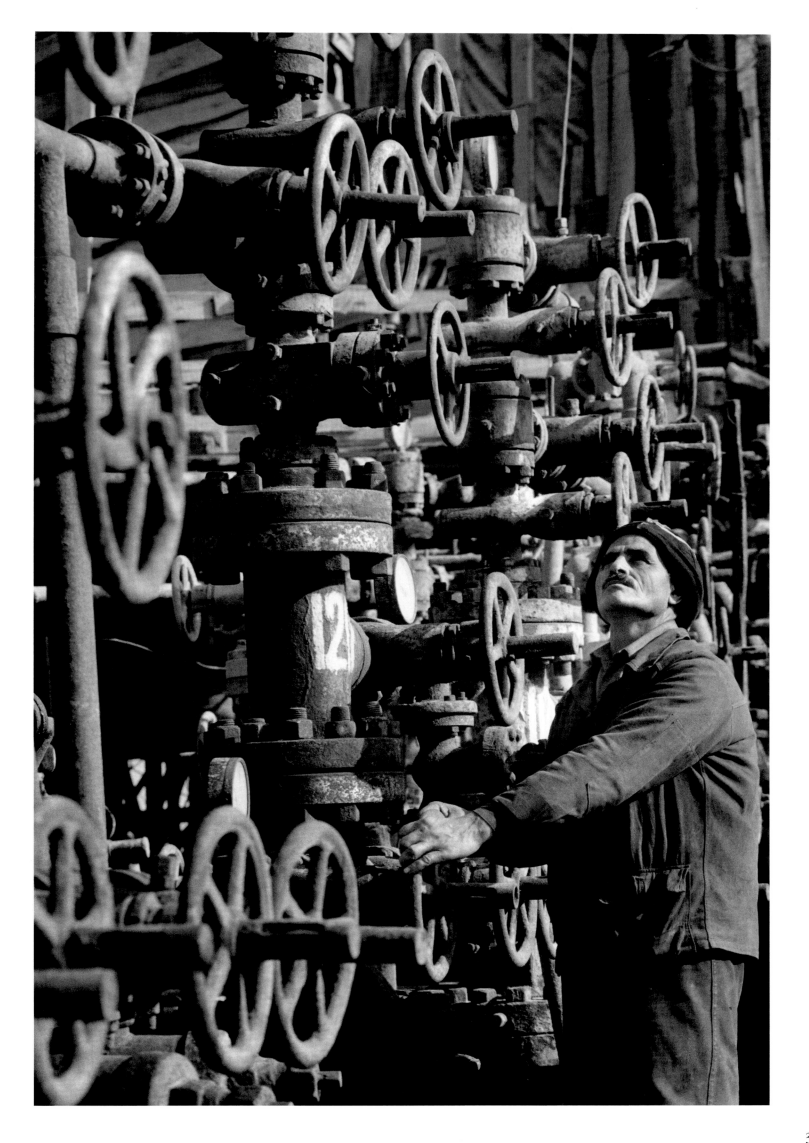

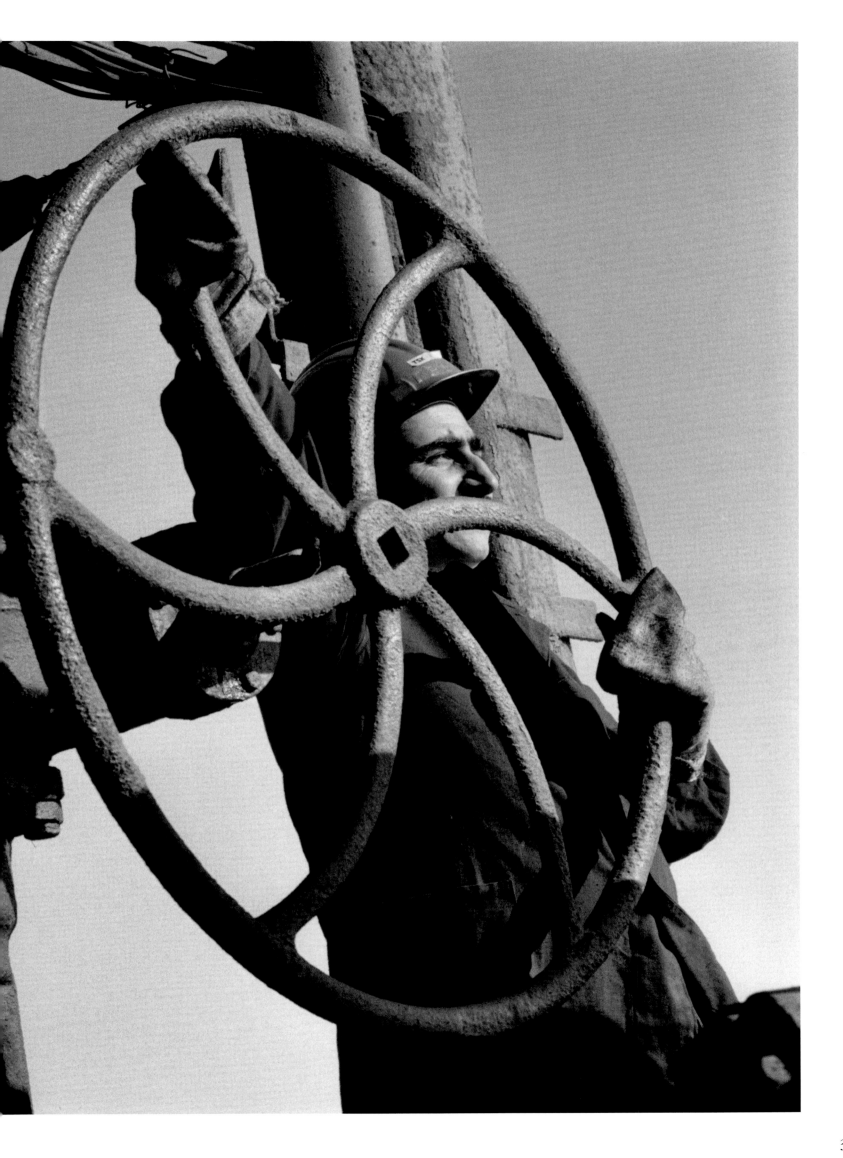

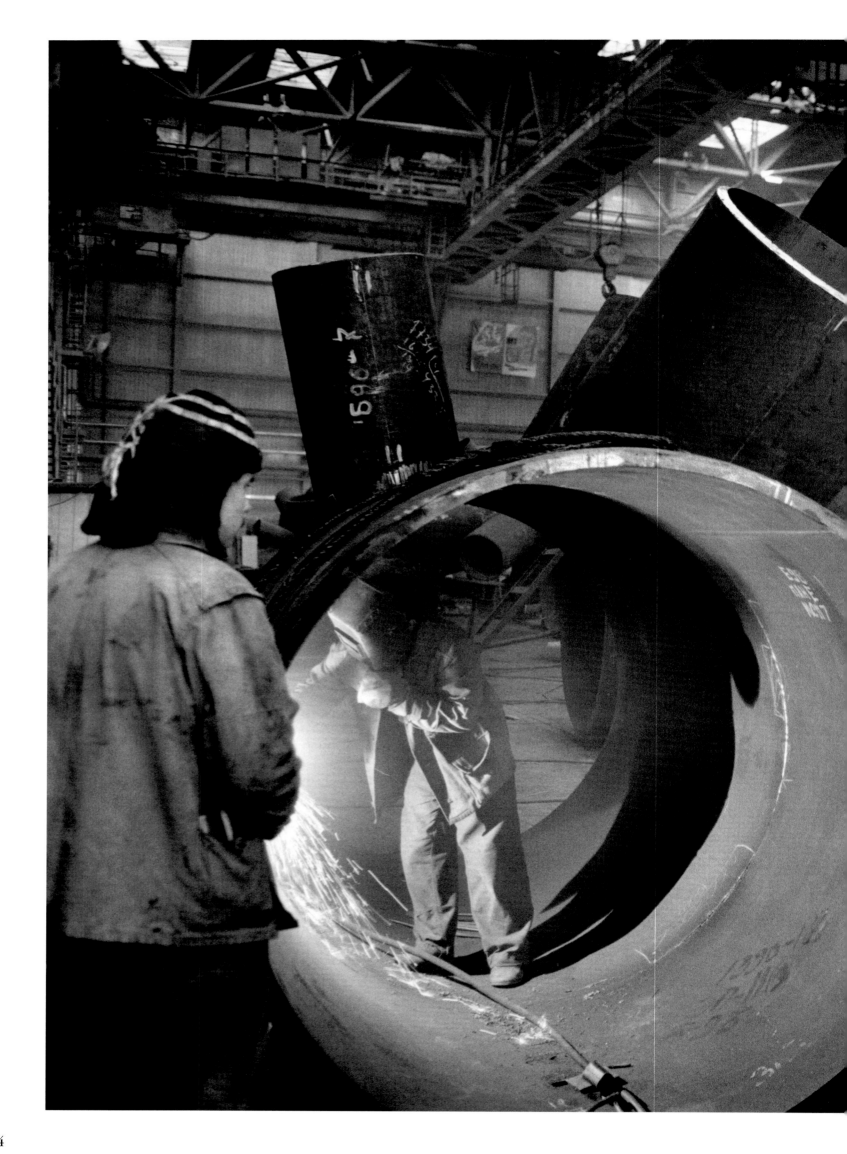

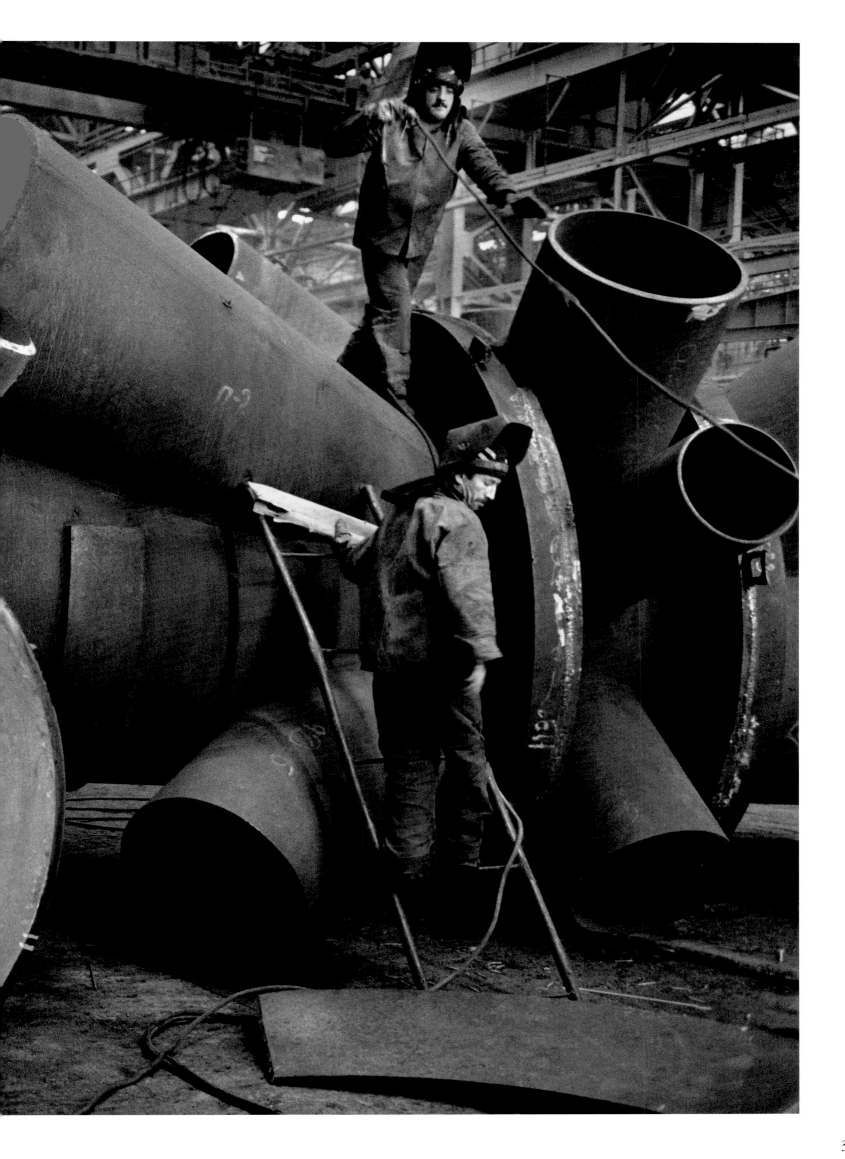

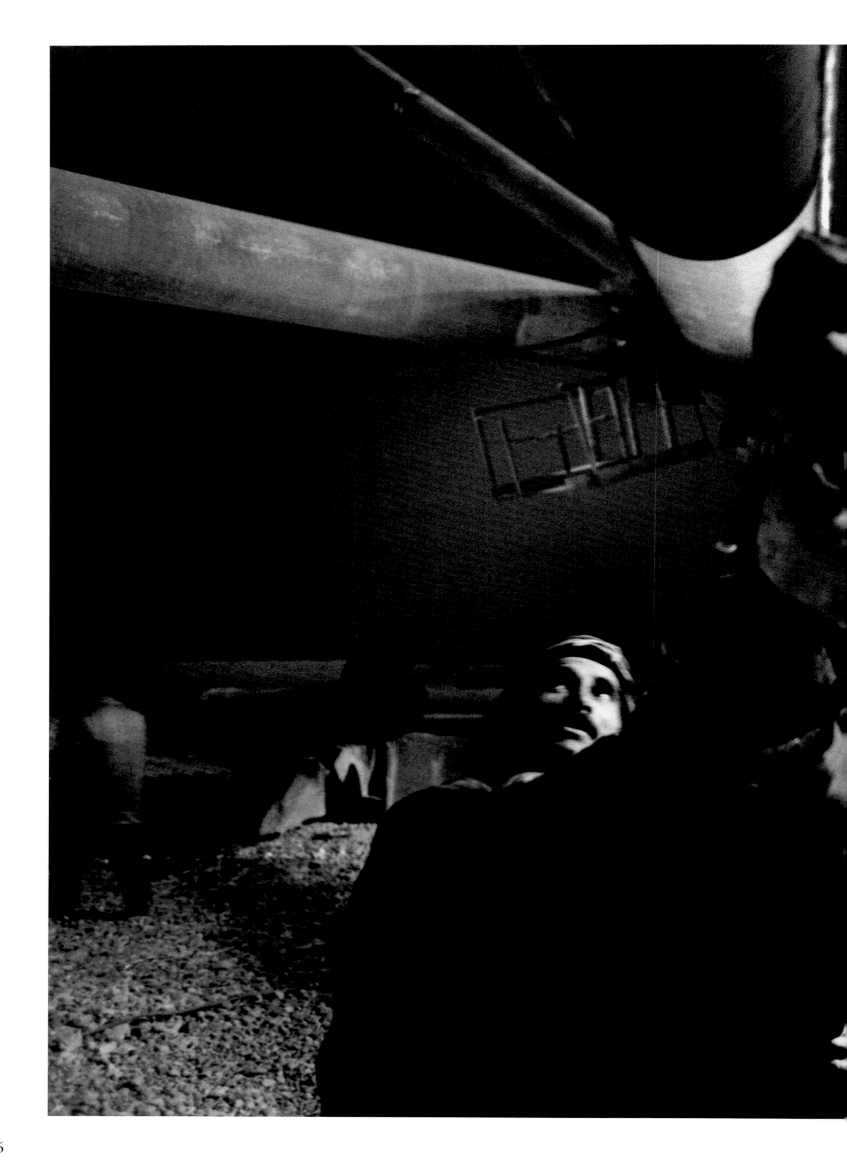

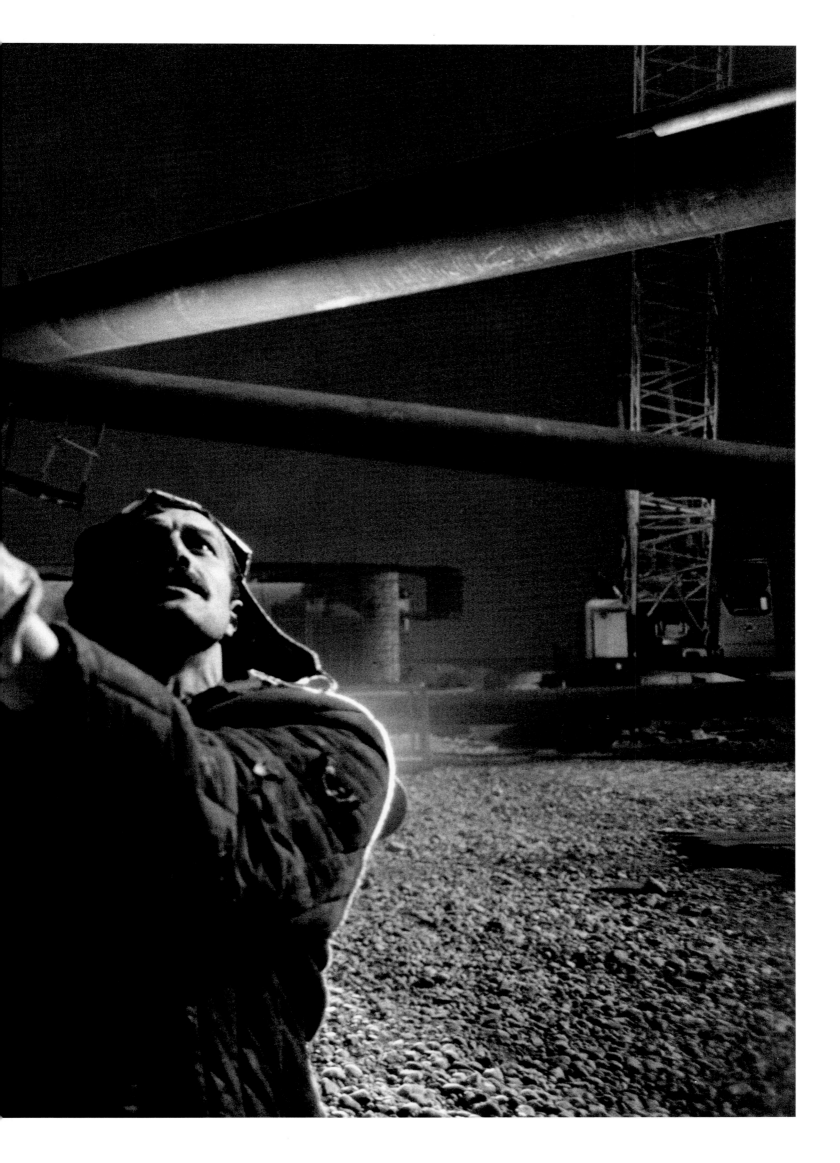

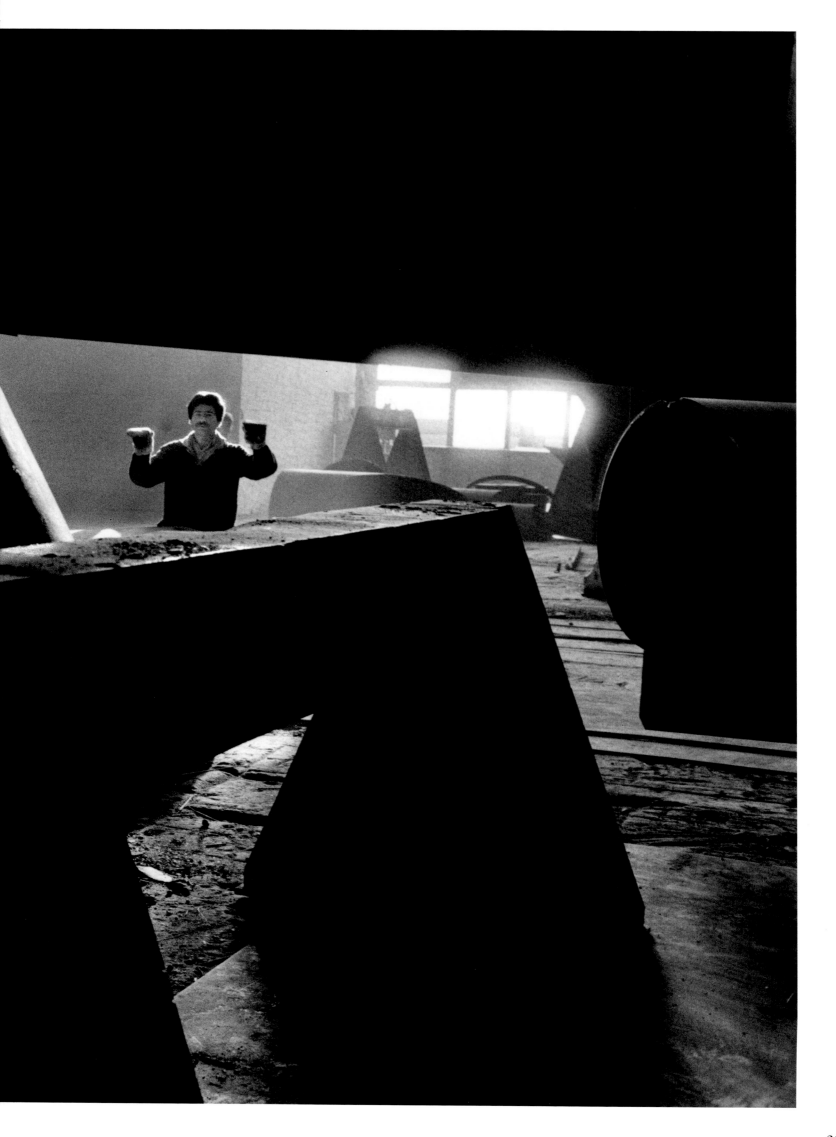

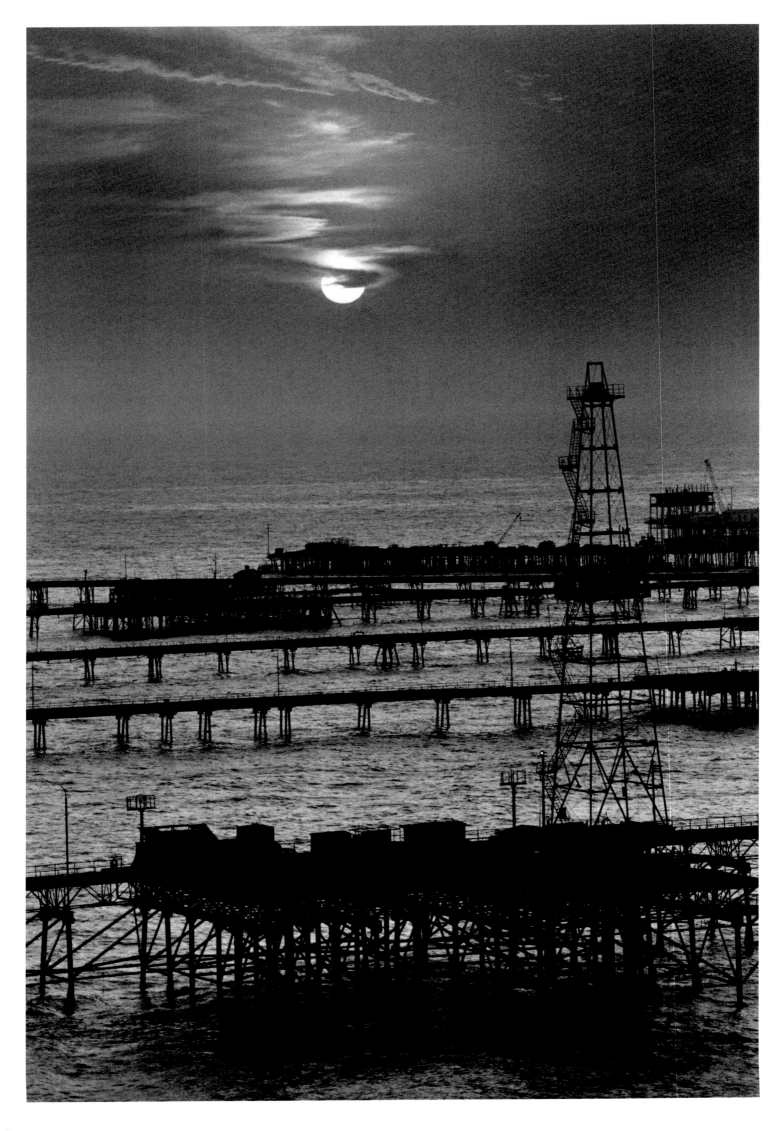

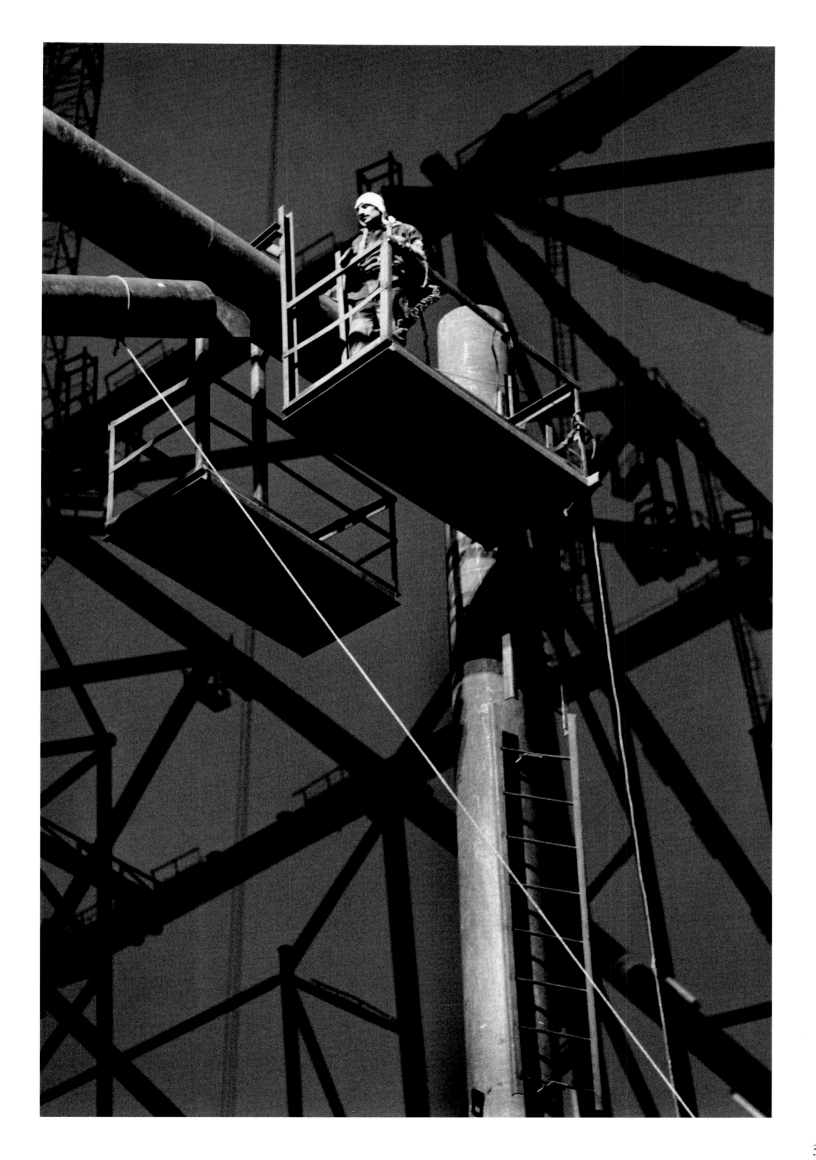

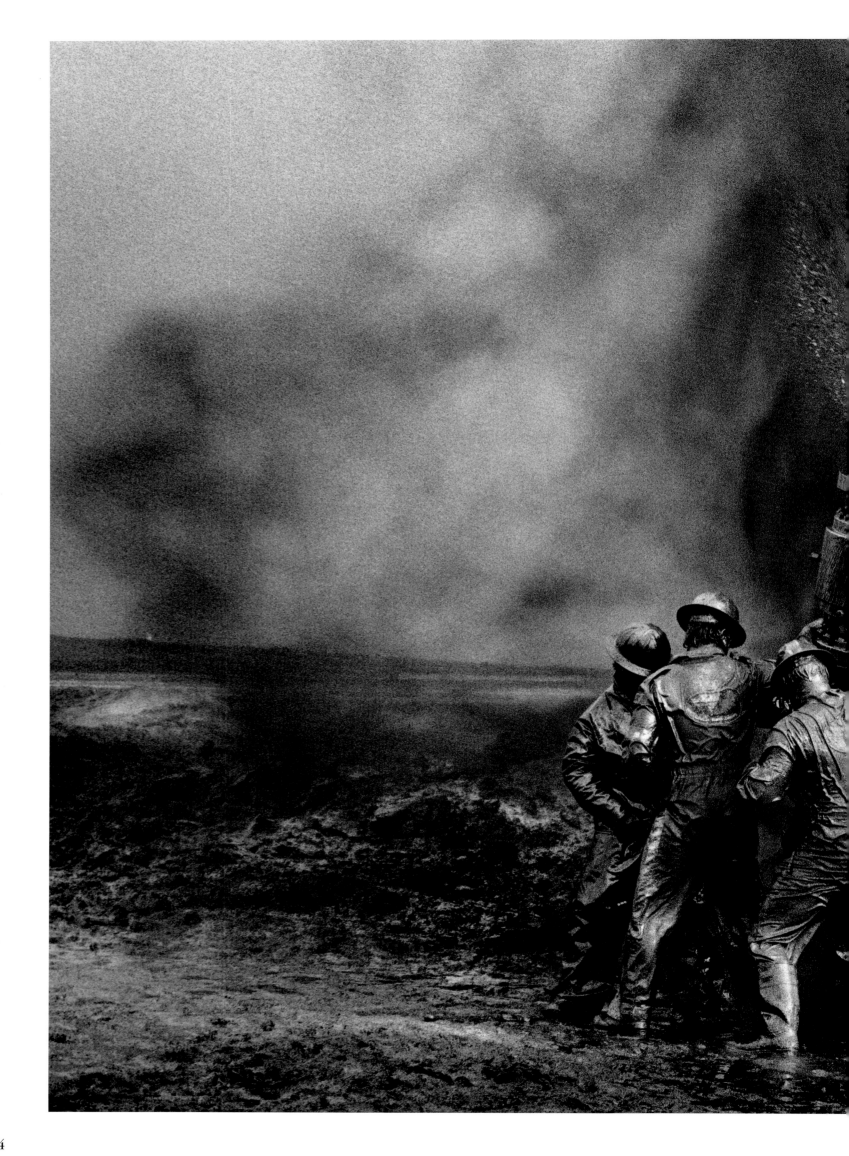

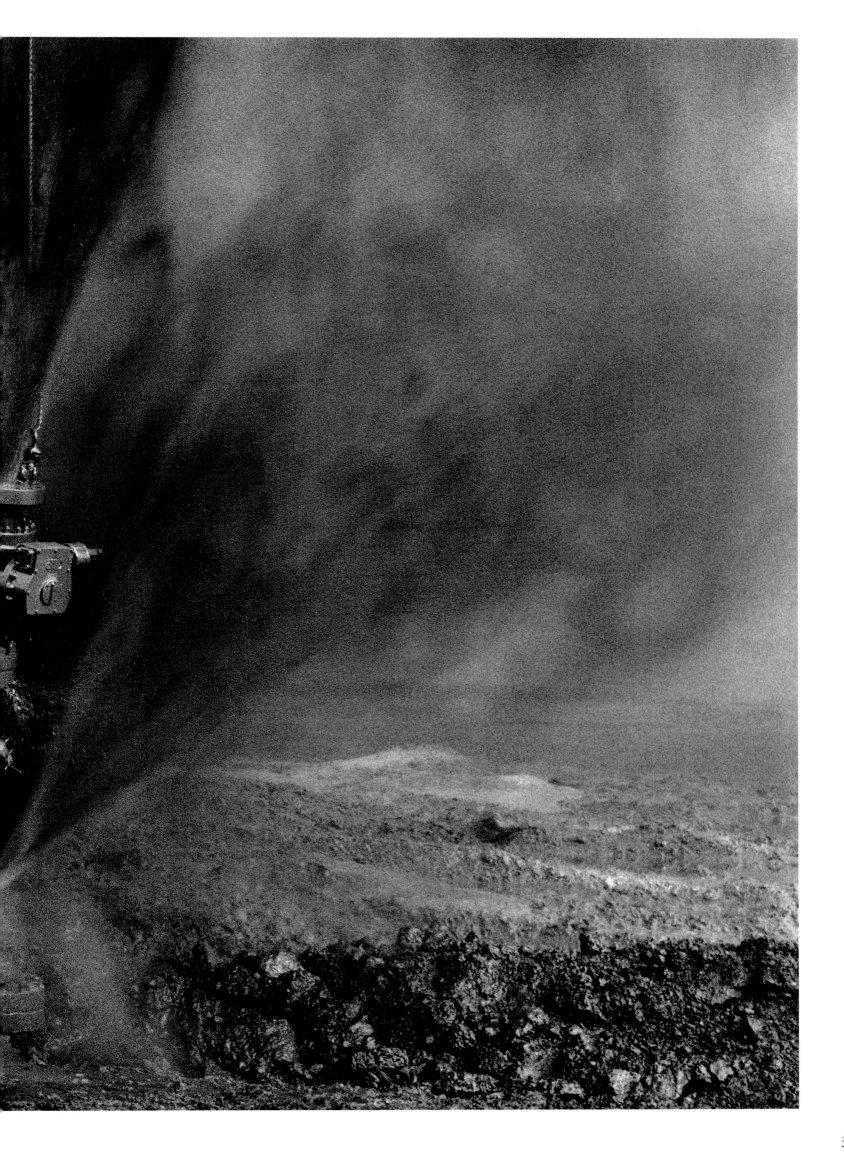

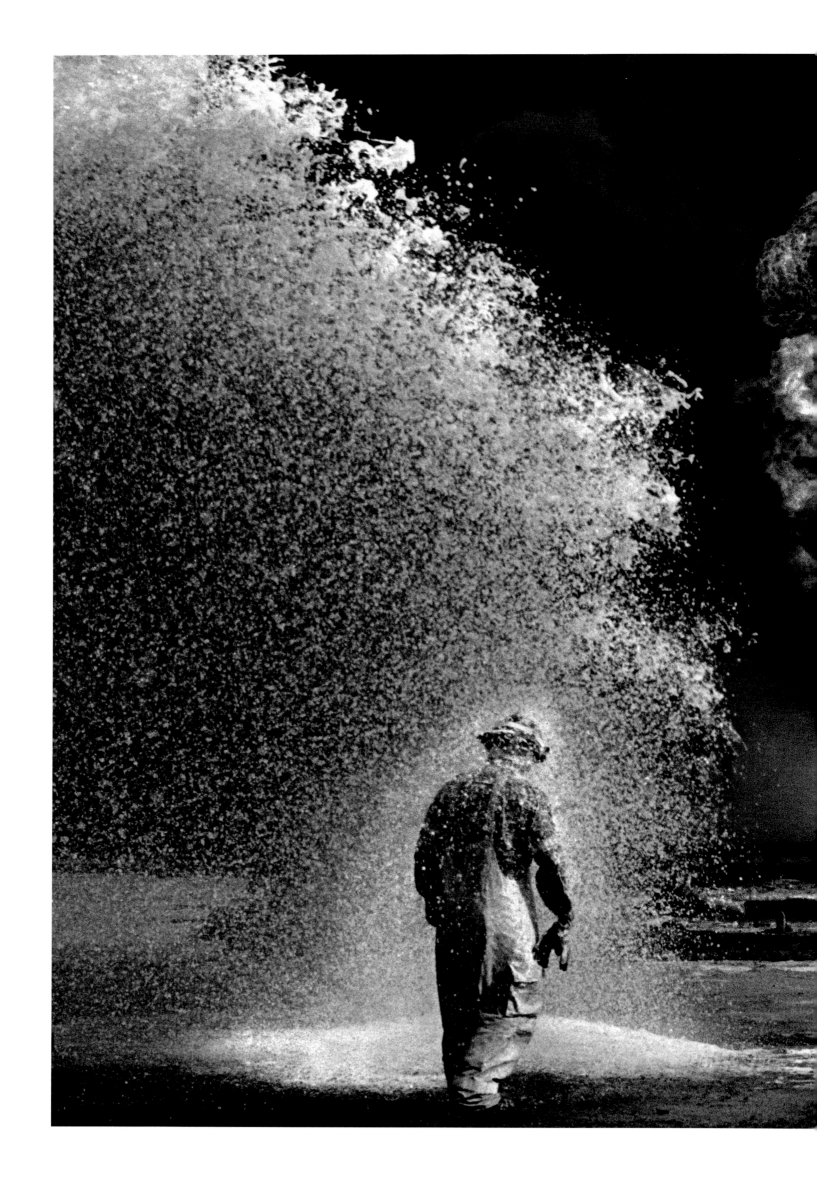

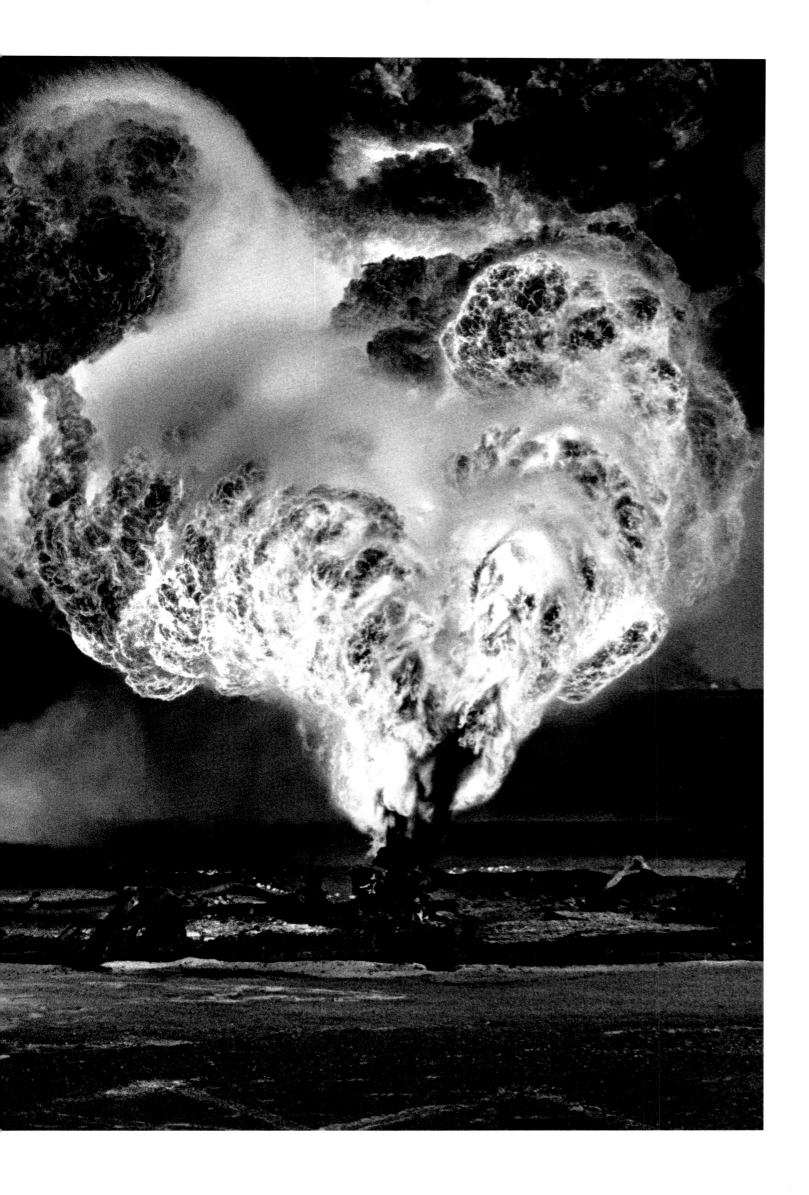

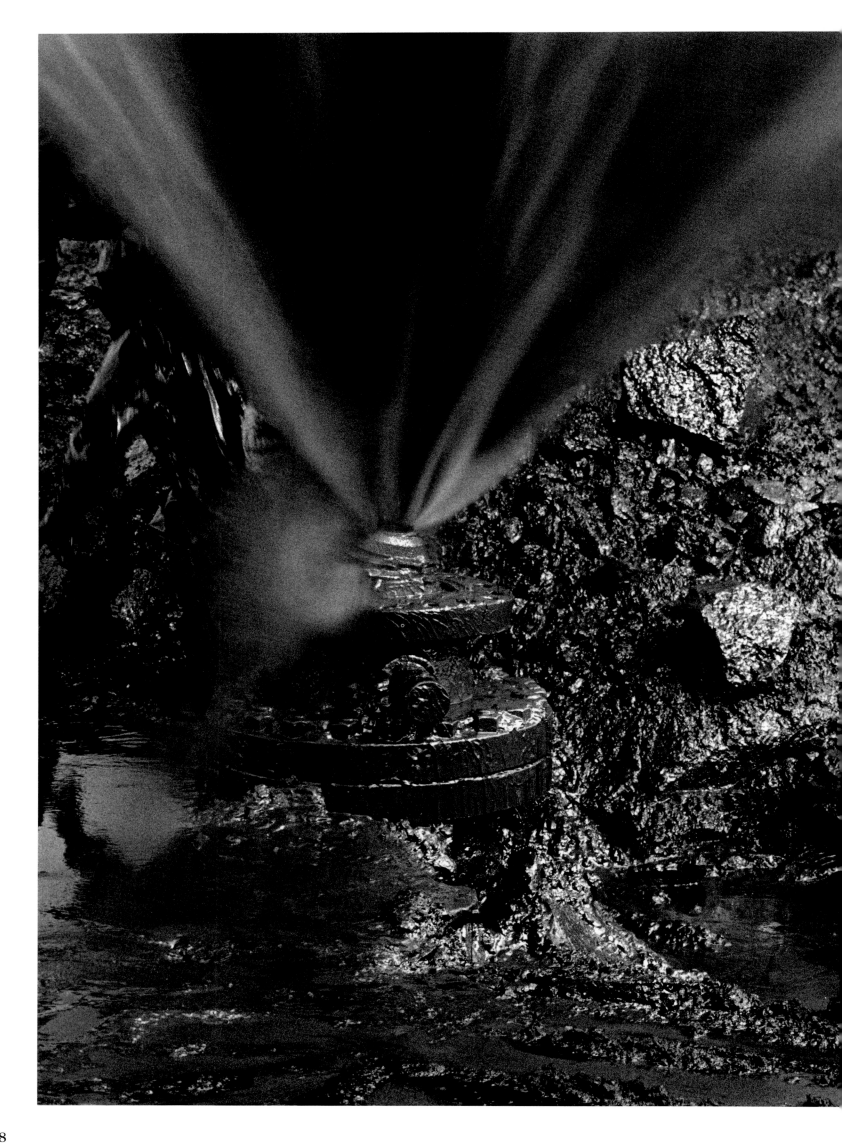

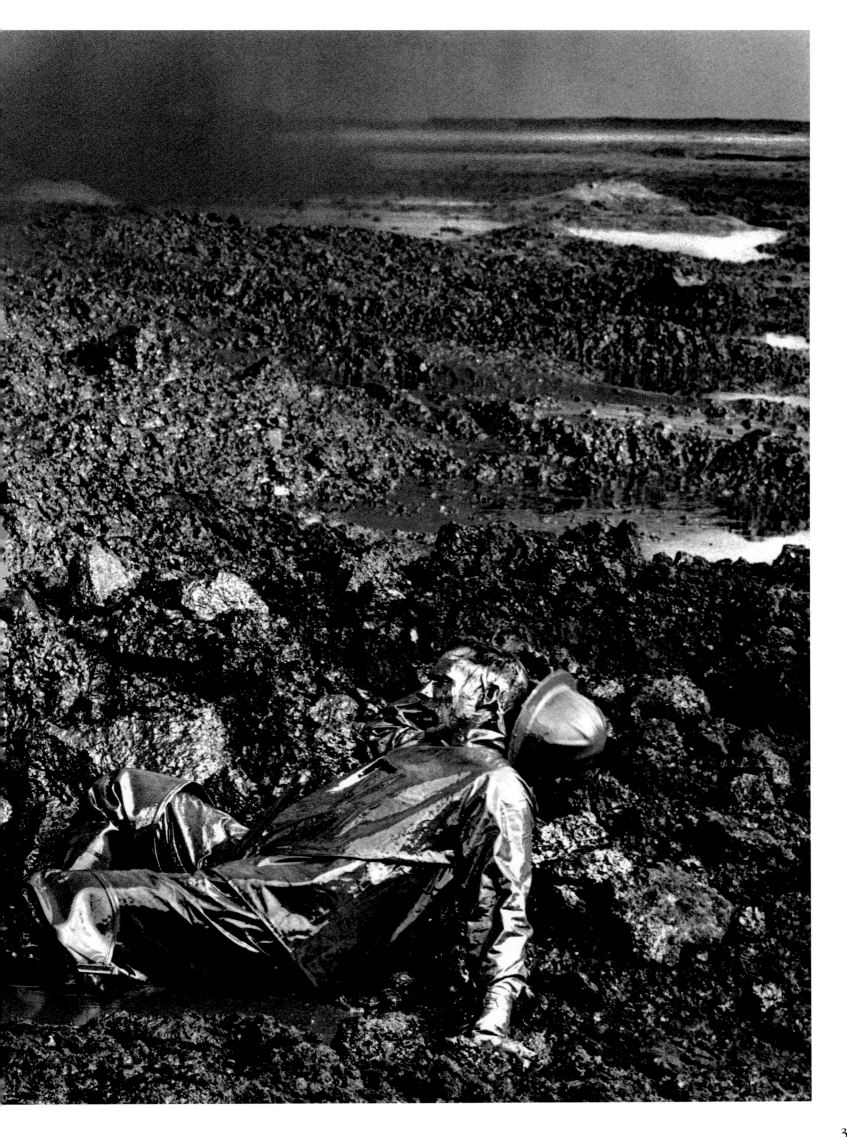

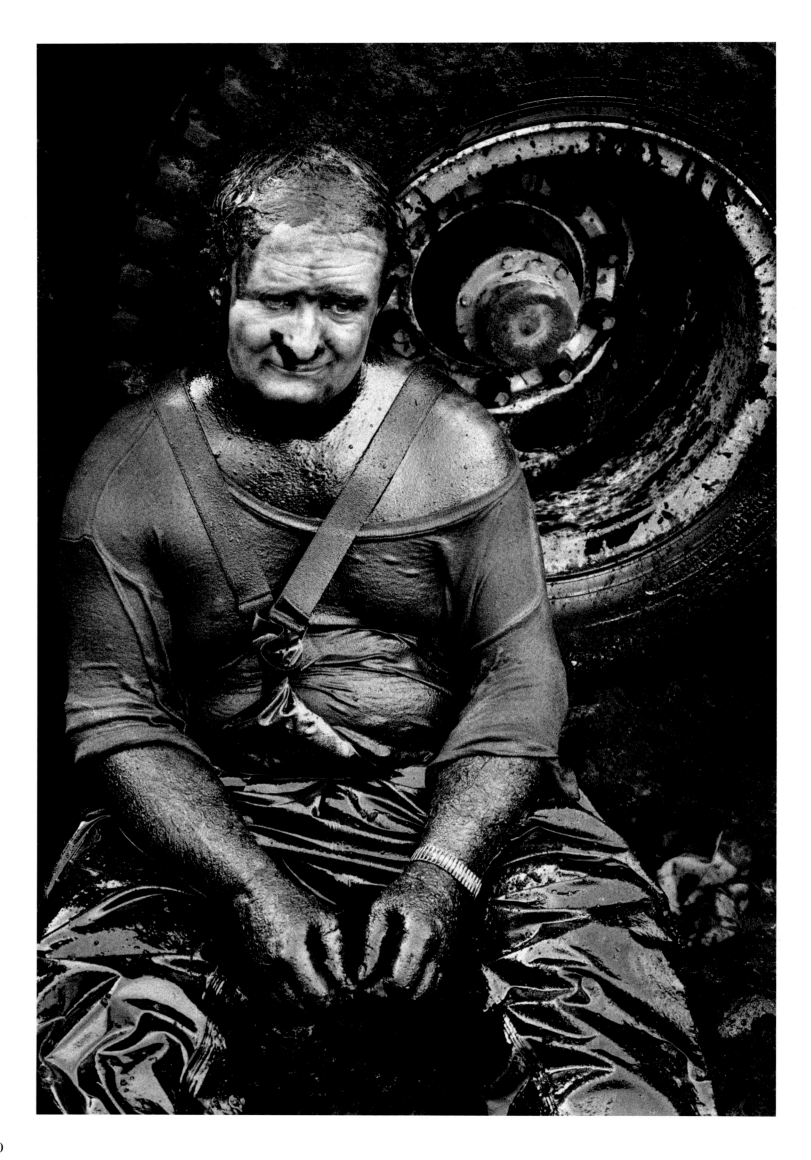

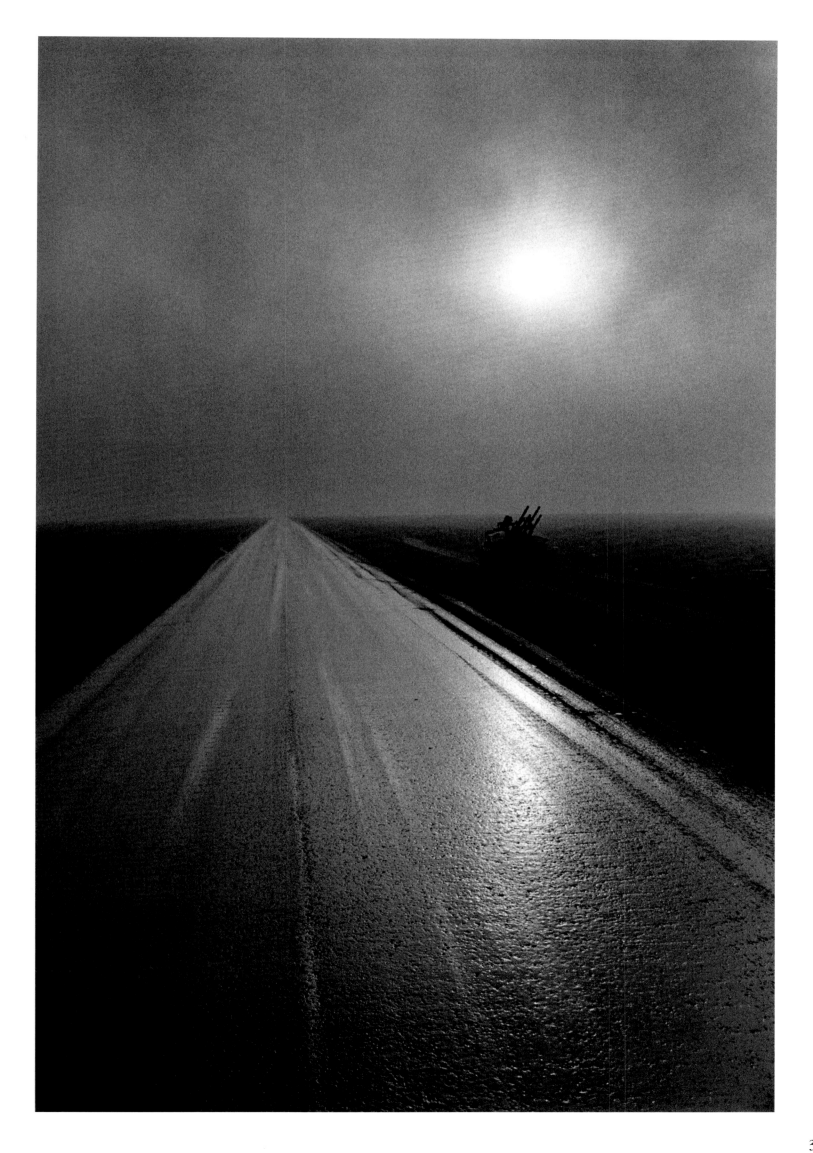

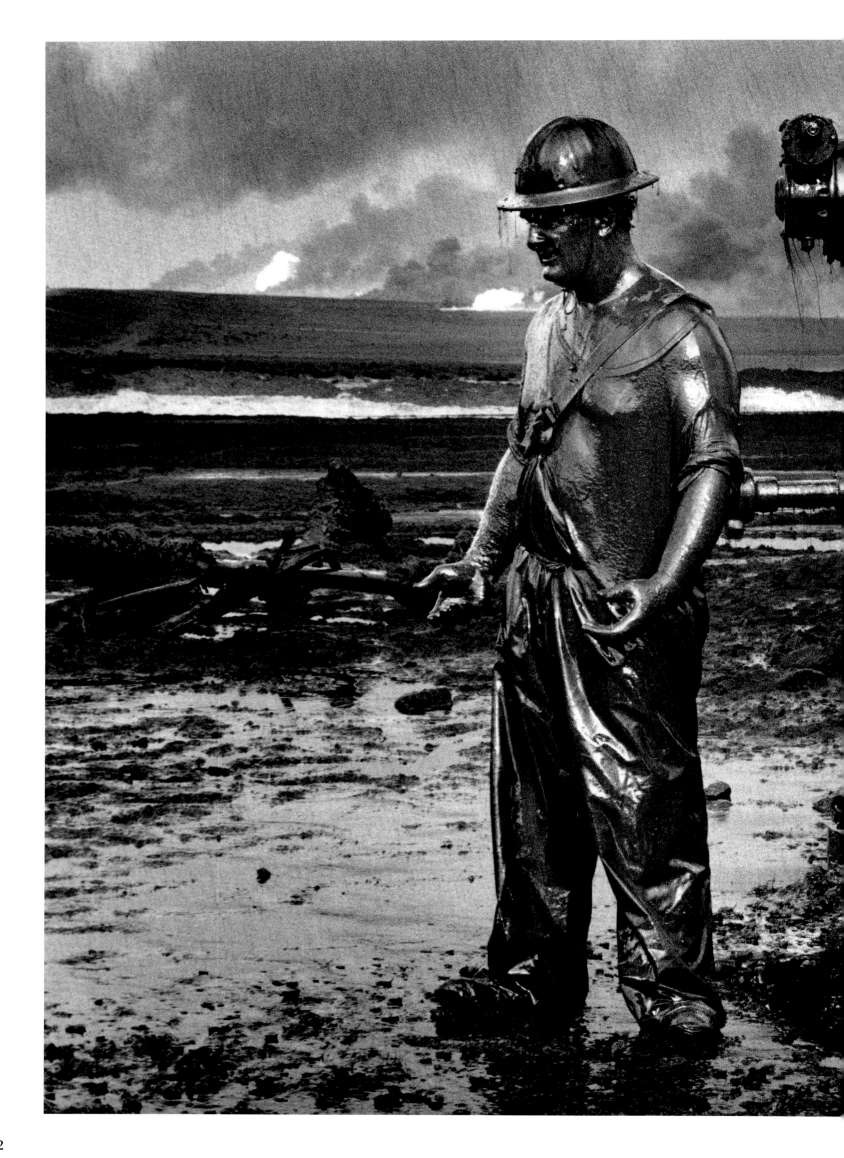

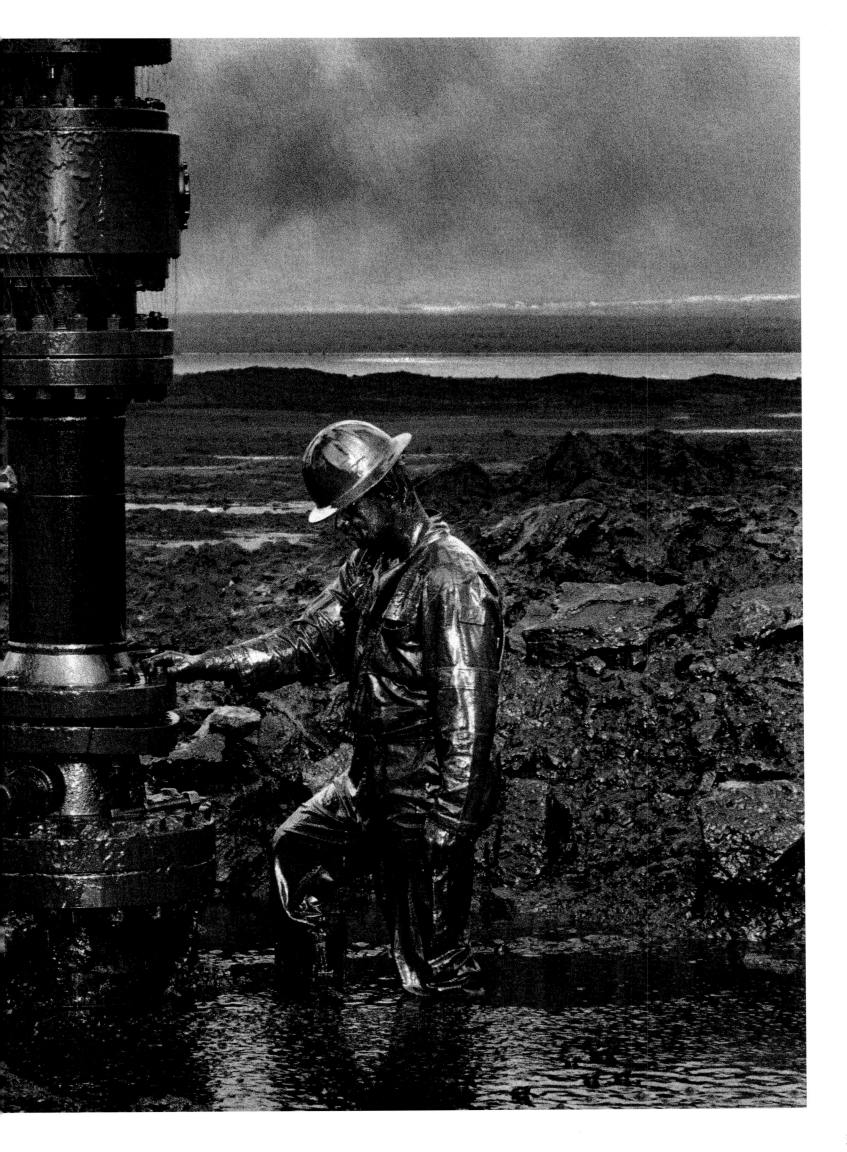

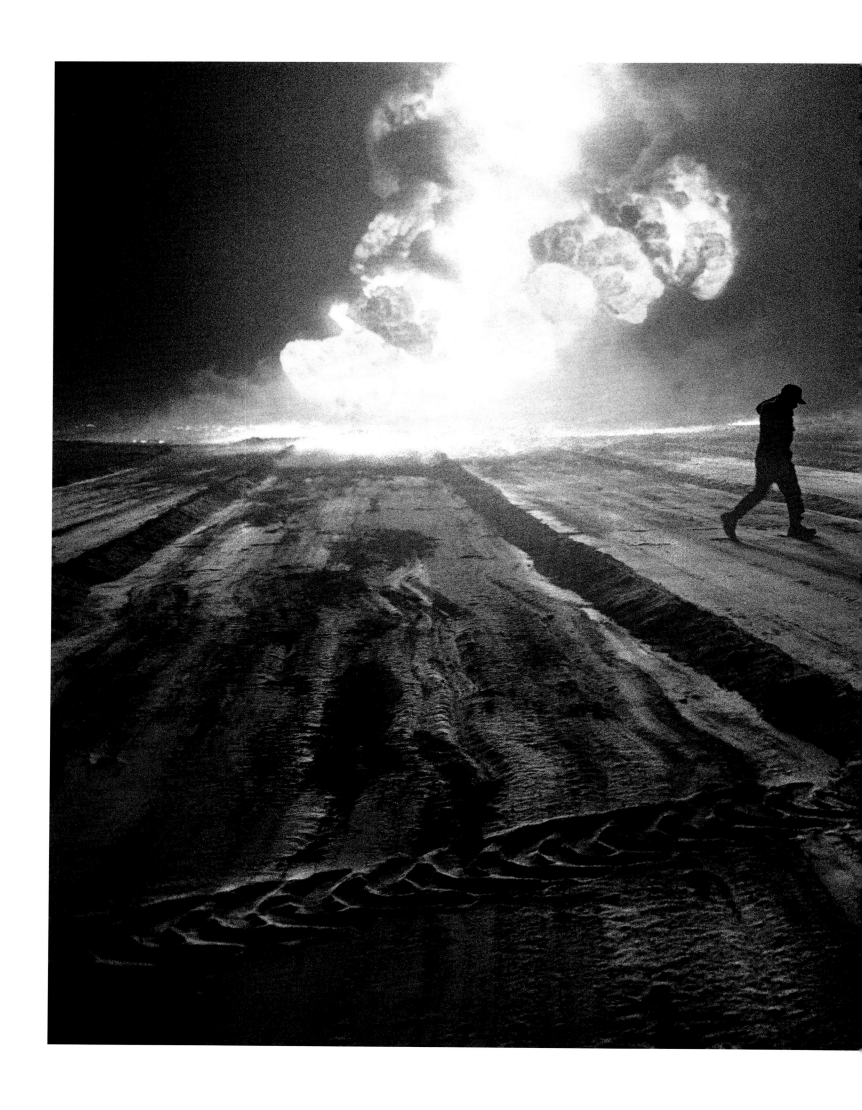

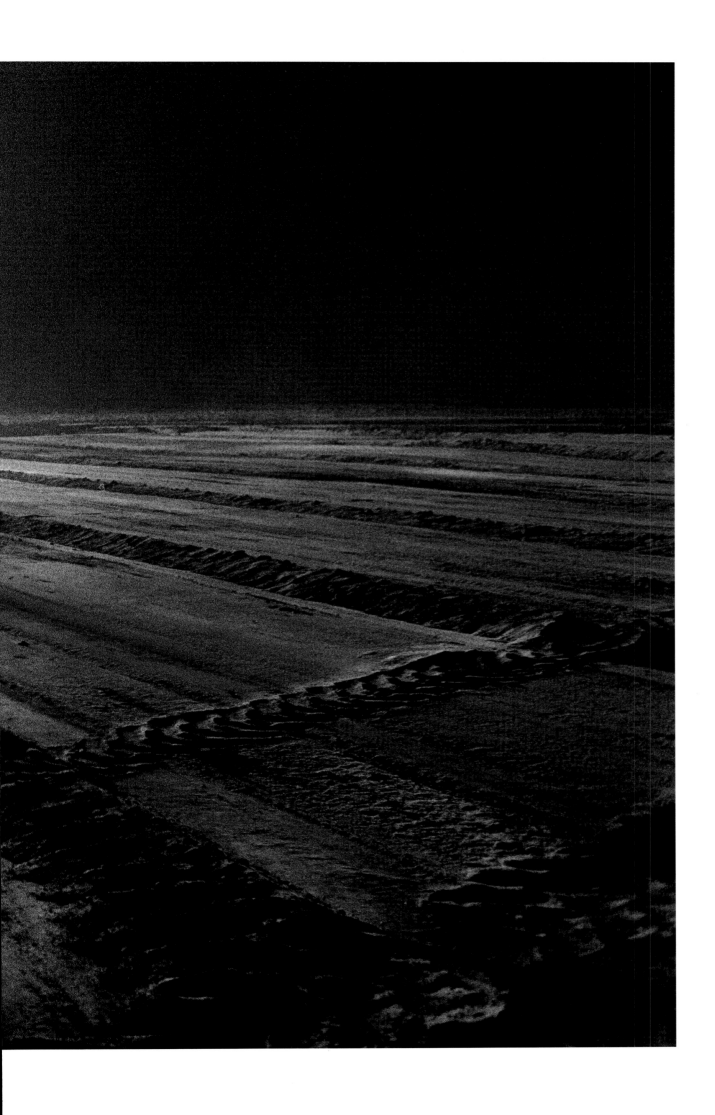

VI

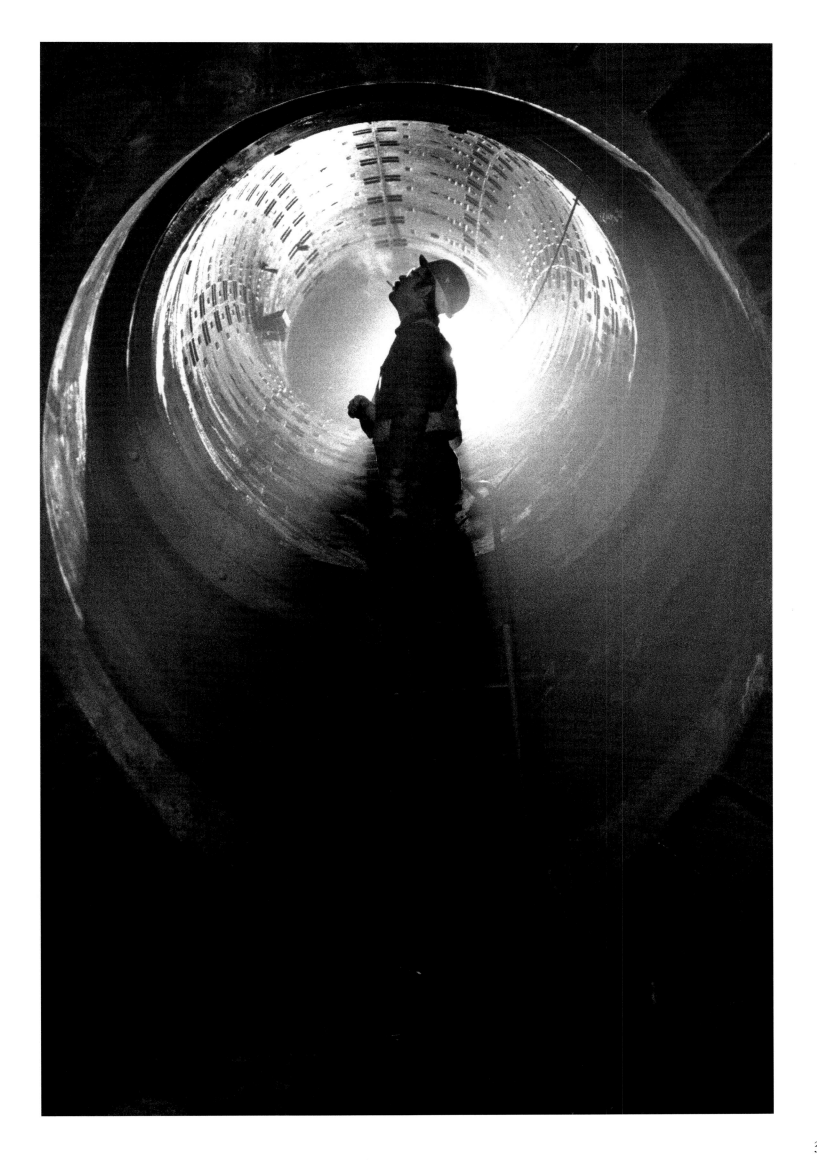

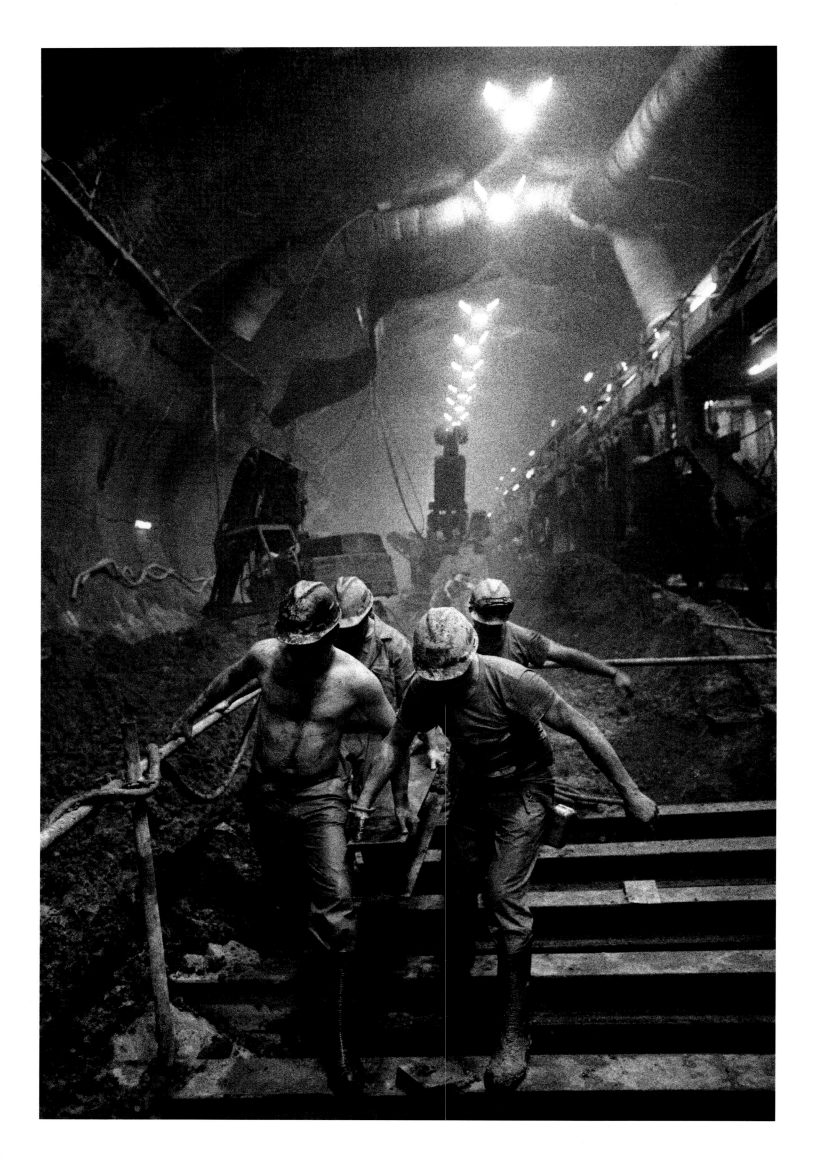

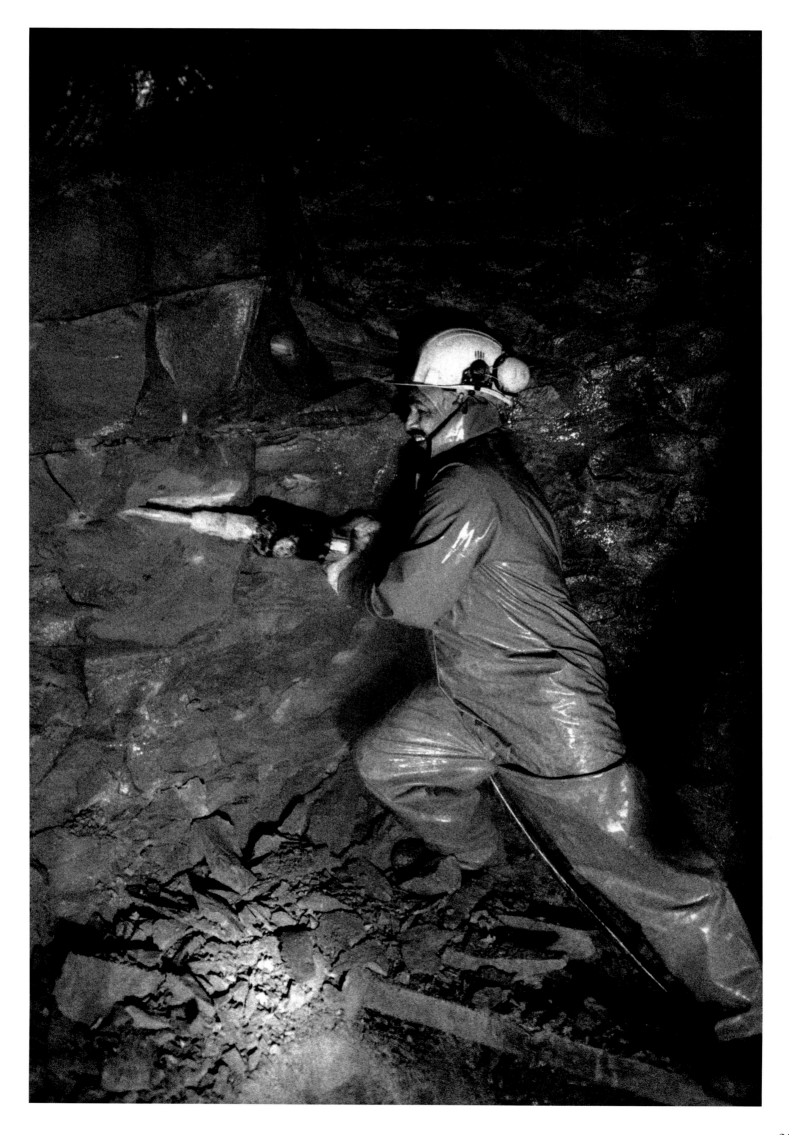

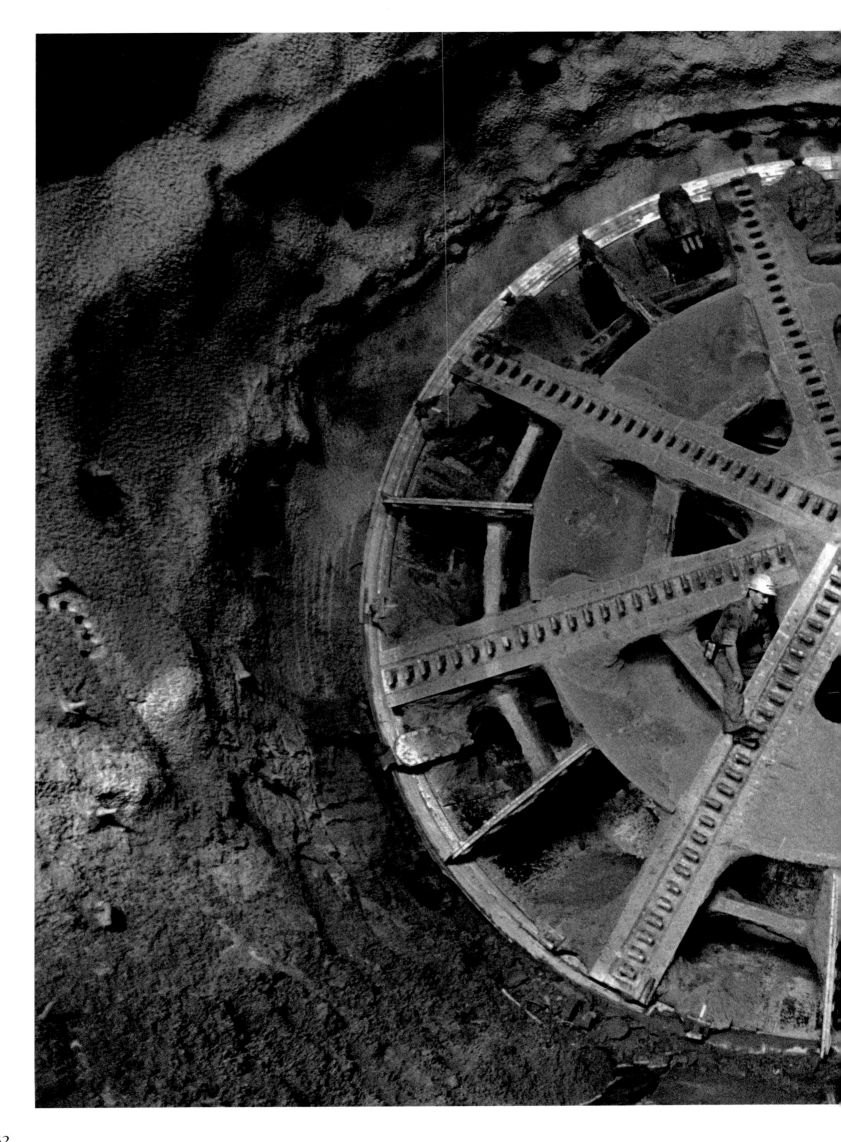

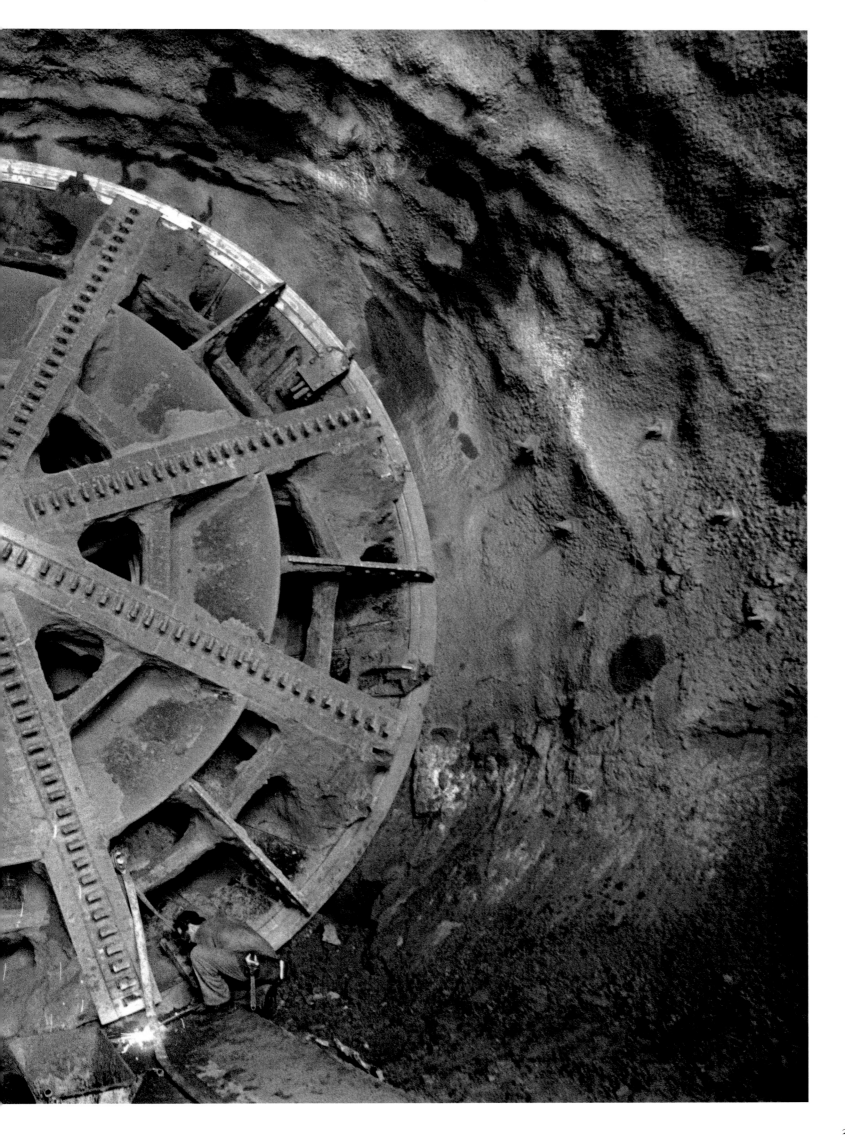

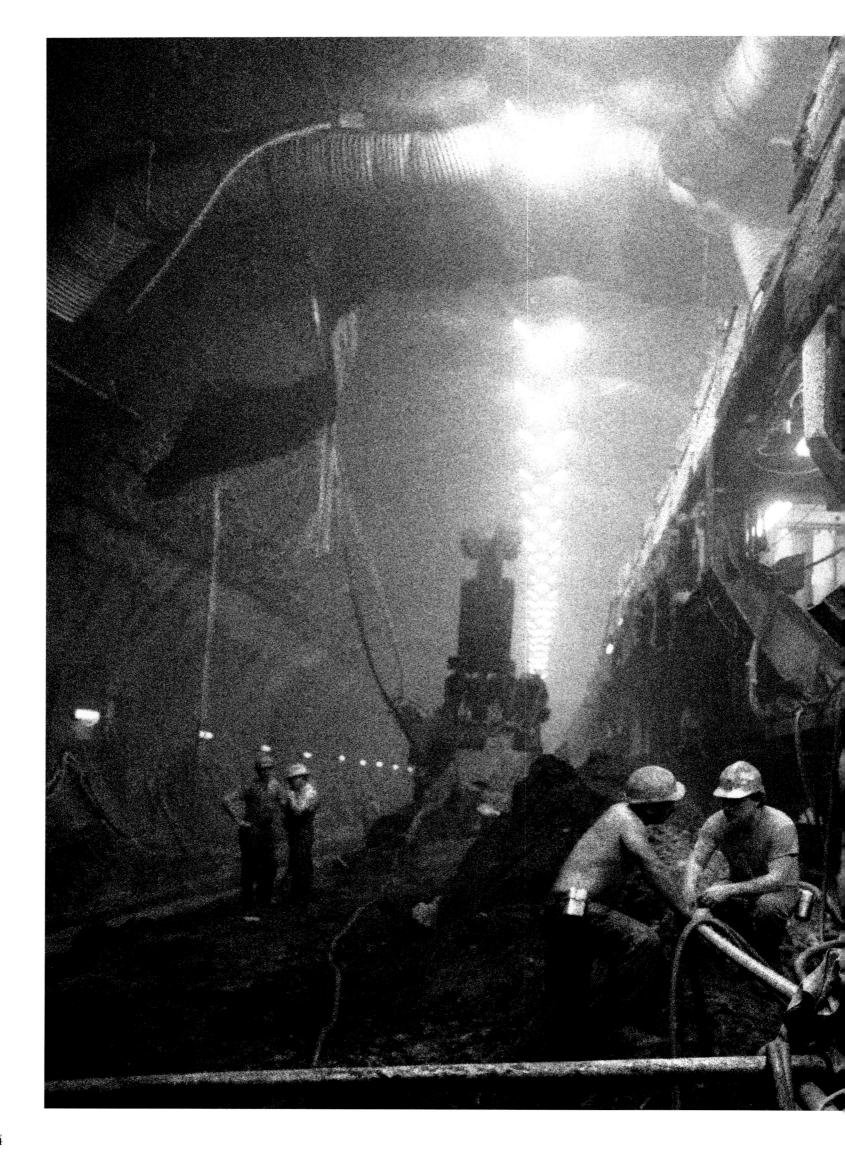

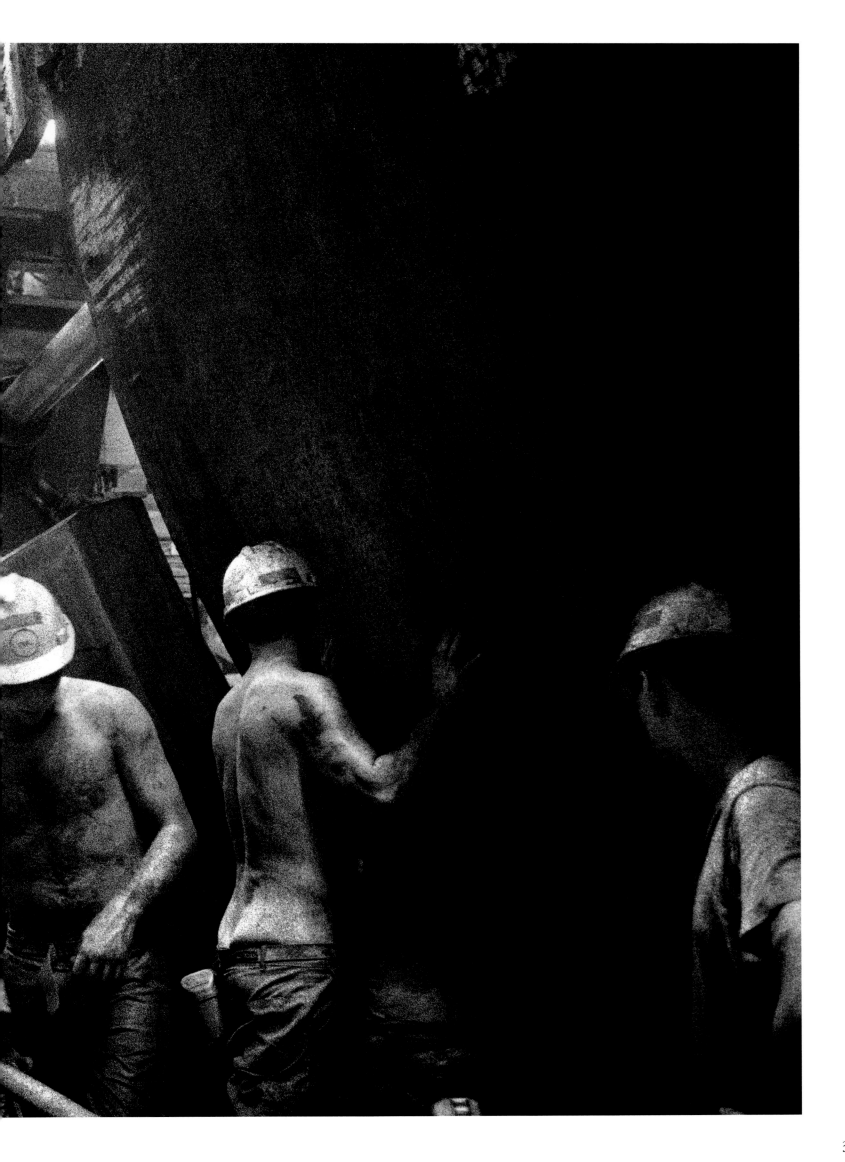

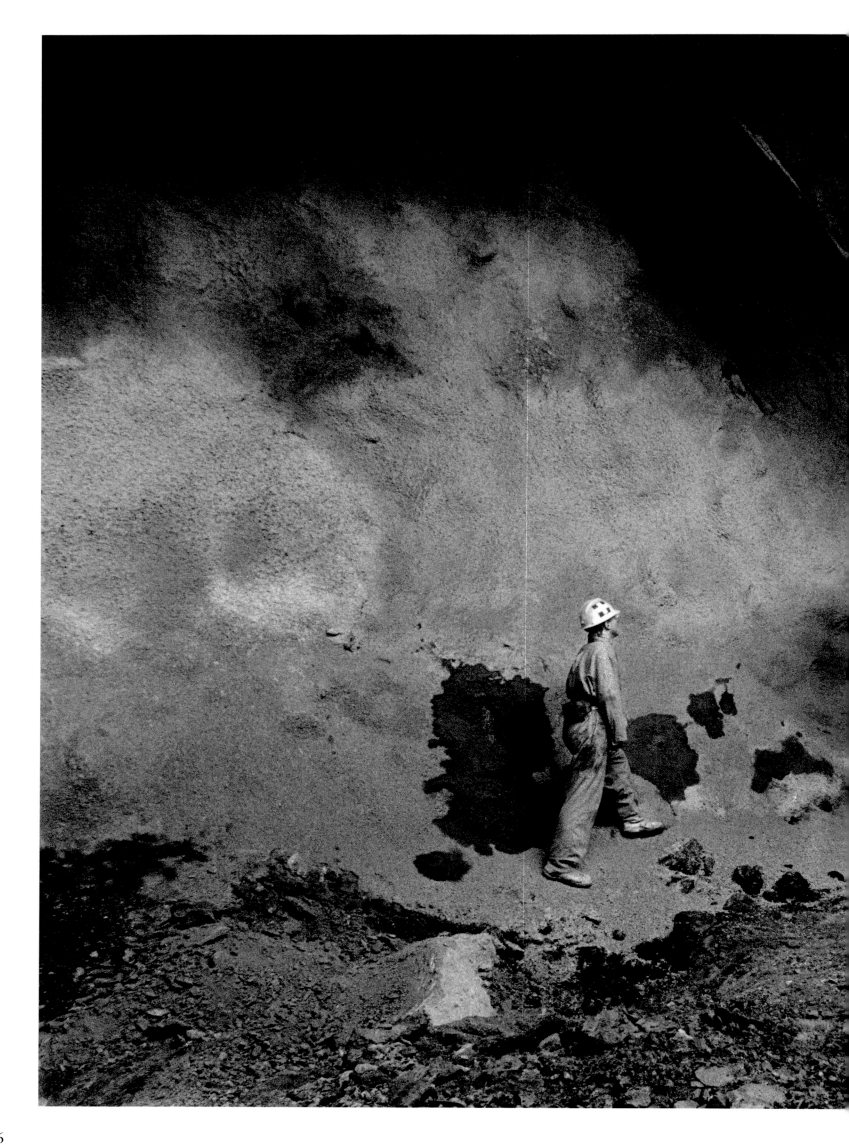

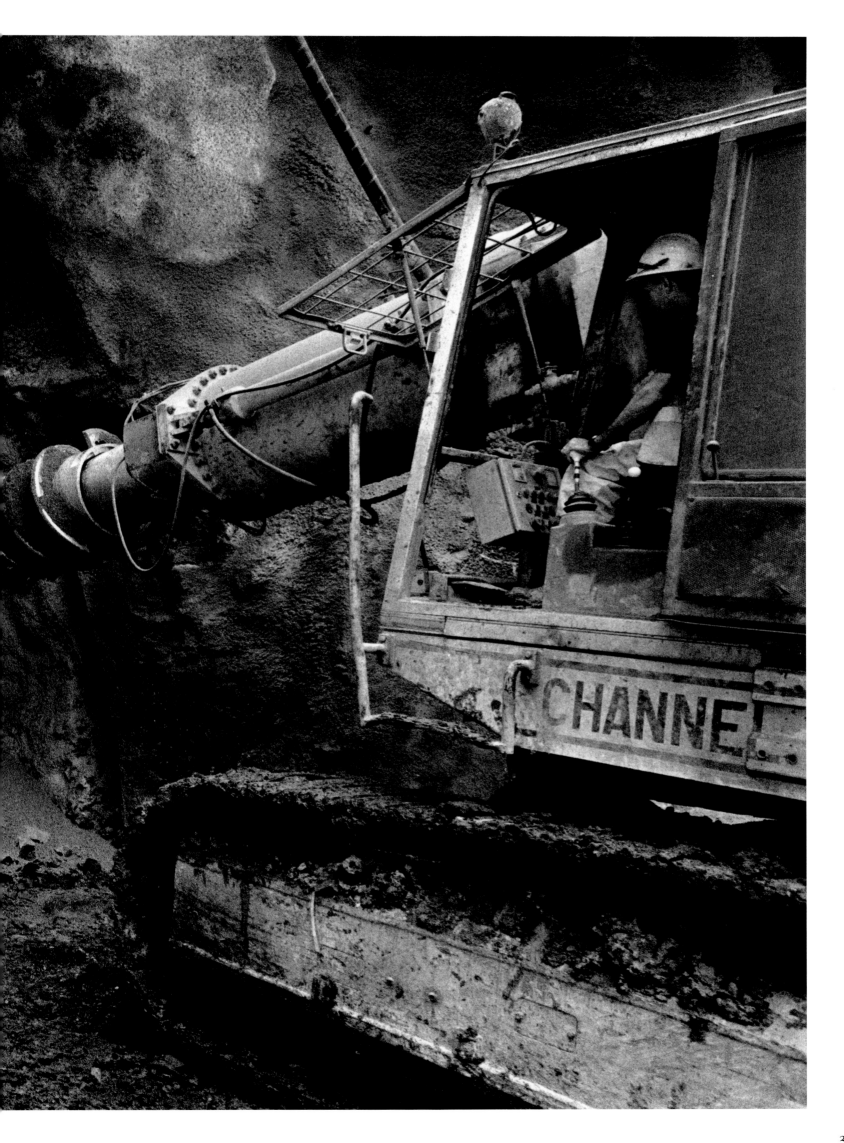

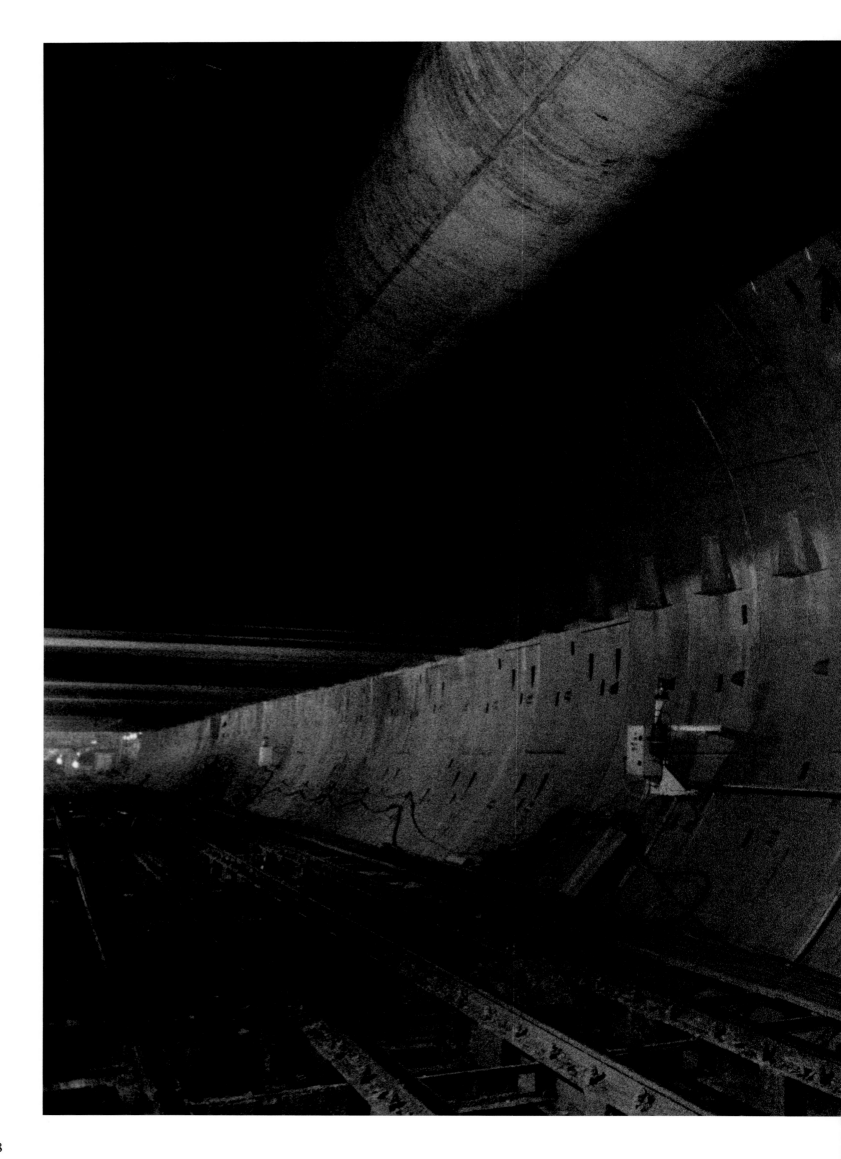

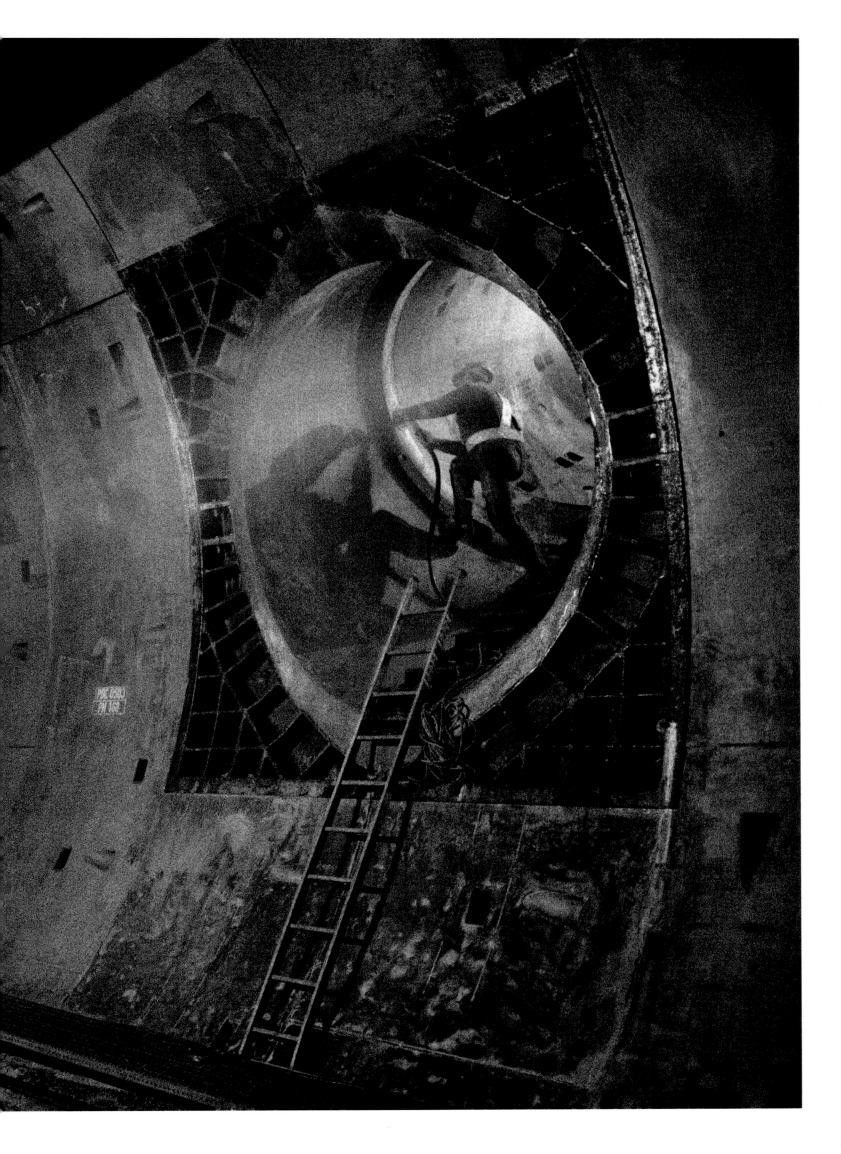

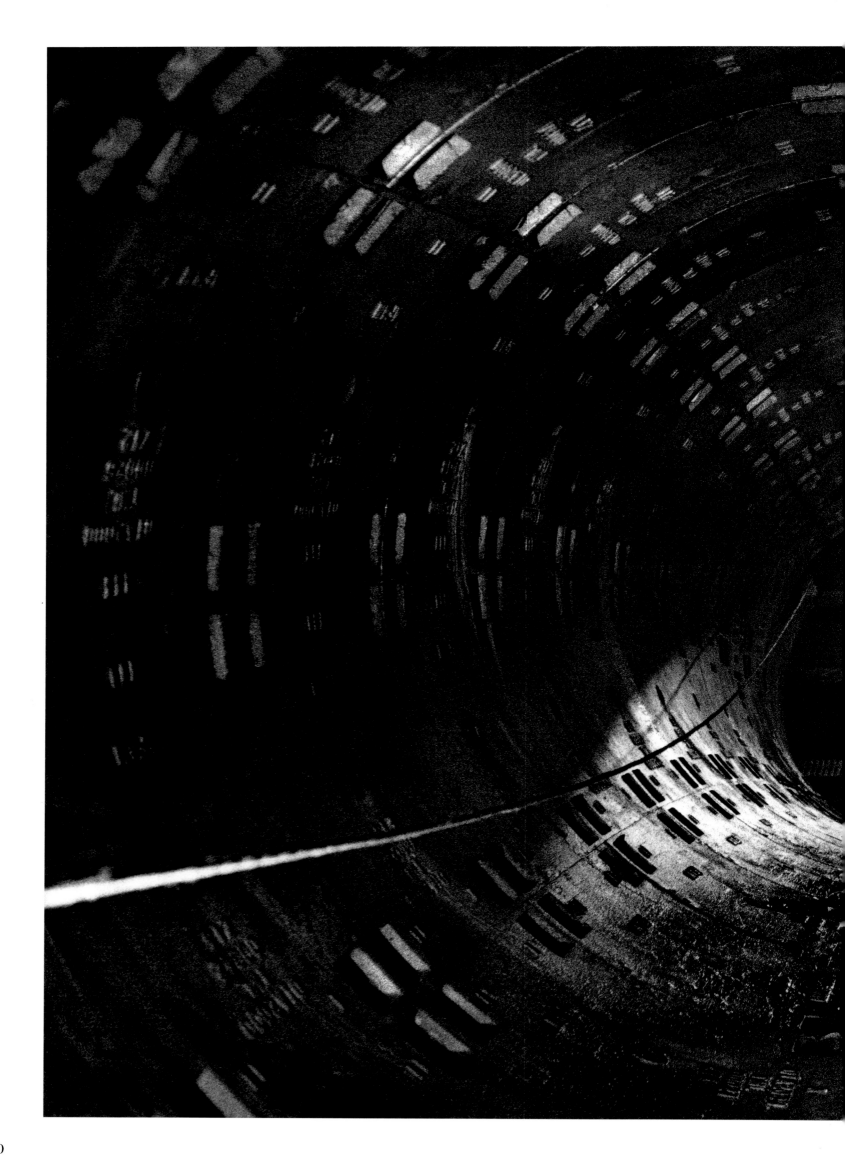

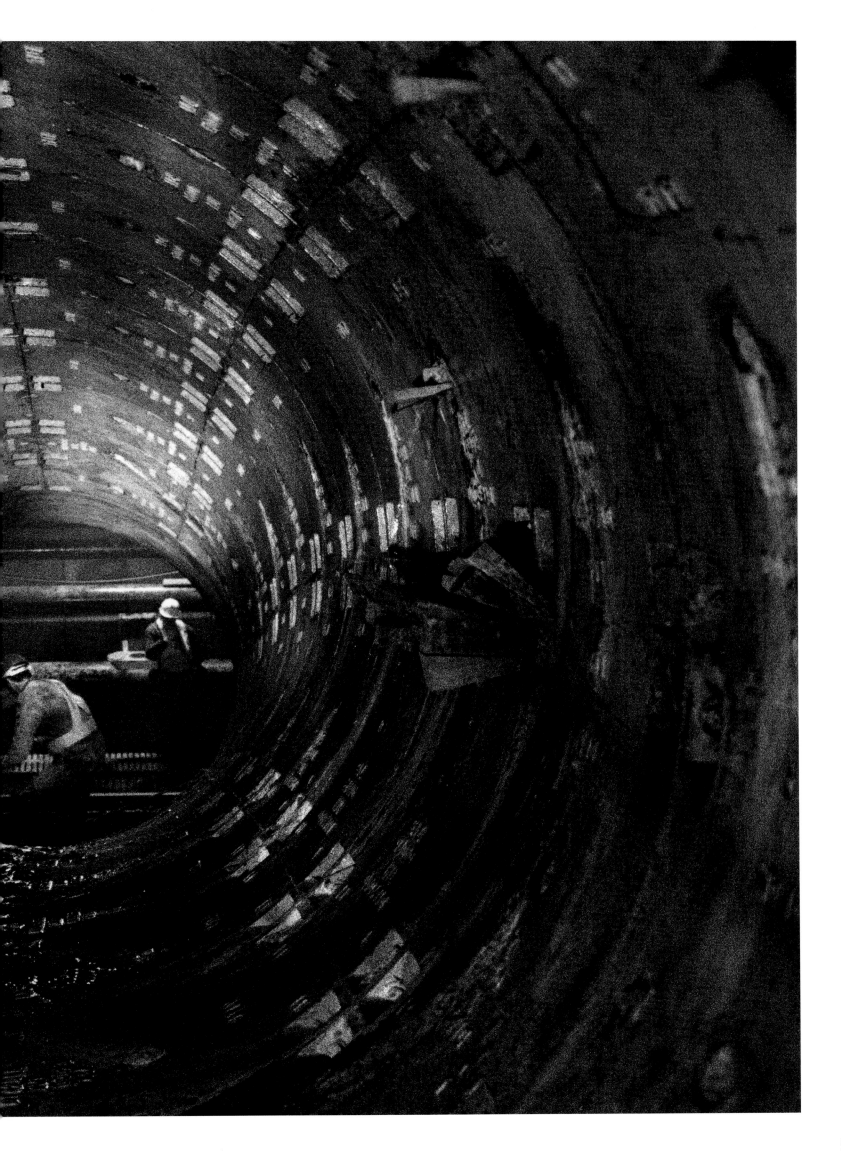

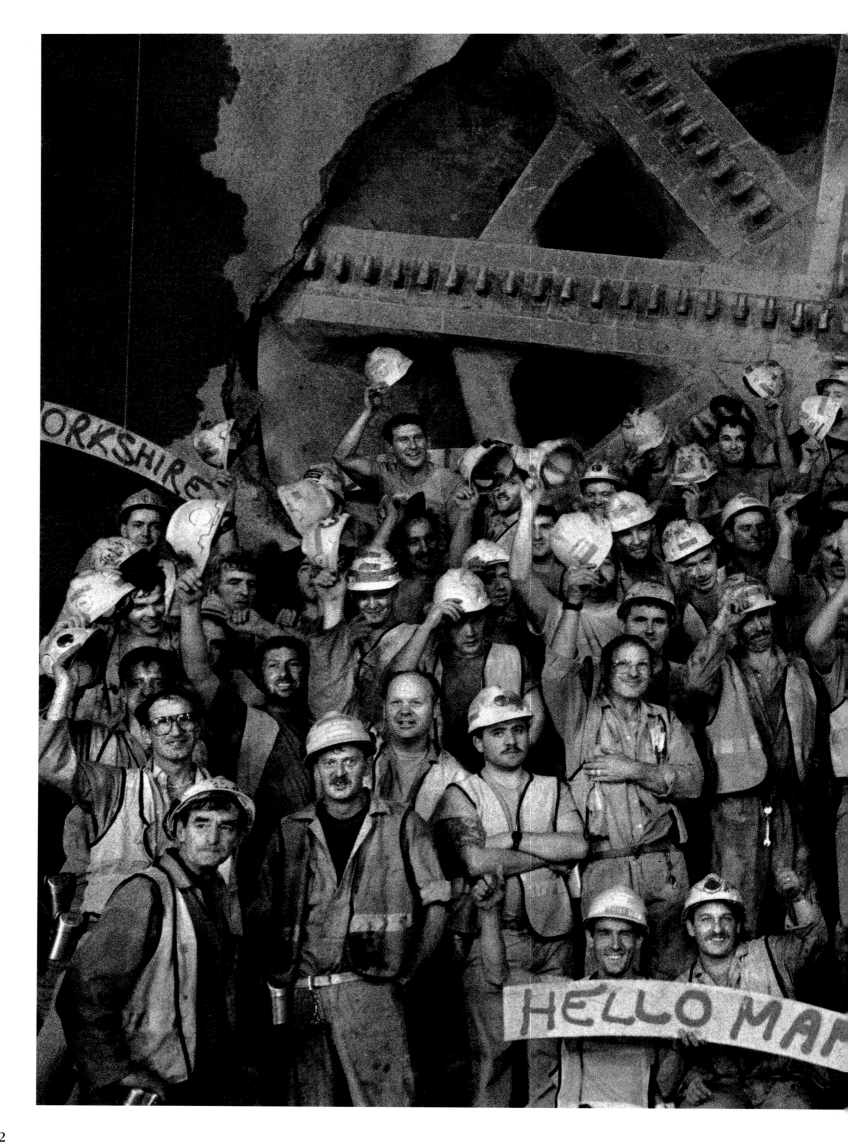

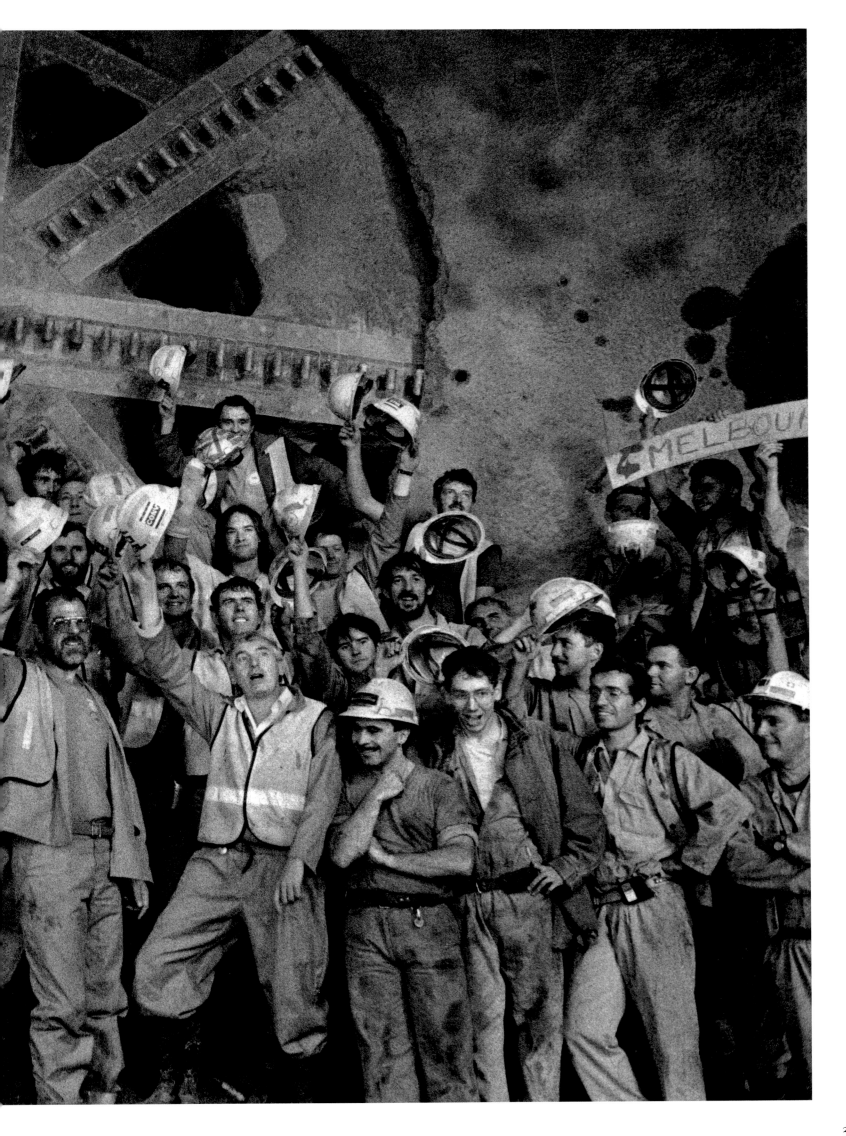

363

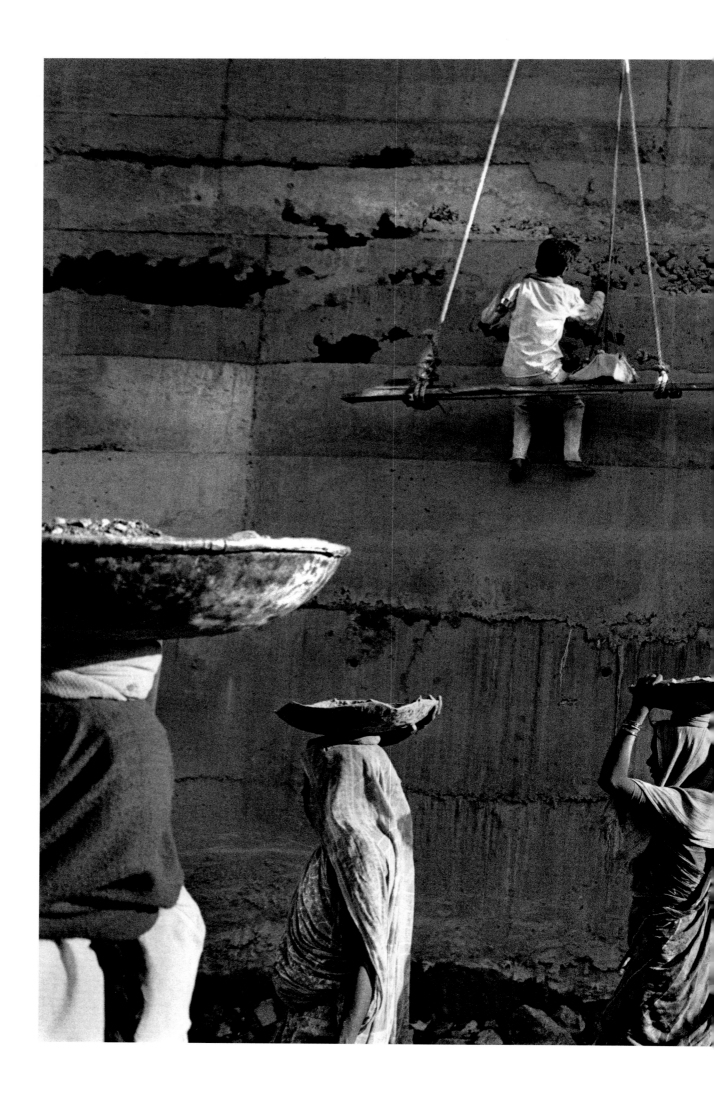

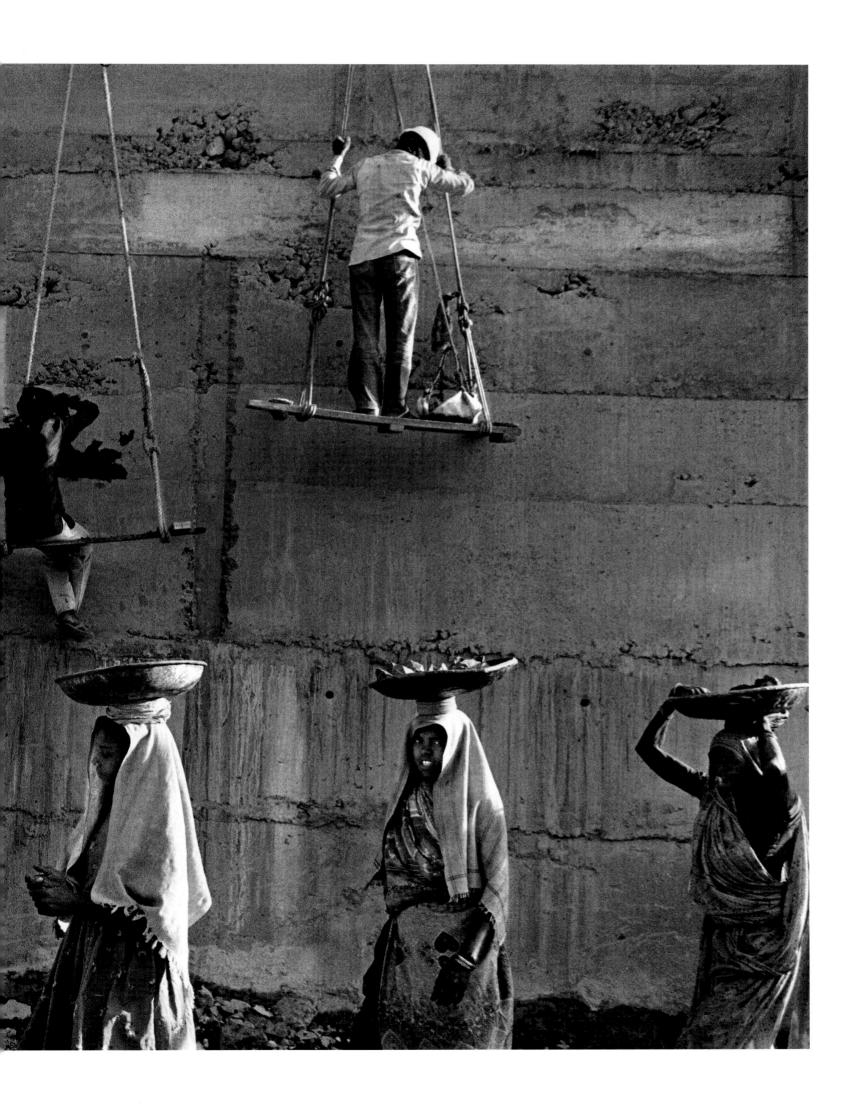

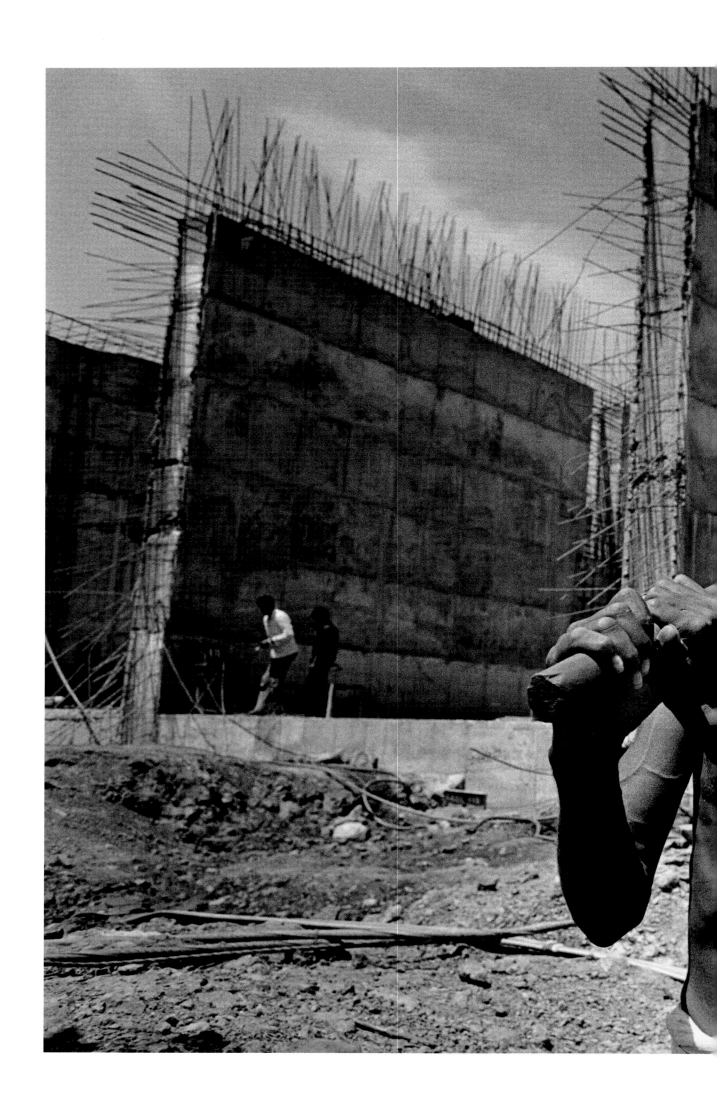

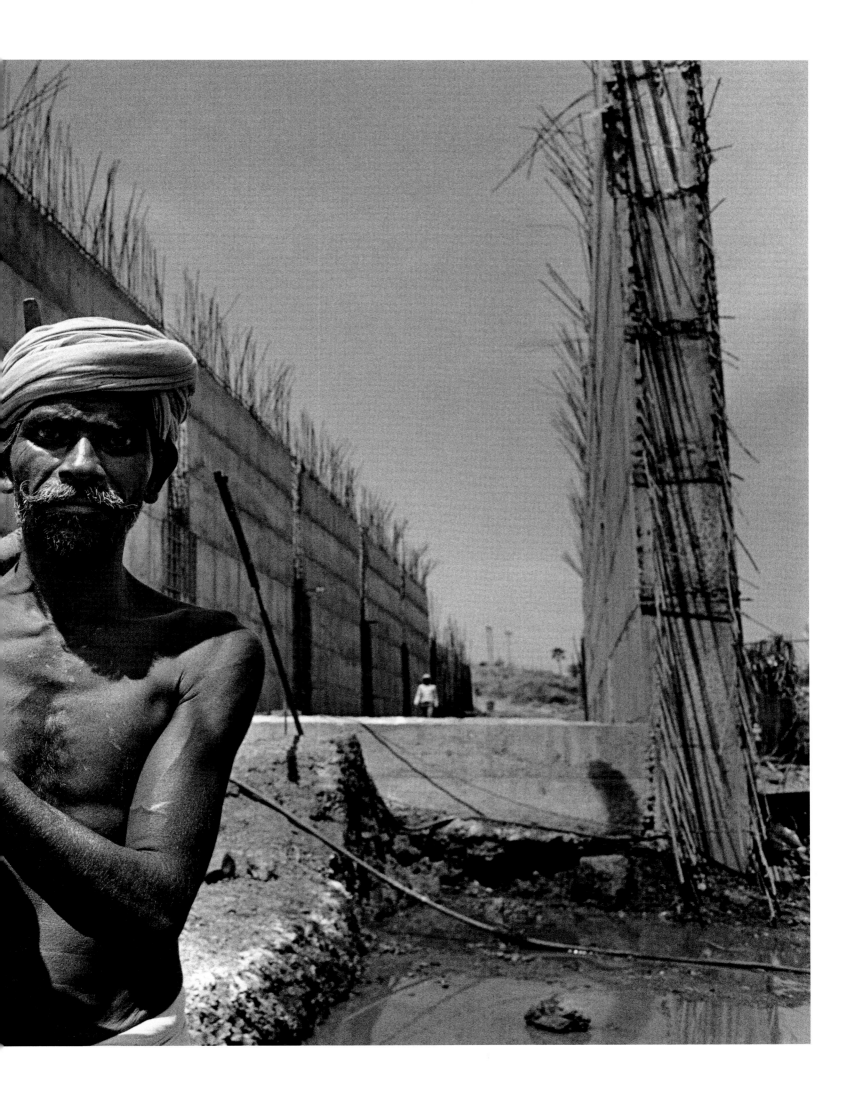

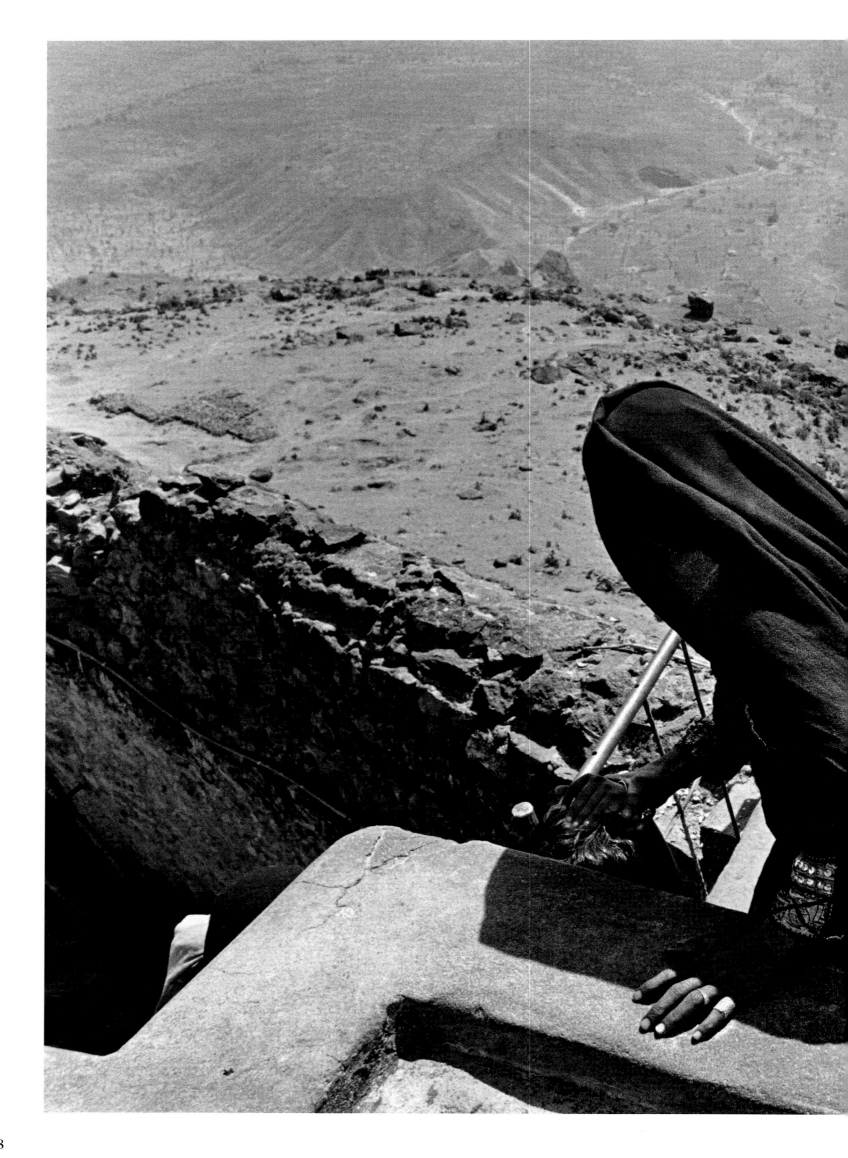

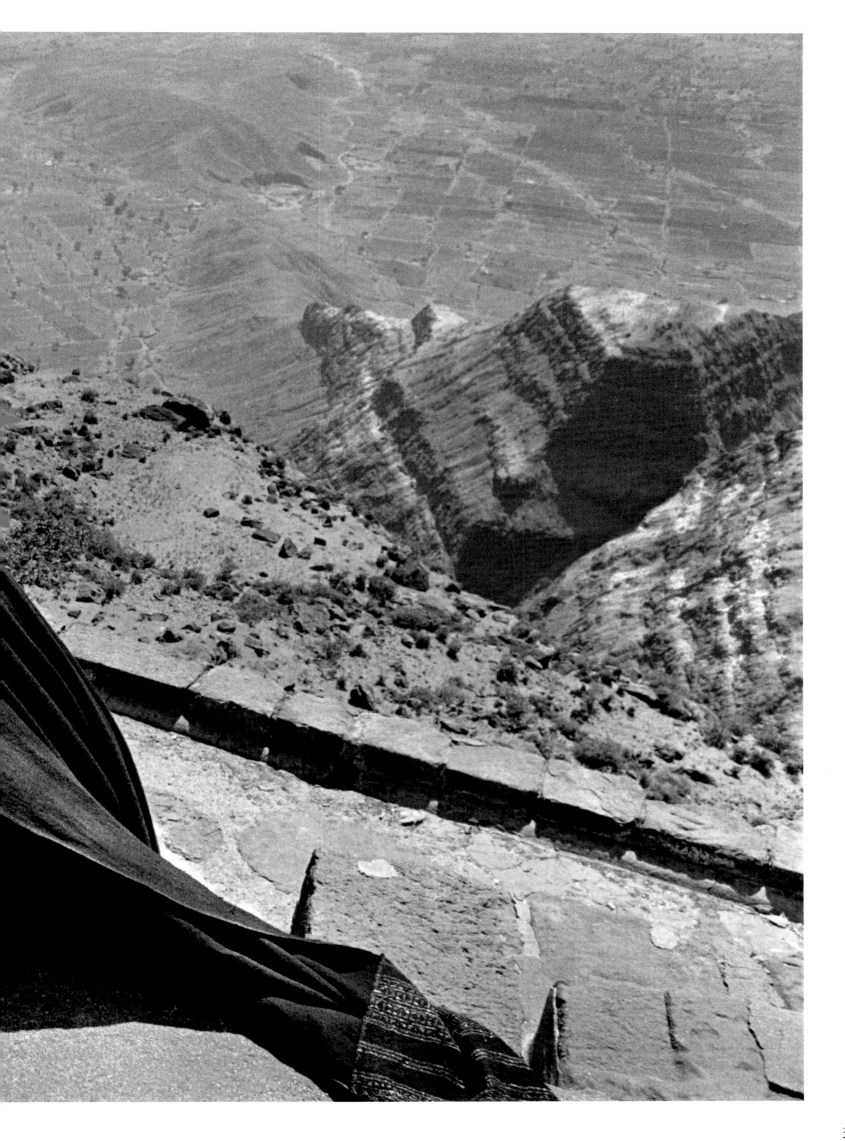

369

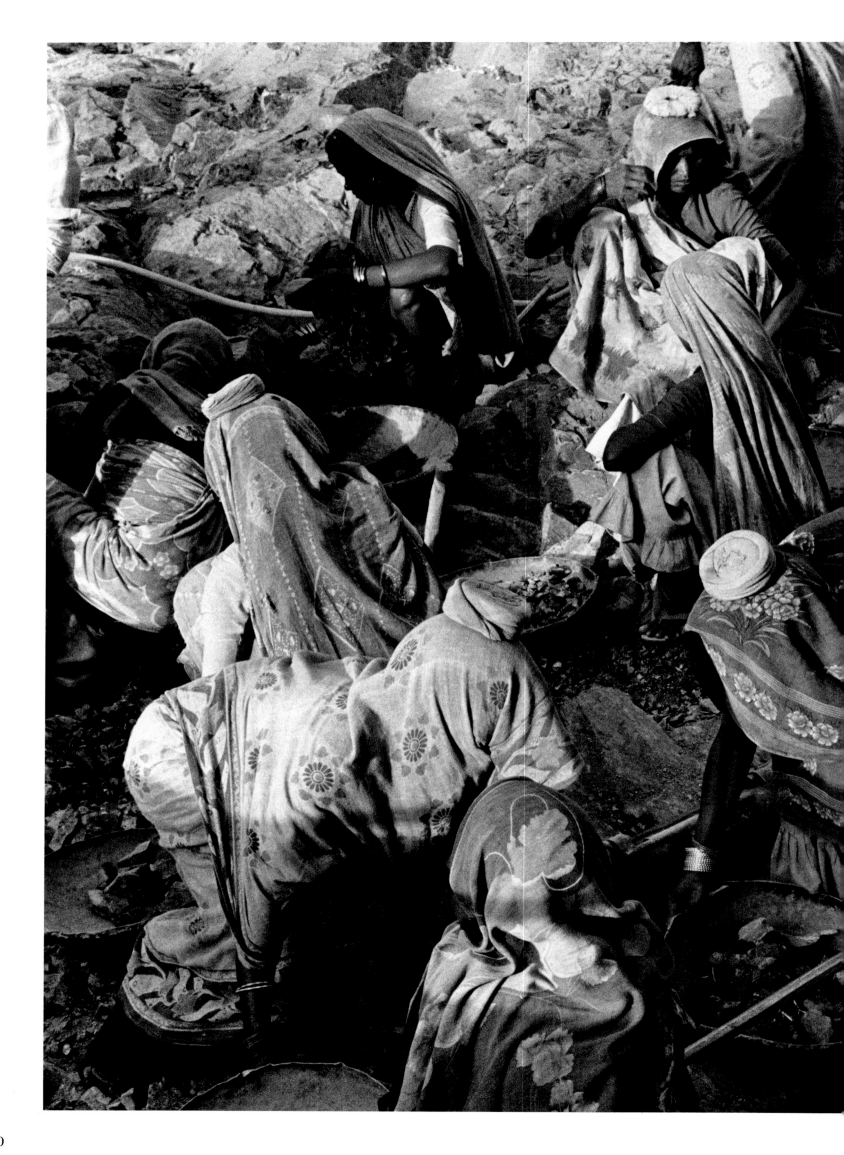

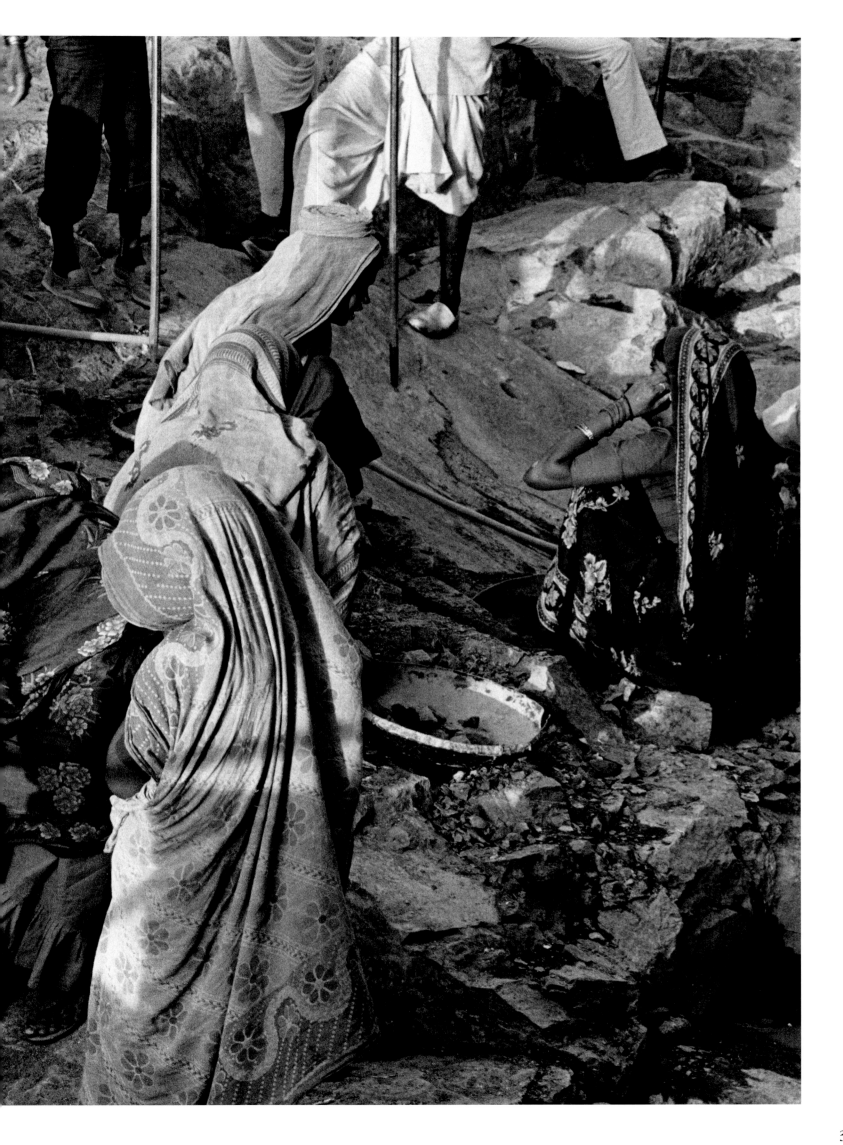

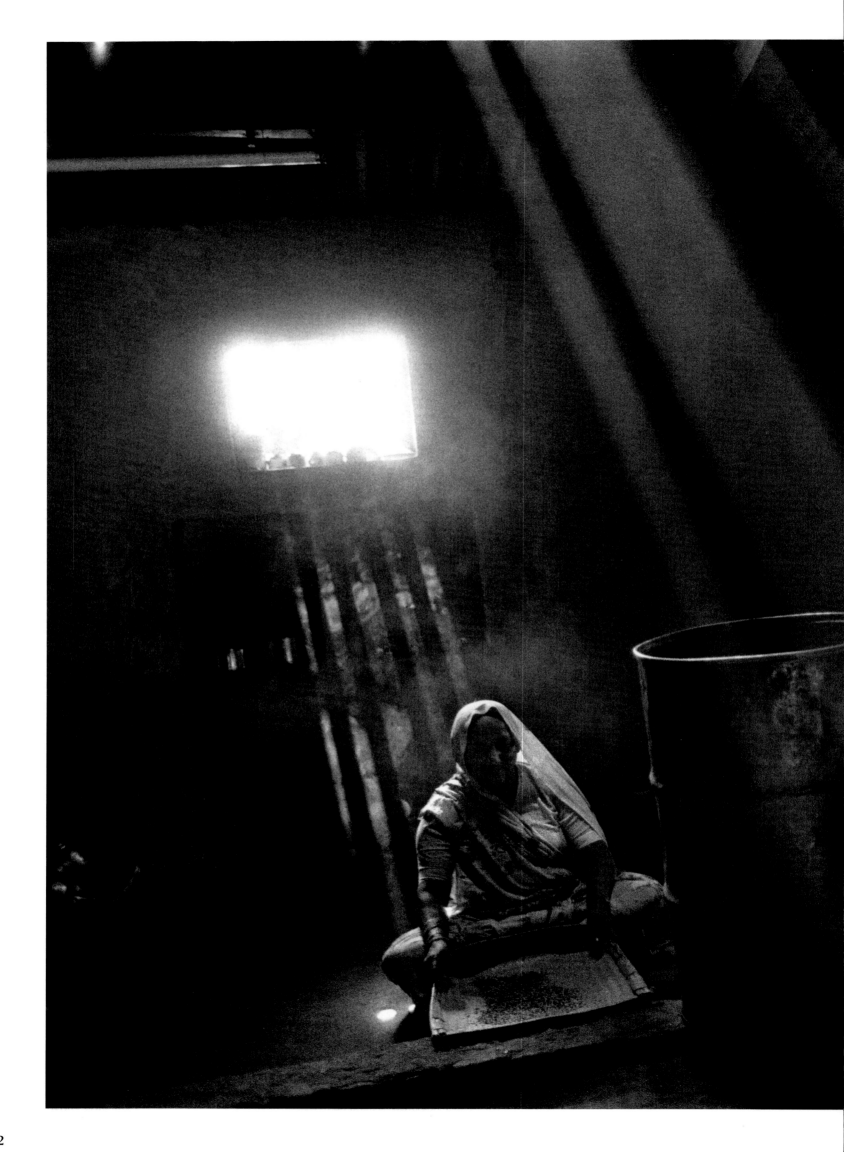

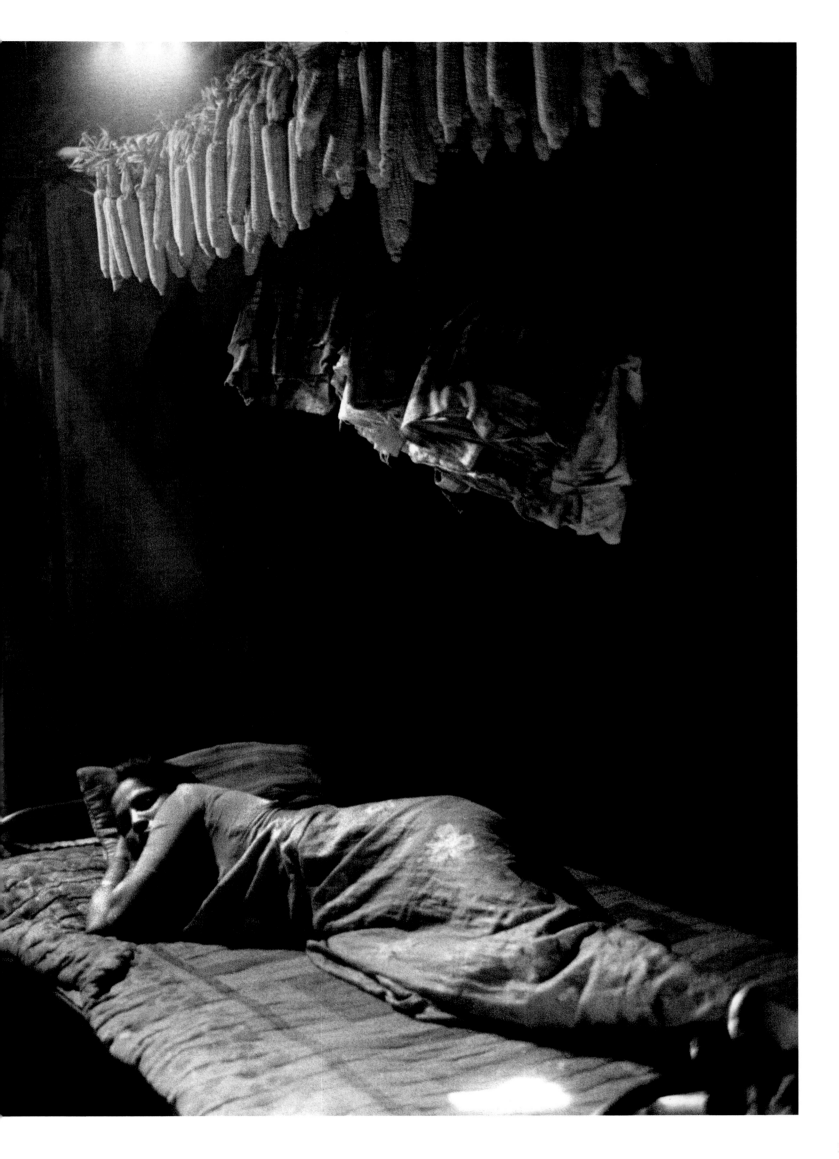

374

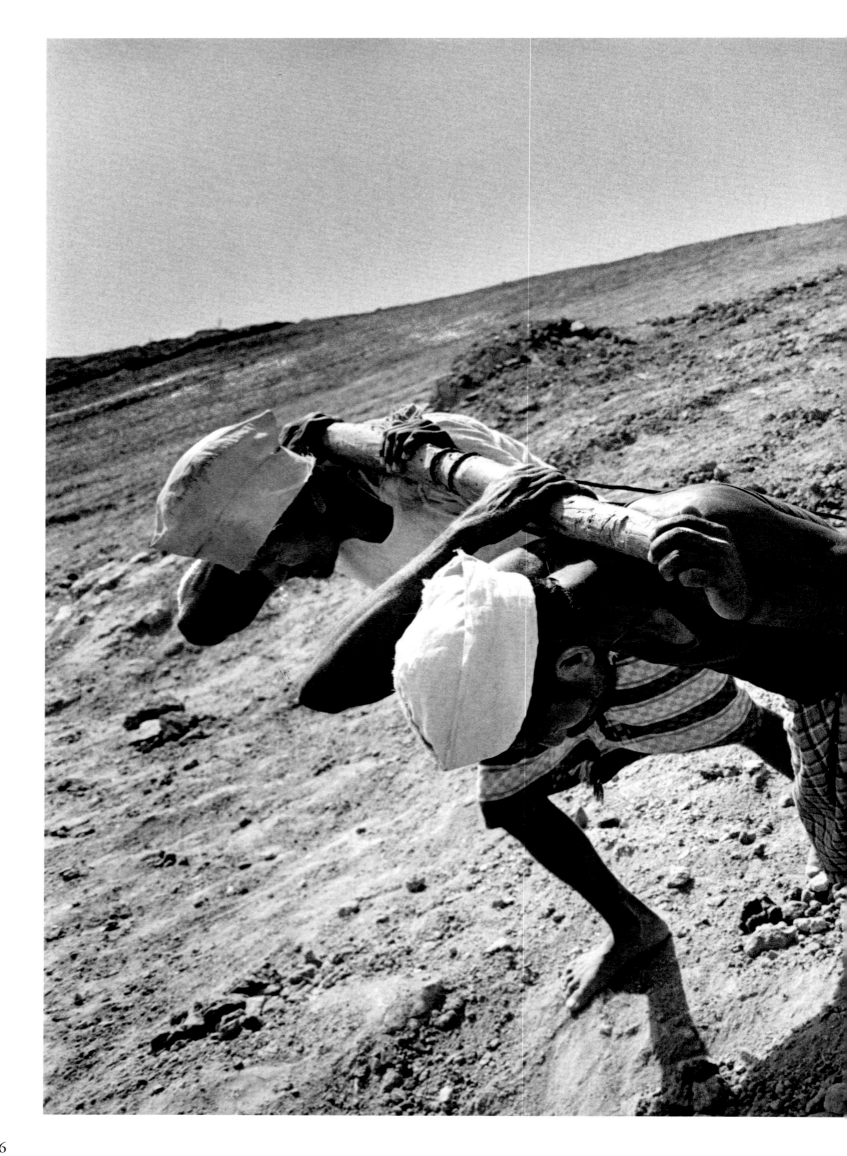

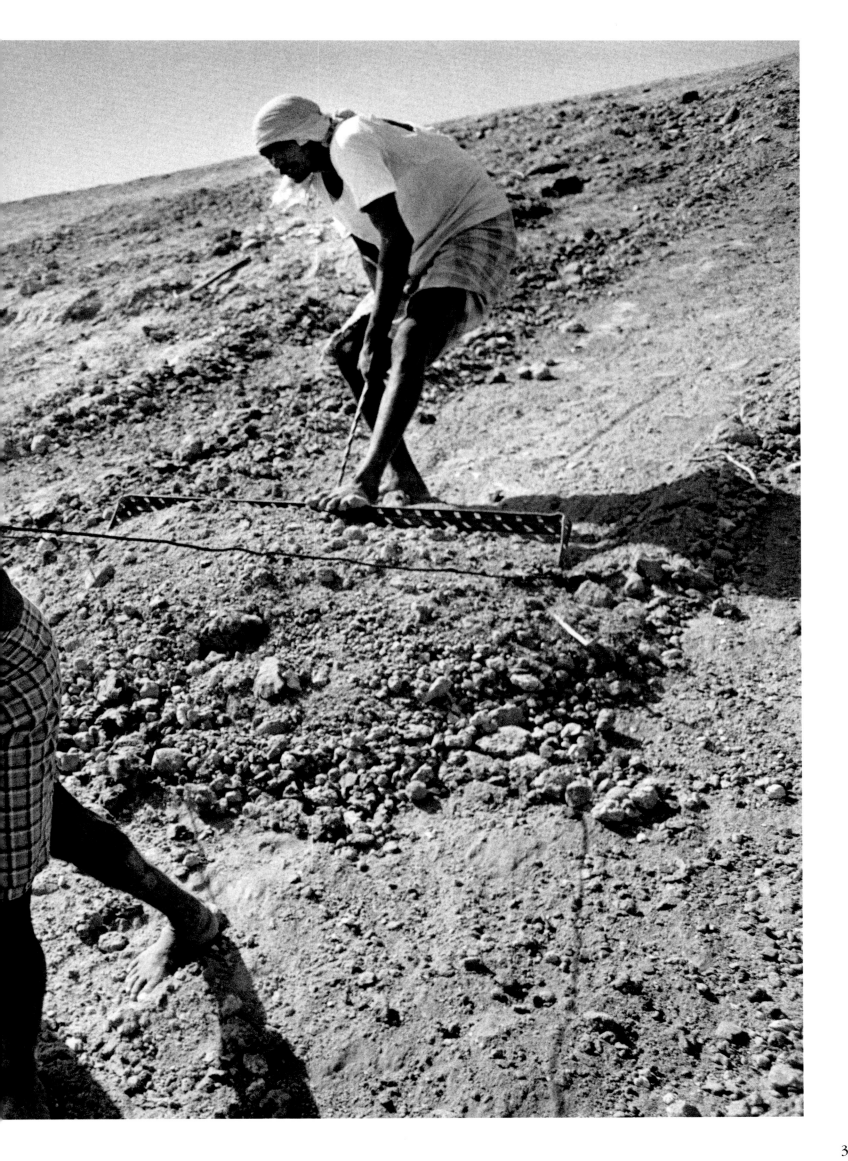

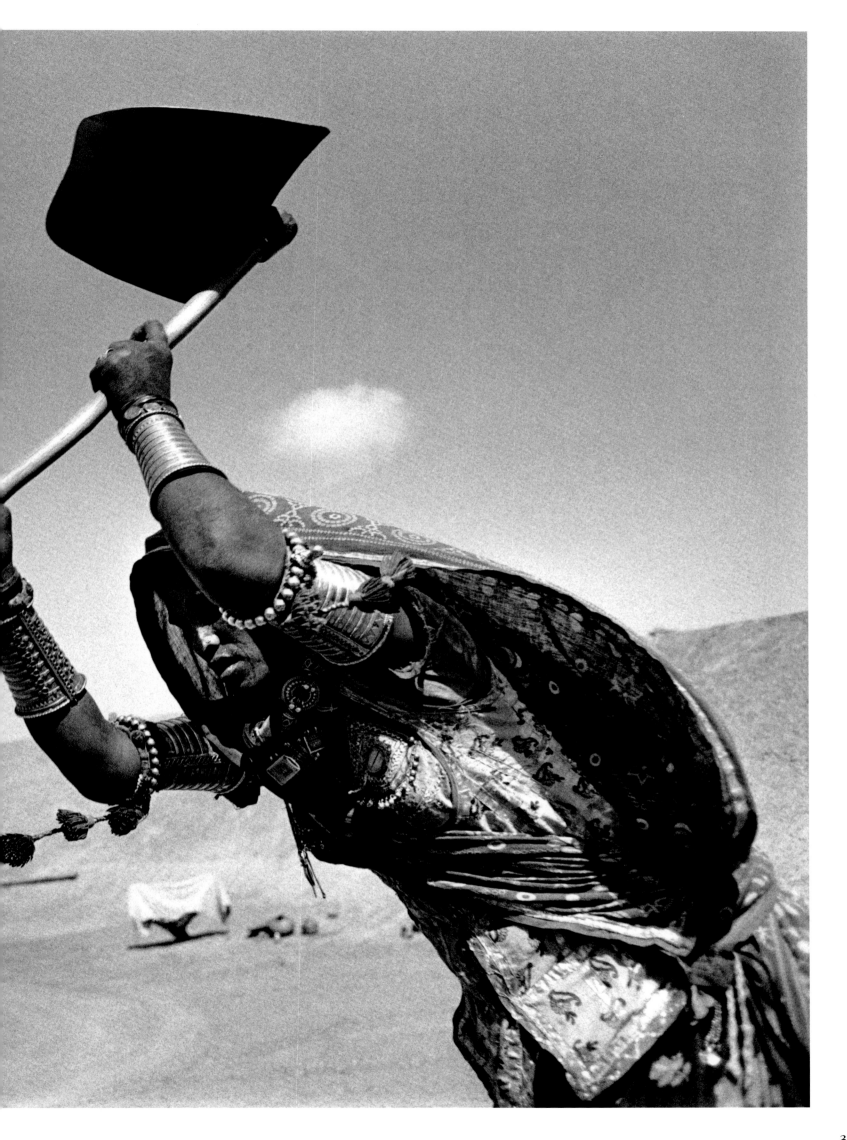

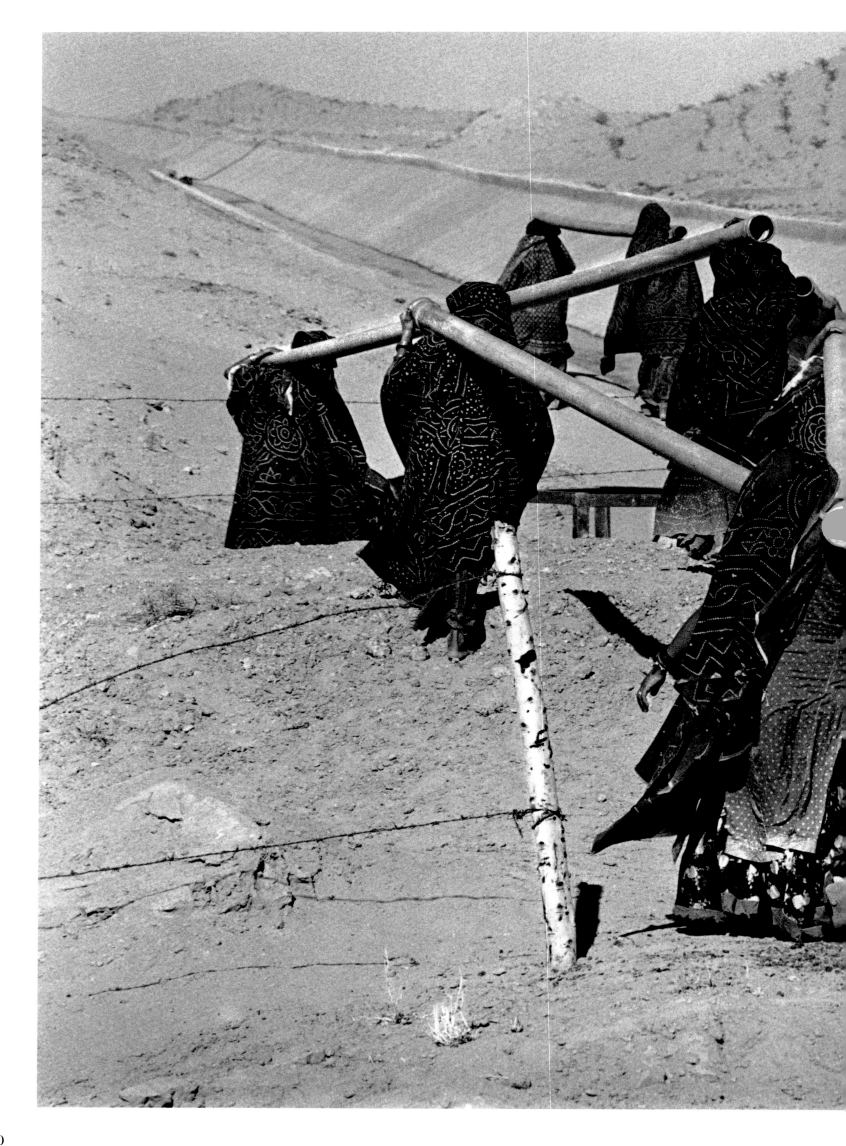

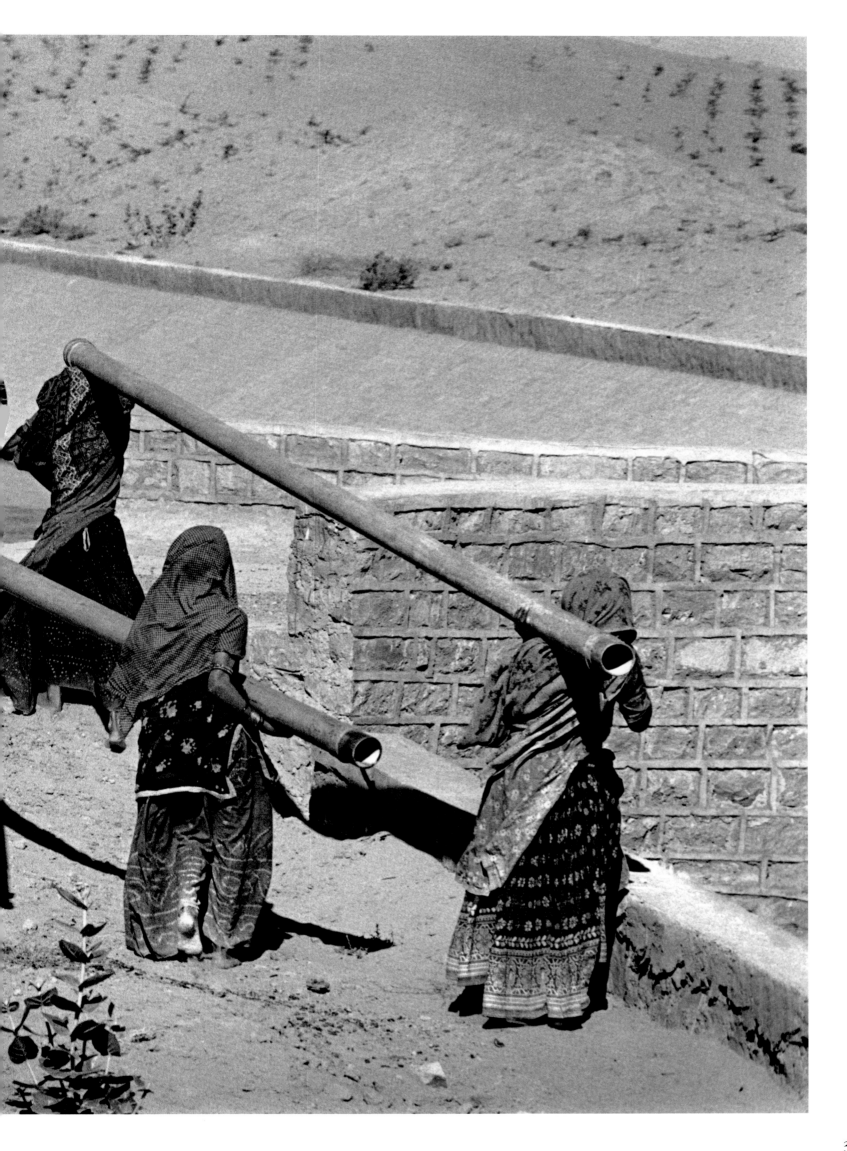

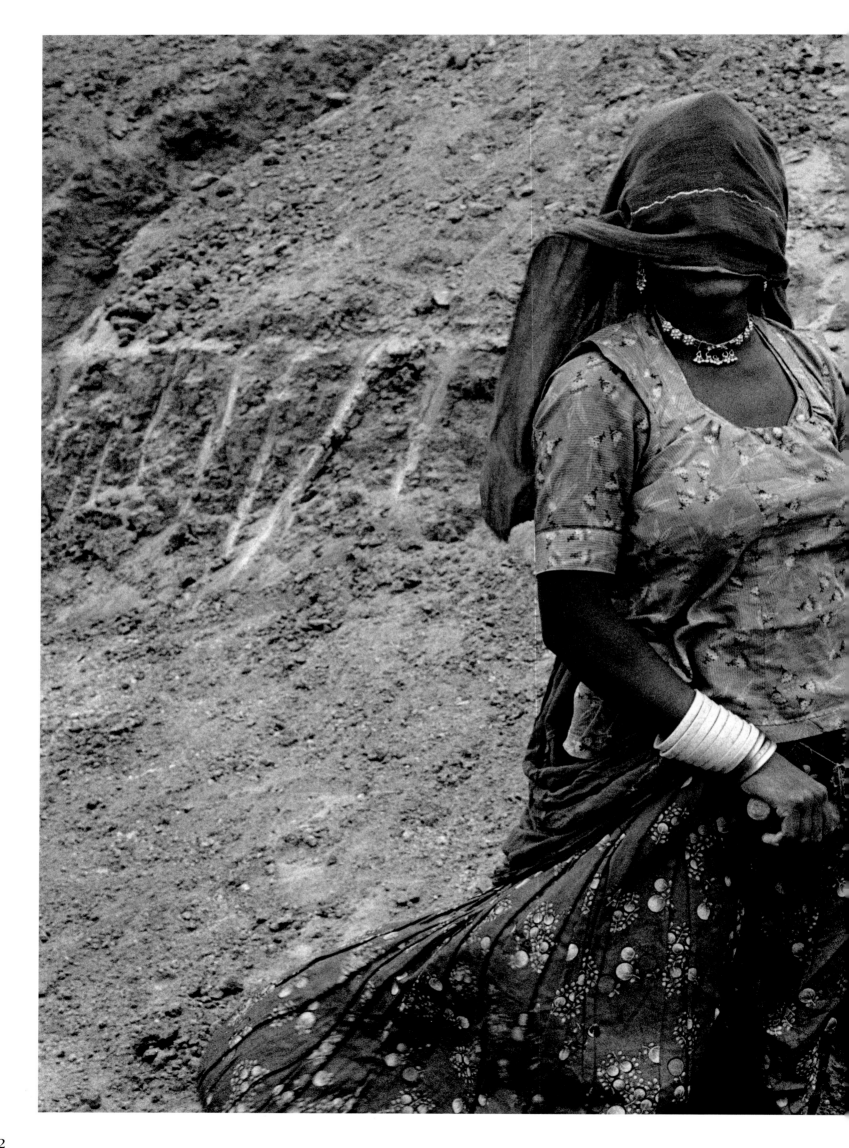

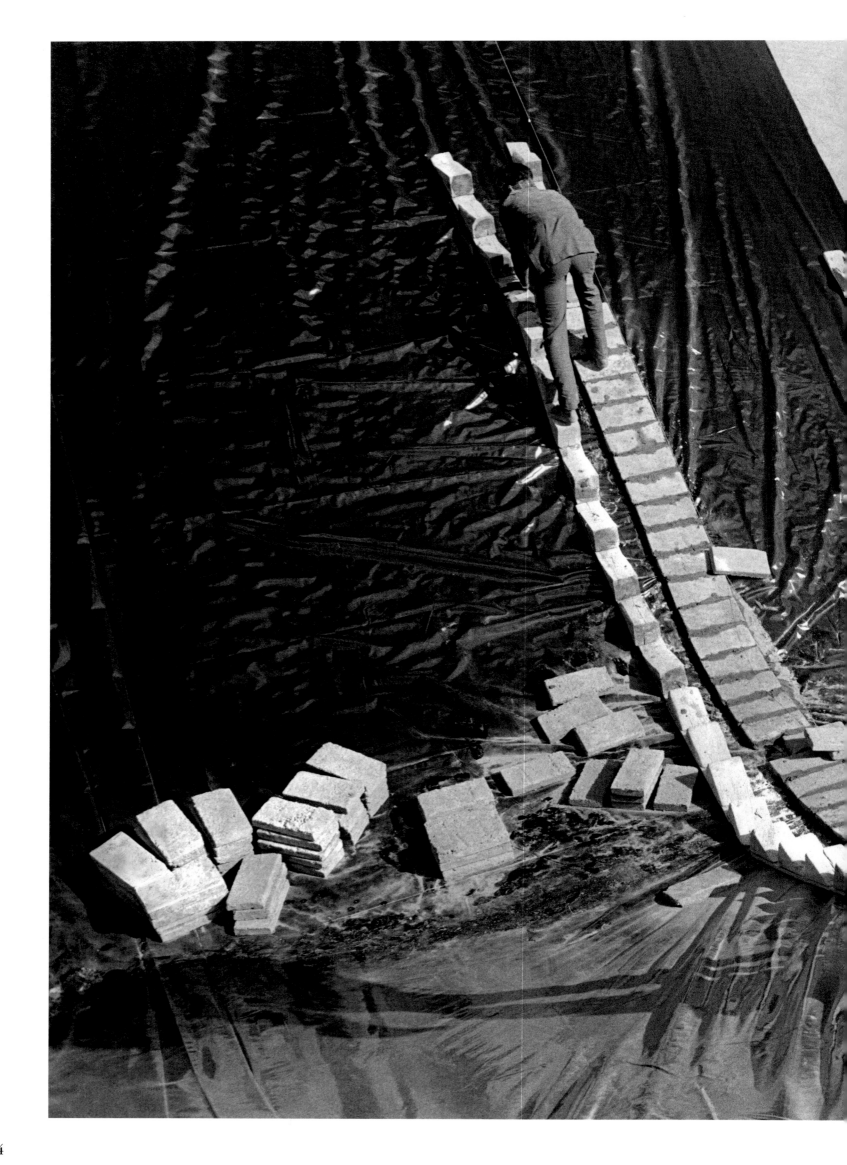

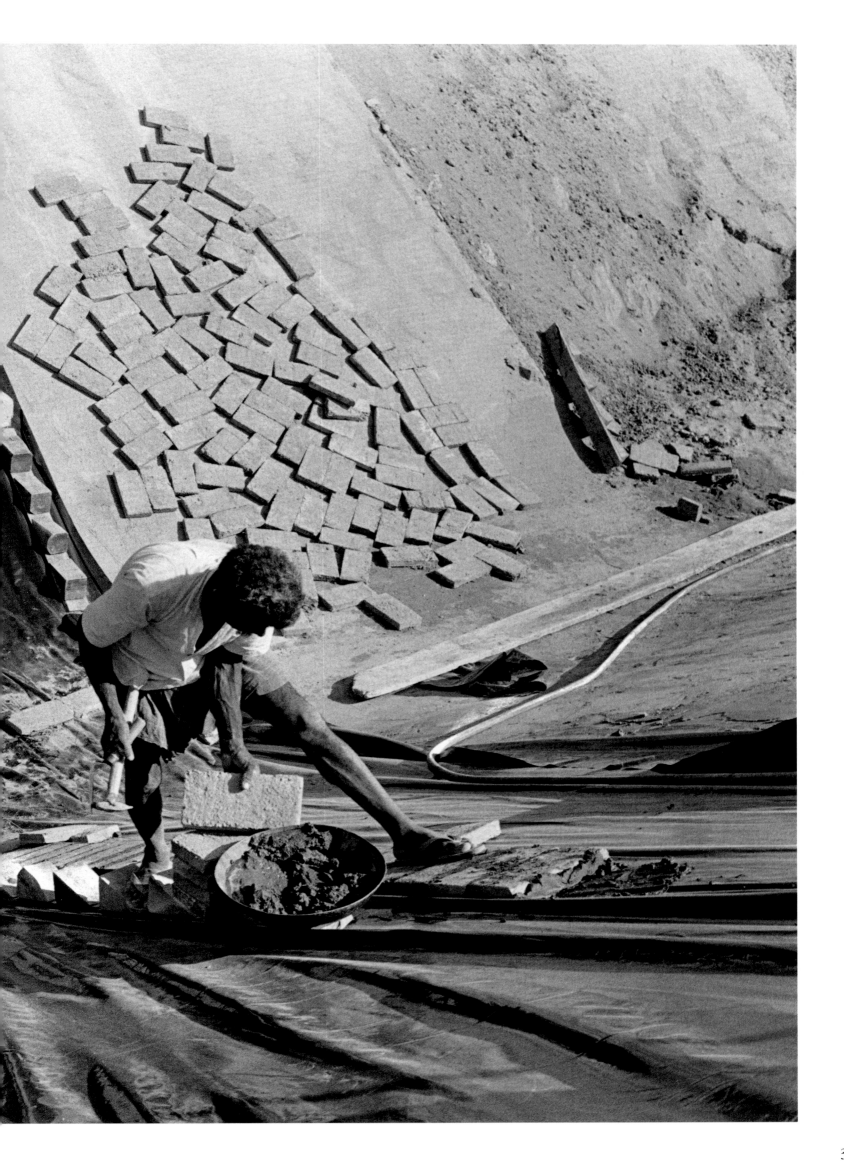

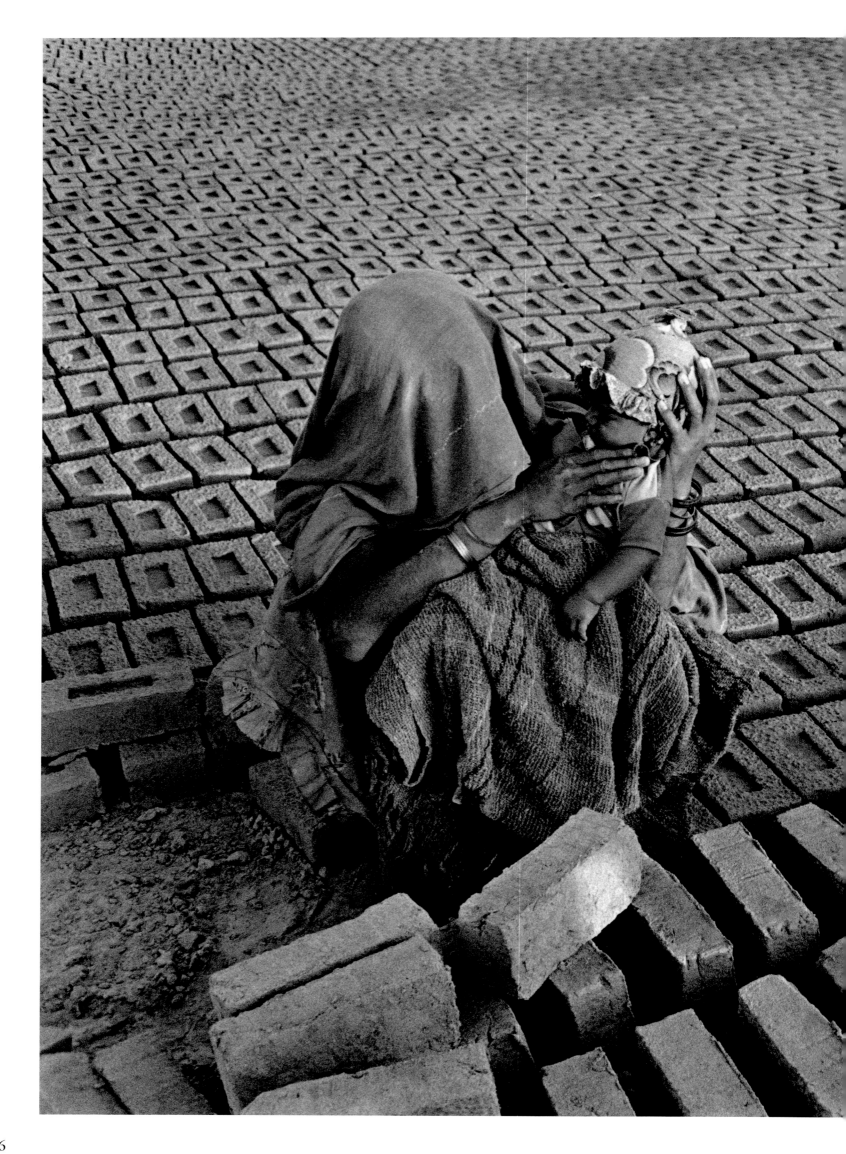

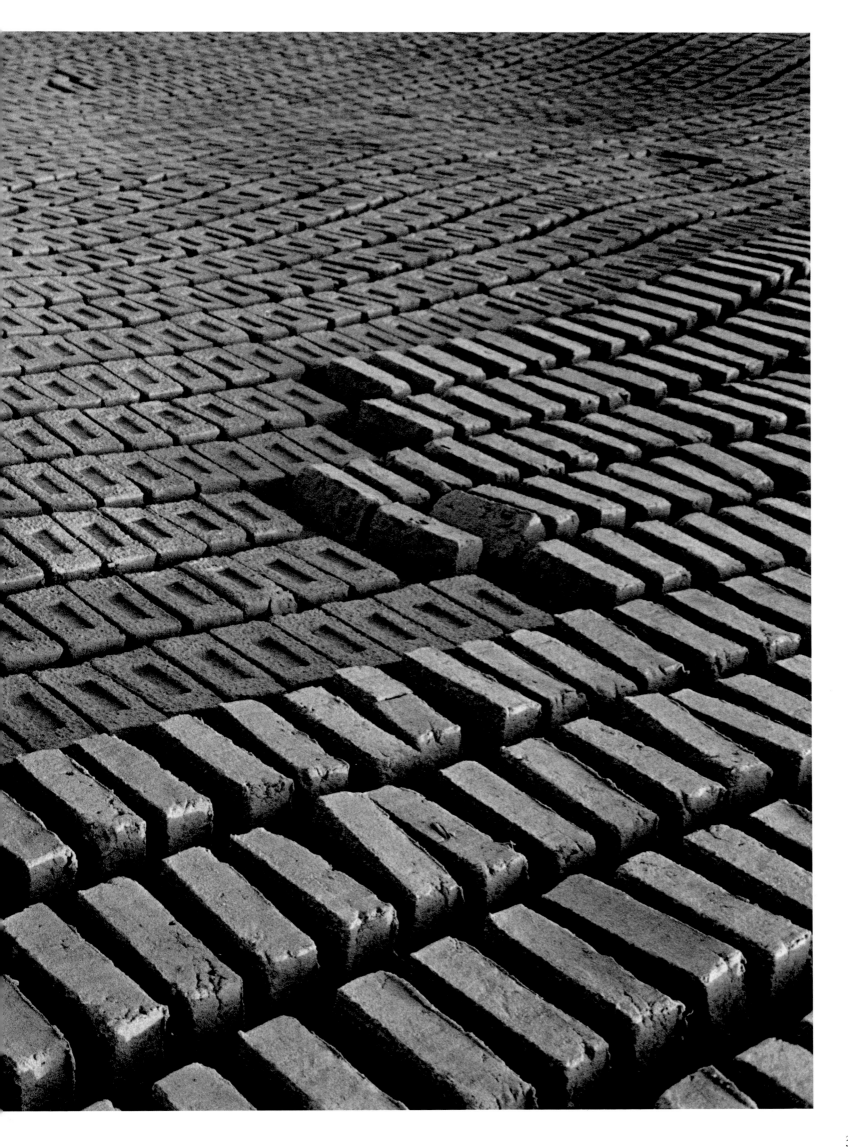

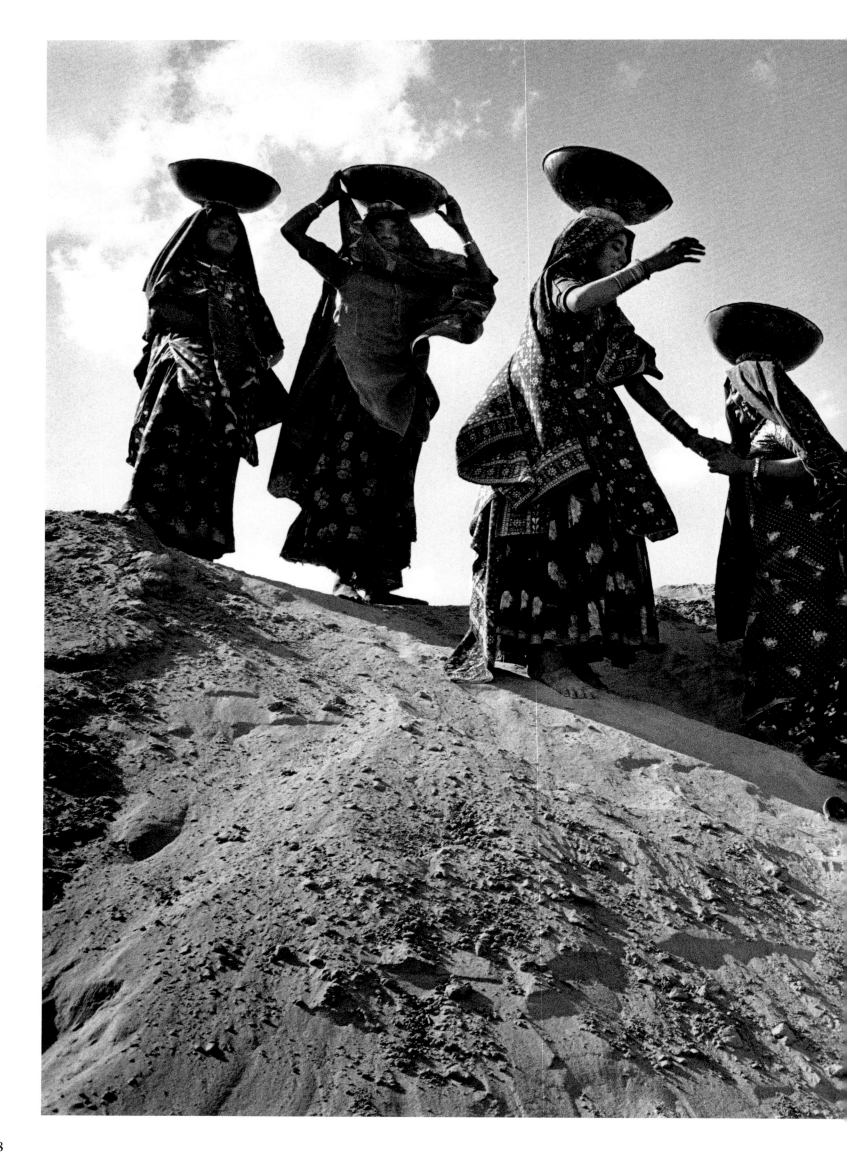

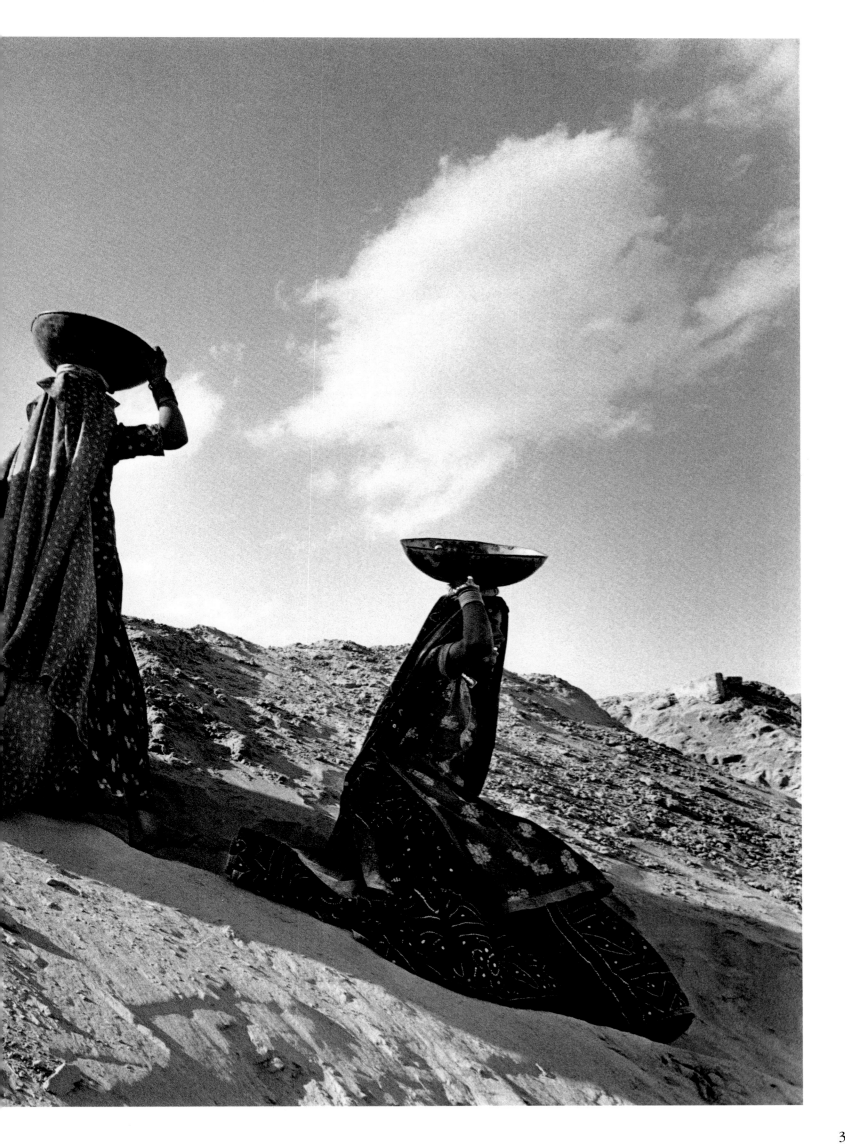

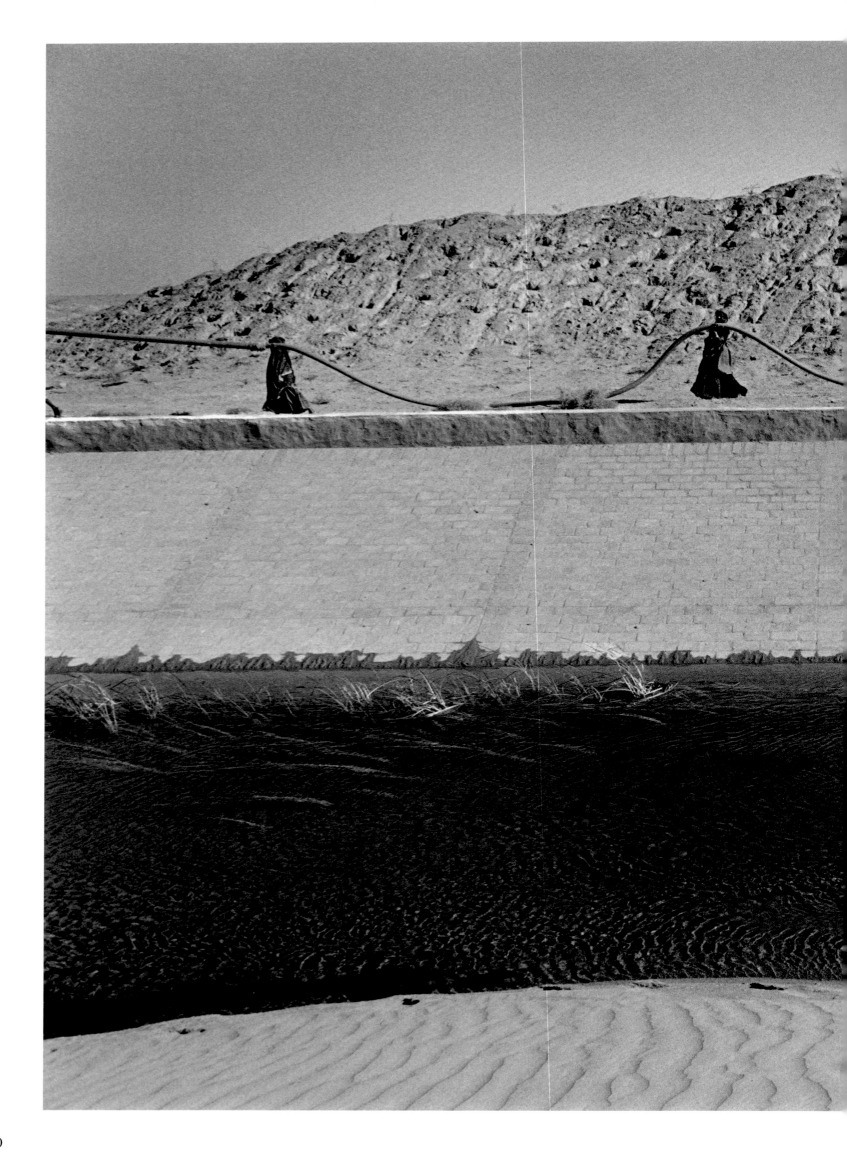

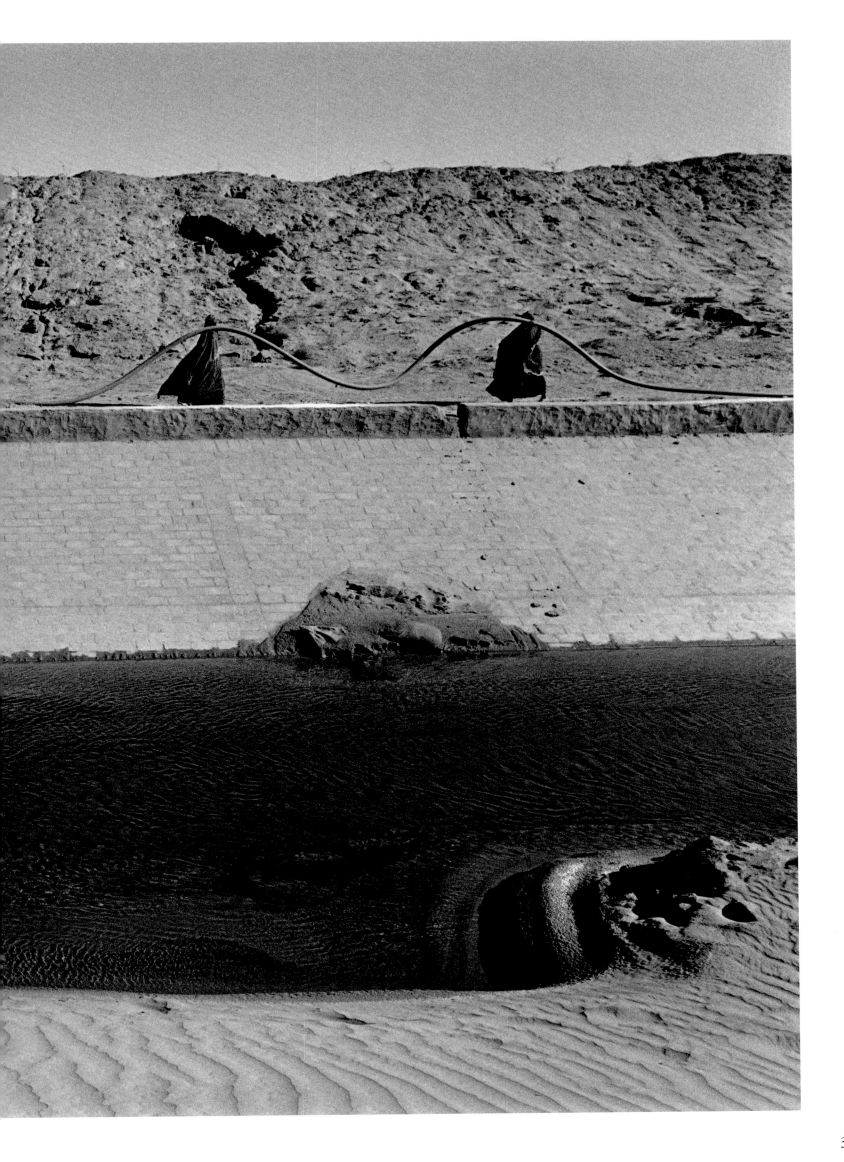

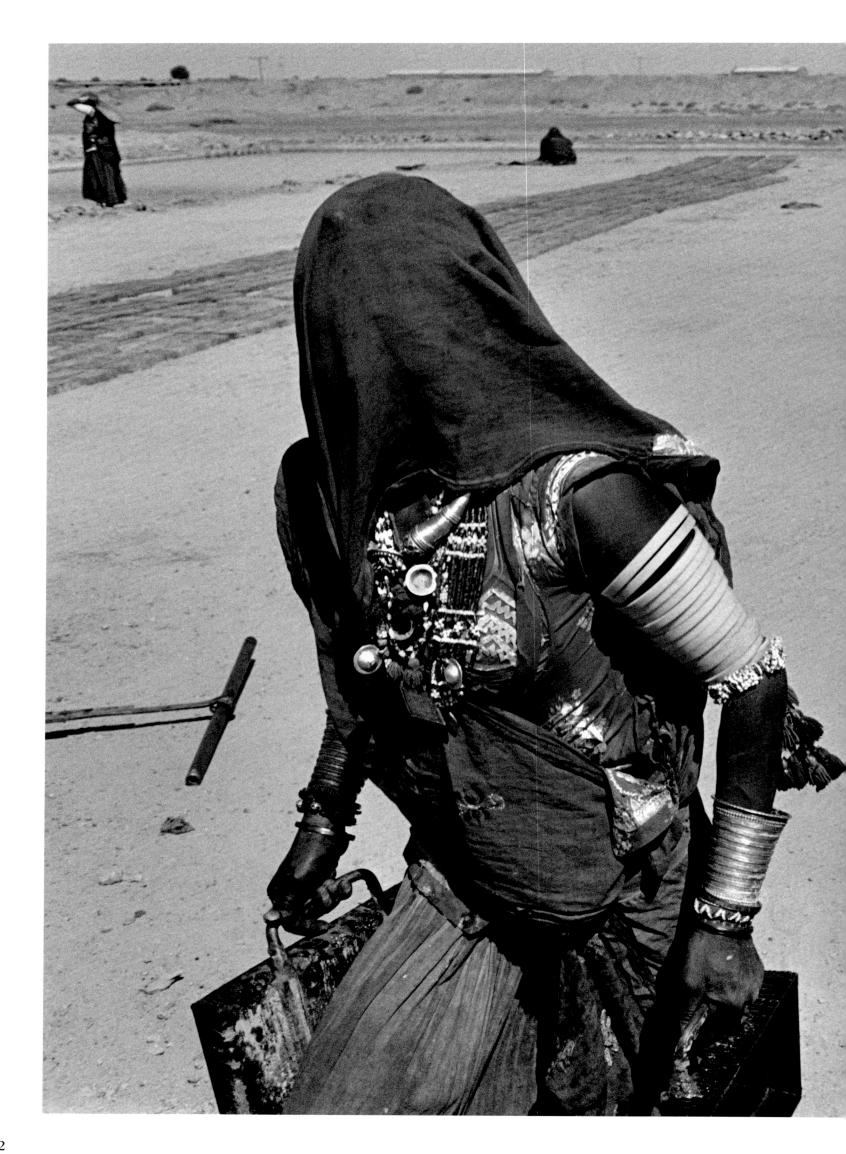

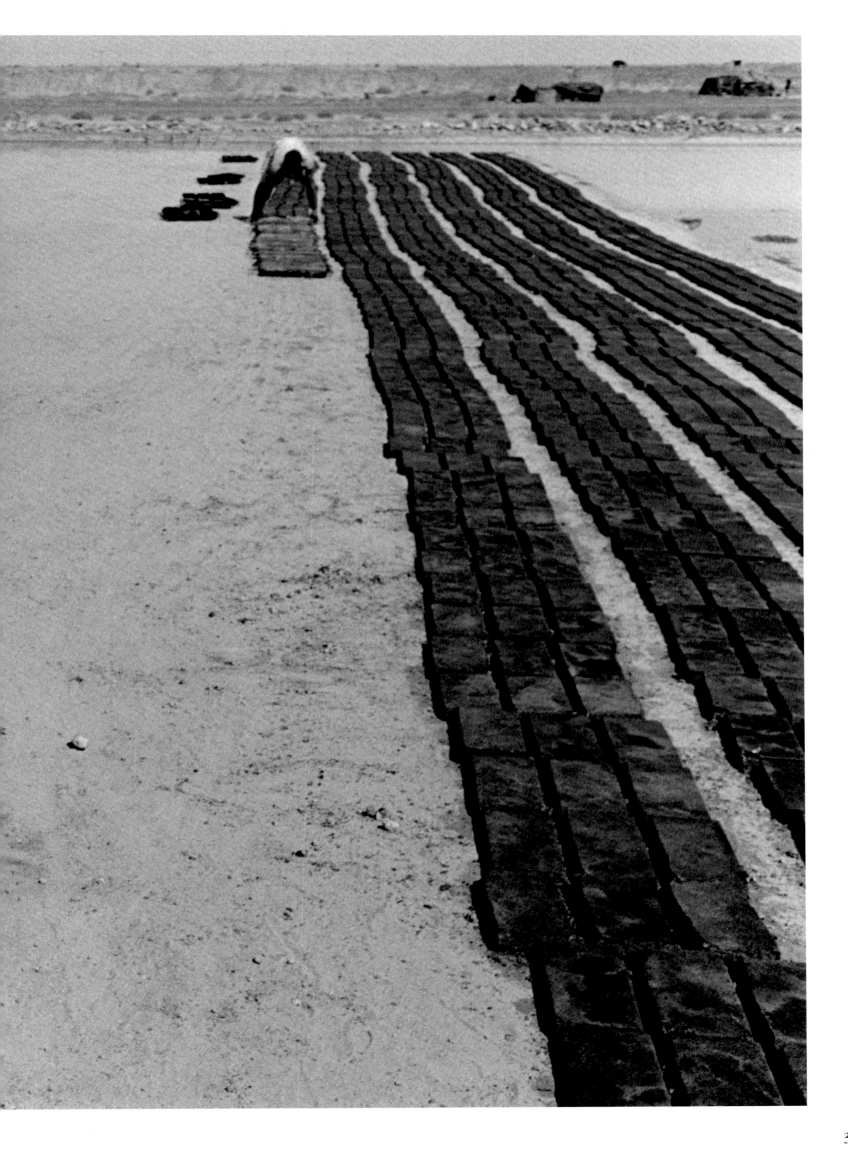

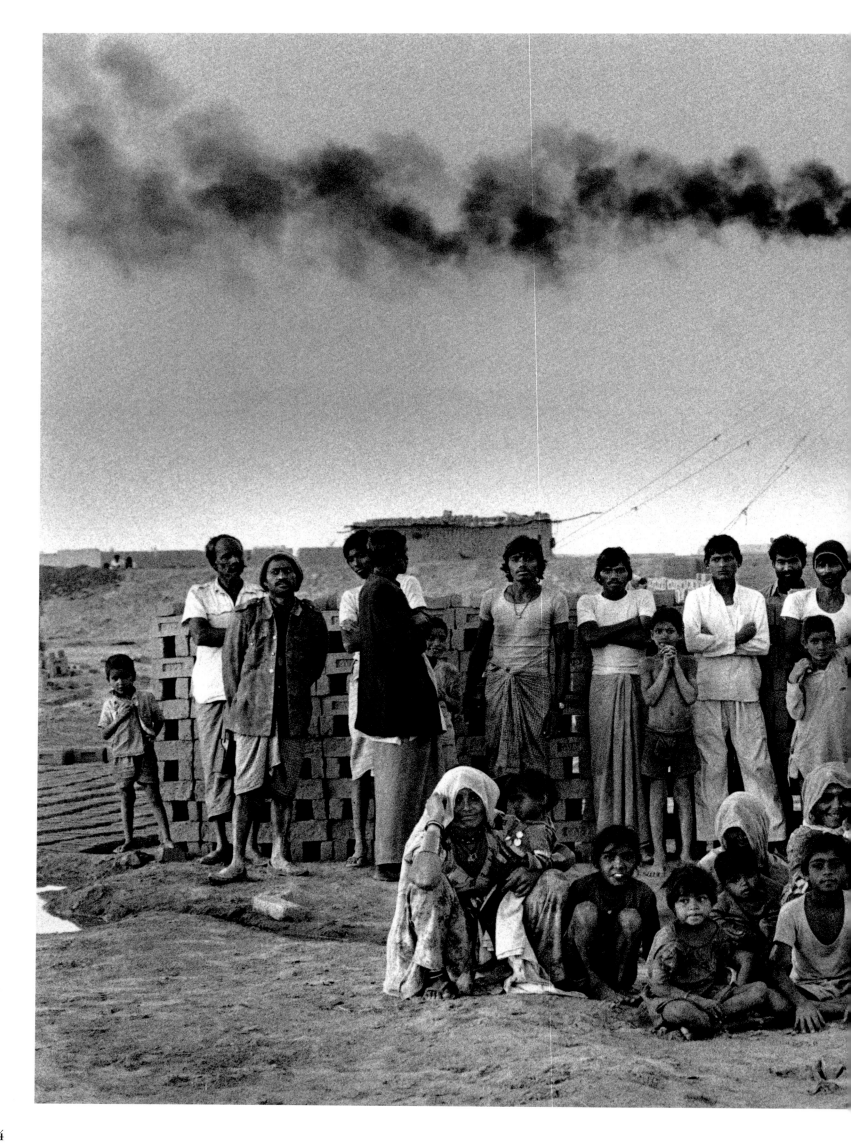

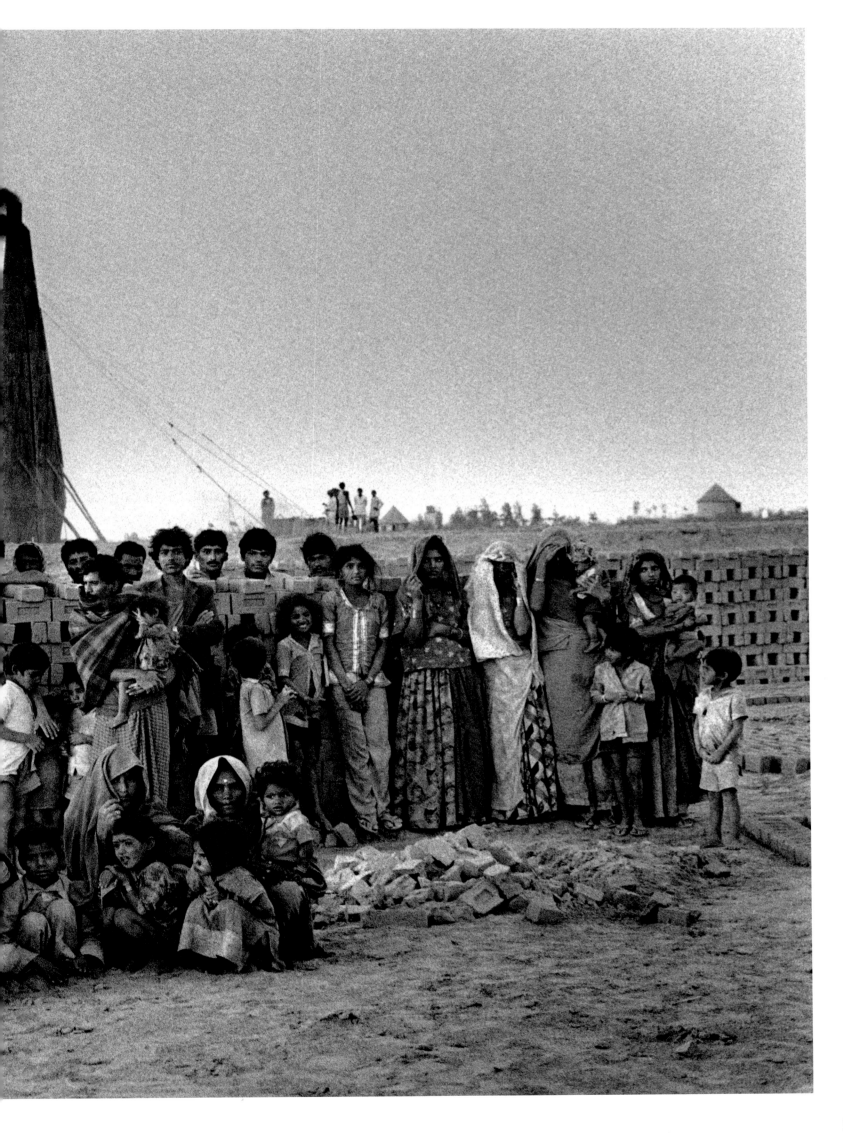

In 1984, when Sebastião Salgado had finished a major project on the peasants of Latin America, our discussions began to focus on an insistent and troubling theme: the phasing-out of manual labor on a global scale.

In this same year, Sebastião was compelled to travel to Africa, where he stayed for fifteen months, in order to show the public that an immense tragedy—famine—was sweeping down on the Sahel. The resulting work is a testimony to the devastation of countless human lives.

This current project began to take shape in the beginning of 1986, after important talks in New York with Robert Danin, then head of the editorial department at Magnum USA, and in Paris, with Jimmy Fox, Editor in Chief of Magnum France, and with Pierre Olivieri, a journalist, now director of Editions P.O. We knew that we needed to establish some guidelines for the work. With this in mind, we set out on an enormous task: to select the industries and define the geographical range of the project.

Kodak believed in the project from the outset, and supported Sebastião from the very beginning. In 1989, with about half the work accomplished, we prepared a preliminary dummy of the book based on our original concept and showed it to Raymond DeMoulin, then Vice President and General Manager of the Professional Photography Division at Kodak, in Rochester, New York. To our great pleasure, he and his staff fully understood the purpose of our efforts, and a wonderful mutual rapport and confidence were established.

Kodak thus became our main partner in this project and granted us the necessary subsidies for the achievement of our goals—the creation of this book, and arrangements for exhibitions that we hope will travel around the world. In these early efforts we worked in close collaboration with Rolf Fricke and Charles Styles. Later, when David Biehn became head of the Professional Imaging business unit, and Keith Boas took on responsibility for its worldwide sponsorship activities, our association with Kodak was renewed and strengthened. It is due to their support that this project has achieved the scope and magnitude it has.

In our collaboration with Kodak in France and Europe, we worked with Jean Francheteau, Carl Steinorth, Claude Genin, and Guy Bourreau, all of whom helped to find solutions to the innumerable challenges that arose.

Many other partners joined us once the project was underway. We would like to thank the following organizations for their participation: the French Ministries of Industry and Culture, through the Centre National de la Photographie, and the Ministry of Foreign Affairs, with the Prix Villa Medicis. Also, Paris Audio Visuel; the Musée de l'Elysée in Switzerland; Leica Camera; Apple USA; and the Comité Central d'Entreprise of the SNCF, who helped with the story on railway workers.

While Sebastião was still shooting, several magazines participated in the project by publishing photo essays: *Life* magazine (United States), *The Sunday Times Magazine* (England), *Il Venerdi di Repubblica* (Italy), *El País Semanal* (Spain), *Stern* magazine (Germany), *Paris Match* and *Libération* (France).

After each shoot, Sebastião developed the contact sheets and then went on to make work prints. We would make a rough selection, and the final press prints were chosen with the help of Jimmy Fox, who gave himself fully to the project, also translating and enhancing the Magnum texts and captions.

In the end, the project comprised many thousand work prints. Robert Delpire, head of the Centre National de la Photographie, and Michael Rand, artistic director of *The Sunday Times Magazine,* worked with us in making the first selection. With them, and with the gracious help of Suzanne Hodgart, we looked at the complete body of work over a period of two years, each of us making our respective choices. Marcia Navarro Mariano, our assistant, dispatched and compiled all of the photographs. Once that first edit was done, we were left with more than four thousand images. Much careful reflection was needed to find the main underlying theme of the book, and to proceed with definitive story selections. When we started work on the final dummy, the photographer Miguel Rio Branco was most helpful with the initial image sequencing. Wendy Byrne, at Aperture, and Patricia Pericas, who worked as our intern, also participated in realizing the dummy.

Sebastião and I would like to express our gratitude and our appreciation to all those who helped and encouraged us in bringing this book to life. Our special thanks are extended to our publisher, Michael E. Hoffman; our editor, Rebecca Busselle; and the dedicated Aperture staff; the entire team at Magnum, be they in Paris, London, New York, or Tokyo; and our friend Alan Riding, Paris bureau chief of the *New York Times.* We also thank our sons, Juliano and Rodrigo, for their understanding and patience as they endured Sebastião's long absences and my immersion in work.

—Lélia Wanick Salgado, *Project Director*

BOOKS AND EXHIBITION CATALOGS

Sebastião Salgado: Fotografias. Introduction by Pedro Vasquez. Rio de Janeiro: Ministério da Edução e Cultura/Edição Funarte/Nucleo de Fotografia, 1982.

Sahel: L'homme en Détresse. Introduction by Jean Lacouture. Text by Xavier Emmanuelli. Produced by the Centre National de la Photographie, to benefit Médecins sans Frontières. Paris: Prisma Presse, 1986.

Autres Amériques. Paris: Contrejour, 1986.

Otras Américas. Introduction by Gonzalo Torrente Bellester. Madrid: Ediciones ELR, 1986.

Other Americas. Introduction by Alan Riding. New York: Pantheon Books, 1986.

Sebastião Salgado. Introduction by Jean Dieuzaide. Toulouse: Galerie Municipale du Château d'Eau, 1986.

Sahel: El fin del camino. Introduction by Rosa Montero. Text by José Vargas. Comunidad de Madrid, for Médicos sin Fronteras,1988.

Les Cheminots. Introduction by Christiane Bedon. Comité Central d'Entreprise de la SNCF, France, 1989.

An Uncertain Grace. Introduction by Eduardo Galeano. Text by Fred Ritchin. Aperture, USA; Thames and Hudson, England; SGM, Sygma Union, Japan, 1990.

Une Certaine Grâce. Nathan Image, France, 1990.

As Melhores Fotos—The Best Photos. Introduction by Janio de Freitas. São Paulo: Boccato Editores, 1992.

Sebastião Salgado: Otras Américas. Introduction by Margarita Ledo Andión. Santiago de Compostela, 1992.

Sebastião Salgado: La revelación rescatada. Text by Alvaro Mutis. XIX Festival International Cervantino, Mexico, 1991.

BOOKS AND EXHIBITION CATALOGS THAT INCLUDE SALGADO'S WORK

Brunie, Patrick. *La ville à prendre: (ou une camera dans la ville).* Paris: Hachette, 1979.

Portugal 1974/75: regards sur une tentative de pouvoir populaire. Introduced by Jean-Paul Miroglio and Guy LeQuerrec. Texts by Jean-Pierre Faye. Paris: Hier et Demain, 1979.

"Les Hmongs", in Médecins sans Frontiéres. Paris: Chêne/Hachette, 1982.

Brésil des Brésiliens. BPI Centre Georges Pompidou, Paris, 1983.

Vasquez, Pedro. "Sebastião Salgado: da revolta à serenidade—uma trajetória exemplar," in *Fotografia: Reflexos e Reflexaes.* Coleção Universidade Livre. Porto Alegre, Brazil: L&PM Editores, 1986.

Mois de la Photo à Paris. Paris Audio-Visuel, 1986.

The International Month of Photography. Athens, 1987.

The Second Israeli Photography Biennale. Jerusalem: The Domino Press, 1988.

Regards d'Acier. Sollac, Dunkerque, 1988.

Pinturas, esculturas e fotografias de Uruguay, Argentina, Brasil e Chile. Fundção Calouste Gulbenkian, Lisbon, 1988. (Exhibition catalog, Amsterdam: Stedelijk Museum).

Splendeurs et Misères du Corps. Triennale Internationale de la photographie, Fribourg; and Mois de la Photo, Paris, 1988.

Le Mois de la Photo à Montréal, 1989.

Libertés en Exil. Fondation l'Arche de la Fraternité, Paris, 1989.

Tercera Bienal de la Habana. Havana: Editorial Letras Cubanas, 1989.

Visages Secrets, Regards Discrets. DGA; Contrejour, Paris. 1990.

Triangle Index, Swedish Photographers, and Hasselblad Prize Winner, 1990.

The Past and the Present of Photography. Introduction by Tohru Matsumoto. The National Museum of Modern Art, Tokyo; The National Museum of Modern Art, Kyoto, 1990.

Médecins sans Frontières. Galerie Municipale du Château d'Eau, Toulouse, 1992.

Brasilien—Entdeckung und Selbstentdeckung. Junifestwochen Zürich. Kunsthaus Zürich, 1992.

World Press Photo 1956–1992. Asahi Shimbun, Tokyo, 1992.

PERIODICALS

Lindström, Per, and Claes Löfgren."Sebastião Salgado; Viktigt att avslöja krigets grymheter." *Aktuell Fotografi* (September 1978).

Hinstin, Jérôme. "Sebastião Salgado: le reveil de la conscience indienne en Amérique du Sud." *Zoom,* no. 64 (July/August 1979).

Soares, Renato. "Salgado Junior: A fotografia é uma forma

de vida." *A Gazeta* (Vitória, Brazil) (November 1981).

Mandery, Guy. "Sebastião Salgado: un nouveau parmi les grands." *Photo Cinema Magazine,* no. 27 (February 1982).

Caujolle, Christian. "Le Brésil sec de Salgado." *Libération* (2 May 1984).

Van der Spek, Dirk. "Sebastião Salgado, Magnum." *Foto* (Hilversum) 39:10 (October 1984).

"Sebastião Salgado." *Photo* (Paris), no. 206 (November 1984).

Gustafsson, Tom. "Etiopien— Den Lônsamma Svältkatastrofen: Sebastião Salgado." *Fotograficentrums Bildtidning* (Stockholm) (1985).

"2 morts à la minute." *Photo* (Paris), no. 209 (February 1985).

Pontual, Roberto. "O mundo de Sebastião Salgado." *Jornal do Brasil* (1 March 1985).

Roegiers, Patrick. "World Press: l'Ethiopie de Salgado." *Photomagazine* (Paris) no. 61 (April 1985).

Markus, David. "Moving Pictures: How Photographers Brought the Ethiopian Famine to Light in the Shadow of Television." *American Photographer* 14:5 (May 1985).

d'Aguiar, Rosa Freire. "Fotografia: com o foco na fome." *Isto É* (São Paulo) (1 May 1985).

Andión, Margarita Ledo. "Hambre que mata: el gran cinismo de los paises ricos." *El Noticiero Universal* (26 June 1985)

Roegiers, Patrick. "Salgado au Palais de Tokyo: hommes en détresse." *Le Monde* (13 June 1986).

"Sahel: l'homme en détresse." *Photo* (Paris) no. 226 (July 1986).

Riding, Alan, and Sebastião Salgado. "Faces of the Other Americas." *New York Times Magazine* (7 September 1986).

Roegiers, Patrick. "Pour que les images ne meurent." *Le Monde* (18 October 1986).

Utzeri, Fritz. "Os deserdados." *Jornal do Brasil* (Rio de Janeiro) (16 November 1986).

Bauret, Gabriel. "Sebastião Salgado." *Camera International,* no. 9 (Winter 1986).

"Humain: Salgado." *Photomagazine* (Paris) no. 78 (December 1986/January 1987).

Sabóia, Napoleao. "A outra América, vista por um brasileiro." *Jornal da tarde* (São Paulo) (ca. 1986).

Bos, Rolf. "Kleur is zelfmoord: Braziliaan Salgado fotografeerde het andere Amerika." *de Volkskrant* (Amsterdam) (27 February 1987).

"América: Tierra a la vista." *La Vanguardia: domingo* (Barcelona) (29 March 1987).

Young, Jacob. "Photography: Seeing the 'Other Americas.'" *Newsweek* (13 April 1987).

Livingstone, Kathryn. "Books: South of the border: A Haunting Latin American Sojourn with Sebastião Salgado." *American Photographer* 18:5 (May 1987).

Skelsey, Nigel. "Salgado: Interview." *Photography* (London) no. 9 (June 1987).

Shawcross, William, and Francis Hodgson. "Sebastião Salgado: Man in Distress." *Aperture,* no. 108 (Fall 1987).

Taylor, Liba. "Sebastião Salgado." *British Journal of Photography* (12 November 1987).

Wilson, Keith. "Salgado's Homecoming." *Amateur Photographer* 176:21 (21 November 1987).

"Brazil Nuts: Sebastião Salgado's Dramatic Pictures of Gold-Fever in the Amazonian Hell-Hole of Serra Pelada." *Photography* (London) no. 15 (December 1987).

Bauret, Gabriel. "Portrait: Salgado: un certain monde industriel." *Photographies Magazine* (Paris), no. 1 (December 1987/January 1988).

Mémoires de la photographie, "Visages du Travail." *Le Courrier, UNESCO* translated into 35 languages (April 1988).

Borhan, Pierre. "Adieux pour prendre date." *Clichés* (Brussels), no. 48 (July 1988).

Ollier, Brigitte. "Doisneau-Salgado: duo sur les années boulot." *Libération* (3 January 1989).

Pizzati, Carlo. "Salgado." *Il Venerdi di Repubblica,* no. 55 (6 January 1989).

Pacelle, Mitchell. "Salt of the Earth." *American Photographer* (April 1989).

Persson, Hasse. "Sebastião Salgado: de fattigas fotograf." *Foto* (Stockholm), no. 10 (October 1989).

Armand, Pierre. "Sebastião Salgado: Arràt sur l'histoire." *Témoignage Chrétien* (Paris), no. 2364 (30 October –5 November 1989).

Rodes, Salvador. "El fotoperiodisme: Sebastião Salgado: creació fotogràfica i comunicació social." *Avui* (Barcelona) (11 November 1989).

Cheshyre, Robert. "The man who makes us see." *The Sunday Times Magazine* (London) (11 March 1990).

Sarusky, "El hombre de hoy visto por Salgado." *Revolución y Cultura* (Cuba) (September 1988).

Hopkinson, Amanda. "Sebastião Salgado." *British Journal of Photography* (29 March 1990).

Carta, Gianni. "Lentes abertas." *Isto É Senhor* (São Paulo) (25 July 1990).

Guerrin, Michel. "Salgado en solo." *Le Monde,* Sans Visa (Paris) (10 November 1990).

Bloom, John. *Photo Metro* (San Francisco) (November 1990).

Isarrualde, Marcelo. "La fotografía debe ennoblecer al hombre." *Foto Mundo* (Buenos Aires) (February 1991).

"Iceberg under the sea—Sebastião Salgado." *Switch* (Japan) (March 1991).

Thackrey, Susan. "Looking Again." *Camerawork* (San Francisco) (Spring 1991).

Brenna, Susan. "Beyond the image: Hell on Earth." *New York Newsday* (9 April 1991).

Plagens, Peter. "The Storm of the Eye." *Newsweek,* (8 April 1991).

Sabóia, Napoleão. "A força da emoção." *Jornal da Tarde,* Caderno de sábado (24 August 1991).

Sischy, Ingrid. "Good Intentions." *The New Yorker* (9 September 1991).

Harris, Patricia, and David Lyon. "More light on the subject." *Americas* (Washington, D.C.) vol. 43, no. 4 (1991).

Speiser, Iràne. "Sebastião Salgado: Mitgefühl und Respekt." *Photographie* (Düsseldorf) (October 1991).

Cott, Jonathan. "Sebastião Salgado. The Visionary Light." *Rolling Stone* (12–26 December 1991).

Allen, Henry. "Of Beatitudes and Burdens." *The Washington Post* (19 January 1992).

Van Scheers, Rob "Meester van het tegenlicht." *Elsevier* (Amsterdam) (1–4 January 1992).

Faerman, Marcos. "O olhar do artista" *Jornal da Tarde* (1 August 1992).

Ponzio, Ana Francisca. "Salgado conta as histórias de suas imagens." *O Estado de São Paulo* (7 August 1992).

Guimaraes, Helio. "Ilustrada" *Folha de São Paulo* (3 August 1992).

"Imagens de um humanista", *Isto É* (12 August 1992).